THE ART INSTITUTE OF PORTLAND

VARIORUM COLLECTED STUDIES SERIES

Sacred Images and Sacred Power in Byzantium

Dr Gary Vikan

Gary Vikan

Sacred Images and
Sacred Power in Byzantium

VARIORUM

Published in the Variorum Collected Studies Series by

Ashgate Publishing Limited
Gower House, Croft Road,
Aldershot, Hampshire
GU11 3HR
Great Britain

Ashgate Publishing Company
Suite 420
101 Cherry Street
Burlington, VT 05401–4405
USA

Ashgate website: http://www.ashgate.com

ISBN 0–86078–934–9

British Library Cataloguing-in-Publication Data
Vikan, Gary
 Sacred images and sacred power in Byzantium. – (Variorum
 collected studies series)
 1. Art and religion–Byzantine empire 2. Art, Byzantine
 3. Pilgrim badges–Byzantine Empire 4. Icons, Byzantine
 5. Pilgrims and pilgrimages–Byzantine Empire–History
 I. Title
 704.9'482'09495'0902

US Library of Congress Cataloging-in-Publication Data
Vikan, Gary.
 Sacred images and sacred power in Byzantium / Gary Vikan.
 p. cm. – (Variorum collected studies series; CS778)
 Includes bibliographical references and index (hardback: alk. paper).
 1. Art, Byzantine. 2. Art, Early Christian. 3. Devotional objects–
 Orthodox Eastern Church. I. Title. II. Collected studies; CS778.
 N7852. 5 V55 2003
 246'.1–dc21 2003045226

The paper used in this publication meets the minimum requirements of the American National Standard for Information Sciences – Permanence of Paper for PrintedLibrary Materials, ANSI Z39.48–1984. ∞ ™

Printed and bound in Great Britain by TJ International Ltd, Padstow, Cornwall

VARIORUM COLLECTED STUDIES SERIES CS778

B&T

NOW/ON

CONTENTS

This volume contains x + 314 pages

INTRODUCTION

I was fortunate to be a student of the formidable Kurt Weitzman, though neither of us could have guessed in 1970, when I chose my dissertation topic, that his impact on me through his philological approach to iconographic analysis would be transmuted as radically as it has been, into the studies collected in this volume. For the "method" Kurt taught was basically ahistorical, having as its end game the identification of recensional affiliations among the major picture cycles of the middle ages. The one I chose was Pseudo-Ephraim's "Life of Joseph," together with "The Romance of Joseph and Aseneth," and since these texts, as a coupled and illustrated unit, are attested only in three post-Byzantine manuscripts, my early scholarship was very distant from that in which I later came to specialize. The transformation in my outlook, which took the better part of a decade, began with that project. As I followed the trail of my dissertation to Romania, as an IREX exchange fellow (1974–75), I found myself being more attracted to the historical reality of Byzance *après Byzance* than the ahistorical construct of a pictorial recension, whose seventeenth-century Wallachian exemplar seemed to suggest a middle Byzantine archetype by way of a Palaeologan intermediary. Who made these books, why, and for who? – These were questions that interested me much more.

My second piece of good fortune was extended exposure to the scholarship and atmosphere of Dumbarton Oaks, where I was initially hired to do a book of the museum's sculpture holdings, but where I lingered in various positions and projects for ten years (1975–1985). This period was intensely informed and inspired by the scholarship of Peter Brown, and through such non-art colleagues and friends as Ken Holum, Susan Ashbrook Harvey, and John Nesbitt, I was drawn to that meaty-soup world of late antiquity, and within it, to patterns of ritual and belief such as might serve as an armature for organizing the residue of late antique art. During those same years I had the privilege of working with the hundreds of daily-life Byzantine artifacts Dominique de Menil had collected, and through them, to be drawn into what remains for me the seductive world of archaeology and material culture.

The course for my scholarly life had been set by the late 1970s, and my two watershed publications were "The Trier Ivory" article I did with Ken Holum in 1979, published in the *Dumbarton Oaks Papers*, and *Byzantine Pilgrimage Art* of 1982 (here in its updated form, "Byzantine Pilgrim Art"), which I wrote to accompany a small exhibition at Dumbarton Oaks. In the former we tried to tease out the iconographic syntax of an enigmatic ivory against the backdrop of *adventus*

ceremonial in late antiquity, and in the latter I struggled to assemble a menu of material culture that could reveal the earliest centuries of Christian pilgrimage, and to anchor it in the textual tradition and archaeology of the period. Initially, I was especially attracted to the two early Simeons on columns, the stylites, and to the Holy Sepulchre in Jerusalem. For these, the evidence is abundant, the questions definitive, and the narrative compelling.

In one of my two favorite pieces, "Ruminations on Edible Icons" of 1985, I took a last look back at recensions and the Weitzman approach, within the context of copying in Byzantine art generally, and the admonition to *mimesis* in Christian life of the period. There then remained for me only to follow the two paths that necessarily lead on from the world of pilgrimage: icons and magic. The former because, as Ernst Kitzinger and others have shown, the emergence of the icon in early Byzantium is inextricably intertwined with the emergence of the objectified holy, whether person, place, or object, and the latter because the workings of pilgrimage *eulogiai* and the workings of amulets form a seamless matrix. If I had any claim to be a pioneer in any field of Byzantine studies, it would be in pilgrimage art, and in the stuff of magic, and perhaps, in the piety of icons. This is where I left off nearly ten years ago, with the piece I did for Kurt's *Festschrift* ("Icons and Icon Piety in Early Byzantium").

A third stoke of good fortune had more to do with my professional life than with my scholarly life. It was, in the late 1970s, an invitation to teach adults, because this obliged me to reconcile the distant world of early Byzantine piety, belief, and material culture with our own world. Out of this grew my interest in the Shroud of Turin, which is first reflected in my 1985 "Ruminations" article, and my attachment to the phenomenon of the post-mortem Elvis Presley, which is reflected in my second favorite article in this volume, "Graceland as *locus sanctus.*" In this, the last piece of significant scholarship that I have done, I have no doubt that I have broken new ground.

Since 1985 I have been in a public fine-arts museum, the Walters, and since 1994 I have been its director. And while I do a very different job from the one I did twenty-five years ago at Dumbarton Oaks, the same perspective informs me. Through our collections, and working with my staff, I struggle to give meaning, a "today meaning," to the art of the past, using as my assembling armature the belief, rituals, and everyday realities, both ancient and modern, that attracted me as a young scholar more than two decades ago, and continue to attract and motivate me today.

GARY VIKAN

Baltimore
January 2003

ACKNOWLEDGEMENTS

Grateful acknowledgement is made to the following persons, institutions, journals and publishers for their kind permission to reproduce the papers included in this volume: The Trust for Museum Exhibitions, Washington, D.C. (I); Princeton University Press, N.J. (II); National Gallery of Art, Washington, D.C. (III); Rizzoli, New York (IV); The Pennsylvania State University Press, Pennsylvania (V); Aschendorffsche Verlagsbuchhandlung GmbH & Co., Münster (VI, VIII); University of Chicago Press, Chicago (VII); The Dumbarton Oaks Research Library and Collection, Washington, D.C. (IX, X, XIV); The Walters Art Gallery, Baltimore (XI, XIII); Otto Harrassowitz, Wiesbaden (XV).

PUBLISHER'S NOTE

The articles in this volume, as in all others in the Variorum Collected Studies Series, have not been given a new, continuous pagination. In order to avoid confusion, and to facilitate their use where these same studies have been referred to elsewhere, the original pagination has been maintained wherever possible.

Each article has been given a Roman number in order of appearance, as listed in the Contents. This number is repeated on each page and is quoted in the index entries.

I

Sacred Image, Sacred Power

The icon is the legacy of Byzantium (A.D. 330–1453), the Christian, East Roman Empire governed from Constantinople. In Greek the word *eikon* simply means "image," and today it is usually understood to mean an abstract religious portrait painted in egg tempera on a gold-covered wooden board (fig. 1). But an icon could also be a mosaic, or even a coin; it could be elaborate or simple, one of a kind or mass produced (Weitzmann, 1978, 13 ff.). What defined an icon in Byzantium was neither medium nor style, but rather how the image was used, and especially, what people believed it to be. An icon was, and in the Orthodox Church remains, a devotional image, one deserving special reverence and respect (*Byzantine Art*, 1964, 269). This is so because an icon is believed to be a *holy* image, one which literally shares in the sanctity of the figure whose likeness it bears. The accepted Orthodox view was succinctly stated nearly twelve centuries ago by St. Theodore the Studite (Mango, 1972, 173):

> Every artificial image...exhibits in itself, by way of imitation, the form of its model...the model [*is*] in the image, the one in the other, except for the difference of substance. Hence, he who reveres an image surely reveres the person whom the image shows; not the substance of the image.... Nor does the singleness of his veneration separate the model from the image, since, by virtue of imitation, the image and the model are one....

In the eyes of Orthodoxy, Christ and his icon, the model and its image, are one. Yet, the divinity of Christ (his *ousia* or "substance," as opposed to his *prosopon* or "person") remains distinct from the wood and paint of the panel, which if covered over loses both picture and holiness. From the point of view of "devotional utility," the panel as a palpable thing therefore necessarily disappears. For on the one hand, because of imitation (the fact that it looks like what people think the historical Jesus looked like), the icon becomes one and the same with what it portrays, whereas on the other, because of veneration (the Christian's devotional attitude toward it), the icon becomes effectively transparent—it is transformed into a "window" or "door" *through* which the worshipper gains access to sanctity. In the words of St. Basil (Mango, 1972, 47), "the honor shown to the image is transmitted to its model."

What does this reveal about the art of icon painting? First, it is remarkable that the icon as a category of object, aesthetic or otherwise, is ignored; there are no qualifications placed on what constitutes an icon, what a good icon is, or a bad one, or how close to the accepted portrait type a painting must come in order to qualify as an icon. Theodore the Studite goes on to note that an icon will lose its "iconness" through obliteration, and thereby revert to base substance, but he begs the more fundamental question of what it takes for substance to become icon in the

I

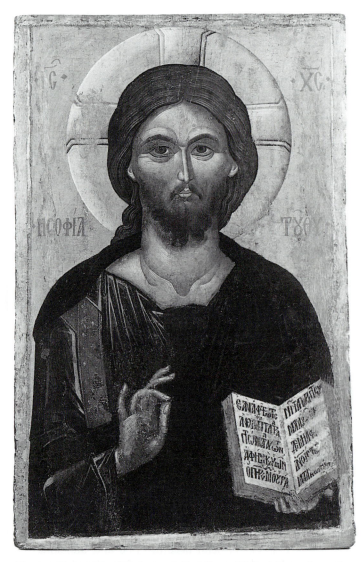

Fig 1. Christ "the Wisdom of God," *ca. 1400. Athens, Byzantine Museum.*

first place. To him and those around him it must have been obvious: an icon was simply what they all *recognized* to be an icon. Term and object were, for them, affectively defined: a painting became an icon at the moment when it began to function as an icon. In this sense, it was created "in the eye of the beholder," which suggests that natural phenomena, like clouds, could become icons too. And in fact, that seems to have been true, at least to judge from stories like that preserved in the diary of a fifteenth-century Spanish visitor to Constantinople named Clavijo, who describes Christians of that city venerating a slab of richly veined marble in Hagia

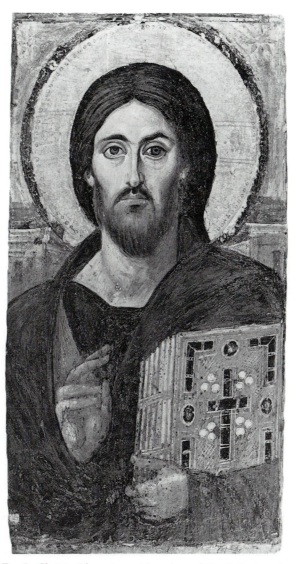

Fig 2. Christ, *6th century. Monastery of St. Catherine at Mount Sinai.*

Sophia that they thought looked like the Virgin and Child with St. John the Baptist (*Clavijo*, 1928, 75):

> These figures as I have said are not drawn or painted with any pigment, nor graven in the stone artificially, but are entirely natural and of its substance; for the stone evidently was formed thus by nature with this veining.... These sacred figures on the stone appear as if standing on the clouds in the clear heaven, indeed it is as though a thin veil were drawn before them....

I

In Byzantium the theory of sacred images and the artistic form they took were closely intertwined; many have called icons "theology in colors." When a Byzantine Christian stood before an icon of Christ he believed himself to be standing face-to-face with his Savior; this, for him, was a sacred place and moment of encounter with God. Frontality and direct eye contact were therefore essential; references to earthly time or "real" space were potentially distracting, and in any case, irrelevant. Gold backgrounds, bust-length portraits, over-large eyes, gestures of blessing, "otherworldliness," timelessness, a sense of transcendental power—these defining characteristics of icons were all dictated by the theology of sacred images and, more specifically, by the nature of the icon experience itself. And so, too, was the intense psychological "dialogue" with the beholder that the style of many icons seems to imply. Christ, through his image, dramatically confronts the worshipper; he sees into the soul to comfort or condemn. "His eyes...," so begins a Byzantine description of an image much like that illustrated in our Figure 2, "His eyes are joyful and welcoming to those who are not reproached by their conscience...but to those who are condemned by their own judgment, they are wrathful and hostile" (Maguire, 1974, 133: Mesarites, ca. 1200). The right side of Christ's face (our left) is open, receptive, and welcoming, whereas his left side—Byzantium's traditional side of judgment and condemnation—is harsh and threatening, the eyebrow arched, the cheekbone accentuated by shadow, and the mouth drawn down as if in a sneer. Christ's judgment, whether comfort or condemnation, is here literally created in the eye and conscience of the beholder.

Not all Byzantine icons are portraits; many instead show Gospel scenes, especially those sacred events evocative of major church holidays, such as Easter, Christmas, and Epiphany. Because most of these icons have a specific story to tell, the figures portrayed must somehow be shown interacting, yet at the same time the image as a whole is subject to the same principles of frontality and timelessness that, much more easily, shaped the format and style of portrait icons. On the restrictive two-dimensional surface of a panel the solution was to suppress anecdotal detail and to set the actors in three-quarter frontal poses, so that in effect they *are* looking out of the picture plane, and thereby engaging the beholder, at least obliquely, in a shared sacred space (Demus, 1947, 6 ff.). Mural icons, on the other hand, were subject to more flexible rules, insofar as their supporting architectural surface need not be flat. The Byzantine response, exemplified by the Annunciation mosaic at Daphni, was ingenious: the Virgin Mary is shown frontally, yet at the same time she faces the Archangel Gabriel across the void created as the squinch which supports them recedes into space— a sacred space now dramatically charged by the spiritual power they share.

What did the theology of sacred images mean for the artist? When a Byzantine painter painted an icon, the model before him and the panel in his hands had to be, in all essential characteristics, identical. Like a scribe transcribing the Gospels, an icon painter was bound by sacred tradition; he could neither add nor take away. For an icon to be an icon it must be easily recognizable; its "image" could no more be subject to change than could a saint, or Christ himself. Thus, neces-

sarily, an icon of Christ "Almighty" from the fourteenth century (fig. 1) is, in all of its most salient qualities, essentially like one from the sixth century (fig. 2); eight hundred years separate the two, but on first view they seem virtually identical. In actuality, however, they are not identical, for Byzantine painters of talent, as these two certainly were, could distinguish themselves even within a strictly circumscribed iconographic tradition, much as scribes, through expert calligraphy, could set themselves apart even in transcribing the Gospels. But by any standard, the icon painter's art was one of subtleties, which strove for perfection only over an extended time. Originality and self-expression as we know and value them in modern art had no counterparts in Byzantium; there were not "better" icons, or those that were judged inferior, nor was there talk of originals or copies. And from the point of view of image theory it could be no other way, since, as Theodore the Studite observed, "every artificial image...exhibits in itself, by way of imitation, the form of the model," and the model is "the person whom the image shows." By definition, then, the real model behind a Byzantine icon was not another icon (that was the proximate model only), but rather the deity or saint represented. This means that every sacred image was a copy, and that none was closer than another to the prototype (Vikan, "Ruminations").

But to view Byzantine art simply as an art of copies is, on the one hand, to misunderstand its broader role in Byzantine culture generally, and on the other, to misrepresent and grossly undervalue its achievement. Continuity through replication was not simply a Byzantine workshop practice, nor even was it distinctive to the theology of sacred images; it was a broadly-based religious ideal governing the actions and relationships of all Christians. Jesus was himself the ultimate prototype, and the individual—by way of chains of "copies," from biblical heros to saints to holy men to local monks—was charged to be his imitator (Brown, 1983). St. Basil gives the following advice (*Saint Basil*, 1961, I, 15 ff.):

> [In the scriptures] the lives of saintly men, recorded and handed down to us, lie before us like living images... for our imitation of their good works. And so in whatever respect each one perceives himself deficient, if he devotes himself to such imitation, he will discover there, as in the shop of a public physician, the specific remedy for his infirmity.

Basil's two key words, image and imitation, are already familiar from icon theory, and this was no accident, for just a few lines later he draws an explicit parallel between the workshop practice of artists and the appropriate mimetic behavior of Christians generally:

> ...just as painters in working from models constantly gaze at their exemplar and thus strive to transfer the expression of the original to their artistry, so too he who is anxious to make himself perfect in all the kinds of virtue must gaze upon the lives of saints as upon statues, so to speak, that move and act, and must make their excellence his own by imitation.

For an artist as for a Christian, copying was both normative and good; indeed, it was among the central ingredients in a millennium of Byzantine piety.

I

Stated in this way it seems as if the icon painter were little more than a craftsman, but this is correct only if icons are judged anachronistically, according to modern aesthetic notions. For while it is true that originality, self-expression, and even beauty were not the icon painter's main goals, other still loftier aims were in their place. An icon was not simply a work of art, it was a door to heaven; but even more than that, an icon was heaven's door to earth—literally, a channel through which Christ, the Virgin, or a saint could exercise sacred power among men. The "spiritual traffic" of sacred images thus moved in both directions, and icons frequently functioned not simply as devotional images, but as miraculous images, for converting the heathen, for preserving the Empire, and especially, for healing the sick (Kitzinger, 1954, 100 ff.). A characteristic icon miracle is recounted in Chapter 118 of the *Life* of St. Symeon Stylites the Younger (A.D. 521—592), a column-dwelling holy man whose pilgrimage shrine near Antioch was renowned for its supernatural healings (van den Ven, 1962/1970): A hemorrhaging woman in Cilicia (i.e. far from the saint's shrine) invokes Symeon's aid with the words: "If only I see your image [icon] I will be saved." How, one wonders, can this be? Because "the Holy Spirit which inhabits Symeon covers it with its shadow." Thus it is through a spontaneous "spiritual infusion" not unlike that of the Incarnation that a picture painted by man is believed capable of healing. Certainly the label "craft" is inappropriate for an art form like this, which opened vistas to heaven and brought heaven's power down to earth; and certainly the makers of this art, anonymous though they were, should not be considered mere craftsmen.

The idea that iconic verisimilitude alone was enough to gain access to sacred power was slow to develop in the Byzantine mind. Only by the sixth and seventh centuries was it well accepted (Kitzinger, 1954, 95 ff.), and this was long after the belief had taken firm root that holy objects (relics) and holy places (pilgrimage sites) could channel and deliver miracles (Delehaye, 1933, 50 ff.; Vikan, 1982, 1 ff.). Moreover, it is remarkable that even at that relatively late period images were often believed sacred only because their substance was believed sacred. This hybrid object type might best be called a "relic-icon," and it came in at least two distinct but closely related forms. On the one hand there were a few famous *acheiropoietai*, icons "not made by human hands," foremost of which was the Mandylion of Edessa: Christ wiped his face with a towel, and the towel miraculously retained his image. It is an icon because of that image, but it is also a relic because of Christ's contact. (And it was the source of miracles, including the defeat of the Persian army at the gates of Edessa in A.D. 544; Cameron, 1981.) On the other hand, there were the many types of pilgrim *eulogiai* ("blessings") that were then becoming popular (Vikan, 1982, 10 ff.). Usually these were small portions of earth, wax, oil, or water which had been sanctified by contact with a relic or holy person, and then mechanically impressed by a stamp (into the solid material itself, or onto the vessel containing the liquid) with an appropriate image of whatever or whoever was the source of the sanctification. They are icons because of that image, but they are also relics because of sacred contact. The most characteristic representatives of this category of relic-icon are Symeon Tokens—hardened bits of earth from the "Miraculous Mountain" of Symeon Stylites, sanctified by direct contact

with the saint (or his column), and stamped with an image of Symeon atop his column.

The surprising fact about the Edessa Mandylion and Symeon Tokens is that both are known to have existed first simply as sacred objects, without images. Averil Cameron (1981) has shown how the Edessa "towel"—which according to early texts was not a cloth at all, but a papyrus letter from Christ to Edessa's King Abgarus—literally "acquired" its sacred image in the later sixth century, long after it had become a popular and potent non-iconic relic. And regarding Symeon Tokens, one need only read the saint's *Life* to discover how frequently his miracle-working earth was dispensed without its stamped icon. For both towel and token, images were associated with sacred power, but this association came only after the fact. Apparently relics without images were good, but relics *with* images were even better. Why? One senses at least part of the answer in the intimate link, even from the earliest years of the cult of relics, between miraculous imagery and the quasi-mystical relic experience. St. Jerome's account of Paula's first encounter with the wood of the True Cross (ca. 400) is typical (Wilkinson, 1977): "she fell down and worshipped...as if she could see the Lord hanging on it." Proximity to a holy object evoked in Paula a profound spiritual experience, and that experience had a strongly visual dimension; one even suspects that her vision was somehow a necessary condition for her experience of the deity's physical presence—a presence which was certainly potential, but perhaps not fully realized, in the relic itself.

The evidence from Symeon's "Miraculous Mountain," about two centuries later, is much more explicit. Chapter 231 of the saint's *Life* describes the misgivings of a father who is told to return home from his pilgrimage with his still gravely ill son to await Symeon's cure (van den Ven, 1962/1970). "The power of God...is efficacious everywhere," assures the saint. "Therefore, take this *eulogia* ["blessing"] made of my dust, depart, and when you look at the imprint of our image, it is us that you will see." The father is being offered—in the form of a Symeon Token— two distinct assurances that his son will eventually be saved: the blessed earth, a well-known *eulogia* whose powers he must already have recognized, and the saint's image impressed on it. Somehow, when they return home and gaze on that image, father and son will in effect be confronted with a vision of the saint himself. But why should that be reassuring? The answer comes later in the same story. The man's third son falls ill and he, too, asks to be taken to the "Miraculous Mountain." But his father recalls the instructions of the saint and assures him that Symeon will come to visit him there, at home, and he will be healed. At this point—assumedly with Symeon Token in hand—the young man gasps and calls out, "St. Symeon, have pity on me." He then turns to his father and cries, "Get up quickly, throw on incense, and pray, for the servant of God, St. Symeon, is before me...." In that moment Symeon appears in a vision, attacks (through his *eulogia*) the demon that has tormented the youth, and saves him.

Other Symeon miracles suggest the same scenario—namely, that a vision of the saint was instrumental in making effective the miraculous powers of his earthen *eulogia*, and that the vision could be induced by a man-made image. And the same

was true at other Early Byzantine *loca sancta* ("holy sites"). As incubation (sleeping near relics) was instrumental to miraculous healing at "Holy Doctor" shrines like those of Sts. Cosmas and Damian, Cyrus and John, and Artemios, so a dream-like vision of the saint was instrumental to successful incubation (Vikan, 1984, 73). And this vision seems most often to have been induced by images of the saint set up around the shrine. The common denominator is clear: seeing the saint through his icon ensured his presence, and his presence ensured the miraculous efficacy of his relic. In other words, the power of the relic was being "triggered" and released by the saint's icon.

But this seems not to have been the sole, or perhaps even the main reason for adding images to relics. One need only survey the iconography of these "added pictures" to discover that most of them share something surprising in common: they repeat distinguishing architectural elements of the relic shrine from which they were issued. This is especially prevalent among the so-called Palestinian Ampullae—small pewter flasks of sixth- to seventh-century date which, having been filled with oil sanctified by contact with the True Cross, were carried home as medico-magical pilgrim *eulogiai* from the Shrine of the Holy Sepulchre in Jerusalem (Vikan, 1982, 20 ff.). Nearly all, as one might expect, bear some imagery evocative of the two major biblical events that had taken place at that famous *locus sanctus*—namely, the Crucifixion and the Resurrection. But surprisingly, most interpose between the two Marys and the Angel in the scene of the Women at the Tomb a small piece of architecture that clearly corresponds in its most salient features (columns, pointed roof, grilles) to what we know the Holy Sepulchre itself looked like at the time. Certainly this was not simply a visual reminder of what the pilgrim had just seen, nor could it have been intended literally to illustrate the Gospel narrative, which describes a simple rock-hewn grave. The point must instead have been to capture, through iconic verisimilitude, a portion of the sacred power, the *eulogia*, which emanated on-site from the Jerusalem shrine.

For the pilgrim the *eulogia* was the spiritually-charged "blessing" received from a holy place, holy object, or holy person (Vikan, 1982, 10 ff.). Most often it came through physical contact, which could either be direct but fleeting, for example, by kissing the wood of the True Cross, or indirect but concrete, for example, through oil that had itself touched the True Cross. Both modes, of course, depended for their spiritual efficacy on the commonly held conviction that sanctity and its power were in some measure transferrable through touch (Vikan, 1982, 5). But there were other, more "iconic" ways of gaining the power of the *eulogia*. For example, an anonymous pilgrim from Piacenza, traveling south through Palestine around 570, describes the following scenes at Mount Gilboa (Wilkinson, 1977, 85):

> ...when we had travelled straight down for twenty miles [*from Jerusalem*] we came to Mount Gilboa, where David killed Goliath.[....] Goliath's resting-place is there in the middle of the road, and there is a pile of wood at his head. There is also a heap of stones—such a mountain of them that there is not a pebble left for a distance of 20 miles, since anyone going that way makes a gesture of contempt by taking three stones and throwing them at his grave.

In the Valley of Gethsemane this same pilgrim lies on each of the three couches upon which Christ had reclined during the night of his betrayal, "...to gain their blessing." Similarly, at Cana he reclines at the wedding table where Christ had reclined, fills with wine one of the two surviving jugs in which Christ had transformed water into wine, then lifts it to his shoulder and offers it at the altar—again, ". . . to gain a blessing." In each instance the Piacenza pilgrim performs an appropriate imitative action at the appropriate *locus sanctus*; the sacred spot provides his stage and the relics his props.

From these and many other similar stories it is clear that the ritualized reenactment of biblical events was a central ingredient in the pilgrim's experience (Vikan, "Pilgrims"). The reenactment might be performed privately, as it was at Mount Gilboa and Cana, or it might be performed communally, as it frequently was in Jerusalem as part of public liturgical processions. On Palm Sunday, for example, a special afternoon service held on the Mount of Olives would conclude with the Gospel account of the Triumphal Entry (Wilkinson, 1971, 74, 132 f.). Then the entire congregation, with palm fronds in hand, would escort the bishop down from the Mount and into the city along the path once followed by Jesus. A similar dramatic reenactment was staged each Sunday morning in the Anastasis Rotunda before the Holy Sepulchre; a late fourth-century Spanish pilgrim, Egeria, describes the scene(Wilkinson, 1971, 125):

> ...at [*the first cock crow*] the bishop enters, and goes into the cave of the Anastasis [*i.e. the Holy Sepulchre*].[...] After [*the recitation of*] three Psalms and prayers, [*the clergy*] take censers into the cave of the Anastasis so that the whole...basilica is filled with the smell. Then the bishop, standing inside the screen, takes the Gospel book and goes to the door, where he himself reads the account of the Lord's resurrection. At the beginning of the reading the whole assembly groans and laments at all the Lord underwent for us....

Such a highly theatrical event must have left the pilgrim with a deep spiritual and visual impression. The service was celebrated on the day of the Resurrection in the shrine which was taken to be its proof, and from the very spot where the angel once announced the good news to the two Marys, a bishop now announces the same news to the assembled congregation.

Such reenactments might be taken as a natural extension of the mandate for Christian *mimesis* expressed by, among others, St. Basil. But more specifically, these were the ritualized actions and the empathic identification which gave shape and meaning to the pilgrim's day-to-day existence; this was how he experienced the *locus sanctus* and this was how he secured for himself the transfer of its *eulogia*. It was as if that congregation in the Anastasis Rotunda, the bishop and clergy, and the Holy Sepulchre itself converged for a moment to become a "living icon" of the Resurrection. For like an icon, they, by virtue of iconographic verisimilitude, collectively joined the chain of imparted sanctity leading back to the archetype, to the sacred biblical event itself. And in doing so they achieved what Theodore the Studite said all icons achieved: identity of image and model. These pilgrims did not merely touch the holy site, nor were they satisfied just to take away its blessed

I

oil; they wanted to be, at least briefly, iconically one and the same with it. And this, at least in part, is how they gained access to its sacred power.

This, too, is one way they took that sacred power home with them: in the form of *eulogia* images that were (as they just had been) iconically one and the same with the *locus sanctus*. These were not simply "triggers" to enhance the efficacy of the relic; they were potent forms of spiritual power in their own right. This is clear from the frequency with which such images began to appear alone, without relics, yet still in contexts which presuppose the presence of sacred power. Especially revealing are many Early Byzantine amulets, which bear iconography originally developed for and popularized among pilgrim *eulogiai*. In this case, the sanctified oil of the Palestinian Ampulla is gone, but the site's distinctive image remains—though now it is simply impressed into a copper disc with a hole at the top to allow for its suspension around the neck as amuletic jewelry. Side by side, amulet and *eulogia* look much the same, but what has happened to distinguish them is profound in its implications for the cult of sacred images. For the sanctity and miraculous power formerly thought transferrable only through physical contact is now believed transferrable simply by iconic verisimilitude. The theology of sacred images implicit in such objects is the same as that explicit in the contemporary *Life of Symeon Stylites*: "If only I see your image [icon] I will be saved...[for] the Holy Spirit which inhabits Symeon covers it with its shadow." Relics have helped to give birth to icons, and those icons—now fully liberated from their relics—are free to function and develop on their own.

Bibliography

P. Brown, "The Saint as Exemplar in Late Antiquity," *Representations*, 1/2 (1983), 1–25.

Byzantine Art: An European Art, Athens, Zappeion Exhibition Hall, 1964 (Athens, 1964) (exhibition catalogue).

A. Cameron, *The Sceptic and the Shroud*, Inaugural Lecture in the Department of Classics and History, King's College, London, 29 April, 1980 (London, 1980).

Clavijo: Embassy to Tamerlane, 1403–1406, The Broadway Travellers, G. Le Strange, trans. (London, 1928).

P. Delehaye, *Les origines du culte des martyrs*, Subsidia hagiographica, 20 (Brussels, 1933).

O. Demus, *Byzantine Mosaic Decoration: Aspects of Monumental Art in Byzantium* (London, 1947).

E. Kitzinger, "The Cult of Images in the Age Before Iconoclasm," *Dumbarton Oaks Papers*, 8 (1954), 83–150.

H. Maguire, "Truth and Convention in Byzantine Descriptions of Works of Art," *Dumbarton Oaks Papers*, 28 (1974), 113–140.

C. Mango, *The Art of the Byzantine Empire: 312–1453*, Sources and Documents in the History of Art Series (Englewood Cliffs, N.J., 1972).

Saint Basil, The Letters, R. J. Deferrai, ed. and trans., Loeb Classical Library (Cambridge, Mass., 1961).

P. van den Ven, *La vie ancienne de S. Symeon Stylite le Jeune(521–592)*, Subsidia hagiographica, 32 (Brussels, 1962 [I], 1970 [II]).

G. Vikan, "Ruminations on Edible Icons: Originals and Copies in the Art of Byzantium," forthcoming in *Studies in the History of Art*.

I

G. Vikan, "Pilgrims in Magi's Clothing: The Impact of *Mimesis* on Early Byzantine Pilgrimage Art," forthcoming in *The Blessings of Pilgrimage*, R. Ousterhout, ed.

G. Vikan, "Art, Medicine, and Magic in Early Byzantium,"*Dumbarton Oaks Papers*, 38 (1984), 65–86.

G. Vikan, *Byzantine Pilgrimage Art*, Dumbarton Oaks Byzantine Collection Publications, 5 (Washington, D.C., 1982).

K. Weitzmann, *The Monastery of Saint Catherine at Mount Sinai. The Icons, Volume One: From the Sixth to the Tenth Century* (Princeton, 1976).

K. Weitzmann, *The Icon: Holy Images Sixth to Fourteenth Century* (London, 1978).

J. Wilkinson, *Jerusalem Pilgrims Before the Crusades* (Warminster, 1977).

J. Wilkinson, "The Tomb of Christ: An Outline of its Structural History," *Levant*, 4 (1972), 83–97.

J. Wilkinson, *Egeria's Travels* (London, 1971).

1: Courtesy of the Byzantine Museum; 2: After Weitzmann, 1976, Bl

II

Icons and Icon Piety in Early Byzantium

Kurt Weitzmann's encounter with the icons in the monastery of St. Catherine at Mount Sinai, at about midcareer, had a profound impact on the direction of his scholarship. After that he often sought out among the Sinai icons new evidence bearing on unresolved iconographic and stylistic questions. It was in this spirit that, in 1974, he wrote "*Loca Sancta* and the Representational Arts of Palestine" (*DOP* 28), with the aim of showing how the treasures of Sinai, as an intact Palestinian holy site, could help to clarify the identity of Palestinian art generally and of its lost *loca sancta* more specifically. The thrust of the article was toward iconography, and one of its major contributions was to introduce icons into the old debate over whether the compositions associated with the great Holy Land pilgrimage shrines, as preserved on the Monza and Bobbio ampullae, derived from local monumental murals (Dmitrii Ainalov) or from Constantinopolitan metalwork (André Grabar). Weitzmann revealed that choice to be an artificial and misleading one by establishing the icon as a critical ingredient in the pilgrim's experience—and as such, as appropriate as any other medium (and more so than most) for the creation and dissemination of pilgrimage iconography.

This study in Kurt Weitzmann's honor will also address early icons, and, indirectly, pilgrimage as well, though not from the perspective of iconography but rather from that of piety. Using as its point of departure three familiar icon-related texts from the Lives of the earliest Syrian stylites, each of which presupposes basically the same imagery, it will examine some of the different roles that icons could play in the piety life of contemporary pilgrims, the various forms of icons that those roles presuppose, and the ways in which they might have been iconographically interdependent. Its broader aim will be to establish a typological framework, according to function (piety) as opposed to iconography, style, or medium, for differentiating Early Byzantine icons generally.[1]

[1] K. Holl, "Der Anteil der Styliten am Aufkommen der Bilderverherung," in *Philotesia. Paul Kleinert zum LXX Geburtstag Dargebracht* (Berlin 1907), 51–66, used two of these texts, plus three others relating to Symeon the Younger (Vita, 118, 158; and Vita of St. Martha, 54; see notes 4 and 28 below), to support his theory that it was out of the piety milieu of the early Syrian stylites that the icon emerged. Although Holl was justly criticized for the selectivity of his evidence and the bias in its presentation, most notably by H. Delehaye (*AnalBoll* 27 [1908], 443–445), his basic working assumption, that the notion of "icon" underlying these various texts was a constant and that they could therefore be assembled into a single evolutionary model, was never questioned. Indeed, that presumed continuity of meaning is integral to the evolutionary model for early icons later articulated by André Grabar (*Martyrium* [as in note 35 below]), and elaborated by Ernst Kitzinger ("Cult of Images" [as in note 13 below]). P. Speck, "Wunderheilige und Bilder: Zur Frage des Beginns der Bilderverehrung" in *Poikila byzantina* 11, Varia III (Bonn 1991), 163–247, uses Kitzinger as a foil for his thesis that icon veneration did not emerge in Byzantium before the seventh century. Speck goes against the grain of both the textual and the archaeological evidence presented in this article.

All three texts fall between the early fifth and the end of the sixth century; the passage from Theodoret's *Historia religiosa* on Symeon Stylites the Elder (386–459) may be dated to around 440, the vita of Daniel Stylites (409–493) to about 500, and the vita of Symeon Stylites the Younger (521–592) to around 600.

> Symeon the Elder (Theodoret, *Hist. rel.* 26.11):
>
> They say that he became so well-known in the great city of Rome that small portraits of him were set up on a column at the entrances of every shop to bring through that some protection and security [*phylaken...kai asphaleian*] to them.[2]

> Daniel (Vita 59):
>
> As a thank offering [*hyper de eucharistias*] he dedicated a silver image, ten pounds in weight, on which was represented the holy man and themselves a repentant, exorcised heretic with his family] writing these words below, "Oh father, beseech God to pardon us our sins against thee." This memorial is preserved to the present day near the altar.[3]

> Symeon the Younger (Vita 231):
>
> The power of God...is efficacious everywhere. Therefore, take this blessing [*eulogia*] made of my dust, depart, and when you look at the imprint of our image [*sphragidi tou tupon*], it is us that you will see.[4]

Charisterion

Considered from the point of view of its role in expressing the piety of the individual who dedicated it, the inscribed silver icon showing Daniel Stylites in the company of a repentant heretic is of a type with the icon mentioned, without reference to medium, donor portrait, or inscription, in chapter 158 of the vita of Symeon the Younger:

> Having returned to his house, this man [an exorcised artisan from Antioch], by way of thanksgiving [*kat' eucharistian*] set up an image of him [Symeon] in a public place and conspicuous part of the city, namely above the door of his workshop.[5]

Both icons are votives, dedicated after the fact in acknowledgement of a miracle. Nearly contemporary icons of this sort in mosaic survive (or survived until the fire of 1917) in the church of St. Demetrios, Thessalonike,[6] and these have their counter-

2 *The Lives of Simeon Stylites*, trans. and intro. R. Doran (Cistercian Studies Series 112) (Kalamazoo, Mich. 1992), 75; and P. Canivet, *Le monachisme syrien selon Théodoret de Cyr* (Théologie historique 42) (Paris 1977), 31–35 (for the dating).

3 *Les saints stylites*, ed. H. Delehaye (SubsHag 14) (Brussels 1923), 58 (and livf., for the dating); *Three Byzantine Saints*, trans. E. A. Dawes and N. Baynes (Oxford 1948; reprint Crestwood, N. J. 1977), 42.

4 *La vie ancienne de S. Syméon Stylite le Jeune* (521–592), ed. and trans. P. van den Ven (SubsHag 32/1, 32/2) (Brussels 1962 and 1970), 204–208, 230–235 (and 101*–108*, for the dating).

5 C. Mango, *The Art of the Byzantine Empire, 312–1453* (Sources and Documents in the History of Art) (Englewood Cliffs, N.J. 1972), 134; *La vie ancienne* (as in note 4), 121, 164.

parts among the *Miracula* of the saint, one of which (1.24; early seventh century) tells the story of the prefect Marianos who, having been healed of paralysis, commissioned a mosaic on the exterior of the sanctuary showing the miracle.[7] Similarly, miracle 30 (pre-tenth century) of Sts. Kosmas and Damianos describes a suppliant, after having been healed of a fistula, arranging to have the miracle portrayed "in the church of the saints, in the colonnade at the left, above the entrance to the diakonikon."[8]

Pietistically if not iconographically related are the votive silver eyes (sixth century) discovered with the Ma'art al-Nu'mān Treasure,[9] and their counterpart in the textual tradition, the various body-part votives described by Theodoret (*Graec. affec. cur.*, 8.64; mid-fifth century):

> That they obtained what they so earnestly prayed for is clearly proven by their votive gifts, which proclaim the healing. Some bring images of eyes, others feet, others hands, which are sometimes of gold, other times of wood [silver?]....[10]

In this general category as well would be the (presumably aniconic) votive plaque described by Sophronios at the entrance to the shrine of Sts. Kyros and John (*Mir. 69*, early seventh century):

> I, John, from the great city of Rome, being blind [and] remaining here steadfastly for eight years, through the power of Sts. Kyros and John recovered my sight.[11]

And one would also have to include a significant proportion of the effectively limitless variety of martyrium and *locus sanctus* dedications, from hastily scratched graffiti and volunteer labor, to exotic birds and precious jewelry, to gold or silver donations for the poor—provided that the suppliant's intention (were it knowable) was to acknowledge a blessing received and not to make a down payment on a blessing hoped for.[12]

[6] R. Cormack, *Writing in Gold: Byzantine Society and Its Icons* (New York 1985), 50–94, figs. 23, 27–31.

[7] *Les plus anciens recueils des miracles de saint Démétrius et la pénétration des Slaves dans les Balkans*, vol. 1, *Le texte*, ed. P. Lemerle (Paris 1979), 67; Cormack, *Writing in Gold* (as in note 6), 62f.

[8] *Kosmas und Damian: Texte und Einleitung*, ed. L. Deubner (Leipzig and Berlin 1907), 176; *Sainte Thècle, saints Côme et Damien, saints Cyr et Jean (extraits), saint George* (Collections grecques de miracles), trans. A.-J. Festugière (Paris 1971), 172.

[9] M. Mundell Mango, *Silver from Early Byzantium: The Kaper Koraon and Related Treasures*, exhib. cat., Baltimore, Maryland, the Walters Art Gallery (Baltimore 1986), no. 72.

[10] *Theodoreti graecarum affectionum curatio*, ed. I. Raeder (Leipzig 1904), 217. The reference here is to martyria in general and not specifically to pilgrim shrines.

[11] *Los thaumata de Sofronio*, ed. N. Fernández Marcos (Madrid 1975), 393.

[12] For Early Byzantine votives in general, see H. Leclercq, DACL V/1 (Paris 1922), 1037–1049; B. Kötting, *Peregrinatio religiosa: Wallfahrten in der Antike und das Pilgerwesen in der alten Kirche* (Forschungen zur Volkskunde 33/34/35) (Regensberg and Münster 1950), 398–402; and P. Maraval, *Lieux saints et pèlerinages d'orient* (Paris 1985), 230–233. For many, the quid pro quo basis of donation (before or after the fact) was probably only vaguely understood, and even when its purpose was explicitly in mind, the votive itself might be anonymous. Miracle 36 in the vita of Daniel Stylites records the healing of the elder daughter of the ex-consul Kyros, in thanks for which he had inscribed on the saint's column honorific verses ("Great Symeon's rival he...") which mentioned neither the miracle, nor him, nor his daughter. See *Les saints stylites* (as in note 3), 34; and *Three Byzantine Saints* (as in note 3), 28.

The Daniel icon was set up in the shrine itself, near the altar, whereas that of Symeon was placed over the workshop door of the healed suppliant at some distance from the shrine. The latter, placed "in a...conspicuous part of the city," was clearly intended as a public acknowledgement, as was the mosaic of the paralyzed prefect cured by St. Demetrios, which was set on the exterior of the church, facing the stadium. Both stylite icons were dedicated in response to miracles (exorcisms), though it is not revealed whether imagery or words specifically documented the event on either of them. The Symeon icon earned recognition in the saint's vita because it worked miracles (repelling its attackers), while that of Daniel was thought noteworthy because it evoked the memory of (and in part documented) a miracle.[13]

The Daniel icon and the icon in chapter 158 of the Symeon vita are in effect identified as *charisteria* or "thank-offerings"—as distinct, for example, from *psychika*, which would be proactive offerings dedicated for the salvation of the soul.[14] According to the vita of St. Thekla (*Mir.* 13, fifth century), the general Satornilos presented *"polla...charisteria"*—apparently valuable implements or furnishings—to the saint's sanctuary in acknowledgement of her miraculous intervention on his behalf in battle.[15] The Luxor Treasure silver cross (sixth century) bears the words "Thank-offering [*eucharisterion*] of Taritsene..." and the same votive notion, evoked through the *euchariston...prosenegken* ("in thanks-giving... presented") formula, is otherwise attested from this period on at least two other votive crosses (one silver, one bronze), and on a silver chalice from the Phela Treasure inscribed: "Elpidios, in thanksgiving to the Theotokos, presented [this chalice].... "[16] As in the case of the icon of Daniel, which is said to be "silver...ten pounds in weight," material worth seems typically to have been an important ingredient in the donor's piety, as was the inscription and, at least potentially, the iconography, should it include portraits or specific healing

[13] The miraculous power of the Symeon icon was apparently unrelated to any direct contact with or blessing by the saint. In the case of a Symeon votive icon placed inside an exorcised woman's house (Vita 118), healing power is specifically ascribed to the "overshadowing" of the image by the Holy Spirit which inhabits the saint (*La vie ancienne* [as in note 4], 38*f., 98). On the significance of this passage for the iconophile apologia, see F. Kitzinger, "The Cult of Images in the Age Before Iconoclasm," *DOP* 8 (1954), 117f., 144f.

[14] In the sense of *hyper anapauseos psyches*. See Mundell Mango, *Silver from Early Byzantium* (as in note 9), 5f., where the distinction is drawn, on the basis of inscriptions, among donations given on behalf of the deceased, of the living, as atonement for sins, in thanksgiving, and "in fulfillment of a vow" (in the sense of a request).

[15] *Vie et miracles de Sainte Thècle*, ed. and trans. G. Dagron (SubsHag 62) (Brussels 1978), 324f.

[16] K. Weitzmann and I. Ševčenko, "The Moses Cross at Sinai," *DOP* 17 (1963), 397 n. 48; Mundell Mango, *Silver from Early Byzantium* (as in note 9), 240, nos. 62, 76. It should be noted, however, that while both the Luxor cross and the Phela chalice were "thank-offerings," neither inscription indicates what the donor was thankful for; on the contrary, both couple the donation with wishes for future blessings. Similarly, while the Daniel icon was given as a "thank-offering" for miraculous healing, the icon's inscription ("pardon us our sins") emphasizes atonement:

Within three days the Lord healed them after they had been given oil of the saints to drink. As a thankoffering he dedicated a silver icon....(*Three Byzantine Saints* [as in note 3], 42).

imagery, since, as thank-offerings, their role at or away from the shrine was mainly documentary.[17]

The appearance of the Daniel *charisterion* is suggested by the silver gilt repoussé icon of Symeon Stylites the Elder in the Louvre (Fig. 1; sixth–seventh century) which, like the chalice and crosses, bears the *euchariston...prosenegken* dedicatory formula: "In thanksgiving to God and to St. Symeon, I have offered [this icon]."[18] But probably closer still is a later Georgian icon in silver gilt that includes, in addition to the saint (here, Symeon the Younger) and a dedicatory inscription, a portrait of the donor-suppliant (Fig. 2; early eleventh century).[19]

Thank-offering votives, sometimes inscribed as *charisteria*, were common features at pagan healing shrines—most notably, those of Asklepios—up until the latter fell into disuse, about the time of the appearance of their Christian counterparts.[20] Given in acknowledgement (effectively, as payment) after incubation and successful treatment, many included an image of Asklepios, often with his snake.[21] It is possible, perhaps likely, that the large snake entwining the column on the Louvre Symeon votive, even if inspired by a passage in the saint's vita, functioned symbolically as a generic evocation of ancient healing in the tradition of Asklepios.[22]

[17] The prefect Marianos, healed of paralysis by St. Demetrios and so documented in a votive mosaic on the exterior of the church (see note 7 above), expressed his thanks as well through the donation of gold and silver objects from among his personal possessions, gold coins, and money for the poor and sick. Here one recalls the evidence of the early icons in Rome (La Madonna della Clemenza, the Virgin with Crossed Hands [S. Maria Antiqua]) recently published by Per Jonas Nordhagen, where an image of the Virgin with donor has been so composed and physically modified as to allow for the attachment of precious votives over the Virgin's hand(s). See J. Nordhagen, "Icons Designed for the Display of Sumptuous Votive Gifts," in *Studies on Art and Archeology in Honor of Ernst Kitzinger on His Seventy-Fifth Birthday* (*DOP* 41 [1987]), 453–460.

[18] Paris, Musée du Louvre, no. Bj 2180. Mundell Mango, *Silver from Early Byzantium* (as in note 9), no. 71 (with earlier bibliography); C. Metzger, "Nouvelle observations sur le 'vase d'Emèse' et la 'plaque du Saint Syméon,'" in *Ecclesiastical Silver Plate in Sixth-Century Byzantium*, ed. S. A. Boyd and M. Mundell Mango (Washington, D.C. 1992), 109f. The absence of the distinguishing epithet for Symeon the Younger ("in the Miraculous Mountain") suggests that this is Symeon the Elder (see J.-P. Sodini, "Remarques sur l'iconographie de Syméon l'Alépin, le premier stylite," *MonPiot* 70 [1989], 52). It was said to have been found in northern Syria as part of the Ma'art al-Nu'mān Treasure, with the votive eyes.

[19] Tbilisi, Georgian State Museum of Art. See K. Weitzmann, G. Alibegašvili, A. Volskaja, M. Chatzidakis, G. Babić, M. Alpatov, and T. Voinescu, *The Icon* (New York 1987), illus. p. 102. The donor is Anton, bishop of Tsageri.

[20] Asklepios votives could vary, depending in part on the customs at the particular shrine, from expensive gifts, to animals or cakes, to body parts in various media, to simple tokens, to inscriptions. Like the healed blind man's votive at the shrine of Sts. Kyros and John, and the Marianos mosaic in Thessalonike, some votives were plaques describing and/or depicting the specific cure. See R. Jackson, *Doctors and Diseases in the Roman Empire* (Norman, Oklahoma 1988), 145, 157; and R. J. Rüttiman, "The Form, Character, and Status of the Asclepius Cult in the Second Century C.E. and Its Influence on Early Christianity," Th.D. diss., Harvard University, 1987, 19, 50, 77–84 (for votive inscriptions at the Pergamon Asklepieion using the word *charisterion*), 106–108, 205–211 (for the decline of the cult).

[21] E. Töpperwein, *Terrakotten von Pergamon* (Pergamenische Forschungen 3) (Berlin 1976), 82–86, nos. 373–385; Rüttiman, "Asclepius Cult" (as in note 20), 31, 33, 77–81, 106–108, Appendix III.B.

[22] Suggested by Mundell Mango (*Silver from Early Byzantium* [as in note 9], 241), who cites similarities in format and function between the Symeon plaque and Roman silver votive tablets showing the god within an aedicula (H. B. Walters, *Catalogue of the Silver Plate [Greek, Etruscan and Roman] in the British Museum* [London 1921], 59, nos. 231–236, etc.). While it is not impossible that

II

Eulogia

The passage cited from chapter 231 of the vita of Symeon the Younger refers to an iconically stamped earthen token identified as an *eulogia* or "blessing." A priest has brought his second-born son to the Miraculous Mountain to be cured of an unspecified disease; Symeon blesses the young man but sends him home to await the healing. The father is skeptical, suggesting that they stay near the saint a bit longer, since "the presence at your side assures us a more complete cure." Symeon becomes annoyed and scolds the priest for his lack of faith, but then offers some reassurance:

> The power of God...is efficacious everywhere. Therefore, take this blessing [*eulogia*] made of my dust [*konis*], depart, and when you look at the imprint of our image, it is us that you will see.

The Old Testament notion of blessing evoked by the word *eulogia* was abstract; among the early Christians, however, the term gradually came to be applied to various blessed substances, such as *eulogia* bread, and, eventually, even unblessed objects (e.g., wine, fish) exchanged as gifts among the faithful.[23] But for the pilgrim, specifically, *eulogia* designated the blessing that could be received through sacred contact with a relic, a holy man, or a *locus sanctus*.[24] It could be gained either immaterially, as by kissing the wood of the True Cross, or taken away materially, as in the form of a relic fragment or, more typically, by way of some everyday substance such as earth, oil, wax, or water, which had been blessed through sacred contact. Among the latter are the hundreds of extant early pilgrimage *devotionalia* (tokens, ampullae, flasks), which by virtue of their special origin were believed to be receptacles of sacred power. Valued above all for their presumed amuletic potency, they were used mainly to preserve the pilgrim on his journey homeward and to heal him once he arrived there.[25]

A large, loosely interrelated group of more than two hundred Early Byzantine *eulogia* tokens survives, and many previously unknown examples enter the art market every year.[26] They are identifiable by their size (under 5 centimeters in diameter), medium (fired clay, clay, or wax), technique of manufacture (intaglio stamp), provenance (eastern Mediterranean basin), and by their iconography,

this creature was intended to evoke the male serpent described in miracle 25 of the Greek vita (see Sodini, "Remarques" [as in note 18], 52), such narrative specificity is otherwise unknown among Early Byzantine stylite iconography. The bonds connecting Early Christian healing shrines with the ancient Asklepieion went beyond votives and votive iconography to include the notions of "holy space," contact healing, and the use of seemingly mundane intermediary substances (e.g., ashes or pine nuts) as vehicles for the miraculous. See Rüttiman, "Asclepius Cult" (as in note 20), 61.

[23] A. Stuiber, "Eulogia," *RAC* VI (1966), 900–928.

[24] Kötting, *Peregrinatio religiosa* (as in note 12), 403–413; Maraval, *Lieux saints* (as in note 12), 237–241; for the *eulogia's* manifestation in pilgrimage art, see G. Vikan, *Byzantine Pilgrimage Art* (Dumbarton Oaks Byzantine Collection Publications 5) (Washington, D.C. 1982), 10f.

[25] For the former, see G. Vikan, "'Guided by Land and Sea': Pilgrim Art and Pilgrim Travel in Early Byzantium," in *Tesserae: Festschrift für Josef Engemann* (*JbAC* Ergänzungsband 19 [1991]), 74–92; and for the latter, idem, "Art, Medicine and Magic in Early Byzantium," *DOP* 38 (1984), 65–86.

[26] For a more detailed discussion of the tokens, see G. Vikan, "Two Unpublished Pilgrim Tokens in the Benaki Museum," Θυμίαμα: στη μνήμη τῆς Λασκαρίνας Μπούρα (Athens 1994), 341–346.

which includes Symeon Stylites, various *locus sanctus* scenes, a few amuletic motifs, and occasional portraits of Christ and of the Virgin and child. The token described in chapter 231 of Symeon the Younger's vita probably looked much like that in the Menil Collection, Houston (Fig. 3; sixth–seventh century), which bears around its circumference the words "Blessing of St. Symeon [in the Miraculous Mountain]."[27]

Although iconographically much like the Symeon *charisterion* icon in the Louvre, its function in pilgrimage piety, as an *eulogia* icon, was quite different. In chapter 231 Symeon offers the priest two different assurances that his son's cure will eventually occur: his blessed earth and his image impressed on it. Earth, obviously; but why the image? The answer comes later in the same story, when the priest's third son becomes ill. He, too, asks to be taken to the Miraculous Mountain, but his father recalls the words of the saint and replies, "St. Symeon, my son, has the power to come and visit you here, and you will be healed and you will live." (At this juncture, Symeon's image-bearing earthen *eulogia* is presumably brought into play.) The boy gasps, falls into a trance, and cries out, "St. Symeon, have pity on me." He then turns to his father and shouts, "Get up quickly, throw on incense, and pray, for the servant of God, St. Symeon, is before me...." The conclusion is predictable; Symeon appears to the boy in a vision, attacks the demon that possesses him, and (with his blessed earth) restores the boy to good health.

The critical issue, though, is the image, and the direct role it plays in making real and effective the saint's healing presence away from the shrine. It functions here in a devotional sense to help precipitate the vision of the saint, which is in turn instrumental, through the blessed earth, to the realization of the boy's cure. Interestingly, those few other contemporary references to image-bearing *eulogiai* evoke a similar scenario.[28] In two out of three instances, including chapter 54 of the vita of St. Martha (Symeon's mother), the supplicant, like this priest, is away from the shrine, where an image would be especially critical to making sacred contact with the saint; and in the third instance (St. Artemios, *Mir.* 16), the miracle is triggered by an iconic match between a midnight vision experienced by a supplicant undergoing incubation and the image stamped into the wax *eulogia* he wakes up with the next morning. Again, the image brings the saint and the blessed substance—and not the icon itself—brings the cure.

In this respect the Symeon *eulogia* icon is effectively identical with his artistic representation, in whatever form or forms it might take, at the shrine itself, since both act to stimulate the epiphany that is critical for the saint's miraculous intervention. The mechanism is clearly documented in the *miracula* associated with the Christian incubation centers that began to appear around the eastern Mediterranean basin beginning in the later fourth century—most notably, those of

[27] Houston, Menil Collection, no. II.J3. See Vikan, *Pilgrimage Art* (as in note 24), 27f., fig. 22.

[28] Chapter 54 in the vita of St. Martha (ca. 600; see *La vie ancienne* [as in note 4], 289); miracle 16 of St. Artemios (later seventh century; A. Papadopoulos-Kerameus, *Varia Graeca Sacra* [St. Petersburg 1909], 16f.); and miracle 13 of Sts. Kosmas and Damianos (*Kosmas und Damian* [as in note 8], 134).

Sts. Kosmas and Damianos, and Sts. Kyros and John.[29] The patient needed mysti-
cally to experience a vision of the saint in order for an appropriate diagnosis to be
made and treatment applied; most often this vision happened during incubation,
but sometimes it occurred while the supplicant was fully awake. Significantly, the
figure seen in the epiphany seems usually to have matched in features and
costume the saint as he was portrayed in art, presumably around the shrine.[30] The
saint was recognized (that was critical), because he appeared in his "usual form."
In this respect the silver *charisterion* icon in the shrine of Daniel Stylites might well
have performed a secondary function for other suppliants, analogous to the
function of the image stamped into the Symeon *eulogia*, and to which its precious
metal, donor portrait, and identifying inscription would have contributed
nothing.

Dream visions were critical as well to the healings of Asklepios, and at his
shrines, too, the clients imagined their healer in the form that his "icons" (usually
statues) had sanctioned.[31] Dreams were at once courted and stimulated not only
by art, but by fasting and heavy incense ("the incense of Epidaurus"), concocted
from exotic recipes.[32] The Louvre Symeon votive and the Houston Symeon token
had their functional counterparts in the large and small statues used in the
ancient Asklepieion to induce dream visions. Moreover, the Houston token's
central field bears the inscription "Receive, [O Saint,] the incense [offered] by
Constantine." A near twin to this token, in the Museo di San Colombano, Bobbio,
shows in the same central location "Receive, O Saint, the incense, and heal all."
On both tokens a suppliant kneels before the column while another climbs toward
the saint on a ladder with a censer in his hands. For these suppliants, incense
undoubtedly played a propitiatory role complementary to prayer as it rose
heavenward. But perhaps at the same time, as in the Asklepieion, it functioned as
a mild hallucinogen, to help precipitate the saint's epiphany. An incense-vision
link is at least suggested in chapter 231 of Symeon's vita, wherein the young man
cries out to his father to "Get up quickly, throw on incense, and pray, for the
servant of God, St. Symeon, is before me...."

In response to their role in donor piety, *charisteria* icons would tend to be
intrinsically valuable, and to bear an inscription and perhaps actual portraits of
suppliants, either as donors or as players in a miraculous *tableau vivant*. Such
icons would usually be prominently displayed. By contrast, *eulogia* icons would
characteristically be made of earth or wax, or, if for blessed liquids, terracotta or
pewter; they would be mass produced, small, private, and anonymous. But
although clearly distinct in function and form, these two categories of icons

[29] See C. Mango, "Healing Shrines and Images," an as yet unpublished paper delivered at the
1990 Dumbarton Oaks Spring Symposium. Professor Mango kindly made his paper available to me
in typescript. For the visionary dimension of incubation, see G. Dagron, "Holy Images and
Likeness," *DOP* 45 (1991), 31–33.

[30] Mango, "Healing Shrines" (as in note 29); Dagron, "Holy Images" (as in note 29), 31 n. 31.

[31] Rüttiman, "Asclepius Cult" (as in note 20), 79f.; R. Lane Fox, *Pagans and Christians* (San
Francisco 1986), 158.

[32] Lane Fox, *Pagans and Christians* (as in note 31), 152

probably had direct iconographic links. Indeed, in light of the frequency with which seemingly specific though unidentified suppliants appear with the saint in *eulogia* icons,[33] one could easily imagine that these inexpensive, mass-produced items had been modeled iconographically after more ambitious and complex *charisteria* icons displayed around the shrine. A stamped earthen token from the shrine of Symeon the Elder, inscribed "Mar Shem'ōn" in Syriac (Fig. 4; sixth–seventh century),[34] and showing a pair of suppliants to each side of the column, is remarkably similar to the Georgian votive already discussed (Fig. 2), and basically matches what one might imagine the Daniel *charisterion* looked like, with the repentant heretic and his family beside the column. Such a scenario would explain the anomalous presence on the Houston *eulogia* (Fig. 3) of the name "Constantine." Does it make sense to imagine that a certain Constantine, otherwise unidentified, had a pilgrim stamp custom made for himself? Or would it not be more logical to suppose that it was modeled after an admired precious metal or perhaps mosaic votive icon made for a more fully identified Constantine and dedicated in the shrine? The latter possibility would explain why the Bobbio token noted above is a virtual twin, compositionally, to the Houston specimen, differing only in that its invocation, "Receive, O Saint, the incense...," substitutes the generic and therefore more *eulogia*-suitable "and heal all" ending for what on the Houston token is the more *charisterion*-suitable "offered by Constantine."

Phylakterion

The passage in Theodoret mentioning the custom in Rome and, by implication, elsewhere of setting up "small portraits" of Symeon at workshop doors has always been something of a puzzle, since it evokes a power-infused image of a saint, aided neither by accompanying relic nor *eulogia*, nearly a century and a half before what is usually thought to be the efflorescence of the Byzantine icon.[35] But the puzzle need not exist, since from the contemporary user's point of view this fifth-century doorpost "icon" is quite different, pietistically and in terms of the image tradition to which it belongs, from those icons of the later sixth century that it seems, almost impossibly, to anticipate. The contrast between Theodoret's passage on Symeon the Elder (*Hist. rel.* 26.11; ca. 440) and chapter 158 of the vita of Symeon the Younger (ca. 600) is most revealing:

[33] G. Vikan, "Pilgrims in Magi's Clothing: The Impact of Mimesis on Early Byzantine Pilgrimage Art," in *The Blessings of Pilgrimage* (Illinois Byzantine Studies 1), ed. R. Ousterhout (Champaign 1989), 97–107; idem, "Guided by Land and Sea" (as in note 25).

[34] Toronto, Royal Ontario Museum, no. 986.181.84. I owe this reading to Susan A. Harvey. See E. Dauterman Maguire, H. P. Maguire, and M. J. Duncan-Flowers, *Art and Holy Powers in the Early Christian House* (Illinois Byzantine Studies 2), exhib. cat., Urbana, Illinois, Krannert Art Museum (Urbana and Chicago 1989), no. 127.

[35] See A. Grabar, *Martyrium. Recherches sur le culte des reliques et l'art chrétien antique*, vol. II (Paris 1946), 343–357; Kitzinger, "Cult of Images" (as in note 13), 115–128; and G. Vikan, "Sacred Image, Sacred Power," in *Icon*, ed. G. Vikan (Washington, D.C. 1988), 18f.

> They say that he became so well-known in the great city of Rome that small portraits of him were set up on a column at the entrances of every shop to bring through that some protection and security [*phylaken...kai asphaleian*] to them.

> Having returned to his house, this man [an exorcised artisan from Antioch], by way of thanksgiving [*kat' eucharistian*], set up an image of him [Symeon] in a public place and conspicuous part of the city, namely above the door of his workshop.

Both texts involve artisan-suppliants away from the shrine, and, true, both involve images set at or over the entrance to artisans' workshops. But significantly, while the later image is placed there (*en demosioi kai emphanei topoi tes poleos*) as a publicly visible thank-offering, with all that implies about *charisteria*, the early one is set up to obtain "protection and security" (*phylaken...kai asphaleian*), a role that carries quite different implications.[36]

The pervasive pre-Christian tradition of miraculous (magical) doorway protection is most familiar in the form of floor mosaics of the evil eye. By the fifth century, however, the same prophylactic effect was being achieved through a variety of Christian symbols, words, and letters, including the cross, the *chrismon*, and the *chi-mu-gamma* formula; through such patently amuletic biblical texts as Psalms 90 and 120; and through several purely magical shapes, among them eight-pointed stars and whorls.[37] Some of the evidence is preserved among the magical papyri, but most is to be found on house and shop lintels in northern Syria. In this same "piety arena" of *prophylactica*, images of Symeon Stylites occupy an unusual position, insofar as this saint, almost to the exclusion of all others in that region and period, appears in what often seems to be an explicitly apotropaic role on church exteriors, reliquaries, stelae of various sorts, and on chancel panels, one of which (Fig. 5; Refāde) bears the date 489 and the words: "Christ, protect [*phylaxi*] your servant Kosmas."[38] Corroboration comes in the form of a familiar but still poorly understood category of stamped glass pendants popular around the east

[36] Both Van den Ven (*La vie ancienne* [as in note 4], 121 n. 6) and J. Lafontaine-Dosogne (*Itinéraires archéologiques dans la région d'Antioche. Recherches sur le monastère et sur l'iconographie de s. Syméon Stylite le Jeune* [Bibliothèque de *Byzantion* 4] [Brussels 1967], 174f.) interpreted these as parallel passages, as did Holl (see note 1 above). Lafontaine-Dosogne rationalized the chronological problem by confining Theodoret's description to Syrians in Rome, and using the two passages to "measure ainsi le chemin parcouru sur la voie de l'iconophile."

[37] J. Engemann, "Zur Verbreitung magischer Übelabwehr in der nichtchristlichen und christlichen Spätantike," *JbAC* 18 (1975), 22–48; Dauterman Maguire, Maguire, and Duncan-Flowers, *Art and Holy Powers* (as in note 34), 1–24. See also W. K. Prentice, "Magical Formulae on Lintels of the Christian Period in Syria," *AJA* 10 (1906), 137–150; and, for evidence of syncretistic magical doorway protection among the papyri, *Papyri graecae magicae: Die griechischen Zauberpapyri*, ed. and trans. K. Preisendanz, 2d ed. (Stuttgart 1974), 210f.

[38] Refāde, chancel panel. See G. Tchalenko, *Villages antiques de la Syrie du Nord*, vol. II (Paris 1958), 16f., no. 15, pl. CXLIV. For an overview of these reliefs and related Symeon items of the later fifth to early sixth century, see V. H. Elbern, "Eine frühbyzantinische Reliefdarstellung des Älteren Symeon Stylites,"*JDAI* 80 (1965), 280–304 (esp. 303f); Tchalenko, *Villages*, 16–18 (H. Seyrig), figs. 8, 9, 13–20; and Sodini, "Remarques" (as in note 18), 29–32. That Symeon the Elder is specifically represented is indicated by the object's early dating, by that saint's dominance of this genre of asceticism in the fifth century, and by the appearance on some of the reliefs of the identifying "St. Symeon" inscription.

Mediterranean basin from the later Roman period at least through the fifth century, and on which stylite (Symeon) images are unusually conspicuous (Fig. 6).[39] And even from a cursory analysis of the range of iconography of these pendants, including Old Testament salvation scenes, the striding lion with crescent, Medusa, Helios and Selene, and the *chrismon*, it is clear that their role was more specifically amuletic than decorative.[40]

Very abstractly rendered, these fifth-century Symeon "portraits" were at once compositionally assimilated to the cross and substantively assimilated to the sacred power that the cross was believed to convey—as was the saint himself, through his mimetic cruciform *stasis* on the column.[41] The juxtaposition of the basalt stela of Symeon from Gibrin in the Louvre (Fig. 7; *Abraamis Azizon / Hagios Symeones*) with a contemporary Syrian/Palestinian amulet bearing a conflated image of Christ and the Cross (Fig. 8) makes this explicitly clear.[42]

This, in the fifth century, was how Symeon imagery was understood: whether worn around the neck, carved into the facade of a church, or set up at the doorpost of a workshop or home, the image was there not for devotion or documentation, but for protection. Like the typical *charisterion* icon of the next century, this Symeon *phylakterion* image would be prominently displayed, but unlike a *charisterion* it would tend to be iconographically anonymous and highly simplified. What counted was neither representational accuracy nor the record of a specific event, but rather that the image functioned effectively in the world of power signs, which were usually simple and easily recognizable, like the evil eye, the *chrismon*, and the pentalpha. In this respect, the *phylakterion* icon was more like the *eulogia* icon (for which, however, some naturalism seems to have been valued); but while the *eulogia* was instrumental to the working of a miracle by the accompanying blessed substance, the former was miraculous in its own right.[43]

[39] Location unknown. See J. Lassus, "Images de stylites," *BEODam* 1 (1931), 75, no. X, pl. 19. For others, see Lafontaine-Dosogne, *Itinéraires archéologiques* (as in note 36), 158, 171f., figs. 95–97.

[40] For some representative examples of the genre, see *Objects with Semitic Inscriptions, 1100 B.C.–A.D. 700, Jewish, Early Christian and Byzantine Antiquities*, sale catalogue, Frank Sternberg, Zurich, Auction XXIII, 20 November 1989 (Zurich 1989), 75–78, nos. 264–296.

[41] For the *stasis* of the stylites, see Van den Ven, *La vie ancienne* (as in note 4), 20 n. 2; and Lafontaine-Dosogne, *Itinéraires archéologiques* (as in note 36), 184.

[42] Paris, Museé du Louvre, no. MA 3466. See É. Coche de la Ferté, *Antiquité chrétienne au Musée du Louvre* (Paris 1958), no. 5, fig. p. 10; and Elbern "Reliefdarstellung" (as in note 38), 284f., fig. 3. Baltimore, the Walters Art Gallery, no. 54.2666; unpublished, but for similar amulets, see Tchalenko, *Villages* (as in note 38), 18f., fig. 12; and C. Bonner, *Studies in Magical Amulets, Chiefly Graeco-Egyptian* (Ann Arbor and London 1950), 306, no. 318. The Holy Rider appears on the other side of the amulet. Interestingly, this Christ/cross motif takes the place that on other such (very popular) amulets, is occupied by the evil eye. On the prophylactic powers of the cross at this period, see Dauterman Maguire, Maguire, and Duncan-Flowers, *Art and Holy Powers* (as in note 34), 18–22. A Syrian lintel inscription (Engemann, "Magischer Übelabwehr" [as in note 37], 42) makes the cross-evil eye interchangeability explicit: "Where the cross is set in front, envy has no power."

[43] The boundary between the *phylakterion* image and the *eulogia* image was likely a porous one. The stylite sometimes portrayed on Early Byzantine glass cruets—which presumably were containers for "blessed" liquid—is in its simplicity of the type on stelae, church facades, and glass pendants. But was its role on the cruets the same, or was it there, like the Symeon token image, to stimulate a vision—or perhaps both?

Finally, while the *charisterion* icon would have been made in response to the exercise of miraculous power (and might, after the fact, act miraculously), and the *eulogia* icon would have been made to help precipitate a miracle, the *phylakterion* icon, by definition, would have been created to be the source of it. Of the three, the *phylakterion* icon was the most closely interwoven with pre-Christian traditions, since it was effectively interchangeable with and complementary to its pagan or Jewish counterpart. Much as one set up little images of Symeon in workshops to repel danger, one set up, according to the magical papyri, little images of Hermes in workshops to attract business:

> *Business spell*: Take orange beeswax and the juice of the aeria plant and of ground ivy and mix them and fashion a figure of Hermes having a hollow bottom, grasping in his left hand a herald's wand and in his right a small bag. Write on hieratic papyrus these names, and you will see continuous business "[magical names]....Give income and business to this place, because Psentebeth lives here." Put the papyrus inside the figure and fill the hole with the same beeswax. Then deposit it in a wall, at an inconspicuous place....[44]

Image and miracle (or magic) are central to each of these three stylite texts, but the notion of "icon" and the piety that motivated it are distinct in each case, as is the material form that the image characteristically took to suit that function. What does this imply about the history of "the icon"? That perhaps there is no such thing, for that period at least, but that there is rather a history of the *charisterion*, of the *eulogia*, and of the *phylakterion*—each of which could be, and probably usually was, *aniconic*. Iconographically, the three could look alike, and to the extent that one was modeled on (or stood in for) another, which likely happened, their histories are intertwined. One imagines the *phylakterion* image came first, before the mid-fifth century, followed soon thereafter by *charisteria* icons, with their portraits, inscriptions, and specific narrative iconography. The devotional sort of image coupled with the substantive *eulogia* seems to be later, since its textual attestations all fall in the later sixth and seventh centuries.

In the Middle Byzantine period, when the iconography of Symeon the Younger was revived during the reoccupation of the area of Antioch (969–1074), the *eulogia* notion was no longer part of the piety equation (Fig. 9; late tenth–eleventh century):[45] "blessed" earth was replaced by cast lead, and the miracle-seeking suppliants were transformed into Symeon's mother, Martha, and his chief disciple, Konon, arranged beside the column in a Deesis-like configuration. Late Antiquity's rich and varied tradition of *phylakteria*—of magical symbols, words, and phrases— was by this time all but exhausted, and the *eulogia* image, now without "blessed" substance, was disempowered and, with the *charisterion*, assimilated into the mainstream of Middle Byzantine icon piety.

[44] *The Greek Magical Papyri in Translation*, ed. H. D. Betz, vol. I (Chicago and London 1986), 81 (*Papyri graecae magicae* [as in note 37], IV.2359–72).

[45] Houston, Menil Collection, no. II.J4. See Vikan, "Art, Medicine and Magic" (as in note 25), 73f., fig. 7. It is inscribed: "Blessing of St. Symeon the Miracle-Worker." For the genre, see P. Verdier, "A Medallion of St. Symeon the Younger," *BClevMus* 67 (1980), 17–27; and Sodini, "Remarques" (as in note 18), 35f.

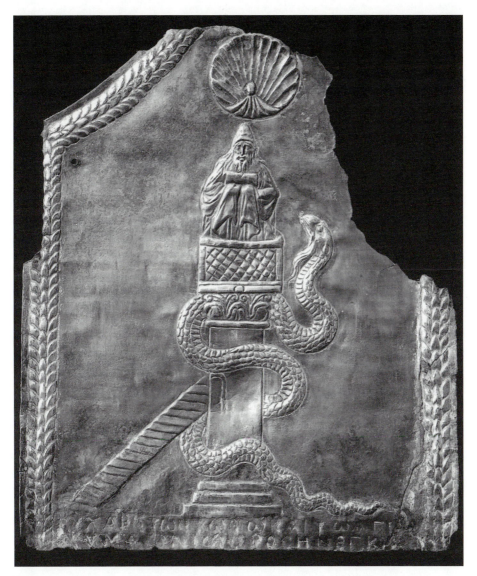

Fig. 1. Paris, Louvre, no. Bj 2180, silver gilt votive icon of Symeon Stylites the Elder.

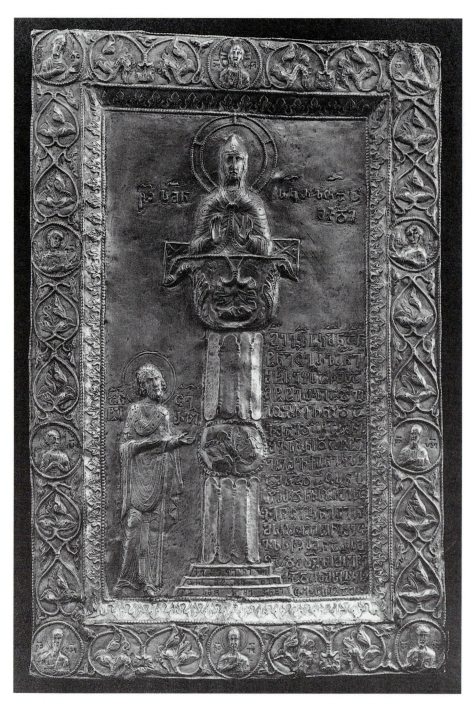

Fig. 2. Tbilisi, Georgian State Museum of Art, silver gilt votive icon of Symeon Stylites the Younger.

Fig. 3. Houston, Menil Collection, no. II.J3, terracotta *eulogia* token of Symeon Stylites the Younger.

Fig. 4. Toronto, Royal Ontario Museum, no.986.181.84, terracotta *eulogia* token of Symeon Stylites the Elder.

Fig. 5. Refãde, stone chancel panel with Symeon Stylites the Elder.

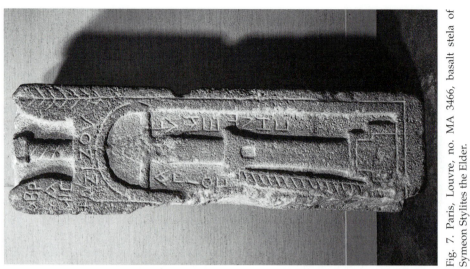

Fig. 7. Paris, Louvre, no. MA 3466, basalt stela of Symeon Stylites the Elder.

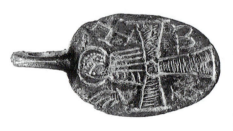

Fig. 8. Baltimore, Walters Art Gallery, no. 54.2666, bronze amulet with Christ and the Cross.

Fig. 6. Location unknown, glass amulet with Symeon Stylites the Elder.

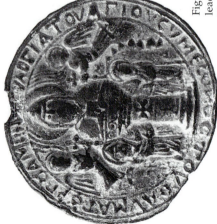

Fig. 9. Houston, Menil Collection, no. II.J4, lead medallion of Symeon Stylites the Younger.

III

Ruminations on Edible Icons:
Originals and Copies in the Art of Byzantium

The art of Byzantium is distinguished perhaps above all else by its remarkable conservatism. A Saint Sergios of the sixth century is basically like one of the fourteenth; a Christ Pantocrator in a dome mosaic is, save for size and medium, virtually identical with one of an ivory triptych or a gold coin. This essay will address a few of Byzantium's most characteristic model-copy relationships in terms of the presumed motives for the copying processes; it will also examine the underlying values and beliefs implied by that process and product.

This discussion will begin with the relatively common, basically quite simple model-copy relationship epitomized by the juxtaposition of two miniature paintings, one of the twelfth century (fig. 1) and one dating around 1300 (fig. 2).[1] At least a portion of the iconography of Byzantium was transmitted from generation to generation substantially unchanged along rootlike stemmata very much like those governing the transmission of texts.[2] This process is most clearly traced in cycles of narrative text illustration to books of the Bible. The hypothetical scenario is straightforward. At some point a scribe or illuminator iconographically rendered the biblical text using a set of narrative, cartoonlike vignettes such as these. This first narrative picture cycle (the "archetype") in turn served as the root of a centuries-long family tree comprising copies, and copies of copies, usually within the context of manuscript illumination but occasionally in other media as well. The result was that Byzantine narrative iconography maintained its integrity and momentum, even after having been physically separated from its text of origin.

Illustrated in figures 1 and 2 are miniatures from a pair of well-known picture cycles occupying the same branch of the stemmatic family tree to which belong the illustrated Byzantine Octateuchs.[3] This particular vignette illustrates several verses from chapter sixteen of Numbers, the fourth of the eight Old Testament books comprising the Byzantine Octateuch. The episode describes how three among the congregation of Israel rebel against the leadership of Moses and Aaron and as punishment for that rebellion are swallowed up by the earth along with all their household. Two of the three, Dathan and Abeiram, are clearly distinguished atop the heap of humanity, livestock, and buildings disappearing into a cleft in the earth at the lower right; the younger of the two raises an arm over his head to shield himself against the powerful rays emanating from the hand of God at the top center. Moses passively stands at the left, gesturing as though to condemn the doomed rebels, while the righteous elders of his congregation appear at the center

in various agitated poses; one seems to be pleading with Moses, another is clearly weeping, and a third throws up his arms in despair.

In overall composition and minute details of gesture, clothing, and color selection these two miniatures are virtually identical. Indeed the later miniature, along with its entire picture cycle, was directly copied from the twelfth-century picture cycle;[4] a comparable level of fidelity of copy to model may thus be traced through the scores of scenes they share. That both model and copy survive is quite unusual. The model-copy process to which these two miniatures attest, however, was in no way unusual; this was the modus operandi for the production of much of Byzantium's narrative iconography. This process was, moreover, the basis for its own art-historical methodology, which for several decades Kurt Weitzmann taught at Princeton University. His students first learned of the basic existence of iconographic stemmata and then of an essentially philological method of picture criticism whereby it could be documented. The goal of such analysis, beyond mere documentation, was threefold: first, to establish genealogical relationships among all surviving representatives of a given tradition (assuming that fidelity to text was gradually lost over time through copying and that cycles with "better iconography," therefore, had priority in the family tree); second, to identify innovative qualities characteristic of any one picture cycle within that tradition and to interpret those innovations against the culture and history of their time; and third, to reconstruct as much as possible from all surviving representative picture cycles the breadth and detail of the lost archetype.

This methodology was painstaking, and for some, not easily mastered. In gaining an understanding of this methodology, however, one can easily overlook a fundamental question posed by the very evidence this approach was designed to master; namely, the question of motive. Why were the copies made in the first place? Why, when it came to narrating the biblical story in pictures, did the Byzantines so consistently choose imitation over invention? For the art historian's counterpart, the biblical philologist, this question simply does not exist; the text of the Book of Numbers was copied and recopied with absolute fidelity because it was believed to have been given by God to Moses on Mount Sinai. But these picture cycles, of course, were not, and any number of different ways of rendering the punishment of Dathan and Abeiram were possible, one no less iconographically valid than the other. For such major biblical books as Genesis there are multiple surviving recensions, each iconographically distinct from the other and possessing its own stemma. Moreover, within each of these iconographic stemmata is encountered a phenomenon unparalleled among sacred texts. Over time a significant portion of the original set of episodes will be reduced so that characteristically the further one descends through the roots of an iconographic tradition, the shorter its picture cycle becomes.[5] Pictures such as these clearly were not considered sacred and inviolable; there is little about them that would qualify as iconic, and they surely were not objects of veneration; yet they were copied and recopied over generations. Why?

Insofar as I ever attempted to answer this question, I did so assuming that such copying took place mainly for convenience sake. I somehow imagined the

manuscript illuminator working side by side with the scribe and, when obliged to illustrate a text, either copying over the scribe's shoulder or running off to a well-stocked library to find a manuscript with an appropriate model picture cycle. This same basic scenario I imagined for ivory carvers, mosaicists, and icon painters as well. After all, it saved them the trouble of reading the text themselves and inventing their own picture cycle, and it seems not to have offended the sensibilities of patrons. I assumed (and still assume) that whoever paid for the later manuscript (fig. 2) was fully satisfied in receiving a set of miniature paintings virtually identical to that in the earlier manuscript (fig. 1). In sum, then, my thinking was this: artists, working for patrons oblivious to modern notions of originality, acted out of convenience.

I would now like to consider quite a different sort of Byzantine model-copy relationship: the one posed by small objects of personal devotion like the one-inch-square cast-bronze icon of the Virgin and Child illustrated in figure 3 [6] Such pieces were typically designed in conscious imitation of iconic types otherwise familiar on grander scale and in more expensive media (for example, fig. 4).[7] They were usually manufactured in multiples, of bronze, lead, or glass, by means of reusable molds or dies.[8] This quite literally was Byzantine art in mass production and as such was a vastly more common and available part of daily life than were illustrated biblical manuscripts. Compared with their models, objects like these had two distinct advantages: they were portable and inexpensive. Since portability could easily be achieved in gold, enamels, and precious stones, it may be assumed that their primary advantage was economic, the goal being to produce as many such items as cheaply as possible. If so, one can legitimately impute to those who made and distributed such objects two quite different, although not necessarily contradictory motives. On one hand, there is the essentially Christian, democratic ideal of putting those things instrumental to religious experience into the hands of as many people as possible, irrespective of their wealth. There is evidence from the world of early Byzantine pilgrimage that the production of such small devotional objects was, in effect, a Church monopoly, and that they were distributed free, as a kind of "sacred dole."[9] The very abundance and variety of these mass-produced implements of piety suggest, however, that their primary point of distribution was not the church but the marketplace and that by implication the primary motivation was less one of idealism than of pure economics—of supply and demand.[10] But whether given away or sold, these objects were mass produced only because there was a great demand for them across a broad spectrum of Byzantine society. And this demand could only have existed as long as the consumer believed he was getting, in his cast-bronze, mass-produced copy, something of comparable spiritual value to the original on which it was based.

We are here finally beginning to penetrate the heart of the model-copy relationship in Byzantium, for we are moving beyond the realm of material evidence and beneath the layer of putative motives toward that substratum of shared values and beliefs on which both rest and of which both are necessarily the reflection. What bound the producer and consumer of the bronze plaquette together and what made the economics of their relationship work was their shared

conviction that the object was no less functional as an icon than was an object like that illustrated in figure 4. The Byzantines believed that the power and sanctity of revered iconic archetypes resided collectively and individually in all copies, regardless of medium, style, aesthetic merit, or expense.[11] The icon should thus not be considered in isolation but rather as the mediating vehicle between the venerating supplicant and the deity or saint represented. The Orthodox view was succinctly stated by Saint Theodore the Studite (ninth century):

> Every artificial image...exhibits in itself, by way of imitation, the form [that is, *charakter*] of its model [that is, *archetupon*]...the model [is] in the image, the one in the other, except for differences of substance. Hence, he who reveres an image surely reveres the person whom the image shows; not the substance of the image....Nor does the singleness of this veneration separate the model from the image, since, by virtue of imitation [that is, *mimesis*], the image and the model are one.[12]

In the eyes of Orthodoxy the icon as an art object virtually disappears. By virtue of mimesis it has become one and the same with the archetype, while by virtue of veneration it has become effectively transparent—that through which one gazes to gain access to the deity. Insofar as the palpability of the object is acknowledged, it is acknowledged as base substance whose "nature" must not be confused with that of the archetype. Theodore continues in his explanation of the essential insubstantiality of icons by introducing the metaphor of a signet ring:

> Or take the example of a signet ring engraved with the imperial image, and let it be impressed upon wax, pitch and clay. The impression is one and the same in the several materials which, however, are different with respect to each other; yet it would not have remained identical unless it were entirely unconnected with the materials....The same applies to the likeness of Christ irrespective of the material upon which it is represented.[13]

For art historians there is much here to consider. First, the icon as an object, artistic or otherwise, is ignored. Second, there are no qualifications placed on what constitutes an icon. In the same text Theodore describes an icon as losing its quality as an icon through obliteration and thereby reverting to a state of base substance, but neither he nor apparently any other Byzantine ever addressed the fundamental question of what it took for a man-made object to become an icon in the first place. An icon was whatever was universally recognized to be an icon. A representation became an icon when it began to function as an icon, and at the same moment it effectively disappeared as a work of art.

A third point is worthy of note: there apparently is no qualitative hierarchy imposed among representations that have qualified as icons. There are no better or inferior icons; no originals or copies. This raises the fourth and most interesting point to emerge from Theodore's discourse; namely, that in his words "every artificial image...exhibits in itself, by way of imitation, the form of its model," and the archetype is "the person whom the image shows." Thus the real model behind a Byzantine icon—its archetype—was not and could never be another icon but rather must be the represented deity or saint. By their own definition every icon ever made in Byzantium necessarily was a copy. There could never be qualitative

distinctions based on relative priority when one exemplar was by definition no less distant than another from the original—since each was, in effect, one and the same with it.

We seem to have come to a dead end in this iconophile dictum of Theodore the Studite; we are awash in a world of "substanceless" copies from which originals are excluded. In the real world of Byzantine piety, however, icons were not such pure and abstract entities. They were palpable objects to venerate and touch, which, despite their base substance and human manufacture, were often thought to possess and exercise miraculous powers. That this was true is substantially due to the fact that very early on, at least by the sixth century, the world of Byzantine icons intersected that of relics.[14] Consider again the bronze plaquette in figure 3. True, its archetype was the Virgin and Child, but its proximate prototype—its model in the art-historical sense—was a famous icon preserved in the Hodegon Monastery in Constantinople.[15] This particular icon was believed to have been painted from life by Saint Luke himself (fig. 5); according to legend, it was brought from Jerusalem to Constantinople in the fifth century by Empress Eudocia. Figures 3 and 5 tell the whole story: the theoretical archetype for both the bronze plaquette and the painted panel in the arms of Saint Luke was the Mother with Child posing before him, but the real model for both bronze worker and miniaturist—although surely at several removes—was a famous painted panel in their own city, around which had formed an acknowledged, conventional portrait type, precisely because it was revered as an icon and powerful relic. Thus the *Hodegetria* icon in the Hodegon Monastery was an original, insofar as it was unique and the art-historical source of multiple copies. This original *Hodegetria*, however, was revered not so much for its beauty or even for its "iconness" as for its "relicness."

According to Theodore the Studite's signet-ring metaphor, the holy image is insubstantial, existing between and independent of the sealing die and malleable medium into which the die is pressed. Not only does Theodore's definition of an icon allow for the production of an infinite number of identical copies, the very metaphor he chooses is one that presupposes such replication. But Theodore's world of icons becomes at once richer and more complex the moment relics are introduced. In the absence of relics an icon's sacred power derives solely from its representational identity with its archetype; the signet-ring metaphor, however, allows for a situation wherein the "forming agent," the die or its equivalent, was itself considered holy; that is, a relic, saint, or deity. The image produced would then have a double measure of sacred power, by virtue of iconic verisimilitude and physical contact with something or someone holy.

The most famous representatives of this special category of relic-icon are the holy textiles believed to have been miraculously imprinted with an image of Christ's face or body. Among the earliest is one formerly preserved in Egypt, at Memphis, and described there around A.D. 570 by an anonymous pilgrim from Piacenza:

> We saw there [in Memphis] a piece of linen on which is a portrait of the Saviour. People say he once wiped his face with it, and that the outline remained. It is

venerated at various times and we also venerated it, but it was too bright for us to concentrate on since, as you went on concentrating, it changed before your eyes.[16]

The most famous holy cloth for the Byzantines was one "invented" about the same time for the city of Edessa, in Syria.[17] This cloth, which like the other seems to have shown only Christ's face, was taken to Constantinople in the tenth century by Emperor Romanos I and venerated as one of the city's prized relics (fig. 6).[18] It is with this now-lost cloth, the so-called Mandilion of Edessa, that some have mistakenly tried to identify the famous textile showing the entire body of Christ; namely, the Shroud of Turin (fig. 7).[19]

Since for our purposes what applies to one of these textiles applies to all, and since the Turin Shroud is the most famous one still to survive, I will direct my comments toward it. Certainly the Shroud had, and still has, sacred power, and certainly that power derives in part from the iconic likeness it bears. But much more than that, it is a world-famous object of veneration and miracle working precisely because it is believed to have touched the body of Christ. The Byzantines were always clear in their understanding of the implications of this, since for them (as for many still today) the sanctity of holy people, objects, and places was in some measure transferable through physical contact. In describing the True Cross, John of Damascus (active eighth century) could as well have been talking about the Shroud of Turin: "So, then, that honorable and most truly venerable tree upon which Christ offered Himself as sacrifice for us is itself to be adored, because it has been sanctified by contact with the sacred body and blood."[20] The implication of this for the question of originals and copies is basic: relic-icons like these, which the Byzantines called *acheiropoietai* (that is, "made without human hands"), derived both their sacred power and their imagery from the mechanical process that brought them into existence. It is as if Theodore the Studite's signet ring were itself holy; the mass-production metaphor still applies, but now each copy has a double portion of sanctity. There would again be no original, except for Christ himself, since each new shroud or mandilion would essentially be identical with and no less potent than the last.

Of course, no Christian believes that Christ more than occasionally wiped his face with a linen cloth, and there could only have been one burial shroud; yet divine impressions—whether of hands, feet, faces, or whole bodies—inevitably suggest mass production, and the general demand for copies of such powerful relic-icons must have been great. By the mid-sixth century an impression of Christ's body was to be seen on the Column of the Flagellation in the Church of Sion at Jerusalem.[21] According to the pilgrim from Piacenza, visitors to the church would mark off the dimensions of Christ's chest, fingers, or hands on little strips of cloth and then wear these strips around the neck as a means of combating disease. I know of no comparable textual or art-historical record of how the sacred power of the Mandilion of Edessa was made available to everyday Byzantine Christians, but I can offer by way of analogy a recent newspaper advertisement for the Shroud of Turin (fig. 8).

The basic idea is quite simple: Send twelve dollars to Richmond, Virginia, and someone there will send you a 2½-foot-long linen replica of the Turin Shroud (which, in fact, is more than fourteen feet long). This, the "Holy Shroud Miracle Cloth," will, in the words of the ad, "bring you everything in life that you desire and so rightly deserve." Drape it over your bed or fold it up in your wallet and "the same miraculous forces that brought about the creation of the Shroud...[will]...go to work for you," bringing you "remarkable cures, good luck, love, money, robust health and happiness," not to mention success "at bingo, the races, card games, the casino and other games of chance." One can get all this, "guaranteed or your money back," for just twelve dollars. From the point of view of Byzantine models and copies, there is something puzzling here. The ad itself bears a replica of a replica, a copy of a copy. What is it about the twelve-dollar Richmond replica that makes it so powerful, while the one at the center of this newspaper ad is apparently worthless? The ad makes no claim that what it offers for sale was ever blessed or that any contact was ever made with the real Turin Shroud; this object has, in other words, no real relic power.[22] What seems instead to be happening is that for purely economic reasons—that is, to encourage demand and restrict supply—a Richmond entrepreneur has chosen to impose his own, very unByzantine "threshold of verisimilitude," below which the sacred power of the archetype is apparently no longer accessible. The modern buyer must simply be convinced that 2½ feet and a linen backing make for a twelve-dollar difference; a Byzantine, of course, would have been fully satisfied with the newspaper clipping or with the image repro-duced with this essay.

That is what could happen to icons when the "forming agent," the signet ring of Theodore's metaphor, was itself believed to be holy. Now imagine the other possi-bility; namely, that the medium into which the die was pressed was thought to possess sacred power.

One of the central phenomena of early Byzantine culture was pilgrimage, and among the central phenomena of pilgrimage was the eulogia.[23] Eulogia is the Greek word for "blessing," and to the pilgrim this meant the blessing received by contact with a holy place, object, or person. It could either be received directly and immate-rially, as by kissing the wood of the True Cross, or it could be conveyed indirectly and materially, customarily by way of a substance of neutral origin that itself had been blessed by such direct contact—as, for example, through flasks of oil that had been touched against the True Cross. Substantive eulogiae like these were generally taken to be apotropaic and often specifically medicinal.[24]

Among the most popular pilgrim eulogiae of the early Byzantine period were Symeon tokens (fig. 9).[25] Symeon tokens are round bits of hardened reddish clay about the size of a quarter; they are named for Saint Symeon Stylites the Younger, a sixth-century Syrian ascetic who spent more than six decades atop a series of ever-taller columns.[26] The ruins of Symeon's shrine (fig. 10) may still be seen atop the so-called Miraculous Mountain, which rises above the Mediterranean Sea, almost ten miles southwest of Antioch.[27] Included in the complex were a cruciform church, monastery, and Symeon's column, the surviving base of which appears at the center of figure 10. Symeon tokens customarily bear a stamped representation of the saint.

Typically, as here, Symeon appears bust-length atop his column; a supplicant is often shown climbing a ladder toward the saint, angels fly forward to offer him crowns, and occasionally, as at the lower left of this token, a large jug is represented as well. Symeon tokens qualified as eulogiae not by virtue of that image but rather because they had been molded out of the red earth found near the base of the column, for this earth, by virtue of its physical contact with the column and thereby with the saint, was thought to be infused with sacred power. Specifically it was believed to be highly efficacious in the treatment of diseases.[28] In chapter 255 of Symeon's *vita* his biographer describes the various ways in which the saint custom-arily worked healing miracles: "For many [the healing] was [accomplished] by [Symeon's words]; for certain others...by visions; and for others again, by the appli-cation of his holy dust."[29] This "holy dust," at once Symeon's token and the very stuff of his Miraculous Mountain, was usually consumed in the process of effecting its curative powers; that is, it would either be rubbed on the body or, with water, taken internally. For example, chapter 232 of the *vita* describes the healing of a certain praetorian prefect named Theodore Pikaridios, who suffered from an intes-tinal disorder. A monk from the Miraculous Mountain named Thomas offered Theodore a bit of Symeon's hair and some of "the dust of his eulogia" and then gave the following prescription: "take some, break them up in pure water, in faith drink them up, and [then] wash yourself with this water, and you will see the glory of God."[30]

Here at last is what seems to be the ultimate Byzantine copy: the edible icon. Here is an object that drew its miraculous powers in part from its stamped iconic image but mostly from the fact that its very medium has been "pre-blessed" with sacred power. Like the Shroud of Turin, the Symeon token is at once a relic and an icon, and, like the Shroud, it has been produced through the mechanical process of stamping. Unlike the Shroud, however, it truly presupposes mass production, and for two obvious reasons: first, because its medium (a mountain of red earth) and its means of production (from reusable, man-made dies) easily allowed for the manufacture of thousands of identical copies; and second, because its very function, which required that it be consumed, literally demanded serial production on a large scale.[31] Pharmaceutically speaking Symeon tokens were the "Bufferin of Byzantium," but at the same time they were Byzantine "art," albeit on its most plebeian level. As art they at first strike us as so many crude copies. But in truth this simply cannot be so, since none among them can be identified as the original, nor can the stamping die or its model, nor can the Magic Mountain or even Saint Symeon himself, since each token was essentially created anew at the moment when image and earth (icon and relic) converged. Either without the other would have been insufficient. In effect these tokens are at once copies without originals, and originals without copies.

What, then, are the common threads that draw together Symeon tokens, holy shrouds, *Hodegetria* icons, and Octateuch miniatures? First, it seems to me that there are basically just two categories of iconography here, nondevotional narrative illus-tration (figs. 1–2, 5–6) and devotional iconic imagery (figs. 3–4, 7–9), and for the latter there are two relic-related subgroups characterized by the likes of shrouds

and tokens. Together, narrative illustration and iconic imagery account for a signif-
icant portion of the totality of Byzantine religious art. Moreover, they share much
in common. The concept of archetype and principle of genealogical succession are
intrinsic to both, and through time the history of each is characterized by extended
model-copy "chains," the individual links of which essentially exist in function of
the chain itself. That is, for narrative text illustration and iconic imagery the
"tradition" will usually dominate the individual work of art—iconographic
creativity and artistic personality will usually defer to the authority of the model.[32]
The result for Byzantium is a millennium of art characterized by continuity through
replication and dominated by mimesis, or imitation.

Why is that so? This is the question with which this essay began, and it is the one
with which it will end. I am now prepared to offer at least a partial answer—and one
that may encompass the spectrum of Byzantine models and copies, from Octateuch
miniatures to Symeon tokens.[33] The motives that may be imputed from the evidence
of surviving Byzantine art may be imputed as well from Byzantine texts (theological,
historical, hagiographic, and liturgical), and these two categories of evidence in fact
complement one another to form a single coherent, conceptual whole. From nonart
sources it becomes clear that continuity through replication was not simply a
workshop procedure governing the behavior of Byzantine painters and die-cutters,
it was a religious ideal that in a much broader sense governed the actions and
relationships of all Byzantine Christians. Christ was the ultimate archetype, and the
individual Christian, by way of chains of replication through biblical heroes,
martyrs, monks, and holy men, was his imitator.[34] No more clearly is this principle
stated than in an early letter of Saint Basil written about A.D. 360:

> [In the scriptures] the lives of saintly men, recorded and handed down to us, lie
> before us like living images [that is, icons] of God's government, for our
> imitation [that is, mimesis] of their good works. And so in whatever respect each
> one perceives himself deficient, if he devotes himself to such imitation, he will
> discover there, as in the shop of a public physician, the specific remedy for his
> infirmity. The lover of chastity constantly peruses the story of [the Patriarch]
> Joseph, and from him learns what chaste conduct is....Fortitude he learns from
> Job, who, when the conditions of his life were reversed...always preserved his
> proud spirit unhumbled.[35]

Basil's key words—icons and mimesis—are those familiar to us from the world of
art, and this was not by accident, for just a few lines later he draws an explicit,
intimate parallel between the proper behavior of artists and the proper behavior of
Christians. It is this passage that is quoted and illustrated in the famous ninth-
century *Sacra Parallela* manuscript now in Paris (fig. 11);[36] above, Saint Basil points
toward the incipit, while below, in response to the text, a Byzantine artist is shown
at work:

> Just as painters in working from models constantly gaze at their exemplar and
> thus strive to transfer the expression of the original to their artistry, so too he
> who is anxious to make himself perfect in all the kinds of virtue must gaze upon
> the lives of saints as upon statues, so to speak, that move and act, and must make
> their excellence his own by imitation (*dia mimeseos*).[37]

It was the business of the Byzantine artist to copy—to imitate and thereby perpetuate his model—as it was the business of the Byzantine Christian to do likewise. For each, mimesis was an act of value in its own right, through which they might gain access to the sanctity and power of the archetype. Thus by necessity theirs was a world wherein copying was normative behavior.[38] It is no wonder that the manuscript painter who produced the illumination in figure 2 virtually copied his Octateuch model line for line; the artist was not acting out of convenience but out of a sense of conviction and in full conformity to the accepted, age-old rhythm of Byzantine pious behavior. This for the painter was something inherently good and at the same time the only natural and appropriate way of doing things. To have asked that miniaturist or the icon painter in the illumination in figure 11 why he chose to copy would have been as absurd as to ask Andy Warhol why he chose not to: the question would simply have been meaningless. As, I think, would most of my essay, since the questions it poses are substantially predicated on notions of artistic originality foreign to the Byzantine mind. So after all my ruminations—on models and copies, mass production, icons, sanctified dies, and sanctified media—all I have really concluded is that a Byzantine artist's art was an art of imitation just as a Byzantine Christian's life was a life of imitation. This for a Byzantine would only have been obvious; but perhaps that is the most that I could have hoped for.

[1] See John Lowden, "The Production of the Vatopedi Octateuch," *Dumbarton Oaks Papers* 36 (1982), 120, figs. 13–14.

[2] See Kurt Weitzmann, *Illustrations in Roll and Codex: A Study of the Origin and Method of Text Illustration*, Studies in Manuscript Illumination 2, 2d ed. (Princeton, 1970).

[3] For the Octateuchs in general see Lowden 1982, 115 nn. 1–14.

[4] Lowden 1982.

[5] For evidence of this for the Octateuchs, Books of Kings, and other biblical texts see Kurt Weitzmann, "The Illustration of the Septuagint," *Studies in Classical and Byzantine Manuscript Illumination*, ed. Herbert L. Kessler (Chicago and London, 1971), 53–57 (translated and reprinted from *Münchner Jahrbuch der bildenden Kunst* 3–4 [1952–1953], 96–120).

[6] It bears the inscription: "Flesh, she holds the Word who existed before the ages."

[7] Reinhold Lange, *Die byzantinische Reliefkone* (Recklinghausen, 1964), no. 9.

[8] For a contemporary diorite casting mold for the production of tiny lead icons of the Virgin and Child see Etienne Coche de la Ferté, *L'antiquité chrétienne au Musée du Louvre* (Paris, 1958), no. 58.

[9] For example, at the healing shrine of Saints Cosmas and Damian, in Constantinople, "blessed" iconic tokens were distributed, apparently without charge, to infirm pilgrims during the all-night Saturday vigil (Ludovicus Deubner, *Kosmas und Damian* [Leipzig and Berlin, 1907], miracle 30). For more such evidence see Gary Vikan, "Art, Medicine, and Magic in Early Byzantium," *Dumbarton Oaks Papers* 38 (1984), 72 n. 43.

[10] For clear evidence of the economic dimension to the production of pilgrim *devotionalia* in the late medieval West see Esther Cohen, "*In haec signa:* Pilgrim-Badge Trade in Southern France," *Journal of Medieval History* 2, no. 3 (1976), 193–214. In my forthcoming catalogue of more than seven hundred Byzantine small objects in the Menil Collection, Houston, substantial new evidence will emerge to show that the Byzantine bronze industry was largely dedicated to the production of inexpensive imitations of precious-metal originals. See also Gary Vikan and John Nesbitt, *Security in Byzantium: Locking, Sealing, and Weighing*, Dumbarton Oaks Byzantine Collection Publications 2 (Washington, 1980), 16.

[11] For an excellent review of some of the most important primary texts relating to the Byzantine cult of images see Cyril Mango, *The Art of the Byzantine Empire, 312–1453: Sources and Documents* (Englewood Cliffs, N.J., 1972), 149–177. See also Norman H. Baynes, "Idolatry and the Early Church" and "The Icons before Iconoclasm," in *Byzantzne Studies and Other Essays* (London, 1955), 116–143, 226–239; and Ernst Kitzinger, "The Cult of Images in the Age before Iconoclasm," *Dumbarton Oaks Papers* 8 (1954), 83–150.

[12] Cited in Mango 1972, 173. The same principles applied as well to architecture. Robert Ousterhout, University of Illinois, Urbana-Champaign, in a forthcoming paper ("*Loca Sancta* and the Architectural Response to Pilgrimage," *The Blessings of Pilgrimage*), discusses two chapels in Constantinople laid out "eis mimesin tou naou tou taphou Christou" ("in imitation of the church of the tomb of Christ").

[13] Cited in Mango 1972, 174.

[14] See Kitzinger 1954, 96–115; and Gary Vikan, "Sacred Image, Sacred Power," *ICON* (Washington, 1988), 12–18.

[15] See Victor Lasareff, "Studies in the Iconography of the Virgin," *Art Bulletin* 20 (1938), 46–65.

[16] Translated in John Wilkinson, *Jerusalem Pilgrims before the Crusades* (Warminster, 1977), 88.

[17] See Averil Cameron, "The Sceptic and the Shroud," *Inaugural Lecture in the Department of Classics and History, King's College, London, 29 April 1980* (London, 1980).

[18] Kurt Weitzmann, *The Monastery of Saint Catherine at Mount Sinai: The Icons, Volume One: From the Sixth to the Tenth Century* (Princeton, 1976), no. B58.

[19] Most notably Ian Wilson (*The Shroud of Turin: The Burial Cloth of Jesus Christ* [London, 1979]), whose thesis is effectively refuted by Cameron 1980.

[20] Translated in *Fathers of the Church* (Washington, 1958), 37:165 (Orth. Faith, 4.11).

[21] See Wilkinson 1977, 60, 84.

[22] Interestingly the word *Turin* does not appear in the ad.

[23] For the meaning of eulogia see Gary Vikan, *Byzantine Pilgrimage Art*, Dumbarton Oaks Byzantine Collection Publications 5 (Washington, 1982), 10–20. For early Byzantine pilgrimage in general see that same publication as well as Wilkinson 1977, "Introduction," and 79–89; and Bernard Kötting, *Peregrinatio religiosa* (Regensburg, 1950).

[24] For the medicinal, magical properties of the eulogia see Vikan 1984, 68–72.

[25] On Symeon tokens see Vikan 1982, 31–39; and Vikan 1984, 67–74.

[26] On Symeon the Younger, his *vita*, and his shrine see Paul van den Ven, *La vie ancienne de S. Syméon Stylite le Jeune (521–592)*, 2 vols. Subsidia hagiographica 32 (Brussels, 1962, 1970).

[27] I wish to thank Dr. Elizabeth Fisher, Georgetown University, for permission to use her photograph.

[28] See Vikan 1984, 68.

[29] Cited in van den Ven 1962.

[30] Cited in van den Ven 1962.

[31] For Symeon stamping dies see Vikan 1984, 70, fig. 5.

[32] There are, of course, exceptions, such as the famous Joshua Roll, where the Octateuch iconographic tradition, although clearly present, takes second place to the creative impulse for a specific, extraordinary work of art (see Kurt Weitzmann, *The Joshua Roll: A Work of the Macedonian Renaissance*, Studies in Manuscript Illumination 3 [Princeton, 1948]).

[33] I owe much of what follows to the insight and scholarship of Susan Ashbrook Harvey, Brown University, and to an article by Peter Brown, "The Saint as Exemplar in Late Antiquity," *Representations* 1, no. 2 (1983), 1–25.

[34] See Brown 1983, 5–8, 16–20. This is not to suggest that Christian mimesis was not an ideal in other cultures and at other times. What distinguished Byzantium in the realm of mimesis and icon veneration was the breadth and intensity with which a single belief molded artistic production and popular piety as well as more sophisticated theological debate (Kitzinger 1954).

[35] *Saint Basil: The Letters*, trans. and ed. Roy J. Deferrari, Loeb Classical Library (Cambridge, Mass., 1961), 1:15–17 (letter written to Gregory Nazianzenus). Many other texts of various types and dates express the same conviction. The author of the *Martyrdom of Saint Polycarp*, for example, writes that "he was...a conspicuous martyr, whose testimony, following the Gospel of Christ, everyone desires to imitate" (cited in Herbert Musurillo, *The Acts of the Christian Martyrs* [Oxford, 1972], 17). Similarly the author of the *vita* of Saint Anthony (c. 357) notes in his introduction that he is recording this information "so that you [that is, 'monks abroad') may also lead yourselves in imitation of him" (see *Athanasius: The Life of Antony and the Letter to Marcellus*, trans. and intro. by Robert C. Gregg, with preface by William A. Clebsch [New York, 1980], 29).

III

For mimesis in the stational liturgy see John Wilkinson, *Egeria's Travels* (London, 1971), 124; in the behavior of the pilgrim see Gary Vikan, "Pilgrims in Magi's Clothing: The Impact of *Mimesis* on Early Byzantine Pilgrimage Art," in *The Blessings of Pilgrimage* (forthcoming); and in the Byzantine view of history see, for example, Averil Cameron, "Images of Authority: Elites and Icons in Late Sixth-Century Byzantium," *Past and Present* 84 (1979), 17, 21, 33.

[36] Kurt Weitzmann, *The Miniatures of the Sacra Parallela, Parisinus graecus* 923, Studies in Manuscript Illumination 8 (Princeton, 1979), 213, fig. 569.

[37] Here the Christian "anxious to make himself perfect" becomes the artist trying to replicate the biblical icon through behavior, while for John of Ephesos (c. 507–586) hagiographers are like artists, striving to:

> draw, through obscurity, by means of the vile and common pigments of...words, the pattern of their [saints'] likenesses for posterity...[so that]...souls entangled in the vanities of this world...may be eager to imitate them, and to receive their patterns in themselves (*John of Ephesus: Lives of the Eastern Saints*, trans. and ed. Ernest W. Brooks, Patrologia Orientalis 17 [Paris, 1923], 1–2).

In both cases the model—the icon—is the immutable given, and precise replication the goal.

Applying the same basic metaphor but to quite a different end, Asterius of Amaseia (c. 400; Mango 1972, 51) argues against the wearing of image-bearing garments and recommends instead that Christians:

> sell those cloths and honor instead the living images of God....bear in your spirit and carry about with you the incorporeal Logos. Do not display the paralytic on your garments, but seek out him who lies in bed.

There is also the related theme of the saint being a mirror, at once the model for and reflection of the imitating Christian. The biographer of Antony (*Athanasius*, 37) noted that the saint: "used to tell himself that from the career of the Great Elijah, as from a mirror, the ascetic must always acquire knowledge of his own life."

[38] Brown 1983, 6. For a less-pious sort of mimetic behavior see Franz Tinnefeld, "Zum profanen Mimos in Byzanz nach dem Verdikt des Trullanuoms (641)," *Byzantina* 6 (1974), 331.

Fig. 1. *The Punishment of Dathan and Abeiram*, twelfth century, tempera on vellum. Vatican Library, Vatican City (cod. gr. 746, fol. 340v).

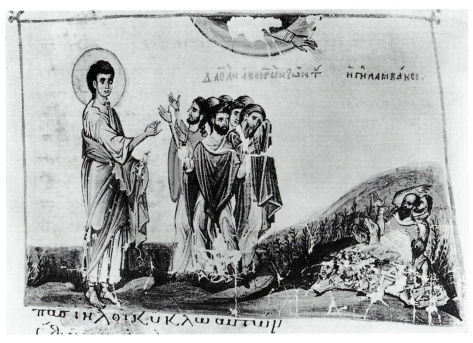

Fig. 2. The Punishment of Dathan and Abeiram, c. 1300, tempera on vellum. Mount Athos (Vatopedi cod. 602, fol. 150r).

14 Ruminations on Edible Icons

Fig. 3. *The Virgin Hodegetria*, eleventh–twelfth century, bronze. The Menil Collection, Houston.

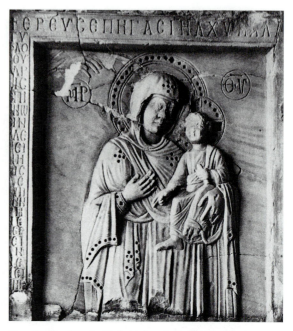

Fig. 4. *The Virgin Hodegetria*, eleventh–twelfth century, marble. Archaeological Museum, Istanbul (4730).

Fig. 5. *Saint Luke Painting a Portrait of the Virgin and Child*, tempera on vellum. Patriarchate, Jerusalem (Taphou cod. 14, fol. 106r).

III

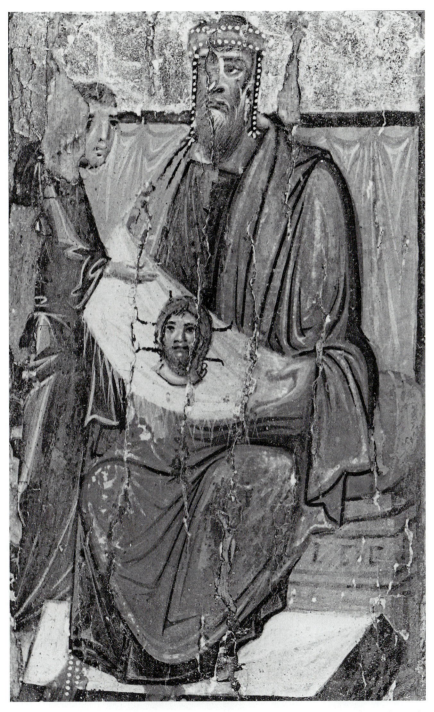

Fig. 6. *King Abgarus with the Mandilion* (detail), tenth century, tempera and wood panel. Monastery of Saint Catherine, Mount Sinai (B58).

Fig. 7. Shroud of Turin, linen. Duomo San Giovanni, Turin.

Fig. 8. Advertisement from the *National Enquirer*.

Fig. 9. Symeon token, sixth–seventh century, clay. The Menil Collection, Houston.

Fig. 11. *Sacra Parallela*, ninth century, tempera on vellum; with Saint Basil (above) and an icon painter at work (below). Bibliothèque Nationale, Paris (cod. gr. 923, fol. 328v).

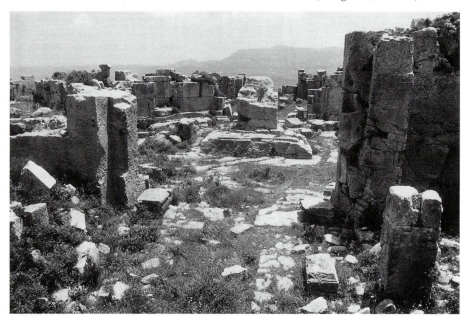

Fig. 10. Remains of column within monastery, sixth century. Kutchuk Djebel Semaan (Miraculous Mountain of Saint Symeon, the Younger), Turkey.

IV

Graceland as *Locus Sanctus*[1]

Prologue: Elvis as Saint[2]

So that the reader does not stop at "saint" Elvis, a notion explicitly sanctioned not only by the tabloids[3] but also by the *Washington Post*[4], the following points should be born in mind:

- that saints, as charismatic mediating agents between our everyday world and remote and powerful spiritual forces, have existed in all religions, and outside conventional religion as well;
- that within Christianity, *de jure* canonization, as now practiced by the Vatican, was a development of the second millennium, and that the Orthodox Church still follows a practice closer to the *de facto* form of canonization which dominated early Christianity, whereby a saint was informally "elected" to sainthood by the collective belief and actions of his followers;
- that Christianity has allowed for saints of vastly varying backgrounds and life-styles, including those despised by their contemporaries;
- that there is a profound difference between the image of the saint held dear by his followers, and the historical reality of the individual, who may not ever have existed;
- and finally, that even within the conventional typology of western saints, comprising martyrs, confessors, ascetics, etc., Elvis, in the eyes of his ardent fans, has his place as a "martyr."

The last point is abundantly clear from even a brief survey of Elvis *vita* literature, such as May Mann's *Elvis, Why Won't They Leave You Alone?* in which we learn the King's last thoughts as he lay dying on the floor of his bathroom: "This must be like what Jesus suffered."[5] Purged from the singer's factual life history are any references to drug abuse, obesity, or paranoic violence. The *vitae*, most of which constitute an extended *apologia* responding to Albert Goldman's damning portrait of Elvis,[6] speak instead of a dirt-poor southern boy who rose to fame and glory, of the love of a son for his mother, of humility and generosity, and of superhuman achievement in the face of adversity. They emphasize Elvis' profound spiritualism and his painful, premature death—a death described as coming at the hands of his own fans, whose merciless demands for Elvis entertainment exhausted and ultimately killed Elvis the entertainer ("uppers" to prepare for a concert, "downers" to get necessary rest afterwards). In their eyes, he had died for them, and any further revelations of his seeming debauchery would, ironically, only reconfirm and intensify their image of his suffering.

2 GRACELAND AS *LOCUS SANCTUS*

The stickiness of the word "saint" may be avoided entirely by adopting Max Weber's non-religious, value-neutral terminology, which centers instead on the word charisma ("gift"). Weber identified the charismatic as possessing "a certain quality of an individual personality by virtue of which he is set apart from ordinary men and treated as endowed with supernatural, superhuman, or at least specifically exceptional powers or qualities."[7] Significantly, this extraordinary individual is identifiable not by any specific behavioral or physical characteristics, but rather by the impact he has on others, by how he is "treated as endowed" by his followers. This "affectual action" definition (Weber's term) is especially critical for "saints" whose life-styles strike nonfollowers as inappropriate, since what counts is not saintlike performance, but audience reception and reaction. Again, the "saint" need never, in fact, have existed, for like Mickey Mouse or the legendary Saint Christopher, he is created and re-created to suit his evolving clientele. Weber's value-neutral approach to charisma shifts emphasis away from the source of the charismatic "gift," as a grace from God or as a reward for an exemplary life, to its recognition. This allows for the existence among the ranks of charismatics of the likes of Jesús Malverde, a mustachioed brigand who was hanged as a bandit in Culiacán, Mexico, in 1909, but who today is venerated there as a saint, with his own chapel-shrine, icons, and votives, and an impressive list of attributed miracles.[8]

Miracle-working was part of the "charisma package" that came with the early Christian saint; this, after all, was what saints were supposed to do. By contrast, the charisma of Elvis the superhuman entertainer included miracle-working only as one of its various potentialities, one of its possible "exceptional powers" (Weber's characterization). Elvis demonstrated the possession of charisma through his initial phenomenal success as an entertainer (1955–1957); this "gift" he had in fact earned through his own on-stage and record-industry performance, and its potentiality was then multivalent and unrealized. From that point on, though, through the dismal movie years of the 1960s and the increasingly degenerate Vegas years of the 1970s, Elvis was endowed by his fans with inalienable charisma, and gradually he, together with his inner circle, began to cultivate its latent spiritual and miraculous potentialities. Eventually, Elvis became an acknowledged healer and a self-proclaimed messenger from God. Larry Geller, Elvis' hairdresser and spiritualist, discusses both qualities:

> Elvis...was interested in telepathy, healing through touch and a number of other phenomena that are only now being scientifically studied.

> I once saw Elvis heal a man who was having a heart attack. Another time Elvis treated Jerry Shilling after he had taken a nasty spill on his motorcycle and was unable to move. "The next thing I knew," Jerry said later, "I woke up the following morning healed."

> In the seventies...I witnessed hundreds of concertgoers carrying their sick and crippled children to the stage and crying out, "Elvis, please touch my baby," or "Elvis, just hold her for a minute."

> In Elvis' mind, his life was being directed divinely....And he truly felt that he was chosen to be here now as a modern-day savior, a Christ.

[Elvis recounts:] "Think back when I had that experience in the desert. I didn't only see Jesus' picture in the clouds—Jesus Christ literally exploded in me. Larry, it was me! I was Christ."[9]

Some of Elvis' posthumous miracles were gathered by clinical psychiatrist Raymond A. Moody, Jr., in *Elvis: After Life*,[10] and these are supplemented almost weekly by the tabloids. Elvis appears to a small-town policeman, helping him locate a runaway son by revealing a vision of the Los Angeles rooming house where, in fact, the boy turns up a few days later. Elvis receives into paradise a young girl dying of complications from Down's Syndrome, just as she utters her last words, "Here comes Elvis!" Elvis mostly comforts and guides, but sometimes he heals. "Elvis' Picture Has Cured Me of Cancer!" shouts the headline in the *Weekly World News*.[11]

Graceland as *Locus Sanctus*[12]

The saint has his holy place; this is how we know him for who he is and how we know where to find him, and this, in part, is how he has traditionally effected his miraculous powers on earth. The holy place has existed since the early centuries of Christianity; the Latins called it *locus sanctus* and the Greeks *hagios topos*, but for both the meaning was the same. And for the faithful, its physical attraction was intense: a *locus sanctus* presupposed pilgrimage, pilgrimage required a *locus sanctus*.

A holy place could be the home of an important relic, like the chair in which the Virgin sat during the Annunciation, or the site of miraculous waters, like the leper-curing Baths of Elijah; or it could be the setting of some major religious event, like the Nativity or the Crucifixion. But outside the Holy Land, where the Old and New Testaments dominated the sacred landscape, a *locus sanctus* usually turned out to be the home of a saint. It might be the place of a saint still living (a "holy man") or, more likely, the place of his bodily remains, sealed in a tomb or reliquary and enshrined in elaborate architecture: the martyr ("witness") for Christ enshrined in his *martyrion*.

The tiny rock-cut Tomb of Christ in the Church of the Holy Sepulchre in Jerusalem has always been Christianity's most important *locus sanctus*.[13] Its shrine, a vast complex of churches, courtyards, and colonnades, now mostly destroyed, was built in the early fourth century by Emperor Constantine. Nearly as important is the Basilica of St. Peter in Rome, originally also fourth century in date, with its bones of the Prince of the Apostles, and very important too, though only from a much later period, is the cathedral of Chartres, near Paris, with its Veil of the Virgin Mary. There are thousands more, of every description and size, from those that dominate an entire city to those hidden away in a forest or isolated on a mountaintop, from those commanding international pilgrimage to those drawing pious traffic only from a nearby village. Just a fraction date from the first millennium of Christianity, and a smaller proportion still is to be found on the sacred real estate of Christ and the Apostles.[14]

4 Graceland as *Locus Sanctus*

In the desert hills north of Santa Fe is one of Christianity's newer holy places: El Sanctuario de Chimayó.[15] Unassuming by medieval standards, its shrine is not a cathedral but a simple adobe chapel, its "witness" not holy bones or sacred cloth but a kettle-size hole in its clay floor. Chimayó is a *locus sanctus* because in the early nineteenth century, during Holy Week, a local Penetente brother discovered a partially buried crucifix there of Our Lord of Esquípulas, and each time that he dug it up and carried it to the church at Santa Cruz, it returned of its own accord to that spot, to the hole that has ever since given forth miracle-working *tierra bendita*. Now each year on Good Friday, thirty thousand or more make the pilgrimage to El Sanctuario, because they believe, as Christians have nearly always believed, that the sacred power of a saintly body or a miraculous event literally charges its physical surroundings with holiness.

But what is now taken for granted by hundreds of millions of Christians worldwide was not always part of Christian belief. Initially, the Holy Land was simply Palestine, and Jerusalem was only one among many locations in Palestine which bore witness to the historical truth of Christ the man. Constantine's act of unearthing and enshrining the Tomb of Christ in the early fourth century betrays a critical transformation in attitude, after which the documentary dimension of Jerusalem and Palestine, and of important Christian sites and objects generally, was superseded by their spiritual dimension, by the belief that they bore sacred power and miracle-working potential.[16] The eighth-century Byzantine theologian John of Damascus explained the sanctity and thus the attraction of the True Cross, and, by extension, of the *martyrion* that once enshrined it: "So, then, that honorable and most truly venerable tree upon which Christ offered Himself as a sacrifice for us is itself to be adored, because it has been sanctified by contact with the sacred body and blood."[17]

Unlike the tourist, who goes places mostly to see, the pilgrim has a distinctly tactile notion of travel. Paulinus of Nola (d. 431) observed that "the principal motive which draws people to Jerusalem is the desire to see and touch the places where Christ was present in the body."[18] As early Christianity came to accept the notion that the holy was susceptible to concentration in places, people, and things (the "objectification of charisma"), it inevitably came to accept the corollary notion that the power of that localized holy was susceptible to retransfer through contagion. Christ is nailed to the cross and the cross is infused with the power of his sanctity; Christ's (now) relic-cross, the "True Cross," comes into contact with earth and that earth becomes similarly empowered; when the pilgrim takes away a small packet of that holy earth, he takes away the sacred power of Christ. In the vocabulary of contemporary travel diaries and saints' lives, this is the pilgrim's *eulogia* or "blessing."[19] The diary of an anonymous pilgrim from Piacenza in northern Italy, who made his trip to Jerusalem around 570, records the practice of bringing earth into Christianity's preeminent contact relic, the Holy Sepulchre, so that "those who go in [may] take some as a blessing."[20] In Jerusalem today one may still buy little packets of earth labeled "from Calvary" and small vials of oil that are said to have touched the Tomb of Christ. In the eyes of faith, the tomb of

a saint was (and is) understood to be much more than mere tangible evidence of the historical reality of that individual; it is a sacred point of intersection between the physical and the metaphysical, between earth and heaven. The soul of the saint is believed to dwell there, and in being nearby, one is in the company of "the invisible friend."[21] Conversely, to be separated from the tomb was to be apart from one's friend, and the remedy for that was pilgrimage.

Tourist as Pilgrim

Pilgrimage has always been intertwined with tourism, even in the days of the early Christian saints.[22] True, major biblical sites and the shrines of famous saints were the great attractions that then set the Christian world in motion, and each, by itself, would have been worthy of a trip. Yet once near sacred soil, the pious traveler would have been drawn to a wide range of lesser attractions, not all of which would be religious. The pilgrim from Piacenza, on his journey toward Jerusalem around the year 570, kept a detailed diary from the point he entered the Holy Land, at Ptolemais (modern Acco). He stopped first at Diocaesarea (modern Zippori) to see the chair in which the Virgin sat during the Annunciation, and then went on to Cana to touch the two surviving water jugs whose contents Christ had miraculously turned to wine. From there he was off four or so miles to Nazareth where, among other things, he saw preserved in the local synagogue the book in which Christ, as a child, had written his ABCs. These sacred detours substantially dictated this pilgrim's zigzag path toward Jerusalem, yet he was occasionally drawn as well to sightsee such local curiosities as the magical, birth-ensuring geodes on Mount Carmel, the huge one-pound dates at Jericho (which he picked and took home), the beautiful Jewesses in Nazareth, and the Ethiopians in the Negev, who "had their nostrils split, their ears cut, boots on their feet, and rings on their toes."[23]

Undoubtedly most of the seven hundred thousand annual visitors to Graceland come in the tourist mode, even if some among them may eventually experience there a vague sense of "localized sacred." And certainly, many among that minority whose initial travel aims are closer to those of the Piacenza pilgrim might still be distracted by such local Memphis curiosities as Mud Island, Beale Street, and the baby-back ribs at Corky's. The trick is to disentangle the pilgrim from the tourist, both as a statistically identifiable group, and as a qualitatively identifiable attitude.[24] It is the contention of this article that Graceland is essentially of a type with the medieval *locus sanctus*. Since the *locus sanctus* is identifiable not by any single set of physical characteristics, but rather by what people do in relationship to it (Weber's "affectual action" notion), so the relative degree of "holy-place-ness" of Graceland can only be so defined. The history of religiously motivated travel to holy places inside and outside of Christianity suggests several activity-defined criteria for identifying the pilgrim, and thus, by extension, the holy place.

6 GRACELAND AS *LOCUS SANCTUS*

When does the Pilgrim go?

The travel schedule of the tourist is dictated primarily by vacation time and the seasons, whereas that of the pilgrim is dictated by the yearly calendar of holy days associated with the sanctification of the destination site. The Piacenza pilgrim goes to the Jordan River on January 6, the day upon which the Baptism of Christ is commemorated there; similarly, since the earliest centuries of Christianity, Bethlehem has been the preferred pilgrimage destination for December 25, and Jerusalem for Holy Week. This is so because in the eyes of faith the holy day, within the unending yearly cycle of sacred remembrances, is the occasion of complete time collapse between the now and the then. To be in the Church of the Holy Sepulchre on any day is to be proximate to the sacred, but to be there on Good Friday is to be there at the Crucifixion. Of course, sacred time exists independent of sacred locale in Easter services worldwide, but to be in Jerusalem for those services is to compound the intensity of the spiritual encounter. Sacred experience is, in this respect, a function of the where and the when.

Disney World is fully booked in mid-March because this is when school children have their spring vacation and when the weather in Florida is especially attractive. By contrast, Chimayó is most active during Holy Week, and Graceland's peak activity time is always in mid-August, in that special "holy week," Elvis International Tribute Week, surrounding the anniversary of Elvis' death, on August 16.[25] Contributing to a powerful sensation of "time collapse" around Graceland then are the steamy weather, the nighttime crowds on Elvis Presley Boulevard, the ubiquitous Elvis imitators and impersonators, ever-present Elvis music, and periodic rebroadcast, on radio station 56-WHBQ, of the heart-wrenching interview with Vernon Presley on the afternoon of August 16, 1977, shortly after Elvis had been pronounced dead.

The appearance of the Elvis grave shrine in mid-August and the quality and tempo of activity around it are very different from the non-holiday season. During Tribute Week alone there are fifty thousand visitors to Graceland, and one senses immediately that as a group they stand apart; these make up the most concentrated pool of Elvis Friends, and these, disproportionately, account for the pilgrimage activity described below.[26]

What is the Nature of the Pilgrim's Itinerary?

The organizing criterion for a tourist's itinerary might be Civil War monuments, theme parks, three-star restaurants, or campgrounds. By contrast, the pilgrim organizes his itinerary around ancillary holy places, while all the time maintaining strong directionality toward the paramount sacred destination. We have already encountered this in the diary of the Piacenza pilgrim, who, like most other Holy Land travelers then and since, made use of specially tailored maps and guidebooks. His counterpart during Tribute Week will likely have, in addition to the site map for Graceland, the Red Line "Map and Guide, with Historical Addresses to Elvis

Presley." This will point him southward on Route 78 toward the Elvis birth shrine in Tupelo, and in Memphis, toward such important local sites as Lauderdale Courts (Elvis' first Memphis home), Lansky Brothers (Elvis' clothier), Sun Records (Elvis' first recording studio), and Chenault's Restaurant, "where Elvis and his guests would have hamburgers in the sealed off back room." Everywhere on the tour there will be an intense feeling of Elvis' "presence," heightened by specificity of place and time, and by relics; one sits on the very stoop at Lauderdale Courts where Elvis once sat as he sang to his first girlfriend, Betty McMann, and in Humes High School, one touches the Elvis football uniform, and then one writes on the Elvis blackboard. Again, the Piacenza pilgrim:

> Three miles further on [from Diocaesarea] we came to Cana, where the Lord attended the wedding, and we actually reclined on the couch [where the Lord had reclined]. On it (undeserving though I am) I wrote the names of my parents....Of the water-pot [in which Jesus changed water to wine] two are still there, and I filled one of them up with wine and lifted it up to my shoulder.[27]

Characteristically, the August Graceland pilgrim travels a greater distance than the June Graceland tourist and expends greater effort; almost certainly, this will not have been the first visit. Paradigmatic, though extreme, is Pete Ball, the "EP"-tattooed London laborer who between 1982 and 1987 came to Graceland fifty-three times, all the while never stopping anywhere else in the United States.[28]

What is the Pilgrim's Relationship to his Fellow Travelers?

Nothing could be more unlike the anonymity and dispassion of tourist travel than the intense bonding that takes place among the faithful during Tribute Week. Anthropologists speak of the *communitas* of pilgrimage, and emphasize the liminoid nature of the experience, which like a rite of passage takes the pilgrim out of the flow of his day-to-day existence and leaves him in some measure transformed.[29] Nowhere are community and bonding more apparent than at the Days Inn Motel on Brooks Road, between Graceland and the airport, which each year sponsors the Tribute Week Elvis Window Decorating Contest. *Communitas* begins in the parking lot, with its rows of Cadillacs and Lincolns bearing Elvis vanity plates, and it continues around the pool, where pilgrims gather to drink Budweiser and reminisce.

One senses in the poolside conversation of Tribute Week the inevitable evolution of recalled anecdote from those relating to the living Elvis to those relating to extraordinary events surrounding *post mortem* August gatherings. This, too, must have had its counterpart in the early Christian world, as those pilgrims and locals with memories of the living saint died off. The texture of conversation at the Days Inn is now weighted toward stories of extraordinary pilgrimage (long distance, great sacrifice), although these are interwoven with accounts of the seemingly supernatural, the stuff of future Elvis *miracula*. One such account was later documented in the Fall 1988 *Elvis Fever* fan club quarterly (Baltimore), under the heading "Report from Memphis":

> [We] went back to Graceland [from the Days Inn] for the Candlelight Service. As we were sitting across from Graceland waiting to get in line (we learned last year the hard way to wait until after midnight to get in line), my sister and I noticed that there was only one star in the sky and it was directly over Elvis' grave. Understand this was the third year that this has occurred. It gave you an eerie feeling.

Group identity is acknowledged through Elvis clothing, jewelry, and in some cases, tattoos. There is first-name familiarity among the "we," and an openness to new members, who are initiated through friendly interrogation: "How many times have you been to Graceland?" "How many concerts did you attend?" "How many Elvis videos do you own?" Elvis' motto in life was "Taking Care of Business," and the unspoken motto among the *post mortem* "we" is "Taking Care of Elvis." The despised "other" extends well beyond the circle of Colonel Parker, Albert Goldman, and Geraldo, to include Priscilla, whose infidelity is believed by most to have destroyed Elvis' will to live, and who in any event is generally acknowledged as having been "uppity" and to have wrecked Graceland by redecorating it Hollywood-style.

As the "living Elvis" oral tradition of Tribute Week is institutionalized in the annual Humes High Symposium, featuring, among others, Elvis' belt maker and horse trainer (Mike McGregor), drummer (D. J. Fontana), and cook (Nancy Rook), so the "Taking Care of Elvis" tradition is institutionalized in the yearly Fan Appreciation Social at the Memphis Airport Hilton. Here Elvis Friends petition for Elvis stamps and Elvis holidays, and then gather to grill the powers within the circle of "we" on the present state of the Elvis Image. A report in a local fan newsletter on a recent Fan Social included the following characteristic exchange:

> The fans let Jack Soden [Elvis Presley Enterprises Executive Director] and the Graceland Executives know how upset they were by the movie "Elvis and Me." Mr Soden's only reply was he was also upset by it, but they really did not have control over what was finally shown. If they had, it would have been stopped. Mr. Soden was also questioned as to why Graceland was not responding to the "Elvis is Alive" thing. His main reply was that Graceland did not want to fuel the publicity by replying and were hoping it would just go away. But it hasn't. Does Graceland have to dig up Elvis' body to prove that he died?[30]

The universally acknowledged, often-repeated aim of this is to present the world with a positive image of Elvis, "the real Elvis."

What does the Pilgrim do when he gets there?

The behavior profile of the August Graceland pilgrim will be quite different from that of the June Graceland tourist. While the latter's (substantially dispassionate) experience will likely be restricted to a few hours, and center on the Graceland Mansion tour, the former's will probably extend over several days, and will be distinctly "bi-polar," both by location and by tone. One pole, already discussed, will be the Days Inn poolside, or wherever peer-group bonding and "liminality" are at

that moment most attractive, and the other will be the Meditation Garden, and specifically, the Elvis grave. The former, obviously, is a social experience, whereas the latter is thoroughly private, and devotional; the mood at poolside will be festive and at the Fan Social feisty, whereas at graveside, it will be somber.

The two poles of the mid-August experience, social and devotional, merge in the ritual which is the highlight of Tribute Week: the Annual Candlelight Service. The "order" of the service, which commences outside Melody Gates at 10:00 p.m., includes a Bible reading, silent prayer, spirituals (sung by Elvis over strategically placed loudspeakers), and a homily based on a song or a value associated with Elvis. A few years back the homily was based on the song "Always on My Mind," and it focused on the shared guilt implicit in the notion of Elvis' "martyrdom." Recited tearfully to a hushed crowd of more than ten thousand, it included these revealing sentiments:

> Looking back through the years as we take this moment to remember—I have regrets. I regret all of those little things that I should have said and done to let you know how much you mean to me, Elvis....

> A thousand souls joined together in harmony, as we are tonight, can only hope to return some of the love that Elvis has shared with each and every one of us. Though we are united as one, we know that Elvis belongs to each and every one of us exclusively....

> Elvis...left us all with a very special gift—the gift of his love. Elvis gave unselfishly of himself to all of us, but did we, his fans, give as much of ourselves to him?[31]

Following a group-sing of "Can't Help Falling in Love," the song with which Elvis closed his concerts in later years, the Melody Gates swing open and the candlelight procession begins to snake its way up the driveway to the Meditation Garden and the graveside. The last pilgrim will lay his votive rose on the bronze tomb slab well after 2:00 a.m. The vigil or evening service before the commemoration day of a saint or an important biblical event has been part of *locus sanctus* pilgrimage ritual for more than fifteen centuries, as has the link between fire and "imminent presence" at holy graveside. Its earliest and still most familiar manifestation is Holy Fire, the miraculous flame markmg the Resurrection of Christ; it comes as the culmination of the pascal vigil, at the stroke of midnight between Holy Saturday and Easter Sunday.

What does the Pilgrim take away?

The tourist and the pilgrim will both take things home from Graceland, but their mix of "souvenirs" will be different. True, the Tribute Week visitor will likely buy a few of the traditional sorts of tourist trinkets available in the shops across from Graceland Mansion, but his real interest will be in what is colloquially called "Elvis stuff"—which means, at least in part, relics (such as the sweaty concert scarf that has never been washed). Although the souvenir shops along Elvis Presley Boulevard sometimes stock prepackaged *eulogia*-like items, such as Graceland

earth, and Uncle Vester is still there to sign and instantly "relicize" copies of *A Presley Speaks*, formal trade in this sort of material during Tribute Week centers mostly on the Annual Elvis Presley Benefit Auction at the Whitehaven United Methodist Church on Elvis Presley Boulevard. Some informal trading takes place on the sidewalks of Graceland Plaza, where, for example, Elvis' classmate Sid McKinney could be found during a recent Tribute Week hawking his 1953 Humes High Yearbook, with Elvis' handwritten dedication, for 4,500 dollars. But mostly, Elvis stuff is bought, sold, and exchanged in the rooms of the Days Inn and other motels nearby, where the Elvis Friends congregate.[32] And while much of the material available these days—Elvis clocks, lamps, and placemats—does not technically qualify as "relic," since it has never had direct Elvis contact, some of it does, including the ubiquitous trays of original Elvis concert photographs, which are valued much less as documents of specific events than as almost-tactile appropriations of Elvis, as his handprint or footprint might be.[33]

What does the Pilgrim leave behind?

The Christian pilgrim not only took something away from the *locus sanctus* (a relic, an *eulogia*), he usually left something behind. It might be an elaborate, custom-made image set up in a prominent place in the *martyrion* to acknowledge publicly the pilgrim's encounter with his spiritual "friend," or it might be an anonymous personal item, like the "bracelets, rings, tiaras, plaited girdles, and belts," which according to the Piacenza pilgrim were draped "in vast numbers" over the Tomb of Christ—or it might be a simple greeting or prayer hastily drawn on any available surface, like that in the Chapel of St. Vartan beneath the Church of the Holy Sepulchre, which shows a pilgrim's boat and bears the words "O Lord, we have come."[34] Each is a votive, and in its various forms a votive could serve at once as a record of the pilgrim's visit, as a perpetuation of his devotional contact with his "friend," and as a thank-you for a blessing received or anticipated.[35]

At Graceland there are two main types of votives and each has its own characteristic setting. The first type is found mostly in the Meditation Garden; its primary medium is the flower, and it usually is based on an iconographic conceit evocative of an Elvis quality, motto, or event, or of the geographical origin of the pilgrim who dedicated it. Sometimes an explicit typological identity between Elvis and pilgrim is evoked, specific to place (Meditation Garden) and time (Tribute Week). Elvis, with head bowed, is presented among flowers, and against the evoked backdrop of the hymn "In the Garden," which begins: "I come to the garden alone / while the dew is still on the roses / and the voice I hear...."[36] Elvis is thus one and the same with the Tribute Week pilgrim, who comes to the Meditation Garden alone during the dawn "free walk-up period," from 6:00 to 7:30 a.m. But on its simplest level, the Elvis votive is the artificial rose sold from the huge cardboard boxes at the 7-Eleven across Elvis Presley Boulevard in the days leading up to August 15, and dedicated at graveside by the thousands that evening, as each Elvis Friend reaches his destination.

The second type of Graceland votive is the graffito message, the counterpart to the fourth-century sketch in the Chapel of St. Vartan. (Recall that the Piacenza pilgrim wrote the names of his parents on the couch at Cana.) In the early Christian *locus sanctus* such impromptu votive communications were common. Some called for or acknowledged help from the "friend," and some simply recorded a name, either of the pilgrim himself, or else of a relative or friend who could not make the journey. In either case the intention was the same: to perpetuate the pilgrim's "presence" at the holy place, and more specifically, to actualize his communication with the saint commemorated there, as later pilgrims would read his words, and perhaps even recite them aloud.

The rules laid down by Elvis Presley Enterprises are explicit and strict; nothing can be touched, and graffiti is of course forbidden, except in one location: the Fans' Memorial Wall. Here messages are not merely tolerated, they are actively encouraged, by occasional sandblasting, which frees up the limited writing space, and by the frontage road off Elvis Presley Boulevard, which allows the mobile pilgrim to pull off in his car and scrawl his message in magic marker without upsetting traffic. The Wall is simply that: a pinkish-yellow field-stone barrier about six feet high and 175 yards long, setting off the Graceland complex from the road. It is illegal to scale this barrier, but one is encouraged to write on it, and at least ten thousand Elvis Friends do so every year.

The messages, with a few cynical exceptions—"Elvie Baby, Can I have your doc's #?"—carry conviction. Some, echoing the *vitae*, are angry and combative, and addressed to the "other"—"The King never did drugs"—but most are sweet and sentimental, and addressed to the King. Beyond the hundreds of simple confessions of eternal love and devotion ("Elvis, I miss you and love you tender—Loving you, Annette"), there are scores of messages carrying raw, seemingly spontaneous evocations of sorrow or loss: "8–16–77 is the saddest day of / my life. I was too young to realize / it at the time. I was ten. / Love / Ralph." Others, in much the same tone, offer thanks for Elvis' spiritual intervention: "Elvis / Thanks / for all you helped me through. / I wouldn't be me / without you. / See you in heaven. / I love you / Carla." And there are many, like the graffito in the Chapel of St. Vartan, that evoke the very act of pilgrimage: "Fm London—Memphis / Too young to remember / here to respect / Alan, Tim, Lisa & Bev." Within just a few feet of one another are messages in Japanese, Spanish, French, German, Greek, and Russian, as well as those written in English by pilgrims identifying themselves as Swedes, Austrians, and Brazilians. And everywhere, there is reference to multiple visits, either promises to return or, more frequently, allusions to past pilgrimages: "We love you Elvis. Carol Horn, Caroline Kuszuk. 8–15–86, '87, '88, '89—Chicago." There are votives with overt religious messages, like "Elvis Lives" above a radiating Calvary Cross, and finally, there are votives that capture the very essence of pilgrimage piety, and of Graceland: "I have seen / Graceland, my life is complete. / Miss you terribly / Soren Skovdal."

Epilogue: Elvis as "An Icon for Our Time"

Although the August 1989 Sotheby's catalogue *Rock 'n' Roll and Film Memorabilia* pictured Elvis on its cover, it included "relics" of many other celebrities, including Marilyn Monroe, whose black stiletto shoes from *Some Like it Hot* (lot 30) were projected to bring a price nearly as high as Elvis' 1976 coney jacket (lot 39). On July 26, 1992, the *New York Times* lead article in the Arts and Leisure Section, entitled "Marilyn's Magic Lingers 30 Years After Her Death," characterized Marilyn Monroe as a "serious icon...gifted with a bizarrely passive charisma." As for trading in celebrity earth, this, too, is not unique to Elvis; a Californian claims to have sold twenty thousand packets of dirt from the lawns of Johnny Carson, Shirley MacLaine, Katharine Hepburn, and nearly four dozen other stars for $1.95 each, by mail order and in novelty shops. Elvis' charisma-infused corpse, like that of some Christian saints, required special security, but this has been true as well of all sorts of famous figures in modern times, including dictators: in 1987, on the thirteenth anniversary of his death, thieves broke into Juan Perón's locked tomb and surgically removed his hands.[37] Over the last two decades thousands have made the pilgrimage to gather "sanctified soil" from the gravesite of Jim Morrison in Père-Lachaise cemetery in Paris, and many have left "votive" messages of the Elvis sort. And on the anniversary of John Lennon's death, "Lennon Friends" gather in Manhattan for a candlelight vigil at the assassination site outside the Dakota.

Insofar as the cult of the dead Elvis differs from these, or from that of John Kennedy for that matter, it probably differs more in degree than in kind: fifty thousand gathered at Graceland for the tenth anniversary of Elvis Presley's death, whereas just a few hundred gathered at the Dakota for the tenth anniversary of John Lennon's death; on any given day two thousand or more will pass through Graceland's Meditation Garden, whereas just a couple dozen "Morrison Friends" per day will find his grave in Père-Lachaise.

The analytical model of the Centers for Disease Control may be useful here, since it differentiates among etiology or "cause," phenomenology, which is the aggregate of symptoms as presented in the individual, and epidemiology, which is the pattern of distribution among the general population. What sets the Elvis "affliction" apart is its epidemiology, its sheer scale, and probably also its phenomenology, its intensity as presented in the individual. For an excellent primer in the extremes of the latter, one need only check out Rhino Video's *Mondo Elvis: The Strange Rites & Rituals of the King's Most Devoted Disciples* (Monticello Productions, 1984), to meet Artie "Elvis" Mentz, the EP impersonator who equates his relationship to the King to that of a priest to God, since both are filling in for "someone not there in body."

As for etiology, whether the case study be Graceland or Chimayó, the question of root cause lies beyond the scope of comparative religion and this article, in the realm of social anthropology and psychology. That the idiom of Elvis' charismatic performance might be like that of a pentecostal evangelist,[38] and that the idiom of Graceland pilgrimage might be like that of an early Christian *locus sanctus*, should not be taken to imply and certainly does not require that there be a genealogical link between the cult of Elvis and historical or contemporary Christianity. On the

contrary, such resonances suggest that the predisposition toward "charisma objectification" that is their shared inspiration is primal and ahistorical, and that over time and across cultures this predisposition will tend to manifest itself in similar though potentially fully independent ways.

Finally, it is striking that among the inscriptions at Graceland, and in Elvis *vitae* and tabloid literature generally, there is seldom any hint of Elvis as intercessor, even when he is clearly the proximate source of the miraculous, and even when the context is richly flavored with conventional religion.[39] Rarely is God or Jesus ever mentioned, and rarely is there any talk of Elvis as being the recipient of prayer. In this respect, Elvis' "sainthood" is strikingly different from the conventional Christian sort, wherein the role of one's spiritual "friend" as one's advocate before God is always central.

Though, of course, sainthood, either as performed or as acknowledged, is not a constant, even in Christianity; the great martyrs mostly date from before the Peace of the Church (fourth century), and retreating into the desert as an expression of saintly piety went out of fashion more than a millennium ago. As the early Christian saint was a product of and a window upon his world, so also is Elvis Presley. In the words of Elvis Friend Anna Norman, written on the Fans' Memorial Wall: "Elvis, You've become such an icon for our time."

[1] This article is adapted from *Saint Elvis*, a book-length study in preparation.

[2] Peter Brown, *The Cult of the Saints: Its Rise and Function in Latin Christianity* (Chicago: University of Chicago Press, 1982); Richard Kieckhefer and G. D. Bond, eds., *Sainthood: Its Manifestations in World Religions* (Berkeley: University of California Press, 1988); Stephen Wilson, ed., *Saints and Their Cults: Studies in Religious Sociology, Folklore, and History* (New York: Cambridge University Press, 1983).

[3] "Thousands Worship Elvis and He Answers Prayers," *Globe* (January 9, 1990).

[4] "Saint Elvis," *Washington Post* (August 13, 1987).

[5] May Man, *Elvis, Why Won't They Leave You Alone?* (New York: New American Library, 1982).

[6] Albert Harry Goldman, *Elvis* (New York: McGraw-Hill, 1981).

[7] Max Weber, *Economy and Society I–III* (New York: Bedminster Press, 1968), I, 241.

[8] "In a Most Unsaintly City, a Bandit Wears a Halo," *New York Times* (May 11, 1989).

[9] Larry Geller and Joel Spector, with Patricia Romanowski, *If I Can Dream: Elvis' Own Story* (New York: Simon & Schuster, 1989), pp. 137–40, 187.

[10] Raymond A. Moody, Jr., *Elvis After Life: Unusual Psychic Experiences Surrounding the Death of a Superstar* (Atlanta: Peachtree Publishers, 1987).

[11] *Weekly World News*, (December 29, 1987).

[12] Hippolyte Delehaye, "Les Origines du culte des martyrs," *Subsidia hagiographica* 30 (1933); André Grabar, *Martyrium: Recherches sur le culte des reliques et l'art chrétien antique*, I , II (Paris: College de France, 1946); Bernhard Kötting, *Peregrinatio Religiosa: Wallfahrten in der Antike und das Pilgerwesen in der alten Kirche* (Munster: Regensburg, 1950); Pierre Maraval, *Lieux saints et pèlerinages d'orient* (Paris: Cerf, 1985); *Jerusalem Pilgrims before the Crusades*, trans. John Wilkinson (Warminster: Aris & Phillips, 1977).

[13] John Wilkinson, "The Tomb of Christ: An Outline of Its Structural History," *Levant* 1 (1969): 83–97; *Jerusalem Pilgrims before the Crusades; Jerusalem Pilgrimage: 1099–1185*, trans. John Wilkinson with Joyce Hill and W. F. Ryan (London: Hakluyt Society, 1988).

[14] Mary Lee Nolan and Sidney Nolan, *Christian Pilgrimage in Modern Western Europe* (Chapel Hill: University of North Carolina Press, 1989); Victor Turner and Edith Turner, *Image and Pilgrimage in Christian Culture: Anthropological Perspectives* (New York: Columbia University Press, 1978).

[15] Elizabeth Kay, *Chimayó Valley Traditions* (Santa Fe: Ancient City Press, 1987).

16 Peter W. L. Walker, *Holy City, Holy Places?: Christian Attitudes to Jerusalem and the Holy Land in the Fourth Century* (Oxford: Clarendon Press, 1990).

17 *Orthodox Faith* 4.11. The Fathers of the Church 37 (Washington, D.C.: Catholic University of America Press, 1958), pp. 165 ff.

18 Epistle 49:402.

19 A. Stuiber, "Eulogia," *Reallexikon für Antike und Christentum* 6 (1966): 900–28.

20 Wilkinson, *Jerusalem Pilgrims Before the Crusades*, p. 83.

21 Brown, p. 50. At the gathering marking the fifteenth anniversary of Elvis' death, Anita Massey, a middle-aged nurse from Big Spring, Texas, vowed that once her son had finished high school, she was going to move to Memphis permanently. "It's because I love Elvis and I want to be where he grew up. He has become part of what we are. We're not Elvis fans, we're Elvis friends." ("We're not Elvis Fans, We're Elvis Friends," *The Commercial Appeal* August 16, 1992.) The group designation "Elvis Friends" is more descriptive than fan, devotee, "Presleyterian" ("The Elvis Cult Has the Makings of a Rising New Religion," *Time*, October 10, 1988) or "Elfan" (Jane Stern and Michael Stern, *Elvis World* [New York: Knopf, 1987]), since it reveals at once the relationship of the individuals to the deceased and the interrelationship among the individuals.

22 Lionel Casson, *Travel in the Ancient World* (London: Allen & Unwin, 1974), pp. 262–91, 300–29.

23 Wilkinson, *Jerusalem Pilgrims Before the Crusades*, pp. 79–89.

24 Since the notion of "sight-seeing" for its own sake, which had been part of elite culture during the Greco-Roman period, seems to have all but disappeared during the leaner, more spiritually focused Middle Ages, one would not expect anything close to the lopsided tourists-to-pilgrim ratio at Graceland to have obtained in fourth-century Jerusalem. Nowadays, Vatican City provides a closer parallel, insofar as it annually draws millions of each sort of visitor, many of whom alternately assume both identities.

25 The second most critical Elvis holiday is January 8, his birthday, and after that comes Christmas and then Mother's Day, reflecting Elvis' deep family ties and his reverence for his mother, Gladys. And the list goes on: calendars are sold highlighting three or four days every month of special Elvis significance, including the birthday of Lisa Marie (February 1), the day Elvis was discharged from the army (March 5), Elvis' wedding anniversary (May 1), and the day Elvis was divorced (October 9).

26 The August Elvis pilgrim was poetically evoked on site by Elvis Friend Selby Townsend on the August 14, 1987, "Nightline" segment entitled "Remembering Elvis":

> Most of the women are in their thirties and forties. They tease their hair, chew gum, swear, drink Pepsi Cola, smoke cigarettes, and dress too young for their years. They come here in Chevies and Fords, some in pretty bad shape, with bumper stickers, loud mufflers, and a loan on the title. No telling how long they saved for the trip. And the men, they come with short hair slicked to perfection, rolled-up short sleeves, a pack of Luckies in their shirt pocket, and white socks on their feet. Most of them went to high school and some even finished. And they all know what it's like to work for a livin'. As I sit here in the Hickory Log on Elvis Presley Boulevard, I'm proud to be one of those very special people. My clothes come from K-Mart, my hands are rough and ugly from too many years in the beauty shop, and my only real jewelry is my wedding band. I've got a run in my pair of panty hose, and I'm soaking wet just like the rest, from [having been] out walking in the rain to visit the grave of Elvis Presley. We are the blue-collar workers, the fans, the believers in magic and fairytales. We're not smart enough not to fall in love with someone we never met. We're not rich enough to buy everything we want from the souvenir shops. We don't even have sense enough to come in out of the rain. But Lord, we've got something special.
>
> Only one that feels it can understand it. We share the sweetness, the emptiness, the understanding. We're the Elvis generation—wax fruit on our kitchen table, Brand X in our cabinet, a mortgage on our home, Maybelline on our eyes, and love in our hearts that cannot be explained or rained out. He was one of us.

27 Wilkinson, *Jerusalem Pilgrims Before the Crusades*, p. 77.

28 "Words on the Wall Leave Heartfelt Passions to Elvis," *Baltimore Evening Sun* (August 13, 1987).

IV

29 Turner and Turner. The authors also emphasize the porous boundary between pilgrimage and tourism: "a tourist is half a pilgrim...a pilgrim is half a tourist," p. 20.

30 *Elvis Fever*, fan club quarterly, Baltimore (Fall 1988).

31 "11th Annual Candlelight Service, August 15, 1989" (brochure, Elvis Country Fan Club, Austin, Texas).

32 While it is known that Elvis was reading, or at least looking at, pornography on the toilet when he was stricken with his drug-induced heart attack (Charles C. Thompson II and James P. Cole, *The Death of Elvis: What Really Happened* [New York: Delacorte, 1991] p. 30 ff.), the saint-making story was soon promulgated, apparently from within Graceland, that what he had taken with him to the bathroom that morning was "a religious book on the Shroud of Turin" (Lee Cotten, *The Elvis Catalog: Memorabilia, Icons, and Collectibles Celebrating The King Of Rock 'n' Roll* [Garden City, N.Y.: Doubleday, 1987], p. 217).

33 Early ritual contact with the sacred involved sight as an extension of touch (Brown, p. 11), since it was then believed that it was through invisible contact with the object seen that the eye is able to see.

34 M. Broshi and G. Barkay, "Excavations in the Chapel of St. Vartan in the Holy Sepulchre," *Israel Exploration Journal* 35 (1985): 125–28.

35 Kötting, pp. 398–402; Maraval, pp. 230–33; Gary Vikan, "Icons and Icon Piety in Early Byzantium," *Byzantine East, Latin West: Art Historical Studies in Honor of Kurt Weitzmann* (Princeton: Princeton University Press, 1995).

36 C. Austin Miles, "In the Garden," 1912.

37 "Perón's Missing Hands: Police Find Trail Elusive," by Shirly Christian, *New York Times* (September 6, 1987). The article suggests that the hand-stealing was a variant on the body veneration traditionally extended to Eva Perón:

> The theft of the hands seemed to fit into the pattern of the two-decade-long battle for possession of the body of one of Mr Perón's wives, Eva....After Eva Perón died of cancer in 1952 at the age of 33, her body was permanently embalmed and left on display at the headquarters of the General Federation of Labor, whose members revere her still today as someone who approaches sainthood.

38 S. R. Tucker, "Pentacostalism and Popular Culture in the South: A Study of Four Musicians," *Journal of Popular Culture* 16 (1982): 68–80.

39 "Saint Elvis," *Washington Post* (August 13, 1987); "New Fast-Growing Sect Worships Elvis Presley as a God," *Baltimore Sun* (July 26, 1988); "Elvis Used Miracle Healing Power to Cure Sick Fans," *Baltimore Sun* (December 19, 1989); "Thousands Worship Elvis and He Answers Prayers," *Boston Globe* (January 9, 1990).

16 GRACELAND AS *LOCUS SANCTUS*

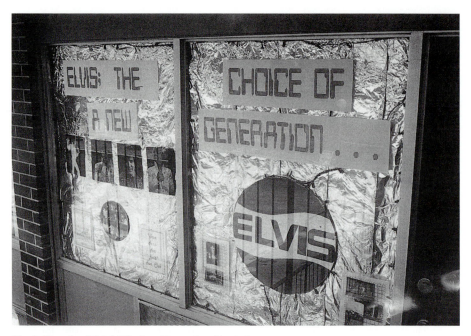

Fig. 1 Days Inn Motel, Window Decorating Contest.

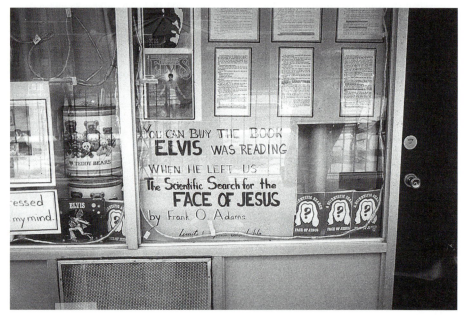

Fig. 2 Days Inn Motel, window

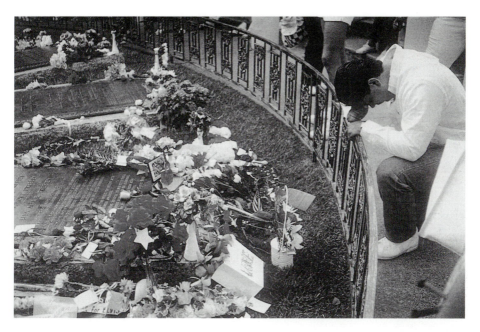

Fig. 3 Meditation Garden, Elvis Grave veneration.

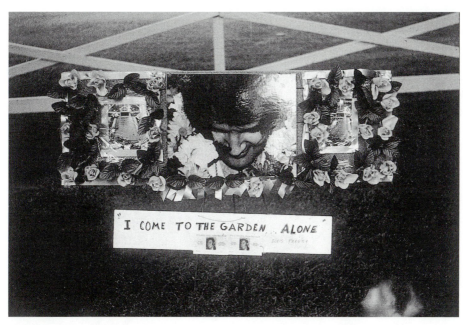

Fig. 4 Meditation Garden, votive.

Fig. 5 The Fans' Memorial Wall, votive.

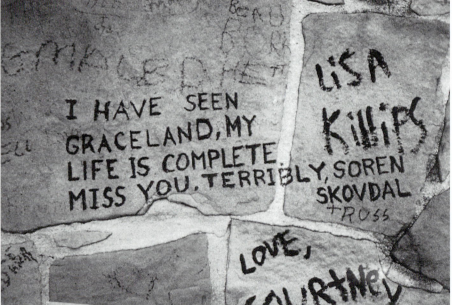

Fig. 6 The Fans' Memorial Wall, votive.

V

BYZANTINE
PILGRIMS' ART

Although mandated neither by the Bible nor by the church fathers, pilgrimage became a critical ingredient in the spiritual and material culture of Byzantium, especially between the fourth and seventh centuries, when vast numbers of pious travelers journeyed from all corners of the Christian world to those places in Byzantine Palestine associated with the life of Christ, as well as to sites in Egypt, Syria, Asia Minor, and Greece made sacred by association with the relics of saints, or with living holy men or women. *Peregrinatio*, from which our word "pilgrimage" derives, meant in the Latin of that time only "going abroad," and the *peregrinus* was simply the "foreigner"; then religiously motivated travel was universally evoked by the phrase "going to pray at," with the destination being the "holy place" (*locus sanctus*). The foreigner, in Greek, was the *xenos*, his destination the *hagios topos*, and his pious act *proskynesis*, "veneration." During this period a religiously motivated traveler might be from the other end of the Mediterranean, or from the next town; a pilgrimage shrine might cater mostly to international traffic (e.g., Jerusalem), or to regional or local traffic (e.g., Thessalonike). The criterion for "pilgrimage" was simply that the individual had interrupted his or her normal life activities for the purpose of visiting a *locus sanctus*, whether nearby or far away.

Within a few generations of the Edict of Milan (313 C.E.) the eastern Mediterranean had come alive with Christian pilgrims. Among the first was Emperor Constantine's mother, Helena, who went to Palestine at her son's request to dedicate his newly built churches located at the sites identified with the birth, death, and ascension of Christ: Bethlehem, Golgotha, and the Mount of Olives. Thousands, from all strata of society, followed in a mass mobilization of body and spirit that grew uninterrupted

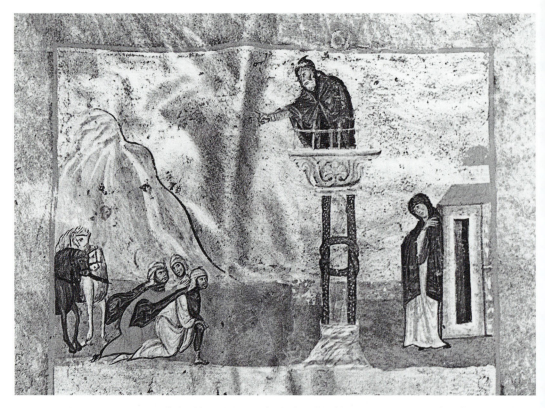

Fig. 8.1 Athos, Esphigmenou, cod. 14, fol. 2v. Symeon the Stylite the Elder receiving a group of Arabs. Manuscript miniature, tempera on parchment, eleventh–twelfth century. Compare Color Plate XIII. (after S. Pelekanides et al., *The Treasures of Mount Athos* [Athens, 1975], 2, no. 328)

until the Arab conquest of the eastern Mediterranean in the seventh century, after which it declined precipitously. The fifth-century writer Theodoret of Cyrrhus (d. ca. 466) gives an eyewitness account of the multiethnic crowd drawn to Symeon the Stylite the Elder (d. 459), the famous Syrian holy man who spent nearly four decades atop one or another column (Greek *stylos*) on a barren hilltop, Qal'at Sem'ān, some thirty-seven miles (60 km) northeast of Antioch (see map, page viii; Fig. 8.1 and Color Plate XIII):

> So with everyone arriving from every side and every road resembling a river, one can behold a sea of men standing together in that place, receiving rivers from every side. Not only do the inhabitants of our part of the world flock together, but also Ishmaelites, Persians, Armenians subject to them, Iberians, Homerites, and men even more distant than these; and there came many inhabitants of the extreme west, Spaniards, Britons, and the Gauls who live between them. Of Italy it is superfluous to speak.[1]

Constantine's act of enshrinement attests to a critical sea change then taking place in the perceived status of Palestine generally and Jerusalem specifically. What had formerly been simply that region where the historical Jesus lived and died—as Greece and Athens were for Aristotle—was becoming that special place in the world uniquely and continuously "charged," by virtue of Christ's former physical presence there, with miracle-working sanctity. A historical site was becoming a sacramental site. Although the term "Holy Land" became popular only much later, the notion is clearly implicit in this incarnation-inspired belief in the "localized holy"; moreover, it is precisely in this period of the emerging *locus sanctus* that relics and then "holy men" become central features of Christian piety. In each—holy place, holy thing, holy person—the power of the sacred had become objectified.

The story of Byzantine pilgrimage is preserved in travel diaries and guide books, in historical texts and theological tracts, in *Miracula* and Vitae documenting miracle-working relics and saints, and in four distinct but interrelated categories of pilgrimage art: the shrine itself, locally relevant mural decoration within the shrine, votives dedicated at the shrine, and "souvenirs" taken away from the shrine. For the *locus sanctus* of Symeon the Stylite the Elder these would include the huge cruciform church (Figs. 8.2 and 8.3) that was built during the last quarter of the fifth century to enshrine the saint's column; image-bearing, often precious "thank-offerings" (Greek *charisteria*), like the sixth-century silver plaque in the Louvre inscribed "In thanksgiving to God and to Saint Symeon, I have offered [this]" (Fig. 8.4); and scores of humble take-home "blessings" (Greek *eulogiai*), like the sixth- to seventh-century terra-cotta pilgrim token in the Royal Ontario Museum, Toronto (Fig. 8.5), bearing an image of the saint on his column labeled in Syriac "Mar Shem'on," Saint Symeon. This chapter will focus less on the architecture and murals of pilgrimage—which were usually commissioned by the elite of state and church, with the twofold aim of enshrining the holy and controlling visitor access to it, and proclaiming their personal identification with it—than on everyday pilgrims' art, the *eulogiai* taken away from the *locus sanctus* by the anonymous "many," and on the votives they left behind.

Why would Christians sacrifice their resources and jeopardize their safety (risking sea storms, wayside bandits, and wild animals) in an arduous journey covering, perhaps, no more than twenty miles (32 km) a day, and extending over many months? Immediate motives varied: the sick sought healing; the penitent, forgiveness; the troubled, guidance—and many seem to have been motivated to travel simply by the desire to affirm and strengthen their faith. (The same is true of modern pilgrims to the new Marian shrine at Medjugorje in Croatia.) Ultimately, each pious traveler was (and is) driven by the same basic conviction; namely, that the "objectified holy" that he or she will encounter at journey's end is in some measure transferable through physical contact, as if it were a charge of sacred electricity. The eighth-century Byzantine theologian John of Damascus (d. ca. 753) explained the sanctity, and thus the attraction, of the True Cross this way: "So, then, that honorable and most truly venerable tree upon which Christ offered Himself as a sacrifice for us is itself to be adored, because it has been sanctified by contact with the sacred body and blood."[2] Unlike the tourist, who goes places mostly to see, the pilgrim

V

Fig. 8.2 Qal'at Sem'ān. Pilgrimage shrine of Symeon the Stylite the Elder, late fifth century. (courtesy Dumbarton Oaks)

Fig. 8.3 Qal'at Sem'ān. Pilgrimage shrine of Symeon the Stylite the Elder, reconstruction. (after G. Tchalenko, *Villages antiques de la Syrie du Nord* [Paris, 1953], II, pl. LXXVIII, 4).

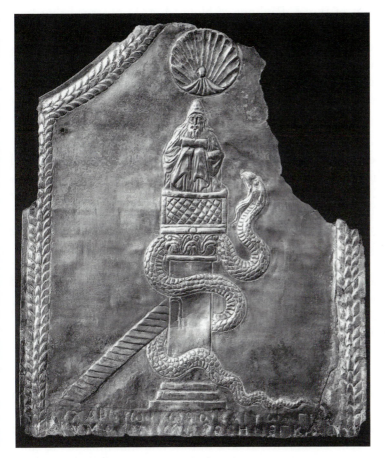

Fig. 8.4 Votive plaque, Symeon the Stylite the Elder, silver-gilt, sixth century
(Paris, Musée du Louvre, no. Bj 2180). (after M. Mundell Mango, *Silver
From Early Byzantium: The Kaper Koraon and Related Treasures* [Baltimore, 1986],
no. 71)

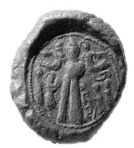

Fig. 8.5 Pilgrim *eulogia* token, Symeon the Stylite the Elder, terra-cotta, sixth–seventh
century (Toronto, Royal Ontario Museum, no. 986.181.84). (courtesy Royal Ontario
Museum)

has a distinctly tactile notion of travel. Paulinus of Nola (d. 431) observed that "the principal motive which draws people to Jerusalem is the desire to see and touch the places where Christ was present in the body."[3] This conviction, and the contact rituals to which it gave birth, are no more clearly evoked than in the diary of Egeria, the Spanish noblewoman who made a grand tour of the Holy Land around the year 380. The time is Thursday of Great Week, the week before Easter; the place, Constantine's church at Golgotha:

> A table is placed before him [the bishop] with a cloth on it, the deacons stand around, and there is brought to him a gold and silver box containing the Holy Wood of the Cross. It is opened, and the Wood of the Cross and the Title are taken out and placed on a table.
>
> As long as the Holy Wood is on the table, the bishop sits with his hands resting on either end of it and holds it down, and the deacons around him keep watch over it. They guard it like this because what happens now is that all the people come up one by one to the table. They stoop down over it, kiss the Wood, and move on. But on one occasion (I don't know when) one of them bit off a piece of the Holy Wood and stole it away, and for this reason the deacons stand round and keep watch in case anyone dares to do the same thing.[4]

As early Christians came to accept the notion that the holy was susceptible to concentration in places, things, and people, they inevitably came to accept the corollary notion that the power of that localized holy was susceptible to transfer through contagion. Symeon the holy man stood on a column and the column was infused with the power of his sanctity; Symeon's (now) relic-column rested on a hillside and that hillside was similarly empowered. When the pilgrim took away a handful of Symeon's hillside earth he took with him a portion of Symeon's sacred power—power to ensure safe passage home, and power to perform miracles once he got there. This, in the vocabulary of contemporary travel diaries and saints' lives, was the pilgrim's *eulogia* or "blessing" (Latin *benedictio*). An *eulogia* could be gained immaterially, as in the Egeria story, by kissing a relic, or simply by reenacting a biblical event near its *locus sanctus* (as, for example, by mimetic stone-throwing at the grave of Goliath); but usually the pilgrim's *eulogia* was an object, typically a portion of some everyday substance like earth, water, oil or wax. It was a "blessing" because by virtue of contact with a holy site, a holy person, or a relic it had been infused with a miracle-working potential. With the *eulogia* the supply problem implicit in Egeria's account of the veneration of the True Cross was solved; while finite "primary relics" like the cross could not be infinitely subdivided and dispersed, they could, through touch, generate an infinite number of "secondary relics." The diary of an anonymous pilgrim from Piacenza, in Italy, who made his trip to Jerusalem around 570, records the practice of bringing earth into Christianity's preeminent contact relic, the Holy Sepulchre, so that "those who go in [may] take some as a blessing." He then goes on to describe the creation of sacred oil by contact with the True Cross:

In the courtyard of the basilica [at Golgotha] is a small room where they keep the Wood of the Cross. We venerated it with a kiss. . . . At the moment when the Cross is brought out of the small room for veneration . . . a star appears in the sky, and comes over the place where they lay the Cross. It stays overhead whilst they are venerating the Cross, and they offer oil to be blessed in little flasks. When the mouth of one of the little flasks touches the Wood of the Cross, the oil instantly bubbles over, and unless it is closed very quickly it all spills out.[5]

In Jerusalem today one may still acquire little packets of earth labeled "from Calvary," and small vials of oil that are said to have touched the tomb of Christ.

What was the *eulogia* for? Cyril of Skythopolis (fl. 555) writes that Saint Sabas, among others, used the oil of the True Cross to exorcise evil spirits,[6] while a century earlier Theodoret described how he had been protected from the power of demons by "the flask of oil of the martyrs, with a blessing [*eulogia*] gathered from very many martyrs, which was hung up by my bed."[7] For many, the pilgrim "blessing" was explicitly medicinal. A Coptic text describes pilgrim practice at the shrine of Saint Menas, southwest of Alexandria, in Egypt: "The pilgrim suspended a lamp before the grave [of Saint Menas]. It burned day and night, and was filled with fragrant oil. And when anyone took oil of this lamp . . . and rubbed a sick person with it, the sick person was healed of the evil of which he suffered."[8]

For others, the power of the *eulogia* was valued in a more general way, for the amulet-like protection it was believed to convey to its owner: "he has made it [his mountain] distinguished and revered, although formerly it was totally undistinguished and sterile. So great is the blessing it is confidently believed to have now received that soil on it has been quite exhausted by those coming from all sides to carry it off for their benefit [as prophylactics]."[9]

Such pilgrim amulets were frequently called upon, and then consumed, during the dangerous trip home. One of the miracles of Symeon the Stylite the Younger recounts the story of a monk named Dorotheos who made the mistake of setting out to sea during the dangerous winter months. Encountering a storm, "the monk took the dust of the saintly servant of God that he carried with him as an *eulogia*, and after having put it into water, he threw it on the sea and sprinkled all the boat, saying 'Holy Servant of God, Symeon, direct us and save us.' With these words, all those on the boat were impregnated with perfume, the sea water surrounded the boat like a wall, and the waves were powerless against it."[10]

What may initially seem to be little more than religiously sanctioned "contagious magic" is actually an eloquent expression of New Testament incarnation theology. God became man in the body of Christ, and Christ, through his physical birth, death, and resurrection, fulfilled God's mission in the world—as, by imitation, do his saints. Thus, it is through the core belief of Christianity that the human body became at once the vehicle for and the reservoir of the sacred. It was empowered, and through contact, through successive "re-incarnations," it was believed capable of passing that holiness to inanimate

objects. In the words of Saint Gregory of Tours (d. 594/5), "faith believes that everything the sacred body touches is holy."[11]

The pilgrim blessing, as bearer through contagion of the power of the sacred, could function without any artistic or inscriptional tag, and in that state it was (and is) effectively unidentifiable as anything other than a clump of earth or a flask of oil. The *eulogia*'s "art," when it did exist, was the imagery stamped into it, for earth or wax, or embossed onto the vessel that contained it, in the case of oil or water. But while the *eulogia* was an important, ever-present ingredient in the Early Byzantine pilgrimage experience, at sites throughout the Balkans, Asia Minor, Syria, Palestine, and Egypt, few image-bearing *eulogiai* survive, and a significant proportion of those that do derive from just four pilgrimage centers. Moreover, most of the individual items constituting those four groups seem datable to a relatively brief period, bracketed, more or less, by the efflorescence of the cult of images in the sixth century and the Arab conquest in the mid-seventh.

One group, known through more than 150 examples, centers around the Symeon shrine at Qal'at Sem'ān. Ranging in size between a dime and a quarter, these Qal'at Sem'ān tokens, in their most familiar form, show the saint on top of his column, with crowning angels above and various venerating suppliants below, often with censers in their hands (Fig. 8.5); just a few examples bear a full-face, iconic portrait of the saint (Color Plate XVI.A). More than half of the tokens in the group, however, show non-Symeon imagery, including more than half a dozen New Testament scenes (Figs. 8.6–8.8: Adoration of the Magi, Tempest Calmed, Women at the Tomb), as well as iconic portraits of Christ (Fig. 8.9) and of the Virgin and Child (Fig. 8.10). All of these tokens were manufactured from the earth around the shrine with now-lost intaglio (engraved) metal stamps, probably much like a rare surviving example in bronze from the *locus sanctus* of

Fig. 8.6 Pilgrim *eulogia* tokens, Adoration of the Magi, terra-cotta, sixth–seventh century (London, British Museum, nos. 1973, 5–1, 1–17). (courtesy Trustees of the British Museum)

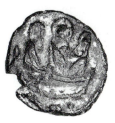

Fig. 8.7 Pilgrim *eulogia* token, Tempest Calmed, terra-cotta, sixth–seventh century (London, British Museum, no. 1973, 5–1, 38). (courtesy Trustees of the British Museum)

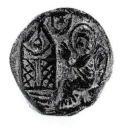

Fig. 8.8 Pilgrim *eulogia* token, Women at the Tomb, terra-cotta, sixth–seventh century (London, British Museum, no. 1973, 5–1, 52). (courtesy Trustees of the British Museum)

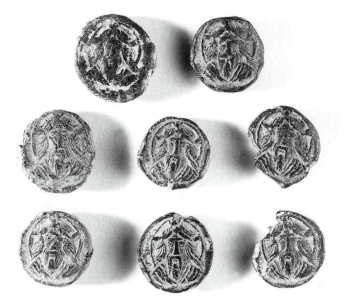

Fig. 8.9 Pilgrim *eulogia* tokens, Christ, terra-cotta, sixth–seventh century (London, British Museum, no. 1973, 5–1, 71–78). (courtesy Trustees of the British Museum)

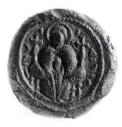

Fig. 8.10 Pilgrim *eulogia* token, Virgin and Child, terra-cotta, sixth–seventh century (London, British Museum, No. 1980, 11-5, 1). (courtesy Trustees of the British Museum)

Fig. 8.11 Pilgrim *eulogia* token stamp, Saint Isidore, copper alloy, sixth–seventh century (Baltimore, Walters Art Gallery, no. 54.230). (courtesy Walters Art Gallery)

Fig. 8.12 Pilgrim *eulogia* token, Symeon the Stylite the Younger, terra-cotta, sixth–seventh century (Houston, Menil Collection, no. II.J3). (courtesy Menil Collection)

Saint Isidore on the island of Chios preserved in the Walters Art Gallery, Baltimore (Fig. 8.11: "Saint Isidore. Receive the Blessing").

A contemporary, closely related subgroup consists of just a handful of tokens from the pilgrimage shrine of Symeon the Stylite the Younger, the homonymous sixth-century imitator of the "elder" (fifth-century) Symeon, located on a hill ten miles (16 km) southwest of Antioch (see map, page viii). These pilgrim blessings were formed of earth from the so-called Miraculous Mountain upon which the younger's column had stood, and like the elder Symeon's tokens, they show the saint as a stylite (column-dweller), with crowning angels above and censer-bearing suppliants below (Fig. 8.12). What distinguishes the two series, besides slight differences in manufacture and in size (these were mold-made, and are about the size of a half-dollar), are their respective identifying inscriptions: simply "Saint Symeon" for the elder's tokens, but for his younger imitator, the distinguishing epithet signaling his *locus sanctus*, "*Eulogia* of Saint Symeon in the Miraculous Mountain."

Just as image-bearing tokens of blessed pilgrim earth have traditionally meant Symeon

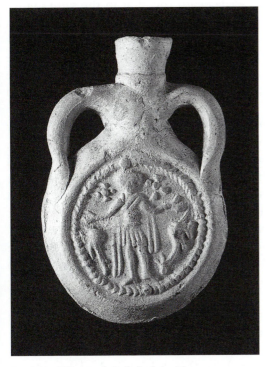

Fig. 8.13 Pilgrim *eulogia* flask, Saint Menas, terra-cotta, sixth–seventh century (Baltimore, Walters Art Gallery, no. 48.2541). (courtesy Walters Art Gallery)

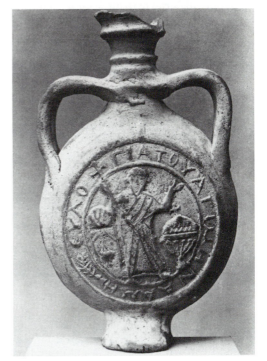

Fig. 8.14 Pilgrim *eulogia* flask, Saint Menas, terra-cotta, sixth–seventh century (Paris, Musée du Louvre, Département des antiquités grecques et romaines, MNC 1926). (after C. Metzger, *Les ampoules à eulogie du musée du Louvre*, Notes et documents des musées de France, 3 [Paris, 1981], fig. 80b)

Fig. 8.15 Ephesus, Church of Saint John the Evangelist.
(after R. Ousterhout, ed., *The Blessings of Pilgrimage*
[Urbana, 1990], fig. 40, Keil and Hormann)

the Stylite, image-bearing flasks of blessed pilgrim water have traditionally meant Saint Menas, and his shrine in the Maryut desert southwest of Alexandria (see map, page viii). Menas flasks comprise the second group. Recently, however, it has been shown that despite the vast cisterns at the site, the *eulogia* carried away in these flasks was probably not water but oil, drawn from a large alabaster pot set beneath the altar in the saint's grave church. The vast majority of the hundreds of surviving Menas flasks, which range in height from about two to six inches (6 to 14 cm), show the saint as orant-intercessor between the pair of camels that inexplicably stopped while transporting his body across the desert, and so identified the future *locus sanctus* (Fig. 8.13). A few of the more elaborate members of the group (Fig. 8.14) bear an inscription much like that already encountered on tokens of Symeon the Younger, "*Eulogia* of Saint Menas, amen."

A quite different group of terra-cotta pilgrim flasks (the third group), which is only slightly less abundant in American and European museum collections than Menas flasks, is that traditionally associated with the west coast of Asia Minor, and more recently and specifically with the shrine of Saint John the Evangelist in Ephesus (Fig. 8.15). Somewhat differently designed and slightly smaller than Menas flasks (they are the size of a small flattened pear), and much more varied in their imagery, these Asia Minor flasks, or at least some of them, were apparently used as containers for the so-called manna (dust) "exhaled" by Saint John in tiny geysers through holes in his subfloor tomb, just in front of the altar of his church. Like Symeon earth and Menas oil, Saint John manna was believed to be miraculous, with multivalent powers: "And this manna is marvelously good for many things; for instance, he who drinks it when he feels fever coming on will never have fever again. Also, if a lady is in travail and cannot bring forth, if she drinks it with water or with wine, she will be delivered at once. And again, if there is a storm at sea and some of the manna is thrown in the sea . . . at once the storm ceases."[12] Some of the Asia Minor flasks show a seated Evangelist-scribe, presumably Saint John (Fig. 8.16a), and others a standing figure (Fig. 8.16b) or a figure *en buste*, again presumably John, though there are still others (from the same site?) labeled "Andrew," and a significant number that show simplified biblical scenes with riding figures (Fig. 8.17: Entry into Jerusalem) or figures in a boat (Fig. 8.18: Tempest Calmed).

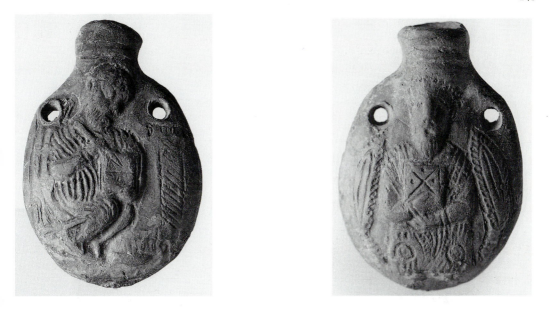

Fig. 8.16 a–b Pilgrim *eulogia* flask, Saint John the Evangelist (front/back), terra-cotta, sixth–seventh century (Princeton, Art Museum, Princeton University, Antioch 3581-P34624-L). (after R. Ousterhout, ed., *The Blessings of Pilgrimage* [Urbana, 1990], fig. 42)

The last of the four most characteristic groups of Early Byzantine image-bearing pilgrim blessings—which, like the others, is datable more or less between 500 and 650—is the rarest in museum collections but the most well known among scholars. It comprises the forty or so surviving pewter ampullae associated by their inscriptions, by their iconography, and by contemporary pilgrim accounts describing their sanctification with the Church of the Holy Sepulchre in Jerusalem (Fig. 8.19). (Recall the Piacenza Pilgrim's account, quoted above.) Most have been preserved in northern Italy, at Monza and Bobbio, since the early Middle Ages. The relative fame of these Monza/Bobbio flasks derives in part from the richness and intricacy of their decoration, but mostly from the traditional— but substantially mistaken—notion that their imagery derives from now-lost monumental mosaics in the most famous *locus sanctus* of the Holy Land. Actually, place- or event-specific pilgrimage murals were then relatively rare, and played only a secondary role in pilgrim piety.

Most Monza/Bobbio ampullae bear imagery responsive to the two most famous relics in the Jerusalem church shrine (Fig. 8.20): the Tomb of Christ and the True Cross. It was contact with the latter, specifically, that was said to have sanctified the oil that they once contained. Among the finest and most richly detailed of the group is an example in the Dumbarton Oaks Collection in Washington, D.C. The front (Color Plate XVI.B, left) shows a pair of kneeling suppliants venerating the cross (relic), much as the single kneeling suppliant is venerating the column (relic) of Symeon the Younger on a token already discussed (Fig. 8.12); the bust of Christ is above, the crucified thieves are to left and right,

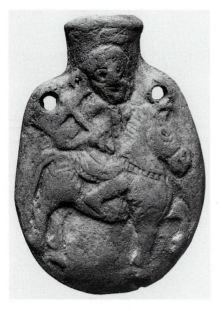

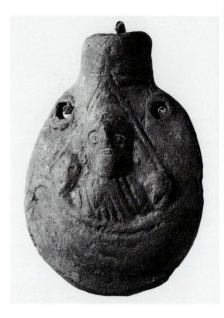

Fig. 8.17 Pilgrim *eulogia* flask, Entry into Jerusalem, terra-cotta, sixth–seventh century (Paris, Musée du Louvre, no. MND 648). (courtesy Musée du Louvre, © Réunion des Musées Nationaux)

Fig. 8.18 Pilgrim *eulogia* flask, Tempest Calmed, terra-cotta, sixth–seventh century (Princeton, Art Museum, Princeton University, no. 118). (courtesy Art Museum, Princeton University)

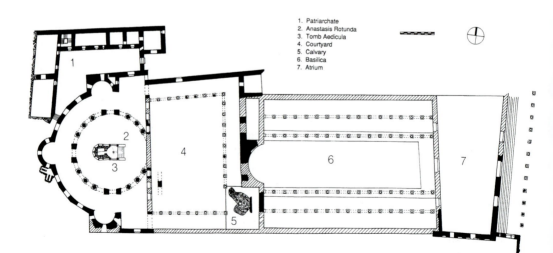

1. Patriarchate
2. Anastasis Rotunda
3. Tomb Aedicula
4. Courtyard
5. Calvary
6. Basilica
7. Atrium

Fig. 8.19 Jerusalem, Church of the Holy Sepulchre, plan. (after R. Ousterhout, ed., *The Blessings of Pilgrimage* [Urbana, 1990], fig. 25, based on Corbo)

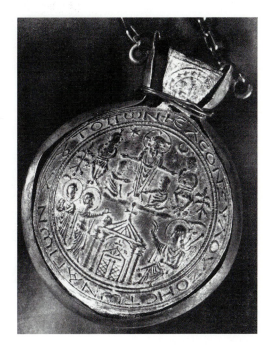

Fig. 8.20 Pilgrim *eulogia* ampulla, Crucifixion and
Women at the Tomb, pewter, sixth–seventh century
(Monza, Treasury of the Cathedral of Saint John the
Baptist, no. 13). (after A. Grabar, *Ampoules de Terre
Sainte* [Paris, 1958], pl. XXIV)

and surrounding the field is the inscription "Oil of the Wood of Life of the Holy Places of
Christ." Like the image on the front, that on the back (Color Plate XVI.B, right: "The
Lord is Risen") is in part literal biblical storytelling and in part visual documentation of
the contemporary pilgrim's experience at the shrine. Three figures, an angel and two
Marys, act out the Easter morning story of the Women at the Tomb. Their backdrop,
however, is not the rock-cut tomb of the Gospel account, but rather Constantine's richly
embellished aedicula shrine at the center of the Anastasis Rotunda, as the contemporary
pilgrim then experienced it (Fig. 8.21). Despite their likely origin in Jerusalem, some
among the Monza/Bobbio group show scenes relating to other Holy Land *loca sancta*; one
especially well-preserved example in Monza (Figs. 8.22 and 8.23) bears seven tiny vi-
gnettes evoking the Annunciation (upper left), the Visitation (upper right), the Nativity
(center), the Baptism (lower left), the Crucifixion (lower right), the Women at the Tomb
(bottom center), and the Ascension (top center).

If the pilgrim's *eulogia* could exercise its miraculous power without imagery, as contem-
porary texts indicate, why was imagery sometimes added? Much of the art associated with
Early Byzantine pilgrim *eulogiai* fulfilled one of two basic functions: either it reflected and
facilitated the devotion dynamic in which the power of the *eulogia* was put to use, or else
it contributed its own iconic power in a way complementary to the power of the sanctified
material that bore it.

Let us first consider devotional imagery. Menas flasks typically show the saint in the
orant (arm-extended) pose of prayer (Figs. 8.13 and 8.14), evoking visually the suppliant-
saint-deity intercessory dynamic described literally in many contemporary texts, includ-

Fig. 8.21 Jerusalem, Holy Sepulchre, model by J. Wilkinson. (courtesy J. Wilkinson)

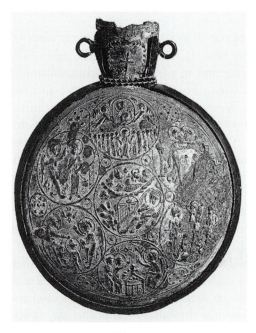

Fig. 8.22 Pilgrim *eulogia* ampulla, *locus sanctus* scenes, pewter, sixth–seventh century (Monza, Treasury of the Cathedral of Saint John the Baptist, no. 2). (after A. Grabar, *Ampoules de Terre Sainte* [Paris, 1958], pl. V)

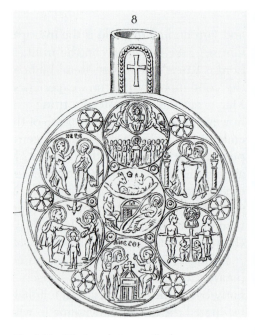

Fig. 8.23 Pilgrim *eulogia* ampulla, *locus sanctus* scenes, pewter, sixth–seventh century (Monza, Treasury of the Cathedral of Saint John the Baptist, no. 2, drawing). (after R. Garrucci, *Storia dell'arte cristiana* [Prato, 1880], VI, fig. 433)

ing miracle 163 in the Vita of Symeon the Stylite the Younger: "Instantly the paralytic was healed [through the application of *eulogia* dust], after having invoked the power of our Lord Jesus Christ, the Son of God, by the intermediary of his saintly servant Symeon, whom he saw with his own eyes under the aspect of a long-haired monk, who extended his hand and put him upright."[13] Both the intense visual presence of the (physically absent) saint and his role as intercessor on the suppliant's behalf are graphically evoked through iconic votives as well, like those in mosaic in the *locus sanctus* church of Saint Demetrios in Thessalonike. Some show suppliants actively beseeching the orant saint (Fig. 8.24), and at least one adds Christ above Demetrios, as if the plea being received from the mortal below were at that moment being retransmitted by the saint heavenward. This is the same spiritual dynamic evoked in silver-gilt on a later votive plaque of Symeon the Younger in Tblisi (Fig. 8.25), and on Symeon tokens like those in Figures 8.5 and 8.12 and on the Monza/Bobbio ampulla in Color Plate XVI.B, which were likely modeled on such votives. In each case, pilgrim-suppliant beseeches saint-intercessor; in the case of the Menas flask the suppliant, as holder or wearer of the flask (Fig. 8.26), performs his supplicating role outside the visual field of the image.

Such multifigure *eulogia* images, then, documented and evoked the devotional interchange associated with their use, whereas compositionally simpler and more explicitly iconic *eulogia* images, like those in Color Plate XVI.A and Figure 8.9, must more aggressively have helped to precipitate that interchange. Miracle 231 in the Vita of Symeon the Younger refers explicitly to an iconically stamped token. A priest has brought his second-born son to the Miraculous Mountain to be cured of an unspecified disease; Symeon blesses the young man, but sends him home to await the healing. The father

Fig. 8.24 Thessalonike, Church of Saint Demetrios. Saint Demetrios and suppliant, votive mosaic, seventh century (W. S. George watercolor). (after R. Cormack, "The Church of St. Demetrios: The Watercolours and Drawings of W. S. George," in *The Byzantine Eye: Studies in Art and Patronage* [London, 1989], pl. II, no. 29)

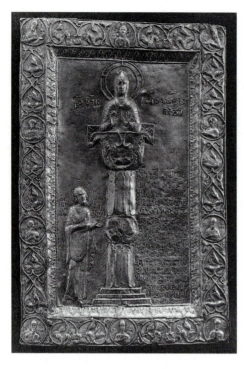

Fig. 8.25 Votive plaque, Symeon the Stylite the Younger and suppliant, silver-gilt, eleventh century (Tblisi, Georgian State Art Museum). (after V. Beridze, G. Alibegašvili, A. Volskaja, L. Xuskivadze, *The Treasures of Russian Art* [London, 1983], 201)

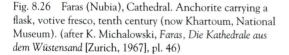

Fig. 8.26 Faras (Nubia), Cathedral. Anchorite carrying a flask, votive fresco, tenth century (now Khartoum, National Museum). (after K. Michalowski, *Faras, Die Kathedrale aus dem Wüstensand* [Zurich, 1967], pl. 46)

is skeptical, suggesting that they stay near the saint a bit longer, since "the presence at your side assures us a more complete cure." Symeon becomes annoyed and scolds the priest for his lack of faith, but then offers some reassurance: "The power of God . . . is efficacious everywhere. Therefore, take this *eulogia* made of my dust, depart, and when you look at the imprint of our image, it is us that you will see." [14] Symeon gives the priest two different assurances that his son's cure will eventually occur: his blessed earth and his image impressed on it. The earth had come into contact with the saint, but why did he insist on an image? The answer comes later in the same story, when the priest's third son becomes ill. He, too, asks to be taken to the Miraculous Mountain, but his father recalls the words of the saint and replies, "Saint Symeon, my son, has the power to come and visit you here, and you will be healed and you will live." (At this juncture, Symeon's image-bearing *eulogia* is presumably brought into play.) The boy gasps, falls into a trance, and cries out "Saint Symeon, have pity on me." He then turns to his father and shouts "Get up quickly, throw on incense, and pray, for the servant of God, Saint Symeon, is before me." The conclusion is predictable: Symeon appears to the boy in a vision, attacks the demon that possesses him, and (with his blessed earth) restores the boy to good health.

The focus of this healing is less on *eulogia* than on image, because of the instrumental role that the latter plays in bringing about the saint's "presence" away from the shrine— the miracle of "bi-location." The image in its devotional capacity helps to precipitate the vision of the saint, who, once there, effects his cure through blessed earth. Interestingly, the few other contemporary textual references to image-bearing *eulogiai* evoke a similar scenario, involving someone away from the shrine, where an artificial image would be especially useful in making sacred (visionary) contact with the saint. The image brings the saint, and the blessed substance brings his miraculous power.

A basically different situation obtains with *eulogia* images bearing little or no iconic reference to their shrine or saint, like the Qal'at Sem'ān token in Figure 8.7 showing Christ in a boat, flanked by two disciples. Inscribed *eulogiai* provide important clues to their meaning. Occasionally, pilgrim blessings bear words that simultaneously evoke how they were used and invoke the desired result; one Symeon token is inscribed "Health," another has the phrase "Receive, O Saint, the Incense, and Heal All," and on a Monza/Bobbio flask may be read the words "Oil of the Tree of Life that Guides Us by Land and Sea." These inscriptions both recall the *eulogia*'s critical role in medicine and travel, and call down, through a short prayer, the *eulogia*'s desired result, good health and safe passage. Basically the same pietistic equation is achieved with a token image like that in Figure 8.7. Although highly simplified, it should be identified as the Tempest Calmed, because of the relative prominence in the Gospels of that miracle on the Sea of Galilee in which Christ, having been roused from sleep, calms a storm and saves his disciples: "Then he arose and rebuked the winds and the sea; and there was a great calm. But the men marveled, saying, What manner of man is this, that even the winds and the sea obey him" (Matt. 8:23–27).

Some among the Asia Minor flasks bear the same scene (Fig. 8.18), and there are a pair of Monza/Bobbio ampullae that show Christ Walking on Water (Fig. 8.27), a traveler's

V

(seafarer's) biblical episode that, like the Tempest Calmed, is unrelated to any specific *locus sanctus* of the period. Recall the story quoted above of the monk Dorotheos, who calms a storm at sea by throwing some Symeon dust overboard, and the account of the miraculous powers of Saint John's manna, which concluded with the claim that "if there is a storm at sea and some of the manna is thrown in the sea . . . at once the storm ceases." As the phrase "guide us by land and sea" on an *eulogia* would invoke and thus help to guarantee safe passage, so too would the image of the Tempest Calmed evoke the memory of a similar phrase: "even the winds and sea obey him."

This belief helps to explain why it is that among Qal'at Sem'ān tokens bearing imagery other than that of Symeon himself, by far the most common subject is the Adoration of the Magi, despite the fact that there was no local association for it at the Symeon shrine, and even at Bethlehem the Magi story was only of secondary interest behind the Nativity. As already noted, the pilgrim sometimes gained the blessing of his pilgrimage encounter immaterially, through ritualized mimetic identification with the sacred heroes and events along his route. This might involve simple imitative gestures at appropriate places and times, such as throwing stones at the grave of Goliath or lifting one of the surviving water-to-wine jugs at Cana "to gain a blessing" (as the Piacenza Pilgrim did). Or it might entail a more subtle, ongoing identification with a particularly appropriate sacred figure whose career was believed to provide a model for the pilgrim's own. Thus, many pilgrims sought burial proximate to the Cave of the Seven Sleepers, near Ephesus, and thereby identification with the sleepers' miraculous fifth-century "resurrection" after having been

Fig. 8.27 Pilgrim *eulogia* ampulla, Christ Walking on Water, pewter, sixth–seventh century (Bobbio, Museo di San Colombano, no. 11). (after A. Grabar, *Ampoules de Terre Sainte* [Paris, 1958], pl. XLIII)

sealed in a cave for nearly two hundred years. In this category of protracted "identity mimesis" is probably where the Magi belong, for as gift-bearing strangers (*xenoi*) who traveled to the Holy Land to worship Christ, they were Christianity's archetypal pilgrims; moreover, they were guided and guarded pilgrims, since with divine protection they eventually returned home safely. The pilgrim with an *eulogia* like those in Figure 8.6 would have had access to sacred power both through blessed substance and, as pilgrim-Magus, through the coincidence of his or her action and that of the figures portrayed on it. Aboard ship, one became a Disciple in Christ's care; overland, one became a Magus under the guardianship of his angel.

Devotional piety explains some *eulogia* imagery, and the compounding of sacred power through mimesis explains other imagery, but what of that anachronistic image that mixes biblical narrative with *locus sanctus* architectural details, as does the Women at the Tomb (with the Holy Sepulchre) on many of the Monza/Bobbio ampullae (Color Plate XVI.B, right)? Why was the shrine imposed on the biblical story, which calls instead for a cave? The Holy Sepulchre, as a relic, was itself a source of sacred power, and the identity of *eulogia* image and shrine architecture was valued by pilgrims because it was believed capable of directly conveying the sacred power of the relic depicted, just as the blessed oil inside the ampulla and the blessed earth of the token could directly convey the power of the relic once touched. Identity of image is in this respect like the ceremonial identity of action achieved when the pilgrim acted out the appropriate biblical story at a holy site, to gain its intangible blessing.

How precise need the identity of action or image have been? It was enough for the Piacenza Pilgrim, at Mount Gilboa, to throw three stones at the grave of Goliath to gain the blessing there, and in the Garden of Gethsemane to lie briefly on the couch where Christ had reclined to receive the special *eulogia* of that holy site.[15] As for the tangible, carry-away sort of pilgrim *eulogia*, there are Holy Sepulchre tokens as simple as that in Figure 8.8 (compare with Figure 8.21), where the drum and columns of the Anastasis Rotunda have been deleted, the Tomb shrine has been reduced to a crude aedicula only vaguely reminiscent of the original, and the two Marys have been left out altogether. To ask how little iconographic or ceremonial coincidence with the original was necessary still to achieve the intangible "sanctity link" is like asking how fleeting or at how many removes physical contact with a relic might be in order still to achieve the transfer of sacred power; it is a question that transcends the boundary between religion and magic.

The Holy Sepulchre (Fig. 8.21) may be used as a paradigmatic reduction model for blessing transfer via image identity—or more specifically, the Holy Sepulchre's many architectural copies in the medieval West may be so used. With these copies, like that of the eleventh century in the Cathedral at Aquileia (Fig. 8.28), came not only the historical meaning of Christ's tomb, but also a portion of its sacred power; thus their characteristic association with cemeteries (corporeal resurrection), baptisteries (spiritual rebirth), and Holy Week mimetic rituals. But surprisingly, variations in execution among the architectural "copies" were so wide as in some instances actually to mask the copy link, except to those informed of the builder's intention. In fact, mere coincidence of crude shape

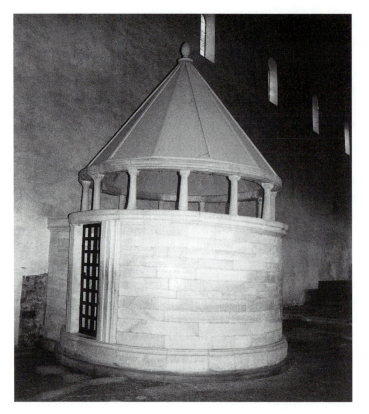

Fig. 8.28 Aquileia (Italy),
Cathedral. Architectural copy
of the Holy Sepulchre.
(R. Ousterhout)

(basic roundness) or significant measure (the absolute size of one feature or the relative proportions among features) was enough to establish the link. In this a parallel may be drawn with the primal belief that motivated pilgrims to take "measures" from relics. The Piacenza Pilgrim witnessed the custom in the basilica of Holy Sion: "In this church is the column at which the Lord was scourged, and it has on it a miraculous mark. When he clasped it, his chest clove to the stone, and you see the marks of both his hands, his fingers, and his palms. They are so clear that you can use them to take 'measures' for any kind of disease, and people can wear them around their neck and be cured."[16] Here, too, the link to sacred power is distilled to a measure, in effect, to a numerical value, much as the power of *Kyrie* (Greek, "Lord") was then distilled to the number 535 and "Amen" to 99, representing the sum of the numerical values of the word's Greek letters. And although, as with the architectural copies of the Holy Sepulchre, the carrier is tangible (a building, a strip of cloth), the actual transfer of sacred power is achieved intangibly, through a simple shape or with a mere number.

In the context of pilgrimage *eulogiai* the Holy Sepulchre image functioned amuletically, complementing the sacred power of the *eulogia* it accompanied with its own sacred power. It also imparted this power to non-*eulogia* objects like that in Figure 8.29 (compare Figure 8.20), a Byzantine-Egyptian pendant amulet in copper alloy of around 600 C.E. inscribed

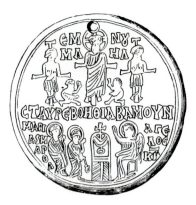

Fig. 8.29 Amuletic pendant, Crucifixion and Women at the Tomb, copper alloy, ca. 600 (Paris, Cabinet des Médailles). (after G. Schlumberger, "Quelques monuments byzantins inédits," *Byzantinische Zeitschrift* 2 [1893], 188)

with the prayer "Cross, help Aba Moun." This piece of jewelry had nothing directly to do with pilgrims or pilgrimage. Similarly, the full Holy Land "cycle" of *locus sanctus* scenes gathered on the Monza/Bobbio ampulla in Figure 8.22, and preserved individually among the Qal'at Sem'ān tokens (see Figure 8.8), reappears on a familiar category of armband amulet then being produced independently of the pilgrimage trade in Syria-Palestine and Egypt (Figs. 8.30 and 8.31). A parallel may be drawn between this sequence of images as it encircles the armband and the amuletic words from Psalm 90(91) interspersed with it, "He that dwells in the help of the Highest . . . ," because both are ever-repeating protective charms. This method of invoking sacred power independent of contagion and only indirectly dependent on image identity is noted among Christians as early as Origen (d. 254?), who in response to a pagan's charge that his co-religionists got their "power" from reciting the names of demons, countered by saying that "it is not by incantations that Christians seem to prevail [over evil spirits], but by the name of Jesus, accompanied by the announcement of the narratives which relate to Him; for the repetition of these has frequently been the means of driving demons out of men."[17]

Leaving aside the pilgrimage shrine itself and whatever figurative murals may have decorated it, both of which are typically more reflective of elite, self-interested patronage than of the spiritual needs of individual pilgrims, the category of pilgrims' art that follows the *eulogia* in significance is the votive. While the former was taken away, the latter was left behind.

The author of the Vita of Daniel the Stylite (d. 493) records a pious gesture that must then have been commonplace: "As thankoffering [a repentant exorcised heretic] dedicated a silver image, ten pounds in weight, on which was represented the holy man and themselves [heretic and family] writing these words below, 'Oh father, beseech God to pardon us our sins against thee.' This memorial is preserved to the present day near the altar."[18] Considered from the point of view of its role in expressing the spirituality of the individual who dedicated it, the inscribed silver image showing Daniel the Stylite in the company of an exorcised heretic is similar to an image mentioned—without reference to medium, donor portrait, or inscription—in the Vita of Symeon the Younger: "having returned home, he [an exorcised artisan from Antioch] set up to the saint, by way of

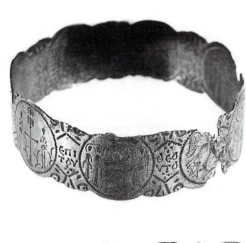

Fig. 8.30 Amuletic armband, *locus sanctus* scenes and Psalm 90(91), silver, sixth–seventh century (Columbia, Museum of Art and Archaeology, University of Missouri–Columbia, no. 77.246). (courtesy University of Missouri–Columbia)

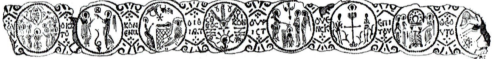

Fig. 8.31 Amuletic armband, *locus sanctus* scenes and Psalm 90(91), silver, sixth–seventh century (Columbia, Museum of Art and Archaeology, University of Missouri-Columbia, no. 77.246), line drawing. (after J. Maspero, "Bracelets-amulettes d'époque byzantine," *Annales du service des antiquités de l'Égypte* 9 [1908], fig. 1)

thanksgiving, an image in a public place and in full view of the city, above the entry to his workshop." [19] Both are votives, dedicated after the fact in acknowledgment of a miracle received at the *locus sanctus* of a holy man. Nearly contemporary images of this sort in mosaic survive in the church of Saint Demetrios in Thessalonike (Fig. 8.24), and these have their counterparts among the *miracula* of the saint, one of which (no. 1.24, seventh century) tells the story of a local official who, after having been healed of paralysis, commissioned a (now-lost) mosaic on the exterior of the sanctuary showing the miracle. Similarly, miracle 30 (pre-tenth century) of Saints Kosmas and Damianos describes a suppliant, after having been healed of a fistula, arranging to have the miracle portrayed "in the church of the saints, in the colonnade at the left, above the entrance to the side chapel."

Pietistically if not iconographically related are the votive eyes discovered with the Ma'arat al-Nu'mān silver treasure in northern Syria (Fig. 8.32: "In fulfillment of a vow"; sixth century), and their counterpart in the textual tradition, the various body-part votives described by Theodoret: "That they obtained what they so earnestly prayed for is clearly proven by their votive gifts, which proclaim the healing. Some bring images of eyes, others feet, others hands, which are sometimes of gold, other times of wood [silver?]." [20]

One would also include as pilgrim votives a significant proportion of the almost limitless variety of *locus sanctus* dedications, from graffiti like that in Figure 8.33 ("Theologian, help Sissinios and his mother"), scratched into a column of the church of

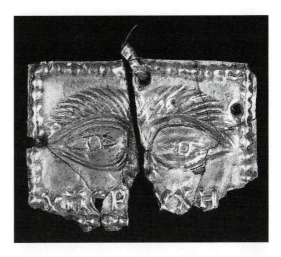

Fig. 8.32 Votive eyes, silver, sixth–seventh century
(Baltimore, Walters Art Gallery, no. 57.1865.563).
(courtesy Walters Art Gallery)

Saint John at Ephesus in the seventh century, to the exotic birds left behind as thank-offerings at the shine of Saint Thekla at Seleukeia, which became a veritable zoo for the entertainment of pilgrims' children, to the precious jewelry draped over the Holy Sepulchre: "ornaments in vast numbers, which [hung] from iron rods: armlets, bracelets, rings, tiaras, plaited girdles, belts, emperor's crowns of gold and precious stones, and the insignia of an empress."[21] The Daniel votive was set up in the shrine itself, near the altar, whereas that thanking Symeon was placed over the workshop door of the healed suppliant at some distance from the shrine. The latter, placed "in full view of the city," was clearly intended as a public acknowledgment, as was the mosaic of the paralyzed official cured through the intervention of Saint Demetrios, which was set on the exterior of the church facing the stadium.

Both stylite votives were dedicated in response to miracles (exorcisms), though it is not revealed whether imagery or words specifically documented the event. The Symeon votive earned recognition in the saint's Vita because it worked miracles (repelling its attackers), whereas that of Daniel was thought noteworthy because it evoked the memory of (and in part documented) a miracle. Both stylite votives are identified in the Vitae as *charisteria*. Material worth ("silver . . . ten pounds in weight") seems typically to have been an important ingredient in pilgrim donor piety, as were inscription and image, especially if the latter should include a portrait or the miracle, for as a public thank-offering the votive's role was mainly propagandistic. The appearance of the Daniel *charisterion* is suggested by the silver-gilt repoussé plaque of Symeon the Stylite the Elder in the Louvre (Fig. 8.4) inscribed "In thanksgiving to God and to Saint Symeon, I have offered [this]." But probably closer still is the later Georgian votive in gilt silver (Fig. 8.25) that includes, in addition to the saint (here Symeon the Younger) and a dedicatory inscription, a portrait of the donor-suppliant.

The idea that image identity alone, independent of contagion, was enough to gain access to sacred power was relatively slow to take hold in Byzantium. Only by the sixth cen-

Fig. 8.33 Ephesus, Church of Saint John the Evangelist. Pilgrim graffito, seventh century (courtesy Dumbarton Oaks)

tury was it widely accepted, long after the notion that holy people, places, and things could channel and deliver miracles had become entrenched in the Christian mind. Moreover, it is remarkable that even then images were usually believed sacred only because their medium was otherwise taken to be sacred. These hybrid "icon-relics" were called by the Greeks of the period *acheiropoieta*, "objects [icons] not made by human hands." Their most familiar representative nowadays is the Shroud of Turin (detail, Fig. 8.34)—the supposed burial cloth of Jesus imprinted with his death image—although this is only one of the more recent and now the most famous of a long series of iconic cloth relics of Christ, the earliest of which date to the sixth century (see the discussion of *acheiropoieta* in Chapter 3). As if in reaction to seeing the Shroud itself—though actually looking at a face-only "sweat towel" of the living Christ—the Piacenza Pilgrim recorded these impressions on his visit to Memphis, Egypt: "We saw there a piece of linen on which is a portrait of the Saviour. People say he once wiped his face with it, and that the outline remained. It is venerated at various times and we also venerated it, but it was too bright for us to concentrate on it since, as you went on concentrating, it changed before your eyes." [22]

The most famous Byzantine *acheiropoieton* was the Mandylion of Edessa (Fig. 8.35). According to legend, Christ wiped his face with a towel (Greek *mandylion*) that miraculously retained his image, and this towel was sent by Christ to King Abgar of Edessa as a guarantee that his kingdom would not fall. The Mandylion was an icon because of its picture, but it was also, and more basically, a relic, by virtue of Christ's contact with it. And as such it was a source of miracles, including the defeat of the Persian army at

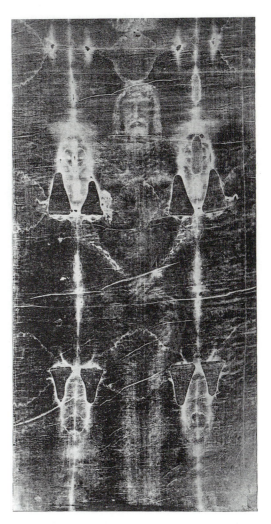

Fig. 8.34 Shroud of Turin (detail), linen, fourteenth
century (Turin, Cathedral of Saint John). (after I. Wil-
son, *The Shroud of Turin: The Burial Cloth of Jesus Christ*
[London, 1979])

the gates of Edessa in the year 544. But it is interesting to note, and at the same time
indicative of the slow development of the cult of images, that the object given by Christ
to King Abgar was initially not an image-bearing towel at all, but rather a papyrus letter.
(Egeria received a replica of the letter during her travels in Syria in the late fourth
century.) Over time, in response to evolving belief, the papyrus became a towel (the legal
document became a relic), and then finally, in the later sixth century, the towel "ac-
quired" its sacred image (the relic became an icon), long after it had become a popular
and potent aniconic source of sacred power. Basically the same scenario characterizes
the history of the Column of the Flagellation in Jerusalem, which remained unmentioned
by pilgrims until the fifth century, and only in the sixth century "acquired" the chest
and hand impressions of Christ (*acheiropoieton*) remarked upon by the Piacenza Pilgrim
and cited above.

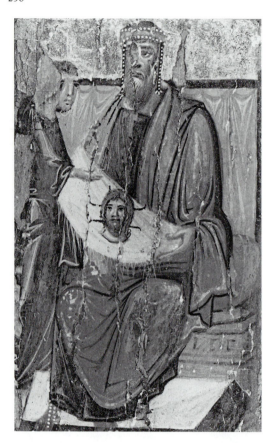

Fig. 8.35 Icon (detail), King Abgar Receiving the Mandylion of Edessa, tempera on wood, tenth century (Mount Sinai, Monastery of Saint Catherine, no. B58). (after K. Weitzmann, *The Monastery of Saint Catherine at Mount Sinai: The Icons*, I, *From the Sixth to the Tenth Century* [Princeton, 1976], B58)

The Mandylion of Edessa (Fig. 8.35) and the Christ pilgrim token from Qal'at Sem'ān (Fig. 8.9) have much in common, insofar as both are icons coupled with sacred material, and this applies as well to many other image-bearing *eulogiai* (cf. Figs. 8.10, 8.13, and 8.16). The difference is that the Mandylion, like the True Cross relic, was "primary" and unreproducible, because of its one-time miraculous contact, whereas the earth of the tokens and the oil and manna of the flasks were infinitely reproducible. It is also true that those *eulogia* images were valued mostly for their instrumental value as vision-inducing catalysts for miraculous encounter with the deity or saint, whereas the Mandylion, as an *acheiropoieton*, was itself the bearer of miraculous potential. (Unique and inherently powerful, the *acheiropoieton* might become the focus of a local, regional, or even empirewide cult.) The transition is a subtle but profound one from these hybrids to icons, sacred images that even without associated sanctified material were believed to have miraculous potential (see Chapter 3). In the Vita of Symeon the Stylite the Younger, from around 600, there is a report of one such image and a theological explanation for how its power originated. A barren woman possessed by a demon was exorcised by Symeon; she returned home, conceived, and delivered a child: "[then] . . . motivated by her faith, she put up the image of the saint inside her house, and this image per-

formed miracles, because the Holy Spirit which inhabited Symeon covered it with its shadow, and demoniacs were purified in that place and those ill with various afflictions were healed."[23]

This icon did not originate at the Miraculous Mountain; it had not been touched by the saint, nor even blessed, yet like the saint's earth *eulogia* it could perform miraculous healings. The notion of "overshadowing" by the Holy Spirit is used in the Gospels to describe the incarnation, as the angel addresses Mary: "The Holy Ghost shall come upon thee, and the power of the Highest shall overshadow thee" (Lk 1:35). In this Symeon icon the sacred is channeled not through touch but solely by virtue of iconographic coincidence. Because the icon "looked" the way it ought to look, in conformity with the recognized iconic type, it received the overshadowing of the sacred, and with that the potentiality for miracles (see Chapters 2, 3, and 5). Interestingly, this stage in the evolution of image belief and piety, which allowed for the channeling of sacred power anywhere, independent of place-specific relics, *loca sancta*, or holy people, more or less coincided with the loss of the Holy Land and adjacent pilgrimage centers to Islam.

Persian incursions in the second decade of the seventh century followed a generation later by the Arab conquest of the entire east Mediterranean basin effectively brought to an end the high-volume, internationally based pilgrimage traffic reflected in the portable pilgrimage art described above, and to the portable pilgrimage art "industry" that it presupposes. And an industry it must have been; this is clear not only from the mass-production methods (stamps, molds, and matrices) by which these items were produced, the relatively high numbers in which they have survived, and their wide distribution, but also from archaeological evidence at Abu Mina and the Miraculous Mountain of workshops and storerooms dedicated to the making and storing of material pilgrim blessings.

Devastated by the Persian raid of 614, the ancient port city of Ephesus retreated within medieval fortifications, as sea traffic declined and the local population dwindled.[24] Although a trickle of pilgrim accounts attests to the continuity of veneration and manna collection at the tomb shrine of Saint John the Evangelist into the Late Byzantine period, there is no evidence for the continued production of image-bearing manna flasks after that relatively brief period around 600 when they were apparently quite popular. The same applies to the tourist "boom town" of Abu Mina, adjacent to the pilgrimage complex of Saint Menas.[25] First the Persians came, and then the Arabs; but in this case, the profound change their military conquests brought in visitor traffic has been meticulously documented by archaeologists, who have charted the declining local population from the reduced number and size of active households, and have calculated as well the very modest level of transient visitation that could then have been supported by the limited number of active local bakeries: no bread, no pilgrims. A moribund agricultural village by the ninth century, Abu Mina was finally abandoned to the desert in the eleventh.

Much the same scenario, short of the site's complete abandonment, apparently unfolded as well in the pilgrimage town of Deir Sem'ān at the foot of Qal'at Sem'ān.[26] Hotels, shops, and houses built in the expansive decades of the later fifth and sixth century

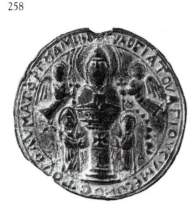

Fig. 8.36 Pendant medallion, Symeon the Stylite the Younger, lead, ca. 1000 (Houston, Menil Collection, no. II, J4). (courtesy Menil Collection)

were neglected and abandoned after the seventh, as, to a substantial extent, was the hill-top *locus sanctus* of Saint Symeon, until a brief Byzantine reoccupation of the area around the year 1000, when the sanctuary precinct surrounding the column was transformed into a frontier fortress. However, at Qal'at Sem'ān there is some evidence that a modest conti-nuity in regional pilgrimage was accompanied by at least a modest continuity in pilgrims' art production. Because the Symeon token "industry" was less sophisticated technically than was that of the Menas and Ephesus flasks, requiring only a stamp and potentially, at least, no firing of the clay, one can imagine that it could have continued even in the bleakest times, with limited local staff and even more limited clientele.

Closer to Antioch and farther from the frontier, the Miraculous Mountain of Symeon the Younger experienced a longer and more peaceful Middle Byzantine revival than did Qal'at Sem'ān, from the later tenth to the later eleventh century.[27] But although the site seems briefly to have prospered, to judge from an abundance of datable inscriptions and from the re-edition then of the saint's Vita, the traditional notion of blessed earth and the miraculous power it was believed to convey through contagion was apparently no longer such a central part of pilgrimage piety. Figure 8.36 ("Blessing of Saint Symeon the Mira-cle Worker, amen") shows the sort of Symeon "souvenir" being mass-produced for pil-grims around the year 1000. While the inscription closely matches that of the Early Byzantine token type upon which it was certainly modeled (Fig. 8.12: "Blessing of Saint Symeon in the Miraculous Mountain"), and the overall composition is substantially the same, with angels above and suppliants below, there have been two very significant changes. First, note how the iconography of the earlier token stresses the experiential re-ality of pilgrim piety through the direct participation of pilgrim-suppliants in the imagery: below, a kneeling suppliant touches the column itself, while above, a censer-bearing sup-pliant climbs the ladder toward the saint with his plea, which is spelled out in the field at the right: "Receive, O Saint, the incense offered by Constantine." Significantly, on the later Symeon piece the pilgrim-suppliants have been replaced by Symeon's mother Martha at right and his disciple Konon at left. The two turn toward the saint with raised hands, as if they were the Virgin Mary and John the Baptist in a Deesis (Greek for "peti-tion") icon, such as the eleventh-century example in Figure 8.37, indicating that the em-phasis now is much less on direct encounter with the objectified, tangible holy than on an

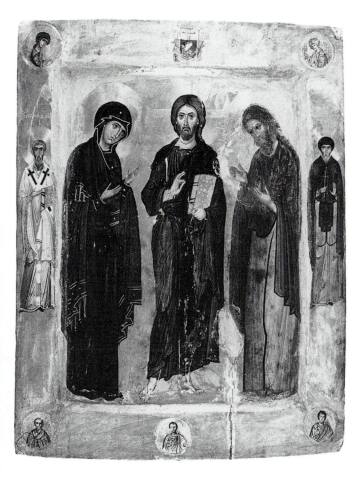

Fig. 8.37 Icon, Deesis with Saints, tempera on wood, eleventh century (Mount Sinai, Monastery of Saint Catherine). Compare Figures 3.8 and 3.21. (after K. Weitzmann et al., *The Icon* [New York, 1987], 49)

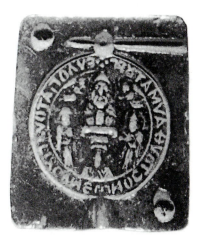

Fig. 8.38 Casting mold, Symeon the Stylite the Younger, steatite, eleventh century (Paris, Thierry Collection). (after J.-P. Sodini, "Remarques sur l'iconographie de Syméon l'Alépin, le premier stylite," *Fondation Eugène Piot. Monuments et Mémoires* 70 [1989], fig. 3)

extended chain of intercession through prayer. This subtle but basic change in focus is paralleled by an equally basic change in the identity and substance of the object: this is not a token but a pendant whose suspension loop has broken away. No longer a stamped handful of sanctified, health-bringing earth from the Miraculous Mountain, it is a lead pendant medallion, produced in a casting mold much like that in Figure 8.38 ("Blessing of Saint Symeon the Miracle Worker"), perhaps on the Miraculous Mountain, perhaps in Antioch, or perhaps in Constantinople; in this transformed world of later pilgrimage piety the place of manufacture likely would have made little difference.

Jerusalem, too, experienced a revival of Christian pilgrimage in the medieval period, though on a much grander scale than did the Miraculous Mountain. During the twelfth-century crusader occupation of the city the Church of the Holy Sepulchre was rebuilt, re-decorated, and rededicated, and with the influx of new pilgrims, especially from Western Europe, lead oil flasks were briefly reintroduced, apparently from the same workshops that were then producing the official lead seals of the patriarch and king. Only a few such flasks survive, and their imagery is varied. Like their Early Byzantine counterparts, which may have inspired them, these crusader ampullae place special emphasis on the two pre-eminent sanctifying events of the Holy Land in general, and of the Holy Sepulchre in particular (Fig. 8.39a and b): the cross and the tomb. Moreover, both compositions, the Crucifixion and the Anastasis, were likely based on now-lost mosaics of the period within the Holy Sepulchre complex (cf. Fig. 8.40). That derivative relationship, which long ago was mistakenly posited for the early Monza/Bobbio ampullae as well, is here symptomatic of an important shift in the "flavor" of the pilgrim experience generally, from one dominated early on by objects to one dominated in later centuries by images. To sense this shift, one need only contrast the Holy Land diary of the Piacenza Pilgrim, from around 570, with the later twelfth-century Holy Land account of the monk Theoderich from Germany; where one touches relics the other sees icons.[28]

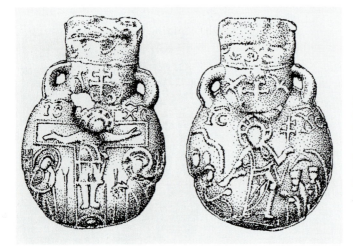

Fig. 8.39a and b Pilgrim ampulla, Crucifixion/Anastasis, lead, twelfth century (Berlin, Frühchristlich-Byzantinische Sammlung [Skulpturengalerie], SMPK, no. 25/73), drawing. (after L. Kötzsche, "Zwei Jerusalemer Pilgerampullen aus der Kreuzfahrerzeit," *Zeitschrift für Kunstgeschichte* 51 [1988], fig. 8)

Fig. 8.40 Chios, Nea Moni, squinch mosaic. Anastasis, eleventh century. (after D. Mouriki, *The Mosaics of Nea Moni on Chios* [Athens, 1985], pl. 48)

This same shift in emphasis is apparent in the imagery with which the crusader ampullae are decorated. On the early flasks the Easter story is evoked by a version of the Women at the Tomb wherein one sees the Holy Sepulchre tomb relic (Color Plate XVI.B, right), whereas later it is conveyed through the conventional, topographically anonymous Byzantine liturgical icon of the Anastasis (Fig. 8.39b). Similarly, on the early flasks (Color Plate XVI.B, left) the historical dimension of the Crucifixion is partially suppressed in order that the pilgrims might be shown in the act of venerating the cross (relic), whereas on the later flasks (Fig. 8.39a) one encounters a more or less canonically iconic (pilgrimless and relicless) presentation of the story, as one might then find it anywhere, in an illustrated manuscript, on an iconostasis, or on a devotional medallion suspended from someone's neck.

After the Arab conquest the volume, the imagery, and the piety of portable pilgrimage art changed in the eastern Mediterranean. There was much less of it, it was produced only sporadically and only in a few centers, and its emphasis shifted from relic palpability and pilgrim participation to icons and intercession—to the stuff of later Byzantine piety in general. Moreover, as Palestine, Syria, and Egypt faded from the horizon of international Christian pilgrimage, other centers within the boundaries of the diminished Byzantine

1. Ciborium
2. So-called "Tomb" of St. Demetrius
3. Narthex
4. Staircase
5. Remains of the Roman Baths
6. Altar with small crypt below
7. Transept wings
8. Chapel of St. John Prodromos
9. Auxiliary room
10. Chapel of St. Euthemius
11. Tomb of Loukas Spandounis

Fig. 8.41 Thessalonike, Church of Saint Demetrios as restored in the seventh century. (after R. Ousterhout, ed., *The Blessings of Pilgrimage* (Urbana, 1990), fig. 48 [Bakirtzis])

Empire took their place: most notably Constantinople and Thessalonike, with their focus, respectively, on the churches of Hagia Sophia and Saint Demetrios (Fig. 8.41). The *loca sancta* of early local martyrs, like Demetrios in Thessalonike, and a steady flow of Holy Land relics westward to Constantinople can easily account for this. But again, as one follows in the footsteps of these later, "transplanted" pilgrims, through the words of their diaries, one senses a different "experience-flavor" from that of the early Holy Land pilgrims: fewer and less varied *loca sancta*, fewer and less varied relics, fewer and less varied miraculous healings, and everywhere, icons.

Notes

1. Theodoret of Cyrrhus, *Religious History*, 26.11; see *Theodoret of Cyrrhus: A History of the Monks of Syria*, trans. and intro. R. M. Price, Cistercian Studies 88 (Kalamazoo, Mich., 1985), 165. See also *The Lives of Simeon Stylites*, trans. R. Doran, Cistercian Studies 112 (Kalamazoo, Mich., 1992).

2. Saint John of Damascus, *Orthodox Faith*, 4.11; trans. F. H. Chase Jr., *Fathers of the Church* 37 (Washington, D.C., 1958), 165.

3. Paulinus of Nola, *Epistles*, 49.402; see *Jerusalem Pilgrims Before the Crusades*, trans. and intro. J. Wilkinson (Warminster, 1977), 40. Although "touch" was preeminent, the substantiality of the sacred was accessible variously through *all* the senses. As Gregory of Nyssa (d. after 394) said, "Those who behold them [relics] embrace, as it were, the living body in full flower: they bring eye, mouth, ear, all the senses into play": Encomium on Saint Theodore, in *Patrologiae cursus completus, Series graeca*, ed. J.-P. Migne (Paris, 1857–66) (hereafter *PG*), 46, col. 740B; see P. Brown, *The Cult of the Saints: Its Rise and Function in Latin Christianity* (Chicago, 1981), 11.

4. Egeria, *Travels*, 37.1; *Egeria's Travels*, trans. and intro. J. Wilkinson (Warminster, 1981), 137.

5. Piacenza Pilgrim, *Travels*, 20; see Wilkinson, *Jerusalem Pilgrims Before the Crusades*, 83.

6. Cyril of Skythopolis, *Vita Saba*, 63; see *Cyril of Scythopolis: Lives of the Monks of Palestine*, trans. R. M. Price, Cistercian Studies 114 (Kalamazoo, Mich., 1991), 174.

7. Theodoret of Cyrrhus, *Religious History*, 21.16; see *Theodoret of Cyrrhus: A History of the Monks*, 139ff.

8. B. Kötting, *Peregrinatio religiosa: Wallfahrten in der Antike und das Pilgerwesen in der alten Kirche* (Regensburg–Münster, 1950), 198.

9. Theodoret of Cyrrhus, *Religious History*, 21.4; see *Theodoret of Cyrrhus: A History of the Monks*, 134.

10. *Ancient Life*, 235; see *La vie ancienne de S. Syméon Stylite le Jeune (521–592)*, ed. and trans. P. van den Ven, Subsidia hagiographica 32. 1, 2 (Brussels, 1962, 1970), 236ff.

11. Gregory of Tours, *Glory of the Martyrs*, 6; see *Gregory of Tours, Glory of the Martyrs*, trans. R. van

Dam, Translated Texts for Historians (Liverpool, 1988), 27. Gregory is here discussing the earthen tokens from the Holy Sepulchre, and their ability to cure diseases and repel snakes.

12. Ramon Muntaner, *Chronicles*, 499f.; see *Ramon Muntaner, Chronicles*, trans. Lady Goodenough, Hakluyt Society II/50 (London, 1921), 499ff.

13. *Ancient Life*, 163; see *La vie ancienne de S. Syméon Stylite le Jeune*, 169ff.

14. *Ancient Life*, 231; see *La vie ancienne de S. Syméon Stylite le Jeune*, 230ff.

15. Piacenza Pilgrim, *Travels* 31, 17; see Wilkinson, *Jerusalem Pilgrims Before the Crusades*, 85, 83.

16. Piacenza Pilgrim, *Travels*, 22; see Wilkinson, *Jerusalem Pilgrims Before the Crusades*, 83ff.

17. Origen, *Contra Celsus*, 1.6; see *Origène, Contre Celse*, ed. M. Bourret, I (Paris, 1967), 1.6.

18. *Vita*, 59; see *Three Byzantine Saints*, trans. E. A. Dawes and N. Baynes (Oxford, 1948; repr. Crestwood, N.Y., 1977), 42.

19. *Ancient Life*, 158; see *La vie ancienne de S. Syméon Stylite le Jeune*, 164.

20. Theodoret of Cyrrhus, *The Cure of Pagan Maladies*, 8.64; see *Theodoreti Graecarum affectionum curatio*, ed. I. Raeder (Leipzig, 1904), 217.

21. Piacenza Pilgrim, *Travels*, 18; see Wilkinson, *Jerusalem Pilgrims Before the Crusades*, 83.

22. Piacenza Pilgrim, *Travels*, 44; see Wilkinson, *Jerusalem Pilgrims Before the Crusades*, 88.

23. *Ancient Life*, 118; see *La vie ancienne de S. Syméon Stylite le Jeune*, 119ff.

24. See especially C. Foss, *Ephesus After Antiquity* (Cambridge, 1979).

25. See P. Grossman, *Abu Mina: A Guide to the Ancient Pilgrimage Center* (Cairo, 1986).

26. See G. Tchalenko, *Villages antiques de la Syrie du Nord* (Paris, 1953), I, 205–242.

27. See *La vie ancienne de S. Syméon Stylite le Jeune*, 214ff.

28. See, respectively, Wilkinson, *Jerusalem Pilgrims Before the Crusades*, 79ff.; and *Jerusalem Pilgrimage, 1099–1185*, trans. and intro. J. Wilkinson (London, 1988), 274–314.

Suggestions for Further Reading

J. Engemann, "Palästinensische Pilgerampullen im F. J. Dölger-Institut in Bonn," *Jahrbuch für Antike und Christentum* 16 (1973), 5–27.

A. Grabar, *Martyrium: Recherches sur le culte des reliques et l'art chrétien antique* (Paris, 1946).

———, *Ampoules de Terre Sainte* (Paris, 1958).

E. D. Hunt, *Holy Land Pilgrimage in the Later Roman Empire (A.D. 312–460)* (Oxford, 1982).

E. Kitzinger, "The Cult of Images in the Age Before Iconoclasm," *Dumbarton Oaks Papers* 8 (1954), 83–150.

L. Kötzsche, "Zwei Jerusalemer Pilgerampullen aus der Kreuzfahrerzeit," *Zeitschrift für Kunstgeschichte* 51 (1988), 13–32.

L. Kötzsche-Breitenbruch, "Pilgerandenken aus dem Heiligen Land," *Vivarium: Festschrift Theodor Klauser zum 90. Geburtstag, Jahrbuch für Antike und Christentum*, Ergänzungsband 11 (Münster, 1984), 229–246.

R. Krautheimer, "Introduction to an 'Iconography of Medieval Architecture,' " *Journal of the Warburg and Courtauld Institutes* 5 (1942), 1–33, repr. in his *Studies in Early Christian, Medieval and Renaissance Art* (New York, 1969).

J. Lafontaine-Dosogne, *Itineraires archéologiques dans la region d'Antioche*, Bibliothèque de Byzantion 4 (Brussels, 1967).

P. Maraval, *Lieux saints et pèlerinages d'orient* (Paris, 1985).

C. Metzger, *Les ampoules à eulogie du musée du Louvre*, Notes et documents des musées de France 3 (Paris, 1981).

R. Ousterhout, ed., *The Blessings of Pilgrimage*, Illinois Byzantine Studies I (Urbana, 1990).

G. Vikan, " 'Guided by Land and Sea': Pilgrim Art and Pilgrim Travel in Early Byzantium," in *Tesserae: Festschrift für Josef Engemann, Jahrbuch für Antike und Christentum*, Ergänzungsband 19 (Münster, 1991), 74–92.

————,"Two Unpublished Pilgrim Tokens in the Benaki Museum and the Group to Which They Belong," *Thymiama ste mneme tes Laskarinas Mpoura* [*Essays in Memory of Laskarina Bouras*] (Athens, 1994), I, 341–346; II, pls. 197–198.

P. W. L. Walker, *Holy City, Holy Places* (Oxford, 1990).

K. Weitzmann, "*Loca Sancta* and the Representational Arts of Palestine," *Dumbarton Oaks Papers* 28 (1974), 33–55.

J. Wilkinson, "The Tomb of Christ: An Outline of Its Structural History," *Levant* 4 (1972), 83–97.

VI

EARLY BYZANTINE PILGRIMAGE *DEVOTIONALIA* AS EVIDENCE OF THE APPEARANCE OF PILGRIMAGE SHRINES*

As traditionally posed the question has centered on the relationship between the images on pilgrimage *devotionalia,* like the sixth- to seventh-century pewter ampullae in Monza and Bobbio, and the mural decoration within or general appearance of the *loca sancta* shrines from which they presumably originated. The early theory, conceived by IAKOB SMIRNOV and developed by DMITRII AINALOV, around 1900, saw in these flasks more or less faithful copies of lost monumental murals at the shrines; according to this view the seven tiny vignettes on Monza ampulla 2 (pl. 50a) would offer direct testimony of wall paintings in Nazareth, Bethlehem, at the Jordan river, in Jerusalem, and on the Mount of Olives[1]. In the 1940s ANDRÉ GRABAR, a student of AINALOV, expanded on this notion in the second volume of »Martyrium«, suggesting that the *locus sanctus* murals of Palestine, as attested on the flasks, provided the link between Dura Europos in the late Roman East and Sta Maria Maggiore in the early Christian West, the former (paradigmatically) the inspiration for and the latter (paradigmatically) the product of a great lost reservoir of eastern, holy site mural iconography[2]. But then surprisingly, in his 1958 monograph on the Monza/Bobbio ampullae, GRABAR took a counter-position[3]. Noting, among other things, the scant and often dubious archaeological and textual evidence for the early existence of figural murals at the famous Palestinian holy sites, and the puzzling fact that the ampullae sometimes preserve variant iconographic interpretations of the same Gospel episode (e.g., the Ascension, with the Virgin shown both frontally and in profile), he suggested that the primary source of the pilgrim flask iconography was small-scale imperial metalwork, and that Constantinople and not Palestine was the crucible from which this iconography emerged.

This was the *status quo* as recently as the early 1970s, when JOSEF ENGEMANN, KURT WEITZMANN, and ROBERT GRIGG, each apparently without knowledge of the others' work, took up the question in studies separated by just one year. Introducing a pair of unpublished pilgrim flasks of the Monza/Bobbio sort, ENGEMANN noted that their compositional richness and »theophanic character« (e.g., arcs in heaven, the *stella clipeata*) supported the

* This article will focus on image-bearing *eulogiai* and votives made on-site at *loca sancta* for pilgrims, and on the piety to which these objects attest. It will not consider compositions in manuscript illumination (e.g., the Rabbula and Rossano Gospels), ivory carving (e.g., the Grado Chair ivories) or liturgical silver (e.g., the Riha and Stuma patens) that may ultimately draw on *locus sanctus* art. (For these, see the article by KURT WEITZMANN cited in footnote 6, below.)

[1] Pl. 50a = Monza, Treasury of the Cathedral of St. John the Baptist, ampulla 2. See A. GRABAR, Les ampoules de Terre Sainte (Paris, 1958) pl. V; and for the object type, J. ENGEMANN, Palästinensische Pilger-

ampullen im F. J. Dölger-Institut in Bonn, in: Jahrbuch für Antike und Christentum 16 (1973) 5–27. For the theoretical issue see J. I. SMIRNOV, Hristianskija mozaiki Kipra, in: Vizantinjskij Vremennik 4 (1897) 91f.; and D. V. AINALOV, The Hellenistic Origins of Byzantine Art (New Brunswick, 1961) 224–245 (= Ellinisticheskie osnovy visantiiskogo iskusstva [St. Petersburg, 1900]).

[2] A. GRABAR, Martyrium. Recherches sur le culte des reliques et l'art chrétien antique, II: Iconographie (Paris, 1946).

[3] Idem, Les ampoules, 45–50 (and 61, where the position is softened).

earlier idea of monumental models[4]. ROBERT GRIGG also came down on the side of the SMIRNOV/AINALOV theory, although with major reservations, in a 1974 doctoral dissertation focussed specifically on this issue[5]. After critically reviewing and eliminating AINALOV's most doubtful texts (notably, Petronius of Bologna), GRIGG nevertheless concluded that the remaining evidence (e.g., Choricius' description of the Church of St. Sergios at Gaza, the Sinai apse mosaic, the Piacenza pilgrim's account of the Praetorium of Pilate) supported the idea that at least by the sixth century, if not the fourth, the practice existed of decorating the *loca sancta* of Palestine with monumental murals. In principle, then, the sixth- to seventh-century flask images could derive from those walls; but in the case of only three flasks, specifically, did GRIGG feel that compositional and iconographic peculiarities (again, heavenly arcs, starry mandorlas, *etc.*) indicated that this was likely. Finally, KURT WEITZMANN, in an article published that same year, interjected a new element into the debate: icons[6]. He, too, found the metalwork-to-flask scenario unpersuasive, and like AINALOV envisioned Palestine as a fountainhead of Gospel iconography. But WEITZMANN added an important qualifier to the AINALOV scheme by suggesting that Palestinian panel painting (witness the Sancta Sanctorum reliquary lid) provided an even more accommodating format than murals for the development and dissemination of *locus sanctus* imagery. He noted that icons – that is, multiple icons from a single holy site – could explain those perplexing instances of variant iconographies (i.e., multiple »archetypes«).

Today the value of image-bearing *devotionalia* in reconstructing the famous holy shrines of early Byzantium is acknowledged to be limited. We know now that there were fewer *locus sanctus* murals than AINALOV had imagined and that they were generally later in date than he had thought. Moreover, panel painting is now recognized to be part of the iconographic mix and even, perhaps, the more critical medium. The assumption is no longer that the flask images likely reflect mural models, but that they probably do not; only when the iconography they convey is so compositionally and theologically complex as practically to preclude creation on such a small format are large-scale sources invoked. Bobbio ampulla 1 (pl. 50b), for example, shows the sort of starry mandorla, heraldic angels, and eschatological cross that one would expect in an apse mosaic – and at the same time, a breadth of conception and a level of detail implausible for an object just seven centimeters in diameter[7]. But nowadays, even when such a genealogical scenario as this is argued, it is usually argued only in principle, without the specific aim of reconstructing an identifiable monument[8].

However, there is one prominent exception: the Holy Sepulchre. It has almost always been assumed that the tomb itself and not a mosaic on a nearby wall was the proximate

[4] ENGEMANN, Pilgerampullen, 22–25 (and notes 123–127, with additional, secondary bibliography relating to the debate).

[5] R. J. GRIGG, The Images on the Palestinian Flasks as Possible Evidence of the Monumental Decoration of Palestinian Martyria, unpublished Ph. D. dissertation (University of Minnesota, 1974).

[6] K. WEITZMANN, Loca Sancta and the Representational Arts of Palestine, in: Dumbarton Oaks Papers 28 (1974) 33–55 (esp. 48f.).

[7] Pl. 50b = Bobbio, Museo di S. Colombano, ampulla 1 (»Oil of the Wood of Life that guides us by land and sea«). See GRABAR, Les ampoules, pl. XXXII; and more generally GRIGG, Images 193–277.

[8] In addition to ENGEMANN, GRIGG, and WEITZMANN see, more recently, the general formulations of the principle in: Age of Spirituality: Late Antique and Early Christian Art, Third to Seventh Century, K. WEITZMANN, ed., New York, Metropolitan Museum of Art, 1977–1978 (New York, 1979) 565 (exhibition catalogue); and: Spätantike und frühes Christentum, Frankfurt am Main, Liebieghaus Museum alter Plastik, 1983–1984 (Frankfurt am Main, 1983) no. 173 (exhibition catalogue).

source for the ampullae. The model's existence is in this instance secure, and details of the structure as rendered on the flasks (pl. 50c) – the lattice-work gates, the low arched entrance, the conical roof with cross – match up well with the archaeological record and with descriptions of the monument by contemporary pilgrims[9]. As for compositional variations from flask to flask, these are easily explained by the notion that the different craftsmen responsible for the molds were choosing to emphasize different aspects of a visually dynamic, three-dimensional environment encompassing the tomb aedicula proper and the Anastasis Rotunda that enclosed it. In this case, and just a few others[10], the ampullae's documentary value remains significant, for through a convergence of texts, flask iconography, and archaeology the appearance of the original, Constantinian Holy Sepulchre (i.e., the Holy Sepulchre before the Persian sack of 614) can be substantially reconstituted, as JOHN WILKINSON so ably did about twenty years ago (pl. 50e)[11].

Through nine decades of speculation on the possible relationship between *devotionalia* imagery and pilgrimage shrines, the methodologically requisite assumption underlying the question has never been challenged; namely, that the function of the early Byzantine pilgrimage image, like the picture on a modern tourist souvenir, was essentially mnemonic[12]. Whether of a sacred event, like the Ascension, or of a sacred object, like the Holy Sepulchre, its role was to replicate something seen on pilgrimage (a mural, a relic) so that the pilgrim might reexperience the *locus sanctus* at a distance. If this were not so, how could the flask be trusted accurately to reflect the appearance of the shrine?

If one considers only the evidence of the Monza/Bobbio ampullae that is a reasonable assumption. On the one hand, the origin of these flasks in the Church of the Holy Sepulchre is confirmed by their »Oil of the Wood of Life . . .« inscription and by the Piacenza pilgrim's eyewitness account (*Travels* 20) of the blessing there of oil flasks through contact with the True Cross; and on the other hand, their dominant iconography (pl. 50d) – the Crucifixion/Adoration of the Cross, and the Women at the Tomb – responds specifically to that holy site's two major attractions[13]. But it is also true that those same two scenes, in basically the same iconography, appear on a contemporary copper amulet likely from

[9] Pl. 50c = Washington, D.C., Dumbarton Oaks Collection, no. 48.18 (»The Lord is risen«). See M. C. Ross, Catalogue of the Byzantine and Early Medieval Antiquities in the Dumbarton Oaks Collection, Volume 1: Metalwork, Ceramics, Glass, Glyptics, Painting (Washington, D.C., 1962) no. 87; and G. VIKAN, Byzantine Pilgrimage Art, Dumbarton Oaks Byzantine Collection Publications 5 (Washington, D.C., 1982) 20–24.
[10] Notably, the Nativity Grotto; see ENGEMANN, Pilgerampullen, 17–21; and WEITZMANN, Loca Sancta, 36–39.
[11] Pl. 50e = WILKINSON model of the Holy Sepulchre. See J. WILKINSON, The Tomb of Christ: An Outline of Its Structural History, in: Levant 4 (1972) 83–97.
[12] Interestingly, JOSEF ENGEMANN (Pilgerampullen, 25) articulated this assumption in the form of a question: »Muß man nicht annehmen, daß die Pilger auf ihren Andenken Erinnerungsbilder wünschten, die wenigstens im wesentlichen wiedergaben, was sie selbst auf ihrer Wallfahrt gesehen hatten?« – The assumption is

implicit in the terms now most frequently applied to what the Byzantines called *eulogiai* (»blessings«); that is, »souvenirs« and »Andenken«.
[13] Pl. 50d = Monza, Treasury of the Cathedral of St. John the Baptist, ampulla 13 (»Oil of the Wood of Life of the holy places of Christ«). See GRABAR, Les ampoules pl. XXIV. The ratio between the frequency of appearance of these two scenes and nearly all others on the flasks is more than 4:1. – The same is true of the Menas flasks, which originated at the Abu Mena *locus sanctus* and show an even higher concentration of locally appropriate iconography. It is not true, however, of Qal'at Sim'ān pilgrim tokens (see below) or of the ubiquitous Asia Minor pilgrim flasks, which although originating at the shrine of St. John the Evangelist at Ephesos, show a wide and confusing range of themes and compositions. For both categories of flask, see C. METZGER, Les ampoules à eulogie du Musée du Louvre, Notes et documents des musées de France 3 (Paris, 1981).

VI

380

Egypt (pl. 50f)[14], and that the »cycle« of Holy Land vignettes on Monza ampulla 2 (pl. 50a) reappears on contemporary amuletic rings (pl. 51a) and amuletic armbands (pl. 51b) manufactured outside the Holy Land for purposes unrelated to pilgrimage[15]. Consider as well the evidence from the Simeon shrine at Qal'at Sim'ān, to which about 150 figural terracotta pilgrim tokens of the period may be localized[16]. Interestingly, more than half of those tokens bear iconography drawn from the same repertoire of »Holy Land« scenes that appears on the Jerusalem ampullae, including the Women at the Tomb (pl. 51c), and among the five dozen or so tokens that show Simeon (pl. 51d. e), there are at least two dozen distinguishable iconographic interpretations[17]. Clearly, many pilgrims left Qal'at Sim'ān with an image-bearing »souvenir« thematically unrelated to the *locus sanctus* they had just visited; moreover, those who did carry away a Simeon token could not later have expected to reexperience with it a specific visual memory, since there is so little iconographic convergence among those tokens that survive as to preclude the possibility that they derive from one or even several monumental models[18].

If not to be a reminder of something seen, what was the purpose of pilgrim *devotionalia* imagery? Contemporary texts suggest three substantially distinct function-categories of image within the »piety world« of the early Byzantine pilgrim, each of which, in its own way, relates to the *devotionalia* image question[19].

[14] Pl. 50f = Paris, Cabinet des Médailles (»Emmanuel; Cross, help Aba Moun; Mary and Martha; Angel of the Lord«). See G. SCHLUMBERGER, Quelques monuments byzantins inédits, in: Byzantinische Zeitschrift 2 (1893) no. 1.
[15] Pl. 51a = Baltimore, The Walters Art Gallery, no. 45.15. See P. VERDIER, An Early Christian Ring with a Cycle of the Life of Christ, in: The Bulletin of The Walters Art Gallery 11/3 (1958); and G. VIKAN, Art and Marriage in Early Byzantium, in: Dumbarton Oaks Papers 44 (1990) 57–61.
Pl. 51b = Columbia, Museum of Art and Archaeology, University of Missouri-Columbia, no. 77.246 (inscribed with Psalm 90). See G. VIKAN, Two Byzantine Amuletic Armbands and the Group to Which They Belong, in: The Journal of The Walters Art Gallery 49/50 (1991/92) note 11, no. 10 (and passim).
[16] G. VIKAN, Two Pilgrim Tokens in the Benaki Museum and the Group to Which They Belong, forthcoming in the Laskarina Bouras memorial volume.
[17] Pl. 51c = Paris, Robert-Henri Bautier Collection. See G. VIKAN, Art, Medicine and Magic in Early Byzantium, in: Dumbarton Oaks Papers 38 (1984) 81f., fig. 22; R. CAMBER, A Hoard of Terracotta Amulets from the Holy Land, in: Actes du XVᵉ congrès international d'études byzantines, Athènes, septembre 1976, II/A (Athens, 1981) 99–106; and G. VIKAN, »Guided by Land and Sea«: Pilgrim Art and Pilgrim Travel in Early Byzantium, in: Tesserae: Festschrift für JOSEF ENGEMANN, Jahrbuch für Antike und Christentum, Ergänzungsband, 19 (1991) 76f.

Pl. 51d = Baltimore, The Walters Art Gallery, no. 48.2666 (»Simeon« [= Simeon the Elder]). Unpublished; but for a nearly identical token, see J. LASSUS, Images de Stylites, in: Bulletin d'études orientales, Institut Français de Damas 1 (1931) no. IX.
Pl. 51e = Toronto, Royal Ontario Museum, no. 986.181.84 (»Mar Shem'ōn« [= Simeon the Elder]). See E. DAUTERMAN MAGUIRE, H. P. MAGUIRE, and M. J. DUNCAN-FLOWERS, Art and Holy Powers in the Early Christian House, Illinois Byzantine Studies 2, Urbana, Illinois, Krannert Art Museum 1989 (Urbana/Chicago, 1989) no. 127 (exhibition catalogue); and G. VIKAN, Icons and Icon Piety in Early Byzantium, forthcoming in: Byzantine East, Latin West: Art Historical Studies in Honor of KURT WEITZMANN. – A significant proportion of the Simeon tokens that survive may be found illustrated in the following publications: C. CELI, Cimeli bobbiesi, in: La civiltà cattolica 74/3 (1923) 429–433; LASSUS, Images, 71–75; J. LAFONTAINE-DOSOGNE, Itinéraires archéologiques dans la région d'Antioche, Bibliothèque de Byzantion 4 (1967) 148–159, 170f.; and J.-P. SODINI, Remarques sur l'iconographie de Syméon l'Alépin, le premier stylite, in: Fondation Eugène Piot. Monuments et mémoires 70 (1989) 29–53. See also the discussion in VIKAN, Art, Medicine, 67–74.
[18] Additionally, there is for this shrine neither textual nor archaeological evidence of monumental figural mosaics of the period.
[19] This three-part image typology is presented in detail in my forthcoming contribution to the volume in honor of KURT WEITZMANN cited in footnote 17, above.

1. Votive Images (pl. 52a. b)

... having returned home, he [an artisan from Antioch exorcised by Simeon the Younger] set up to the saint, by way of thanksgiving *[kat' eucharistian],* an image in a public place and in full view of the city, above the entry to his workshop.[20]

2. Devotional (*eulogia*) Images (pl. 51d. e)

The power of God is efficacious everywhere. Therefore, take this blessing [*eulogia*] made of my dust [says Simeon the Younger to a visiting priest with a sick child], depart, and when you look at the imprint of our image, it is us that you will see.[21]

3. Amuletic Images (pl. 52c)

It is said that this man [Simeon the Elder] became so famous in the great [city of] Rome that in the porches of all the workshops they have set up little images of him so as to obtain protection and security *[phylaken. . . kai asphaleian].*[22]

The most familiar votive images of the period are those in mosaic in the Church of St. Demetrios in Thessalonike, one of which (no longer extant) was set up on the exterior of the building by the prefect Marianos in gratitude to the saint for his having been healed of paralysis.[23] The votive's characteristic combination of the interrelated functions of documentation and »repayment« is reflected in its (often) public placement, intrinsic worth, explicit inscriptions (pl. 52a: »In thanksgiving to God and to St. Simeon, I offered [this]«), and in its iconography, which might typically include the thankful party (pl. 52b: Anton, Bishop of Tsageri) and perhaps even a dramatization of the miracle.[24] A votive, if it bore an image, might subsequently perform a miracle, by virtue of its iconic potency, but more

[20] *Vita* of Simeon Stylites the Younger, chap. 158 (ca. 600). See: La vie ancienne de S. Syméon Stylite le Jeune (521–592), P. VAN DEN VEN, ed. and trans., Subsidia hagiographica 32/1, 2 (Brussels, 1962, 1970) 121, 164.
Pl. 52a = Paris, Musée du Louvre, no. Bj 2180 (6th–7th c. [= Simeon the Elder]). See M. MUNDELL MANGO, Silver from Early Byzantium: The Kaper Koraon and Related Treasures, Baltimore, The Walters Art Gallery, 1986 (Baltimore, 1986) no. 71 (exhibition catalogue).
Pl. 52b = Tbilisi, Georgian State Art Museum (early 11th c. [= Simeon the Younger]). See K. WEITZMANN, G. ALIBEGAŠILI, A. VOLSKAJA, M. CHATZIDAKIS, G. BABIĆ, M. ALPATOV, and T. VOINESCU, The Icon (New York, 1987) illus. p. 102.
[21] *Vita* of Simeon Stylites the Younger, chap. 231. See: La vie ancienne, 204–208, 230–235 note 22. Theodoret, Historia religiosa, 26.11 (ca. 440). See: Das Leben des Heiligen Symeon Stylites, H. LIETZMANN, ed., Texte und Untersuchungen zur Geschichte der altchristlichen Literatur 32/4 (1908) 8; and: The Lives of Simeon Stylites, R. PORAN, trans. and intro., Cistercian Studies Series, 112 (Kalamazoo, Michigan, 1992) 75.
[22] Pl. 52c = Location unknown (5th c. [= Simeon the Elder]). See LASSUS, Images no. X.
[23] Les plus anciens recueils des miracles de saint Démétrius et la pénétration des Slaves dans les Balkans. I. Le texte. II. Commentaire, P. LEMERLE, ed. (Paris,

1979, 1981) I, 67; and R. CORMACK, Writing in Gold: Byzantine Society and Its Icons (New York, 1985) 62f. (and more generally 50–94, figs. 23, 27–31).
[24] Each of these characteristics of votives, as well as the variant terms applied to votives and their typical dedication locations, are treated in more detail in VIKAN, Icon Piety. Many early examples involve healing shrines, and the dedicating suppliant is often from the region (the Antioch artisan) or the city (Marianos) of the shrine, although one textually attested votive in the shrine of Sts. Kyros and John in Alexandria was dedicated by a man from Rome (Sophronios, *mir.* 69). Each shrine would have had its own distinctive mix of local, regional, and international visitors, and its own characteristic proportion of »health seekers« – sometimes with their own distinctive pattern of diagnoses (e.g., genital disorders at the shrine of St. Artemios). – There is an elaborate sixth-century bronze votive cross in the Monastery of St. Catherine at Mount Sinai – a »prepayment« votive for salvation and repose of the soul – which shows Moses Receiving the Law; interestingly, its iconography is distinct from that of the nearby *locus sanctus* mosaic of the same theme. See K. WEITZMANN and I. ŠEVČENKO, The Moses Cross at Sinai, in: Dumbarton Oaks Papers 17 (1963) 385–389 (esp. 387). – The Piacenza Pilgrim (*Travels* 18) describes precious aniconic votives of all sorts (mostly jewelry) draped over the Holy Sepulchre.

typically its role was simply to attest to and give thanks for a miracle received; thus, its contemporary identification as a *charisterion* or »thankoffering«.[25] Pilgrim votives, which comprise a major subcategory within the genre, might be dedicated at the shrine or, as in the passage cited above, in the hometown of the pilgrim.

The pilgrim devotional image evoked in chapter 231 of the *Vita* of Simeon Stylites the Younger, and by our plate 51d and e, is that coupled with the pilgrim's *eulogia,* the substantive »blessing« typically of earth, wax, oil or water (these last in pewter or terracotta flasks) that the suppliant received at the *locus sanctus* and took home as a potent and portable bit of the location's sacred power.[26] Unlike pilgrim votives, pilgrim *eulogiai* would characteristically be anonymous, inexpensive, small, and private; moreover, this sort of image, unlike the other, had an integral role to play in the working of miracles. According to his *Vita,* Simeon offered the priest two different assurances that his son's cure would eventually occur: his blessed earth and his image impressed on it. Earth, obviously; but why the image? The answer comes later in the story when the man's third son falls ill and wants to be taken to Simeon. The priest recalls the saint's promise to reappear through his image-bearing *eulogia,* and in the context of prayer and incense-burning Simeon does indeed manifest himself to the boy, attacking the demon that possesses him and, presumably with his earthen »blessing«, restoring him to good health.

The image played a critical role in facilitating the saint's healing presence away from the shrine (i.e., in effecting »bi-location«). It helped devotionally to precipitate the vision of the saint that was in turn instrumental, through the *eulogia,* to the realization of his cure. Interestingly, those few other contemporary references to image-bearing *eulogiai* evoke a similar scenario[27]. In three out of four instances the suppliant is away from the shrine, where an image would be especially critical to making sacred contact; and in the fourth instance (St. Artemios, *mir.* 16) the miracle is triggered by a match between the suppliant's midnight incubation vision and the image stamped into the wax *eulogia* he wakes up with the next morning. Again, the image brings the saint, and the blessed substance, not the image itself, brings the cure.

In this respect the devotional *(eulogia)* image is effectively identical with the saint's artistic representation (in whatever form) at the shrine itself, since both act to stimulate the epiphany that is critical for his miraculous intervention[28]. The mechanism is clearly

[25] MUNDELL MANGO, Silver from Early Byzantium, 5f.; and VIKAN, Icon Piety.

[26] A. STUIBER, Eulogia, Reallexikon für Antike und Christentum 6 (Stuttgart, 1966) 900–928; B. KÖTTING, Peregrinatio religiosa: Wallfahrten in der Antike und das Pilgerwesen in der alten Kirche, Forschungen zur Volkskunde 33/34/35 (Münster, 1950) 403–413; P. MARAVAL, Lieux saints et pèlerinages d'orient (Paris, 1985) 237–241; and for the *eulogia's* manifestation in art, VIKAN, Pilgrimage Art, 10f.

[27] *Vita* of St. Martha, chap. 54 (ca. 600; see: La vie ancienne, 289); St. Artemios, *mir.* 16 (later 7th c.; see A. PAPADOPOULOS-KERAMEUS, Varia graeca sacra [St. Petersburg, 1909] 16f.); and Sts. Kosmas and Damianos, *mir.* 13 (7th c.; see: Kosmas und Damian: Texte und Einleitung, L. DEUBNER, ed. [Leipzig/Berlin, 1907] 134).

[28] This interpretation overlaps with that offered for the ampullae by ANDRÉ GRABAR in Martyrium (129–206 [esp. 172–184]). He saw the amuletic phrases shared by many of the flasks, like »Emmanuel be with us . . .«, as working in concert with the amuletic oil to invoke the deity, and believed that such »theophanic images« as the Nativity, the Adoration of the Magi, the Baptism, *et cetera* were added to the *eulogiai* to accomplish the same thing. But, following AINALOV, he thought that those images were repeating theophanic apse mosaics that gave artistic expression to the specific epiphany that had sanctified that holy site. GRABAR did not envision the devotional/interactive role for the *eulogia* image that the Simeon *Vita* describes, and thus, at least by implication, understood the image itself as empowered to perform miracles independent of »blessed« substance.

documented in the *miracula* associated with the first Christian incubation centers, especially those of Sts. Kosmas and Damianos and of Sts. Kyros and John[29]. The patient needed mystically to experience a vision of the saint in order that an appropriate diagnosis be made and treatment applied; most often this happened during incubation, but it sometimes occurred while the suppliant was fully awake. Significantly, the figure seen in that epiphany seems usually to have matched in features and costume the saint as he was portrayed in art, presumably around the shrine; he was recognized because he appeared in his »usual form«[30]. Image-bearing votives like those in our plate 52a and b, were they dedicated at the shrine, almost certainly performed a secondary function for those incubating suppliants who gazed at them before sleep[31] – a function essentially identical to that performed by the otherwise quite different image stamped into the *eulogia*.

The contrast between chapter 158 of the *Vita* of Simeon the Younger (Text 1) and Theodoret's passage on Simeon the Elder (Text 3) is revealing, for while both involve images set over the entrance to an artisan's workshop remote from Qal'at Sim'ān, one image was placed there as a publicly visible thankoffering whereas the other was set up »to obtain protection and security«. The pervasive pre-Christian tradition of amuletic doorway protection is most familiar in the form of floor mosaics of the evil eye, but by the fifth century the same prophylactic effect was being achieved through a variety of Christian symbols, words, and letters[32]. Some of the evidence is preserved among the magical papyri but most is to be found on house and shop lintels in Northern Syria. In this same piety arena of *phylakteria,* images of Simeon Stylites the Elder occupy an unusual position, insofar as this saint, substantially to the exclusion of all others in that region and period, appears in what may often be taken to be an explicitly apotropaic role, on church exteriors, reliquaries, stelae of various sorts, and chancel panels – and on a familiar but still little understood category of amuletic glass pendant, popular around the east Mediterranean basin from the later Roman period at least through the fifth century (pl. 52c)[33].

[29] C. MANGO, Healing Shrines and Images, an as yet unpublished paper delivered at the 1990 Dumbarton Oaks Spring Symposium. Professor MANGO kindly made his paper available to me in typescript. See also G. DAGRON, Holy Images and Likeness, in: Dumbarton Oaks Papers 45 (1991) 31–33.

[30] CORMACK, Writing in Gold 66; DAGRON, Holy Images, 31 note 31; and more generally, MANGO, Healing Shrines.

[31] A secondary function for which the documentary dimension and intrinsic worth of the votive would no longer have been meaningful. – Dream visions were critical as well to the healings of Asklepios, and at his shrines, too, the clients for healing imagined their healer in the form that his »icons« (usually statues) had sanctioned. See R. J. RÜTTIMAN, The Form, Character, and Status of the Asclepius Cult in the Second Century C.E. and Its Influence on Early Christianity, unpublished Th. D. dissertation (Harvard University, 1987) 79f.; and R. LANE FOX, Pagans and Christians (San Francisco, 1986) 158.

[32] J. ENGEMANN, Zur Verbreitung magischer Übelabwehr in der nichtchristlichen und christlichen Spätantike, in: Jahrbuch für Antike und Christentum 18

(1975) 22–48; and DAUTERMAN MAGUIRE, MAGUIRE, and DUNCAN-FLOWERS, Art and Holy Powers, 1–24. See also W. K. PRENTICE, Magical Formulae on Lintels of the Christian Period in Syria, in: American Journal of Archaeology 10 (1906) 137–150; and for evidence of syncretistic magical doorway protection among the papyri, Papyri graecae magicae: Die griechischen Zauberpapyri, K. PREISENDANZ, ed. and trans., 2nd ed. (Stuttgart, 1974) 210f.

[33] Very abstractly rendered, these fifth-century stylite relief »portraits« were at once compositionally assimilated to the Cross and substantially assimilated to the sacred power that the Cross was believed to convey – as was the stylite himself, through his mimetic cruciform *stasis* on the column. The juxtaposition of the basalt stela of Simeon from Gibrin in the Louvre with contemporary Syrian/Palestinian amulets bearing a conflated image of Christ and the Cross makes this explicitly clear. See, respectively, É COCHE DE LA FERTÉ, Antiquité chrétienne au Musée du Louvre (Paris, 1958) no. 5, fig. p. 10; and C. BONNER, Studies in Magical Amulets, Chiefly Graeco-Egyptian (Ann Arbor/London, 1950) 306, no. 318.

For an overview of these reliefs and related Simeon

Like the typical image-bearing votive of the sixth century (pl. 52a), the Simeon amuletic image of the fifth century would be prominently displayed (in order to effect its protective powers); but unlike the votive it would characteristically be anonymous and simplified, since what counted was neither representational accuracy nor the record of a specific event, but rather that the image function effectively in the world of power signs, which were usually simple and easily recognizable, like the evil eye, the Chrismon, and the pentalpha. In this respect the amuletic image was more like the devotional image (in which, however, some vision-inducing naturalism seems to have been valued); but while the latter was instrumental to a miracle worked by the accompanying blessed substance, the former was believed to be miraculous in its own right. Of the three, the amuletic image was the most tightly woven into pre-Christian traditions, since whether on neck (pl. 52c) or doorpost (Text 3) it was effectively interchangeable with and complementary to its pagan or Jewish counterpart; one »set up . . . little images« of Simeon in workshops to repel danger much as, according to the magical papyri, one set up little images of Hermes in workshops to attract business[34]. Moreover, of the three, the amuletic image was the least directly related to pilgrimage, for while the popularity of Qal'at Sim'ān as a *locus sanctus* undoubtedly contributed to the spread of Simeon's image to Rome (this was Theodoret's point), there is no suggestion that the Roman shopkeepers who used it to protect themselves had ever gone to visit his shrine.

The principal issue is not the relationship between pilgrimage *devotionalia* images and pilgrimage shrines, as SMIRNOV and AINALOV had originally conceived it, but rather the relationship between pilgrimage images and the objects that bear them: pilgrimage *eulogiai*. These were not tourist souvenirs but, through the magic of contagion (with holy place, person or thing), bearers of sacred power. Valued above all for their presumed amuletic potency, they were used mainly to preserve the pilgrim on his journey homeward, and to heal him once he arrived there[35]. Inevitably, the imagery they bear responded to that function; this is true of the vision-inducing devotional image already discussed and it is true as well of a wide range of miraculous travel imagery (e.g., Christ Walking on Water, the Flight into Egypt) coupled with *eulogiai* to enhance their protective power for seafaring and

items of the later fifth to early sixth century, see V. H. ELBERN, Eine frühbyzantinische Reliefdarstellung des Älteren Symeon Stylites, in: Jahrbuch des Deutschen Archäologischen Instituts 80 (1965) 280–304 (esp. 303 f.); G. TCHALENKO, Villages antiques de la Syrie du Nord, III (Paris, 1958) 16–18 (H. SEYRIG), figs. 8, 9, 13–20; and SODINI, Remarques, 29–32. For the amuletic glass pendants, see LAFONTAINE-DOSOGNE, Itinéraires archéologique, 158, 171f., figs. 95–97; and Objects with Semitic Inscriptions, 1100 B.C.–A.D. 700, Jewish, Early Christian and Byzantine Antiquities, Zürich, FRANK STERNBERG, Auction XXIII, 20 November 1989 (Zürich, 1989) 75–78, nos. 264–296 (sale catalogue). That Simeon the Elder specifically is represented is indicated by the objects' early dating, by that saint's dominance of this genre of asceticism in the fifth century,

and by the appearance on some of the reliefs of the identifying »St. Simeon« inscription, without the younger stylite's »in the Miraculous Mountain« epithet. The terracotta *eulogia* tokens from Qal'at Sim'ān, like those from the »Miraculous Mountain« of Simeon the Younger, likely date no earlier than the later sixth century (for dating criteria, see VIKAN, Pilgrim Tokens).

[34] The Greek Magical Papyri in Translation, H. D. BETZ (Chicago/London, 1986) 81; and more generally, VIKAN, Icon Piety.

[35] For the former, see VIKAN, »Land and Sea«, 74–92; for the latter, idem, Art, Medicine, 65–86; and for the pilgrim's *eulogia* more generally, footnote 26, above. Both GRABAR (Les ampoules, 63–67) and ENGEMANN (Pilgerampullen, 12f.) emphasized the inherently amuletic nature of the *eulogia*.

overland pilgrims[36]. For the latter, especially, there would be no presumption of (or point in) thematic identity between the shrine visited (its appearance, its decoration) and the image-bearing *eulogia* carried away[37].

From this perspective consider again the one category of pilgrimage *devotionalia* iconography wherein the link to a shrine is uncontested: the Holy Sepulchre. If not as a simple tourist reminder, why was the shrine image added to the *eulogia*? Because the Holy Sepulchre, unlike the mural paintings that were thought to have inspired the other scenes, was, as a relic, itself a source of sacred power. The identity of *eulogia* image and shrine architecture was valued by pilgrims because it was believed capable of conveying directly the sacred power of the relic depicted, just as the »blessed« oil inside could directly convey the power of the relic it had once touched. Identity of image is in this respect like the ceremonial identity of action achieved when the pilgrim acted out the appropriate biblical story at a holy site, to gain its intangible »blessing«[38]. The Piacenza pilgrim entered the Jordan at the place of Christ's Baptism »to gain a blessing« (*Travels* 11) – the same *benedictio (eulogia)* he received when he took sanctified earth from Christ's Tomb (*Travels* 18). Such stories make it clear that the ritualized reenactment of biblical events was a central ingredient in the pilgrimage experience; the pilgrim would perform the appropriate imitative action at the *locus sanctus,* where the sacred spot would provide his stage and its associated relics his props. It might be performed either privately or communally, as it frequently was in Jerusalem as part of the stational liturgy[39]. Egeria (*Travels* 31.1–2) describes a special Palm Sunday afternoon service on the Mount of Olives that would conclude with the Gospel account of the Triumphal Entry, after which the entire congregation, with palm branches in hand, would escort the bishop into the city along the path once followed by Jesus, chanting as they went the same acclamation that greeted His arrival. Earlier (*Travels* 24.9–10) she describes a similarly dramatic event staged each Sunday in the Anastasis Rotunda, which included censing by the clergy of the inside of the Tomb and reading by the bishop of the Gospel account of Christ's Resurrection from the spot where the angel had first announced it, prompting in the whole assembly »groans and laments for all the Lord underwent for us . . .«[40]. Such dramatic moments must have left the pilgrim with a strong visual impression. It was as if that congregation, the bishop and clergy, and the Holy Sepulchre converged briefly to become a »living icon« of the Resurrection – an icon captured on the ampulla in a form evocative, at once, of the Gospel story and contemporary ceremonial, with, at its center, an empowered replication of the relic-prop.

[36] VIKAN, »Land and Sea«, passim (esp. 83). Recall that Bobbio ampulla 1, illustrated in our pl. 50b, bears the words: »Oil of the Wood of Life that guides us by land and sea«. The apotropaic power of such travel-specific imagery as Christ Walking on Water (e.g., on Bobbio ampulla 11) derives from an »as . . . so also« typological bond posited between the biblical character (in that case, St. Peter) and the person possessing the image (the seafaring pilgrim): »as Peter was saved from drowning so also may I be«.

[37] Two biblical »types« for protected overland travel, the Adoration of the Magi and the Flight into Egypt, are disproportionately represented, respectively, among the terracotta *eulogia* tokens from Qal'at Sim'ān and the terracotta *eulogia* flasks from Ephesos (VIKAN,

»Land and Sea«, 80 f., 84 f., figs. 9c, 10g); in neither case is there any thematic link to the *locus sanctus*.

[38] For a more detailed treatment of this idea, see G. VIKAN, Pilgrims in Magi's Clothing: The Impact of Mimesis on Early Byzantine Pilgrimage Art, in: The Blessings of Pilgrimage, Illinois Byzantine Studies, 1, R. OUSTERHOUT, ed. (Urbana/Chicago, 1990) 97–107.

[39] J. F. BALDOVIN, The Urban Character of Christian Worship: The Origins, Development, and Meaning of Stational Liturgy, Orientalia christiana analecta 228 (1987) 67, 238 (where the distinction is drawn between supplicatory and mimetic processions).

[40] J. WILKINSON, Egeria's Travels to the Holy Land (Warminster, 1981) 125.

How precise need the identity of action or image have been? It was enough for the Piacenza pilgrim, at Mount Gilboa, to throw three stones at the grave of Goliath to gain the blessing there (*Travels* 31), and in the Garden of Gethsemene to lie briefly on the couch where Christ had reclined to receive the special *eulogia* of that holy site (*Travels* 17). As for the tangible, carry-away sort of pilgrim *eulogia,* there are Holy Sepulchre tokens as simple as that in our plate 51c (contrast pl. 50c), whereon the drum and columns of the Anastasis Rotunda have been deleted, the Tomb shrine has been reduced to a crude aedicula only vaguely reminiscent of the original, and the two Marys have been left out altogether. To ask how little iconographic or ceremonial coincidence with the original was necessary still to achieve the intangible »sanctity link« is like asking how fleeting or at how many removes physical contact with a relic might be, in order still to achieve the transfer of sacred power; it is a question that transcends the boundary between religion and magic[41].

The Holy Sepulchre may be used as a paradigmatic »reduction model« for *eulogia* transfer via image identity – or more specifically, the Holy Sepulchre's multiple architectural copies may be so used[42]. With these copies (e.g., in Fulda, Paderborn, Aquileia, etc.) came not only the historical meaning of the Christ's tomb but also a portion of its sacred power; thus their frequent incorporation of Holy Land relics and their characteristic association with cemeteries, baptisteries, and Holy Week mimetic rituals. But, surprisingly, variations in execution among the architectural »copies« were so wide as in some instances actually to mask the copy link, except to those informed of the builder's intention. In fact, mere coincidence of crude shape (basic roundness) or significant measure (the absolute size of one feature or the relative proportion among features) was enough to establish the link. And therein a parallel may be drawn with the primal belief that motivated pilgrims to take »measures« from relics. The Piacenza pilgrim witnessed the custom in the basilica of Holy Sion (*Travels* 22):

> In this church is the column at which the Lord was scourged, and it has on it a miraculous mark. When he clasped it, his chest clove to the stone, and you see the marks of both his hands, his fingers, and his palms. They are so clear that you can use them to take »measures« for any kind of disease, and people can wear them around their neck and be cured[43].

Here, too, the link to sacred power is distilled to a measure, in effect, to a numerical value, much as the power of »kyrie« was then distilled to the number 535 and »amen« to 99, representing the sum of the numerical values of the word's Greek letters[44]. And although,

[41] The magic of contagion emerges unequivocally both within and without religion in the diary of the Piacenza pilgrim, who, like his fellow Christian travelers, continually seeks physical contact with all things holy, yet marvels at the »contact phobia« (manifesting xenophobia) of the Samaritans he encounters when they burn away his footprints behind him and refuse to take his money unless he first drops it in water (*Travels* 8).

[42] This line of argumentation derives from RICHARD KRAUTHEIMER's seminal study (Introduction to an »Iconography of Medieval Architecture«, in: Journal of the Warburg and Courtauld Institutes 5 [1942] 1–33), and its later elaboration by ERNST KITZINGER (The Cult of Images in the Age Before Iconoclasm, in: Dumbarton Oaks Papers 8 [1954] 105), and ROBERT OUSTERHOUT

(Loca Sancta and the Architectural Response to Pilgrimage, The Blessings of Pilgrimage, 108–124).

[43] J. WILKINSON, Jerusalem Pilgrims Before the Crusades (Warminster, 1977) 84. Gregory of Tours (Glory of the Martyrs 6) describes the same practice:

> ... many who are filled with faith approach this column and tie around it cords they have woven; they receive these cords back as a blessing that will help against various illnesses.

See: Gregory of Tours, Glory of the Martyrs, R. VAN DAM, trans., Translated Texts for Historians, Latin Series 3 (Liverpool, 1988) 27.

[44] PRENTICE, Magical Formulae, 145–150; and F. DORNSEIF, Das Alphabet in Mystik und Magie, 2nd ed., Stoicheia 7 (Leipzig/Berlin, 1925) 106–113.

as with the architectural copies of the Holy Sepulchre, the carrier is tangible (a building, a strip of cloth), the actual transfer of sacred power is achieved intangibly, through a simple shape, or with a mere number.

In the context of pilgrimage *eulogiai* the Holy Sepulchre image functioned amuletically, complementing the sacred power of the *eulogia* it accompanied with its own sacred power – which it imparted as well to non-*eulogia* (non-pilgrimage) amulets like that in our plate 50f[45]. But sometimes, as on Monza ampulla 2 (pl. 50a) and on the amuletic rings (pl. 51a) and armbands (pl. 51b) iconographically related to it, the Holy Sepulchre image played another role as well, as the penultimate episode in a cycle of Christological scenes. A parallel may be drawn between this sequence of images as it encircles the armband and the amuletic *incipit* from the 90th Psalm (»He that dwells in the help of the Highest . . .«) interspersed with it (pl. 51b); both are ever-repeating amuletic charms[46]. Similarly, this Christological picture cycle may be said to function amuletically much like the Christological »narrative cycle« sometimes invoked in the magical papyri:

> Fly, hateful spirit! Christ pursues thee; the Son of God and the Holy Spirit have outstripped thee. O God (who healed the man at) the sheep pool, deliver from every evil thy handmaid Joannia whom Anastasia also called Euphemia bare . . . O Lord Christ, Son and Word of the living God, who healest every sickness and every infirmity, heal and regard they handmaid Joannia, whom Anastasia also called Euphemia bare. Chase from her and put to flight all fevers and every kind of chill, quotidian, tertian, and quartan, and every evil . . . Upon thy name, O Lord God, have I called, the wonderful and exceeding glorious name, the terror of thy foes. Amen[47].

On its most basic level this amulet draws its power from the invocation of the sacred name, and thereby from the primal, magical belief that such names share in the being and participate in the power of their bearers[48]. But this papyrus is magical as well on a secondary, »aretalogical« level, since the power of the deity, as if this were Isis, is also being invoked through a recitation of His most glorious deeds[49]. And the same is true of the armbands, rings, and ampullae that bear the *locus sanctus* picture cycle, insofar as their individual scenes may be read as sequential verses in a visual aretalogy[50]. This method of invoking sacred power is attested among Christians as early as Origen, who in response to Celsus' charge that his co-religionists got their power from reciting the names of demons, countered by saying that (*Contra Cels.* 1.6):

[45] On the amulet it complements an inscription (»Cross, help . . .«) and a second image (the Crucifixion) that together invoke the presence and power of the Cross.

[46] E. KITZINGER, Reflections on the Feast Cycle in Byzantine Art, in: Cahiers archéologiques 36 (1988) 60 f.

[47] See A. S. HUNT, The Oxyrhynchus Papyri VIII (London, 1911) 251–253; and H. MAGUIRE, Garments Pleasing to God: The Significance of Domestic Textile Designs in the Early Byzantine Period, in: Dumbarton Oaks Papers 44 (1990) 221.

[48] See D. E. AUNE, Magic in Early Christianity, in: Aufstieg und Niedergang der Römischen Welt 23/2: Principat (Berlin/New York, 1980) 1546. This is the same magical belief implicit in GRABAR's understanding of the ampullae's imagery (see footnote 28, above). As the sacred name »Emmanuel« participates in and thereby brings to bear the power of the deity, so also

does the accompanying sacred image (e.g., the Adoration of the Magi, on Monza ampulla 1). But arguing against so broad an interpretation of such »theophanic images« as the Nativity, the Adoration of the Magi, the Baptism, *et cetera* is the fact that most of these scenes do not otherwise appear alone on objects which, by virtue of accompanying magical words or symbols, are clearly amuletic. (Contrast here the amuletic rings and armbands cited in footnote 15, above [fig. 6]; and see VIKAN, Amuletic Armbands.)

[49] Ibid., 1547.

[50] The pair of double-sided gold pendant amulets from Adana in the Archaeological Museum, Istanbul provides an even closer parallel in art for that papyrus text and for the general notion of Christian »aretological magic«, insofar as the one side with a *locus sanctus*-like infancy cycle is complemented on the other side by a miracle cycle. See D. T. RICE, The Art of Byzantium (New York, 1959) no. 66.

. . . it is not by incantations that Christians seem to prevail [over evil spirits], but by the name of Jesus, accompanied by the announcement of the narratives which relate to Him; for the repetition of these has frequently been the means of driving demons out of men . . .[51]

What, in conclusion, may be said of the value of image-bearing pilgrimage *devotionalia* in regaining a visual impression of the early Byzantine pilgrimage shrine? Notwithstanding the inapplicability of the modern »souvenir model« to the early Byzantine pilgrim *eulogia,* it is true that some *eulogiai* bear images that reflect local monumental models. Holy Sepulchre *devotionalia,* where the goal was to capture a relic's sacred power through identity of image and object, constitute the prime example, but there are as well a few individual ampullae (e.g., pl. 50b) whose decoration is compositionally and iconographically incomprehensible without the assumption that, for whatever reason, it was copied from a wall, or perhaps an icon[52]. Yet even in those rare cases, it can be said only that the *eulogia* composition suggests the appearance of large-scale imagery then current in Palestine – as otherwise attested, for example, in Choricius' description of the Church of St. Sergios at Gaza – and not that it necessarily speaks for the monumental art (or panel painting) within the shrine from which it originated. In this context the archaeological value of pilgrimage *devotionalia* is limited, and has by now been substantially realized.

But perhaps there is another category of *locus sanctus* art to consider, for which the *devotionalia* might hold special meaning. In response to their role in donor piety, pilgrim votives would have been prominently displayed, and to judge from contemporary texts and monuments – notably the *miracula* of the healing shrines and the mosaics in St. Demetrios – they must have been, at least by the early sixth century, a prominent element in the pilgrim's visual environment, independent of whether or not the shrine might otherwise include monumental murals[53]. The frequency with which seemingly specific though unidentified suppliants appear in various configurations with the saint on Simeon tokens (e.g., pl. 51e) suggests that these mass-produced items may have been copied from votives displayed around the shrine (cf. pl. 52b); after all, the two performed basically the same function, though in different places[54]. Ironically, this model of iconographic dissemination, from (mostly lost) shrine votives to (abundantly extant) pilgrimage *eulogiai,* recalls the DMITRII AINALOV thesis. Though AINALOV, like most who later took up the issue he raised, was concerned primarily with the monumental arts, biblical iconography, and the Holy Land; this did not leave much room for the possibility that votives – in all media and sizes, biblical and non-biblical, iconic and aniconic – may have constituted the dominant artistic feature of early Byzantine pilgrimage shrines.

[51] Origène, Contre Celse, M. BOURRET, ed., I (Paris, 1967) 1.6.

[52] Assuming that there was some pietistic motive behind the copying, might it not simply have been, following GRABAR, to invoke a divine epiphany through a recognized theophanic image?

[53] C. MANGO, Healing Shrines. A votive much like that in our plate 52b is described, *circa* 500, in the *Vita* of Daniel the Stylite (chap. 59; see Les saints stylites, H. DELEHAYE, ed., Subsidia hagiographica, 14 [Brussels, 1923] 58 [and LIVf., for the dating]).

[54] This scenario would explain the anomalous presence on one Simeon token of the inscription: »Receive, O Saint, the incense offered by Constantine«.

Does it make sense to imagine that some otherwise unidentified Constantine had a pilgrim stamp custom-made for himself (the only one so personalized among hundreds of *eulogiai*)? Or would it not be more logical to suppose that a prominent votive image (in precious metal or mosaic?) of a more fully identified Constantine dedicated at the shrine served as its model? The latter scenario would explain why a virtual twin to that token substitutes the generic and therefore more *eulogia*-suitable »and heal all« ending for what on the first token is the more votive-suitable »offered by Constantine«. For the two tokens, see VIKAN, Pilgrimage Art, figs. 22, 24.

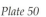
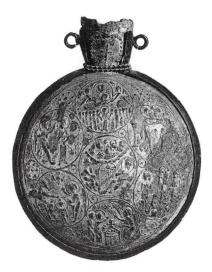

a. Monza, Treasury of the Cathedral
of St. John the Baptist, ampulla 2.

b. Bobbio, Museo di S. Colombano,
ampulla 1.

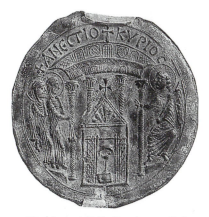

c. Washington, D.C., Dumbarton Oaks
Collection, no. 48.18

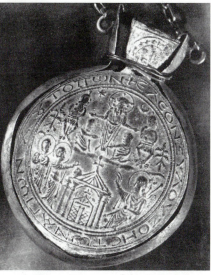

d. Monza, Treasury of the Cathedral
of St. John the Baptist, ampulla 13.

e. WILKINSON model of the Holy Sepulchre.

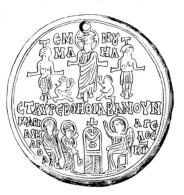

f. Paris, Cabinet des Médailles.

Plate 51

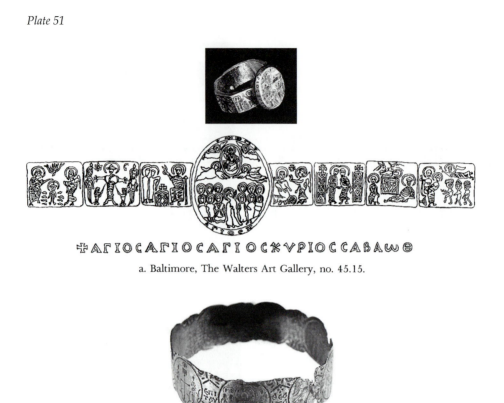

a. Baltimore, The Walters Art Gallery, no. 45.15.

b. Columbia Museum of Art and Archaeology, University of Missouri-Columbia, no. 77.246.

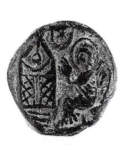

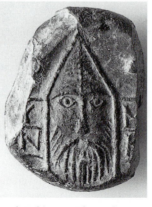

c. Paris, Robert-Henri
Bautier Collection, no. 2.

d. Baltimore, The Walters
Art Gallery, no. 48.2665.

e. Toronto, Royal Ontario
Museum, no. 986.181.84.

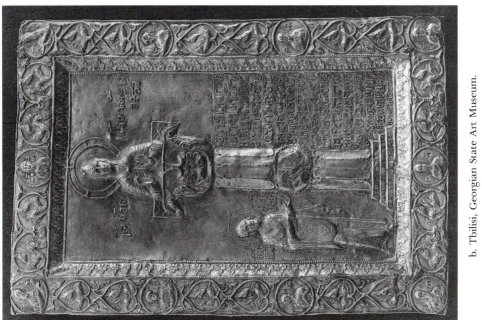

b. Tbilisi, Georgian State Art Museum.

a. Paris, Museé du Louvre, no. Bj 2180.

c. Location unknown.

Pilgrims in Magi's Clothing:
The Impact of Mimesis
on Early Byzantine Pilgrimage Art

INTRODUCTION

Frequently the essence of a pilgrimage was the combination of ritual and sensory experience. By repeating sacred, often mimetic, actions the worshippers could place themselves within the realm of the holy. Appropriate Bible verses could be read, and the movements of the worshippers could reflect those of the sacred event. By visiting an important biblical site, the pilgrim could visualize the events it commemorated, and thereby participate mystically in them. The site was the evidence, the proof of the validity of the Scripture, and this was enhanced by the actions of the pilgrim. In the cave of the Nativity in Bethlehem Jerome's companion Paula

> solemnly declared . . . that, with the eye of faith, she saw a child wrapped in swaddling clothes, weeping in the Lord's manger, the Magi worshipping, the star shining above, the Virgin Mother, the attentive fosterfather; and the shepherds coming by night to see this word which had come to pass, already, even then, able to speak the words which open John's Gospel, "In the beginning was the Word" and "The Word was made flesh."[1]

And when Paula first came before the wood of the True Cross in Jerusalem, "she fell down and worshipped . . . as if she could see the Lord hanging on it."[2] Through ritualized movements and actions, the

1. Jerome, *Letter* 108, to Eustochium; trans. J. Wilkinson, *Jerusalem Pilgrims before the Crusades* (Warminster, 1977), 49.

2. Jerome, *Letter* 108, to Eustochium; trans. Wilkinson, *Jerusalem Pilgrims*, 49. See also W. Loerke, "'Real Presence' in Early Christian Art," *Monasticism and the Arts*, ed. T. Verdon (Syracuse, 1984), 29-51.

pilgrimage could become a sort of "exteriorized contemplation," as Victor Turner called it.[3]

Such a "presence" could be experienced at the tomb of a martyr as well. Gregory of Nyssa described how the faithful worshipped relics: "Those who behold them [the relics] embrace, as it were, the living body in full flower: they bring eye, mouth, ear, all senses into play, and then, shedding tears of reverence and passion, they address to the martyr their prayers of intercession as though he were present."[4]

In all instances the culmination of the pilgrimage is described in physical, sensory terms, and the personal and experiential nature of the process is stressed. Just how physical the experience could be is demonstrated in the account of the visit of a Carthaginian woman, Megetia, to the shrine of St. Stephen at Uzalis: "When she prayed at the place of the holy relic shrine, she beat against it not only with the longings of her heart, but with her whole body, so that the little grille in front of the relic opened at the impact; and she, taking the Kingdom of Heaven by storm, pushed her head inside and laid it on the holy relics resting there, drenching them with her tears."[5]

In the following chapter, Gary Vikan explores the experiential nature of pilgrimage and its reflection in the arts. The mystical participation of the pilgrim in the commemorated event led to the creation of so-called *locus sanctus* art in which elements of the contemporary site and its worship affected the representations of sacred events.

"THE PRINCIPAL MOTIVE which draws people to Jerusalem," wrote Paulinus of Nola, "is the desire to see and touch the places where Christ was present in the body."[1] Indeed, while seeing might be enough for the modern tourist, it was certainly not enough for the early pilgrim, who wanted most of all to *touch*—to be closely proximate to and physically involved with holy places, holy objects, and holy men, and thereby to draw from them a dose of their spiritual power, their *eulogia*.[2] They could touch simply by bending down to kiss the sanctified earth beneath their feet, as we know many did, or could touch in

3. V. and E. Turner, *Image and Pilgrimage in Christian Culture* (New York, 1978), 33.
4. Gregory of Nyssa, *Encomium on St. Theodore*, PG 46, 740B; trans. P. Brown, *The Cult of the Saints: Its Rise and Function in Latin Christianity* (Chicago, 1981), 11.
5. *Miracles of St. Stephen*, 2.6, PL 41, 847; trans. Brown, *Cult of the Saints*, 88.

the course of more formal acts of veneration.[3] Sophronios, for example, describes three sequential steps in his contact with a relic at Bethlehem: "The shining slab which received the infant God, I will touch with my eyes, my mouth, [and] my forehead, to gain its blessing."[4]

Touching and kissing were the simplest and most obvious means whereby the pilgrims could make contact, but there was yet another important way to become physically involved with the holy sites and objects along the route; they could, in effect, reenact the sacred events that had rendered the sites holy in the first place. The anonymous pilgrim from Piacenza, traveling south through Palestine around 570, described the following scene at Mount Gilboa:

> when we had traveled straight down for 20 miles [from Jerusalem] we came to Mount Gilboa, where David killed Goliath. . . Goliath's resting-place is there in the middle of the road, and there is a pile of wood at his head. There is also a heap of stones—such a mountain of them that there is not a pebble left for a distance of 20 miles, since anyone going that way makes a gesture of contempt by taking three stones and throwing them at his grave.[5]

Further north, in the Valley of Gethsemane, this same pilgrim lay on each of the three couches upon which Christ had reclined during the night of his betrayal, "to gain their blessing."[6] Similarly, at Cana he reclined at the wedding table where Christ had reclined, and then filled one of the two surviving water jugs with wine, lifted it to his shoulder, and offered it at the altar, again "to gain a blessing."[7] In each instance, the Piacenza Pilgrim performed an appropriate imitative action at the appropriate *locus sanctus*; the sacred spot provided his stage set and the relics his props. And occasionally there was yet a third criterion for his experience, namely, appropriate time. Thus this pilgrim, along with hundreds of others, journeyed to the River Jordan on the Feast of Epiphany so that he, in remembrance and imitation of Christ, could go down into the water "to gain a blessing."[8]

From the many accounts like this that survive, it is clear that the ritualized reenactment of biblical events was a topos of the early pilgrim's experience. The reenactment might be performed privately, as it was at Mount Gilboa and Cana, or it might be performed communally, as it was in the Jordan River, or as it would be frequently in Jerusalem, as part of the stational liturgy. On Palm Sunday, for example, a special afternoon service was held on the Mount of Olives,

which would conclude with the Gospel account of the Triumphal Entry.[9] Then the entire congregation, with palm fronds in hand, would escort the bishop down from the Mount and into the city along the path once followed by Christ. A similar dramatic reenactment was staged each Sunday morning in the Anastasis Rotunda, where Egeria described the following scene:

> at [the first cock crow] the bishop enters, and goes into the cave in the Anastasis. . . . After [the recitation of] three Psalms and prayers, [the Clergy] take censers into the cave of the Anastasis so that the whole . . . basilica is filled with the smell. Then the bishop, standing inside the screen, takes the Gospel book and goes to the door, where he himself reads the account of the Lord's Resurrection. At the beginning of the reading the whole assembly groans and laments at all the Lord underwent for us.[10]

This is a service which was celebrated on the day of the Resurrection, and in the very place which was its testimony. The bishop read the Gospel account from the spot where the angel once sat and announced the same news to the Holy Women. It is even possible and perhaps probable that the incense—which is mentioned only in connection with this particular service—was brought to the Holy Sepulchre specifically to recall the spices which the women had brought. By any standards, this was an event that must have exercised a powerful and dramatic impact on the pilgrim, and one that, like the services celebrating Palm Sunday and Epiphany, drew much of its power from the convergence of significant *place*, significant *time*, and significant, mimetic *action*.

In a general sense, this sort of behavior might be taken as a natural extension of the mandate to Christian *mimesis* expressed by, among others, St. Basil, in an early letter to Gregory of Nazianzus: "he who is anxious to make himself perfect in all the kinds of virtue must gaze upon the lives of the saints (and scriptures) as upon statues, so to speak, that move and act, and must make their excellence his own, by imitation."[11] But more specifically, these were the familiar, ritualized actions—and empathic, typological identifications—that gave shape and meaning to the pilgrims' day-to-day existence; this was how they actually experienced the spiritual power of the *locus sanctus*, and how they secured for themselves the transference of its *eulogia*. It is as if the congregation in the Anastasis Rotunda, the bishop and clergy, and Sepulchre itself converged for a moment to form a "living icon" of the

Resurrection. For like an icon, they, by virtue of iconographic verisimilitude, collectively joined that chain of imparted sanctity leading back to their archetype, to the biblical event itself. And in so doing, they achieved what Theodore the Studite said all artificial images achieved: "Every artifical image . . . exhibits in itself, by way of imitation, the form of its model . . . the model [is] in the image, the one in the other."[12] Thus these pilgrims did not merely touch the *locus sanctus*, they became, at least briefly, iconically one and the same with it, and with that sacred event which had once made it holy.

But whether or not a "theology of pilgrimage" can legitimately be deduced from the behavior of individual pilgrims is really not at issue. Rather, what concerns us is the potential relationship which may be drawn between the behavior and the implicit beliefs of the pilgrims and the art that was created to serve them. The object illustrated in Figures 19-20 is a case in point.[13] Certainly one of the most important and familiar categories of early Byzantine pilgrimage art to have survived is that comprised of the more than three dozen embossed pewter ampullae perserved, for the most part, in the church treasuries at Monza and Bobbio in northern Italy. This unusually fine specimen, however, is in the Dumbarton Oaks Collection.[14] All of these flasks draw on a fairly limited range of scenes and inscriptions, and all may be assigned to Jerusalem and to the decades around A.D. 600. This makes them more or less coincident, both geographically and chronologically, with the Piacenza Pilgrim. Like many in the series, the Dumbarton Oaks ampulla shows on the reverse the Women at the Tomb, with the inscription "the Lord is risen." On the obverse is the Crucifixion, with the inscription "oil of the Wood of Life of the holy places of Christ." The "Wood of Life," of course, is the True Cross, and the oil in the ampulla, that which was sanctified by contact with it. Indeed, the Piacenza Pilgrim describes an impressive ceremony in the Basilica of Constantine orchestrated specifically for the blessing of such flasks: "At the moment when the Cross is brought out of this small room for veneration . . . a star appears in the sky, and comes over the place where they lay the Cross . . . They offer oil to be blessed in little flasks. When the mouth of one of the little flasks touches the Wood of the Cross, the oil instantly bubbles over, and unless it is closed very quickly it all spills out."[15]

What is striking about the imagery on all of these ampullae, and on this one in particular, is the extent to which it diverges from the Gospel account of the event in favor of the pilgrim's experience at the shrine

itself. The composition of the Women at the Tomb shows, instead of the rock-hewn cave described in the Bible, a complex architectural ensemble modeled on the Holy Sepulchre and Anastasis Rotunda as they then existed.[16] Directly below the inscription is the windowed drum of the Rotunda, with four of its tall columns, and beneath that a schematic rendering of the porch of the Tomb aedicula. Flanking the open entrance are the "grilles" described by Egeria, while within it are an arch, which likely marks the low entrance to the Tomb chamber proper, an oil lamp on a stand, and below, the rhomboid shape of the "Stone of the Angel," a famous relic that the Piacenza Pilgrim describes as lying in front of the Tomb door.[17] *In toto*, this ensemble constitutes the so-called Chapel of the Angel where, according to Egeria's account, the bishop stood as he read the Gospel text of the Resurrection: "After . . . three Psalms and prayers, [the Clergy] take censers into the cave of the Anastasis . . . Then the bishop, standing inside the screen, takes the Gosepl book and goes to the door, where he himself reads the account of the Lord's Resurrection."[18] At this point, of course, his words, the words of the angel, and the words embossed on the flask are essentially one and the same: *anesti ho Kyrios* or "the Lord is risen."

In effect, then, this ampulla has captured a momentary, experiential reality very much of the sort that is captured on the Riha and Stuma patens.[19] Neither strictly historical nor strictly liturgical, it is a reality more or less seen and experienced on the spot, but one wherein the *dramatis personae*, the bishop and the clergy, are subsumed beneath their typological equivalents: in this instance, the angel and the Maries. Yet interestingly, among the liturgical *realia*, the spice jars of the Holy Women have been replaced by censers.[20]

Like the composition on the back of the ampulla, that on the front has much more to do with the pilgrim's participatory experience at the shrine of the Holy Sepulchre than with the Gospel narrative of Christ's Passion and Resurrection. Indeed, this scene should more accurately be entitled the Veneration of the True Cross than the Crucifixion, as it usually is, since the only element in it strictly accurate to the historical, biblical account is the pair of crucified thieves.

At the center of the composition is a small, equal-armed cross set upon a shaft that rises above the trilobed hillock of Golgotha. From that hillock flow the four rivers of Paradise, which on a symbolic level specifically identify this cross as the Tree or "Wood" of Life planted in the garden of Paradise. Above the cross, just at the edge of the inscription, is a tiny *tabula ansata*, the plaque that identified Christ as the

"King of the Jews." Of course both items, the plaque and the cross, were famous relics, and as such were the subject of the pilgrims' veneration. Just moments before witnessing the blessing of the oil flasks, the Piacenza Pilgrim described his own encounter with them in these words: "In the courtyard of the basilica is a small room where they keep the Wood of the Cross. We venerated it with a kiss. The title is also there which they placed over the Lord's head, on which they wrote 'This is the King of the Jews.' This I have seen, and had it in my hand and kissed it."[21] Compositionally interposed between cross and plaque is a bust portrait of Christ. And with good reason, for it was Christ, and specifically contact with His body, that had sanctified these relics in the first place, and that now enabled them to transfer a portion of that sanctity to the pilgrim, either through the contact of his veneration or through the intermediary of blessed oil.

Flanking the bust are the sun and the moon and, further out, the two thieves: all standard accoutrements of "historical" Crucifixion scenes. However, the two kneeling figures below are not.[22] They are instead part of the seen and experienced reality at the Golgotha shrine itself, insofar as they represent generic suppliants who, in the characteristic pose and gesture of veneration, lean forward to touch the relic. But more specifically, they are the pilgrims—the *xenoi* or "strangers"—for whom the hospices of Jerusalem were obliged to care.[23] This is clear from the fact that they are portrayed with bushy beards and flowing hair, and in foreign, exotic clothing such as pantaloons. And it is certainly no coincidence that in both appearance and pose these figures have much in common with the Magi as they are portrayed on other ampullae (Fig. 21).[24] Some among them, in fact, even wear the Magi's distinctive Phrygian cap.[25]

But why are pilgrims shown in Magi's clothing? The reason should by now be obvious: the pilgrim is here being at least partially subsumed within the identity of his biblical antetype. After all, the Magus was the archetypal pilgrim, the gift-bearing stranger from afar who journeyed to the Holy Land to worship Christ. As foreign travelers and bearers of votive gifts, pilgrims in effect *became* Magi and the goal of their pilgrimage—whether holy site or holy man—*became* Christ. Thus, one understands Paula's reaction to a community of Egyptian desert-dwelling monks: "In each holy man she believed she was seeing Christ, and every gift she gave gladly, as if to Christ."[26] And thus one understands why the empress Theodora, in a rare Byzantine example of hidden symbolism, places herself among the Magi, the archetypal

bearers of gifts, as she herself becomes a bearer of gifts (Fig. 22).[27]

So now, let us rethink the entire issue. It is certain that pilgrims often involved themselves in imitative behavior of one sort or another, from simple mimetic gestures to complex ceremonial reenactments. It is also certain that they could and did see the world around them according to typological equivalents, at least on one level of reality. Thus, on the basis of common sense alone, it would seem reasonable— if not necessary—to suppose that one of those typological equations involved pilgrims on one side and Magi on the other.

So with that in mind, let us consider Figures 23 and 24.[28] Each represents a distinct genre of early Byzantine pilgrimage art, comparable in significance to the ampullae, but as yet substantially unknown. The object illustrated in Figure 23 is one of more than a hundred small earthen pilgrim tokens that, though contemporary with and functionally and structurally similar to the more familiar tokens of St. Simeon, show one or another biblical scene or holy figure, instead of the Stylite atop his column.[29] Among the representations, the biblical scenes run to a nearly complete Christological cycle, including the Annunciation, Nativity, Adoration of the Magi, Miracle at Cana, Transfiguration, Entry into Jerusalem, Crucifixion, and the Women at the Tomb—that is, basically the same cycle with basically the same *locus sanctus* iconography as that found on the ampullae. But what is surprising about these tokens is that among those with biblical scenes nearly 40 percent bear the Adoration of the Magi. This is is more than twice the proportion of any other scene and fully five times that of the Women at the Tomb, despite the fact that the latter iconography served the single most important *locus sanctus* in the Holy Land, whereas the Magi were a secondary attraction at a secondary shrine.[30] What was significant in Bethlehem, after all, was not the Magi but the Nativity grotto. There is, in other words, something statistically anomalous about these pilgrim tokens, and it calls for an explanation.

Now consider the object illustrated in Figure 24. It is one of nearly twenty surviving pieces of pilgrimage jewelry—mostly fibulae and pendants—that may be grouped together through similarities in design, iconography, and function, and that collectively may be dated and localized, along with the ampullae and the tokens, to Syria or Palestine, and to the 6th to the 7th centuries.[31] As a group, these objects draw on the repertoire of *locus sanctus* scenes shared by the ampullae, but like the tokens, they betray a grossly disproportionate attraction for the Adoration of the Magi. Moreover, two additional facts about

them are noteworthy: first, that a significant proportion—including this fibula—were found in western European graves; and second, that a significant proportion—again including this fibula—bear invocations. Usually these invocations call upon the "help" of Christ, as in this example, or of Holy Mary; and occasionally they name the recipient of that help as "the wearer."

How can we explain the disproportionate attraction of the Magi in the decoration of the jewelry and the tokens, the western graves, and the invocations of help? And what does this all have to do with the suppliants on the ampullae, who seem to be dressed in Magi's clothing?

The solution to this puzzle is to be found in the indisputable fact that all three of our categories of pilgrimage art—ampullae, tokens, and jewelry—share a common function; namely, they were all made to be worn or carried as *amulets*.[32] Abundant textual evidence leaves no doubt of this. We know that they functioned generically to ward off demons and, more specifically, to heal the sick and to preserve the traveler in transit; indeed, one of the Monza ampullae is inscribed: "oil of the Wood of Life, that guides us by land and sea."[33] And naturally, it was in this particular arena of protection that the Magi, through the power of their sympathetic magic, had a special role to play.[34] Not only were the Magi the archetypal *xenoi* and the archetypal gift-givers, accounting for their representations on the ampullae and on the hem of Theodora's dress, they were also the archetypal travelers. And this is where the pilgrim must have struck his closest and most beneficial typological bond, because as travelers the Magi were guided and protected by a guardian angel—as shown on the fibula—and by the invoked help of the deity. Thus they were not only Christianity's archetypal travelers, they were its archetypal protected travelers. They were the ones who went to worship in a foreign land and came back safe and sound. Their modern counterparts, the pilgrims, with the aid of the sympathetic magic that their amulets had to offer, would return home among their own people, and later could be buried with the amulet that had helped on the journey.

Byzantine art was a functional art. As such, it was highly responsive to the shared beliefs, chronic fears, and characteristic modes of behavior of those for whom it was made. Certainly this was true of Byzantine pilgrimage art. In the course of their journeys, the pilgrims acquired any number of passing identities, and some of them are reflected in their art. But as a foreigner, suppliant, gift-giver, and traveler all rolled into

one, the pilgrim appears most often—as here—dressed in Magi's clothing.

<center>NOTES</center>

This chapter is essentially an annotated version of a paper delivered in October 1985 at the 11th Annual Byzantine Studies Conference in Toronto, Canada. The formative role of pilgrimage mimesis on pilgrimage art was introduced in my booklet, *Byzantine Pilgrimage Art*, Dumbarton Oaks Byzantine Collection Publications, 5 (Washington, D.C., 1982), 23 ff.

1. Paulinus of Nola, *Ep.* 49.402, in J. Wilkinson, *Jerusalem Pilgrims before the Crusades* (Warminster, 1977), 40.

2. See Vikan, *Byzantine Pilgrimage Art*, 5 f., 10 f.

3. For example, the Piacenza Pilgrim, *Travels*, 19; in Wilkinson, *Jerusalem Pilgrims*, 83 (and 6 f.).

4. Sophronios, *Anacreonticon* 19, 45, in Wilkinson, *Jerusalem Pilgrims*, 92 (and 7).

5. Piacenza Pilgrim, *Travels*, 31, in Wilkinson, *Jerusalem Pilgrims*, 85. According to the Old Testament (I Kings 17.40), David had picked up five stones for his shepherd's bag, but the Byzantines, and the Piacenza Pilgrim, understood this number to be three, for the Trinity.

6. *Ibid.*, 17 (Wilkinson, *Jerusalem Pilgrims*, 83).

7. *Ibid.*, 4 (Wilkinson, *Jerusalem Pilgrims*, 79).

8. *Ibid.*, 11 (Wilkinson, *Jerusalem Pilgrims*, 83).

9. See J. Wilkinson, *Egeria's Travels to the Holy Land* (Warminster, 1981), 74, 132 f. (Egeria 31.1-2).

10. Egeria, 24.9-10 (Wilkinson, *Egeria's Travels*, 125).

11. *St. Basil: The Letters*, ed. and trans. R. J. Deferrari (Cambridge, Mass., 1961), I, 15 ff. For other such texts, and observations on Christian mimesis drawn from them, see G. Vikan, "Ruminations on Edible Icons: Originals and Copies in the Art of Byzantium," *Studies in the History of Art* (Washington, D.C., forthcoming).

12. Theodore the Studite, *Epist. ad Platonem;* in C. Mango, *The Art of the Byzantine Empire, 312-1453: Sources and Documents* (Englewood Cliffs, N.J., 1972), 173.

13. Fig. 20: Washington, D.C., Dumbarton Oaks, 48.18. M.C. Ross, *Catalogue of the Byzantine and Early Medieval Antiquities in the Dumbarton Oaks Collection*, I: *Metalwork, Ceramics, Glass, Glyptics, Painting* (Washington, D.C., 1962), no. 87.

14. *Ibid.;* for the genre as a whole, see A. Grabar, *Ampoules de Terre Sainte* (Paris, 1958); Vikan, *Byzantine Pilgrimage Art*, 20 ff.; and, most recently L. Kötzsche-Breitenbruch, "Pilgerandenken aus dem heiligen Land," *Vivarium:*

Festschrift Theodor Klauser zum 90. Geburtstag, Jahrbuch für Antike und Christentum, Erganzungsband, 11 (1984), 229 ff.

15. Piacenza Pilgrim, *Travels,* 20 (Wilkinson, *Jerusalem Pilgrims,* 83).

16. See the discussion in Vikan, *Byzantine Pilgrimage Art,* 19 ff.

17. See Egeria, 24.2 (Wilkinson, *Egeria's Travels,* 123); and the Piacenza Pilgrim, *Travels,* 18 (Wilkinson, *Jerusalem Pilgrims,* 83).

18. Egeria, 24.10; Wilkinson, *Egeria's Travels,* 125.

19. See W. C. Loerke, "The Monumental Miniature," *The Place of Book Illumination in Byzantine Art* (Princeton, 1975), 78 ff.

20. As they often are in this period; see for example the ivory pyxis in K. Weitzmann, ed., *The Age of Spirituality: Late Antique and Early Christian Art, Third to Seventh Century* (New York, 1979), 281-82, no. 520.

21. Piacenza Pilgrim, *Travels,* 20 (Wilkinson, *Jerusalem Pilgrims,* 83).

22. For various attempts to identify these figures, see R. J. Grigg, "The Images on the Palestinian Flasks as Possible Evidence of the Monumental Decoration of Palestinian Martyria" (Ph.D. Diss. University of Minnesota, 1974), 234 f. See also Vikan, *Byzantine Pilgrimage Art,* 23 f.

23. See B. Kötting, *Peregrinatio religiosa* (Regensberg, 1950), 378 ff.

24. Fig. 21: Monza, Treasury of the Cathedral of St. John the Baptist, no. 1; see Grabar, *Ampoules,* Monza 1.

25. See for example *ibid.,* Bobbio 3, Bobbio 4.

26. St. Jerome, *Letter* 108, to Eustochium, 14.2, in Wilkinson, *Jerusalem Pilgrims,* 52.

27. Fig. 22: Ravenna, San Vitale; see A. Grabar, *Christian Iconography: A Study of Its Origins* (Princeton, 1968), 99.

28. Fig. 23: Detroit, The Detroit Institute of Arts, U.L.26.152; see L. Y. Rahmani, "The Adoration of the Magi on Two Sixth-Century C.E. Eulogia Tokens," *Israel Exploration Journal,* 29 (1979), 35. Fig. 24: "Attalens fibula"; see J. Engel, "Une découverte enigmatique: la fibule chrétienne d'Attalens," *Dossiers histoire et archeologie,* 62 (1982), 93.

29. For the genre, including list of surviving examples and full bibliography, see G. Vikan, "Art, Medicine, and Magic in Early Byzantium," *Dumbarton Oaks Papers,* 38 (1984), 81 ff.

30. For example, the Piacenza Pilgrim, *Travels,* 29 (Wilkinson, *Jerusalem Pilgrims,* 85), makes no mention of the Magi in his brief account of Bethlehem, noting instead the cave of the Nativity and the Manger.

31. For the genre, including list of surviving examples and full bibliography, see Vikan, "Art, Medicine, and Magic," 83, n. 116.

32. *Ibid.,* 81 ff.

33. Grabar, *Ampoules,* Bobbio 1.

34. See C. Bonner, *Studies in Magical Amulets, Chiefly Graeco-Egyptian* (Ann Arbor, 1950), 71 ff.

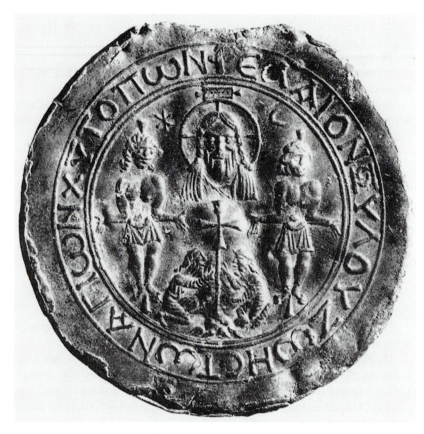

19. Pewter pilgrim ampulla from Palestine, Dumbarton Oaks Collection, Washington, D.C., 48.18, obverse. Adoration of the Cross (photo courtesy of Dumbarton Oaks).

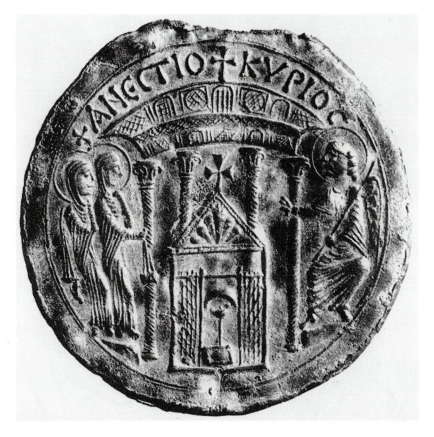

20. Pewter pilgrim ampulla from Palestine, Dumbarton Oaks Collection, Washington, D.C., 48.18 reverse. Holy Women at the Tomb (photo courtesy of Dumbarton Oaks).

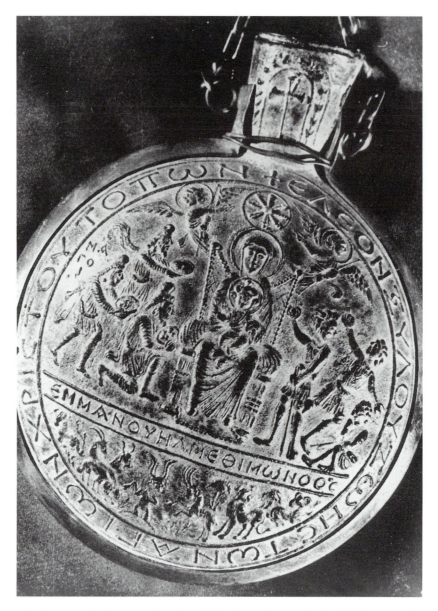

21. Pewter pilgrim ampulla from Palestine, Monza Cathedral Treasury, 1. Adoration of the Magi (after Grabar, *Ampoules;* courtesy of Monza Cathedral Treasury).

22. Ravenna, San Vitale. Detail, Theodora mosaic. Adoration of the Magi, represented on the hem of Theodora's dress (photo courtesy of German Archaeological Institute).

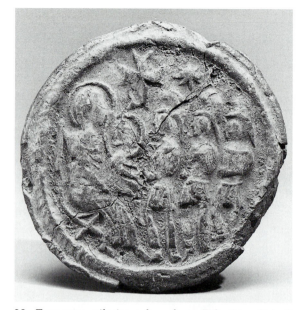

23. Terracotta pilgrim token from Palestine, Detroit Institute of Arts, U.L.26.152. Adoration of the Magi. Anon., Byzantine 8-12th century A.D., 1.5 inches in diameter (photo copyright The Detroit Institute of Arts, City of Detroit Purchase; courtesy of Detroit Institute of Arts).

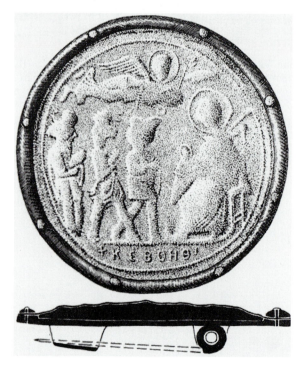

24. Bronze fibula from Palestine, Attalens. Adoration of the Magi (after *Dossiers histoire et archéologie*, 1962).

VIII

»GUIDED BY LAND AND SEA«

Pilgrim Art and Pilgrim Travel in Early Byzantium*

Byzantine art was a functional art, and as such, it was responsive to the shared beliefs, chronic fears, and characteristic patterns of behavior of those for whom it was made. In effect, it was a mirror of all of these.

This article will be devoted to early Byzantine art (artifacts, material culture) as a mirror of contemporary travel, though only in a specific, restricted sense, as art functioned thematically, in response to belief, to address anxieties associated with travel. It will therefore not be concerned with the crafted paraphernalia of travel, like decorated harness fittings, nor with such practical though artistic travel documents as the Madaba mosaic map, nor even with the *realia* of travel as one might discover them among depictions of the Jonah story or the Flight into Egypt. Rather, it will be devoted to »travel art« as a subset of the art of amulets, recognizing that travel was then, much more than now, a risky affair, and that neither Christian, pagan nor Jew of the period was above using implements of the supernatural to help ensure his physical safety in transit. But even here, there will be an additional restriction on my field of inquiry, though in this case it is not one that I have imposed, but rather one derived *de facto* from what we know about what little survives. Certainly merchants, sailors, soldiers, and the like all had reason to travel, and just as certainly, many of them must have used amulets to protect them in their travels. But, at least insofar as we can judge from the available evidence, they had no artistic idiom through which to give these travel concerns appropriate material expression; there is no such thing, in other words, as »merchants' art« or »sailors' art«[1]. But there is pilgrims' art, and pilgrims, after all, were late antiquity's quintessential travelers; moreover, the art they carried with them, almost by definition, was amuletic[2]. So it will be within the world of early Byzantine pilgrimage, specifically, that evidence will be sought of early Byzantine travel art, though always with the presumption that non-pilgrims as well may have been its patrons and beneficiaries. Accordingly, the focus of this article will be on the east Mediterranean basin, between Emperor Constantine's discovery of the Holy Land in the early fourth century and its conquest by Moslem Arabs in the mid-seventh; nearly all of the pilgrimage artifacts herein discussed, however, are more specifically datable to the sixth to seventh century, the most materially productive period of Byzantine pilgrimage.

*

* This article is offered in grateful recognition of one of the finest and most enduring contributions to the study of Byzantine pilgrimage art, published by JOSEF ENGEMANN in 1973 in the Jahrbuch für Antike und Christentum: »Palästinensische Pilgerampullen im F. J. Dölger-Institut in Bonn«.

[1] There is merchants' art to the extent that there is a range of characteristic iconography associated with the weights they used in commerce; but this is unrelated to whatever travel they may have undertaken in their capacity as merchants. See G. VIKAN / J. NESBITT, Security in Byzantium: Locking, Sealing, and Weighing = Dumbarton Oaks Byzantine Collection Publications, 2 (Washington, D.C., 1980) 29/37.

[2] ENGEMANN, 1973, 12f.; and G. VIKAN, Byzantine Pilgrimage Art = Dumbarton Oaks Byzantine Collection Publications, 5 (Washington, D.C., 1982) 10/40. On the pilgrim as late antiquity's traveler *par excellence*, see L. CASSON, Travel in the Ancient World (London, 1974) 300/29.

Chapter 235 of the *vita* of Simeon Stylites the Younger († 592) recounts a miracle at sea[3]. Dorotheos, priest and monk at the monastery of St. Simeon, was for personal reasons forced to make a trip by boat during the perilous winter season. Halfway into the journey a violent wind came up and the sea became extremely rough. The passengers panicked as the captain and crew prepared to abandon ship; but Dorotheos intervened, exhorting them to call upon the help of the Lord, through his intermediary, St. Simeon. Then:

> ... the monk took the dust [*konis*] of the saintly servant of God that he carried with him as a blessing [*eulogia*], and after having put it into water, he threw it on the sea and sprinkled all the boat, saying: »Holy servant of God, Simeon, direct us and save us«. With these words, all those on the boat were impregnated with perfume, the sea water surrounded the boat like a wall, and the waves were powerless against it.

This *eulogia* of Simeon's »dust« was the reddish earth gathered by his followers from near the base of the saint's column atop his Miraculous Mountain, sixteen kilometers southwest of Antioch[4]. Valued above all for its presumed medicinal powers, Simeon dust was used as well for such various miraculous effects as bringing an ailing donkey back to life (chap. 148), growing hair on a bald man (chap. 194), restoring a vat of sour wine to its former sweetness (chap. 230), and, in this instance, calming a storm at sea[5].

What might Dorotheos' *eulogia* have looked like? While the particular bit of earth involved in this miracle need not necessarily have taken the form of an image-bearing token, we know that Simeon dust often did. On the one hand, dozens of »Simeon tokens« have been found throughout the Mediterranean basin, identifiable by an image of the saint

[3] P. VAN DEN VEN, La vie ancienne de S. Syméon Stylite le Jeune (521–592) = Subsidia Hagiographica, 32 (Brussels, 1962 [1], 1970 [2]); and H. J. MAGOULI-AS, Lives of Byzantine Saints as Sources of Data for the History of Magic in the Sixth and Seventh Centuries A.D.: Sorcery, Relics, and Icons: Byzantion 37 (1967) 256.
[4] G. VIKAN, Art, Medicine, and Magic in Early Byzantium: DumbOPap 38 (1984) 67/73.
[5] Parallel *miracula* may be drawn from the *vita* of Simeon Stylites the Elder, who died atop his column at Qal'at Sim'an in 459. See, generally, A.-J. FESTUGIÈRE, Antioche païenne et chrétienne. Libanius, Chrysostome, et les moines de Syrie = Bibliothèque des Écoles françaises d'Athènes et de Rome 194 (Paris, 1959) 347/401; H. LIETZMANN, Das Leben des heiligen Symeon Stylites = TU 32,4 (Leipzig, 1908). Mostly used for medicinal purposes, Simeon the Elder's blessed dust, often complemented with his blessed water, was employed as well to restore the productivity of a farmer's field (Syr. 77), stop a plague of rats and mice (Syr. 96), repel man-eating wild animals (Syr. 97), put water back into a dry well (Syr. 98), and preserve ships at sea (Syr. 103/6). Miracle 104 of the Syrian *vita* is especially revealing of Simeon's maritime powers. Once a great ship with many passengers sailed from Arabia toward Syria, but in the middle of the journey a great storm came up, with high waves and strong winds. The terrified passengers saw a black man (an »Indian«) on the point of the mast, which they recogni-

zed to be a sign that the ship would soon sink. But one among them, a man from Atama near Ames, had some of St. Simeon's blessed dust (LIETZMANN, 1908, 152): »He remembered this, stepped forward and took the blessed dust and made from it a cross on the mast, which stood in the middle of the ship, and extended his hands, as they were yet full of the blessed dust, to the one side of the ship and to the other, and all the people cried out as they [his hands] lay there: ›Simeon, ask your Lord and help us through your prayer‹. Suddenly the Blessed One appeared and held a whip in his right hand, climbed to the heights and placed himself on the point of the mast and seized the Indian [black man] by the hair and raised him up and punished him with the whip ... [etc.]«. More or less contemporaneously with the *vita* of Simeon the Younger, Gregory of Tours relates a legend (glor. mart. 5) according to which Constantine's mother, St. Helena, calmed storms on the Adriatic with a relic: »The far-sighted empress [Helena], concerned over the disasters of these miserable men [sailors on the Adriatic], ordered one of the four nails [of the Lord's cross] to be thrown into the sea. She relied upon the pity of the Lord that he was able to calm the savage rolling of the waves. Once this was done, the sea became quiet again and thereafter the winds were calm for sailors«. See Gregory of Tours, Glory of the Martyrs, R. VAN DAM, trans. = Translated Texts for Historians, Latin Series 3 (Liverpool, 1988) 25.

atop his column (pl. 8a) and, occasionally, by the inscription »*Eulogia* of St. Simeon in the Miraculous Mountain«[6]. On the other hand, chapter 231 of the *vita* has Simeon himself dispensing such an iconographic token. The saint addresses a priest with a sick child at home with these words:

> The power of God . . . is efficacious everywhere. Therefore, take this *eulogia* made of my dust, depart, and when you look at the imprint [*sphragis*] of our image [*eikon*], it is us that you will see.

One may imagine, then, that the monk Dorotheos carried with him a Simeon token much like that illustrated in plate 8a, as a generic bit of sacred power useful in any emergency while he was away from the monastery. But it is also possible, because he was setting out on an unusually risky journey by sea, that Dorotheos took an *eulogia* specifically responsive to the needs of seafarers, like that illustrated in plate 8b, showing Christ in a boat flanked by a pair of his disciples[7]. Although highly simplified, it should probably be identified as the Tempest Calmed, because of the relative prominence in the synoptic Gospels of that miracle on the Sea of Galilee in which Christ, having been roused from sleep, calms a storm and saves his disciples:

> Then he arose and rebuked the winds and the sea; and there was a great calm. But the men marvelled, saying, What manner of man is this, that even the winds and the sea obey him[8].

This *eulogia* is one of a pair of identical impressions among a hoard of ninety-three stamped iconographic tokens now divided between the British Museum and the Robert-Henri Bautier Collection, Paris[9]. Said to have been found in a glass dish near (at?) Qal'at Sim'an, the pilgrimage shrine of Simeon Stylites the Elder († 459), about sixty kilometers northeast of Antioch, they are divisible into twenty-three distinct mold types representing twelve different iconographic themes:

[6] Pl. 8a = Houston, Menil Collection. See G. Vikan, Ruminations on Edible Icons. Originals and Copies in the Art of Byzantium: Studies in the History of Art 20 (1989) 55, fig. 9. For the object type, and the inscription, see Vikan, 1984, 67f., and note 16. Since it does not directly bear on the arguments put forward in this paper, the question of which Simeon tokens should be assigned to which Simeon shrine, the Miraculous Mountain or Qal'at Sim'an, will not be considered. Findspot evidence plus the recent appearance of tokens inscribed »Simeon« in Syriac suggest that the question deserves thorough rethinking.

[7] Pl. 8b = Paris, Robert-Henri Bautier Collection. Unpublished. For its twin, see R. Camber, A Hoard of Terracotta Amulets from the Holy Land: Actes du XVe congrès international d'études byzantines, Athens, September 1976, 2/A (Athens, 1981) 101 (»the Tempest Calmed [?]«), fig. 6.

[8] Mt. 8:23/27 (quoted); Mc. 4:35/41; Lc. 8:22/25. In his description of the contemporary painted decoration in the Church of St. Sergios at Gaza, Choricius characterizes the Tempest Calmed scene this way: »Endowed with so much power, He has even the winds under His control. The boat is tossed about; the onset of the waves does not allow it to maintain an even keel and drags one side down. But He rebukes the raging winds and, immediately, they tremble at His threats. For no longer ›doth the crash of waves beset my ears‹ (Iliad, 10.535)«. See C. Mango, The Art of the Byzantine Empire: 312–1453 = Sources and Documents in the History of Art Series (Englewood Cliffs, N. J., 1972) 66 (Laudatio Marciani, 1.65).

[9] Vikan, 1984, 81/83, and note 109; and Camber, 1981. Coincidence of mold types leaves little doubt that the two groups derive from the same hoard. The larger part of the hoard was acquired by the British Museum in 1973 (acc. nos. 1973,5-1, 1-80); it consists of seventy-nine tokens (plus one Simeon token), and was published by Camber. The smaller part, comprising fourteen tokens, was purchased in 1980 through H. Drouot by Professor Robert-Henri Bautier, who kindly supplied photographs and granted permission to publish them. See Vikan, 1984, figs. 22/24. The tokens measure between .5 and 1.5 cm. in diameter, making them about half the size of a typical Simeon token. I owe the provenance information, which applies specifically to the British Museum portion of the hoard, to Christopher Entwistle of the British Museum.

1. Adoration of the Magi (pl. 9c)	21 specimens (3 molds)
2. *Aphlaston?* (pl. 11e)	21 specimens (3 molds)
3. Baptism	11 specimens (2 molds)
4. Christ *en buste*	9 specimens (1 mold)
5. Nativity	7 specimens (3 molds)
6. Women at the Tomb	6 specimens (2 molds)
7. Entry into Jerusalem (pl. 10d)	5 specimens (1 mold)
8. Adoration of the Cross	5 specimens (2 molds)
9. Annunciation	4 specimens (2 molds)
10. Tempest Calmed (pl. 8b)	2 specimens (1 mold)
11. Miracle at Cana	1 specimen (1 mold)
12. Healing of the Blind Man	1 specimen (1 mold)

The stylistic homogeniety of these tokens and their apparent association with a single findspot, coupled with the topographical »anonymity« of some of their iconography (e. g., Christ *en buste*; Healing of the Blind Man), suggest that they all came from a single blessed earth source, and not from so many different pilgrim holy sites[10]. But the point is not whether such seemingly »directed« *eulogia* tokens were in fact available to Dorotheos at the Miraculous Mountain of Simeon the Younger, for undoubtedly they could have been, or even whether they were believed, by virtue of their specific imagery, to be more effective on the high seas than the generic sort of token, though likely they were (see below). Rather, the point is that among the hundreds of surviving early Byzantine pilgrimage *eulogiai* generally (notably tokens, ampullae, and flasks), there are some which bear iconography apparently directed toward some specific amuletic function. Moreover, within this group those that were apparently designed for the protection of travelers are especially prominent[11].

Among the more than three dozen extant Palestinian pewter ampullae (ca. 600), mostly preserved at Monza and Bobbio, there is one with the inscription »Oil of the Wood of Life that guides us by land and sea«, and two others showing Christ Walking on Water (pl. 8c), an unusual theme in pilgrimage art which, because it is unassociated with a *locus sanctus*, should probably be understood as having been made in response to the anxieties of sea travelers[12]. Of comparable date, and likely made with the same basic intent, are the

[10] VIKAN, 1984, note 113. Neither textual nor archaeological evidence suggests the existence of a significant *locus sanctus* associated with the Tempest Calmed miracle. See J. WILKINSON, Jerusalem Pilgrims Before the Crusades (Warminster, 1977), (gazeteer); and P. MARAVAL, Lieux saints et pèlerinage d'orient. Histoire et géographie des origines à la conquête arabe (Paris, 1985) 294.

[11] Surprisingly, although saints' lives, pilgrim diaries *et cetera* leave no doubt that pilgrimage *eulogiai*, like early Byzantine amulets generally, were for the most part used medicinally, only rarely do they bear words such as »health« or images such as the Woman with the Issue of Blood that directly mirror that function. See VIKAN, 1982, 12; and *idem*, 1984, 69f., and notes 52 and 106. I have previously treated the interrelated issues of directed *eulogiai* and the pilgrim's typological identification with pilgrimage iconography in Byzantine Pilgrimage Art (footnote 2, above), 14/17, 23/27; and in Pilgrims in Magi's Clothing. The Impact of

Mimesis on Early Byzantine Pilgrimage Art: R. OUSTERHOUT, ed., The Blessings of Pilgrimage = Illinois Byzantine Studies 1 (Urbana/Chicago, 1990) 98/107.

[12] Pl. 8c = Bobbio, Museo di S. Colombano, no. 11. See A. GRABAR, Ampoules de Terre Sainte (Paris, 1958), Bobbio 11, and page 59; and, for the inscription, ENGEMANN, 1973, 10, and note 35. (For the amuletic role of this scene on ring bezels, see footnote 84, below.) For the object type, see GRABAR, 1958; and ENGEMANN, 1973. For the *locus sanctus* issue, see WILKINSON, 1977, (gazeteer); and MARAVAL, 1985, 294. In the Church of St. Sergios at Gaza, this scene follows directly on the Tempest Calmed (see footnote 8, above); it is described by Choricius this way: »It is not surprising that He should walk over the sea and gradually save His companion. The latter is shown incomplete in the painting, i. e., the half of him that is hidden is meant to be under water, while the part that emerges is as yet in safety«. See MANGO, 1972, 67 (Laudatio Marciani, 1.66).

occasional terracotta pilgrim flasks from the water shrine of St. Menas which, instead of showing the saint flanked by camels, bear a sailing ship (pl. 8d), thereby evoking that specifically maritime intercessory role of Menas recorded in a hymn in which he addresses Christ as the »Lord Most Serene« (*Kyrie Galenotate*), and asks him to »save from danger those upon the sea«[13]. Counterparts to these Egyptian flasks, by date, probable function, and relative frequency of appearance within their object type, may be found among the terracotta pilgrim flasks from the shrine of St. John the Evangelist at Ephesos (pl. 8e); indeed, their specific seafarers' iconography is a near match for that of the earthen tokens already discussed, and thus should be interpreted in the same way, as the Tempest Calmed[14]. These were apparently containers for the holy dust or »manna« reputedly exhaled by the sleeping saint from his tomb[15]. The *Chronicle* of Ramon Muntaner, although dating from the fourteenth century, records among the mostly medicinal powers of St. John's manna, the same miraculous capability that is evoked in chapter 235 of Simeon's *vita*:

> ... if there is a storm at sea and some of the manna is thrown in the sea three times in the name of the Holy Trinity and Our Lady Saint Mary and the Blessed Saint John the Evangelist, at once the storm ceases[16].

Much earlier textual corroboration for the notion that an *eulogia* could be especially efficacious for sea travelers appears in the well-known travel diary of the Piacenza pilgrim (ca. 570), which records the following ceremony on the banks of the Jordan on the Feast of the Epiphany:

> All the ship-owners of Alexandria have men there that day with great jars of spices and balsam, and as soon as the river has been blessed, before the baptism starts, they pour them out into the water, and draw out holy water. This water they use for sprinkling their ships when they are about to set sail[17].

The Tempest tokens are not the only earthen *eulogiai* with a likely connection to safe passage by sea. Sts. Phokas and Isidore were both guardians of seafarers[18]; among the early cult centers of the former was Cherson, and of the latter, Chios. In the Hermitage is a large clay token inscribed »*Eulogia* of St. Phokas of the poor house of Cherson«, showing the saint standing in a miniature boat (pl. 8f)[19]. The lost stamp that made it probably looked more

[13] Pl. 8d = Cairo, Coptic Museum. See C. M. KAUFMANN, Ikonographie der Menas-Ampullen (Cairo, 1910), 168f. (169 for the hymn), fig. 104. For the object type, see C. METZGER, Les ampoules à eulogie du musée du Louvre (Paris, 1981) 9/16. CASSON, 1974, 328, too, saw a specifically amuletic correlation between these Menas ship-flasks and seafaring pilgrims.

[14] Pl. 8e = Princeton, The Art Museum, Princeton University, no. 118. See S. ĆURČIĆ / A. ST. CLAIR, eds., Byzantium at Princeton, Princeton, The Art Museum, Princeton University, 1986 (Princeton, 1986), no. 151 (exhibition catalogue). For the object type, see METZGER, 1981, 17/23.

[15] M. DUNCAN-FLOWERS, A Pilgrim's Ampulla from the Shrine of St. John the Evangelist at Ephesus: R. OUSTERHOUT, ed., The Blessings of Pilgrimage = Illinois Byzantine Studies 1 (Urbana/Chicago, 1990) 126/139.

[16] Quoted from DUNCAN-FLOWERS, 1990, 130.

[17] WILKINSON, 1977, 82 (Travels from Piacenza, 11).

[18] C. VAN DE VORST, Saint Phocas: AnalBoll 30 (1911) 261f., 288f.; and, for Isidore, H. DELEHAYE, ed., Synaxarium ecclesiae Constantinopolitanae = ASS Propyl. Nov. (Brussels, 1902) 683 (May 14).

[19] Pl. 8f = Leningrad, State Hermitage Museum. See V. LATYSEV, Etjudy po vizantijskoj epigrafike 4: Neskol'ko pamjatnikov' s' nadpisjami vizantijskoj epohi iz' Hersonisa Tavriceskago: Vizantijskij Vremennik 6 (1899) 344.

or less like the bronze stamp of St. Isidore in The Walters Art Gallery (pl. 8g), which was likely used to make amuletic tokens for seafaring visitors to Chios[20]. Its retrograde inscription reads »Jesus Christ / St. Isidore / Receive the blessing«; toward the right background is a tiny shrine with a hanging lamp and standing censer, and to the left, protected under the saint's extended arm, a sailing ship[21].

Finally, mention should be made of a dedicatory stone plaque discovered during recent excavations in the Chapel of St. Vartan beneath the Holy Sepulchre (pl. 8h)[22]. Assigned by its excavators to the fourth century, it bears an ink drawing of a ship, accompanied by the Latin inscription »O Lord, we have come« (*Domine ivimus*). According to the most convincing of several interpretations, that of M. BROSHI, the drawing was made by a pilgrim as an *ex voto*, offered in thanks for a successful voyage to the Holy Land – a voyage whose peril is graphically evoked by what appears to be a broken or dismantled mast[23].

St. Isidore protected the Christian seafarer of early Byzantium much as Isis had protected the pagan seafarer a few centuries earlier[24]. Indeed, the association of Isis (as Isis Pelagia, Isis Euploia, Isis Pharia) with the sea is well attested from the late Ptolemaic period onward, when she was identified as the mistress of the winds, inventor of the sail, and protector of seafarers. Her most characteristic maritime iconography shows her holding a billowing sail (pl. 9a), the pose she assumes on a marble matrix of around A.D. 200, recently published from the Athenian agora excavations (pl. 9b)[25]. Although more than twice the size of the Walters Isidore stamp and compositionally quite different, the Athens matrix nevertheless is to be interpreted iconographically in basically the same way, insofar as on both, a guardian of seafarers is portrayed in a characteristically protective and controlling role over the ship. Moreover, the publisher of the matrix, ELLEN REEDER, has convincingly argued that its function was to produce metal votives for dedication at the Athens Isis shrine by sailors thankful for a successful voyage, or in anticipation of a voyage to come[26]. Its specific piety, if not its iconography, is thus much like that of the pilgrim drawing beneath the Holy Sepulchre, whereas its iconography, if not its precise ritualistic use, is closer to the *eulogia* tokens whereon Phokas and Isidore preside over safe passage by sea[27].

*

[20] Pl. 8g = Baltimore, The Walters Art Gallery, no. 54.230. See VIKAN, 1982, 15, fig. 8.
[21] St. George assumes the same protective pose in relationship to a kneeling suppliant on a contemporary bronze votive cross in the Cabinet des Médailles (no. Z27411).
[22] Pl. 8h = Jerusalem, Holy Sepulchre, Chapel of St. Vartan. See M. BROSHI / G. BARKAY, Excavations in the Chapel of St. Vartan in the Holy Sepulchre: IsrExplJourn 35 (1985) 125/128, fig. 7; and K. G. HOLUM / R. L. HOHLFELDER / R. J. BULL / A. RABAN, King Herod's Dream (New York/London, 1988) 195, fig. 143. For a similar seafarer's graffito at the Menas shrine, see KAUFMANN, 1910, 169, fig. 106.
[23] BROSHI/BARKAY, 1985, 127.

[24] E. REEDER WILLIAMS, Isis Pelagia and a Roman Marble Matrix from the Athenian Agora: Hesperia 54 (1985) 111, and note 17, with additional bibliography.
[25] Pl. 9a = London, British Museum (Maximus: A.D. 238). See B. V. HEAD, A Catalogue of the Greek Coins in the British Museum 14. Catalogue of the Greek Coins of Ionia (London, 1892) 226, pl. XXIII.18; and REEDER WILLIAMS, 1985, 112. Pl. 9b = Athens, Agora excavations, no. ST 527. See REEDER WILLIAMS, 1985.
[26] REEDER WILLIAMS, 1985, 118.
[27] For the »Eulogy of St. Phokas«, describing customs which seamen followed for showing gratitude to the saint for their safe arrival, see LATYSEV, 1899, 344/349.

Travel in general, and pilgrimage travel specifically, was more often than not overland, on foot or by donkey, and this route, too, had its characteristic dangers, including remote, unfamiliar territory, harsh climates, bandits, wild animals, and hostile local populations[28]. Gregory of Tours, in the *Glory of the Martyrs*, describes his father's apotropaic (overland) travel *encolpion*, which Gregory inherited many years later:

> Because he wished himself to be protected by relics of saints, he asked a cleric to grant him something from these relics, so that with their protection he might be kept safe as he set out on his long journey. He put the sacred ashes in a gold medallion and carried it with him. Although he did not even know the names of the blessed men, he was accustomed to recount that he had been rescued from many dangers. He claimed that often, because of the power of these relics, he had avoided the violence of bandits, the danger of floods, the threats of turbulent men, and attacks from swords[29].

One would assume that if some among the miraculous pilgrimage *eulogiai* of the period were iconographically tailored to the needs of sea travelers, as many or more would be responsive to the concerns of travelers by land. And in fact, the surviving evidence, although usually less explicit than that involving boats, seems to bear this out, beginning with the Palestinian ampulla inscribed »Oil of the Wood of Life that guides us by land and sea«.

Consider again the hoard of amuletic tokens. Examined strictly from the point of view of iconography, they appear simply to repeat the series of *locus sanctus* scenes familiar from the ampullae and their close relatives, the amuletic armbands (see below) and octagonal marriage rings; the Annunciation, Nativity, Adoration of the Magi, Baptism, Entry into Jerusalem, Adoration of the Cross, and Women at the Tomb all have their counterparts[30]. This leaves, besides Christ *en buste*, only the Tempest Calmed, which has already been discussed, the Miracle at Cana, which may have been wine directed (recall chapter 230 of Simeon's *vita*), the Healing of the Blind Man, with its obvious medicinal dimension, and the *aphlaston* (ship's sternpost), which will be considered later in this paper as yet another seafarer's image[31]. But if one goes beyond iconography to consider the relative frequency of appearance of each of these *locus sanctus* scenes, quite a different picture emerges, for one is then immediately struck by the statistical dominance of Adoration of the Magi iconography (pl. 9c)[32]. Among those tokens with Christological scenes (there are ten different Christological scenes in all), fully one-third show the Magi; this is twice the proportion of any other scene, and well over three times the frequency rate of the Women at the Tomb, despite the fact that the latter iconography served the most important *locus*

[28] CASSON, 1974, 176/196, 315/319; B. KÖTTING, Peregrinatio religiosa (Münster, 1950) 343/366; WILKINSON, 1977, 15/32; and MARAVAL, 1985, 169/177.

[29] Greg. M. glor. mart. 83 (VAN DAM, 1988, 107f.): »The relics that my father owned«. The medallion is described variously as being worn around the neck or carried in the pocket.

[30] ENGEMANN, 1973, 16/22; VIKAN, 1984, 81/85; and E. KITZINGER, Reflections on the Feast Cycle in Byzantine Art: CahArch 36 (1988) 58/62.

[31] The story of the Miracle at Cana is recalled in the context of the wine miracle in the Simeon *vita*. For amulets incorporating both text and image of the

Miracle at Cana, see Papyrus Erzherzog Rainer. Führer durch die Ausstellung (Vienna, 1894) 124f. As for the Healing of the Blind Man token (CAMBER: »woman bent together«), recall the »directed« use of this scene on the ivory medicine box in the Vatican. See W. F. VOLBACH, Elfenbeinarbeiten der Spätantike und des frühen Mittelalteres[3] = Kataloge vor- und frühgeschichtlicher Altertümer 7 (Mainz, 1976) no. 138.

[32] Pl. 9c = London, British Museum, nos. 1973,5-1, 10–26. See CAMBER, 1981, 101, fig. 4. For a more in-depth discussion of this statistical anomaly and the piety of pilgrimage mimesis that it likely reflects, see VIKAN, 1990, 104f.

VIII

sanctus in the Holy Land, whereas the Magi were a secondary attraction at a secondary shrine[33].

That this was not likely an accident of preservation is suggested by the statistics of yet another category of pilgrimage-related artifact; namely, the twenty or so pieces of jewelry (mostly fibulae and pendants) that may be grouped together through similarities in design, iconography, and function, and that collectively may be dated and localized, along with the ampullae and tokens, to Syria or Palestine, and to the sixth to seventh centuries[34]. As a group these objects, too, draw on the repertoire of *locus sanctus* scenes shared by the ampullae, armbands, and marriage rings, but like the tokens, they betray a disproportionate attraction for representations of the Adoration of the Magi (pl. 10b: »Lord, help«)[35]. Moreover, two additional points are noteworthy: first, that those pieces showing the Adoration characteristically include a guiding angel over the Magi (as here), even though the Bible does not mention one; and second, that sometimes (as here) an invocation has been added in the exergue[36].

Why so many Adoration scenes? Why the angels? Why the invocations? Part of the answer lies in the fact that virtually all pilgrimage-related artifacts, whether ampullae, flasks, tokens or this jewelry, functioned on some level amuletically, deriving their power from a combination of medium, image, and words[37]. The blessed earth, the guardian angels, and the invocations of divine help are thus all easily explained. But there must have been something about the Magi themselves to account for the dominance of their imagery. This, certainly, is the more difficult and interesting part of the question, whose answer may well lie in more than one facet of the pilgrim's behavior and belief.

The pilgrim sometimes gained the blessing (literally, the *eulogia*) of his pilgrimage encounter immaterially, through ritualized mimetic identification with the sacred heroes and events along his route[38]. This might involve simple imitative gestures at appropriate places and times, such as throwing stones at the grave of Goliath »to gain a blessing«, or lifting one of the surviving amphorae at Cana »to gain a blessing«[39]. Or it could entail a

[33] The Piacenza Pilgrim (WILKINSON, 1977, 85 [Travels from Piacenza, 29]), for example, makes no mention of the Magi in his brief account of Bethlehem, noting instead the Cave of the Nativity and the Manger. If one broadens the survey to include similar tokens found independently of the hoard (see VIKAN, 1984, 81f., and note 111), the statistical dominance of the Adoration of the Magi becomes even greater; indeed, nearly half of the two dozen or so such tokens bearing Christological scenes show the Adoration. Also, nearly one-quarter of surviving Simeon tokens bear an abbreviated Adoration to one side of the saint's column. See J. LAFONTAINE-DOSOGNE, Itinéraires archéologiques dans la région d'Antioche. Recherches sur le monastère et sur l'iconographie de S. Syméon Stylite le Jeune = Bibliothèque de Byzantion 4 (Brussels, 1967), fig. 91. Noteworthy also is the fact that the Adoration of the Magi appears three times as frequently in the token hoard as does the Nativity, the episode with which it would ordinarily be coupled, both narratively and in terms of the *locus sanctus* iconography of Bethlehem.

[34] For the object type, see VIKAN, 1984, 83, and note 116; and for its analysis, VIKAN, 1990, 104f.
[35] Pl. 10b = Attalens, excavations. See J. ENGEL, Une découverte énigmatique. La fibule chrétienne d'Attalens: Histoire et archéologie 62 (1982) 93. Among nineteen objects showing twenty-five distinct iconographic elements, the Adoration of the Magi accounts for eight – that is, nearly one-third of the total.
[36] For Magi iconography at this period, see J. ENGEMANN, Eine spätantike Messingkanne mit zwei Darstellungen aus der Magiererzählung im F. J. Dölger-Institut in Bonn: Vivarium, Festschrift Theodor Klauser zum 90. Geburtstag = JbAC Erg.-Bd. 11 (Münster, 1984) 117/127; and J. SPIER, Early Byzantine Rock Crystal Intaglios: D. CONTENT, ed., Byzantine Jewelry (London, forthcoming), with a list of those objects including an angel.
[37] ENGEMANN, 1973, 12f.; and VIKAN, 1984.
[38] For a more in-depth discussion of this issue, including its theological basis, see VIKAN, 1990.
[39] WILKINSON, 1977, 85, 79 (Travels from Piacenza, 31, 4).

more subtle, ongoing identification with a particularly appropriate sacred figure whose career was believed to provide a model for the pilgrim's own; thus many pilgrims sought burial proximate to the Cave of the Seven Sleepers, near Ephesos, and thereby identification with their miraculous resurrection[40]. And here, probably, is where the Magi would come in as well, for as gift-bearing strangers who traveled to the Holy Land to worship, they were Christianity's archetypal pilgrims; but more than that, they were its archetypal guided and guarded pilgrims, who with divine protection returned home safely[41]. The pilgrim with an *eulogia* like that in pl. 9c would thus have access to sacred power both through blessed substance and, as Magus-pilgrim, through the coincidence of his action with that of the figures portrayed on it[42].

On the level of everyday pilgrim ritual the *eulogia* was believed accessible through mimetic action; as Holy Land traveler, the pilgrim would thus effectively become a Magus, much as Empress Theodora, in the San Vitale procession mosaic, effectively becomes a Magus through the identity of her action as gift-giver with that of Christianity's primal gift-givers, who appear on the hem of her mantle (pl. 10a)[43]. But viewed within the broader framework of Christian piety generally, it was the responsibility of *every* man and woman to study and imitate the lives of saints as a means of perfecting his or her own virtue. St. Basil gives the following practical advice:

> . . . in [Scriptures] are not only found the precepts of conduct, but also the lives of saintly men, recorded and handed down to us, lie before us like living images of God's government, for our imitation of their good works . . . so he who is anxious to make himself perfect in all the kinds of virtue must gaze upon the lives of the saints as upon statues, so to speak, that move and act, and must make their excellence his own by imitation[44].

Basil goes on to invoke the Patriarch Joseph as a model of chaste conduct, Job as a model of steadfastness in adversity, and so forth; and thus one might imagine, though Basil does

[40] KÖTTING, 1950, 310f. (noting seven hundred graves and chambers by the sixth century); C. FOSS, Ephesus After Antiquity (Cambridge, 1979) 43; and, more generally for the issue of burial *ad sanctos* among pilgrims, MARAVAL, 1985, 151.

[41] Significantly, the pilgrim-suppliants (the *xenoi*) portrayed venerating the cross on the Palestinian ampullae are dressed the same as the Magi. See VIKAN, 1990, 102/104, figs. 19, 21 (GRABAR, 1958, pls. II and XVI, etc.).

[42] Is there an icon-like »theology« implicit in the pilgrim's mimetic activities? Consider the community-wide ceremonial that took place on the outskirts of Jerusalem each Palm Sunday, during the stational liturgy (see J. WILKINSON, Egeria's Travels to the Holy Land [Warminster, 1981] 74, 132f.; and J. F. BALDOVIN, The Urban Character of Christian Worship = Orientalia Christiana Analecta 228 [Rome, 1987] 67, 238 [on the distinction between supplicatory and mimetic processions]). The pilgrim waved a palm branch before the bishop as he walked down from the Mount of Olives, while chanting »Blessed is he that cometh in the name of the Lord«. At that moment the

pilgrim (the crowd), the bishop, and the surrounding Holy Land topography formed what was, in effect, a living icon of the Triumphal Entry. And like an icon, they, by virtue of verisimilitude, would collectively have joined the chain of imparted sanctity leading back to the archetype, the biblical event itself, for through mimesis they achieved what Theodore the Studite († 826) said all artificial images achieved (MANGO, 1972, 173): »Every artificial image . . . exhibits in itself, by way of imitation, the form of its model . . . the model [is] in the image, the one in the other«. These Palm Sunday pilgrims did not merely touch the Jerusalem *locus sanctus*, nor was their blessing confined to taking part of it away in an earthen *eulogia*, for they became, through their actions, one and the same with it, and thereby drew yet another portion of its sacred power.

[43] Pl. 10a = Ravenna, San Vitale, procession mosaic. See A. GRABAR, Christian Iconography. A Study of Its Origins = Bollingen Series 35.10 (Princeton, 1968) 99.

[44] Basil. M. ep. 2: St. Basil, The Letters 1 = Loeb Classical Library (Cambridge, Mass., 1961) 15f.

not mention it, that the Magus would be seen as a model for spiritually motivated travel (the pilgrim) and for pious gift-giving (the donor).

But on a more basic level still, the rationale for the amuletic identification of pilgrim with Magus – and the primary motivation for carrying pilgrimage artifacts with directed iconography – may well lie in the primal belief in magic, much as it may be seen to operate on gem amulets and among magical papyri and inscriptional phylacteries of the period[45]. Consider, for example, the popular late Roman gem amulet for lower back pain (pl. 10c), which shows a field worker bending over to cut stalks of grain with a long-handled sickle[46]. Explaining this iconography as reflecting »naive reasoning«, CAMPBELL BONNER went on to observe:

> Reapers, of all laborers, seem most to need the power of free and supple movement from the waist; perhaps to a sufferer from lumbago or sciatica a reaper in the fields seemed to be immune from such tortures, and hence the figure of a man reaping grain would be good magic for his ailment[47].

Similarly, the Magi might be seen as immune from the dangers associated with pilgrimage, and the pilgrim in possession of their image could likewise feel immune. Among magical papyri and in magical inscriptions generally, this protective power is invoked though a *hos . . . houto* formula: »as such and such happens (or does not happen) to X, so also may such and such happen (or not happen) to Y«[48]. Though even with magical words, the visual aspect could potentially be critical, such that a »reversal of fortune« for person Y might be invoked through a spell whose letters were aligned backwards[49]. Also critical, of course, was the physical possession of the amulet. And this, perhaps more than anything else, may explain the existence of seemingly directed pilgrimage artifacts, for while the potential benefit to the pilgrim of his mimetic identification with the Magi, whether in the form of everyday ritualized behavior or through lifelong adherence to Basil's lofty injunction to Chrisitian piety, was realizable only through *action*, the potential benefit of their magic was realizable through mere possession of an appropriately decorated *object*.

But even if, as seems likely, some combination of ritual, piety, and magic lies behind the disproportionate attraction for pilgrims of Magi iconography, these same complex forces should not necessarily be seen as critical to all seemingly directed pilgrimage imagery – which in any event, accounts for only a relatively small proportion of pilgrimage iconography generally. Indeed, with the Menas-Phokas-Isidore sort of composition, the intent was probably no more spiritually complex nor magical than that implicit in the Isis matrix; namely, to invoke the saint iconographically in his optimal maritime capacity. And perhaps the same was true for the Tempest Calmed tokens and flasks, and for the Christ Walking on Water ampullae, insofar as on them Christ's power over the sea (». . . even the winds and sea obey him«) is invoked by images evoking his most famous sea miracles; as

[45] R. KOTANSKY, A Silver Phylactery for Pain: The J. Paul Getty Museum Journal 11 (1983) 173/175. For evidence of sympathetic magic in saint's lives of the period, see MAGOULIAS, 1967, 230, 236/238.

[46] Pl. 10c = Ann Arbor, University of Michigan, Bonner 39. See C. BONNER, Studies in Magical Amulets, Chiefly Graeco-Egyptian (Ann Arbor, 1950), no. 124, illus.

[47] *Ibid.*, 74.

[48] KOTANSKY, 1983, 174.

[49] *Ibid.*, 175.

there was once an Isis Pelagia, there was now a *Kyrios Galenotatos*. Though of course for both categories of image, there was as well a potential *hos . . . houto* amuletic bond with the pilgrim: »as Christ saved his disciples on the Sea of Galilee, so also may he save me on my voyage«; »as Christ drew Peter up from the waves, so also may he draw me up«. And finally, there was probably a devotionally functional component to these and to many other pilgrimage images as well. The *vita* of St. Simeon the Younger leaves no doubt that the portrait on his tokens was more than simply a visual reminder of their origin at the Miraculous Mountain; it was an iconic stimulant devotionally instrumental to conjuring up the presence of the saint so that he could, through his *eulogia*, perform his miracle[50]. That icon-devotional mechanism is implicit as well among those *eulogiai* showing Christ in action on the water, and those with standing frontal portraits of Sts. Isidore and Phokas, insofar as seeing the agent of maritime protection would likely make more real and effective to the seafarer in distress his saving presence on his own boat.

Might not the pilgrim be hidden as well on other pilgrimage artifacts bearing representations of overland travel? The most likely candidates would be the many *eulogiai* showing figures on donkeys or horses; in other words, those with what otherwise may simply appear to be – and, on the model of the Magi tokens and fibulae, *in fact* be – the Entry into Jerusalem, the Flight into Egypt or the Holy Rider. The Ephesos manna flasks are especially suggestive in this regard, since after standing figures, representations of men and women on horses (donkeys?) are among their most common form of decoration (pl. 10f, g)[51]. And even if their highly simplified iconography can be identified as, respectively, the Entry into Jerusalem and the Flight into Egypt, as perhaps it can, one is still left with a puzzle, since the *locus sanctus* for the former was in Palestine and for the latter was in Egypt[52]. Would it not make more sense to categorize these rider flasks with those Ephesos flasks showing a boat (pl. 8e), and recognize them both as having been made in response to the concerns of traveling pilgrims?

Indeed, even where Triumphal Entry iconographic elements are unmistakably present, as they are on the five hoard tokens showing a nimbed rider with cross-staff on a donkey (pl. 10d), an amuletic identification with the traveling pilgrim still seems to have been the

[50] VIKAN, 1984, 72f., and note 44. In this respect the image is comparable to the suppliant's dream of the saint during incubation, an issue taken up by C. MANGO in »Healing Shrines and Images«, a paper that he presented at the 1990 Dumbarton Oaks Spring Symposium.

[51] Pl. 10f, g = Paris, Musée du Louvre, no. MND 648. See METZGER, 1981, no. 102. A quick survey of a representative sample, the thirty figurative specimens in the Louvre catalogued by METZGER (1981, nos. 98/127), reveals, on fifty-six decorated surfaces, the following thematic breakdown:

Standing figure	24
Riding figure	11
Busts	11
Scribes	3
Figure in door	2
Figure with animal(s)	2

[Cross	2]
Christ in a boat	1

[52] The Triumphal Entry identification would be applicable specifically to METZGER's »second group« (e. g., our pl. 10f), where the figure holds a cross-staff (compare our pls. 10d and e, and their discussion); in her »first group«, there is no cross-staff, and the horse(?) is apparently at full gallop. Both of her groups show a mounted female on the other side of the flask (pl. 10g), and in both cases she seems to be holding something in her arms. A two-sided *eulogia* stamp(?) discussed in footnote 59, below, bears counterpart images to both sides of the flask here illustrated; one is clearly the Triumphal Entry and the other, with Joseph leading the way, is just as clearly the Flight into Egypt. For an inconclusive discussion of the iconography of these »ampoules aux cavaliers«, see METZGER, 1981, 18f.

aim[53]. Why else would there be, in contradiction to the Gospel account, an escorting figure in front of the donkey – a figure which on larger, more detailed clay tokens (outside the hoard) bearing the same composition is clearly winged (pl. 10e)?[54] Neither biblical storytelling nor the evocation of some sacred place seems to have been the main intention here; rather, it likely was – on the model of the Magi tokens and jewelry – the invocation of supernatural protection, with blessed substance and mimetic identification acting in concert to invoke sacred power on behalf of the traveler[55]. Christ on Palm Sunday was Christianity's archetypal visitor to the Holy City, and at the same time, he was its primal model of a traveler by donkey, just as the Virgin Mary was, specifically for women, during her Flight into Egypt[56]. The pair of tokens in pls. 8b and 10d and the pair of flasks in pls. 8e and 10f, g thus seem to offer the same message: by sea one sailed with Christ, by land one rode with Christ.

But is it certain that these two »holy riders«, Christ and the Virgin, were offering amuletic protection specifically for travelers, or were they simply Christianized versions of the old-fashioned Holy Rider, with multivalent power like his, equally applicable to abdominal pains, the evil eye, and roadside bandits?[57] Without attempting here to disentangle the iconography of the Entry into Jerusalem from that of the Holy Rider, or to determine once and for all the relative mix of straightforward biblical narrative, traditional Holy Rider magic, and simple travelers' *realia* on objects like those illustrated in pls. 10f, g, d, e, one may yet suggest an answer to that question, in the form of a terracotta *eulogia*

[53] Pl. 10d = Paris, Robert-Henri Bautier Collection. See VIKAN, 1984, 82, fig. 23.

[54] Pl. 10e = Toronto, Royal Ontario Museum, no. 986.181.80. See E. DAUTERMAN MAGUIRE / H. P. MAGUIRE / M. J. DUNCAN-FLOWERS, Art and Holy Powers in the Early Christian House, Urbana-Champaign, Krannert Art Museum, 1989 (Urbana/Chicago, 1989), no. 129 (exhibition catalogue). The Entry into Jerusalem is compositionally modeled on traditional imperial *adventus* iconography; here the angel takes the place of the traditional escort or *propempōn*. See K. G. HOLUM / G. VIKAN, The Trier Ivory, *Adventus* Ceremonial, and the Relics of St. Stephen: DumbOPap 33 (1979) 118f. See also GRABAR, 1968, 45, with reference to an Egypto-Byzantine relief in Berlin whereon Christ in the Entry is accompanied by two angels; and SPIER, forthcoming, noting a rock crystal with Christ on a donkey preceded by an angel. The relationship between these Triumphal Entry *eulogiai* and non-pilgrimage Holy Rider amulets of the period is very close. See VIKAN, 1984, 75, and note 57; and DAUTERMAN MAGUIRE/MAGUIRE/DUNCAN-FLOWERS, 1989, 25/28. One of the most elaborate and familiar types of Holy Rider amulet (BONNER, 1950, no. 324) shows on one face a galloping Holy Rider impaling a demon; before the horse is an angel, gesturing toward the demon. The circumference of that amulet is inscribed with Psalm 90 (see below) and the field bears the apotropaic *Heis Theos* acclamation (see below).

[55] Words are involved as well, though less obviously than on the Magi fibula in pl. 10b. The reading of the

theta, epsilon, sigma?) as the common apotropaic *Heis Theos* (»One God [who conquers evil]«) acclamation is suggested by comparison with an inscribed Holy Rider amulet in the British Museum. See O. M. DALTON, Catalogue of Early Christian Antiquities and Objects from the Christian East in the ... British Museum (London, 1901), no. 543; and, for *Heis Theos*, E. PETERSON, Εἶς Θεός. Epigraphische, formgeschichtliche und religionsgeschichtliche Untersuchungen = Forschungen zur Religion und Literatur des Alten und Neuen Testaments N.S. 24 (Göttingen, 1926). More subtle but no less important is the fact that the Triumphal Entry iconography presupposes the shouted acclamation »Blessed is he that cometh in the name of the Lord«, which likewise invokes the protection of the Lord. For a Triumphal Entry amulet bearing the word *Eulogemonos* (»Blessed One«), see O. WULFF, Altchristliche Bildwerke = Königliche Museen zu Berlin, Beschreibung der Bildwerke der christlichen Epochen 2,1 (Berlin, 1909) no. 825.

[56] Joseph and Mary, like the Magi, were guided and protected in their travels (Mt. 3:12, 13).

[57] VIKAN, 1984, 75, 79/81; and DAUTERMAN MAGUIRE/MAGUIRE/DUNCAN-FLOWERS, 1989, 25/28. The question is not whether the core iconography shared by the pagan and Christian versions of the Holy Rider-Triumphal Entry was apotropaic, for clearly it was. The question is whether there was a conscious attempt, at least some of the time, to link the power of the image with the iconography of the image; that is, to the make a miraculous rider miraculous specifically for riders.

stamp recently excavated at Aegina (pl. 11a)[58]. Large enough to have produced an impression the size of the Hermitage's St. Phokas token, it shows a nimbed rider, apparently impaling a snake, escorted by an angel toward an *aedicula* shrine of the sort found on many pilgrimage artifacts, including the Walters Isidore stamp (pl. 8g). True, on one level this is a Holy Rider; but with a specific destination, must he not also be understood as a traveler? And, more specifically, must he not be interpreted as a pilgrim, guided and guarded on his way toward that shrine – no less than, as on the fibula in pl. 10b, the Magi-pilgrims are guided and guarded on their way toward Christ?[59]

Before leaving the flasks and ampullae, and the issue of their responsiveness to pilgrim travel, one should recall a relevant insight published several years ago in the *Festschrift* for Theodor Klauser by LIESELOTTE KÖTZSCHE-BREITENBRUCH, regarding their general design[60]. She made note of the fact that virtually all pilgrim vessels, whether from Palestine, Egypt or Asia Minor, look much like the traditional traveler's canteen of the period, and that this must have been a conscious choice, since in the case of the Palestinian ampullae there was already a traditional shape for oil containers that could have been adapted, and for the Egyptian and Asia Minor flasks the absence or poor quality of a sealing glaze and their characteristically constricted neck openings made them generally inefficient as containers of any sort. Her point was as logical as it was simple; namely, that »He [the pilgrim] had brought home the most important utensil of the trip, the canteen, in miniature format as a reminder«[61]. Or, to state it more broadly: while the inscriptions and imagery on many *eulogia* containers evoked for the pilgrim his *locus sanctus* destination, and the decoration on some seems to have addressed perils of the trip itself, the very shape of all of them in effect symbolized the total act of pilgrimage.

A connection was recognized long ago between the series of *locus sanctus* scenes shared by the Palestinian ampullae and those on the octagonal hoops of four closely interrelated gold rings, three of which bear marriage iconography on their bezels; more recently, single *locus sanctus* scenes have been identified on the bezels of a number of individual rings, mostly in bronze[62]. Such proliferation was possible because the amuletic power of the

[58] Pl. 11a = Aegina, acropolis excavations, no. RC 43 (drawing published by WURSTER). See W. W. WURSTER / F. FELTEN, Alt-Ägina 1,2. Die spätrömische Akropolismauer (Mainz, 1975) 73, no. 143 (F. FELTEN inappropriately links the piece, which is clearly late antique in design and iconography, to the presence of the head of St. George at Aegina in the fourteenth to fifteenth centuries).

[59] Corroboration comes in the form of a smaller, stone *eulogia* stamp(?) in the Limbourg Collection, Cologne, which bears two intaglio devices: on one side a figure with cross-staff riding toward an *aedicula* shrine very much like that on the Aegina stamp, and on the other, the Flight into Egypt, with Joseph. Although in this case the rider is unaccompanied by an angel, he is otherwise a close iconographic match for the Triumphal Entry riders on the tokens; moreover, the field around him bears the apotropaic acclamation from the 90th Psalm, »He that dwells in the help of the Most High ...« (ὁ κατοικῶν ...). The Flight into Egypt, which appears as well on one of the pilgrimage-related pendants referred to above (see E. B. SMITH, A Lost

Encolpium and Some Notes on Early Christian Iconography: ByzZs 23 [1920], fig. 9), probably lies at the core of the female-rider side of the Ephesos flasks (pl. 10g).

[60] L. KÖTZSCHE-BREITENBRUCH, Pilgerandenken aus dem Heiligen Land: Vivarium, Festschrift Theodor Klauser zum 90. Geburtstag = JbAC Erg.-Bd. 11 (Münster, 1984) 239f.

[61] *Ibid.*, 1984, 240. Much more suitable for sanctified liquid are glass vials of the sort preserved along with the Palestinian ampullae in Monza. See R. CONTI, ed., Monza. Il Duomo e i suoi tesori (Milan, 1988) nos. 26/29. In The Metropolitan Museum of Art is a small copper water jug (no. 67.200.2: »pilgrim flask«) with attached handle and lid, whose metal neck band bears three impressed medallions of a rider on a horse, with cross-staff(?). This further corroborates the notion of a direct connection between apotropaic riders and overland travel.

[62] For the octagonal rings, see G. VIKAN, Art and Marriage in Early Byzantium: DumbOPap 44 (1990) 158/161; and, for the rings with individual scenes, see

decorated Holy Land *eulogia* was believed transferrable independently of blessed substance, through the images themselves, whether taken over in series or individually – a process we have already seen at work in the pendants and fibulae discussed above[63]. As for those themes associated with travel, each of the three major Christological scenes thus far considered have counterparts on ring bezels: the Tempest Calmed (pl. 11b), the Adoration of the Magi (pl. 11c), and the Entry into Jerusalem (pl. 11d)[64]. The ring with the Tempest Calmed, which looks as if it could have produced the Tempest tokens, is rare, as is the Adoration ring, whose Three Magi *sans* Virgin and Child are a near match, reversed left to right, for the Magi without Virgin and Child on the hem of Theodora's mantle in the San Vitale procession mosaic (pl. 10a)[65]. By contrast, rings bearing some form of the Entry into Jerusalem are relatively common. Most show a version even simpler than that of the tokens, with just a figure on a donkey, with cross-staff; only a few include elements of Jerusalem topography, or the welcoming crowd[66]. The pilgrim with a full arsenal of travel amulets might thus have, in addition to variously directed *eulogiai*, an appropriate pendant around his neck (like Gregory's father), a travel fibula binding his mantle, and a ring like one of the three here illustrated on his finger[67].

<center>*</center>

After the Adoration of the Magi, the iconographic theme attested with greatest frequency among the ninety-three *eulogia* tokens in the British Museum/Robert-Henri

KÖTZSCHE-BREITENBRUCH, 1984, 244f.; L. Y. RAHMANI, On Some Byzantine Brass Rings in the State Collections: 'Atiqot English Series 17 (1985) 175/178; and, most recently, DAUTERMAN MAGUIRE/MAGUIRE/DUNCAN-FLOWERS, 1989, no. 89 (compare our pl. 11k).

[63] G. VIKAN, Sacred image, sacred power: *idem*, ed., Icon (Washington, D.C., 1988) 15/18.

[64] Pl. 11b = Oxford, Ashmolean Museum, no. F790. Unpublished. Pl. 11c = Houston, Menil Collection, no. R33. See G. VIKAN, Byzantine Objects of Daily Life in the Menil Collection 1 (Houston, forthcoming), no. R33. That this is not the Three Hebrews is clear from their unmistakable movement toward the right. For the latter on an amulet of the period, see F. D. FRIEDMAN, ed., Beyond the Pharaohs. Egypt and the Copts in the 2nd to 7th Centuries A.D., Providence, Museum of Art, Rhode Island School of Design, 1989 (Providence, 1989), no. 105 (exhibition catalogue). Pl. 11d = Houston, Menil Collection, no. R35. See VIKAN, forthcoming, R35.

[65] The iconographic complement to this Magi ring is the occasional Simeon token which shows the Virgin and Child in side view, without the Magi. See J. LAFONTAINE-DOSOGNE, 1967, fig. 91.

[66] For a simple example, nearly identical to that here illustrated, see Byzantium at Princeton, 1986, no. 95, and for a ring with fuller iconography, see K. WEITZMANN, ed., Age of Spirituality. Late Antique and Early Christian Art, Third to Seventh Century, New York, The Metropolitan Museum of Art, 1977–1978 (New York, 1979), no. 470 (exhibition catalogue).

[67] Interestingly, such travel iconography is not characteristic of early Byzantine belt fittings (see VIKAN, forthcoming, chap. 9). There is, however, an unusual bronze harness(?) fitting in the Malcove Collection, Toronto, which likely was used to ensure safe travel through supernatural means; that is, through blessed substance (see S. D. CAMPBELL, ed., The Malcove Collection, [Toronto/Buffalo/London, 1985] no. 107; and VIKAN, 1984, note 127). Conforming in general design to late antique belt fittings, it comprises a large horse-head tongue coupled with a sturdy hoop, and a belt plate incorporating a small box with sliding lid; the lid bears a cross and the box's sides are inscribed »Use in good health« (*Hyienon chrou*). (On the inscription, see VIKAN, 1984, note 1; and M. MUNDELL MANGO / C. MANGO / A. CARE EVANS / M. HUGHES, A 6th-century Mediterranean Bucket from Bromeswell Parish, Suffolk: Antiquity 63,239 [1989] 304.) That the lid can be easily drawn open and that the box as a whole is a miniature version of the wooden boxes then used to hold medicinal pellets (see VIKAN, 1984, note 1), together suggest that some blessed, expendable substance, and not a relic, was kept inside. If so, its basic constituent elements – a horse, and a container for blessed substance – would be those of the Ephesos rider flasks, though in this case the object's design presupposes specific association with travel (like the Holy Rider jugs cited in footnote 61, above).

Bautier hoard is one based on a puzzlingly amorphous, snakelike form accompanied by the word *Solomon*. Never convincingly identified, this »Solomon motif« appears in two easily distinguishable mold types: one, with retrograde inscription, that looks like a coiled snake, though with one too many coils (pl. 11e), and one, with direct inscription, that looks more like a steep hill, though with some additional snakelike detail within the hill's outline[68]. This inscription, the only one in the hoard, would unmistakably brand these objects as amulets, no matter what their medium, since in late antiquity Solomon was popularly believed, by Jew and Christian alike, to wield power over evil spirits. According to Josephus, »God granted him knowledge of the art used against demons for the benefit and healing of men«; indeed, according to the *Testament of Solomon*, probably late antiquity's most popular magical treatise, King Solomon was able to control and exploit the forces of evil, and thereby build the Temple, because God had given him a seal ring with which he could »lock up all the demons«[69]. Solomon's name (»Solomon«/»Seal of God«) appears on a common, relatively simple variety of Holy Rider amulet in haematite, as well as on a heterogeneous series of more complex metal amulets bearing a multiplicity of apotropaic motifs – there usually as part of an extended invocation calling on the help of the »Seal of Solomon«[70]. Among these latter sorts of amulets one occasionally finds the Solomon motif as well, though now often topped by a cross or a cross within a circle, and usually flanked by personifications of the sun and moon, *en buste*[71]. Typical, though more clearly incised

[68] Pl. 11e = Paris, Robert-Henri Bautier Collection. See VIKAN, 1984, 82 (»appears to be . . . a coiled serpent«), pl. 11g, f. Pl. 11h = London, British Museum. CAMBER, 1981, 104 (»a moundlike form, with no clearly visible internal features«), fig. 13; and G. P. MAJESKA, A Medallion of the Prophet Daniel in the Dumbarton Oaks Collection: DumbOPap 28 (1974) 365₂₉ (»full-face figure«).
[69] Jewish Antiquities, 8.45 (Loeb Classical Library, 5 [Cambridge, Mass./London, 1935]); C. C. McCOWN, The Testament of Solomon (Leipzig, 1922) 10*; A.-M. DENIS, Introduction aux pseudépigraphes grecs d'Ancien Testament (Leiden, 1970) 67; and VIKAN, 1984, 79f., with additional bibliography.
[70] VIKAN, 1984, 79f., and notes 92, 93, with additional bibliography.
[71] To date, the group includes:
1. BONNER, 1950, no. 326. Lead two-sided pendant amulet with the Holy Rider on one side and on the other the hill-like(?) form (»indistinct moundlike support«) topped by a cross in a circle and flanked by the sun and moon personified, above a lion and a snake. See also RAHMANI, 1985, 173 (»a hill«; »Golgotha«).
2. Objects with Semitic Inscriptions, 1100 B.C. – A.D. 700, Jewish, Early Christian and Byzantine Antiquities, Zurich, L. Alexander Wolfe and Frank Sternberg, Auction XXIII, 20. November 1989 (Zurich, 1989) no. 196, illus. (sale catalogue). Copper two-sided pendant amulet with the Holy Rider on one side and on the other the hill-like(?) form (substantially abraded) topped by a cross in a circle and flanked by the sun and moon personified, above a lion, a snake, the evil eye,

and a prostrate female demon. Inscribed: »Michael, Gabriel, Ouriel, Raphael, guard the wearer«.
3. G. SCHLUMBERGER, Amulettes byzantins anciens destinés à combattre les malefices et maladies: RevÉtGr 5 (1892) 75/77, no. 2. Copper two-sided pendant amulet with the Holy Rider on one side and on the other the snakelike form (»être de forme bizarre, à tête en forme de pleine lune, à corps en forme de larve repliée, avec deux bras difformes [un agathodaemon?]«) flanked by the sun and moon personified, above a lion, a snake, and a prostrate female demon. Inscribed: »Seal of Solomon, protect the wearer«.
4. SCHLUMBERGER, 1892, 77f., no. 3. Copper pendant amulet with the Adoration of the Magi on one side and on the other the snakelike form (»le même être étrange à figure lunaire que sur l'amulette précédent [un agathodaemon?]«) topped by a cross(?) in a circle and flanked by the sun and moon personified, above a lion, a snake, the evil eye, and a prostrate female demon, plus ring signs. Inscribed: unclear (against colic?).
5. G. TCHALENKO, Villages antiques de la Syrie du Nord 3 (Paris, 1958) 43, fig. 29. Steatite casting mold with a lion and the sun and moon as one device, and as the other the snakelike form (»un objet peu distinct«) topped by a cross in a circle. (TCHALENKO takes these to be two sides of the same amulet, which, iconographically, would be appropriate.) Inscribed: »Christ, help«.
6. WULFF, 1909, no. 825, pl. XL (front only illustrated; since destroyed). Bronze two-sided pendant amulet

than most, and better preserved, is a bronze two-sided pendant amulet in the Benaki Museum, whereon the Solomon motif, surmounted by a cross and flanked by the celestial powers of Helios and Selene, accompanies a pair of popular apotropaic devices, a lion and a snake – all of which is enclosed by the inscription »Seal of Solomon, help the wearer« (pl. 11h)[72]. Whereas on the one hand, the internal, snakelike articulation of the motif on this amulet parallels the reverse-inscription tokens (pl. 11e), on the other hand, its taller, more conelike outline is closer to that of the tokens whose inscription reads directly. Moreover, both qualities, internal articulation and general outline, may be recognized in the central motif of yet another mold type among the hoard tokens – one which, like many of the Solomon motifs on the metal amulets, is surmounted by a cross within a circle[73]. And this mold type, in turn, closely parallels another of the amulets, as it is attested in a steatite casting mold which, interestingly, was discovered at Qal'at Sim'an[74].

Among these three mold types, the Solomon motif accounts for fully as many tokens as the Adoration of the Magi, and on that basis alone one might expect some association with travel. But is it a snake? A face? A hill? A wing? A hand?[75] None of these suggestions is very

with the Triumphal Entry on one side and on the other the snakelike form (»ein in Schlangenwindungen zusammengerolltes drachenähnliches Ungeheuer«) with a cross in a circle (to the side?), and a standing figure. Inscribed: »Seal of Solomon«.
7. Unpublished. Paris, Cabinet des Médailles, no. 511. Silver ring bezel with the hill-like form topped with a cross in a circle. Inscribed: »Lord, help the wearer«.
8. Unpublished. Athens, Benaki Museum (= our pl. 11h). Bronze two-sided pendant amulet with an angel attacking a demon on one side and on the other the snakelike form topped by a cross and flanked by the sun and moon personified, above a lion and a snake, plus ring signs. Inscribed: »Seal of Solomon, help the wearer«.
9. V. ZALASSKAIA, Gnostichesko-Kristianskij Amulet 's izobrazheniem Angela Arlafa: Soobshchenija Gosudarstvennogo Ermitazha 36 (1973) 54/58, illus. Bronze two-sided pendant amulet with the angel Arlaph attacking a demon on one side and on the other, the snakelike form (»Golgotha«) topped by a cross and flanked by the sun and moon (with trident) personified, above a lion and a snake, plus ring signs. Inscribed: »Seal of Solomon, help the wearer«.
[72] Pl. 11h = Athens, Benaki Museum. See the preceding footnote, item 8. The example in the Hermitage (item 9) is very close to this, though its outline is more cone-like, with a spiral effect. ZALASSKAIA's suggestion that this is Golgotha is unsupportable; not only are its spiral striations inappropriate, it appears, as we have seen, both with and without the cross, it does not look at all like Golgotha as portrayed in contemporary *locus sanctus* art (compare, for example, the lid of the Sancta Sanctorum reliquary box), and, finally, it is quite unlike the clearly articulated »Mount Gerizim«, as it appears on coins, lamps, and ring bezels. For the latter, see Y. MESHORER, The City Coins of Eretz-Israel and the Decapolis in the Roman Period (in Herbrew) (Jerusalem, 1984) 52, nos. 147, 148; and Objects with Semitic Inscriptions, 1989, nos. 320/322. For the apotropaic

appearance of celestial deities, notably Helios, on late Roman gem amulets, see BONNER, 1950, 148/155.
[73] Here the motif is flanked by a pair of figures standing in profile. See CAMBER, 1981, 101, fig. 8 (»small mound«). CAMBER's suggestion that this is the Transfiguration initially seems plausible, when one thinks, for example, of the apse mosaic in San Apollinare in Classe – even though no *comparanda* may be cited in pilgrimage art. The convoluted, snakelike form of »Mount Tabor«, however, much more strongly evokes the Solomon motif, as does the cross within a circle. The attendant standing figures might be Helios and Selene, although they both seem to be male, and are too crude to show specific attributes; moreover, one would expect them to appear *en buste*. There is a single unidentified standing figure on the (since destroyed) Solomon motif amulet catalogued by WULFF (see footnote 71, above, item 6). One might also wonder what the craftsman responsible for the execution of this mold understood of the iconography he was reproducing (on which, see footnote 80, below).
[74] See footnote 71, above, item 5.
[75] A hand occasionally appears on a ring bezel, surrounded by »Seal of Solomon«, but it is formally quite different from this motif. See O. M. DALTON, Catalogue of the Finger Rings in the British Museum (London, 1912) nos. 73, 74. Arguing against the notion that this is a coiled snake – besides its patently un-snakelike appearance among those objects whereon it is rendered with greatest care and detail (e. g., pls. 11h, f) – is its clear contrast with what is unmistakably a snake just below it on the Benaki pendant (pl. 11h) and on an adjacent medaillon on the Walters armband (see below). For various (quite different) coiled snake motifs in late antiquity, see D. STUTZINGER, ed., Spätantike und frühes Christentum, Frankfurt am Main, Liebieghaus Museum alter Plastik, 1983–1984 (Frankfurt am Main, 1983) nos. 130 (Agathodaimon), 163 (Chnoubis), 167 (Asklepios' serpent) (exhibition catalogue).

satisfying even on purely formal grounds, much less from the point of view of what role the motif might have played in the object's amuletic function.

The puzzle of the Solomon motif may now be soluble, thanks to the recent appearance at auction of a bronze armband, which was acquired by The Walters Art Gallery (pl. 11g)[76]. It is one of a group of about twenty such armbands, which I have recently made the focus of an independent study[77]. For our present purposes, it will be sufficient to recall that the object type, better known by examples in silver, is identifiable through a combination of design elements, inscriptions, and iconography. It is characterized by a thin band, about 7.5 centimeters in diameter, interrupted with from one to eight medallions (here, eight); almost every member of the group bears the opening words of the apotropaic 90th Psalm, »He that dwells in the help of the Most High . . .« (here, on a medallion), most show either the Holy Rider or (here) the Triumphal Entry, and many have one or more of the *locus sanctus* scenes familiar from the Palestinian ampullae (here, the Annunciation and the Women at the Tomb)[78]. In addition to crosses of one sort or another, various patently magical motifs appear as well, including the *pentalpha*, the evil eye (here), the Chnoubis, ring signs, and the lion and snake (here).

The new iconographic element on this armband is the Solomon motif (pl. 11f), with the inscription but without the cross, looking very much like its counterpart on the first token mold type (pl. 11e), though significantly clearer[79]. Much more like a fan than a coiled snake, and moundlike only in basic outline, it consists of five slightly curving strands or bars, becoming progressively longer as they rise from nearly horizontal to nearly vertical, and all springing from the same point. Its identity here seems clear; it is the *aphlaston* (aplustre), the fan-shaped decorative sternpost of an ancient ship, traceable iconographically and textually, with little variation, from Homer through late antiquity (pl. 11i)[80]. Perhaps originally an imitation of a bud or lotus flower, as on Egyptian ships, the

[76] Pl. 11f, g = Baltimore, The Walters Art Gallery, no. 54.2657A-C. See Antike Münzen . . . Geschnittene Steine und Schmuck der Antike . . . Schweizer Gold- und Silbermünzen, Zürich, Frank Sternberg AG, Auktion XXIV, 19., 20. November 1990 (Zurich, 1990), no. 475 (»wing«) (sale catalogue); and the following footnote.

[77] G. VIKAN, Two Unpublished Byzantine Amuletic Armbands and the Group to Which They Belong, forthcoming in The Journal of The Walters Art Gallery (1991). The traditionally cited publication for these armbands is J. MASPERO, Bracelets-amulettes d'époque byzantine: AnnServAntÉg 9 (1908) 246/58.

[78] For the 90th Psalm (and the armbands), see D. FEISSEL, Notes d'épigraphie chrétienne (VII): BullCorrHell 108 (1984) 571/579.

[79] An unpublished armband belonging to this group, in the Benaki Museum, Athens (no. 11472), shows a cruder version of the Solomon motif on one of its medallions, though without an inscription or the cross. See my forthcoming publication cited in footnote 77, above.

[80] Pl. 11i = The Hague, Kon. Penningkabinet (Mark Antony: 32–31 B.C.). See L. CASSON, Ships and Seamanship in the Ancient World (Princeton, 1971), fig. 121. Compare also M. SCHLÜTER / G. PLATZ-

HORSTER / P. ZAZOFF, Antike Gemmen in deutschen Sammlungen 4 (Wiesbaden, 1975) no. 736 (and compare no. 733). For the *aphlaston*, see CASSON, 1971, 86 etc., and, for examples dating up to the fourth century A.D., his figs. 114, 116, 119, 120, 129, 131, 140, 141. – How can a sternpost look so much like a snake? On another occasion I traced the migration into Byzantium of a similarly unfamiliar antique motif, the Chnoubis, via this same group of armbands, to amuletic pendants and rings, and its gradual reinterpretation as the Medusa (VIKAN, 1984, 77[70], figs. 8, 9, 13/18). A parallel situation may well obtain here, with the armband's unfamiliar *aphlaston* motif, through misunderstanding, taking on for the Byzantines attributes of a snake, a much more familiar form, which would otherwise be equally appropriate (though in different configurations) on amulets – just as the Medusa was. Consider also the puzzlingly cryptic *Chi-Mu-Gamma* inscription that appears in so many late antique amuletic contexts. Recently evidence has emerged to suggest that this group of letters meant quite different things to different people, even in the same region and at the same period. See G. ROBINSON, *Kappa-Mu-Gamma* and *Theta-Mu-Gamma* for *Chi-Mu-Gamma*: Tyche 1 (1986) 175/177.

aphlaston developed into a plume- or fan-shaped object and, as a detachable symbol, was taken as a trophy when the ship was captured[81]. Moreover, it could stand alone, like a ship's prow or rudder, to evoke sea power or seafaring in general (pl. 11j [trophy at right])[82]. As for the cross that surmounts the motif on so many of the metal amulets, and on the third token mold type, this would be the device under which this particular ship was sailing: the sign of the cross. Specifically, there was a pole (*styis*) with crosspiece set up beside the sternpost to carry the name-device (*parasemon*) symbolizing the guardian deity of the ship (e. g., Isis Pharia), or that guardian's name spelled out (e. g., Zeus Soter)[83]. In this case, the ship would have sailed under the guardianship of Solomon and, quite often as well, that of the cross[84]. Interestingly, among the maritime *miracula* of Simeon Stylites the Elder is one wherein the saint instructs a ship's captain to take some of his blessed dust and make three crosses on the vessel, and another wherein a man saves a foundering ship by making a cross on the mast with blessed dust[85]. Moreover, complete ships with the cross or Chrismon on the sternpost (pl. 11k), on the mast, or on the sail, are found among Early Christian hardstone and metal ring bezels[86]. Iconographically, these and the *aphlaston* images read much like the stamp of St. Isidore and the Isis matrix, insofar as the ship in miniature, or some identifiable aspect of it (the sail, the sternpost) is under the guidance and protection of supernatural patronage, evoked through image and word[87].

*

[81] C. TORR, Ancient Ships (Chicago, 1964) 68, and note 152; and CASSON, 1971, 86$_{49}$.

[82] Pl. 11j = London, British Museum (Sextus Pompey: 38–36 B.C.). See E. A. SYDENHAM, The Coinage of the Roman Republic (London, 1952) no. 1347, pl. 30. Compare also SCHLÜTER/PLATZ-HORSTER/ZAZOFF, 1975, no. 731.

[83] See CASSON, 1971, fig. 129, and, for the markings and names on ships, 344/347. The *aphlaston* could also be the location for a statue (*tutela*, as opposed to the *insigne* [*parasemon*]) to differentiate ships belonging to one state from those belonging to another; every Athenian ship, for example, carried a statue of Pallas Athena. See TORR, 1964, 67, and pl. 6/29. There are a number of extant bronze »standards« comprising a cross or Chrismon within a circle. See, for example, Bronzen von der Antike bis zur Gegenwart, Münster, Westfälisches Landesmuseum für Kunst und Kulturgeschichte, 1983 (Berlin, 1983) no. 23 (exhibition catalogue).

[84] According to the Testament of Solomon, a certain sea demon, half horse and half fish, was subject to Solomon's control. Under interrogation, the demon describes his evil potential: »O King Solomon, I am a fierce spirit of the sea, and I am greedy of gold and silver. I am such a spirit as rounds itself and comes over the expanses of water of the sea, and I trip the men who sail thereon. For I round myself into a wave, and transform myself, and then throw myself on ships and come right in on them. And that is my business, and my way of getting hold of money and men. For I take the men, and whirl them round with myself, and hurl the men out of the sea«. After this speech, King Solomon seals the demon in a flask along with »ten

jugs of sea water«. See McCOWN, 1922, 48*; and, for the translation, F. C. CONYBEARE, The Testament of Solomon: JewQuartRev 11 (1899) 33f.

[85] LIETZMANN, 1908, 152f.; and footnote 5, above. Similarly, Gregory of Tours recounts a miraculous sea journey by his deacon (glor. mart. 82) wherein the rigging of the mast »presented the appearance of a cross« (VAN DAM, 1988, 106).

[86] Pl. 11k = London, British Museum. See DALTON, 1901, no. 40 (»sard«), pl. II; and Spätantike und frühes Christentum, 1983, no. 213. See also DALTON, 1901, nos. 70 and 71, with, respectively, a ship surmounted by a Chrismon within a circle and a ship with a cross-shaped mast. For others, see R. GARRUCCI, Storia dell'arte cristiana 6 (Prato, 1880) pl. 478, nos. 13 (Christ Walking on Water), 14 (Chrismon in circle over ship), 15 (ship with Chrismon on sail), 16 (ship with cross on stern), 18 (two-sided intaglio with ship on one side and IHCOY on the other). These all were probably apotropaic, and the last one, with »Jesus«, certainly was. For the amuletic use of the name Jesus, see M. SMITH, Jesus the Magician (San Francisco, 1978) 62/64, and notes on page 138.

[87] On the ship as a device for Early Christian ring bezels, see P. C. FINNEY, Images on Finger Rings and Early Christian Art: DumbOPap 41 (1987) 184 (quoting Clement of Alexandria, paed. 3.59.2); and STUTZINGER: Spätantike und frühes Christentum, 1983, 624, no. 213, observing that while the *navis ecclesiae* idea was then current among the Church Fathers, it is not at all certain that a metaphorical intent lay behind such ring bezels as that in pl. 11k, which under any circumstances would likely be seen on its literal (i. e., apotropaic) level as well.

The Adoration of the Magi, the *aphlaston*, the Triumphal Entry, and the Tempest Calmed together account for just over half of the *eulogia* tokens in the British Museum/ Robert-Henri Bautier hoard; among them, the split is about even between those seemingly directed toward travel by land and those seemingly directed toward travel by sea. But one should not doubt that such tokens, if the need arose, would be employed medicinally; nor should one doubt that the straightforward Simeon token would be employed in the context of travel. After all, the one Palestinian ampulla which bears an invocation on behalf of safe travel (». . . that guides by land and sea«) is decorated with the Adoration of the Cross, a theme which exists as well among the tokens. Perhaps one should be thinking less of the notion that Dorotheos, on facing the prospect of a dangerous sea voyage, would select an appropriate token from the monastery's storehouse, than of the idea that *eulogiai* in general would bear scenes responsive, in a statistical sense, to some of the main pilgrimage activities associated with their use[88]. If a 50 % responsiveness rate to travel seems high for the tokens, one should recall that *all* flasks and ampullae, by their very shape, were travel responsive. The *vita* of St. Martha, Simeon the Younger's mother, describes a Georgian monk as leaving the Miraculous Mountain with several image-bearing *eulogiai*; probably Dorotheos, too, carried several tokens with him when he set sail[89].

Pilgrims were travelers, travel was dangerous, and the pilgrims' »blessing« was a miraculous antidote to that danger. Some *eulogiai* seem to show an appropriately directed image, either of some travelers' patron protecting the means of travel (the boat, the sail, the sternpost), or of Christ performing some appropriate miracle to demonstrate his power over travel (calming a storm, saving a drowning disciple), or of some especially relevant biblical travel story with which the pilgrim could mimetically identify (the Adoration of the Magi, the Triumphal Entry, the Flight into Egypt). The travelers' arsenal of the miraculous was rich and varied, for what counted was neither logic nor economy, but rather effect.

[88] Thus, the relatively high number of Baptism tokens, and the frequency with which the Baptism is conflated onto the standard Simeon token (VIKAN, 1982, fig. 25), may well reflect the relative prominence of conversion and baptism at the shrines. For baptism at Simeon the Elder's shrine, see LIETZMANN, 1908, 115, 117, 141f., etc.; and G. TCHALENKO, Villages antiques de la Syrie du nord 1 (Paris, 1953) 238.

[89] VAN DEN VEN, 1962/1970; and MAGOULIAS, 1967, 257. Quite possibly the entire British Museum/Robert-Henri Bautier hoard was the possession of one individual. Most of the Palestinian ampullae are concentrated in two collections which, originally, may well have been one. See ENGEMANN, 1973, 12f., and note 65.

Sources of Figures: Pl. 8a: Menil Collection. – b: Robert-Henri Bautier. – c: GRABAR (1958). – d: KAUFMANN (1910). – e: The Art Museum, Princeton University. – f: Author. – g: The Walters Art Gallery. – h: Holum *et al.* (1988). – Pl. 9a: British Museum. – b: REEDER WILLIAMS (1985). – c: Courtesy of the British Museum. – Pl. 10a: F. GERKE, Spätantike und frühes Christentum (Baden-Baden 1967) fig. p. 205. – b: ENGEL (1982). – c: University of Michigan. – d: Robert-Henri Bautier. – e: Royal Ontario Museum. – f/g: Musée du Louvre. – Pl. 11a: WURSTER/FELTEN (1975). – b: Ashmolean Museum. – c: Menil Collection. – d: Menil Collection. – e: Robert-Henri Bautier. – f/g: The Walters Art Gallery. – h: Author. – i: CASSON (1971). – j/k: British Museum.

Plate 8

a. Houston, Menil Coll.
Pilgrim token (clay),
Simeon Stylites.

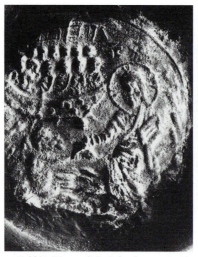

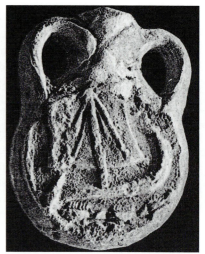

b. Paris, Robert-Henri
Bautier Coll. Pilgrim token
(clay), the Tempest
Calmed.

c. Bobbio, Museo di S. Colombano, no. 11.
Pilgrim ampulla (pewter), Christ Walking
on Water.

d. Cairo, Coptic Museum. Pilgrim flask (terracotta), ship.

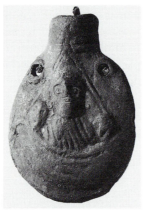

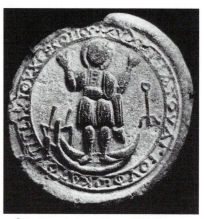

e. Princeton, The Art Museum, Princeton University, no 118.
Pilgrim flask (terrakotta), the Tempest Calmed.

f. Leningrad, State Hermitage Museum.
Pilgrim token (clay), St. Phokas.

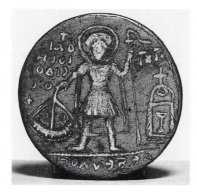

g. Baltimore, The Walters Art Gallery, no. 54.230.
Pilgrim token stamp (bronze), St. Isidore.

h. Jerusalem, Holy Sepulchre, Chapel of St. Vartan.
Votive plaque with drawing (stone), ship.

a. London, British Museum. Coin (bronze),
Isis Pelagia.

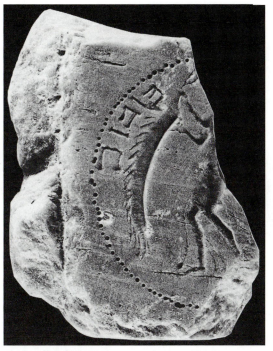

b. Athens, Agora excavation, no. ST 527.
Matrix (marble), Isis Pelagia.

c. London, British Museum, no. 1973, 5-1, 10-26.
Pilgrim token (clay), Adoration of the Magi.

Plate 10

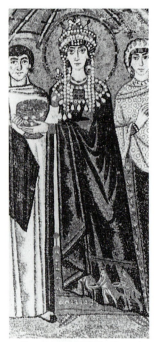

a. Ravenna, San Vitale. Empress
Theodora and her retinue
(mosaic, detail).

b. Attalens, excavations. Fibula
(bronze), Adoration of the Magi.

c. Ann Arbor, University of
Michigan, Bonner 39. Gem
amulet (haematite), field
worker cutting grain.

d. Paris, Robert-Henri Bautier Coll.
Pilgrim token (clay), Entry into
Jerusalem.

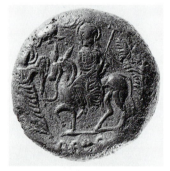

e. Toronto, Royal Ontario Museum,
no. 986.181.80. Pilgrim token (clay),
Entry into Jerusalem.

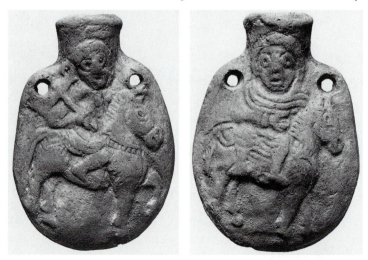

f/g. Paris, Musée du Louvre, no. MND 648. Pilgrim flask (terracotta), the Entry into Jerusalem,
the Flight into Egypt (?).

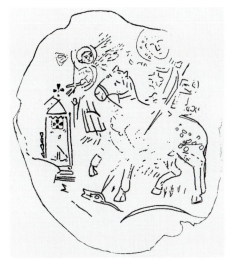

a. Aegina, acropolis excavations, no. RC 43.
Pilgrim token stamp (?) (terracotta), Holy Rider/Pilgrim (?).

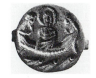

b. Oxford, Ashmolean
Museum, no. F790.
Ring (bronze), the
Tempest Calmed.

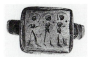

c. Houston, Menil
Coll. Ring (bronze),
the Magi.

d. Houston, Menil
Coll. Ring (bronze),
Entry into Jerusalem.

e. Paris, Robert-Henri
Bautier Coll.
Pilgrim token (clay),
aphlaston (?).

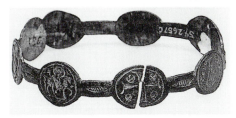

f/g. Baltimore, The Walters Art Gallery, no. 54.2657A–C.
Amuletic armband (bronze), Entry into Jerusalem, cross,
aphlaston (?) et cetera.

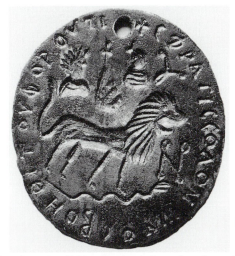

h. Athens, Benaki Museum. Amuletic pendant (bronze),
lion and snake, and Helios and Selene with the *aphlaston* (?).

i. The Hague, Kon. Penningkabinet.
Coin (bronze), ship.

j. London, British Museum. Coin
(bronze), Neptune with sea trophies.

k. London, British Museum.
Ringstone (sard), ship.

ART, MEDICINE, AND MAGIC IN EARLY BYZANTIUM*

In Byzantium the world of art touched that of medicine in a variety of ways and with varying intensity. Among the material remains of the Byzantine physician's trade are finely crafted surgical implements and richly carved ivory medicine boxes—and at least one silver stamp belonging to a certain *iatros* named Ishmael.[1] Aesthetically more impressive are the handful of deluxe medical manuscripts which have survived from Byzantium, including the famous copy of Dioscorides' *De materia medica* in Vienna, and the luxurious medical compendium in Florence (Plut. LXXIV, 7) which contains Soranus of Ephesus' treatise on bandaging, and that by Apollonius of Kitium on the set-

ting of dislocated bones.[2] Unfortunately, however, their miniatures like their texts usually reveal less about contemporary Byzantine medicine than about Antique prototypes. The opposite is true of portraits of such popular healing saints as Cosmas and Damian, Abbacyrus, and Panteleimon who, because they were holy doctors, were portrayed with the paraphernalia of practicing physicians of the time.[3] Yet even here, the relationship between Byz-

[The reader is referred to the list of abbreviations at the end of the volume.]

*This article is adapted from my paper "Medicine, Magic, and Pilgrims," delivered as part of the 1983 Dumbarton Oaks Spring Symposium.

[1] See L. Bliquez's article in this volume. That so few Byzantine surgical implements have survived suggests that they may customarily have been made of iron. Among the *miracula* of St. Artemius is one wherein physicians are ridiculed with the observation that their scalpels were "being consumed by rust." See A. Papadopoulos-Kerameus, *Varia graeca sacra* (St. Petersburg, 1909), *mir.* 25. It is noteworthy that while approximately 60,000 lead sealings survive from Byzantium, only half a dozen of the iron *bulloteria* with which they were made are extant. For ivory medicine boxes, see W. F. Volbach, *Elfenbeinarbeiten der Spätantike und frühen Mittelalters*, Romisch-Germanisches Zentralmuseum zu Mainz: Kataloge, vor- und frühgeschichtlicher Altertümer, 7 (3rd ed.) (Mainz, 1976), nos. 83–85. For a wooden medicine box from Early Byzantine Egypt with what may be medicine tablets still inside, see F. Petrie, *Objects of Daily Use*, British School of Archaeology in Egypt, 42 (London, 1927), pl. LVIII, 52. In the Yale University Art Museum is a doctor's leather instrument case with attached *pyx* (acc. no. 57.48.1). Apparently from Early Byzantine Egypt, it bears an *orans* portrait of a little-known doctor-saint, Antiochus of Sebaste, what appears to be a set of tables for mixing medicines, and, along its upper edge, the phrase "Use in good health" (*Hygienon chro*; cf. *IGLSyr*, no. 370). See also note 3 below for depictions of Byzantine medicine boxes. The silver doctor's stamp is unpublished, and in the Limbourg Collection, Cologne. It is mid-Byzantine in date and bears the following inscription: "Lord, help Ishmael [the] doctor."

[2] H. Gerstinger, Kommentarband to the sumptuous, full-color reproduction, *Dioscurides. Codex Vindobonensis med. gr. 1 der Osterreichischen Nationalbibliothek* (Graz, 1970). A shorter commentary, with selected plates (again in full color) is available: O. Mazal, *Pflanzen, Wurzeln, Säfte, Samen: Antike Heilkunst. Miniaturen des Wiener Dioskurides* (Graz, 1981). The best Greek text remains that edited by M. Wellmann. Soranus' *Bandages* is part of the collected Greek texts of Soranus (ed. Ilberg [*CMG* IV], 159 ff., with black and white reproductions of cod. Laur. LXXIV, 7 as plates I–XV). Apollonius of Kitium (*fl.* c. 50 B.C.) composed a *Commentary on Hippocrates' Joints*, and the best surviving texts are those from the tenth and eleventh century in Florence, perhaps compiled and re-edited by Nicetas (early tenth century). The illuminations of the cod. Laur. LXXIV, 7 seem to be contemporary with the Greek text of Apollonius' *Commentary*. Sarton, *Introduction*, I, 608. The best modern edition is J. Kollesch and F. Kudlien, eds., with translation (German) by J. Kollesch and D. Nickel, *Apollonii Citiensis In Hippocratis De articulis commentarius* (Berlin, 1965 [*CMG* XI 1, 1]), with thirty plates (black and white) of cod. Laur. LXXIV, 7 as an accompanying pamphlet. See also L. MacKinney, *Medical Illustrations in Medieval Manuscripts* (Berkeley, 1965), 89–91, with plate 91A (color: cod. Laur. LXXIV, 7, fol. 200). For the dependence of these picture cycles on Antique archetypes, see K. Weitzmann, *Ancient Book Illumination*, Martin Classical Lectures, 16 (Cambridge, Mass., 1959), 11 ff.

[3] Such hagiographic portraiture provides an especially rich typology of medical boxes. See P. J. Nordhagen, "The Frescoes of John VII (A.D. 705–707) in S. Maria Antiqua in Rome," *ActaIRNorv*, 3 (1968), 58. For two later boxes quite different from those cited by Nordhagen, see S. Pelekanides, *Kastoria*, I (in Greek) (Thessaloniki, 1953), pl. 26 (St. Panteleimon, Church of the Holy Anargyroi); and K. Weitzmann, "The Selection of Texts for Cyclic Illustration in Byzantine Manuscripts," *Byzantine Books and Bookmen*, Dumbarton Oaks Colloquium, 1971 (Washington, D.C., 1975), fig. 23 (St. Panteleimon; icon at Mt. Sinai). Occasionally, as in the icon just cited, a doctor-saint is shown in the act of healing one of his patients. Usually these "healings" are of a generic sort, morphologically dependent on Christ healing scenes from illustrated Gospels. However, some representations

IX

66

antine art and Byzantine medicine remained distant. Much more interesting and illuminating for both are those rarer cases, specifically within the realm of supernatural healing, where the vehicle of the cure (whether pill or amulet) was itself an art object—where, in other words, art and medicine were one and the same. And nowhere was this phenomenon more pervasive or richer in its complexity than within the world of Early Byzantine pilgrimage.[4]

Pilgrimage played a central role in the life and culture of early Byzantium.[5] Indeed, within a few decades of the foundation of the Empire the east Mediterranean had come alive with pious travelers. Among the first was Constantine's own mother, Helena, who journeyed to the Holy Land at her son's request to dedicate his newly built churches located at the sites identified with the Birth and Ascension of Christ: Bethlehem and the Mount of Olives. Thousands were to follow in a mass mobilization of body and spirit which grew uninterrupted until the Arab conquests of the seventh century.

Ultimately, each pilgrim was driven by the same basic conviction; namely, that the sanctity of holy people, holy objects, and holy places was somehow transferable through physical contact.[6] They came not simply to see but to touch, to be close to the power of sanctity. For some, the hope was simply that this proximity would serve to intensify their faith. St. Jerome, for example, writes that when

Paula first came before the wood of the cross "she fell down and worshipped . . . as if she could see the Lord hanging on it."[7] For many others, however, pilgrimage was undertaken with the more specific goal of finding a miraculous cure at journey's end. Among them were the sick who filled the rows of beds in the hospice beside the Basilica of St. Mary in Jerusalem, and the infirm who for months would sleep on mats in the sanctuary of Sts. Cyrus and John in Menuthis, each night hoping for a miracle-working visitation from the shrine's holy doctors so that they could finally return home again, cured.[8] A description of the shrine of St. Thekla at Seleucia, as it functioned at mid fifth century, suggests an atmosphere somewhere between that of the Mayo Clinic and the Shrine of the Immaculate Conception:

One never found her church without pilgrims, who streamed there from all sides; one group on account of the grandeur of the place in order to pray and to bring their offerings, and the other in order to receive healing and help against sickness, pain, and demons.[9]

That "healing and help" were indeed readily forthcoming was manifest to all who might enter the shrine; one need only have paused to listen for the recitation of the patron saint's most impressive *miracula* or have looked for the scores of precious *ex voto*s which had been left behind to acknowledge them.[10] Perhaps the most explicitly "medical" of the many pilgrim votives to have survived from early Byzantium is a series of tiny silver reliefs of eyes found in northern Syria and now preserved in the Walters Art Gallery, Baltimore. Some among them bear the inscription, "Lord help, amen," while others (e.g., fig. 1)[11] show the words, "In fulfillment of a vow"; all, however, have basically the same set of large staring eyes. Like their modern counterparts in the Orthodox churches of Greece, and their ancient counterparts excavated at pagan healing

seem to show patients with identifiable disorders. See, for example, Mt. Athos, Panteleimon cod. 2, fol. 197r: "Sts. Cosmas and Damian heal a man with dropsy" (S. M. Pelekanidis, P. C. Christou, C. Tsioumis, and S. N. Kadas, *The Treasures of Mount Athos*, 2 [Athens, 1975], no. 278). For a rare glimpse into a Byzantine doctor's office, see folio 10v of the fourteenth-century Nicholas Myrepsus manuscript in Paris (BN gr. 2243) (T. Velmans, "Le Parisinus grecus 135 et quelques autres peintures de style gothique dans les manuscrits grecs à l'époque des Paléologues," *CahArch*, 17 [1967], fig. 26).

[4] For a more general discussion of art and Early Byzantine pilgrimage, see G. Vikan, *Byzantine Pilgrimage Art*, Dumbarton Oaks Byzantine Collection Publications, 5 (Washington, D.C., 1982).

[5] For an excellent introduction to Early Byzantine pilgrimage, see J. Wilkinson, *Jerusalem Pilgrims Before the Crusades* (Warminster, 1977), "Introduction." See also, B. Kötting, *Peregrinatio religiosa.* (Regensberg, 1950), *passim*; and E. D. Hunt, *Holy Land Pilgrimage in the Later Roman Empire, A.D. 312–460* (New York, 1982), *passim.*

[6] John of Damascus writes of the True Cross (*Orth. Faith*, 4.11; *Fathers of the Church*, 37 [Washington, D.C., 1958], 165 ff.): ". . . that honorable and most truly venerable tree upon which Christ offered Himself as a sacrifice for us is itself to be adored, because it has been sanctified by contact with the sacred body and blood."

[7] Wilkinson, *Jerusalem Pilgrims*, 49.

[8] *Ibid.*, 84 (the anonymous pilgrim from Piacenza describing the Jerusalem hospice). For the sick sleeping on mats in the shrine (i.e., "incubation"), see H. Delehaye, "Les recueils antiques de miracles des saints," *AnalBoll*, 43 (1925), 11 f., 24 f., 64 f., and Kötting, *Peregrinatio*, 395.

[9] Basil of Seleucia, *Vita S. Teclae* (PG, 85, cols. 473ff. [vit., 1]).

[10] Delehaye, "Les recueils," 17 (for recitation of miracles in the shrine). Sophronius, *SS. Cyri et Ioannis, Miracula* (PG, 87.3, cols. 3423 ff.), *mir.* 69, describes a votive plaque at the entrance to the healing shrine of Sts. Cyrus and John at Menuthis, in northern Egypt: "I, John from Rome, have come here and have been healed by Sts. Cyrus and John of eight years of blindness, after I had suffered here unmoving." For votives at healing shrines, see Kötting, *Peregrinatio*, 399 f.

[11] Acc. no. 57.1865.560; illustrated 1:1. See Vikan, *Byzantine Pilgrimage*, fig. 38, for the "Lord help" type.

shrines around the Mediterranean (e.g., at the Asklepieion in Corinth), these simple, anonymous votives acknowledge a successful healing by showing that part of the body which was formerly diseased.[12] And to judge from the words of Theodoret, the practice was not at all unusual in early Byzantium:

> Christians come to the martyrs to implore them to be their intercessors. That they obtained what they so earnestly prayed for is clearly proven by their votive gifts, which proclaim the healing. Some bring images of eyes, others feet, others hands, which sometimes are made of gold, sometimes of wood. ∴ .[13]

How and with what were such cures accomplished? These questions have been asked and answered by scholars of the caliber of Delehaye and Kötting.[14] Yet typically, each relied on textual evidence to the virtual exclusion of material remains, and in so doing failed to appreciate the integral role that art once played in effecting miraculous cures, and the instrumental role that it can still play in explicating the circumstances under which such cures were accomplished.[15] In order to help establish a more balanced interpretation, I now propose to examine in detail miraculous healing as it was practiced at the shrine of St. Symeon the Younger, because for no other Early Byzantine pilgrim site is our textual evidence (the saint's *Vita*) so effectively complemented by our material evidence ("Symeon tokens")—the how by the what.[16] This

examination will in turn serve as the basis for a reinterpretation of several categories of Early Byzantine amulets, which will be shown to be not merely apotropaic, but specifically medicinal.

The ruins of Symeon the Younger's shrine may still be seen atop his "Miraculous Mountain" (*Kutchuk Djebel Semaan*), which rises above the Mediterranean some sixteen kilometers southwest of Antioch. Included in the complex were a cruciform church, a monastery, and a column, for this famous Symeon, who died in 592, had chosen the life of a stylite in imitation of his equally famous, homonymous predecessor of the fifth century.[17] Evidence of what transpired on the Miraculous Mountain during Symeon's lifetime and in the decades immediately after his death consists of a long, contemporary *Vita* comprising more than 250 miracles, and, as their material complement, several dozen clay Symeon tokens of the sort illustrated in figure 2.[18] Most, like this example, are between the size of a quarter and a half-dollar, and most show basically the same composition. At the center is Symeon's column topped by his bust-length portrait. To the left a monk climbs a ladder toward the saint, with a censer in his raised hands, while just below a second monk kneels in supplication, reaching forward to touch the column. Finally, above and to the right and left of the saint are a pair of flying angels bearing leafy victory crowns.

In a sense, the token identifies itself through the inscription which fills its circumference: "Blessing [i.e., *eulogia*] of St. Symeon of the Miraculous Mountain." "Of the Miraculous Mountain" is simply

[12] Unfortunately, there is nothing in the design of the reliefs to suggest the nature of the disease. Centers for the miraculous healing of the eyes were as well known in Early Byzantine times as they had been in antiquity. That closest to the findspot of these reliefs would likely have been the St. Thekla shrine at Seleucia (Kötting, *Peregrinatio*, 154).

[13] Theodoret, *Graecarum affectionum curatio* 8.64 (I. Raeder, *Theodoreti graecarum affectionum curatio* [Leipzig, 1904; rpt. Stuttgart 1969], 1 ff.).

[14] Delehaye, "Les recueils," *passim*; and Kötting, *Peregrinatio*, 400 ff.

[15] Similarly, those few art historians who have been attracted to pilgrimage art have paid far too little attention to textual evidence, and thus have usually missed the medico-amuletic essence of the genre. Instead, there has been a tendency to view the sort of pilgrim tokens and ampullae discussed below as little more than tourist souvenirs. They are thought to be cheap imitations of (lost) prototypes in precious metal whose iconography derives from (lost) mural archetypes at the shrine. For a recent review of received opinion among art historians, see R. J. Grigg, "The Images on the Palestinian Flasks as Possible Evidence of the Monumental Decoration of Palestinian Martyria," (diss., University of Minnesota, 1974).

[16] P. van den Ven, *La vie ancienne de S. Syméon Stylite le Jeune (521–592)*, SubsHag, 32 (Brussels, 1962 [I], 1970 [II]). For Symeon tokens, see J. Lafontaine-Dosogne, *Itinéraires archéologiques dans la région d'Antioche*, Bibliothèque de *Byzantion*, 4 (Brussels, 1967), 140 ff. (and *passim*, for the shrine in general).

For additions to Lafontaine-Dosogne's list, see *idem*, "Une eulogie inédite de St. Syméon Stylite le Jeune," *Byzantion*, 51 (1981), 631 ff., and notes 3 and 7; R. Camber, "A Hoard of Terracotta Amulets from the Holy Land," *Actes du XVᵉ Congrès International d'Études Byzantine*, Athens, September 1976, II, A (Athens, 1981), 104, fig. 15; and Vikan, *Byzantine Pilgrimage*, figs. 22, 25, 29. Four additional specimens are in the J. Spier Collection, New York City.

[17] For the Elder's shrine, see G. Tchalenko, *Villages antiques de la Syrie du Nord*, I (Paris, 1953), 223 ff.; and for the Younger's, see van den Ven, *La vie ancienne*, I, 191 ff.; and J. Mécérian, "Les inscriptions du Mont Admirable," *Mélanges offerts au Père René Mouterde, MélUSJ*, 38 (1962), II, 298 ff.

[18] Bobbio, Museo di S. Colombano; illustrated 1:1. See G. Celi, "Cimeli Bobbiesi," *La civiltà cattolica*, 74 (1923), III, 429 ff. And for the others, see note 16 above.

It was van den Ven's view that Symeon's *Vita* was written by a contemporary; more recently (in his paper "The Gate of Chalke: The Bulletin Board of the Palace," delivered at the 1984 Dumbarton Oaks Spring Symposium), Paul Speck has suggested a dating for it to the second half of the seventh century. If Speck is correct, the "center of gravity" of the phenomena and objects discussed in this article (and, more generally, of the rise of the cult of images) would shift from the decades around A.D. 600 to the decades around and soon after the Arab Conquests.

the epithet which, for the Byzantines, distinguished the Younger from the Elder Symeon. Specifically, it identifies this Symeon's hill as literally being a source of miracles, since its soil had been sanctified via the column through contact with the saint. Such "sanctified hills" seem not to have been unusual; Theodoret, for example, describes one upon which a certain ascetic named James had stood—a hill which ". . . according to general belief received so powerful a blessing that people come from all sides and carry away [pieces of] earth in order to take them home as *prophylactica*."[19] Significantly, Theodoret uses the word "blessing"—the same as that on the token—to describe the prophylactic quality which the earth of the hill had received from contact with the saint. Among the Jews of the Old Testament, the concept of "blessing" evoked by the word *eulogia* was thoroughly abstract, as in the pietistic acclamation, "Blessed be the Lord God, the God of Israel. . . ."[20] For early Christians, however, *eulogia* gradually came to be applied to blessed objects, such as bread, and eventually even to unblessed objects exchanged as gifts among the faithful. In the fifth century, for example, Akakios of Melitene sent a letter to Firmus of Caesarea and along with it, as a "blessing," a large fish.[21] For the pilgrim the word *eulogia* held a special meaning somewhere between that common in the Old Testament, and the gift of the fish.[22] It was the blessing conveyed—or more precisely, received—by contact with a holy place, a holy object, or a holy person. It could either be received directly and immaterially (through action), as by kissing the wood of the True Cross, or it could be conveyed indirectly and materially. In the latter case it would customarily come by way of a substance of neutral origin which itself had been blessed by direct contact—as, for example, through oil which had passed over the bones of a martyr. Theodoret's hill receives the immaterial blessing contact of the ascetic James, and once having received that contact itself becomes a material blessing which, in pieces, pilgrims can carry away as *prophylactica*.

That the same truth applies to Symeon's Miraculous Mountain and to the token in figure 2 is clear from the saint's *Vita*. The word *eulogia* (in the pil-

grim sense) appears nearly a dozen times among the text's 259 chapters, and in each instance it refers to a substance rather than to an action-variety of blessing. One time (chap. 100) it is water from the cistern near the column; another (chap. 116), bread blessed by the saint; and in still another instance (chap. 130), a bit of hair from Symeon's head. But most often, St. Symeon's *eulogia* came in the form of the reddish earth or "dust" collected from near the base of his column. This was "the *eulogia* made from dust blessed by him" (chap. 163), or "the dust of his *eulogia*" (chap. 232). And this, of course, is at once the material of his tokens and the stuff of his Miraculous Mountain.

Knowing what these tokens are made of raises the much more interesting question of their function. And here, the testimony of *Vita* and token is identical and unequivocal: they were medicinal. First, consider the evidence of the *Vita*: In two places, chapters 41 and 255, Symeon's biographer lists in clinical fashion the half-dozen different ways whereby the saint customarily exercised his healing powers. In chapter 255 the author is nearing the end of his narrative and so attempts an overview of Symeon in his role as holy doctor:

> We shall not be tempted to list the innumerable healings that have been effected by the intermediation of St. Symeon, being weak and incapable of reporting them [all]; for sought cures were obtained as if they were pouring forth from an inexhaustible fountain. For many [the healing] was [accomplished] by [Symeon's] words; for certain others, by the mere invocation of his name; for others, by the imposition of his saintly staff; for others, by visions; and for others again, by the application of his holy dust.

Other passages in Symeon's *Vita* provide specific accounts of the medicinal application of the saint's holy dust. Chapter 115, for example, records the cure of a certain three-year-old boy in the village of Charandamas who suffered from severe constipation. Eventually the child's abdomen became distended to the point of bursting, which prompted his parents to invoke the name of St. Symeon and smear him with holy dust. Immediately, of course, the child found relief. In a similar vein, chapter 163 relates the story of a certain poor cripple in Antioch who is returned to health after having been rubbed with "the *eulogia* made from [Symeon's] blessed dust." In chapter 194 Symeon himself gives the following prescription to a man who has not a strand of hair on his entire body:

> Take my dust and rub it all over your body, and as soon as you do, the Lord, through my humble service,

[19] Theodoret, *Historia religiosa* c. 21 (PG, 82, cols. 1431 ff.).

[20] A. Stuiber, "Eulogia," *RAC*, VI (1966), cols. 900 ff.

[21] Firmus, *Epistolae* 30 (PG, 77, cols. 1481 ff.).

[22] For an excellent survey of the various *eulogiai* current among sixth-century pilgrims, see the account of the anonymous pilgrim from Piacenza (Wilkinson, *Jerusalem Pilgrims*, 79 ff.). See also, Vikan, *Byzantine Pilgrimage*, 10 ff.

will make hair grow [on you] appropriate to the condition of [someone] your age.

These are three typical stories of cures effected through the agency of Symeon's dust. Almost invariably, the dust was applied externally—most often, it seems, dry, but occasionally (e.g., chap. 214) mixed with water or saliva to form a reddish paste. Moreover, the prescription was as consistent and conservative as it was simple, for unlike the well-known doctor-saints of the period—Cosmas and Damian, Cyrus and John, and Artemius—Symeon did not normally make individual diagnoses or recommend such exotic remedies as roasted crocodile, camel dung or Bithynian cheese mixed with wax.[23] The same reddish earth was used year in and year out to cure any number of disparate human afflictions, from deformities and broken bones, to fevers. In fact, the same agent was used to bring an ailing donkey back to life (chap. 148), to restore a vat of sour wine to its former sweetness (chap. 230), and even, on one occasion, to calm a storm at sea (chap. 235). There could be no doubt, in other words, that Symeon's *eulogia* was, from the pharmaceutical point of view, the pilgrim's cure-all.

That Symeon's *eulogia* tokens were specifically medicinal, and that their medical qualities were generic, are both explicitly stated in the inscriptions which some of these objects bear. Within the circular field of the token in figure 2, for example, are the words, "Receive, O Saint, the incense, and heal all," while another type of Symeon token, illustrated in figure 3, bears the word "health" (*hygieia*) across its face.[24] This token, like the first, shows Symeon's column topped by his bust portrait, a pair of flying angels above, and a monk with censer on a ladder at the left. On this token, however, the circular *eulogia* inscription does not appear, and the "heal-all" invocation has been supplanted by a tiny representation of the Baptism of Christ—a scene which, because it bears more on Symeon's theology than on his pharmacology, will not figure in this paper.[25] Rather, the point of most immediate interest is the word *hygieia*, which is spelled backwards and split by the column, slightly above the token's mid-level. That its letters are reversed, and that John incorrectly places his left hand on the head of Christ

instead of his right, simply result from the mechanical process whereby all such tokens were produced. Symeon himself, in chapter 231, uses the word *sphragis* or "seal" to describe a token's image because he understands that it was made with a stamp; the letters of *hygieia* are reversed in the impression simply because the die cutter failed to reverse them on the die.

But what of the word itself? Initially, one might assume that it was added simply to invoke that all-important state of renewed health which the possessor of the token would hope to achieve. But its original significance may well have been more profound. The word *hygieia* is found frequently among the minor arts of early Byzantium, and especially on objects of personal adornment, like rings and belts; it appears, for example, on the clasps of the well-known gold marriage belt at Dumbarton Oaks, which is roughly contemporary in date with the token (fig. 26).[26] There, Christ acting as officiating priest oversees the *dextrarum iunctio*, the joining of the right hands of the bridal couple. Surrounding the group is the inscription, "From God, concord, grace, health." These words are as essential to the meaning of the belt as is the image, since they serve to invoke from God a threefold blessing on the marriage. By analogy, the word *hygieia* on the token serves to invoke from Symeon the blessing of health on the suppliant. But it may have done even more than that. After all, the token differs fundamentally from the belt clasp insofar as its very substance is instrumental to the realization of the blessing. In this respect, it—or rather, the stamp that produced it—belongs to the same tradition as a Late Antique doctor's stamp published more than fifty years ago by Franz Joseph Dölger (fig. 4).[27] Running clockwise around its circumference is the word *hygieia*, while at its center is a *theta* which, according to Dölger's persuasive argument, stands for *thanatos*. Between health and death, literally enclosing and trapping death, is the *pentalpha*, one of the most powerful amuletic signs in the Late Antique lexicon of magic. The *pentalpha* was the de-

[23] For an entertaining survey of such exotic cures, see H. J. Magoulias, "The Lives of Saints as Sources of Data for the History of Byzantine Medicine in the Sixth and Seventh Centuries," *BZ*, 57 (1964), 144 ff.

[24] Houston, Menil Foundation Collection, II.J1; illustrated 1:1. See Vikan, *Byzantine Pilgrimage*, 34 f., fig. 25.

[25] For a discussion of this scene, see *ibid.*, 35.

[26] M. C. Ross, *Catalogue of the Byzantine and Early Mediaeval Antiquities in the Dumbarton Oaks Collection, Volume II: Jewelry, Enamels, and Art of the Migration Period* (Washington, D.C., 1965), no. 38.

[27] Basel, History Museum; illustrated ca. 1:1. See F. J. Dölger, *Antike und Christentum*, I (Münster, 1929), 47 ff. Note that the letters on the stamp have not been cut in reverse. The failure to reverse letters and/or words is a common, random phenomenon among Byzantine stamping and sealing implements—with the exception of the more "legalistic" and "official" lead sealings.

IX

70

vice of the legendary Solomonic seal; it was engraved on the signet ring given by God to King Solomon in order that he might seal and thereby control the power of demons.[28] On the stamp, *hygieia* and *pentalpha* together seal and control *thanatos*; more importantly, their impression conveyed that same magical power to the doctor's pill. The analogy to our Symeon token, both in means of manufacture and in medicinal use, seems inescapable, although for the Symeon pill the impressed word only served to complement the healing power already inherent in Symeon's blessed earth.[29]

As for extant Symeon stamps—the functional descendants of the doctor's stamp illustrated in our figure 4—at least two may be cited: One, published in 1962 by Jean Mécérian, was found on the Miraculous Mountain itself, in the ruins of the gatehouse.[30] Approximately ten centimeters in diameter and made of basalt, it bears inscriptions on both of its faces: "Seal [*sphragis*] of the Holy Thaumaturge, Symeon," and (much abbreviated), "Jesus Christ, Son of God."[31] The second implement, preserved in the Cabinet des Médailles, Paris, is also made of stone, and although it is not inscribed with Symeon's name or epithet, it too should probably be assigned to the Miraculous Mountain, since its iconography closely matches that of extant clay *eulogiai* issued there (fig. 5).[32] One surface shows a monk climbing a ladder toward the saint, who appears *en buste* at the top of his column with victory angels flying in from left and right. At the base of the ladder is a large censer, while on the opposite side is a frontal standing figure—assumedly Symeon's disciple, Konon—in a pointed hat and cape, holding a staff and labeled "sole friend" (*MONOPHILE*).[33] The other side of the stamp shows a

crude iconic portrait of the Virgin with the Christ Child on her lap; its inscription, "Holy Mary," indicates for it an Early Byzantine dating.[34] This device, too, is matched on at least a few extant clay tokens from the Miraculous Mountain.[35] Indeed, that an image of "Holy Mary" should occasionally complement (or even supplant) that of Symeon on his medicinal *eulogiai* is hardly surprising, since her powers were invoked along with his (and Christ's) in the performance of miraculous cures—including that whereby Konon was brought back from the dead.[36]

The inscriptions on both variant token types (figs. 2, 3) corroborate the evidence of the *Vita*; namely, that Symeon's blessed earth was medicinal in its intent and general in its applicability. Yet, the words that these objects bear have something additional to reveal of the specific circumstances under which their generic medicinal powers were brought to bear. Recall the invocation that appears on the token illustrated in figure 2: "Receive, O Saint, the incense, and heal all." Incense—or more specifically, the offering of incense to the saint—is as prominent textually in this invocation as it is visually in the iconography of this and of most other Symeon tokens. Here, we see a man climbing toward the saint with an upright censer in both hands, while in figure 3 an analogously placed suppliant holds a swinging censer in his right hand. Obviously, invocation and iconography mirror one another, and just as obviously, the significance they share for these tokens depends on how we interpret incense, a substance and process which in Early Byzantine Christianity had several variant meanings reflective of its several variant uses. In private piety one of its main uses was as a propitiatory sacrifice offered in conjunction with intense prayer. To cite one typical illustration close in time and place to St. Symeon: Evagrius tells the story of a certain holy man named Zosimas, who happened to be in Caesarea in 526 when a terrible earthquake struck Antioch:

Zosimas, at the very moment of the overthrow of Antioch, suddenly became troubled, uttered lamenta-

[28] C. C. McCown, *The Testament of Solomon* (Leipzig, 1922), 10*. See also note 67, below.
[29] The supposed efficacy of "consumable words" is no more clearly documented than in Julius Africanus' prescription for keeping wine from turning sour: write the words of Psalm 34.8 ("O taste and see that the Lord is good") on an apple and throw it into the cask (see Dölger, *Antike*, 21).
[30] Mécérian, "Les inscriptions," 304, pl. II, 1.
[31] In fact, the raised matrix of the side bearing the *sphragis* inscription is only about 5 cm. across, making it only slightly larger than the token from Bobbio illustrated in figure 2.
[32] Unpublished; my line drawing is reproduced ca. 1:1. The piece is about 1.5 cm. thick, and is made of a hard, dark stone (basalt?).
[33] For such a censer, see O. Wulff, *Altchristliche Bildwerke*, Königliche Museen zu Berlin, Beschreibung der Bildwerke der christlichen Epochen, 2, 1 (Berlin, 1909), no. 977. "Sole friend" is otherwise unattested on Symeon (or any other) *eulogiai*. Konon's miraculous resurrection, one of Symeon's most famous miracles, is described in chapter 129 of the *Vita*. Konon appears,

usually labeled *KONON*, on many of the extant mid-Byzantine "*eulogiai*" of St. Symeon the Younger (e.g., our fig. 7).
[34] The chronology of epithets accompanying portraits of the Virgin will be discussed by Anna Kartsonis in her forthcoming book, *Anastasis: The Making of an Image*. "Holy Mary," as distinct from "Mother of God" or "Theotokos," is confined to the pre-Iconoclastic period.
[35] Lafontaine-Dosogne, *Itinéraires archéologiques*, figs. 98 ff.
[36] *Vita* chaps. 129, 141, 226; and Mécérian, "Les inscriptions," 318 ff.

tions and deep sighs, and then shedding such a pro-fusion of tears as to bedew the ground, called for a censer, and having fumed the whole place where they were standing, throws himself upon the ground, pro-pitiating God with prayers and supplications.[37]

Both in a literal and in a symbolic sense, smoke and prayer were conjoined for Zosimas as they rose toward heaven; one an offering to intensify and fa-cilitate the request conveyed in the other.

That incense shares the same meaning for these tokens as for Zosimas, and that both reflect a real aspect of contemporary piety, are corroborated by a small but important group of inscribed bronze censers from Early Byzantine Sicily (fig. 6).[38] Most show slight variations on the inscription, "God, who received the incense of the Holy Prophet Zachar-ias, receive this [incense]." The allusion, of course, is to the story of the father of John the Baptist, who, according to the first chapter of Luke, en-tered the Temple to burn incense before the altar. As he did he prayed, and at that moment an angel appeared before him with the words: "Fear not, Zacharias, for thy prayer is heard. . . ."

The iconography of these tokens, their inscrip-tions, Evagrius, and extant censers together seem to be painting a single coherent image—one wherein ailing pilgrims would offer Symeon in-cense in propitiation as they invoked his interces-sory aid and the healing power of his *eulogia*. We imagine lines of pathetic suppliants, each waiting his turn to climb the ladder and, with censer in hand, to put his case before the holy doctor. How-ever, to judge from the evidence of Symeon's *Vita*, our imagination would seem to be deceiving us, for while there are a number of references to the burning of incense in the *Vita*, only once is it being offered directly to the saint at the top of the col-umn (chap. 222), and in that one case the offering is expressly refused. In other words, Symeon's biographer neither states nor implies that the saint customarily or even occasionally gave audience to suppliants with censers—which seems to leave us with a fundamental conflict between our material evidence on one hand and our textual evidence on the other, between token and *Vita*. But in fact, this is only an apparent conflict, since it is not inherent in the evidence at all, but lies rather in an assump-tion which we enforce on that evidence; namely, that the scene on the token is to be understood as reflecting the experienced reality at the shrine. To reconcile the two, we need only discard that as-sumption and look away from Symeon's column; we need only suppose, in other words, that the censing suppliant is not at the shrine at all, but that he is offering up his incense prayer from another location.

And here, through this unlikely but in fact nec-essary supposition, token and *Vita* fall into har-mony with one another. Consider the following three cures. Chapter 53 relates the story of a youth from Daphne who is suddenly struck blind; discov-ering this, his parents light lamps and throw on incense, imploring the help of Emmanuel in the name of St. Symeon. Chapter 70 describes an un-named victim of an unspecified disease; he lights a lamp in his house and throws on incense, praying quietly and saying, "Christ, God of Your Servant Symeon of the Miraculous Mountain, have pity on me." And finally, chapter 231 relates the story of a priest from the village of Basileia; his third son, near death with a fever, begs his father to take him to St. Symeon. His father replies, "St. Symeon, my son, has the power to come to visit you here, and you will be healed, and you will live." With these words of the priest, the young man cries out, "St. Symeon, have pity on me," and then tells his father to get up quickly, throw on incense, and pray, for the Servant of God, St. Symeon, is before him. In each instance the scenario is basically the same: a devotee of St. Symeon falls ill while away from the shrine, but instead of traveling to the saint, he in-duces the saint to come to him—to perform "bi-location"—by burning incense, lighting lamps, and by offering a fervent prayer for healing.[39]

It seems, then, that the words and images on these tokens should be taken neither in a strictly literal sense nor in a strictly symbolic sense. There was a real suppliant, he did pray for healing, and he did offer incense to the saint; but this in all probability took place away from the Miraculous Mountain, as part of a private healing ritual. Thus the suppliant is a participant in the iconography, but only at one

[37] *Ecclesiastical History* 4.7 (Bohn's Ecclesiastical Library [Lon-don, 1854], 255 ff.).

[38] Syracuse, Museo Archeologica (P. Orsi, *Sicilia bizantina*, I [Rome, 1942], 171 ff., pl. XIIc). See, more recently, A. M. Fal-lico, "Recenti ritrovamenti di bronzetti bizantini," *Siculorum gymnasium*, 21 (1968), 70 ff.

[39] For a bi-location healing performed by Sts. Cosmas and Damian (*mir.* 13), see Delehaye, "Les recueils," 16, and note 45 below. Symeon's *Vita* describes the process of healing as it ex-isted during his lifetime; the shrine, however, continued to function long after his death in 592. Perhaps lights and incense were then used at the shrine to induce Symeon's healing pres-ence much as they had formerly been used away from the shrine for the same purpose.

remove, since his identity is subsumed by anonymous counterparts who act out the spiritual and, in part, the physical reality of his piety. His supplicatory relationship to his intercessor, St. Symeon, is visualized in the figure kneeling beside the column,[40] his incense offering is presented quite graphically (though in symbolic terms) on the ladder above, and the prayer itself is spelled out to the right of the column.

Suppliant, censer, and saint, entities which did not customarily converge in the experienced reality of the public shrine, here meet in a sort of private, liturgical reality on the face of a Symeon *eulogia*.[41] Moreover, it is clear that the very substance of that imagery, the *eulogia* itself, had an instrumental role to play in the consummation of the healing rite portrayed on it.[42] This only makes sense, and, in fact, is at least implicit in the list of healing techniques enumerated in chapters 41 and 255 of the *Vita*. Were the pilgrim actually at the shrine, he would have had the option of receiving the saint's blessing words or his healing touch, but away from the shrine the pilgrim must necessarily rely on some blessed intermediary to accomplish the same effect. In essence, this was the medicine he was obliged to take when he couldn't reach (or remain with) the doctor. Recall the story of the constipated three-year-old who was smeared with medicinal dust in his native village of Charandamas, and the paralytic who was dusted and healed in Antioch. In fact, there is not one miracle in the entire *Vita* of the saint where a medicinal *eulogia* is described as being used at the shrine itself; rather, they were given out there to accomplish their cures somewhere else. Consider the scenario evoked by chapter 231. A priest brings his second-born son to St. Symeon to be cured of a terrible disease. Symeon blesses the young man, but then sends him home to await his miraculous healing. The father is troubled and suggests that they stay near the saint a bit longer, since, "the presence at your side assures us a more complete cure." At this Symeon becomes annoyed,

scolds the priest for his lack of faith, and sends him on his way with these words: "The power of God . . . is efficacious everywhere. Therefore, take this *eulogia* made of my dust and depart. . . ."[43]

The images on these tokens, their inscriptions, and the healing miracles recounted in Symeon's *Vita* converge in a single coherent medico-religious phenomenon wherein each has a complimentary role to play—with the exception, perhaps, of the image itself. After all, that the iconography found on these tokens is explicable does not explain why it was put there in the first place. Certainly blessed earth could effect miraculous cures all by itself; why, then, the image?

Recall the miracle narrated in chapter 231 of the *Vita*. A priest brings his second son to Symeon to be healed; the saint blesses the boy but then sends him home to await the cure. A sceptical father does not wish to leave, but is persuaded to do so by the following statement from Symeon, the first half of which was quoted above:

[40] Compare analogous suppliants as they appear beside the True Cross on the well-known ampullae in Monza and Bobbio (A. Grabar, *Ampoules de Terre Sainte* [Paris, 1958], *passim*); for "vicarious" participation in pilgrimage iconography, see Vikan, *Byzantine Pilgrimage*, 24 f.

[41] These tokens clearly contradict conventional art-historical wisdom which would trace pilgrimage iconography back to lost mural models at the shrines. And in any event, no evidence exists that the shrine of Symeon the Younger (among others) ever had figurative mural decoration.

[42] That clay is the object's raison d'être obviously contradicts the notion that this medium was chosen for reasons of economy.

[43] No sooner do father and son arrive home than Symeon appears, disguised, in a vision. He puts this question to the priest: "What do you prefer, this *eulogia* that Symeon has sent you, or his right hand?" To which the priest responds, "Don't be angry, Lord, for great is the power of his *eulogia*, but I was seeking his right hand." At this point Symeon extends his right hand and gives the priest his clay *eulogia*, then, revealing his true identity, scolds him once again for his lack of faith. This desire for "the right hand" may explain why palm prints appear so frequently and so clearly on the back sides of Early Byzantine clay tokens (see Vikan, *Byzantine Pilgrimage*, 38 f., figs. 29a, b). There is additional evidence of how Symeon's earthen *eulogiai* were dispersed. Chapter 163 of the *Vita* describes Symeon's practice of giving blessed dust as "a favor . . . to the poor, for their subsistance." The poor in turn give out the *eulogiai* (here, specifically, in Antioch) and thereby the Lord "heals the world." According to chapter 181, a woman places in her bag "the *eulogia* that she got from the saint," while chapter 196 describes a specific building at the shrine for the storage of *eulogiai* (of Symeon's hair). According to chapter 232, a monk attached to the shrine who is traveling to Constantinople on business carries with him pieces of Symeon's hair and "the dust of his *eulogia*," with which he heals the praetorian prefect. Finally, miracle 54 of St. Martha (see note 45 below) describes a Georgian monk as leaving the shrine of St. Symeon with several image-bearing clay tokens. The stamps for the manufacture of clay *eulogiai* were likely made for and controlled by the monastic community which operated the shrine. At the shrine of Sts. Cosmas and Damian, for example, blessed wax was distributed to those undergoing incubation in the church during the all-night Saturday vigil (L. Deubner, *Kosmas und Damian* [Leipzig/Berlin, 1907], *mir.* 30). Molds (in fact, an entire worshop) for the production of clay ampullae for blessed water have been discovered at the Menas shrine in Egypt (see K. M. Kaufman, *Die heilige Stadt der Wüste* [Munich, 1924], 195 ff). Not surprisingly, those *eulogiai* bearing words or images are almost invariably "impersonal," and thus generically applicable to any suppliant and any disease. (For a unique pair of tokens made expressly for a certain Constantine, see Vikan, *Byzantine Pilgrimage*, figs. 22 and 29a.) Multiple surviving specimens from the same mold are not uncommon (cf. Lafontaine-Dosogne, *Itinéraires archéologiques*, figs. 82, 83).

The power of God ... is efficacious everywhere. Therefore, take this *eulogia* made of my dust, depart, and when you look at the imprint of our image, it is us that you will see.

Symeon is here offering the priest two quite different kinds of assurance that his son's cure will indeed eventually be accomplished. One, of course, is the blessed dust, which assumedly the priest will recognize as the saint's typical, highly efficacious curative agent. The other, however, is the saint's image impressed on that dust; somehow the anxiety of the priest should be lessened by knowing that when he and his son get home and look at that impression, they will, in effect, be confronted with a vision of the saint himself. But how can this be reassuring?

The answer comes later in the same chapter, when the priest's third son falls ill. Naturally, he asks that he be taken to the Miraculous Mountain, but his father recalls the words of the saint and replies, "St. Symeon, my son, has the power to come to visit you here, and you will be healed, and you will live." With this the young man gasps, then calls out, "St. Symeon, have pity on me." He then turns to his father and cries, "Get up quickly, throw on incense, and pray, for the servant of God, St. Symeon, is before me. . . ." With these words Symeon appears to the boy in a vision, battles with the demon that possesses him, and soon restores the youth to good health. Other miracles, though in less detail, suggest the same scenario; namely, that a vision of the saint was instrumental to the miraculous cure, and that this vision might be induced by a man-made representation of the saint. In chapter 118, for example, a hemorrhaging woman from Cilicia invokes Symeon's aid with the words, "If only I see your image I will be saved," while chapter 163 describes a healing accomplished in Antioch by means of blessed dust:

Instantly the paralytic was healed . . . by the intermediation of his saintly servant Symeon, whom he saw with his own eyes under the aspect of a long-haired monk, who extended his hand and put him upright. . . .

It is clear that for these people seeing was essential to healing, to making real and effective Symeon's miraculous, healing presence at their side.[44] And

chapter 231 of the *Vita* leaves no doubt that the image stamped on the earthen *eulogia* was itself instrumental to the "seeing" of the saint. In Symeon's own words, "When you regard the imprint of our image, it is us that you will see."[45]

The saint's image, the pilgrim's invocation, the pair of suppliants, the censer, the red clay, the concepts of *eulogia*, bi-location, and visitation, and the magic of *hygieia*; these were all multiple facets of a single medico-religious phenomenon through which one segment of the population of early Byzantium believed that it was effectively treating its diseases. Pilgrim tokens like those illustrated in figures 2 and 3 were at once the distillation of and the catalyst for that phenomenon. Indeed, there is no clearer indication of the subtle cohesion with which they responded to their medico-religious function than to contrast them with their "imitations" of later centuries. Image-bearing, earthen *eulogia* reached their peak of popularity in the later sixth and seventh centuries; a fairly rapid decline seems to have set in soon thereafter. Yet, like many another product of Early Byzantine culture, the Symeon *eulogia* was destined to be exhumed and revived centuries later, during the mid-Byzantine period. For with the reoccupation of the region of Antioch in the later tenth century, the Miraculous Mountain and its pilgrim trade were revitalized, and pilgrim token designs popularized before the Arab Conquest were consciously imitated (fig. 7).[46]

[44] As incubation was instrumental to healing at the most famous of early Byzantium's holy doctor shrines (e.g., those of Cosmas and Damian, Cyrus and John, and Artemius), so a dream-vision was instrumental to successful incubation. And the fact that the healing saint is said to appear "in his customary manner" (e.g., Cosmas and Damian, *mir.* 1), strongly suggests that representations of the saint (whether on tokens, or as icons or murals) were instrumental to the evocation and confirmation of that vision. See Delehaye, "Les recueils," 16; and Kötting, *Peregrinatio*, 217 f.

[45] References to image-bearing, consumable *eulogiai* are not confined to the *Vita* of St. Symeon. Miracle 16 of St. Artemius (Papadopoulos-Kerameus, *Varia graeca sacra*) relates the story of a suppliant undergoing incubation who wakes up with a wax seal in his hand bearing the saint's portrait. The previous night the holy doctor had appeared to him in a dream, and had given him the seal "to drink." The patient is cured through the application of the melted wax. Miracles 54, 55 in the *Vita* of St. Martha (van den Ven, *La vie ancienne*) narrate the story of a certain Georgian monk who leaves the shrine of St. Symeon with several image-bearing clay tokens. On the way home he begins to doubt the saintliness of Symeon, and throws all but one token (which escapes his attention) into a fire. Suddenly, his arms become white from leprosy; he asks forgiveness of the saint, rubs his arms with the blessed earth, and is healed. Miracle 13 of Sts. Cosmas and Damian (Deubner, *Kosmas und Damian*) tells the story of a member of the military who is sent to Laodicea, taking with him an "icon," which is apparently identical with the blessed wax later used to treat his sick wife. See E. Kitzinger, "The Cult of Images in the Age Before Iconoclasm," *DOP*, 8 (1954), 148.

[46] For the revitalization of the Miraculous Mountain in the mid-Byzantine period, see van den Ven, *La vie ancienne*, 214* ff. Figure 7: Houston, Menil Foundation Collection, II.J4; illustrated 1:1. See Vikan, *Byzantine Pilgrimage*, fig. 30, 39 f. It is

Superficially, this typical mid-Byzantine descendant shares much in common with its Early Byzantine ancestor (fig. 2); its iconography appears to be much the same and its inscription is virtually identical. Yet over the centuries, much had changed: gone are the kneeling suppliant, the man on the ladder, the censer, and the invocation—gone, in other words, is the "incense prayer" and the concept of bi-location it evoked. We see instead Symeon's disciple Konon on the left and his mother Martha on the right, each turning toward Symeon's column as though an intercessor in a Deësis; they have, in effect, not only physically supplanted the suppliants, they have interposed themselves spiritually between suppliant and stylite. Above, the angels still appear but they have been altered in a most telling way. By the well-established canons of Late Antique victory iconography, they ought to be carrying either crowns (figs. 2, 3) or palm fronds to the victorious "athlete of Christ," St. Symeon. But instead, each carries a small martyr's cross, as if about to hand it to the saint. Yet, iconographic substitutions such as these are only symptoms of what was a very profound transformation in the function of the object, and thereby in its very genre. For in fact, what appears in figure 7 is not a clay token at all, but rather a cast lead pendant whose suspension loop has broken away.[47] It is, in other words, an object which by its very nature cannot possibly convey the medicinal earthen "blessing" of the Miraculous Mountain.

What these mid-Byzantine lead medallions still had to offer, however, was the inherent power of their image—the same power which Theodoret ascribed to representations of Symeon Stylites the Elder († 459) more than five hundred years earlier:

Of [pilgrimage from] Italy it is unnecessary to speak, since they say that this man [Symeon the Elder] has become so famous in Rome, the greatest city, that they have set up small images of him in the vestibules of all the workshops for the warding off of danger and as a means of protection.[48]

Indeed, it was this belief in the power of images which made it inevitable that pilgrimage iconography, popularized and disseminated through the idiom of the *eulogia*, should come to enjoy its own existence and evolution independent of blessed substance.[49] And it is hardly surprising to discover that some of these pilgrimage-generated images were thought to possess specifically medicinal powers. In chapter 118 of the *Vita*, for example, is the story of a woman from Cilicia who, after having been purged of a demon by St. Symeon, returns home and there sets up an icon of the saint. This image, even though it was never blessed by Symeon, performs a variety of miracles, including cures, "because the Holy Spirit which inhabits Symeon covers it with its shadow"; thus, a hemorrhaging woman can invoke Symeon's power with the words, "If only I see your image I will be saved."[50] Similarly, there is recorded among the *miracula* of Cosmas and Damian one (no. 15) wherein a pious woman is cured of colic simply by consuming plaster fragments scraped from the frescoed portraits of those holy doctors which had been painted on the walls of her house.[51]

Yet, it is one thing to know that some pilgrimage-generated imagery could sometimes be medicinal, even without the aid of accompanying blessed substance, and quite another to identify specific, extant objects which by their imagery may be said to have been medicinal in intent at their point of manufacture. Most simply stated, the problem is to identify implements of supernatural healing among the much larger categories of pilgrimage-related amulets and votives.[52]

One such implement—a true "medical amulet"—is represented by our figures 8 to 10.[53] These

inscribed: "Blessing of St. Symeon of the Miraculous [Mountain], Amen."

[47] For the genre, see P. Verdier, "A Medallion of Saint Symeon the Younger," *The Bulletin of the Cleveland Museum of Art*, 67, 1 (1980), 17 ff. For a mid-Byzantine mold for the casting of lead Symeon pendants, see J. Lassus, "Un moule à eulogies de Saint Syméon le Jeune," *MonPiot*, 51 (1960), 149 f., fig. 6.

[48] *Historia religiosa*, 26.11 (H. Leitzmann, *Das Leben des heiligen Symeon Stylites*, *TU*, 32, 4 [Leipzig, 1908], 1 ff.).

[49] For some examples, see Vikan, *Byzantine Pilgrimage*, 40 ff.

[50] On the implications of this passage for the icon cult, see Kitzinger, "The Cult of Images," 117 f., 144 f.

[51] Deubner, *Kosmas und Damian*; and Kitzinger, "The Cult of Images," 107, 148.

[52] Ever since Gustave Schlumberger's pioneering study of 1892, "Amulettes byzantins anciens destinés à combattre les maléfices et maladies" (*REG*, 5, [1892], 73 ff.), Byzantinists have tended to blur the distinction between amulets that were intended to be only generally efficacious, and those among them which were intended to act specifically against, for example, the Evil Eye, stomach pains or infertility. Students of Greco-Egyptian amulets have evolved a much richer and far more precise typology, in part of course, because of the greater number and variety of objects with which they deal. See C. Bonner, *Studies in Magical Amulets, Chiefly Graeco-Egyptian* (Ann Arbor, 1950); and A. Delatte and P. Derchain, *Les intailles magiques gréco-égyptiennes* (Paris, 1964).

[53] Figure 8: Fouquet Collection, Cairo; illustrated 1:1. Found in Egypt. Inscriptions: Psalm 90; *Heis Theos*. Iconography: As-

are three of more than a dozen surviving examples of a type of amuletic armband produced in the east Mediterranean (i.e., Syria-Palestine and/or Egypt) in the sixth and seventh centuries.[54] The group is distinguished by recurrent inscriptions and images, and by a ribbon-like design highlighted by incised, figurative medallions; finer specimens, like the three here illustrated, are of silver. That the iconographic roots of these armbands lie in the pilgrim trade is clear from: (1) the fact that their version of the Women at the Tomb (figs. 8–10) includes architectural elements of the Holy Sepulchre Shrine (e.g., the "grills"); and (2), the striking similarity that exists between the choice and configuration of their scenes and those that appear on the well-known Palestinian metal ampullae preserved in Monza and Bobbio.[55] For example, six of the eight medallions on the Fouquet armband (fig. 8: Ascension, Annunciation, Nativity, Baptism, Crucifixion, and the Women at the Tomb) closely match those found on the reverse of Monza ampulla 2 (fig. 11).[56] Similarly, that these armbands were intended to be at least generally amuletic is clear from

their recurrent use of the apotropaic verse from Psalm 90, "He that dwells in the help of the Highest . . . ," and from their inclusion of the so-called holy rider and of such patently magical symbols as the *pentalpha* (figs. 8, 9).[57] Yet, what has thus far escaped notice is that the magic they were supposed to convey was specifically medicinal.[58] The evidence is of two sorts. First, there is the recent addition to the group of an armband bearing the word *Hygieia* on its holy rider medallion (fig. 10).[59] And second, there is the fact, somehow hitherto unnoticed, that several of the best-known members of the group, including our figures 8 and 9, show the Chnoubis, one of Antiquity's most popular medical "gem amulets"—and one long recognized as specifically effective in the cure of abdominal disorders.[60] The *Peri lithon* of Socrates and Dionysius, for example, gives the following instruction:

> Engrave on it [a kind of onyx] a serpent coil with the upper part or head of a lion, with rays. Worn thus it

[54] For the group in general, see Maspero, "Bracelets-amulettes," 246 ff.; and M. Piccirillo, "Un braccialetto cristiano della regione di Betlem," *Liber Annuus*, 29 (1979), 244 ff. (with illustrations of several specimens). For additional, related examples, see J. Strzygowski, *Koptische Kunst*, Catalogue général des antiquités Égyptiennes du Musée du Caire (Vienna, 1904), 331 f.; Wulff, *Altchristliche Bildwerke*, no. 1109; and Bonner, *Magical Amulets*, no. 321.

[55] For the Holy Sepulchre, see J. Wilkinson, "The Tomb of Christ: An Outline of its Structural History," *Levant*, 1 (1969), 83 ff.; and for the ampullae, see Grabar, *Ampoules, passim*, and the following note.

[56] Monza, Treasury of the Cathedral of St. John the Baptist; illustrated 1:1. Tin-lead ampulla for sanctified oil. See *ibid.*, pl. V. The only scene without a match is the Visitation, at the upper right of the ampulla. For the dating, localization, iconography, and function of these ampullae, see, in addition to Grabar, J. Engemann, "Palästinische Pilgerampullen im F. J. Dölger Institut in Bonn," *JbAChr*, 16 (1973), 5 ff.; Vikan, *Byzantine Pilgrimage*, 20 ff.; and, most recently, L. Kötzsche-Breitenbruch, "Pilgerandenken aus dem heiligen Land," *Vivarium: Festschrift Theodor Klauser zum 90. Geburtstag, JbAChr*, Ergänzungsband, 11 (1984), 229 ff.

census, Annunciation, Nativity, Chnoubis, Baptism, Crucifixion, Women at the Tomb, Holy Rider. See J. Maspero, "Bracelets-amulettes d'époque byzantine," *Annales du service des antiquités de l'Égypte*, 9 (1908), 246 ff., fig. 1. Figure 9: Egyptian Museum, Cairo; illustrated ca. 1:1. Found in Egypt. Inscription: Psalm 90. Iconography: Annunciation, Nativity, Trinity (?), Baptism, Chnoubis, Crucifixion, Women at the Tomb, Holy Rider. See *ibid.*, 250 ff., figs. 2–5, pls. at end of volume. Figure 10: New York, J. Spier Collection; illustrated ca. 1:1. Inscriptions: Psalm 90; *Trisagion*; *Theotoke Boethei Anna, Charis*. Iconography: Women at the Tomb, Virgin and Child, Holy Rider. Unpublished. I would like to thank Mr. Spier for these photographs, and for permission to publish them.

[57] For Psalm 90.1 and the holy rider, see Bonner, *Magical Amulets*, 5, nos. 294 ff. The holy rider in figure 10 differs from the more common sort illustrated in Bonner (and appearing, for example, in the central medallion in the front view of fig. 9) insofar as he does not impale an evil, prostrate figure or beast. This more stately version likely derives from traditional *adventus* iconography as it was adapted for Christ in the Entry into Jerusalem—a scene which appears with remarkable frequency on Early Byzantine amulets (e.g., Wulff, *Altchristliche Bildwerke*, no. 825). This was the one biblical episode wherein Christ was, in effect, a "holy rider"; moreover, the victorious nature of the event was itself fully appropriate to amulets, which necessarily relied on the invocation of Christ's power. Usually, as here, the iconography is reduced to a single figure (holding a large cross) and the animal that carries him; often, though not here, that animal is characterized as a donkey by its long ears (cf. our fig. 23). Both types of holy rider appear on one armband in our group; see W. Froehner, *Collection de la comtesse R. de Béarn* (Paris, 1905), 10.

[58] For the most recent statement of received opinion, see E. Kitzinger, "Christian Imagery: Growth and Impact," *Age of Spirituality: A Symposium*, ed. K. Weitzmann (New York, 1980), 151 f. (illustrating the armbands in our figures 8 and 9).

[59] Remarkably similar in general design and apparent function is a bronze medico-amuletic *tabella ansata* (?) in the British Museum which shows a stately rider (not Christ) and his attendant, three snakes, and the inscriptions: *Heis Theos* and *Hygieia*. Dalton assigned the piece, which came from Tyre, to the sixth century, and suggested that it was made "to bring health or luck." See O. M. Dalton, *Catalogue of Early Christian Antiquities and Objects from the Christian East in the . . . British Museum* (London, 1901), no. 543.

[60] On the Chnoubis, see Bonner, *Magical Amulets*, 54 ff.; and Delatte and Derchain, *Intailles magiques*, 54 ff. There is an unpublished armband with the Chnoubis in the Benaki Museum, Athens (no. 11472). This was kindly brought to my attention by L. Bouras.

prevents pain in the stomach; you will easily digest every kind of food.[61]

Most often the Chnoubis takes the form it has at the bottom center of the central medallion in figure 8; namely, as stipulated above, that of a lion-headed snake with nimbus and rays—either seven for the planets or twelve for the signs of the zodiac. Indeed, this Chnoubis closely matches that of a jasper intaglio in the Cabinet des Médailles, on whose back side are the words, "Guard in health the stomach of Proclus" (fig. 12).[62] On the other hand, the Chnoubis which fills the central medallion of our figure 9, second view, is of a more unusual, highly abstract sort; although its seven rays are immediately recognizable, its tail is now much withered and its lion head, within a bean-shaped nimbus, seems almost more human than leonine. Nevertheless, its iconographic identity and functional significance remain unmistakable: not only were these armbands specifically medicinal, they were very likely designed specifically to treat distress in the abdomen.

This group of medico-amuletic armbands, once recognized for what it is, holds the key to the identification of several other related types of implements for supernatural healing among the arts of early Byzantium. Consider, for example, the octagonal silver ring, of seventh- or eighth-century date, illustrated in figure 13.[63] It appears to have been designed as a condensed, "finger-sized" version of an armband, for not only are its technique and medium the same, its hoop bears the familiar words from Psalm 90, while its (single) incised medallion shows—in even more degenerate form—the armband's Chnoubis. Actually, this ring's Chnoubis bears closer comparison with the "mummified," human-headed form that the creature takes on some earlier amuletic gems (fig. 14).[64] Besides the face and

seven rays,[65] note that on both amulets the creature is set over a rectangular base (inscribed *Iaw* on the gem), and that it is accompanied by much the same assortment of complementary magical characters or "ring signs."[66] Two of the three characters on the ring—the stars and the "Z"—are matched on the back of the gem, while the third—the *pentalpha*—accompanies the Chnoubis in the medallions of our two illustrated armbands.[67] Notice that the "Z" also appears with the Chnoubis on the Fouquet armband (fig. 8); significantly, this specific character is known to have had a long and close association with Chnoubis (i.e. abdominal) amulets.[68] In fact, it is this character that Alexander of Tralles instructs be placed "on the head" (bezel?) of medico-amuletic rings used to treat colic—rings which, like this one, were to have eight-sided hoops.[69] Thus it seems that in both iconography and function this ring may legitimately be charac-

[61] F. de Mély and C. E. Ruelle, *Les lapidaires de l'antiquité et du moyen age, II: Les lapidaires grecs* (Paris, 1896–1902), II, 177 (quoted in Bonner, *Magical Amulets*, 55).

[62] Paris, Cabinet des Médailles, no. 2189; illustrated 1.5:1. See Delatte and Derchain, *Intailles magiques*, no. 80. Another such gem is in the Benaki Museum, Athens (no. 13537).

[63] Houston, Menil Foundation Collection, II.B24; illustrated 1:1. Said to have come from Asia Minor. Inscription: Psalm 90. Iconography: Chnoubis head with *pentalpha* and ring signs. See G. Vikan and J. Nesbitt, *Security in Byzantium: Locking, Sealing, and Weighing*, Dumbarton Oaks Byzantine Collection Publications, 2 (Washington, D.C., 1980), 20. A dating to the seventh or eighth century is indicated by the form of the *beta* ("R" with a bar across the bottom).

[64] Formerly in a private collection, Paris; illustrated ca. 1:1. For the iconography and inscriptions of this intaglio, see Bonner, *Magical Amulets*, 59; and E. R. Goodenough, *Jewish Symbols*

in the Greco-Roman Period, Bollingen Series, 37 (New York, 1953), II, 263 f., fig. 1137.

[65] One "ray," detached and at the bottom of the bezel, may well be an echo of the creature's lost serpent's tail. The rays on the Paris gem terminate in the letters for the semitic formula *semes eilam*, "eternal sun" (*ibid.*, 263).

[66] This "base" may well have developed from the *cista* which sometimes appears below the Chnoubis (cf. Delatte and Derchain, *Intailles magiques*, nos. 70, 79). On magical characters or "ring signs" (so-called because they often terminate in tiny rings), see Bonner, *Magical Amulets*, 58 f., 194 f.; Delatte and Derchain, *Intailles magiques*, 360; and A. A. Barb, "Diva matrix," *JWarb*, 16 (1953), note 48. Such symbols appear frequently on Greco-Egyptian medico-magical gems.

[67] These armbands and the stamp illustrated in our figure 4 suggest that the *pentalpha* may have been a specifically "medical" character. Among the Pythagoricians it was recognized as the symbol of health and was, in fact, named *hygieia*. See P. Perdrizet, *Negotium perambulans in tenebris*, Publication de la Faculté des Lettres de l'Université de Strasbourg, 6 (Strasbourg, 1922), 35 ff.

[68] See Bonner, *Magical Amulets*, 59. The bottom character on the reverse of the gem in figure 14 is also distinctive to Chnoubis amulets.

[69] Alexander of Tralles VIII, 2 (= *On Colic*): Grk. text, ed. Puschmann, *Alexander*, II, 377; Fr. trans., Brunet, IV, 81:

Take an iron ring and make its hoop eight-sided, and write thus on the octagon: "Flee, flee, O bile, the lark is pursuing you." Then engrave the following character on the head of the ring: N. I have used this method many times, and I thought it inappropriate not to draw your attention to it, since it has a power against the illness. But I urge you not to communicate it to people you happen to meet, but to reserve it to those who are virtuous and capable of guarding it.

The "Z" (or "N") symbol Alexander recommends has qualities of that of the Fouquet armband (fig. 8) and that of the Menil ring (fig. 13): the terminations of the bars are marked by small rings, and two more tiny rings appear to each side of the transverse stroke. No ring with precisely the above characteristics is known to have survived, which is hardly surprising considering the metal that Alexander stipulates. However, the Menil Foundation Collection does include an octagonal iron ring (no. II.B23)

terized as the Byzantine descendant of Greco-Egyptian ancestors like those illustrated in our figures 12 and 14. True, the medium and format have changed, the inscription is now biblical, and the Chnoubis itself has turned into a creature very much like Gorgon—it's tail, once compressed (fig. 8), desiccated (fig. 9), and detached (fig. 13), has been all but forgotten, and its seven "rays," now fully circumscribed by their traditional solar disc, have acquired monster heads. Yet, through all of this, the basic function of this object type remained the same and, even today, the genealogical thread that binds its distinctive imagery over centuries and cultures is unmistakable.[70]

The Menil ring (fig. 13) is one of a group of Byzantine amuletic rings of similar design and decoration, some of which bear inscriptions shedding additional light on their medical use.[71] One silver specimen in the British Museum shows a bezel much like the Menil ring, with a human head and seven monster-headed rays; its octagonal hoop, however, is inscribed with the words, "Lord, help the wearer."[72] Now significantly, the gerund used for "wearer" bears a feminine case ending, which sug-

gests the possibility that the abdominal distress against which this Chnoubis' powers were invoked was of a specifically womanly sort[73]—a possibility which is substantially strengthened if not confirmed by yet another silver ring in the group, excavated at Corinth (fig. 15).[74] Again, the bezel takes the form of a solar disc, at the center of which is the rayed Chnoubis/Gorgon, though this time without the monster terminations. The point of special interest, however, is the inscription on the hoop, which reads, "Womb amulet" ([Hy]sterikon Phylakterion). For not only does the uterus fall naturally within the Chnoubis' abdominal domain,[75] the Chnoubis was one of just a few magical creatures—all "masters of the womb"—who were specifically charged with control over the uterus on Greco-Egyptian gem amulets. The Chnoubis will, for example, often appear atop a bell-shaped representation of the womb, at the lower orifice of which will be the great key by which the organ is "closed" and thereby controlled (fig. 16).[76]

As silver armbands led naturally into this group of rings, so these rings draw us into a much larger, generally much later group of uterine pendant amulets which have long been recognized as medico-amuletic, because the inscriptions that many of them bear address the womb (Hystera) directly, as though it were a living creature.[77] They usually apply to it the double epithet "dark and black one," and often accuse it of "coiling like a serpent, hissing like a dragon, and roaring like a lion"—and then admonish it to "lie down like a lamb."[78] Most

with a large square bezel bearing the opening words of Psalm 90.

[70] It is unmistakable, thanks to the silver armbands illustrated in figures 8 and 9, which show clearly the process whereby the rayed Chnoubis head, in its human form, came to dominate and then eliminate the creature's snake tail—even while the distinctive number of rays and associate magical characters remained constant. For the Byzantines, the rayed Chnoubis head thus acquired the character of a Gorgon-like emblem. Indeed, there is evidence that Gorgon and the Chnoubis may fairly early on have been confused with one another: a gem amulet published three decades ago by Campbell Bonner shows on one of its faces a very classical Gorgon head; on its other side a later inscription addresses that creature as "Gorgon" at its beginning and "Chnoubis" at it closing. See C. Bonner, "A Miscellany of Engraved Stones," Hesperia, 23:2 (1954), no. 42. The adaptation of the Chnoubis to ring bezels and pendants (cf. our fig. 18), and its seeming identification with (and partial transformation into) Gorgon, was probably facilitated by the fact that Late Antiquity already knew a tradition of Gorgon (Medusa) pendants. Compare, for example, M. Hewig, A Corpus of Roman Engraved Gemstones from British Sites, BAR British Series 8, 2nd ed. (Oxford, 1978), nos. 750 ff.

[71] The group is characterized by large, thin bezels with flat, usually octagonal hoops, and by Chnoubis heads and magical ring signs; like the armbands, most of these rings are silver. See Dalton, Early Christian Antiquities, no. 142; Orsi, Sicilia bizantina, fig. 68; and G. R. Davidson, Corinth, XII: The Minor Objects (Princeton, 1952), 231, nos. 1947–1953. There are two unpublished members of this group in the Clemens Collection, Cologne (Kunstgewerbemuseum nos. H 937 and G 848). Both are from Sicily, and are close to those published by Orsi. One (G 848) shows a six-rayed Chnoubis head set upon shoulders. I would like to thank B. Chadour for bringing them to my attention.

[72] Dalton, Early Christian Antiquities, no. 142.

[73] It is worth noting here that the Spier armband (fig. 10) carries an invocation naming a certain "Anna."

[74] Davidson, Corinth, no. 1947 ("not later than the tenth century"); illustrated 1:1.

[75] This is true whether considered simply as a potentially troublesome organ, as the process of healthy childbirth (or birth control), or as the generic womanly organ whose "wanderings" might cause any number of physical or emotional problems. See Bonner, Magical Amulets, 90; and Barb, "Diva matrix," 193 ff. Cf. PGM, VII, 260–71.

[76] Paris, Cabinet des Médailles, no. B1 14; illustrated 1.5:1. See Delatte and Derchain, Intailles magiques, no. 345. To the left and right of the Chnoubis are Isis and a dog-headed mummy; enclosing the group is the Ouroboros, the snake with its tail in its mouth.

[77] For the most recent treatment of the group, and references to most of the extensive earlier bibliography, see V. N. Zaleskaja, "Amulettes byzantines magiques et leur liens avec le littérature apocryphe," Actes du XIVᵉ Congrès International des Etudes Byzantines, Bucharest, 6–12 Septembre, 1971, III (Bucharest, 1976), 243 ff. See also Bonner, Magical Amulets, 90 f.; and notes 78 and 86 below. Cf. PGM, VII, 260–71.

[78] For the inscriptions, see W. Drexler, "Alte Beschwörungsformeln," Philologus, 58 (1899), 594 ff.; and V. Laurent, "Amulettes byzantines et formulaires magiques," BZ, 36 (1936), 303 ff.

members of this group carry some such uterine charm and an appropriate invocation addressed to the Virgin, while all show a form of the Gorgon-like head familiar from our group of rings. Only relatively few of these amulets are of the period of the earlier extant rings (i.e., seventh to eighth century), and none appears to be contemporary with the armbands (sixth to seventh century). Among the earliest members of the group is a cast lead specimen in the Hermitage (fig. 17),[79] whose apotropaic device is remarkably like that of the Corinth ring; around its circumference is a garbled version of the *Trisagion*, while on its back side the uterus is named, and the help of Holy Mary and the Theotokos are invoked against it. On the other hand, a slightly later—perhaps ninth century—silver pendant in the Menil Foundation Collection (fig. 18)[80] is closer in general design to the Menil ring; moreover on both, the creature's seven rays individually take a form surprisingly close to that of the more traditional lion-snake Chnoubis.[81] The many errors in transcription on this pendant betray the hand of a craftsman basically ignorant of the rich medico-magical tradition that lies behind it. Between the creature's serpentine solar rays are the letters for "Grace of God" (without the initial *chi*) and *Iaw*,[82] while around its circumference is, again, the *Trisagion* (with *alphas* for *lamdas* and a *kappa* for a *beta*).[83] On the pendant's back side is a complete but confused rendition of the *Hystera* charm common to the group: (around the circum-

ference) "Womb, dark [and] black, eat blood [and] drink blood";[84] (within the field) "As a serpent you coil; as a lion you roar; as a sheep, lie down; as a woman. . . ." Framing the inscription is a series of traditional but again confused magical characters and symbols: above are the *pentalpha*, two crescent moons, a star, an erect snake(?), and a figure—perhaps a misunderstood archangel—holding a long cross staff, while below are a pair of "Z"s and a ring-sign star lacking two of its normal eight points. All of these symbols appear frequently on Late Antique gem amulets and, as we have already seen, the "Z," the star, and the *pentalpha* have strong traditional ties with Chnoubis abdominal amulets—and now through them, with the uterus.[85] Indeed, that these pendants bear charms which admonish the uterus to "lie down," and here, moreover, to consume blood—presumably the blood that it would otherwise discharge—suggest that they may have functioned specifically to enhance fertility; that is, a tranquil, bloodless womb will avoid miscarriage and favor healthy parturition.[86]

Those for whom our silver armbands were made need not have relied solely on the magic of the

[79] Leningrad, State Hermitage Museum, *omega* 1159; illustrated 1:1. The suspension loop has broken away. See Zalesskaja, "Amulettes," 244, fig. 3; and for an identical specimen, Laurent, "Amulettes," 308, fig. 2 (who renders and discusses the inscription. Note that the rays again number seven, and that above the head of the creature is a three-pronged fork motif which recalls the central, Chnoubis medallion of the Fouquet armband (fig. 8).

[80] Houston, Menil Foundation Collection, no. 824; illustrated ca. 1:1. The suspension loop has broken away. Said to have come from Asia Minor. Unpublished. I wish to thank Nicolas Oikonomides and Werner Seibt for help in reading and dating this inscription. A nearly-illegible bronze pendant much like this one is preserved in the Benaki Museum, Athens.

[81] Characteristics, besides the serpentine body, include the rearing head, long snout, open mouth, and projecting tufts of mane behind the head. Compare, in addition to our figures 8, 12 and 16, Bonner, *Magical Amulets*, nos. 81, 82; and Delatte and Derchain, *Intailles Magiques*, no. 62. The device on the Menil pendant is formed as if of a single human-headed Chnoubis which itself sprouts seven lion-snake Chnoubis rays.

[82] Compare our figure 14. On *Iaw* as an amuletic expression of divine power, see Bonner, *Magical Amulets*, 134 f.

[83] That a *K* could be substituted for a *B* (in *Sabaoth* of the *Trisagion*) suggests that the form of the *beta* in the craftsman's model was that characteristic of the seventh and eighth centuries (and found on the hoop of the Menil ring), which looks like a Latin "R" with an (easily overlooked) bar across the bottom.

[84] I take this as an injunction addressed to the uterus. Although references to the consumption of blood have not hitherto been documented among this particular group of pendant uterine charms, they do appear on earlier amulets of similar function. See Bonner, *Magical Amulets*, 88, 217 f.; and A. A. Barb, "Bois du sang, Tantale," *Syria*, 19 (1952), 271 ff.

[85] For the stars, moons, "snake," and "Z," see Bonner, *Magical Amulets*, nos. 75, 108, 163, 222, 280, 339, etc. For the figure with the long staff, see M. C. Ross, *Catalogue of the Byzantine and Early Mediaeval Antiquities in the Dumbarton Oaks Collection, Volume I: Metalwork, Ceramics, Glass, Glyptics, Painting* (Washington, D.C., 1962), no. 117 (one of many of this type).

[86] Barb ("Bois du sang," 279) offers a similar interpretation for an amulet bearing Tantalus, a representation of the uterus, and the injunction that Tantalus "drink blood." The origin and meaning of the Gorgon-like device that dominates the pendants in this group has intrigued and puzzled scholars for more than a century. (For a brief review of scholarship, see Zalesskaja, "Amulettes," 243 f.; Bonner, *Magical Amulets*, 90; and Barb, "Diva matrix," 210 f.) That no satisfactory solution was ever offered is due in large measure to the fact that these pendants were never studied within the broader context of Early Byzantine medical amulets, for it is only by way of related rings and armbands that their imagery (and function) may be traced back to Antique Chnoubis gems. Most recently Zalesskaja, taking up Sokolov's arguments of 1889, rightly rejected all prevailing theories with the observation that none accounted for the fact that the creature's serpentine rays usually number seven (on earlier specimens) or twelve (on later examples). Yet, when he chose to disregard Greco-Egyptian gem amulets and instead to explain the "seven" textually, by way of the "seven female spirits" from the *Testament of Solomon* (McCown, *Testament*, 31* ff.) who have control over (e.g.) "deception, strife, jealousy, and error," Zalesskaja failed to account for the pendants' uterine connection, much less for their rich iconographic tradition, and that of their accompanying magical characters.

Chnoubis, for there were two other iconographic "charms"—the holy rider and the Palestinian christological cycle—whose powers converged toward the same end. Indeed, two of the earliest members of our uterine pendant group show a holy rider on their reverse side.[87] Surely this rider and the Chnoubis on the obverse were thought to act in concert against a common evil, and surely that evil is to be recognized in the bare-breasted female who, beneath the hooves of the horse, is about to be impaled by the rider's lance (cf. figs. 9, 19, 20).[88] But who is she? As many scholars have already concluded in discussing the same iconography on other, contemporary amulets, this can only be antiquity's female archdemon: Lilith among the Jews, Alabasdria in Early Byzantine Egypt (and so labelled in the well-known fresco at Bawit), Gyllou to the Byzantines, and Abyzou in the *Testament of Solomon*.[89] The evil intent of this creature, who went by as many as forty names and took nearly as many shapes, is spelled out in the *Testament of Solomon*:

> I am Abyzou [or Obizuth]; and by night I sleep not, but go my rounds over all the world, and visit women in childbirth. And . . . if I am lucky, I strangle the child.[90]

Obviously, in attacking this archenemy of parturient women the holy rider was serving one and the same goal as that implicit in the very presence of the Chnoubis/Gorgon (as "master of the womb") and explicit in uterine charms like "lie down," and "drink blood"; namely, the goal of healthy, successful childbirth.[91]

The holy rider was one of Late Antiquity's most popular amuletic motifs; indeed, in this statistical sense alone it may be said to have taken over the role once played by the Chnoubis.[92] One of its most characteristic appearances is on the obverse of a distinctive genre of intaglio haematite amulet; the rider is labelled "Solomon" and the gem's back side usually bears the words: *Sphragis Theou*, "Seal of God" (figs. 19, 20).[93] Although Solomon was not, in fact, a mounted warrior, he was renowned as the most powerful of the Kings of Israel; endowed with exceptional wisdom, he was believed by Jews and Christians alike to wield power over evil spirits. According to the *Testament of Solomon*, which was probably the most popular magic treatise in early Byzantium, King Solomon was able to control and exploit the forces of evil, and thereby build the Temple, only because God had given him a "little

[87] See Schlumberger, "Amulettes," 79; and H. Möbius, "Griechisch-orientalische Bleimedaillons aus Ionien," *AA*, 56 (1941), 26. On the armbands the Chnoubis and the holy rider seem to have been interchangeable as well as complementary. A few of the more elaborate examples in the group (e.g., Froehner, *Collection*, 7) add the apotropaic acclamation *Heis Theos O Nikon Ta Kaka* over the rider; significantly, that same acclamation is coupled instead with the Chnoubis on the Fouquet armband (our fig. 8).

[88] That the figure beneath the horse is indeed female and bare-breasted is clear on a few of the finer armbands, (e.g., *ibid.*, 7; and O. M. Dalton, "A Gold Pectoral Cross and an Amuletic Bracelet of the Sixth Century," *Mélanges offerts à M. Gustave Schlumberger* [Paris, 1924], II, pl. XVII,3).

[89] See Perdrizet, *Negotium*, 15 ff.; A. A. Barb, "*Antaura*: The Mermaid and the Devil's Grandmother," *JWarb*, 29 (1966), 4 ff.; and C. Detleff and G. Müller, "Von Teufel, Mittagsdämon und Amuletten," *JbAChr*, 17 (1974), 99 ff. On Early Byzantine amulets this she-devil is frequently coupled with the "much-suffering" Evil Eye—the destructive eye of envy—which was her *modus operandi*. See Perdrizet, *Negotium*, 30; and, for some examples, Bonner, *Magical Amulets*, nos. 298–303. For the Bawit frescoes, see J. Clédat, *Le monastère et la nécropole de Baoît*, MémInstCaire, 12 (Cairo, 1904), pl. LVI. There is an interesting Early Byzantine rock crystal cone seal in the Malcove Collection, University of Toronto, which shows above the holy rider three letters, *gamma*, *iota* (?), and *lamda*, which were probably intended to label "Gilou" (Gyllou), which here takes a very snakelike form. On variant spellings of this demon's name, see Perdrizet, *Negotium*, 20; and on the Byzantine cone seal as a genre, see Vikan and Nesbitt, *Security*, 20 ff., fig. 46. In the Benaki Museum in Athens is a gold belt(?) clasp of sixth- or seventh-century date with a monogram which may resolve as *Gelou*. See B. Segall, *Museum Benaki, Athens: Katalog der Goldschmiede-Arbeiten* (Athens, 1938), no. 267. Thanks for this reference are due to L. Bouras.

[90] McCowan, *Testament*, 43* ff.; and F. C. Conybeare, "The Testament of Solomon," *JQR*, 11 (1899), 30.

[91] In the *Testament of Solomon* (*loc. cit.*) Abyzou is described as having: a woman's form, a head without limbs, dishevelled hair tossed wildly, and a body in darkness. This Gorgon-like description, plus the close medico-magical association of Abyzou and the Chnoubis (one the demon and the other the antidote) may well have contributed to the latter's iconographic transmutation in medieval Byzantium—where, after all, the Greco-Egyptian Chnoubis would have been little understood. Yet, it would be a mistake to identify Abyzou with Gorgon and, in turn, both with the device on our uterine rings and pendants—as A. A. Barb has done ("*Antaura*," 9). For then left unexplained would be the recurrent choice of precisely seven "rays," the solar disc, the associated Chnoubis magical characters, and the close relationship of the pendants and rings to the armbands, where the Chnoubis is unmistakable. Furthermore, it should be recalled that Abyzou (as a bare-breasted female) does appear occasionally on one and the same object with the Gorgon-like uterine device (note 87 above). And finally, Gorgon-Medusa, when it does appear in early Byzantium (e.g., on Athena bust weights) in fact looks nothing like our pendants' apotropaic device (cf. G.F. Bass, "Underwater Excavations at Yassi Ada: A Byzantine Shipwreck," *AA*, 77 [1962], 560). Contrast also the earlier Gorgon-head pendants cited in note 70 above.

[92] See Bonner, *Magical Amulets*, 208 ff., nos. 294 ff.; B. Begatti, "Altre medaglie di Salomone cavaliere e loro origine," *RACr*, 47 (1971), 331 ff.; and J. Russell, "The Evil Eye in Early Byzantine Society," *XVI. Internationaler Byzantinistenkongress, Akten* II/3, *JÖBG*, 32:3 (1982), 540 ff.

[93] Figure 19: Columbia, University of Missouri Museum of Art and Archaeology, Robinson no. 35; illustrated 1:1. See Bonner, *Magical Amulets*, no. 296. Figure 20: Ann Arbor, University of Michigan, no. 26092; illustrated 1:1. See *ibid.*, no. 294. For the genre as a whole, see P. Perdrizet, "Sphragis Solomonis," *REG*, 16 (1903), 49 f.; Bonner, *Magical Amulets*, 208 ff., nos. 294 ff.; and Delatte and Derchain, *Intailles magiques*, nos. 369 ff.

seal ring" with which he could "lock up all the de-mons."[94] Solomon's identification on the obverse of these amulets with the holy rider—a generic emblem of victory—evokes in a graphic but symbolic way his victory over demons, while the inscription on the reverse simply identifies the vehicle of that victory, the "Seal of God."

From the beginning, Solomon's supernatural powers were thought to have a specifically medical dimension.[95] According to Josephus:

> God granted him knowledge of the art used against demons for the benefit and healing of men. He also composed incantations by which illnesses are relieved, and left behind forms of exorcisms with which those possessed by demons drive them out, never to return.[96]

Similarly, the *Testament of Solomon* includes a number of purely medical encounters between this Old Testament king and sickness-inducing spirits, each of whom Solomon forces—with God's seal ring—to reveal his name and the magical influence to which his powers are subject. Solomon's interrogation of the "Thirty-Six Elements of the Cosmic Ruler of Darkness," for example, provides a veritable litany of human afflictions and of supernatural antidotes:

> And the ninth [Element] said: "I am called Kurtael. I send colics in the bowels. I induce pains. If I hear the words, Iaoth, imprison Kurtael, I at once retreat." And the tenth said: "I am called Metathiax. I cause the reins to ache. If I hear the words, Adonael, imprison Metathiax, I at once retreat." And the eleventh said. . . .[97]

Against this background it is hardly surprising to discover that at least some Solomonic amulets were intended to be specifically medicinal from their point of manufacture. For example, a bronze amuletic ring from Early Byzantine Egypt bears around the circumference of its bezel the words, "Solomon, guard [i.e., preserve] health," while at its center is an anchor-cross with fish, one of the most frequently-employed devices on Early Christian signet rings (fig. 21).[98] In both design and effect

this ring shares much in common with the Chnoubis gem amulet illustrated in our figure 12, on the back side of which are the words: "[Chnoubis], guard in health the stomach of Proclus."[99]

Returning now to the holy rider/Abyzou, and specifically to our group of haematite amulets, several points are worthy of note. First, some of these amulets bear magic characters beneath the inscription on their back side, and the one that appears most frequently—the "barred-triple-S" (fig. 19)—was, even more than the "Z," specifically associated with the Chnoubis (cf. fig. 14).[100] Second, at least a few specimens within this series of intaglios show, instead of the "barred-triple-S," what is unmistakably a key beneath the inscription on their back side (fig. 20). And while it is certainly true that the key was, in early Byzantium (and especially in the *Testament of Solomon*), functionally equivalent to, and interchangeable with, the seal,[101] it is also true that the key had its own special meaning within the tradition of Antique gem amulets: it was the "key to the womb" (note again our figure 16).[102] This brings us to the third and most interesting point: the vast majority of surviving Greco-Egyptian "clé de matrice" amulets are of the same size, shape, and *material* as our group of Solomon amulets—which suggests, of course, that they were part of the same

abbreviated. The beginning of the inscription is marked by what appears to be a simple cross. For another Solomon amulet with similar inscription, see Perdrizet, "Sphragis," 46; and for this verb on amulets, see Bonner, *Magical Amulets*, 179 f. A "neutral" subject already popular among pagans, the anchor-with-fish motif was one of the most readily accepted devices for Early Christian signets. Specifically sanctioned by Clement of Alexandria (*Paed.* 3.11), the anchor evoked the cross and the hope of the faithful for salvation (Hebrews, 6.19). The fish, on the other hand, may have been intended to evoke the *ICHTHYS* acrostic for Christ, the souls of the faithful, or it may have been nothing more than a compositional carryover from pagan prototypes.

[99] Another Solomonic *phylakterion*, though of a less permanent sort, is described to Pseudo-Pliny (3.15: *ad quartanas*): ". . . *in charta virgine scribis quod in dextro brachio ligatum portet ille qui patitur: recede ab illo Gaio Seio, tertiana, Solomon te sequitur.*" V. Rose, ed., *Plinii secundi quae fertur una cum Gargilii Martialis Medicina* (Leipzig, 1875), 89 = A. Önnerfors, ed., *Plinii secundi iunioris: De medicina* (Berlin, 1964 [*CML* III]), III, 15.7–8 (p. 78). Similarly, a papyrus amulet of the fifth or sixth century (PO, 18, 415 ff.) bears the Lord's Prayer followed by "the exorcism of Solomon against all impure spirits"; it concludes with these words: "guard those who carry this amulet from fever, from all sorts of maladies, and bad wounds. Thus be it."

[100] Bonner, *Magical Amulets*, 58 f., nos. 296, 297; Delatte and Derchain, *Intailles magiques*, 56 f., nos. 371, 376.

[101] Thus Solomon was able to "lock up all the demons." See G. Vikan, "Security in Byzantium: Keys," *XVI. Internationaler Byzantinistenkongress, Akten* II/3, *JÖBG*, 32:3 (1982), 503 ff. (esp. 506).

[102] Bonner, *Magical Amulets*, 85 ff.; and Delatte and Derchain, *Intailles magiques*, 245 ff.

[94] It was this ring which, according to some variants of the text, bore the *pentalpha* as its device. See McCown, Testament, 10*. For the composition, text tradition, and scholarship of the *Testament of Solomon*, see A.-M. Denis, *Introduction aux pseudépigraphes grecs d'Ancien Testament* (Leiden, 1970), 67.

[95] Perdrizet, "Sphragis," 44 ff.

[96] *Jewish Antiquities* 8.45 (Loeb, V [Cambridge, Mass./London, 1935]).

[97] McCown, *Testament*, 53*; and Conybeare, "Testament," 35.

[98] Illustrated ca. 1:1. This ring, which should probably be dated from the fourth to the sixth century, was kindly brought to my attention by its owner, who lives in California. Although "Solomon" is spelled out in full, *Hy[ieia]* and *Phyla[xon?]* are much

medico-magical tradition and fulfilled basically the same function.[103] And it seems likely that the most important "constant" in that tradition was neither format nor iconography, but rather the material itself: haematite ("bloodstone").[104] For among the many virtues attributed to haematite over the centuries in treatises on stone, the most important was its ability to stop the flow of blood.[105] And naturally, with this styptic function we are drawn back again to those uterine charms which adjure the consumption of blood and the calming of the womb, and to the impaled Abyzou (with her designs on infants), and to the Chnoubis (as "master of the womb"), and, finally, to that lonely key in figure 20, whose magical function was surely that of closing and controlling the womb.[106]

Complementing the Chnoubis and holy rider medallions on the more elaborate of our armbands is a third inconographic "charm": the Palestinian

christological cycle (figs. 8–10).[107] And it seems likely that this charm, too, was thought to convey a measure of supernatural healing power. After all, on the pilgrim ampullae (fig. 11) it was coupled with *eulogia* oil of the sort often used, like blessed earth, to perform miraculous cures; this, for example, was the practice at the shrine of St. Menas, near Alexandria:

> The pilgrim suspended a lamp before the grave [of St. Menas]. . . . It burned day and night, and was filled with fragrant oil. And when anyone took oil of this lamp . . . and rubbed a sick person with it, the sick person was healed of the evil of which he suffered.[108]

Moreover, there have recently appeared two hoards comprising more than ninety tiny image-bearing clay tokens (figs. 22–24) which in design and fabric are much like small Symeon tokens, but which iconographically match up instead with the ampullae and armbands.[109] Some bear scenes like the

[103] Barb ("Bois du sang," 279) was the first to note this; it had escaped the notice of both Bonner and Delatte.

[104] Haematite is a black iron ore which, when powdered or rubbed against a rough surface, becomes red (cf. Pliny, *Nat. Hist.* 36.147). In the case of the armbands, rings, and pendants, the genealogical thread leading back to Greco-Egyptian gems is iconographic; medium and format had changed radically. Here, on the other hand, medium and format were maintained while the main (though not the secondary) iconographic motifs were changed radically.

[105] See Barb, "Bois du sang," 279.

[106] Both Perdrizet ("*Sphragis*," 50) and Barb ("Bois du sang," 279) recognized the power for "blood control" in haematite amulets. Moreover, Perdrizet drew this conclusion specifically in relation to these Solomon haematites—though, unaware of their links to earlier uterine amulets, he did not see their significance for the womb and for procreation.

That the demon Gyllou, Solomon, and childbirth were closely linked in the Byzantine mind (at least in later centuries), is indicated by a passage in Michael Psellus (K. Sathas, *Bibliotheca graeca medii aevi*, V [Paris, 1876], 572 f.) wherein the latter two are introduced in his short discussion of the former. Late antiquity knew another, specifically Christian blood-control (by implication, "birth") amulet: the healing of the woman with the issue of blood (Mark 5.25 ff.). A rock crystal pendant with that iconography is preserved in the J. Spier Collection, N.Y.C., while one in green jasper is in the Benaki Museum, Athens (no. 13527; with a Crucifixion on its back side). Both are likely of east Mediterranean origin and of sixth- to seventh-century date; a later specimen in haematite is in the Metropolitan Museum (*Age of Spirituality: Late Antique and Early Christian Art, Third to Seventh Century*, ed. K. Weitzmann, Exhibition: Metropolitan Museum of Art, New York [1977–1978; published 1979], no. 398). Pliny notes that "the people of the East" wear green jaspers as amulets (*Nat. Hist.* 36.118); Dioscorides, on the other hand, notes that jaspers in general are effective as amulets for childbirth (*De mat. medica* 5.142). In a well-known passage from his *Church History* (7.16.2) Eusebius describes at Paneas the following sculptural ensemble, which was taken in his day to represent (i.e., commemorate) the miracle of the woman with the issue of blood (*The Nicene and Post-Nicene Fathers*, 2nd series, 1 [Grand Rapids, Mich., 1952], 304):

For there stands upon an elevated stone, by the gates of her house, a brazen image of a woman kneeling, with her hands stretched out, as if she were praying. Opposite this is another upright image of a man, made of the same material, clothed decently in a double cloak, and extending his hand toward the woman. At his feet, beside the statue itself, is a certain strange plant, which climbs up to the hem of the brazen cloak, and is a remedy for all kinds of diseases.

[107] See Kitzinger, "Christian Imagery," 151 f. Contrary to Kitzinger, this "cycle" need not have been complete to convey its magic; only a few scenes (our figures 10 and 27) or just one (Wulff, *Altchristliche Bildwerke*, no. 885) might be excerpted and applied to an amulet.

[108] Kötting, *Peregrinatio*, 198. In fact, both the inscriptional and the iconographic evidence provided by the Monza-Bobbio group of ampullae suggests that they were used as travel amulets—though not necessarily to the exclusion of other magical functions. See Vikan, *Byzantine Pilgrimage*, 24. Cyril of Skythopolis writes that St. Saba used oil of the True Cross—which, according to their inscriptions, the Monza-Bobbio ampullae contained—to exorcise evil spirits, at least some of which must have been sickness-inducing (*Vit. Saba* 26).

[109] One hoard, perhaps of Syrian origin, was acquired by the British Museum in 1973 (acc. nos. 1973,5–1, 1–80); it consists of seventy-nine specimens (plus one Symeon token), and has been published by Richard Camber ("A Hoard," *passim*). The second hoard, as yet unpublished, was purchased in 1980 through H. Drouot by Professor Robert-Henri Bautier, Paris; it consists of fourteen specimens, including our figures 22–24 (slightly enlarged). I would like to thank Professor Bautier for a set of photographs of his tokens, and for permission to published them. Together, these two hoards form a homogeneous group of ninty-three clay tokens measuring between .5 and 1.5 cm. in diameter (making them roughly half the size of most Symeon tokens). A preliminary survey indicates that these ninety-three specimens derive from just twenty-two molds representing twelve iconographic themes:

*1.	Adoration of the Magi	21 specimens (3 molds)
2.	"Solomon" (fig. 24)	16 specimens (2 molds)
*3.	Baptism	11 specimens (2 molds)
*4.	Bust of Christ	9 specimens (1 mold)
*5.	Nativity	7 specimens (3 molds)

Women at the Tomb (fig. 22), which depend on a specific *locus sanctus*,[110] while others show the Entry into Jerusalem (fig. 23) which, though biblical, is substantially amuletic;[111] and finally, there are a number of purely magical tokens which bear the name "Solomon" (backwards) and show what appears to be (at least on the better-preserved specimens) a coiled serpent (fig. 24).[112] That these tokens functioned as medicine—deriving their curative powers from their "blessed" earth and amuletic imagery[113]—is suggested by their inherently "consumable" nature, by their inclusion of Solomon,[114] and by their obvious similarity to medicinal Symeon tokens (cf. figs. 2, 3); indeed, the larger of the two hoards included a Symeon token.[115] And just as a Symeon pendant (fig. 7) was capable of conveying that saint's healing power, independent of blessed substance, so also these scenes

*6.	Women at the Tomb (fig. 22)	6 specimens (2 molds)
*7.	Annunciation	5 specimens (3 molds)
8.	Transfiguration (?)	5 specimens (1 mold)
*9.	Entry into Jerusalem (fig. 23)	5 specimens (1 mold)
*10.	Adoration of the Cross	5 specimens (2 molds)
11.	Tempest Calmed	2 specimens (1 mold)
12.	Miracle of Cana	1 specimen (1 mold)

*Indicates those themes paralleled on the ampullae or the armbands.

The genre represented by these two hoards was not unknown. Indeed, nearly two dozen iconographically related clay tokens have been published from various museum collections; some may actually derive from the matrices attested within our two hoards, though most specimens tend to be larger. See Dalton, *Early Christian Antiquities*, nos. 966–68; Wulff, *Altchristliche Bildwerke*, no. 1149 (limestone?); Tchalenko, *Villages antiques*, III (1958), 62, figs. 27, 28; Lafontaine-Dosogne, *Itinéraires archéologiques*, 159 ff., nos. 20–26 (27–31?); H. Buschhausen, *Die spätrömischen Metallscrinia und früchristlichen Reliquiare, 1. Teil: Katalog, Wiener Byzantinistische Studien*, IX (Vienna, 1971), no. C10; L.Y. Rahmani, "The Adoration of the Magi on Two Sixth-Century C.E. Eulogia Tokens," *IEJ*, 29 (1979), pl. 8, B-D; *idem*, "A Representation of the Baptism on an *Eulogia* Token," *'Atiqot: English Series*, 14 (1980), 109 ff.; and Camber, "A Hoard," notes 6 and 9. Just one additional iconographic theme, the frontally-seated Virgin and Child, is attested in this series (Lafontaine-Dosogne); as in our two hoards, the Adoration of the Magi is by far the most frequently attested subject (see also note 116 below).

[110] Compare our figures 10 and 11. Here, the two Marys have been deleted for lack of space. Note again the "grill" of the pilgrim accounts (see note 55 above).

[111] Compare our figure 10. For this scene of "Christ as Holy Rider," see note 57 above. Here, the animal is clearly identifiable as a donkey. And here, as in several other holy rider compositions of the period (e.g., Dalton, *Early Christian Antiquities*, no. 543; and Bonner, *Magical Amulets*, no. 324), the *propempontos* (escort) of traditional *adventus* iconography appears—even though he is not called for by the Gospel account of the Entry into Jerusalem. See K. G. Holum and G. Vikan, "The Trier Ivory, *Adventus* Ceremonial, and the Relics of St. Stephen," *DOP*, 33 (1979), 118 f.

[112] This reading of these Solomon tokens is corroborated by a bronze amulet from Early Byzantine Egypt published by Wulff (*Altchristliche Bildwerke*, no. 825). Its obverse shows the Entry into Jerusalem, while its reverse bears the words *Sphragis Solomonos*, a standing figure (Solomon?), a small cross in a nimbus, and a coiled serpent-like monster. This same form appears between personifications of the sun and moon on a group of closely-interrelated bronze amulets, all but one of which bear an inscription invoking the *Spragis Solomonos*. They are apparently Syro-Palestinian in origin and of sixth- to seventh-century date. See Schlumberger, "Amulettes," nos. 2 and 3; and *Byzantine Art*

in the Collection of the U.S.S.R. (in Russian), Exhibition: The Hermitage, Leningrad; The Pushkin Museum, Moscow (1975–1977), no. 62 (with earlier bibliography, wherein Zalasskaja suggests that the form is Golgotha). An excellent representative of the type is preserved in the Benaki Museum, Athens. For yet another, slightly different rendition of the same creature (with the inscription "Christ, help") see G. Tchalenko, *Villages antique de la Syrie du Nord*, III (Paris, 1958), 62, fig. 29.

[113] The homogeneity of the tokens within this series, plus the fact that some of them (e.g., those with "Solomon") are topographically "anonymous," suggest that they came from a single blessed source and not from so many *loca sancta*. Indeed, there can be no doubt that christological tokens of this sort were being produced from the *eulogia* clay of the Miraculous Mountain: there is the evidence of the two-faced stamp reproduced in our figure 5, and the fact that many non-Symeon clay tokens (among those cited in the second part of note 109 above) have been discovered in the region of Antioch (Lafontaine-Dosogne, *Itinéraires archéologiques*, nos. 20–26; and Tchalenko, *Villages antiques*, III [1958], 62, figs. 27, 28). Several specimens in the Antioch Museum show a frontal Virgin and Child much like that on the reverse of the stamp (cf. fig. 5 and Lafontaine-Dosogne, *Itinéraires archéologiques*, pl. XLVI, no. 20). The possibility that a single blessed hill could be the source of a variety of iconographically heterogeneous tokens obviously runs counter to prevailing art-historical opinion, which would trace each *eulogia* scene back to its own *locus sanctus* and, in specific, to a mural at that shrine (cf. Rahmani, "The Adoration," 35 f.).

[114] The snake may be symbolic of evil (e.g., of the uterus, which "coils like a serpent") or, more likely, of good (e.g., the Chnoubis snake or the snake of Asklepios and Hygieia [cf. Volbach, *Elfenbeinarbeiten*, nos. 84, 84a, 85]). In the latter case especially, a medicinal function is strongly suggested. Three snakes and the word *Hygieia* appear on the medico-amuletic *tabella ansata* in the British Museum cited in note 59 above.

[115] Camber, "A Hoard," fig. 15. One wonders how these two hoards—which may originally have been one—came to be formed. That so many tokens so much alike should have come from a pilgrim's purse seems unlikely. Perhaps instead they were found in the remains of a storeroom or workshop at some holy site (see note 43 above), or perhaps they represent the contents of a doctor's or churchman's medicine box. They look very much like the dozens of clay/resin pellets preserved in (what certainly must be) a Late Roman medicine box found by Petrie in Egypt (*Objects*, pl. XXXIII, 3). Moreover, we know that churchmen could be doctors (cf. Magoulias, "Lives of Saints," 128), and that doctors were not above putting "blessed" ingredients in their remedies (cf. F. Cabrol, "Amulettes," *DACL*, II, 2 [Paris, 1907], 1855). If a medicine box like that preserved in the Vatican (Volbach, *Elfenbeinarbeiten*, no. 138) can bear a Christ miracle scene on its cover, why should not the pills inside be impressed with comparable imagery? It is worth noting here that a clay token with the Adoration of the Magi was discovered in a reliquary in the Chur Cathedral along with an (earlier) ivory medicine box (Buschhausen, *Metallscrinia*, no. C10).

must have had that ability when transferred from their *eulogia* clay (figs. 22, 23) to a silver armband (fig. 10)—or vice versa.[116]

The Palestinian christological cycle shared by the ampullae and armbands appears in its more or less complete form once again during this period, on a series of well-known octagonal gold rings in Baltimore, London (fig. 25), Palermo, and Washington, D.C.[117] These rings are clearly amuletic, and seem to have been designed to exercise their magical powers specifically for married couples. This is suggested by the fact that three of four show husband and wife on their bezel, and by the somewhat unusual quote from Psalm 5.12 which appears on the Palermo ring, "Thou hast crowned us with a shield of favor."[118] To judge from the three rele-

vant bezel compositions, the "us" should be understood as the bridal couple, and the "crowning"—at once metaphorical and literal—as that which takes place as part of the marriage ceremony (over which, in this case, Christ and the Virgin preside).[119] But what is the nature of the "shield"—the amuletic protection or benefit—with which the wedding couple should thereby be provided? Assumedly, it is a protection that applies to them collectively, as does *Omonia* ("[Marital] Harmony"), which is inscribed below the couple on the bezel of the British Museum ring (fig. 25).[120] But if the arguments put forward in this paper are correct, the octagonal shape of the hoop and the Palestinian christological cycle incised on it would seem to imply (if not require) that the benefit to the couple be somehow medical—if not more specifically abdominal or even uterine. And indeed, to judge from the inscription on the Dumbarton Oaks marriage belt (fig. 26; detail), "Health" was a benefit which, along with "Harmony" and "Grace," the bridal couple might legitimately invoke "from God" on their wedding day.[121] And how else can marital health be understood than in terms of healthy and successful procreation?[122]

[116] Here must be added a caveat which applies to all the "medicinal" amulets and *eulogiai* discussed in this paper. Although their primary purpose seems to have been the inducement of supernatural healing, they were almost certainly not confined to that single function. Consider, for example, these two hoards of "medicinal" tokens: the pair of tokens which show the Tempest Calmed clearly betray concerns of the seafaring pilgrim (cf. Vikan, *Byzantine Pilgrimage*, 24), while the one specimen with the Miracle of Cana probably had something to do with the consumption or preservation of wine (cf. other such wine amulets in *Papyrus Erzherzog Rainer: Führer durch die Ausstellung* [Vienna, 1894], 124 f.; and note 29 above). It should also be recalled that among the many *eulogia*-induced cures narrated in the *Vita* of Symeon the Younger, there is one miracle (chap. 235) wherein Symeon's dust is used to calm a storm at sea, and one (chap. 230) wherein it is used to restore spoiled wine.

Individual scenes very much like those appearing on these clay tokens were used, often in the form of press-gold medallions, on amuletic fibulae and pendants. See E. B. Smith, "A Lost Encolpium and Some Notes on Early Christian Iconography," *BZ*, 23 (1920), 217 ff.; W. F. Volbach, "Zwei frühchristliche Gold medaillons," *Berliner Museen*, 34 (1922), 80 ff.; *idem*, "Un medaglione d'oro con l'immagine di S. Teodoro nel Museo di Reggio Calabria," *AStCal*, 13 (1943–1944), 65 ff.; J. H. Iliffe, "A Byzantine Gold Enkolpion from Palestine (About Sixth Century A.D.)," *QDAP*, 14 (1950), 97 ff.; Ross, *Catalogue* (1962), no. 86; *idem*, *Catalogue* (1965), no. 37; and J. Engel, "Une decouverte enigmatique: La fibule chretienne d'Attalens," *Dossiers histoire et archéologie*, 62 (1982), 88 ff. The famous Strzygowski gold medallion at Dumbarton Oaks (Ross, *Catalogue* [1965], no. 36) is basically a deluxe pendant amulet bearing three typical scenes from the Palestinian christological cycle.

[117] London, British Museum; illustrated ca. 1.25:1. See Dalton, *Early Christian Antiquities*, no. 129. Iconography: Annunciation, Visitation, Nativity, Baptism, Adoration of the Magi (out of order), Crucifixion, Women at the Tomb. For the other three rings, see P. Verdier, "An Early Christian Ring with a Cycle of the Life of Christ," *The Bulletin of the Walters Art Gallery*, 11:3 (1958); C. Cecchelli, "L'anello bizantino del Museo di Palermo," *Miscellanea Guillaume de Jerphanion*, OCP, 13 (1947), 40 ff.; and Ross, *Catalogue* (1965), no. 69. For the group, see Engemann, "Palästinische Pilgerampullen," 20 f.; *Age of Spirituality* no. 446 (G. Vikan); and Kitzinger, "Christian Imagery," 151.

[118] For another Byzantine marriage ring with this inscription, see A. Banck, *Byzantine Art in the Collections of the USSR* (Leningrad/Moscow, n.d.), no. 106c.

[119] Some Byzantine rings of the period show crowns hovering over the heads of the bride and groom (e.g., Ross, *Catalogue* [1965], no. 67); on this bezel and on that of the Dumbarton Oaks ring, Christ and the Virgin appear to be putting the crowns in place. See P. A. Drossoyianni, "A Pair of Byzantine Crowns," *XVI. Internationaler Byzantinistenkongress, Akten* II/3, *JÖBG*, 32:3 (1982), 531 f.

[120] This word appears on many Early Byzantine marriage rings. See Ross, *Catalogue* (1965), nos. 67 and 69; and *Age of Spirituality*, no. 263.

[121] Acc. no. 37.33; illustrated 1:1. See Ross, *Catalogue* (1965), no. 38. "Health" is also invoked on the de Clercq gold marriage belt (A. de Ridder, *Collection de Clercq, catalogue: VII, les bijoux et les pierres gravées, 1, les bijoux* [Paris, 1911], no. 1212), and on at least a few bronze marriage rings of the period, including one in the Cabinet des Médailles (Seyrig Coll.), and one in the Menil Foundation Collection (II.B26).

[122] For the Byzantine marriage ceremony, see P. N. Trempela, "Hē akolouthia tōn mnēstrōn kai tou gamou," *Theologia*, 18 (1940), 101 ff. (based on manuscripts dating from the mid- to post-Byzantine period). In addition to "Harmony" and "Grace," there are repeated references to childbearing in the form of a formula based on biblical "models": (e.g.) "Bless us, O Lord our God, as you blessed Zacharias and Elisabeth" (*ibid.*, 149). One is reminded of the inscribed censers from Sicily of the sort illustrated in our figure 6 (cf. note 38 above), which bear the phrase, "Fear not, Zacharias, for thy prayer is heard. . . ." Perhaps the prayers this censer was intended to accompany were those specifically directed toward conception—as were those of Zacharias. It is noteworthy that Symeon the Younger's mother, Martha, went to the Church of St. John the Baptist in Antioch to pray for the conception of a child; after successful incubation, she awoke with a ball of incense in her hand, with which she censed the entire church (*Vita*, chaps. 2 and 3).

That the function of these marriage rings was not merely amuletic, but more specifically medicinal, is corroborated by a closely-related gold and niello "reliquary" locket in the British Museum (fig. 27).[123] Not only are medium and technique the same, this locket, like the rings, is octagonal in outline, and it bears on its obverse two scenes from the Palestinian christological cycle: the Nativity and the Adoration of the Magi. The locket's back side shows a cross-on-steps whose arms terminate in what are probably the letters of a magical number, name or phrase;[124] around its circumference are the words: "Secure deliverance and aversion [from] all evil," while into the edge of its octagon is inscribed: "of Sts. Cosmas and Damian." That these famous holy doctors are named leaves little doubt that this was a medical amulet—that the "evil" from which its wearer should be "delivered" was first and foremost that of ill health. And of course, the power for that deliverance came from the locket's very shape, from its imagery, and from its words, but more than any of these, it must have come from that sanctified bit of material "of Sts. Cosmas and Damian" that this capsule once contained. Most scholars have assumed that this was a tiny relic but, by analogy with the Monza-Bobbio ampullae, it could as well have been a *eulogia*.[125] And indeed, to judge from the *miracula* of these saints, that would seem to be the more likely conclusion: miracle 30, for example, describes the (customary) distribution of blessed wax in the church-shrine during the all-night Saturday vigil, while miracle 13 evokes the practice, already familiar from Symeon's *Vita*, of taking *eulogiai* to be employed in the event of illness away from the shrine.[126] In that instance, the holy medicine—which was ultimately melted and applied to the body—was carried "under the armpit," but it could just as well have been transported in a locket. This would require, of course, that the

locket be easily opened (as this one can be), and would imply that its contents might be periodically consumed and replenished. But if such were true of this gold and niello locket, the net effect would be to make of it much less a "reliquary" than an "amuletic pill box."[127]

Cosmas and Damian, and the problem of how one might ensure one's health while away from their shrine, draw us toward one final genre of Early Byzantine medical artifact: the invocational votive. In our figure 1 is reproduced a tiny silver plaque with a pair of eyes and the words, "In fulfillment of a vow." This object might legitimately be labelled an "acknowledgment votive," since it was almost certainly designed and dedicated to acknowledge a healing received. But if so, it would seem to presuppose a *proactive* counterpart; that is, a votive designed and dedicated to invoke future healing. Yet, as logical as this seems, and as abundant as surviving Early Byzantine votives are,[128] those among them that are demonstrably "medical" in this invocational sense are extremely rare.

One such object, a richly-incised bronze cross supported by a hand, was recently acquired by the Metropolitan Museum (fig. 28).[129] Likely of sixth- to seventh-century date and east Mediterranean manufacture, it shows on its four arms: the Virgin and Child enthroned (top), Sts. Peter and Paul (right and left, inscribed), and Sts. Cosmas and Damian (bottom), while at its center appears St. Stephen (inscribed), with a censer in one hand and an incense box in the other.[130] There are, in addition, two invocations: that in large letters on the horizontal cross arm, "Christ, help [me]," is at once

[123] London, British Museum; illustrated ca. 1:1. See Dalton, *Early Christian Antiquities*, no. 284. Acquired in Constantinople. See M. Rosenberg, *Geschichte der Goldschmiedekunst auf technischer Grundlage: Niello, bis zum Jahre 1000 nach Chr.* (Frankfurt am Main, 1924), 51; and M. Hadzidakis (Chatzidakis), "Un anneau Byzantin du Musée Benaki," *BNJbb*, 17 (1939–1943), 178 ff. (for its correct dating, along with the rings, to the seventh century).

[124] For the argument that these letters provide a date, see Hadzidakis, "Un anneau," 178 ff. The Cologne ring (G 848) cited in note 71 above, and the Benaki bronze pendant cited in note 112 show the same "number."

[125] To judge from its inscriptions, the well-known Demetrius locket at Dumbarton Oaks held both a relic (of blood) and a *eulogia* (of *myron*). See Ross, *Catalogue* (1965), no. 160.

[126] See Deubner, *Kosmas und Damian*; and Kitzinger, "The Cult of Images," note 89.

[127] Rosenberg (*Geschichte der Goldschmiedekunst*, 51) had, without reference to the *miracula*, come to much the same conclusion. The Malcove Collection at the University of Toronto preserves a very unusual—and as yet unpublished—belt or harness fitting which, like this pendant locket, may have functioned as an "amuletic pill box." In place of the belt plate is a small rectangular box with a sliding lid bearing a large cross. The three sides of the box are inscribed with the same phrase as that appearing on the Yale doctor's case cited in note 1 above. Functioning as a belt, this box would perhaps have been found over that part of the body where its powers were thought most effective (cf. Bonner, *Magical Amulets*, 54). It is bronze and likely dates to the later sixth or seventh century. That its lid can be easily slid open suggests that a consummable *eulogia* and not a relic was preserved inside. This box is like a miniature version of those in wood which were used to hold medicine (cf. note 1 above).

[128] For those in the pilgrim trade, see Vikan, *Byzantine Pilgrimage*, 44 ff.

[129] The Cloisters Collection, 1974; 1974.150; reduced. See *Age of Spirituality*, no. 557 (M. Frazer). This votive is now attached to a chandelier, to which it does not belong.

[130] On this as an incense box, see J. Duffy and G. Vikan, "A Small Box in John Moschus," *GRBS*, 24:1 (1983), 97 f.

common and generic, while that on the lower arm, "Sts. Cosmas and Damian, grant [me] your blessing,"[131] is both less common, and more specific in its request. For what else can the "blessing" of these holy doctors be than the blessing of good health? And indeed, that this object was created with precisely that goal in mind is substantially confirmed by two peculiarities, one in its design and the other in its decoration. First, like only a few other Early Byzantine crosses, this one is supported by a hand, a striking conception which has been shown to derive from apotropaic votive hands of Jupiter Heliopolitanus and of Sabazios.[132] And second, St. Stephen is interjected in a position of prominence among an otherwise predictable pantheon of saints for the simple reason that he, like Zacharias, was traditionally associated with incense—and we have already seen how essential censing was to the ritual invocation of supernatural healing.[133]

CONCLUSIONS

A votive cross (fig. 28) and votive eyes (fig. 1) bracket this survey of "Art, Medicine, and Magic in Early Byzantium" both literally and conceptually; one invoked supernatural healing and one acknowledged it, and everything illustrated and discussed in between—eulogiai and amulets—palpably induced it. These are the objects which could satisfy our criterion of being, at one and the same time, "art" (albeit usually of a plebeian sort) and "medicine" (albeit always of an unscientific sort). As a group they evoke a world of supernatural medicine as pervasive as it was multifaceted: they span the Mediterranean, from Sicily through Greece and Asia Minor to Syria-Palestine and Egypt; they span society, from anonymous lead and bronze through silver to personalized gold.[134] And although fewer than two dozen pieces were illustrated, they can be taken to speak for a significant portion of early Byzantium's "minor arts," since many were items of mass production (from stamps or molds), while those that were not (e.g., the armbands, rings, and intaglios) represent extensive, substantially undifferentiated series. The significant point is that behind most of our illustrations stands a large, often well-known object type or genre. Moreover, those "object types" constitute, in toto, an affectively complete medicine chest, whose remedies were as varied in their mode of application as they were in their medical applicability: there are clays to be powdered and drunk or, as paste, rubbed on the body—and oils and waxes to be used in the same way; there are amuletic lockets and ampullae in which to carry these pills and potions, stamps with which to make them, and censers to swing while they're being used; there are large medico-magical silver bands for the arm, smaller ones for the finger, and single silver discs to be hung around the neck—or, for those of lesser means, bronze and lead equivalents; there are styptic gemstones for the purse and "health" jewelry for newlyweds; and there are, finally, votives to ask for the preservation of health, and votives to give thanks when lost health has been restored.

Harnessed in our hypothetical Early Byzantine medicine chest are the pharmaceutical powers of a truly democratic pantheon which, at once Judeo-Christian and Greco-Egyptian, can accommodate the coexistence of Christ and the Chnoubis, St. Symeon and King Solomon, and the cross and the pentalpha. When applied to consumable eulogiai their powers seem to have been essentially generic; Symeon clay, for example, could cure anything from baldness to leprosy. On the other hand, a surprising number of our amulets seem to have been designed to govern female ailments, and perhaps specifically infertility.[135] Yet these objects, too, pre-

[131] Or, "Sts. Cosmas and Damian, bless [me]."

[132] See M. C. Ross, "Byzantine Bronze Hands Holding Crosses," Archaeology, 17 (1964), 101 ff.; V. N. Zalesskaja, "Un monument byzantin à l'Ermitage et ces prototypes," (in Russian) Palestinsky Sbornik, 17(80) (1967), 84 ff. As with the Chnoubis, there is every reason to believe that this formal continuity carried with it a continuity of meaning and function. Yet even independent of its origins, this hand has qualities which corroborate its "medical" inscription, including an implication of power and prerogative (via the globus cruciger), of magic (note the two rings), and of healing (as in the "healing hand"—cf. Vikan, Byzantine Pilgrimage, 38 f.; and note 43, above). There is a formal, and perhaps contentual, parallelism between the hand that supports the cross and the (healing) hand that each of the two holy doctors raises toward the suppliant before the cross. There is an Early Byzantine bronze ring in the Clemens Collection, Cologne, which shows an open hand surrounded by Sphragis Solomonos. See E. Moses, Der Schmuck der Sammlung W. Clemens (Cologne, 1925), 10 f., fig. 17.

[133] Peter and Paul, of course, frequently accompany the cross, while the Virgin and Child and the holy doctors are called for by their respective invocations. I know of no other Early Byzantine appearance of St. Stephen on a cross (those incised, hinged crosses in bronze upon which Stephen appears with some regularity are mid-Byzantine or later). Stephen carries his censer as the protodeacon. It must be for this medico-liturgical reason also that St. Stephen appears in the company of holy doctors in the so-called Chapel of the Physicians in S. Maria Antiqua. See Nordhagen, "S. Maria Antiqua," 55 ff.

[134] For an archeologist's view of the pervasiveness of Early Byzantine magic, see Russell, "The Evil Eye," 543 f.

[135] A similar observation was made by L. Bouras in her paper on "Security in Byzantium" delivered at the 1983 Birmingham Spring Symposium.

IX

cisely because they invoke a variety of healing powers, could probably be counted on to do much more.

The roots of early Byzantium's supernatural medicine lie in the hellenized east Mediterranean, in Syria-Palestine and Egypt, the same region which saw its flowering during the sixth and seventh centuries. There the Chnoubis, apotropaic hands, haematite, and ring signs all enjoyed (in their various stages of mutation) a Byzantine afterlife, but only in the shadow of the pilgrim's experience, and in the objects and images that were developed to serve it. For it was holy sites and healing shrines—and the curative powers thought to reside there—which gave the artifacts of Early Byzantine medico-magic their distinctive flavor. The Chnoubis, after all, entered Byzantium's medicine chest in the company of a pilgrimage-generated christological cycle, and even the Jewish magician-doctor Solomon was on the pilgrim's agenda, for it was in the Church of the Holy Sepulchre that his famous seal ring was to be revered as a relic, beside the wood of the True Cross.[136]

One final point is worthy of note. Our survey has revealed a continuous spectrum in early Byzantium's world of miraculous healing, between remedies and implements thoroughly Christian and those patently magical. Why? Because while one's local bishop, town doctor, and neighborhood sorceress were almost certainly at odds over how best to evict the demon that possessed one,[137] the possessed did not indulge in the luxury of subtle differentiations. If need be, he called upon Christ, Solomon, and the Chnoubis in one breath; this is the truth that our objects reveal with incontrovertible clarity. They reveal a world thoroughly and openly committed to supernatural healing, and one wherein, for the sake of health, Christianity and sorcery had been forced into open partnership.

[136] See Wilkinson, *Jerusalem Pilgrims*, 59 (*Breviarius*).

[137] The antipathy that existed between doctors and healing shrines is well known. See Magoulias, "The Lives of Saints," 129 ff. As for the attitude of doctors and churchmen to healing magic, the following two examples may be cited from the sixth century: Severus of Antioch, in his Homily CXX (PO, 29, 1, 583 f.), alludes to the practice of wearing medico-amuletic jewelry when he urges Christians to avoid those who propose "the suspension and attachment to necks or arms, or to other members [of those objects] called *phylacteria*, or protective amulets, even if they have an appearance of piety, for fear that, seeking the health of the body, we might not become even more sick of the soul. . . ." On the other hand, Alexander of Tralles (Puschmann, *Alexander*, II, 579) naively confesses that he finds himself obliged to recommend amulets for the treatment of colic, but only because some patients will not follow a strict regimen or endure drugs.

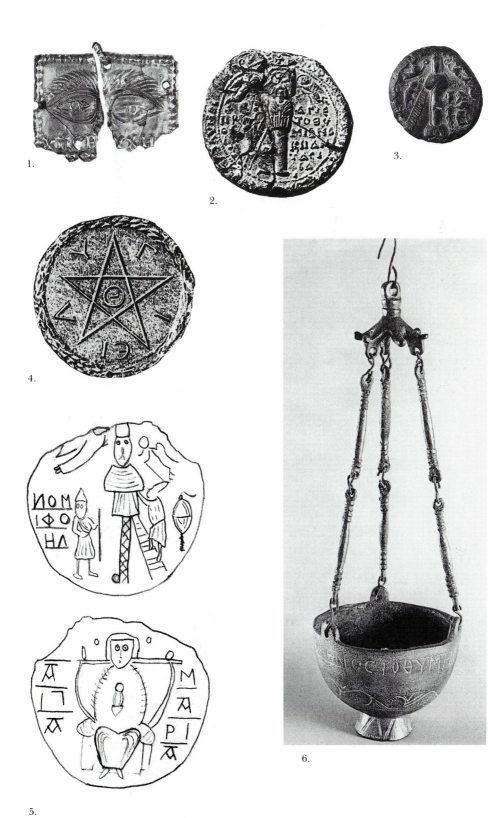

1.

2.

3.

4.

5.

6.

7.

8.

9.

IX

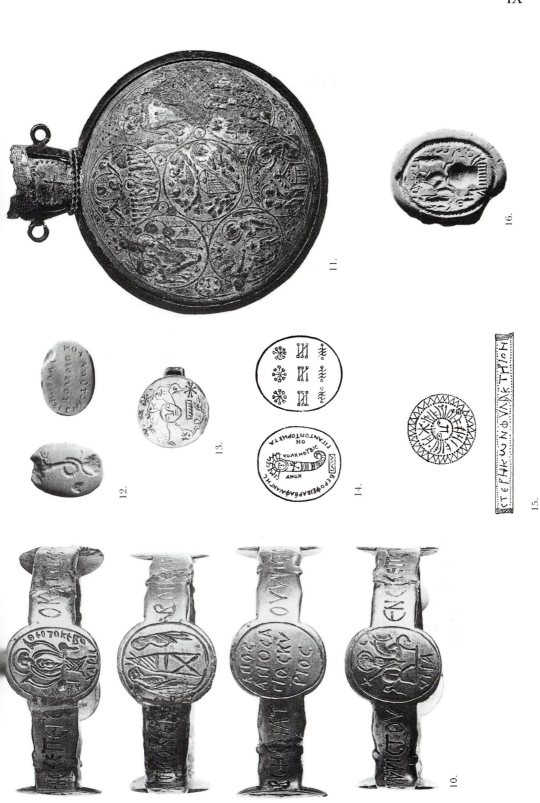

11.

16.

12.

13.

14.

15.

10.

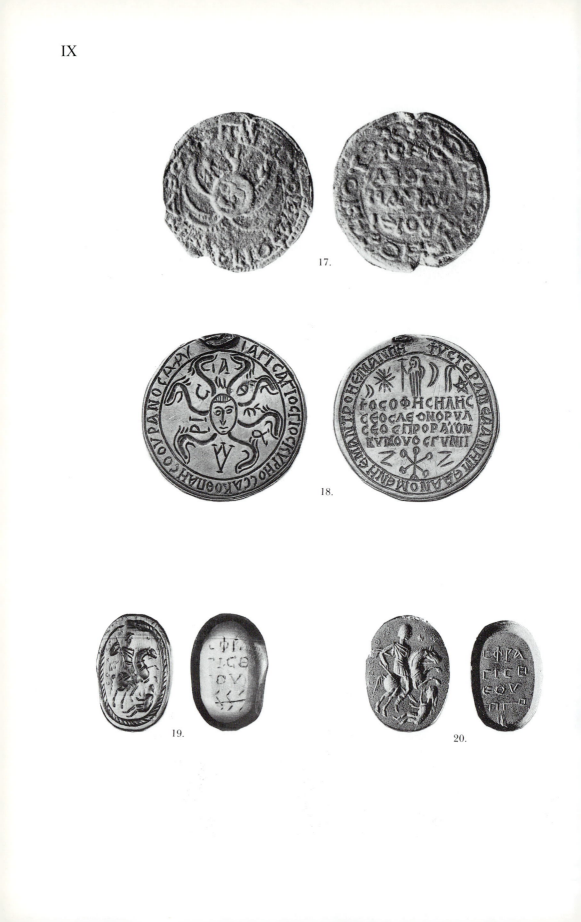

17.

18.

19.

20.

IX

22.

23.

24.

21.

25.

26.

27.

28.

Art and Marriage in Early Byzantium

This article addresses the question of how mar-
riage helped to shape Byzantine material cul-
ture, or, put another way, how the material culture
of Byzantium reflects the rituals and values of
marriage. The question properly encompasses all
facets of betrothal and marriage, the ceremonial,
legal, moral, and sexual. And it should include as
well all potential categories of marriage-related ar-
tifact, from illustrated historical chronicles por-
traying real marriages and the coins issued to com-
memorate them, to the rings, crowns, and belts
used to punctuate and confirm various stages of
the ritualized union, to the gifts exchanged by the
couple or offered by friends, to the amulets worn
by one or the other to protect their union and en-
sure successful procreation.

The evidence, although abundant, is homoge-
neous neither in character nor in quantity across
the millennium of Byzantine history. That from
late Antiquity is at once richer in its variety and
more subtle in its iconography than is the relatively
sparser evidence from the middle and late Byzan-
tine periods, which tends to reflect a more literal
approach. Characteristic of the latter are the mar-
riage scenes in the twelfth-century copy of the
John Skylitzes chronicle in Madrid.[1] The minia-

ture on folio 125r (Fig. 1), for example, represents
the union of Emperor Constantine VII and Helen,
the daughter of Romanos I, Lekapenos.[2] This
scene, when coupled with middle Byzantine texts
of the marriage ceremony and passages in the *Book
of Ceremonies* distinguishing the wedding *stephanos*
from the imperial *stemma,* and surviving marriage
crowns of the period, like the pair in the Byzantine
Museum of Athens (Fig. 2), graphically evokes the
experiential reality of a middle Byzantine wed-
ding.[3] Similarly straightforward in its approach is
an inscribed middle Byzantine betrothal ring in
the Stathatos Collection, Athens (Fig. 3), whose be-
zel bears simply the words "I, Goudeles, give the
betrothal ring to Maria."[4]

Special thanks are due to Leslie S. B. MacCoull for help with
papyrological sources used in this article.

After fifty years the most useful general treatment of early
Byzantine marriage remains that of K. Ritzer's 1940 Würzburg
dissertation, here cited in its French translation, *Le mariage dans
les églises chrétiennes du Iᵉʳ au XIᵉ siècle* (Paris, 1970). As for
marriage-related art of the period, the standard publication is
still the insightful though partial treatment by E. H. Kantoro-
wicz, "On the Gold Marriage Belt and the Marriage Rings of
the Dumbarton Oaks Collection," *DOP* 14 (1960), 3–16.

[1] See S. Cirac Estopañan, *Skyllitzes matritensis,* I. *Reproducciones
y miniaturas* (Barcelona-Madrid, 1965), nos. 133, 221, 305, 325,
481, 491, 511, 549; and, for the dating of the manuscript, N. G.
Wilson, "The Madrid Scylitzes," *Scrittura e civiltà* 2 (1978), 209–
19. See also A. Grabar and M. Manoussacas, *L'illustration du
manuscrit de Skylitzès de la Bibliothèque Nationale de Madrid,* Bib-
liothèque de l'Institut Hellénique d'Etudes Byzantines et Post-
Byzantines de Venise 10 (Venice, 1979), 159, for a brief, general
discussion of the manuscript's marriage iconography.

[2] Figure 1 = Madrid, Biblioteca Nacional, cod. 5–3, no. 2, fol.
125r. See Estopañan, *Skyllitzes matritensis,* no. 305.

[3] For the Byzantine betrothal and marriage ceremonies, see
P. N. Trempela, "He akolouthia ton mnestron kai tou gamou,"
Theologia 18 (1940), 101–96 (based on manuscripts of the 9th
through 17th centuries). For the distinction between the two
crowns, see Constantine Porphyrogenitus, *De ceremoniis aulae by-
zantinae,* II, 6–9.

Figure 2 = Athens, Byzantine Museum, nos. 7663a, b. See
P. A. Drossoyianni, "A Pair of Byzantine Crowns," *XVI. Interna-
tionaler Byzantinistenkongress, Akten II/3 = JÖB* 32.3 (1982), 529–
38. Drossoyianni is overly cautious in identifying these
crowns—which are a match for those in the Madrid Skylitzes,
clearly form a pair, are large enough to be worn, and bear a
passage from the Psalms (20:3) used in the marriage ceremony
(Trempela, "He akolouthia," 153 f)—as specifically marriage
crowns. Because their main inscription is an invocation, on be-
half of "Romanos the *spatharokandidatos* together with his wife
and children," she sees them as "votive offerings to a church"
(even though made of tin-plated copper). Yet Byzantine mar-
riage rings do occasionally bear invocations (see M. Hadzidakis
[Chatzidakis], "Un anneau byzantin du Musée Benaki," *BNJ* 17
[1939–43], nos. 80, 89; and note 97 below), and it was not un-
usual for late Roman marriage rings to invoke long life in a
general and anticipatory way on behalf of the groom's family
(see F. Henkel, *Die römischen Fingerringe der Rheinlande* [Berlin,
1913], 322). Noteworthy also are late Roman sarcophagi where-
on the *dextrarum iunctio,* as generally symbolizing the matrimon-
ial bond, takes place in the presence of the couple's children;
see L. Reekmans, "La 'dextrarum iunctio' dans l'icono-
graphie romaine et paléochrétienne," *Bulletin de l'Institut Histo-
rique Belge de Rome* 21 (1958), 68 f.

[4] ΜΝΗCΤΡΟΝ ΔΙΔΟΜΗ ΓΟΥΔΕΛΗC ΜΑΡΗΑ. Figure 3 =
Athens, Stathatos Collection. See *Collection Hélène Stathatos, 2:*

X

By contrast, the evidence of the early Byzantine gold marriage belt at Dumbarton Oaks (Fig. 31) is much more complex.[5] Christ and Dionysos are interlocked in a common thematic conceit, and the seemingly unrelated notions of concord, grace, and health are inscriptionally linked as "from God." The paired clasps are dominated by an apparently realistic representation of the *dextrarum iunctio*, which actually had no precise visual counterpart in the ritual it evokes.[6] Yet the belt itself played an instrumental role at quite a different juncture in the same ceremony. All of this makes the Dumbarton Oaks belt much less a document of an experiental reality than one of a deeper, conceptual reality.

Further distinguishing the earlier from the later evidence is that the latter is so sparse and heterogeneous that it cannot properly be said to constitute a historically distinct unit within later Byzantine art history generally. Early Byzantine marriage-related art, by contrast, has its own identity and tradition within the history of late antique material culture as, from the fourth to seventh century, it gradually emerges out of later Roman art and is progressively adapted to the needs of a Christian, east Mediterranean clientele. This marriage art will, therefore, constitute the core of this paper.

During the early Byzantine period, as today, the single object most intimately associated with marriage was the ring. And then, as now, there was a distinction between the betrothal ring and the

wedding ring, with the former, the *annulus pronubus*, in part functioning as, or at least symbolizing, the prenuptial *arrabon* or earnest money.[7] Both rings would have been worn on the third finger of the left hand, the *anularius*, since it was then still commonly believed that a nerve or sinew ran directly from that finger to the heart.[8] As Aulus Gellius had explained it:

> When the human body is cut open as the Egyptians do and when dissections, or *anatomai* as the Greeks phrase it, are practiced on it, a very delicate nerve is found which starts from the annular finger and travels to the heart. It is, therefore, thought seemly to give to this finger in preference to all others the honour of the ring, on account of the close connection which links it with the principal organ.[9]

In late Antiquity marriage rings were worn by both men and women, although only the bride-to-be would customarily receive the *annulus pronubus*.[10] Thus, in theory at least, three rings would typically be associated with each marriage.[11] But in fact, the number of rings extant from this period which are identifiable by their inscription or imagery as specifically related to betrothal or marriage is relatively small, and of those that do survive, a disproportionately high number are made of gold.[12] In part this may reflect a perpetuation in

Les objets byzantins et post-byzantins (n.1., n.d.), no. 33. "Goudeles" is a well-known Byzantine family name, attested as early as the 11th century. See Νέος Ελλ. 13 (1916), 212–21. For a pair of similar betrothal rings in gold and silver formerly in the Guilhou Collection, which bear the word *mnestron* and what have been taken to be the names of King Stephan Radoslav of Serbia (1228–34) and his wife Anna Komnene, daughter of Emperor Theodore Angelos Komnenos Doukas of Thessalonike, see Hadzidakis, "Un anneau," no. 90; and S. de Ricci, *Catalogue of a Collection of Ancient Rings Formed by the Late E. Guilhou* (Paris, 1912), nos. 853, 855. The silver ring is now at Dumbarton Oaks (no. 47.2.2294; along with no. 47.2.2293, which appears to be its copy). The appropriateness of an identically inscribed set of gold and silver betrothal rings is confirmed by the text of the Byzantine betrothal ceremony, which assigns a gold ring to the man and a silver ring to the woman; see Trempela, "He akolouthia," 117.

[5] See M. C. Ross, *Catalogue of the Byzantine and Early Medieval Antiquities in the Dumbarton Oaks Collection, Volume II: Jewelry, Enamels, and Art of the Migration Period* (Washington, D.C., 1965), no. 38.

[6] See C. Reinsberg, "Concordia," *Spätantike und frühes Christentum* (Frankfurt am Main, 1983), 312; Reekmans, "La *dextrarum iunctio*," 25; and note 114 below.

[7] In addition to the customary commitment of money and a ring, other less common betrothal gifts included crosses, jewelry, and clothing. See Ritzer, *Le mariage*, 127–29; and for the distinction between the betrothal and the wedding ring, Henkel, *Fingerringe*, 337–39.

[8] Macrobius, *Saturnalia*, VII.13; and Isidore of Seville, *De ecclesiasticis officiis*, II.20.8. See Henkel, *Fingerringe*, 337, 341, and ring no. 1033, showing clasped hands holding a heart. The Orthodox betrothal service, as it had taken shape in the middle Byzantine period (Ritzer, *Le mariage*, 129 f), and as it survives today, stipulates that the betrothal rings—*ta daktylidia tou arrabonos*—be placed on the third finger of the right hand, the hand with which divine authority and power was customarily expressed (Trempela, "He akolouthia," 134 f).

[9] *Noctes atticae*, X.10, in J. Carcopino, *Daily Life in Ancient Rome* (London, 1941), 81.

[10] Henkel, *Fingerringe*, 339; and Ritzer, *Le mariage*, 127 f.

[11] Of course this does not include those rings made for husband or wife to mark significant anniversary dates, birthdays, or the new year. Certainly such rings did exist (Henkel, *Fingerringe*, 338), and there is no reason to think that their inscriptions or imagery would differ fundamentally from true marriage rings.

[12] There is a striking absence of identifiable marriage rings from such rich late antique archaeological sites as Corinth and Sardis. See G. R. Davidson, *Corinth, Volume XII: The Minor Objects* (Princeton, 1952), 227–48; and J. C. Waldbaum, *Metalwork from Sardis: The Finds through 1974* (Cambridge, Mass.-London, 1983), 128–33. For the disproportionate number of late antique gold marriage rings (identifiably Christian, and of eastern Mediterranean manufacture), see notes 22, 45, and 97 below, listing extant examples in all media of the three main iconographic types.

Byzantium of the Roman custom, attested by Pliny, of giving an unadorned iron hoop in betrothal, and in part it simply may have been an unintended byproduct of the church fathers' preaching against the wearing of many rings; for if, as Clement of Alexandria stipulated, a housewife could wear just one ring—a signet to seal doors, cabinets, and food storage vessels around the home—she and her husband may have chosen to make that ring function as a marriage ring as well, even if its device were not specific to that role.[13] In either case the marriage (or betrothal) ring would be unidentifiable from our vantage point.

Viewed more broadly, this disproportion of gold to bronze suggests that it was primarily among the wealthy and powerful of early Byzantium that marriage rings were taken to be a significant genre of personal adornment in their own right.[14] Had the situation been otherwise, it would have been a simple matter for Byzantine craftsmen to replicate gold marriage rings in silver, bronze, or even glass, just as they replicated gold invocational rings and belt fittings, among other jewelry items, in various less expensive media.[15] Furthermore, the close iconographic bond between those relatively few surviving gold marriage rings and contemporary gold coinage, and the frequency with which the bridal couple on ring bezels appears to be "imperial" in portrait type, headgear, or dress, corroborate the notion that the clientele for early Byzantine marriage rings was substantially confined to the topmost level of society.[16]

How can an early Byzantine marriage ring be identified? Theoretically, even a simple iron or bronze band, or an anonymous gold band set with an unincised stone, could be linked to marriage if it were discovered through excavation on the ring finger of the left hand, or if it were found to match a ring portrayed on that finger in a contemporary mural or on a sculpture.[17] Such opportunities, however, are rare, and in any event one cannot be certain that the *anularius* was reserved solely for betrothal and marriage rings. One is left, therefore, with the supposition that a significant portion of the hundreds of simple metal bands extant from the period once functioned as marriage rings, and with the knowledge that only a relatively few, mostly precious metal, rings were explicitly destined for marriage through their inscriptions or iconography.

Many Roman marriage rings are identifiable by the words they bear. Paired names are common, as are a variety of phrases evoking such generic matrimonial good wishes as long life, fidelity, and happiness (e.g., *Prudentia Rodani vivas, concordia nostra perpetua sit*)—phrases which, by the later fourth century, were often given a specifically Christian slant (e.g., *Tecla vivat deo cum marito seo*).[18] By contrast, Byzantine inscriptional marriage rings of any period are uncommon, with the *mnestron didome* ring cited above a rare exception.[19] Beyond this, there are just a few invocational rings with both male and female names (e.g., "Lord, help Basil and Anna"), and even fewer rings with personalized twin bezel devices (e.g., a bisected oval bezel at Dumbarton Oaks, with "Basil-Theodora").[20] At no time in Byzantine history can such rings be said to constitute a genre in their own right.

In effect, a Byzantine marriage ring can be identified almost solely by virtue of the image, often with accompanying inscription, that it bears on its bezel. Whether it might be a betrothal ring, a marriage ring, or perhaps an anniversary ring is not explicitly clear, although it is reasonable to assume that those rings showing the *dextrarum iunctio* or inscribed with *homonoia* ("concord") would not be be-

[13] Pliny, *Natural History*, XXX.12; Henkel, *Fingerringe*, 337; and J. Dölger, "Anulus pronubus," *Antike und Christentum* 5 (1936), 188–200. Clement of Alexandria, *Paidagogos*, III.11.

[14] Although evidence from the Roman period (Henkel, *Fingerringe*, 339) suggests that then, too, many couples of lesser means chose simple metal bands for betrothal and marriage, nevertheless there survives a much higher proportion of inscriptional and iconographic bronze marriage rings from that period than later, in Byzantium.

[15] See, e.g., G. Vikan and J. Nesbitt, *Security in Byzantium: Locking, Sealing and Weighing*, Dumbarton Oaks Byzantine Collection Publications 2 (Washington, D.C., 1980), 5, 16.

[16] For the differential impact of early Byzantine marriage legislation on various strata of society, see E. Patlagean, *Pauvreté économique et pauvreté sociale à Byzance, 4e–7e siècles*, Civilisations et sociétés 48 (Paris, 1977), 117. Marvin Ross (*Catalogue*, no. 66) was so persuaded by the imperial character of some early Byzantine marriage rings as to suggest, with no other evidence, that they were issued by the court in multiples, like medallions, to commemorate imperial marriages.

[17] See Henkel, *Fingerringe*, 342 f. Clement of Alexandria, in the passage from the *Paidagogos* cited above (note 13), stipulated that a man should wear his seal ring on his little finger, below the lowermost knuckle. For a gold marriage ring found in a 3rd-century sarcophagus, see Henkel, *Fingerringe*, 337 f. For a match between the monumental arts and an extant ring, compare the ring on the left hand of the second lady-in-waiting behind Empress Theodora in the San Vitale procession mosaic with, for example, Ross, *Catalogue*, no. 6E.

[18] See Henkel, *Fingerringe*, 322.

[19] See also B. Segall, *Museum Benaki, Athens: Katalog der Goldschmiede-Arbeiten* (Athens, 1938), no. 256a.

[20] Ross, *Catalogue*, nos. 119, 126. Compare Henkel, *Fingerringe*, nos. 819 ff, for Roman friendship rings with similar bezels.

X

148

trothal rings, since that ceremonial act and the moral ideal evoked by that word would by then not yet have assumed their significance for the couple.[21]

The earliest type of Byzantine marriage ring, exemplified by a superb example in the Dumbarton Oaks Collection (Fig. 4: *Aristophanes-Ouigil[a]ntia*), is that whereon husband and wife, in bust portraits, face one another in full profile.[22] There are two basic bezel variants within the type, an inverted pyramid with a deeply cut retrograde device (Fig. 4), and a thin disc with a superficially cut direct device (Fig. 5 [detached bezel]);[23] the former—whereon the groom appears at the right, with his fibula on the "left" shoulder—was clearly intended for sealing, whereas the latter apparently was not. Both variants usually show a cross between the couple, but on the sealing version of this ring type the cross is always small, whereas on the non-sealing version it is usually large. Furthermore, the latter rings are characteristically lightweight and simply executed, whereas the former are usually heavy, very finely crafted, and occasionally personalized.

By the fourth century this type of marriage ring, sometimes with a cross or a Christian inscription,

was in common use in the West (Fig. 6: *Speratu[s]-Beneriae*).[24] The meaning of its composition is no more complex than it appears to be; much as these two figures formally complement one another within the compositional field they share, so they should be understood as complementing one another spiritually in the life they share. Not surprisingly, this formula, which was then also commonly used in the West for co-portraits of Sts. Peter and Paul, had a long history in Roman coinage.[25] For example, a medallion of ca. 257 (Fig. 7), inscribed *concordia augustorum*, shows Gallienus and Salonina face-to-face in a composition designed at once to evoke familial solidarity and imperial harmony.[26] When, as is often the case, an object or symbol appears between the two heads (e.g., a scepter, victory crown, or cross), the intention was simply to augment the solidarity concept by identifying that authority, reward, or belief that unites the pair.

The double-profile marriage ring was taken over by Byzantium from the West fully developed in design and meaning, and already adapted for a Christian clientele. Although the first extant eastern examples may date as early as the mid-fourth century,[27] the core of the sealing version of this ring type probably falls in the first decades of the fifth century. This is suggested by archaeological evidence associated with closely comparable rings discovered in the West, and by parallels between specific eastern rings (Fig. 4) and eastern coinage (Fig. 8: Eudocia, 423; Fig. 9: Theodosius II, 420).[28] The non-sealing version should probably be

[21] See Henkel, *Fingerringe*, 337–39. Although a *dextrarum iunctio* may have taken place in confirmation of the betrothal contract (Ritzer, *Le mariage*, 128), it most likely would have been between the parents.
[22] Figure 4 = Washington, D. C., Dumbarton Oaks Collection, no. 47.18. See Ross, *Catalogue*, no. 50. For others, which may be taken to be Byzantine by virtue of their findspots or inscriptions, see F. Cabrol and H. Leclercq, "Anneaux," *DACL* 1.2 (1924), fig. 678 (gold, with cross); O. M. Dalton, *Catalogue of Early Christian Antiquities and Objects from the Christian East in the Department of British and Medieval Antiquities and Ethnography of the British Museum* (London, 1901), no. 207 (gold, with cross [= our Fig. 10]); E. Dauterman Maguire, H. P. Maguire, and M. J. Duncan-Flowers, *Art and Holy Powers in the Early Christian House*, Illinois Byzantine Studies 2 (Urbana-Champaign, 1989), no. 83 (bronze, with cross); W. de Grüneisen, *Art chrétien primitif du haut et du bas moyen-age* (Paris, n.d.), no. 460A (silver, with cross); de Ricci, *Catalogue*, no. 406A (silver, with cross: *Theodotis*); F. H. Marshall, *Catalogue of Finger Rings, Greek, Etruscan and Roman in the Department of Antiquities, British Museum* (London, 1907), no. 273 (gold, with cross [repoussé, with a child between the couple]); Ross, *Catalogue*, nos. 51, 52 (gold, with cross [no. 52 = our Fig. 5]); G. Vikan, *Byzantine Objects of Daily Life in the Menil Collection, Volume I* (forthcoming), no. R25 (bronze).
To this list may be added a one-sided, 5th-century Byzantine lead sealing at Dumbarton Oaks (Shaw no. 47.2.1971; unpublished), apparently made with such a marriage ring bezel.
[23] Figure 5 = Washington, D.C., Dumbarton Oaks Collection, no. 53.12.61. See Ross, *Catalogue*, no. 52; and for such a bezel still attached to its hoop, Cabrol and Leclercq, "Anneaux," fig. 678.

[24] Figure 6 = London, British Museum. See Marshall, *Catalogue*, no. 208. For the appearance of this ring type in the West, see Henkel, *Fingerringe*, 337–39; M. Henig, *A Corpus of Roman Engraved Gemstones from British Sites*, BAR British Series 8 (Oxford, 1978), no. 790; and Ross, *Catalogue*, no. 50. Many examples in a variety of media and bezel designs are known; most are signets, and inscriptions are common. Occasional examples (Henkel, *Fingerringe*, nos. 98, 99) show just a single profile bust, suggesting that such rings may have been made in pairs.
[25] See J. P. C. Kent, *Roman Coins* (New York, 1978), nos. 156, 188, 219, 258, 276, 351, 383, 389, 457, 480 (= our Fig. 7), 523, 578, 643, 707. For such double portraits of Peter and Paul, see F. Cabrol and H. Leclercq, "Pierre (Saint)," *DACL* 14.1 (1939), figs. 10220–23, 10240, 10245.
[26] Figure 7 = London, British Museum. See Kent, *Coins*, no. 480.
[27] The Menil Collection bronze ring (see note 22, above), shows a male portrait strikingly like the amethyst intaglio portrait in Berlin usually taken to be Constantine I. See E. Zwierlein-Diehl, *Antike Gemmen in deutschen Sammlungen: II, Staatliche Museen Preussischer Kulturbesitz, Antikenabteilung, Berlin* (Munich, 1969), no. 545.
[28] Figures 8, 9 = London, British Museum. See, respectively, Kent, *Coins*, nos. 751, 744. For a summary of the western archaeological evidence, see Ross, *Catalogue*, no. 50.

placed more centrally in the fifth century, because it is clearly further removed from the Roman model, and the cross has come to dominate its field.[29] Following the evidence of imperial portraiture on the coinage, however, one would not expect the profile ring type to have continued much beyond the later fifth century.[30]

There is no question that the figures portrayed on the cruder, non-sealing version of this ring type are generic portraits only, evocative in a general way, by the jewelry that they wear, of people of high rank.[31] Representatives of the more luxurious, more expertly crafted signet version, however, seem to have a portrait-like specificity, and in the case of the finest surviving example, at Dumbarton Oaks, the figures are identified by name. Were these paired profiles intended to be realistic portrayals of Aristophanes and Vigilantia? Almost certainly not, since both are repeated virtually identically on an uninscribed gold marriage ring in the British Museum (Fig. 10),[32] and although Marvin Ross had suggested that these two rings might have been made for husband and wife, it is much more likely that they were simply products of the same Constantinopolitan(?) workshop or goldsmith—expensive stock items to be personalized on demand. In fact, very few marriage rings of this type—or, for that matter, of any other type from the period—bear identifying inscriptions, and yet many among them, including simple bronze examples, show striking similarities to well-known imperial portrait types.[33] The commonality of the rings in our Figures 4 and 10, therefore, would not be one of shared individual portraiture, but rather one of shared workshop technique, and of common dependency on familiar coin types. Indeed, this is the message of early Byzantine marriage art generally; namely, that coinage provided the ultimate models, both for basic iconographic concepts

and for specific figure types, from which such salient imperial elements as diadems and *pendilia* were usually deleted.[34]

Before moving on to the next common early Byzantine iconographic scheme for evoking marriage, mention should be made of the appearance of the double-profile marriage formula in two contexts other than rings. There are a number of stamped glass pendants of eastern Mediterranean manufacture bearing juxtaposed profile portraits of a man and a woman, in some cases separated by a small cross and in others, recalling the *vivas* inscription common on Roman marriage rings, by the word *zoe*.[35] Although this genre of object has pre-Christian roots, it was still in common use during the fifth century, when these specimens should be dated.[36] Although too few marriage pendants and necklaces survive to allow for the possibility that they once constituted a significant category of late antique jewelry in their own right, it is noteworthy that they are, in different forms, attested both earlier in the West (e.g., by a Piazza della Consolazione treasure necklace [Fig. 19]), and later in the East (e.g., by a Mersin treasure necklace [Fig. 18]).[37] But unlike rings, crowns, and belts, necklaces seem not to have had a designated role to play in the marriage ceremony.

Brief mention should also be made of two closely interrelated tiny silver boxes—one found in Thrace (Fig. 11: *homonoia*) and the other apparently in Cilicia—which bear juxtaposed male-

[29] The increasing dominance of the cross, from the early 5th into the 6th century, is a phenomenon traceable (for example) in Byzantine coinage and among Byzantine flat weights. For the former, see P. Grierson, *Byzantine Coins* (London, 1982), 4, 34–36; and for the latter, Vikan, *Menil Collection*, chap. 6.

[30] Grierson, *Coins*, 4. There are, however, Byzantine lead sealings datable to the 6th century bearing juxtaposed profiles of Sts. Peter and Paul separated by a small cross. See, e.g., G. Schlumberger, *Mélanges d'archéologie byzantine* (Paris, 1895), 299, no. 4.

[31] Note especially Ross, *Catalogue*, no. 51, where the bride's earrings and necklace are clearly discernible, as is the groom's elaborate fibula.

[32] Figure 10 = London, British Museum. See Dalton, *Catalogue*, no. 207; and Ross, *Catalogue*, no. 50.

[33] See note 27 above.

[34] The deletion of imperial regalia is especially obvious in the case of the Dumbarton Oaks and British Museum rings (Figs. 4, 8–10).

[35] An unpublished example with a small cross is preserved in the Corning Glass Museum (no. 59.1.205). For a *zoe* pendant, and one with neither cross nor inscription, see *Objects with Semitic Inscriptions, 1100 B.C.-A.D. 700 (and) Jewish, Early Christian and Byzantine Antiquities*, Zurich, L. Alexander Wolfe, and Frank Sternberg, Auktion XXIII (November 20, 1989, Zurich), nos. 288, 294.

[36] Although hundreds of such stamped glass pendants survive, mostly from the eastern Mediterranean region and North Africa, with pagan, early Christian, and Jewish iconography, the genre has received little scholarly attention. See J. Philippe, *Le monde byzantin dans l'histoire de la verrerie (Vᵉ-XVIᵉ siècle)* Bologna, 1970), 37 f. Many specimens appear to have been amuletic in function; their continuity into the 5th century is attested by occasional examples with stylite saints or with the *Chrismon*.

[37] See *Age of Spirituality: Late Antique and Early Christian Art, Third to Seventh Century*, ed. K. Weitzmann (New York, 1979), no. 281; and A. Banck, *Byzantine Art in the Collections of the USSR* (Leningrad-Moscow, n.d.), no. 102 (and below). See also Ross, *Catalogue*, no. 66 (the Anastasius and Ariadne *solidus* at Dumbarton Oaks, mounted as a necklace clasp [= our Fig. 23]). For the late Roman counterpart, in cameo-carved jet, to these eastern glass marriage pendants, see Henig, *Corpus*, no. 759.

female profile portraits separated by a monumental jeweled cross.[38] Although the significance of their other decoration, and even their function, have never been satisfactorily explained, it should be clear from the dominant role of the double portraits and from the "concord" inscription on the Thracian box (cf. Fig. 12) that they were in some way connected with marriage, or at least with the joint action of a married couple.[39] In this respect they recall the much grander mid-fourth-century Roman casket of Proiecta from the Esquiline treasure, which, even if it does not include in its iconographic program the *domum deductio* of the Roman wedding as some had thought, nevertheless may justifiably be linked to the marriage ceremony, thanks to the paired frontal portraits of husband and wife on its lid and to the *vivatis in Christo* inscription just beneath it.[40] Kathleen Shelton has suggested that the casket, as a container for bath articles, was a gift to the bride, and that its imagery was chosen to reflect the traditional bride's toilet, taken on the evening before the wedding.[41]

What was the function of the Thracian and Cilician boxes? Although traditionally, if sometimes unenthusiastically, identified as reliquaries, they would be, among extant reliquaries, unusually

small and early in date.[42] Moreover, their iconography would be unusual for that role, since in addition to paired marriage portraits, the Cilician box bears two votive(?) images of St. Konon accompanied by the word *hygia* ("health") and an animal frieze incorporating patently apotropaic elements. Grabar found these features anomalous on a container intended for relics, but, not recognizing a possible marriage connection, he could suggest no alternative interpretation.[43] Perhaps these boxes— containing some relic-like apotropaica, or maybe rings—were specifically associated with the marriage ceremony, an event in which both the notion of "health" and the warding off of evil had significant roles to play (see below).[44]

Just as the profile soon substantially disappeared from Byzantine coinage, so also it disappeared from the bezels of Byzantine marriage rings. By the sixth century, paired frontal bust portraits (Fig. 12: *homonoia, Theou charis*) and variations on the *dextrarum iunctio* (see below) had become the standard iconographic formulae.[45] Nearly all surviving

[38] Figure 11 = Sofia, Narodni Muzej, no. 2519. It measures 2.9 × 4.5 × 3.0 cm. See H. Buschhausen, *Die spätrömischen Metallscrinia und frühchristlichen Reliquiare, 1. Teil: Katalog*, WByzSt 11 (Vienna, 1971), no. B3; and for the Cilician box, now in Adana, no. B4. See also A. Grabar, "Un reliquaire provenant d'Isaurie," *CahArch* 13 (1962), 49–59; and idem, "Un reliquaire provenant de Thrace," *CahArch* 14 (1964), 59–65. These two boxes are so closely related to one another—and so unlike other silver containers of the period—as to indicate a common origin; because Thekla and Konon, both Isaurian saints, appear on the box now in Adana, which was apparently found in Cilicia (or Isauria), the two may be localized to that region of southeastern Asia Minor. See Grabar, "Isaurie," 55 f.; and idem, "Thrace," 65.

[39] Buschhausen, *Metallscrinia*, 182, 185 f, 205 f, was closer to the mark in labeling these as "private donor portraits," derived from imperial portrait types; he had difficulty, however, in reconciling his inappropriately early dating of the Thracian box— to the second quarter of the 4th century—with the dominant cross, and with his conviction that both boxes were made to be reliquaries (which then hardly existed). Grabar, on the other hand, correctly dated the boxes later (the Thracian box ca. 400, the Cilician box to the mid-5th century), but mistakenly identified the paired profiles as Constantine and Helen, overlooking the fact that the imperial diadems had been deleted from the coin models, and choosing to downplay the fact that no such iconographic formula for that pair of saints is known to have existed at such an early date.

[40] These two elements—paired frontal portraits and a *vivas in deo* inscription—are united on a contemporary marriage ring bezel preserved in Spalato. See O. Pelka, *Altchristliche Ehedenkmäler* (Strasbourg, 1901), 131, no. 50. For the iconography and function of the Proiecta casket, see K. J. Shelton, *The Esquiline Treasure* (London, 1981), 27 f.

[41] Shelton, *Treasure*, 28.

[42] Those few metal boxes of comparable size and date in which relics have been found seem to have been made significantly earlier than their outer protective containers, and quite possibly for other purposes. See Buschhausen, *Metallscrinia*, nos. B19, B20, C12; and *Age of Spirituality*, nos. 568, 569.

[43] Grabar, "Isaurie," 57 f. For closely comparable votive images in repoussé silver, see M. Mundell Mango, *Silver from Early Byzantium: The Kaper Koraon and Related Treasures* (Baltimore, 1986), 244.

[44] For a small, undecorated bronze box of the period discovered with a *phos-zoe* ring in it, see *Objects with Semitic Inscriptions*, no. 339; and for various textually and archaeologically attested uses for small boxes during this period, including as containers for jewelry, see J. Duffy and G. Vikan, "A Small Box in John Moschus," *GRBS* 24.1 (1983), 93–99.

Several iconographic and stylistic elements of the Thracian and Cilician boxes (e.g., the profile marriage portraits, the Lamb of God, Christ Enthroned with Apostles) are paralleled on the bezels of a closely interrelated group of four luxurious gold rings, two of which are the near-twin marriage rings at Dumbarton Oaks and in the British Museum discussed above (Figs. 4, 10). For that group, which should be dated with the boxes to the first half of the 5th century, see G. Vikan, "Early Christian and Byzantine Rings in the Zucker Family Collection," *JWalt* 45 (1987), 33, figs. 5–8. The repetition of juxtaposed profile portraits of Sts. Peter and Paul on the top and back of the Cilician box may have been intended to complement and reinforce the "concord" notion implicit in the double marriage portrait appearing on the box's two ends.

[45] Figure 12 = Washington, D.C., Dumbarton Oaks Collection, no. 59.60. See Ross, *Catalogue*, no. 4E. For others, see *Byzantium: The Light in the Age of Darkness*, New York, Ariadne Galleries (November 2, 1988–January 31, 1989, New York), no. 39 (gold, with crowns: *homonoia*) (now in the Royal Ontario Museum, Toronto); Dalton, *Catalogue*, no. 133 (gold and niello, with Christ: *Theou* [?] *homonoia*); Grüneisen, *Art chrétien*, no. 456 (gold "bague reliquaire" [i.e., thick detached bezel]); P. Orsi, *Sicilia bizantina, I* (Rome, 1942), 158, fig. 73 (gold and niello, with

examples of the frontal portrait ring type are gold, although, unlike profile portrait rings, these exist primarily in just one version, with a series of interchangeable subordinate elements.

The typical frontal portrait ring is characterized by a thick, usually partially nielloed bezel soldered to a sturdy wire hoop. The round field of its non-sealing device is dominated by a flared-arm cross, flanked on the left by the groom and on the right by the bride; frequently a bust portrait of Christ appears just above the cross (Fig. 13: *homonoia*).[46] The exergue is reserved for an inscription, which will usually be the word *homonoia*; the upper and lower edges of the bezel may be inscribed as well, and this secondary inscription will usually be the phrase *Theou charis* ("grace of God"). Stylized marriage crowns are sometimes added, in the form of simple arcs or semicircles suspended over the heads of the bride and groom, even though in some cases (Fig. 13) the bride appears to be wearing a crown already. Two virtually identical bronze rings of this type (Fig. 14: *hygia*) stand somewhat apart from the core group by virtue of their medium, bezel shape, and relative cross size, and because their exergue bears the word "health."[47] The more characteristic gold examples, although subject to iconographic variations, are nevertheless closely interrelated through small details of style and technique; this suggests a common origin and a restricted chronology.[48] Their precious material, substantial weight, and generally fine craftsman-

ship indicate wealthy clients, though surprisingly, not one example of this ring type has been found with a personalized inscription.[49] The word *homonoia* suggests a role in marriage, to the exclusion of betrothal, and significant variations in hoop size presuppose use by both men and women.[50]

Although frontal bust portraits of the sort decorating the lid of the Proiecta casket were common among most categories of late Roman marriage-related art (e.g., sarcophagi, gold glass), they were not characteristic of Roman wedding rings.[51] In this case Byzantium seems to have arrived at the iconographic formula on its own, perhaps developing it directly from the western-derived profile type in its later, non-sealing variant, with the larger cross (Fig. 5).[52] But whatever its immediate origins, the core of the frontal portrait group clearly belongs in the later sixth to early seventh century. This is indicated by the ring design itself, whose thick disk bezel more typically bears a cross monogram, datable after ca. 540, by archaeological evidence associated with related rings and treasures (e.g., the Mersin treasure, discussed below), by the distinctive three-figure configuration of those bezel devices with Christ *en buste* (Fig. 13), which parallels Byzantine glass weights datable to the later sixth century (Fig. 15: *Euthaliou*), and by general similarities between those bezels without Christ (Figs. 12, 14) and coins and bronze weights issued during the reign of Justin II and Sophia (Fig. 16).[53]

crowns and Christ: *homonoia*); Paris, Cabinet des Médailles, Seyrig Collection, unpublished (bronze, with crowns: *hygia*); Ross, *Catalogue*, no. 67 (gold and niello, with crowns and Christ: *homonoia* [= our Fig. 13]); no. 68 (gold and niello, with Christ: *Theou charis*); J.-M. Spieser, "Collection Paul Canellopoulos (II)," *BCH* 96 (1972), no. 9 (gold, with dove: *homonoia, Theou charis* [= our Fig. 17]); no. 11 (gold [raised device]: *charis*); Toronto, the Royal Ontario Museum, no. 986.181.3, unpublished (gold, with Christ: *Theou homonoia*); Vikan, *Menil Collection*, no. R26 (bronze, with cross: *hygia* [= our Fig. 14]); idem, "Zucker," fig. 9 (gold [raised device]).

[46] Fig. 13 = Washington, D.C., Dumbarton Oaks Collection, no. 53.12.4. See Ross, *Catalogue*, no. 67.

[47] Figure 14 = Houston, Menil Collection, no. R26. See Vikan, *Menil Collection*, no. R26. Its unpublished twin, in the Cabinet des Médailles, is much better preserved; on it the crowns are clearly visible, as are the first three letters (*upsilon, gamma, iota*) of the word *hygia*, which is only faintly discernible in the exergue of the Menil ring.

[48] Orsi, *Sicilia bizantina*, I, 158, fig. 73 and Dalton, *Catalogue*, no. 133 are very much alike, as are Ross, *Catalogue*, no. 4E (= our Fig. 12), *Byzantium*, no. 39, and Spieser, "Canellopoulos," no. 9 (= our Fig. 17). Reputed findspots include Constantinople (Ross, *Catalogue*, no. 67), Beirut (Dalton, *Catalogue*, no. 133), and Sicily (Orsi, *Sicilia bizantina*, I, 158, fig. 73); this would suggest central dissemination of the ring type, if not the actual rings, from Constantinople.

[49] On the finer examples (Fig. 12) it is clear that the groom wears a *chlamys* with fibula and the bride a necklace and earrings.

[50] Compare, for example, Ross, *Catalogue*, nos. 4E, 68.

[51] For sarcophagi and gold glass, see F. Cabrol and H. Leclercq, "Mariage," *DACL* 10.2 (1932), figs. 7649, 7664, 7665, 7667, 7670. For a rare Roman ring bezel with frontal portraits, see Pelka, *Ehedenkmäler*, 131, no. 50.

[52] The Grüneisen ring bezel (*Art chrétien*, no. 456), with frontal busts flanking a large cross, is remarkably like the non-sealing profile version. Frontal imperial bust portraits (both male) separated by a small cross appeared in the East in the 5th century on bronze flat weights (see Dalton, *Catalogue*, no. 437), and a small cross appears between seated emperors on the coinage issued during the brief joint reign of Justin I and Justinian I (Grierson, *Coins*, pp. 2, 19); neither, however, appears directly to have inspired the ring bezels, whose compositions are quite different.

[53] Figure 15 = Houston, Menil Collection, no. GW12. See Vikan, *Menil Collection*, nos. GW9, GW12, and chap. 7. The rings closest in composition to the glass weights are those published by Dalton (*Catalogue*, no. 133) and Orsi (*Sicilia bizantina*, I, 158, fig. 73).

Figure 16 = Geneva, Musée d'Art et d'Histoire. See N. Dürr, "Catalogue de la collection Lucien Naville au cabinet de numismatique du Musée d'Art et d'Histoire de Genève," *Genava* 12 (1964), no. 311; and Vikan, *Menil Collection*, chap. 6. For the coinage, see A. R. Bellinger, *Catalogue of the Byzantine Coins in the Dumbarton Oaks Collection. Volume One, Anastasius I to Maurice,*

Although close interrelationships among the gold members of this group argue against a long tradition, a firm terminus ante quem for the type is difficult to fix, since striking compositional parallels exist between the bronze representatives and eighth-century coins and lead sealings.[54]

Concord is iconographically conveyed on these rings with the same directness and simplicity that it had been conveyed on the earlier profile rings. Moreover, this type too has compositional and thematic parallels in imperial iconography, as we have just seen. Justin II and Sophia are united on coins and bronze weights, evoking their imperial and familial unity, and although the figures represented on the glass weights are different from those on the rings—the emperor is above and the eparch of Constantinople and another high official below—their iconographic message is basically the same, for much as husband and wife complement one another in the domestic sphere under the uniting authority of Christ, so the two officials complement one another in the economic sphere under the uniting authority of the emperor. Iconographically, what distinguishes these rings from the earlier type, aside from the portraits, is their much greater emphasis on Christian imagery; specifically, the more prominent cross and the bust portrait of Christ.

Also iconographically distinctive to this ring type, but not specifically Christian, are the crowns that appear on about half the examples in the group (Fig. 13).[55] During the early Byzantine period crowns were essential ingredients in the marriage ceremony, and among the Orthodox they have remained so ever since.[56] Like most other as-

pects of the ceremony, the custom of crowning the bride and groom was taken over by the Byzantines from the Romans. The Roman marriage crown, made of flowers and sacred plants, was initially rejected by the church fathers—most notably Tertullian (De corona) and Clement of Alexandria—because of its superstitious associations.[57] But by the fourth century it was apparently in common use among Christians at both ends of the Mediterranean, signifying in a general way the spiritual triumph of a couple united in Christ—a notion that John Chrysostom developed further, making of the crowns the symbolon tes nikes ("symbol of victory") of the bride and groom over sensual pleasure.[58] And although no Church requirement yet existed, it was becoming increasingly common for a priest to perform the crowning; indeed, when Emperor Maurice married the daughter of his predecessor Tiberius, it was the patriarch of Constantinople who put the wedding crowns in place.[59]

Crowns of various sorts, sometimes held by Christ or simply suspended in mid-air, appear prominently in the marriage iconography of fourth-century Rome, most notably on sarcophagi and in gold glass vessels.[60] Although they may approximate in their leafy appearance the crowns then used in the marriage ceremony, their iconographic role, like that of the figure holding them, was essentially symbolic.[61] In this respect they parallel the victory crown suspended in the hand of God over the head of the empress on contemporary coinage (e.g., Fig. 8),[62] and thus differ fundamentally from the real marriage crowns being set in place in the marriage miniatures of the twelfth-century Skylitzes chronicle (Fig. 1). The same applies to the schematic crowns on the bezels of sixth-century Byzantine marriage rings, which, like their counterparts in the Christian art of fourth-century Rome, may have symbolized a general sort of spiritual triumph or perhaps the more specific moral victory evoked by John Chrysostom. But in either case, they probably still were believed to carry a measure of that amuletic power ascribed to their pre-Christian counterparts. This is suggested by

491–602 (Washington, D.C., 1966), pl. LVIII. For the dating of this ring design (via the cross monogram), see Ross, Catalogue, no. 69; and Vikan, "Zucker," 39; and for the related archaeological evidence, see Ross, Catalogue, no. 4E; and Dalton, Catalogue, no. 189. The motif of Christ en buste above a cross is paralleled on the ca. 600 pewter Holy Land flasks preserved at Monza and Bobbio. See A. Grabar, Les ampoules de Terre Sainte (Paris, 1958), passim.

[54] See Grierson, Coins, pl. 17, 302; and G. Zacos and A. Veglery, Byzantine Lead Seals (Basel, 1972), no. 260.

[55] Marriage crowns, as distinct from whatever secular headgear bride or groom might wear, do not appear on rings of the profile portrait type already discussed, and they are very rare on the dextrarum iunctio rings which will be considered next. Although in a few instances among rings of the latter category, Christ (or Christ with the Virgin) appears to be touching the heads of the couple (Figs. 25, 26), in no case can it be seen that a crown is being set in place.

[56] See Ritzer, Le mariage, 95 f, 136 f; K. Baus, Der Kranz in Antike und Christentum, Theophaneia: Beiträge zur Religions- und Kirchengeschichte des Altertums (Bonn, 1940), 93–109; and note 3 above.

[57] See Baus, Kranz, 99, 100; and Ritzer, Le mariage, 95.

[58] See Baus, Kranz, 101; Reekmans, "La 'dextrarum iunctio'," 69–77; Kantorowicz, "Marriage Belt," 8; and Ritzer, Le mariage, 95, 136 (PG 62, col. 546).

[59] See Ritzer, Le mariage, 136 f (Theophylaktos Simokattes).

[60] See Cabrol and Leclercq, "Mariage," figs. 7647, 7662, 7664, 7665; Reekmans, "La 'dextrarum iunctio'," 69–77; and, for a ring with suspended crowns, Henkel, Fingerringe, no. 404.

[61] See Reekmans, "La 'dextrarum iunctio'," 69–77; and Reinsberg, "Concordia," 315 f.

[62] See Kent, Coins, no. 727 (etc.).

a passage from the Psalms (5:12), "Thou hast crowned us with a shield of favor," inscribed on two seventh-century Byzantine *dextrarum iunctio* marriage rings which will be discussed below—rings whose bezels show Christ between the bride and groom, raising his hands to the tops of their heads as if touching, placing, or blessing crowns.

We have already seen that inscriptions—names and a variety of good wishes—were common on both pagan and Christian marriage rings of the late Roman period in the West; they were rare, however, on the early profile type of Byzantine marriage ring. It is only with the later, frontal portrait type that words appear as a major ingredient on Byzantine marriage rings. Specifically, there are three different inscriptions characteristic of the group, one of which is traditional and two innovative. The traditional inscription, in the exergue of most of the rings, is the word *homonoia* or "concord," which was likely derived directly from the familiar Roman evocation of (and personification for) unity of mind and purpose, *concordia*.[63] *Homonoia* might be applied to a political or dynastic alliance, or to a simple private marriage, but however simple the alliance, its meaning for the married couple was at once specific and profound, since for them "concord" was a succinct statement of the prevailing late antique moral code governing their relationship.[64] Most clearly articulated by the Stoics, the belief was that one's wife was no longer a piece of expendable property, she was a lifelong companion and friend. Thus marriage, now for the first time based on the idea of the couple, was meant to be a durable state of affection between two honorable, civic-minded individuals. To this extent there is no distinction to be drawn

between a Christian couple of the sixth century and a pagan couple of the second, for as defined in the *Digest* of Justinian, "Marriage is a union of a man and woman and a consortium for an entire lifetime. . . ."[65] But among the Romans a harmonious lifelong union was viewed as a personal achievement, whereas in Byzantium matrimonial *homonoia* could only be achieved through divine grace. Novel 26 of Leo VI, summarizing the spirit of Justinian's Novel 22, makes this explicit by characterizing marriage as "a most important and valuable gift, granted by God the creator, to man."[66]

Byzantium's additions to the traditional Roman formula of frontal bust portraits convey this shift in emphasis in the clearest possible terms. The large, ubiquitous cross is one telling addition, the coupling on a few rings of the genitive *Theou* with *homonoia* ("concord of God") another, and the appearance of the bust of Christ over the cross on many rings yet another. But the most direct statement of Byzantium's modification of the old Stoic ideal comes in the innovative inscription shared by nearly half these rings: *Theou charis.* The state of marital concord evoked in traditional terms by the paired portraits and the word "concord" can now be understood only as something available to mankind solely through the "grace of God."[67]

An iconographically unique ring (Fig. 17: *homonoia, Theou charis),* though one still clearly belonging to the frontal portait type, at once corroborates and refines this interpretation.[68] Basically it re-

[63] See H. Zwicker, "*Homonoia,*" *RE* 8 (1913), 2256–69; and Reinsberg, "Concordia," 312–17. Although the Greek word *homonoia,* in the sense of the Latin *concordia,* had a long tradition on eastern Mediterranean coinage, and occurs occasionally as well on pre-Christian Greek marriage rings (with the motif of joined hands), its appearance here, in 6th-century Byzantium, likely owes its immediate inspiration to the pervasive western *concordia* marriage tradition of the later Roman period (which was in turn dependent on the earlier Stoic *homonoia* tradition). For the coinage, see Zwicker, "*Homonoia,*" 2268; and for the rings, Henkel, *Fingerringe,* no. 222; and Henig, *Corpus,* app. 30.
 The *homonoia* inscription with bride, groom, and cross is documentable for the first time in the East in the 5th century, with the Thracian silver box discussed above (Fig. 11). The close relationship of this box's iconography to that of contemporary profile marriage rings suggests that the word *homonoia* may, at that period, have entered the eastern marriage art tradition via (now lost) rings of that type.
[64] See *A History of Private Life, I: From Pagan Rome to Byzantium,* ed. P. Veyne (Cambridge, Mass.-London, 1987), 33–47 (P. Veyne).

[65] *Dig,* 23.2.1; see *The Digest of Justinian,* trans. A. Watson (Philadelphia, 1985), II, 657. For the continuity of this definition into the late Byzantine period, see P. D. Viscuso, *A Byzantine Theology of Marriage: The "Syntagma kata stoicheion" of Matthew Blastares,* Ph.D. dissertation (Catholic University, 1988), 71 f. For a more general overview of the continuity from pagan to Christian marriage, see D. Herlihy, *Medieval Households* (Cambridge, Mass., 1985), chap. 1.
[66] See *Les Novelles de Léon VI,* ed. and trans. P. Noailles and A. Dain (Paris, 1944), Novel 26.
[67] See Kantorowicz, "Marriage Belt," 8–11. A comparable transformation from pagan to Christian values occurred on Byzantine bronze flat weights during the same period. Around 400, paired imperial portraits flank a *tyche* to evoke the idea that the empire's prosperity depends on harmonious co-rulership legitimized by the *polis;* by the later 5th century a cross has replaced the *tyche,* implying that divine sanction is now preeminent; and in the 6th century imperial imagery is usually dispensed with altogether, its place taken by a large cross and, quite often, by *Theou charis.* By then it was only through the "grace of God" that honest commerce could be guaranteed, for in the face of chronic dishonesty in the marketplace, the state had been forced to resort to depositing a standard set of weights in the largest church of the city. See Vikan, *Menil Collection,* chap. 6.
[68] Figure 17 = Athens, Canellopoulos Museum. See Spieser, "Canellopoulos," no. 9.

peats the iconographic configuration of the Dumbarton Oaks ring illustrated in Figure 12, but *Theou charis* has been shifted to the exergue with the *homonoia* inscription, and a bird with a branch in its beak has been placed above the cross. This seemingly incongruous addition (or substitution, for Christ) is in fact a subtle visual quotation from a popular early Christian salvation scene in which a dove returns to the Ark with an olive branch, confirming to Noah and his family that they have been spared from the flood (Gen. 8:10, 11).[69] In this respect the bird symbolizes hope, salvation, and more important here, divine grace.

The other innovative inscriptional element, supplanting *homonoia* on the two bronze rings in the group (Fig. 14 [much worn]), is *hygia*. Is it simply a banal good wish of the sort evoked at all weddings, even now—the Byzantine equivalent of the Roman wedding acclamation *feliciter*—or did it carry a more specific meaning, comparable to *homonoia* and *Theou charis*? The word "health," in various forms (*hygia, hygieia, hygienousa phori, hygienon chro*), sometimes coupled with other words (*hygia-zoe, hygia-chara*), or occasionally personalized (*hygia Ioannou*), appears on a variety of early Byzantine artifacts. On commercial stamps and on water buckets for use in the baths, the intention seems simply to have been to convey a good wish to the consumer or user, whereas belts and rings bearing the word "health" might reasonably be taken to be so inscribed for amuletic purposes—which was undoubtedly the intention when *hygia* appears, as it occasionally does, on earthen pilgrim tokens from holy shrines and on medico-magical armbands used by women to treat gynecological ailments.[70] The fact that the word appears here on an object worn on the body suggests, *prima facie*, a high level of intentionality, but even if this were so, *hygia's* po-

tential amuletic role in relation to marriage is not immediately apparent.

Dioscorus of Aphrodito, in his "Epithalamium for Paul and Patricia" (ca. 566), seems to be using the notion of health on its most banal, least intentional level when he wishes the couple "a life without illness."[71] But in his "Epithalamium for Isakios," his poetry turns to the more serious topic of demons and magic:

> Soon you shall see children on your lap, sweeter than nectar, loved for their beauty—a blessing that your troubles have merited, as you do honor to the ability of your forebears. Go away, evil eye; this marriage is graced by God. . . .[72]

Isakios' marriage is "graced by God" toward the proper goal of every marriage: procreation.[73] And this, too, is a concern at the heart of Justinian's Novel 22, whose summary by Leo VI was already quoted in part above:

> Marriage is a most important and valuable gift, granted by God the creator, to man. For not only does it give aid to nature exhausted by death, not allowing the human species, devoured by death, to disappear entirely, but also it gives men great joy in another way, thanks to the children born to it.[74]

The paramount importance of the reproductive aspect of Byzantine marriage, evoked in Dioscorus' epithalamium and in Novel 26, reappears in even clearer terms in the opening statement of Novel 2 of Justin II, which restored divorce by mutual consent: "There is nothing more honored by men than marriage, from which result children, the succession of future generations, the peopling of villages and towns, and the creation of good polity."[75] The operative principle of this legislation is that an unhappy marriage—one corrupted by "irrational hatred"(*alogon misos*)—necessarily renders impossible the central goal of marriage, childbearing, and therefore can be dissolved by mutual consent, divorce being an effective treatment for the

[69] For a ring with both dove and Ark on its bezel, see R. Garrucci, *Storia della arte cristiana* (Prado, 1880), pl. 478, 10, and for other parallels, pls. 477, 478; Dalton, *Catalogue*, pls. I, II; T. Klauser, "Studien zur Entstehungsgeschichte der christlichen Kunst, IV," *JbAC* 4 (1961), 141, 142; and Vikan, "Zucker," 33, fig. 5.

[70] For the stamps and buckets, see Vikan, *Menil Collection*, S120 and chap. 5; and M. Mundell Mango, C. Mango, A. Care Evans, and M. Hughes, "A 6th-century Mediterranean Bucket from Bromeswell Parish, Suffolk," *Antiquity* 63, 239 (1989), 295–311. For a relevant belt fitting and some *hygia* rings, see *The Malcove Collection*, ed. S. D. Campbell (Toronto, 1985), no. 107 (*hygienon chro*); and Dalton, *Catalogue*, nos. 149–52. For the pilgrim tokens and the armbands, see G. Vikan, "Art, Medicine, and Magic in Early Byzantium," *DOP* 38 (1984), 69 f, 75 f (and for a doctor's instrument case and a doctor's pill stamp so inscribed, pp. 66, 69 f.).

[71] See L. S. B. MacCoull, *Dioscorus of Aphrodito: His Work and His World* (Berkeley, 1988), 81 f.

[72] MacCoull, *Dioscorus*, 111.

[73] The following discussion of the impact of demographic exigencies on Byzantine marriage poetry, morality, and law—and ultimately, on Byzantine marriage art—owes much to a paper entitled "Byzantine Models of Marriage" delivered by Angeliki Laiou at Dumbarton Oaks in 1985, and to Judith Herrin's paper in the 1989 Dumbarton Oaks Spring Symposium, entitled "Divorce." Special thanks are due to both scholars for kindly allowing me to read their papers in typescript. See also Patlagean, *Pauvreté*, chap. 4.

[74] See note 66 above.

[75] Zepos, *Jus*, I, 3–4, 75 (A.D. 566).

disruptive force of that "mischievous demon" (*skaios daimon*) afflicting the couple.[76] Similarly, marriages rendered childless as a consequence of, among other things, homosexuality, impotence, or disease (leprosy) could be terminated by divorce.[77] This means, in effect, that a successful, fruitful marriage would be one blessed with both harmony and good health, the one being no less essential than the other. It is in this spirit that Dioscorus of Aphrodito ends his "Epithalamium for Paul and Patricia":

> Give Paul a pleasant and happy marriage with Patricia, a life quite without illness. . . . Paul and beloved Patricia. . . . Give them the . . . of indissoluble harmony, as they hold children on their laps, and a bright and peaceful life, worthy of poetic praise. . . . [78]

In a society suffering from high infant mortality, an alarming morbidity rate among young women, and a chronic labor shortage—in a society to which God had given marriage to insure its very survival—the words *hygia* and *homonoia*, as invocations of amuletic (i.e., birth-facilitating) power from God, could be viewed as both complementary and inscriptionally interchangeable.[79] And as for the linking of magic with marriage, that bond is as old and intimate as the bond linking magic with childbirth.[80] The date of the Roman wedding was chosen to avoid certain unlucky days, the ring finger was chosen for its supposed connection with the heart, the entrails of an animal were examined to discover the marriage omens, crowns were worn to ward off danger, ribald songs were sung to avert the evil eye, and the bride was carried over the threshold, according to some, to avoid an unlucky first step. The passage from Dioscorus adjuring the evil eye, the *hygia* inscription, and the excerpt from Psalm 5 invoking a "shield of favor," suggest that at least some of the superstitious flavor of the

pagan marriage ceremony survived into Byzantine times. More such evidence will emerge below.

Before proceeding to the last major category of early Byzantine marriage iconography, brief mention should be made of the appearance of the frontal portrait formula outside the context of rings. In the late nineteenth century a treasure of gold jewelry was discovered near Mersin, in Cilicia. Now in Leningrad, it includes, among various earrings, rings, bracelets, belt fittings, and necklaces characteristic of the later sixth to early seventh century, an unusual pendant necklace with a large repoussé medallion of an emperor being crowned, and twenty repoussé links bearing identical frontal bust portraits of a man and woman separated by a cross, with *hygia* in the exergue (Fig. 18).[81] N. P. Kondakov, in his 1896 publication of the treasure, identified the pair as "emperor and empress?," whereas André Grabar, in his extensive study of this necklace in the 1951 *Dumbarton Oaks Papers*, labeled them as Sts. Constantine and Helen, while acknowledging that no contemporary visual evidence could be cited as corroboration, and apparently overlooking the fact that neither wears the appropriate imperial headgear.[82] But clearly, the links' "concord" male-female composition and *hygia* inscription are much more appropriately associated with contemporary marriage iconography (Figs. 12, 14).[83] Highly plausible on its face, this interpretation is rendered more attractive by the presence in the Mersin treasure of a marriage ring and, more important, by the fact that Grabar had already concluded, primarily on the basis of the large medallion, that this necklace fulfilled some magical function.[84] In this respect it recalls the Piazza della Consolazione marriage necklace in the

[76] Ibid., 3–5.

[77] Causes for divorce are enumerated in Justinian's Novels 117 and 134, and in the *Ecloga* of A.D. 741 (references from Herrin, "Divorce").

[78] MacCoull, *Dioscorus*, 81 f.

[79] For an overview of the mortality issue, see A. Laiou, "Family, Byzantium," *Dictionary of the Middle Ages*, ed. J. R. Strayer, 4 (1984), 595 f. E. Kitzinger ("Reflections on the Feast Cycle in Byzantine Art," *CahArch* 36 [1988], 72 note 71), apparently unaware of Byzantine marriage legislation and *hygia* rings, failed to recognize the inherently complementary nature of concord and health in his analysis of Byzantine marriage ring iconography.

[80] For superstitious elements in the Roman marriage, see M. Johnston, *Roman Life* (Glenview, Illinois, 1957), 132–37; and for magic and childbirth in late Antiquity, see Vikan, "Art, Medicine, and Magic," 76–84.

[81] See N. Kondakov, *Russkie klady. Izslêdovanie drevnostej veliko-knjazeskago perioda* (St. Petersburg, 1896), 187–91; A. Grabar, "Un médaillon en or provenant de Mersine en Cilicie," *DOP* 6 (1951); Banck, *Byzantine Art*, nos. 102–5, 107; Ross, *Catalogue*, no. 4; and B. Deppert, "Early Byzantine Jewelry, Fourth to Seventh Century A.D.," *Byzantine Jewelry*, ed. D. Content (forthcoming), section XII. This treasure is datable by virtue of the cross monogram borne by one of its belt tabs, and because of its general stylistic and typological similarities with other treasures datable through coin finds.

Figure 18 = Leningrad, State Hermitage Museum, no. *omega* 107–8. See Banck, *Byzantine Art*, no. 102; and for a line drawing, Kondakov, *Russkie klady*, fig. 101.

[82] Kondakov, *Russkie klady*, 187 f; and Grabar, "Un médaillon," 29 f.

[83] Spieser ("Canellopoulos," no. 9) and Deppert ("Jewelry," section XII) both noted the similarity between these link medallions and contemporary marriage rings.

[84] See Grabar, "Un médaillon," 46.

Metropolitan Museum of Art (Fig. 19) which, although western and earlier, combines in its two pendants traditional marriage iconography and magic.[85] In this case the larger, gold pendant bears the marriage imagery—profile portraits of husband and wife about to be crowned—and the magic comes in the form of a smaller, hematite pendant, a Greco-Egyptian gem amulet bearing the so-called Abrasax, a snake-legged solar deity with the head of a rooster.[86] Although this creature was believed to wield multivalent powers, the material into which its image is cut, hematite, was valued in late Antiquity above all for its supposed styptic quality, verified by the red powder produced when this lustrous black mineral of iron oxide is crushed.[87] Hematite and blood control, in the sense of uterine bleeding, were key ingredients in contemporary medical magic, and here, under the umbrella of marriage, this amuletic power may have been invoked as a protective aid in childbearing—specifically, as an antidote to the uterine bleeding symptomatic of miscarriage.[88]

"Sts. Constantine and Helen" or "Sts. Peter and Paul" are the labels conventionally applied by antiquities dealers to the stamped earthen discs with paired frontal portraits (Fig. 20) which formed the major part of a hoard of several hundred "pilgrim tokens" recently dispersed on the international art market.[89] According to the dealers' explanation, the figures are shown flanking a cross because these objects were issued by Emperor Heraclius in celebration of his returning the True Cross to Jerusalem. However, that the bust to the left is slightly larger than the other argues against the possibility that they might be Peter and Paul, and the absence of contemporary visual parallels or distinguishing imperial regalia militates against an

identification with Constantine and Helen. Additionally, it is important to be clear as to what these objects are, for as stamped earthen tokens they belong to a familiar category of late antique artifact—the earthen *eulogia* ("blessing")—which has been shown to be characteristically amuletic in its intended function and often specifically medicinal in its desired effect.[90] Moreover, while many such tokens, like those showing St. Symeon Stylites the Younger, may be linked through their iconography to specific pilgrimage shrines, others, like those showing Christ *en buste*, the Virgin and Child, or the word "Solomon" with a coiled serpent (Fig. 21), were apparently topographically anonymous, and therefore, in effect, simply portable bits of sacred magic.[91] The same is likely true of the paired bust tokens, which are functionally as well as iconographically equivalent to the Mersin treasure necklace links (Fig. 18) and the bronze *hygia* marriage rings (Fig. 14), insofar as the amuletic invocation of "health" conveyed with an inscribed word on the necklace and rings is conveyed on the tokens with their very substance.[92] One form of magic was to be worn and the other, presumably, to be consumed, as we know Symeon tokens were, either powdered and rubbed on the body or, more rarely, taken internally with water.[93]

How, finally, might a *hygia* marriage ring or necklace, or an earthen *eulogia* marriage token with health-giving properties, have exercised its powers to enhance the couple's chances for successful procreation? Hematite, as we have seen, was used to control bleeding (here, presumably, miscarriage), and other contemporary Byzantine amulets for women were used to induce "calm" in the uterus; indeed, one category bears an incantation addressed directly to the *hystera* ("womb"), accusing that "dark and black one" of "coiling like a serpent, hissing like a dragon, and roaring like a lion," and then admonishing it to "lie down like a lamb."[94] Why? One first assumes that this calmness would enhance the organ's fertility (or at least, discourage dysmenorrhea), and that was probably, on some level, the intention. But it is also true that the "wandering womb" was believed to be the

[85] Figure 19 = New York, the Metropolitan Museum of Art, Rogers Fund, 1958, no. 58.12. See *Age of Spirituality*, no. 281.
[86] On the Abrasax, see C. Bonner, *Studies in Magical Amulets, Chiefly Graeco-Egyptian* (Ann Arbor, 1950), chap. 9.
[87] See Vikan, "Art, Medicine, and Magic," 81. Comparable powers were attributed to heliotrope (red-flecked green calcedony), which may in fact be the material of this gem amulet. See *Age of Spirituality*, no. 281 (wherein this gem is labeled "hematite"), and no. 398 (an anti-hemorrhaging amulet with Christian iconography also labeled "hematite" but likely heliotrope).
[88] See ibid., 83.
[89] Figure 20 = Baltimore, the Walters Art Gallery, nos. TL90.9.1, 2, 3, unpublished. For published tokens from this hoard, which in addition to the present iconographic type includes a type comprising a Greek cross with what appear to be the letters for *nike* ("victory") between its arms, see *Objects with Semitic Inscriptions*, no. 172. For the early Byzantine appearance of such a formula (specifically, on bread stamps), see G. Galavaris, *Bread and the Liturgy* (Madison, 1970), 72–76.

[90] See Vikan, "Art, Medicine, and Magic," 67–73, 81–83.
[91] Figure 21 = Paris, Robert-Henri Bautier Collection. See Vikan, "Art, Medicine, and Magic," 81 f (notes 109–15).
[92] Some Symeon tokens are inscribed with the word *hygia*, and Symeon's *Vita* makes it abundantly clear that this is how they were used. See Vikan, "Art, Medicine, and Magic," fig. 2, 68–73.
[93] See Vikan, "Art, Medicine, and Magic," 69 f.
[94] See ibid., 77 f.

source of both physical and emotional malcontent in a woman.[95] A magical papyrus text of sixth- to seventh-century date recommended to treat "the ascent of the uterus" (*pros metras anadromen*) makes this explicit:

> I conjure you, O Womb, [by the] one established over the Abyss . . . that you return again to your seat, and that you do not turn [to one side] into the right part of the ribs, or into the left part of the ribs, and that you do not gnaw into the heart like a dog, but remain indeed in your own intended and proper place, not chewing [as long as] I conjure by the one who, in the beginning, made the heaven and earth and all that is therein. Hallelujah! Amen!
> Write this on a tin tablet and 'clothe' it in 7 colors.[96]

Like the *anularius*, via its special nerve, the uterus, by virtue of its ability to "wander," was believed to have direct access to the heart, though not for good but for evil. A uterus in place was one in a state of "health," and accordingly more effective for procreation, but a uterus in place was also one that could not "gnaw at the heart," and thus could not, one may assume, create in the heart that irrational hatred (*alogon misos*) which, as effectively as any illness, could inhibit procreation. Thus again, the words *homonoia* and *hygia*, under the umbrella of marriage, could at once be complementary and amuletic.

More or less contemporaneously with the frontal bust portrait type appeared yet another formula for evoking marriage, featuring three (rarely four) standing figures, with the groom on the left, the bride on the right, and between and slightly behind them, Christ (Fig. 22).[97] Unlike the other two

ring types, this one evokes an action, but although the *dextrarum iunctio* is usually taken to be that action, only about a third of these rings actually show the bride and groom clasping hands. On the others, they either approach one another under the guidance of Christ (Fig. 24: *euchi*), or stand frontally, slightly apart, as if being presented or crowned by Christ (Fig. 25: *homonoia*)—or, more rarely, by Christ and the Virgin (Fig. 26: *homonoia*).[98] The groom appears to be wearing a tunic and *chlamys* with fibula, and the bride a long robe, sometimes with a veil—presumably the *flammeum* of the Roman ceremony.[99] The spiked headgear that she wears on a few rings and, with the veil, on the Dumbarton Oaks marriage belt (Fig. 31), is probably just a residual feature carried over from the coin models upon which this iconographic type depends.[100] As evidence of this, one may cite two

[95] See A. A. Barb, "*Diva metrix*," *JWarb* 16 (1953), 193–238 (esp. 214 note 23); and Bonner, *Amulets*, 90.

[96] *The Greek Magical Papyri in Translation*, ed. H. D. Betz (Chicago-London, 1986), 123 f (*Papyri graecae magicae*, VII.260–71).

[97] Figure 22 = Washington, D.C., Dumbarton Oaks Collection, no. 61. 3. See Ross, *Catalogue*, no. 66. For other such rings, see A. Banck, "Dva vizantiĭskikh zolotykh perstnia iz sobraniĭa Ermitazha," *Trudy Gosudarstvennogo Ermitazha. Kul'tura i iskusstvo narodov vostoka* 6 (1961), 31–39 (see also, Banck, *Byzantine Art*, nos. 103b, 106c) (no. 103b = gold, Christ draws the couple together: *homonoia*[?]; no. 106c = gold, niello, and set stones, octagonal hoop, Christ presents the couple: *homonoia*, Psalm 5:12); J. Boardman and D. Scarisbrick, *The Ralph Harari Collection of Finger Rings* (London, 1977), no. 115 (gold, octagonal hoop, Christ draws the couple together: *homonoia*); *Byzantium*, no. 41 (gold [detached bezel], Christ presents the couple, crowns: *homonoia*); Cabrol and Leclercq, "Mariage," fig. 7685 (gold, Christ draws the couple together: *homonoia*); C. Cecchelli, "L'anello bizantino del Museo di Palermo," *Miscellanea Guillaume de Jerphanion* = *OCP* 13 (1947), 40–57 (gold, niello, and set stones, octagonal hoop with *locus sanctus* scenes, Christ presents the couple: Psalm 5:12); Dalton, *Catalogue*, nos. 129–32 (no. 129 = gold, niello, and set stones, octagonal hoop with *locus*

[98] Figure 24 = Baltimore, The Walters Art Gallery, Zucker Family Collection, no. TL10.1985.048. See Vikan, "Zucker," 34 f. Figure 25 = London, British Museum. See Dalton, *Catalogue*, no. 131. Figure 26 = Washington, D.C., Dumbarton Oaks Collection, no. 47.15. See Ross, *Catalogue*, no. 69.

[99] See Carcopino, *Rome*, 81; and compare Reinsberg, "Concordia," fig. 130 (the so-called *pronuba* sarcophagus, whereon the bride wears the wedding veil).

[100] In his discussion of the Dumbarton Oaks marriage belt (*Catalogue*, no. 38), Ross rightly observed that the trace of an imperial diadem on the bride "indicates an imperial prototype" (e.g., a commemorative coin or medallion from an imperial wedding). But contrast the over-interpretation of this vestigial headgear by L. M. Fuchs, in "The Gold Marriage Belt at Dumbarton Oaks," *BSCAbstr* 13 (1987), 22 f. See also Kitzinger, "Reflections," 72 note 72, for remarks on the seeming imbalance

sanctus scenes, Christ and the Virgin bless the couple: *homonoia*; no. 130 = gold and niello, octagonal hoop, Christ draws the couple together: *homonoia*, John 14:27; no. 131 = gold, niello, and set stones, octagonal hoop, Christ blesses the couple: *homonoia*, *Theotoke boethei amen* [= our Fig. 25]; no. 132 = gold, niello, and set stones, octagonal hoop, Christ blesses the couple: *homonoia*, John 14:27); O. M. Dalton, *Byzantine Art and Archaeology* (Oxford, 1911), 545 (gold and niello: John 14:27); de Ricci, *Catalogue*, nos. 822, 845, 848, 861 (no. 822 = gold, *dextrarum iunctio*?; no. 845 = gold, *dextrarum iunctio*?; no. 848 = gold, *dextrarum iunctio*; no. 861 = gold, *dextrarum iunctio*); C. Kondoleon and A. Gonosová, *The Art of Late Rome and Byzantium: A Catalogue of the Collection of the Virginia Museum of Fine Arts* (forthcoming), acc. no. 66.37.7 (gold, octagonal hoop, Christ presents the couple: *homonoia*); Ross, *Catalogue*, nos. 64–66, 69 (no. 64 = gold, *dextrarum iunctio*; no. 65 = gold, *dextrarum iunctio*?; no. 66 = gold, *dextrarum iunctio* [= our Fig 22]; no. 69 = gold, niello, and set stones, octagonal hoop with *locus sanctus* scenes, Christ and the Virgin bless the couple: *homonoia*, *Kyrie boethi tous doulous sou Petrous Theodotis*, John 14:27 [= our Fig. 26]); Vikan, "Zucker," 34 f, figs. 10, 11 (fig. 10 = gold, Christ draws the couple together: *euchi* [= our Fig. 24]; fig. 11 = gold, octagonal hoop, Christ blesses the couple: *homonoia*, *Theotoke boethe Georgi[ou] Plakelas*); W. F. Volbach, *Mittelalterliche Bildwerke aus Italien und Byzanz. Staatliche Museen zu Berlin: Bildwerke des Kaiser Friedrich-Museums* (Berlin-Leipzig, 1930), no. 6810 (gold and niello, octagonal hoop, Christ blesses the couple?: *Theotoke boethe Meaele? [Melane?] amen*).

items from an early Byzantine treasure from Trebizond at Dumbarton Oaks: a marriage *solidus* of Anastasius and Ariadne set as a necklace clasp (Fig. 23) and a marriage ring whose bezel bears what is apparently its copy (Fig. 22).[101] While the groom on the ring has been stripped of Anastasius' imperial diadem, the bride, quite inappropriately, has retained from Ariadne's portrait both diadem and *pendilia.* Just two rings in this group show marriage crowns, which, hovering over the couple's heads, match those more frequently encountered on frontal portrait rings. And finally, three closely interrelated representatives of this type, including that at Dumbarton Oaks illustrated in Figure 26, bear tiny *locus sanctus* Christological scenes on the faceted surfaces of their octagonal hoops.

There are as many known rings of this type (about two dozen examples) as there are of the other two types put together. All are gold, none seems to have been designed for sealing, about a third bear some inlaid niello, and on most of those, the garments of the bride and groom are (or were) inset with semiprecious stones (Figs. 25, 26).[102] Well over half are inscribed on the exergue of the bezel (with *homonoia* or, in one case, *euchi*), and many bear secondary inscriptions as well (an invocation, John 14:27 or Psalm 5:12), either on the faceted surface of the hoop or, more rarely, on the rim of the hoop or the bezel. About half have octagonal hoops, and about as many either a round or an oval disk bezel; others have conical bezels or square bezels with projecting lobes. There is much greater variety in design, iconography, and style among these marriage rings than among the others, even though there are closely interrelated subgroups in the series, most notably that associated with the three octagonal rings bearing *locus sanctus* scenes.[103]

Although the terminus post quem for this iconographic type may be fixed at ca. 450, with the first documented appearance in the East of the *dextrarum iunctio* showing Christ as a symbolic *pronubus* on a coin type issued to commemorate the marriage of Marcian and Pulcheria (Fig. 27),[104] most of the surviving representatives of the type should be assigned to the seventh century. This is suggested by the fact that one of the three octagonal *locus sanctus* rings, which by its weight alone (23.1 grams) presupposes an important owner, was reliably reported to have been part of a treasure found near Syracuse, where Constans II resided with his court from 663 until his assassination five years later.[105] These three rings, for which the iconographically related pilgrim flasks in Monza and Bobbio (Fig. 29) provide a terminus post quem of ca. 600, are in turn linked in design, iconography, and style to the marriage rings in London and Leningrad cited above (note 103), which are related to another marriage ring in London (Fig. 25), and one in Berlin.[106] Furthermore, this core subgroup of seven rings includes enough peculiarities (e.g., substantial niello decoration, inset stones, square bezels with lobes, the John 14:27 inscription) to draw yet more rings into the seventh century.[107]

Other chronological points of reference for the type include the Dumbarton Oaks ring illustrated in Figure 22, which may date as early as ca. 500, and the marriage ring from Mersin, datable with its treasure to the later sixth to early seventh century. That the former ring is only distantly related to most of the others and that the Mersin ring has just one close relative—the ring illustrated in Figure 24—together reinforce the notion that the large subgroup around the Syracuse octagonal ring constitutes, in the seventh century, the core of the surviving evidence. Indeed, a chronological spread of roughly 150 years would help to explain the rich variety among these rings—as do their re-

between the bride's elaborate headgear on some of these rings and the simpler, usually indistinct headgear of the groom. He also implies, quite rightly, that most of these seemingly "imperial" rings (e.g., our Fig. 22) are by their light weight and lack of technical sophistication unlikely candidates for imperial patronage.

[101] Figure 23 = Washington, D.C., Dumbarton Oaks Collection, no. 59.47. See Ross, *Catalogue,* no. 66 (for both objects).

[102] See Banck, "Zolotykh," 35–39 (a ring inset with an emerald and a garnet).

[103] Included in that subgroup are the three *locus sanctus* rings (Cecchelli, "L'anello," 40–57; Dalton, *Catalogue,* no. 129; and Ross, *Catalogue,* no. 69), as well as Dalton, *Catalogue,* no. 132, and Banck, *Byzantine Art,* no. 106c. Also closely related is an octagonal *locus sanctus* ring without explicit marriage iconography in the Walters Art Gallery. See P. Verdier, "An Early Christian Ring with a Cycle of the Life of Christ," *The Bulletin of The Walters Art Gallery* 11.3 (1958).

[104] Figure 27 = Glasgow, Hunterian Museum. See G. Zacos and A. Veglery, "Marriage Solidi of the Fifth Century," *NCirc* 68.4 (1960), 73 f.

[105] On date and patronage see, most recently, Kitzinger, "Reflections," 62, and note 72. Of all Byzantine marriage rings this one, by virtue of the headgear of its bride and groom, its Syracuse findspot, and its substantial weight, has the strongest claim to courtly (if not actual imperial) patronage.

[106] For the Berlin ring, see Volbach, *Bildwerke,* no. 6810. For the dating of the flasks, see J. Engemann, "Palästinische Pilgerampullen im F. J. Dölger Institut in Bonn," *JbAC* 16 (1973), 25 f.

[107] For the rings with these characteristics, see note 97 above.

puted findspots, ranging from Trebizond, Mersin, and Constantinople, to Syracuse.

The immediate inspiration for this ring type, which has no antecedent in the West,[108] was most likely the marriage *solidus* issued in 450 to mark the union of Marcian and Pulcheria (Fig. 27: *feliciter nubtiis*), or perhaps that of 491, commemorating the marriage of Anastasius and Ariadne (Fig. 23: *feliciter nubtiis*).[109] These coins, in turn, drew on a long Roman numismatic tradition analyzed by Ernst H. Kantorowicz, Louis Reekmans, and, most recently, by Carola Reinsberg.[110] The standard three-part configuration, involving two contracting parties (usually husband and wife) clasping right hands, and a third, facilitating party (characteristically Concordia, concord personified) between them, with hands resting on their shoulders, was in more or less continuous use on Roman coinage of the later second and third centuries. Much like the simpler "concord" compositional conceit of juxtaposed profile portraits (Fig. 7), this formula was used to evoke, celebrate, and propagandize all sorts of imperial and familial alliances, in-

cluding that by marriage in 206 of Caracalla and Plautilla (Fig. 28: *concordia felix*).[111]

It was with the marriage *solidus* of Marcian and Pulcheria in the mid-fifth century that this old secular numismatic formula was Christianized, through the substitution of Christ for Concordia.[112] On the level of implied ritual, this meant that the couple was now coming together under the guidance of Christ-*pronubus* instead of Concordia-*pronuba*—recognizing that in the traditional Roman wedding it was a once-married matron, the *pronuba*, who brought the couple together, whereas with increasing frequency in early Byzantium it was a priest who performed that function.[113] But even if on some level of implied ceremonial verisimilitude Christ could be imagined as standing in for his symbolic equivalent, the priest, who in turn could be imagined as standing in for his functional equivalent, the matron *pronuba*, the iconography as presented on the coins and rings should be understood as essentially symbolic.[114] Thus, as the union of Caracalla and Plau-

[108] The western *dextrarum iunctio* marriage ring shows instead just the joined hands of the couple. See Henkel, *Fingerringe*, no. 87. Interestingly, this ring type was not taken up in Byzantium.

[109] There is an earlier Byzantine marriage issue, of 437 (or 439), whereon Theodosius II takes the place of Concordia in overseeing the union of Licinia Eudoxia and Valentinian III. See, for the three *solidi*, Zacos and Veglery, "Marriage Solidi," 73 f; and Kent, *Coins*, no. 752. For the dynastic implications of these issues, see Reekmans, "La 'dextrarum iunctio'," 78 f; and K. G. Holum, *Theodosian Empresses: Women and Imperial Dominion in Late Antiquity* (Berkeley, 1982), 209.
To determine that one *solidus* was the source of the ring type to the exclusion of the other, it would be necessary to date securely one of the rings (or a belt) before the year 491—which has not been done—or to differentiate between the two coin issues iconographically, and then to isolate those distinctive characteristics among the rings. The bride and groom are nimbed, and Christ is apparently beardless on the earlier of the two issues, whereas on the later *solidus* he is clearly bearded, and bride and groom are without nimbi. But while Christ appears to be beardless on some of the rings and the couple perhaps nimbed (Fig. 24), on others he is clearly bearded, and it is apparent that the bride and groom generally do not have nimbi. This could mean that both coins exercised an influence on the rings, although it is also possible that the rings' basic iconographic type, whichever its archetype, was successively adapted to suit prevailing tastes. That many of these rings clearly date well beyond the 5th century, and that at least one (Fig. 22) appears to draw directly on the 491 issue, together suggest that the later coin may have been the proximate source of inspiration for the ring type.

[110] Reekmans, "La 'dextrarum iunctio'," passim; Kantorowicz, "Marriage Belt," passim; and Reinsberg, "Concordia," passim. Also directed toward this same basic subject, but less useful, is an article by C. Frugoni, "L'iconografia del matrimonio e della coppia nel medioevo," *Il matrimonio nella società altomedievale*, *Settimane* 24 (Spoleto, 1977), II, 901–63.

[111] Figure 28 = London, British Museum. See H. Mattingly and E. A. Sydenham, *The Roman Imperial Coinage, Vol. IV, Part 1. Pertinax to Geta* (London, 1936), pl. xii, 7. For the chronology of the type on Roman coinage, see Reekmans, "La 'dextrarum iunctio'," 34; and Reinsberg, "Concordia," 312.

[112] This transformation on the coinage was conceptually anticipated in an epithalamium by Paulinus of Nola (*Carmen XXV*; Kantorowicz, "Marriage Belt," 9): "By those of his who marry in this (Christian) law, Jesus stands as *pronubus*, and he changes water into the nectar of wine." For other such evidence of the Christianization of the traditional Roman marriage during this period, see Ritzer, *Le mariage*, 130–41; and Kantorowicz, "Marriage Belt," 8 f.
Outside the realm of coinage (notably, on sarcophagi and in gold glass), the *dextrarum iunctio* compositional scheme had already been adapted for a Christian clientele in the West during the 4th century (Reekmans, "La 'dextrarum iunctio'," 66–77; and Kantorowicz, "Marriage Belt," 8, fig. 7); however, it was done in such a way (e.g., with a diminutive Christ holding leafy crowns over the couple) that no direct iconographic link can be established either with the 5th-century Byzantine marriage *solidi* or with the 6th- to 7th-century Byzantine marriage rings.

[113] See Ritzer, *Le mariage*, 76, 136–38. Gregory of Nazianzus wrote to Proclus regarding the wedding of the latter's daughter (PG 37, col. 316D; Ritzer, *Le mariage*, 137 f): "It is quite voluntarily that I would have assisted at this celebration, in order to put one into the other the hands of the young couple and their two hands in the hands of God."

[114] While the *dextrarum iunctio*, as a graphic, age-old evocation of the contractual and spiritual bond of marriage, was at this period an essential ingredient in the wedding ceremony (B. Kötting, "Dextrarum iunctio," *RAC* 3 [1957], 883), this three-figure iconographic configuration should not be interpreted as a "snapshot" of some moment in the ritual (Reekmans, "La 'dextrarum iunctio'," 25), no more than the iconography of the Riha and Stuma patens should be taken as literally accurate to a moment in the contemporary communion liturgy. Textual evidence that the *pronuba(us)*, whether matron or priest, actually brought the couple's hands together is slight (Reinsberg, "Con-

tilla is one overseen and characterized by Concordia, the union of Marcian and Pulcheria is one overseen and characterized by Christ. But there is a crucial difference, for while the ideal concord of a pagan marriage could be achieved through the combined virtue of the partners and could be expressed symbolically by their clasped hands (even in the absence of Concordia), the ideal Christian union required Christ's presence. That he was there, united with and uniting the couple, is what was essential, not whatever the bride and groom might be doing in relationship to one another. Thus, while among the Romans a ring showing just clasped hands was sufficient to symbolize marriage and was commonly used ceremonially in conjunction with it, among the Byzantines it would have been insufficient, and in fact, it seems never to have been used. Moreover, while the Romans emphasized the couple's symbolic hand gesture in the presence of Concordia, the Byzantines, as we have already seen, more often than not dispensed with it in the presence of Christ—presumably because it was no longer considered crucial.

How are the various moments or actions represented on the Byzantine rings of this type (Figs. 22, 24–26) to be interpreted? Clearly, the intention was not to show sequential stages of an unfolding marriage ceremony, but rather to convey symbolically the single, simple message that this marriage was one sanctioned by Christ. Of overriding importance is the presence of Christ as the dominant visual element; full length and at the center, he is iconographically equivalent to the dominant cross on rings of the frontal portrait type. But on these rings a more graphic, ceremonially evocative message of Christian benediction is conveyed through Christ's supervisory role in bringing the couple physically together in the *dextrarum iunctio* and, more importantly, through the imposition of his hands upon them in blessing.[115] Moreover, both ac-

tions are inscriptionally mirrored in the word *euchi* ("prayer") in the exergue of one ring (Fig. 24), which undoubtedly refers to the blessing then customarily pronounced on the couple by an invited priest.[116] In those few instances where both Christ and the Virgin appear on the ring bezel, the former blessing the groom and the latter the bride, the intention seems simply to have been to invoke the Virgin's blessing in addition to that of Christ, much as the help of the Virgin is explicitly invoked on the inscribed hoops of several of these rings (Fig. 25: *Theotoke boethei amen*).[117]

The appearance of *locus sanctus* iconography on the faceted hoops of three rings in this group (e.g., Fig. 26) adds further support to the idea that the early Byzantine marriage ring—indeed, early Byzantine marriage art generally (Figs. 14, 18, 20, 31)—was significantly amuletic.[118] Familiar from and apparently invented for Palestinian *eulogia* oil flasks of the sort preserved at Monza and Bobbio (Fig. 29),[119] these Holy Land scenes were transferred from those miracle-working pilgrimage artifacts to various items of jewelry which, by virtue of their inscriptions and complementary imagery, were clearly intended to function as amulets.[120] Closest to these rings is a distinctive category of medico-magical armband produced in the eastern Mediterranean region during the sixth and seventh centuries (Fig. 30: *heis Theos* ["one God"],

cordia," 312), and it would seem unlikely that the early Christian community would have so readily taken over a pagan iconographic scheme (e.g., onto sarcophagi and gold glass) if it were understood to have had some sacramental significance. One should also take as more symbolic than literal the passage from Gregory of Nazianzus cited in note 113 above.

[115] On all but one ring in this series (Fig. 24), Christ appears to be touching the couple, either on the shoulders, the hands, or the head. Since in no instance can it be seen that he (or the Virgin) holds marriage crowns (which in two instances are shown separately, hovering over the couple), this gesture, even when directed toward the head, should be taken as one of blessing and not coronation. A similar situation obtains on coins of the middle Byzantine period whereon the Virgin is seen to touch the crowned head of the emperor in benediction. See P. Grierson, *Byzantine Coinage*, Dumbarton Oaks Byzantine Collection Publications 4 (Washington, D.C., 1982), 26.

[116] For early evidence of the blessing of the bride and groom by a priest through the imposition of his hands, and for John Chrysostom's specific references to the *euchai* and *eulogiai* that the priest pronounces as part of the marriage benediction, see Ritzer, *Le mariage*, 104–10, 134 f (PG 54, col. 443).

[117] To support Kantorowicz's ("Marriage Belt," 13) ingenious interpretation of those rings with both Christ and the Virgin as portraying, in response to Eph. 5:25, a typological bond between the terrestrial couple and "the exemplary concord of King and Queen of Heaven," one would need stronger evidence for the textual and iconographic impact of that Ephesians marriage epistle (5:22–33) in early Byzantium. And even then, one would still have to question how *mimesis* could be involved, since unlike the examples cited by Kantorowicz from Roman coinage (his figs. 31a-c), bride and groom are here not imitating but rather receiving the actions of Christ and the Virgin.

[118] For this interpretation of the *locus sanctus* rings' iconography, see Vikan, "Art, Medicine, and Magic," 83; and Kitzinger, "Reflections," 62.

[119] Figure 29 = Monza, Cathedral of St. John the Baptist, ampulla 2. See Grabar, *Les ampoules*, pl. v. The scenes on the ring and flask are: Annunciation, Nativity, Visitation, Presentation in the Temple (ring), Baptism, Crucifixion, Women at the Tomb (flask), Christ Appearing to the Women (ring), Ascension (flask). For an iconographic analysis of these rings, plus that at the Walters Art Gallery sharing these scenes but lacking explicit marriage imagery (Verdier, "An Early Christian Ring"), see Engemann, "Pilgerampullen," 20–22.

[120] For the issue of how, in contemporary belief and piety, this transference of *locus sanctus* image, and with it, sacred power, took place, see G. Vikan, "Sacred Image, Sacred Power," *Icon* (Washington, D.C., 1988), 14–18.

Psalm 90).[121] Such armbands are distinguished by a few recurrent apotropaic inscriptions—notably Psalm 90: "He that dwells in the help of the Highest . . ."—and by a ribbon-like design highlighted with medallions bearing one or more of the flasks' *locus sanctus* scenes plus such patently magical images as the Holy Rider, the Chnoubis, the pentalpha, and various "ring signs."[122] Made of silver or, more rarely, bronze, they were designed specifically for women and, through the magic of the Chnoubis, "the Master of the Womb," specifically for control of the uterus.[123] While there is nothing about the *locus sanctus* marriage rings to suggest the same amuletic specificity, the parallel between these two object types is suggestive, especially in light of the possible proactive role against the "wandering womb" of the earthen marriage tokens (Fig. 20) discussed above.

Also amuletic is the ring's very shape, the octagon, which is shared by more than half the rings belonging to the *dextrarum iunctio* iconographic type. This is indicated by the high rate of coincidence between octagonal hoops and rings bearing magical words (e.g., *heis Theos*, Psalm 90), magical symbols (e.g., the Evil Eye, the pentalpha, "ring signs"), and magical figures (e.g., the Holy Rider, the Chnoubis),[124] and also by the fact that the octagon is the shape prescribed by Alexander of Tralles for medico-magical rings designed to treat colic:

Take an iron ring and make its hoop eight-side, and write thus on the octagon: "Flee, flee, O bile, the lark

is pursuing you." . . . I have used this method many times, and I thought it inappropriate not to draw your attention to it, since it has a power against the illness.[125]

In addition, there is the apparently amuletic inscription from Psalm 5 ("Thou hast crowned us with a shield of favor"), already discussed, which appears on one of the octagonal *locus sanctus* rings, and on a second octagonal ring, without scenes.[126]

Beyond the words *homonoia* and *euchi*, Psalm 5:12, and occasional invocations calling upon the Lord or the *Theotokos* to help husband and wife, one additional text, the opening passage from John 14:27, is inscribed on the hoops of several rings in this series (Fig. 26): "Peace I leave with you, my peace I give unto you."[127] The intention was probably to invoke a generic sort of matrimonial peace, like that implicit in the word *homonoia*, and that referred to repeatedly, in one form or another, in the text of the later Byzantine marriage ceremony: "protect these your servants in peace and harmony."[128] No doubt the same marital peace was on Dioscorus of Aphrodito's mind when, in his "Epithalamium for Paul and Patricia," he wished the couple:

. . . indissoluble harmony, as they hold children and grandchildren on their laps, and a bright and peaceful life, worthy of poetic praise[129]

Final mention should be made of the appearance of this *dextrarum iunctio* iconography outside the realm of rings, on a pair of luxurious gold marriage belts, one from the de Clercq collection now preserved in the Louvre, and the other at Dumbarton Oaks (Fig. 31: *ex Theou homonoia; charis, hygia*).[130] Both are datable with the marriage

[121] Figure 30 = Columbia, University of Missouri Museum of Art and Archaeology. See J. Maspero, "Bracelets-amulettes d'époque byzantine," *Annales du service des antiquités de l'Egypte* 9 (1908), 246–58, fig. 1 (line drawing); and Vikan, "Art, Medicine, and Magic," 75. The scenes on the armband are: Annunciation, Nativity, Chnoubis and "ring signs," Baptism, Crucifixion, Women at the Tomb, Holy Rider, Ascension (far left).

[122] See Vikan, "Art, Medicine, and Magic," 75–77, and, for an armband bearing the word *hygia*, fig. 10.

[123] For the issue of uterine magic, see the article cited in the preceding note. I took up the gender-specific question as it relates to these armbands in an unpublished paper entitled "The Magic of Silver in Early Byzantium," presented as part of the 1986 NEH sponsored symposium, "Ecclesiastical Silver Plate in Sixth-Century Byzantium," jointly hosted by the Walters Art Gallery and Dumbarton Oaks.

[124] For examples of such rings, see Vikan, "Art, Medicine, and Magic," figs. 13, 15; and *Objects with Semitic Inscriptions*, nos. 25, 340, 347 (and nos. 329, 336, and 338, for faceted hoops that are too crudely executed to be identified specifically as eight sided). Conversely, bezels bearing invocations, monograms, or iconic images are rarely associated with octagonal (or even faceted) hoops. Clearly, this evidence does not square with Kantorowicz's notion ("Marriage Belt," 13 f; repeated by Kitzinger, "Reflections," 72 note 71) that the correlation was with "concord," by way of a perceived identity of shape between octagonal ring hoops and the octagonal Church of Holy Savior in Antioch, originally devoted to *Homonoia-Concordia*.

[125] Alexander of Tralles, VIII.2. See *Alexander von Tralles*, ed. and trans. T. Puschmann (Vienna, 1878–79), II, 377.

[126] See the list of rings in note 97 above.

[127] This same passage, which is otherwise unusual among the minor arts of early Byzantium, is found on one of the amuletic silver armbands described above. See W. Froehner, *Collection de la Comtesse R. de Béarn* (Paris, 1905), 10–12. Interestingly, *Theou charis* does not appear on these rings, perhaps because Christ's active participation in the wedding benediction obviates it.

[128] See Trempela, "He akolouthia," 133; Kantorowicz, "Marriage Belt," 11; and Kitzinger, "Reflections," 72 note 71.

[129] See MacCoull, *Dioscorus*, 81 f. But it is also possible that a more specific, amuletic sort of "*kardia* peace" was being invoked through the addition of John 14:17, comparable to that of the magical uterine papyrus quoted above ("do not gnaw into the heart"), since verse 17 concludes with the phrase "Let not your heart be troubled, neither let it be afraid." One is reminded again of that *alogon misos* which, springing from the heart, can inhibit a happy marriage and thus procreation.

[130] Figure 31 = Washington, D.C., Dumbarton Oaks Collection, no. 37.33. See Ross, *Catalogue*, no. 38. For the de Clercq belt, see A. de Ridder, *Collection de Clercq. Catalogue, tome VII: Les bijoux et les pierres gravées, première partie, les bijoux* (Paris, 1911),

rings to the sixth to seventh century, both are said to have come from the eastern Mediterranean region, and both show basically the same design: two large central repoussé medallions linking twenty (or 21) smaller medallions. The smaller medallions show dionysiac figure types of various ages, pagan gods (Hermes, Apollo), and *tyches*, whereas the larger clasp medallions bear the familiar *dextrarum iunctio* with Christ as symbolic *pronubus*, much as it appears on the *solidus* of Arcadius and Ariadne (Fig. 23). Disregarding differences in style and quality (the Dumbarton Oaks belt is far superior), the two belts are remarkably alike, and disregarding technique and size, their central clasps are remarkably like marriage ring bezels. Even their inscriptions are similar to those of the rings, with the Dumbarton Oaks belt bearing the words "from God concord; grace, health," and the de Clercq example showing "wear in good health; grace of God" (*hygienousa phori; Theou charis*).

What is new is not the word *hygia*, but rather its greater prominence, and, more important, the interlinking of the Christianized *dextrarum iunctio* with various pagan figures, notably Dionysos. But in fact, during late Antiquity Christ and Dionysos could easily be accommodated under the encompassing umbrella of marriage. Again, Dioscorus of Aphrodito provides an illuminating textual counterpart, in his "Epithalamium for Athanasius":

strong Athanasius . . . I have beheld [you] as another new Dionysos; for truly those who look upon the wine, Love's adornment, passing it closely in goblets one to another, have prayed to Poseidon the nurturer for you, O bridegroom[131]

Wine, "love's adornment," was an essential part of late antique wedding festivities, as it remains today and as it was at Cana.[132] Moreover, wine seems

then to have functioned as well on a more practical, therapeutic level in helping to fulfill the couple's childbearing goal. Epithalamia like that in honor of Athanasius suggest it, and magical papyri substantially confirm it. A seventh-century "prayer for pregnancy" papyrus in the Pierpont Morgan Library contains a Coptic charm to be used by a husband in order to get his wife pregnant.[133] First, as if anticipating the later wedding *Akolouthia*, a series of biblical parallels is invoked: God made man in his own image, God promised "our mother Sarah" a child, et cetera. Then, in order to put the charm to use, the husband is instructed to read its text over a cup of wine which, when offered to his wife, will ensure that she be "graced by the seed of man."

Not only was Dionysos with his wine an appropriate ingredient in a late antique wedding, whether Christian or pagan, so were any number of mythological models for love and its fulfillment. Dioscorus' "Epithalamium for Matthew" makes this graphically clear:

Bridegroom, bend your mind to love; Zeus himself in heaven, because of Europa's beauty, is known to have become a bull; for love of Leda he was esteemed a swan. Carry your Europa over the threshold, not over the sea; go to bed with your Leda, but don't worry about wings.[134]

But what, finally, of the belt itself; where did this seemingly utilitarian article of jewelry fit into the marriage ritual? According to the Greek *Vita* of St. Alexis, it was in the nuptial chamber that the groom gave his bride her (ring and) wedding belt (*zone*).[135] And where more appropriately could this have taken place, for following the protocol of the Roman wedding, it was there on the nuptial couch that the groom—after the bride had been delivered by the matron-*pronuba*—loosed the *nodus herculeus* which, hours earlier, she had fastened on the girdle with which her wedding gown (and virgin's modesty) had been secured.[136] Belt, wine, Christ, and Dionysos were in that moment symbolically and functionally intertwined in the literal fulfillment of the mandate of marriage.

The history of marriage-related art in Byzantium, insofar as it constitutes an identifiable tradition in its own right, is one substantially confined

no. 1212; and E. Coche de La Ferté, *L'antiquité chrétienne au Musée du Louvre* (Paris, 1958), no. 47. An unpublished early Byzantine belt(?) in the Hermitage, consisting of copper repoussé links, shows in the large medallion at its center the bust portrait of a woman enframed by the words *charis* and *hygia*. This, too, may be a marriage belt.

Among the 7th-century David silver plates there is one (*Age of Spirituality*, no. 432) that portrays the marriage of David and Michal (1 Sam. 18:27) under the authority of King Saul (-*pronubus*). Iconographically it is conceived as a courtly wedding, much like that portrayed on the marriage *solidus* of Licinia Eudoxia and Valentinian III (ca. 437), where Theodosius II takes the place of Concordia-*pronuba* (see note 109 above). The plate includes as well a pair of flute players and, in its exergue, two money bags and a *modius*. These were probably added to evoke the musical merriment of a traditional Roman wedding (Ritzer, *Le mariage*, 130–32), and, perhaps, the dowry gifts.

[131] See MacCoull, *Dioscorus*, 86 f. See also Macrobius, *Saturnalia*, I.18.9–10.

[132] For the perpetuation of pagan festivities at early Christian weddings, see Ritzer, *Le mariage*, 130–32.

[133] See F. D. Friedman, *Beyond the Pharaohs: Egypt and the Copts in the 2nd to 7th Centuries A.D.* (Providence, R.I., 1989), no. 108.

[134] See MacCoull, *Dioscorus*, 108.

[135] See A. Amiaud, *La légende syriaque de Saint Alexis, l'homme de Dieu* (Paris, 1889), 12 f; and Ross, *Catalogue*, no. 38.

[136] See Carcopino, *Rome*, 82.

X

to late Antiquity, to rings, and to the wealthy. Indeed, it is at once characterized and circumscribed by two superb rings at Dumbarton Oaks: the double-profile signet of Aristophanes and Vigilantia from the early fifth century (Fig. 4) and the octagonal *locus sanctus* amulet ring of Peter and Theodote from the mid-seventh century (Fig. 26). Moreover, much as the Byzantine marriage rite developed directly from the Roman ceremony, so the Byzantine marriage ring developed directly from its Roman antecedent. Sequentially, over half a millennium, Rome and Byzantium engendered an unbroken tradition of marriage art thematically dominated by the Stoic ideal of the harmonious couple—by paired portraits, by the *dextrarum iunctio*, and by the inscribed words *concordia* and *homonoia*. Throughout, coinage remained the crucible for iconographic invention and the reservoir for figure types, and throughout, iconography remained symbolic and "portraiture" anonymous.

Superficially, the bezel of a Byzantine marriage ring of the seventh century (Fig. 26) looks much like a Roman commemorative marriage coin of the third (Fig. 28), and in fact, there is a direct genealogical link between the two. But over the centuries much had changed, beyond the mere substitution of the Greek *homonoia* for *concordia*. Not only has Christ-*pronubus* taken the place of Concordia-*pronuba*, the Virgin Mary has been inserted beside him, dispensing her blessing touch to the head of the bride just as Christ does to the groom, while the couple stands passively apart, facing forward. What is paramount now is no longer the traditional contractual gesture of clasped hands, but rather Christian benediction, since among the Byzantines a harmonious marriage was no longer viewed as an achievement of husband and wife, but as a gift from God. The old Stoic ideal has here

been given a Christian reinterpretation, and reflecting that, marriage iconography and marriage inscriptions have acquired their own distinctly Christian character.

There is another critical distinction to be drawn between a Byzantine marriage ring of the seventh century and its Roman antecedent—or, for that matter, its fifth-century Byzantine antecedent. Over those two hundred years or so the very function of the marriage ring—beyond its immediate ceremonial role—had been fundamentally altered, insofar as what almost invariably used to be a signet was now more often than not an amulet (and never a signet). *Hygia* inscriptions, octagonal hoops, *locus sanctus* scenes, and the "shield of favor" excerpt from the Psalms all contributed to the marriage ring's new amuletic empowerment, which is most appropriately interpreted in light of the demographic concerns pervading Byzantine marriage law and poetry as relating specifically to childbearing.

But even as late as the sixth and seventh centuries, the pre-Christian roots of Byzantium's marriage art (and marriage) are still unmistakably present, most notably on the Dumbarton Oaks marriage belt (Fig. 31). In much the same way that Dioscorus of Aphrodito invokes God's protection on the wedding couple almost in the same breath that he evokes for them the model of Leda and the swan (while adjuring the evil eye), the goldsmith of the Dumbarton Oaks belt interlinks Christ with Dionysos and his *thiasos*, while simultaneously invoking an amuletic sort of "health," *ex Theou*. Such was the breadth and richness of marriage art in early Byzantium.

1 Madrid, Biblioteca Nacional, cod. 5-3, no. 2, fol. 125r, marriage miniature (photo: Madrid, Biblioteca Nacional)

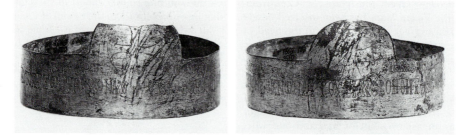

2 Athens, Byzantine Museum, nos. 7663a, b, marriage crowns (after Drossoyianni,
 "Byzantine Crowns," pl. 1)

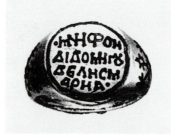

3 Athens, Stathatos Collection, betrothal ring
(after *Collection Hélène Stathatos*, II, no. 33)

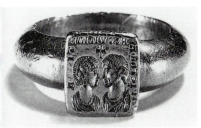
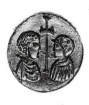
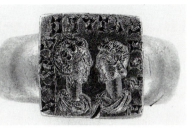

4 Washington, D.C.,
 Dumbarton Oaks Collection,
 no. 47.18, marriage ring
 (photo: Dumbarton Oaks)

5 Washington, D.C.,
 Dumbarton Oaks Collection,
 no. 53.12.61, marriage ring
 bezel (photo: Dumbarton
 Oaks)

6 London, British Museum,
 marriage ring (photo: the
 Trustees of the British
 Museum)

7 London, British Museum,
 medallion (photo: the Trustees
 of the British Museum)

8 London, British Museum, *solidus*
 (photo: the Trustees of the British
 Museum)

9 London, British Museum, *solidus*
 (photo: the Trustees of the British
 Museum)

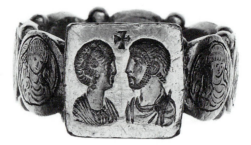

10 London, British Museum, marriage
ring (photo: the Trustees of the
British Museum)

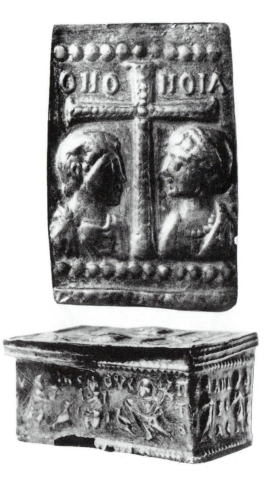

11 Sofia, Narodni Muzeji, no. 2519,
marriage(?) box (after Buschhausen,
Metallscrinia, no. B3)

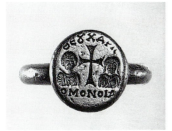

12 Washington, D.C., Dumbarton
 Oaks, no. 59.60, marriage ring
 (photo: Dumbarton Oaks)

13 Washington, D.C., Dumbarton
 Oaks, no. 53.12.4, marriage ring
 (photo: Dumbarton Oaks)

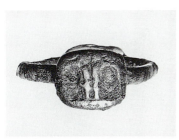

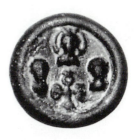

14 Houston, Menil Collection,
 no. R26, marriage ring
 (photo: Menil Collection)

15 Houston, Menil Collection,
 no. GW12, glass weight
 (photo: Menil Collection)

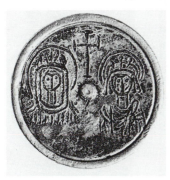

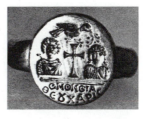

16 Geneva, Musée d'Art et
 d'Histoire, flat weight
 (photo: Musée d'Art et
 d'Histoire)

17 Athens, Canellopoulos
 Museum, marriage ring
 (after Spieser,
 "Canellopoulos," no. 9)

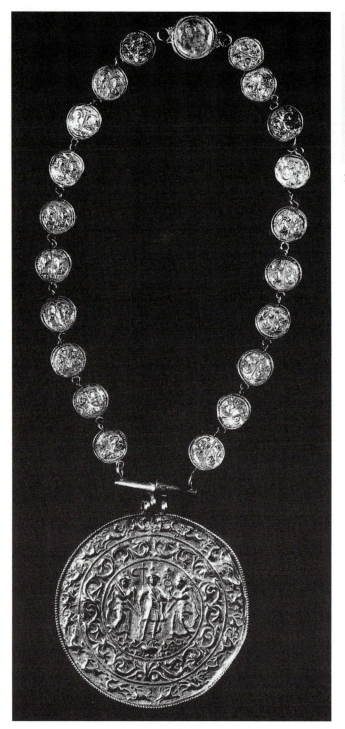

18a *detail*

18 Leningrad, State Hermitage Museum, no. *omega* 107–
 8, marriage necklace (photo: State Hermitage
 Museum)

19 New York, the Metropolitan Museum
 Art, Rogers Fund, 1958, no. 58.12,
 marriage necklace (photo: Metropolita
 Museum of Art)

20 Baltimore, the Walters Art Gallery, no. TL90.9.1, 2, 3, amuletic marriage tokens (photo: same)

21 Paris, Robert-Henri Bautier Collection, amuletic token (photo: Robert-Henri Bautier)

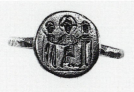

22 Washington, D.C., Dumbarton Oaks Collection, no. 61.3, marriage ring (photo: Dumbarton Oaks)

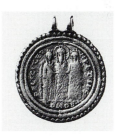

23 Washington, D.C., Dumbarton Oaks Collection, no. 59.47, *solidus* mounted as necklace clasp (photo: Dumbarton Oaks)

24 Baltimore, the Walters Art Gallery, Zucker Family Collection, no. TL10.1985.048, marriage ring (photo: the Walters Art Gallery)

25 London, British Museum, marriage ring (photo: the Trustees of the British Museum)

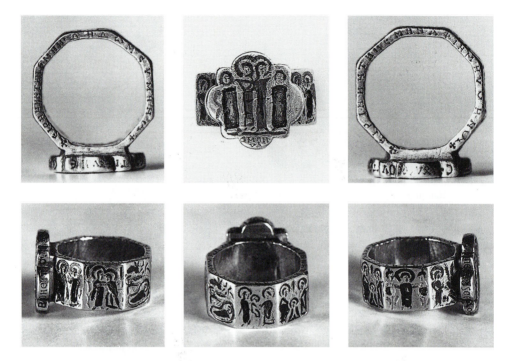

26 Washington, D.C., Dumbarton Oaks Collection, no. 47.15, marriage ring (photo: Dumbarton Oaks)

27 Glasgow, Hunterian Museum, *solidus*
(photo: same)

28 London, British Museum, *aureus*
(photo: the Trustees of the British
Museum)

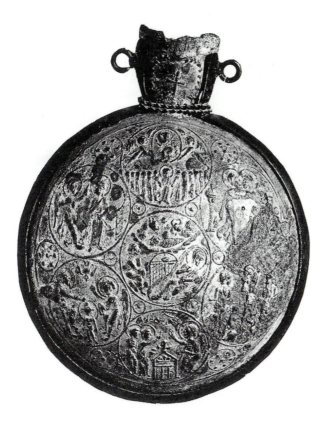

29 Monza, Cathedral of St. John the Baptist, ampulla 2,
 pilgrim flask (after Grabar, *Les ampoules,* pl. v)

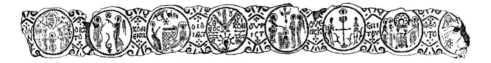

30 Columbia, University of Missouri Museum of Art and Archaeology (olim, Cairo, Fouquet
 Collection), amuletic armband (after Maspero, "Bracelets-amulettes," fig. 1)

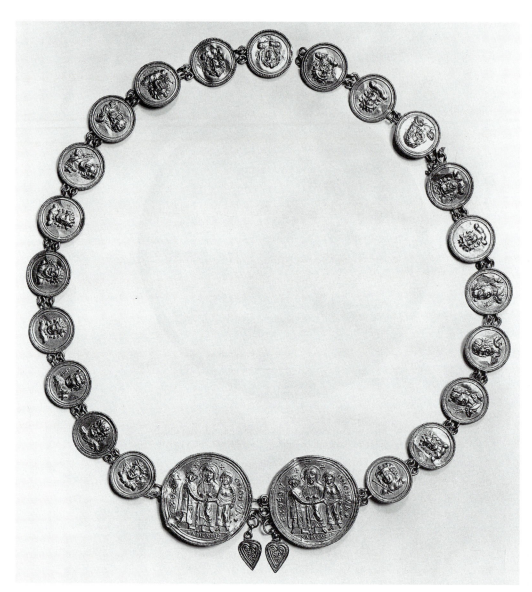

31 Washington, D.C., Dumbarton Oaks Collection, no. 37.33, marriage belt (photo: Dumbarton Oaks)

Two Byzantine Amuletic Armbands
and the Group to which They Belong

*This article has the twofold aim of introducing two unpub-
lished amuletic armbands from the early Byzantine period,
one in the Walters Art Gallery and the other in the Benaki
Museum, Athens, and analyzing the group of twenty-two like
objects to which they belong. The importance of these techni-
cally simple, relatively inexpensive pieces of jewelry lies in
their unusually rich and varied iconography, which unites
traditional pagan and Jewish magical elements with imagery
newly developed for the famous Christian pilgrimage shrines
of the Holy Land. The focus of this article will be on these
armbands, and on the world of piety and belief from which
they emerged.*

T he more elaborate of the two armbands appeared
at auction in Switzerland in November 1990,
where it was acquired by the Walters Art Gallery (fig.
6).[1] Said to be from a private Lebanese collection, it
consists of a thin bronze band (height .6 cm) with nine
equally spaced oval medallions (height 1.8 cm), the
last of which (fig. 6j) was soldered to the back of the
first (fig. 6b) to complete the circle.[2] There is a break
through the fourth medallion (fig. 6e), and part of the
sixth (fig. 6g) and the connecting section to the sev-
enth are missing; otherwise the object is well preserved.
An original circumference of approximately 26 cm
may be reconstructed, which reflects a diameter of just
over 8 cm. On the basis of the narrative sequence of
the armband's Christological scenes, and the composi-
tional direction of its two scenes showing animals, it is
clear that the medallions read from left to right, as do
those of all the other armbands in the group. The re-
duced figure style is that characteristic of the simplest
early Byzantine metalwork; the lower body is evoked by
just a few sketchy diagonal lines of drapery, the upper
torso and arms by a sagging, sack-like protrusion (fig.
6i), and the head by an oval depression within the
halo.

The sequence of eight engraved medallions be-
gins (fig. 6b) with an inexplicably inverted four-line

inscription after a cross, consisting of the first five
words of Psalm 90 (*Septuagint*): †*Ho ka/toikon/ en
boe/thia tou* ("He that dwells in the help of the
[Highest] . . .").[3] The Annunciation appears on the
next medallion (fig. 6c), with the Virgin standing at
the left and Gabriel, with his hand raised in greeting,
at the right. The third medallion (fig. 6d) shows a
beardless nimbed rider with cross-staff. Although one
would expect to see the long ears of a donkey instead
of what seem to be the short ears of a horse, and per-
haps some hint of a cross within the halo, the compo-
sition should nevertheless be understood as a
simplified version of the Entry into Jerusalem. This is
indicated by the cross-staff that the figure carries, by
the medallion's close compositional parallels with the
many other such images of the period that include un-
mistakable elements of the Entry (fig. 11: *Eulogemenos*
["Blessed One"]), and by the fact that one of the arm-
bands in the group (fig. 7) shows this figure plus the
more typical version of the Holy Rider, wherein a
mounted warrior impales a prostrate demon beneath
the hooves of his horse.[4]

The next, broken medallion (fig. 6e) bears a
flared, equal-armed cross with circles enclosing *X*s in
its quadrants (see below), and the one after that (fig.
6f) shows the *aphlaston* (aplustre), flanked above by
the name *Solomonos*. The *aphlaston* is the fan-shaped
decorative sternpost of an ancient ship (fig. 12), trace-
able iconographically and textually, with little varia-
tion, from Homer through late antiquity.[5] Perhaps
originally an imitation of a bud or lotus flower, as on
Egyptian ships, it developed into a plume- or fan-
shaped object and, as a detachable symbol, was taken
as a trophy when the ship was captured; moreover, it
could stand alone, like a ship's prow or rudder, to
evoke sea power or seafaring in general. In its de-
tached state, as here, it appears on a number of bronze
amulets of the period and, with "Solomon," on a
group of contemporary amuletic clay tokens (fig. 13).[6]

After the *aphlaston*, on medallion six (fig. 6g), there is a simple magical character—an *X* within a circle—set inside a hexagonal field defined by a border of dense hatching. Although its origin and specific potency are unknown, and probably unknowable, the general meaning of the symbol is unmistakably clear from its parallel appearance on Greco-Egyptian amuletic gems (fig. 14), and in late Roman magical inscriptions.[7] The seventh medallion (fig. 6h) shows a running lion over a snake, with a crescent moon above, a combination of apotropaic motifs that appears frequently on bronze amulets of the period (fig. 15b);[8] the last medallion (fig. 6i) bears the Women at the Tomb, with one of the Marys to the left, the angel to the right, and between them the tomb aedicula, in the form of a low rectangle (door?) with a starburst above. Finally, mention should be made of the hatched slits that appear on the band between the successive medallions; that these are not merely decorative but rather the blinded or neutralized Evil Eye (Campbell Bonner's suggestion) is indicated by the appearance of the same eye-like motif at the point of the Holy Rider's lance on bronze amulets of the period (fig. 16).[9]

The simpler of the two armbands, in the Benaki Museum, Athens, is silver (fig. 4).[10] Said to be from Egypt, it consists of four iconographic medallions separated by pairs of elongated diamonds with incised circles, and between the diamonds, by a small square with an incised equal-armed cross set within a circle. Somewhat smaller than the Walters armband, its diameter is 6.4 cm. It is in excellent condition, and its figure style, although basically quite close to that of the Walters armband in its reduced, formulaic approach to drapery and the body (cf. figs. 4d and 6i), is executed with fewer, more confident strokes, and there is some internal articulation to the face, in the form of punch dots for eyes and mouth.

The first of its four medallions (fig. 4a) shows the Raising of Lazarus, with Christ to the left and a mummy-wrapped, larva-like Lazarus within a round-topped aedicula to the right. This is followed (fig. 4b) by a simpler (misunderstood?) version of the *aphlaston*, rendered as four snake-like strands or bars becoming progressively longer as they rise from horizontal to nearly vertical, and all springing more or less from the same point, at the lower left. In its crudeness it is closer to the motif on the amuletic token already introduced (fig. 13), and although it lacks *Solomonos*, the memory of that inscription is retained in the form of nine triangular punch marks corresponding in number and location to the letters on the equivalent

Walters medallion (fig. 6f). A galloping Holy Rider, with nimbus and flowing cape, impales a prostrate, mummy-wrapped demon on the next medallion (fig. 4c); and the Women at the Tomb, with a single Mary to the left and a gabled aedicula (with door and hanging lamp?) to the right appears on the last medallion (fig. 4d).

These two objects belong to a group of at least twenty-two early Byzantine amuletic armbands and armband fragments interrelated through a combination of design elements, inscriptions, iconography, figure style, and provenance.[11] Although known to scholars for more than eight decades through an excellent short article published by Jean Maspero in 1908, and cited during recent years with increasing frequency in studies devoted to early Byzantine amulets, pilgrimage art, and Christological iconography, these armbands have never been systematically assembled and analyzed; indeed, Maspero's line drawing of an unusually elaborate silver example then belonging to Dr. Fouquet in Cairo remains their most familiar representation in the literature.[12] It is hardly surprising, therefore, that these armbands have generally, though mistakenly, been understood to be characteristically Egyptian and silver.[13]

Members of the group have a thin flat band showing from one (figs. 1 and 2) to eight (figs. 6, 7, 9, and 10) iconographic or inscriptional medallions, with those bearing four medallions (figs. 3–5 and 8) being the most common.[14] Independent of whether or not the band bears an inscription, its profile may be either narrow and unarticulated, between widely spaced medallions (figs. 1–3 and 6); wide, with a short arc composed of three small arches, between closely spaced medallions (figs. 9 and 10), or wide-narrow-wide in an ABCBA rhythm, with a pair of diamonds and a small medallion (or square) between successive large medallions, which may be either closely or widely spaced (figs. 4, 5, 7, and 8). The narrow band is characteristic of those members of the group showing one or four medallions, although the Walters armband, with eight, falls into that category as well; by contrast, the wide band is confined to a closely interrelated subgroup of three armbands with eight medallions each (items 7, 8, and 11). The third, most richly articulated band profile includes a wide range of variants, from complex to simple, with the intervening small medallion bearing a multi-figure scene (fig. 7), an inscription (fig. 8) or just a symbol (fig. 4)—or becoming nothing more than a vestigial spur (fig. 5).

As for "figure style," the reduced, sketchy mode characteristic of the Walters and Benaki examples is

shared, in levels of greater or lesser sophistication, by well over half of the armbands in the series, whether the medium be bronze (figs. 1–3 and 6) or silver (figs. 4 and 5). Certainly much more detailed and subtle in execution, but known to me only through a line drawing, is a silver armband published by Dalton in the de Béarn Collection in 1905 (fig. 7). Additionally, there is a subgroup of at least four silver armbands (items 5, 7, 8, 11; figs. 8–10) whose linear, etching-like style stands apart from the much simpler sketchy manner of the others, by virtue of its greater precision, detail, and elegance, and through its liberal use of punched and tooled decoration.

About 60 percent of the armbands are bronze (including figs. 1–4 and 6) or, in one case, iron, and of those with known provenance, eleven come from Syria/Palestine or Cyprus (including figs. 1–3 and 5–7), and seven come from Egypt (including figs. 4 and 8–10).

Nearly every armband in the series bears one or more inscriptions, with Psalm 90, *Ho katoikon en boetheia tou hypsistou . . .*, being by far the most common, occurring on the band (figs. 1, 2, 5, 7, 9, and 10) or on one or more medallions (figs. 3a and 6b) of eighteen of twenty-two armbands. The portion quoted varies from just the first few words to nearly all of the first six verses (item 14):

> 1. He that dwells in the help of the Highest, shall sojourn under the shelter of the God of heaven. 2. He shall say to the Lord, Thou art my helper and my refuge: my God; I will hope in him. 3. For he shall deliver thee from the snare of the hunters, from every troublesome matter. 4. He shall overshadow thee with his shoulders, and thou shalt trust under his wings: his truth shall cover thee with a shield. 5. Thou shalt not be afraid of terror by night; nor of the arrow flying by day; 6. nor of the evil thing that walks in darkness; nor of calamity, and the evil spirit at noonday.[15]

The sense of the passage, plus its frequent appearance during this period on amuletic jewelry of all sorts (e.g., fig. 16 [reverse: *Ho katuko*]), house lintels (notably in Northern Syria), and tombs, leave no doubt of its apotropaic intent on the armbands.[16] Also apotropaic are most of the secondary inscriptions, including the popular *Heis Theos . . .* ("One God [who conquers evil]") acclamation (figs. 1, 2, and 10d), the Trisagion (figs. 5b and 8), *Hygieia* ("Health"; fig. 5c), and *Solomonos* (fig. 6f), the name of the Old Testament king renowned for his ability to manipulate the power of demons with his seal ring.[17] Moreover, on one armband (fig. 1) the excerpt from Psalm 90 is followed by an invocation of the "blood of Christ" (. . .*to hema tou Christou pause apo . . .*).[18] Just one armband (fig. 7) bears biblical texts (as captions to its Christological scenes), and three have invocations: "Lord, help your servant and Sissinios" (item 14); "One God (who) preserves, guard (your) servant Severinam" (item 21); and "*Theotoke,* help Anna; Grace" (item 22; fig. 5d), the last one coupled with an iconic frontal image of the Virgin and Child Enthroned.

As dominant iconographically as is Psalm 90 inscriptionally, is the Holy Rider (figs. 1, 2, 3d, 4c, 7, 8c, 9a, and 10h), which in its demon-impaling identity (cf. fig. 15a) appears on sixteen of the nineteen more or less complete armbands; moreover, in at least two of the three cases where it does not appear, its close relative, the Entry into Jerusalem, appears instead (figs. 5c and 6d). That the Entry is here to be understood as functioning apotropaically, as it does on many amulets of the period (e.g., fig. 11),[19] and not as a *locus sanctus* referent or as a Gospel storytelling element, is confirmed by its appearance out of biblical order in two of the three instances when it does appear on the armbands (figs. 5c, 6d and 7), and by its coupling in one case with the word "Health" (fig. 5c). Certainly the most popular amuletic image of the period, the Holy Rider was for Jew, Christian, and pagan alike the primal evocation, and invocation, of the triumph of good over evil.[20]

The notion of magical self-protection is augmented on some of the armbands by such common late antique prophylactic images as the running lion and snake (figs. 1, 2 and 6h; and 15b), Solomon's pentalpha signet device (figs. 9b, 10d, and 10h), ring signs (*characteres*) (figs. 6g and 10d [*zetas*]; and 14), the Evil Eye (figs. 3 and 6; and 16), and the Chnoubis (figs. 9b and 10d), the lion-headed snake with seven planetary rays which, among Greco-Egyptian gem amulets, was a popular *apotropaion* for abdominal pains (fig. 17: "Guard in health the stomach of Proclus").[21] To this extent—with the Holy Rider, *Heis Theos, Ho katoikon,* the lion and snake, the Evil Eye, and ring signs—these armbands are, but for their design and how they were worn on the body, substantially of a kind with the ubiquitous bronze pendant amulets catalogued by Campbell Bonner (figs. 15 and 16 ["late antique; Syro-Palestinian"]).[22]

While slightly over half the medallions on the armbands are dominated by those patently amuletic images and words, the remainder bear explicitly Christian iconography which, with the exception of a medallion with the cross (fig. 6e), another with the Virgin and Child (fig. 5d), one with John the Baptist(?) or Zacharias(?) (fig. 8b), and an armband with four orant saints (including Menas; item 9), is drawn

from the following series of Christological scenes (with frequency of appearance):

Annunciation	6
Nativity	4
Adoration of the Magi	3
Baptism	4
Raising of Lazarus	2
Adoration of the Cross/Crucifixion	4
Women at the Tomb	10
Ascension	2

For the armbands illustrated in our figures 7, 9, and 10 (there are four like this in all), one may speak of a "cycle" of scenes, since there is an extended, narratively consistent string of six (or five) episodes: Annunciation, Nativity, Baptism, Adoration of the Cross/Crucifixion, Women at the Tomb, Ascension.[23] More typically, however, there is only a selection of such iconography which, when interspersed with the various apotropaic images, provides little sense of storytelling: Adoration of the Magi, Women at the Tomb-O-O (fig. 3); Raising of Lazarus-O-O-Women at the Tomb (fig. 4); Women at the Tomb-O-O-O (fig. 5); O-Annunciation-O-O-O-O-Women at the Tomb (fig. 6). Furthermore, there are six armbands, like those illustrated in figures 1 and 2, which show only the Holy Rider.

The numerical differential between the Annunciation (6 occurrences) and the Ascension (2) is probably to be explained by the tendency of any picture cycle to sputter out before its completion (cf. figs. 9 and 10), which is especially likely in the present context, wherein many armbands lack sufficient medallions for the entire story, and the interest in magical imagery is as strong or stronger than the interest in biblical storytelling or in *locus sanctus* iconography. The only other statistically noteworthy episode is the Women at the Tomb (10 occurences), whose significance for the armbands may better be understood against the backdrop of the pilgrimage art from which most of this Christological iconography derives (see below).

As for the significance of the "cycle," it has been noted on several occasions that the Christian imagery on these armbands functioned in a complementary way to the magical motifs, to protect the wearer.[24] Ernst Kitzinger has drawn a general parallel between the sequence of images encircling these armbands, and thereby repeating itself, and the word charm (Psalm 90) interspersed with it. But perhaps the cycle's prophylactic role may more specifically be understood as comparable to that of Gospel miracle stories as they are sometimes invoked among the magical papyri, including a fifth-century health amulet from Oxyrhynchus:

Fly, hateful spirit! Christ pursues thee; the son of God and the Holy Spirit have outstripped thee. O God (who healed the man at) the sheep pool, deliver from every evil thy handmaid Joannia whom Anastasia also called Euphemia bare. . . O Lord Christ, Son and Word of the living God, who healest every sickness and every infirmity, heal and regard thy handmaid Joannia, whom Anastasia also called Euphemia bare. Chase from her and put to flight all fevers and every kind of chill, quotidian, tertian, and quartan, and every evil. . . Upon thy name, O Lord God, have I called, the wonderful and exceeding glorious name, the terror of thy foes. Amen.[25]

On its most basic level this papyrus amulet draws its power from the invocation of the sacred name, and thereby from the primal, magical belief that such names share the being and participate in the power of their bearers.[26] But this amulet is magical as well on a secondary, "aretalogical" level, as the power of the deity (as if this were Isis or Asklepios) is invoked through a recitation of his most glorious deeds.[27] The same is perhaps true of the armbands and their *locus sanctus* picture cycle, whose individual scenes may be read as sequential verses in a visual aretalogy. Indeed, this method of invoking sacred power is attested among Christians as early as Origen (*Contra Cels.,* 1.6), who in response to Celsus' charge that he and his coreligionists got their power from reciting the names of demons, countered by saying that:

. . . it is not by incantations that Christians seem to prevail [over evil spirits], but by the name of Jesus, accompanied by the announcement of the narratives which relate to Him; for the repetition of these has frequently been the means of driving demons out of men. . . .[28]

But as noted, this "empowered" picture cycle is in fact often unidentifiable as a cycle (cf. fig. 3), suggesting that at least some of its scenes were believed to be individually potent. Significantly, the armbands derive their iconography not directly from the Gospel narrative but rather from its selected and transmuted manifestation in pilgrimage art, where compositions were made to respond to the appearance and experience of the *locus sanctus* shrines commemorating the biblical events.[29] This is clear from the fact that their version of the Women at the Tomb (figs. 3c, 4d, 5a, 6i, 7, 9a, and 10g) does not show the cave of the biblical account but rather a small gabled aedicula replicating such salient architectural elements of Constantine's Holy Sepulchre shrine as the "grilles" described by the pilgrim Egeria (ca. A.D. 385), and from the striking similarity that exists between the choice and configuration of their Christological scenes and those that appear on the well-known Palestinian holy oil (pilgrim)

flasks preserved, for the most part, in Monza and Bobbio.[30] For example, six of the eight medallions on the armbands illustrated in our figures 7 and 10 match scenes on the reverse of Monza ampulla 2 (fig. 18).[31] The role of these pewter ampullae as pilgrim amulets, both for healing and for travel protection, has been well established; indeed, one of them bears the inscription "Oil of the Wood of Life that guides us by land and sea."[32] Also well established is the principle that at least some of these scenes could convey the same amuletic power independent of the sanctified oil, simply by virtue of iconographic coincidence with their power-bearing archetype.[33] This is especially likely in the case of the most frequently appearing armband scene after the Holy Rider—namely, the Women at the Tomb—since its compositional verisimilitude was not merely with what the pilgrims may have seen on their journey (whether shrine architecture or shrine mural), but with the most revered of pilgrim relics: the Holy Sepulchre.[34]

The two bronze armbands from Syria now in Ann Arbor (items 1 and 2; fig. 3) are so alike in dimensions, technique, and iconography that Bonner was prompted to suggest that they had been made "in the same shop."[35] Noteworthy, beyond their shared figure style, is the narrow band with Evil Eyes, the medallion with just a few words of Psalm 90, and the solder-join assembly. Very closely related to these two armbands are three armband fragments in the group (items 13, 15, and 16), each of which includes a single medallion with the opening words of Psalm 90, and one of which (item 15) has a short section of a thin band with Evil Eyes; although none has a known provenance, all three may be placed in Syria/Palestine, very near in time and place to the Ann Arbor armbands. Also quite close, and known to have come from Syria/Palestine, is the Walters armband (fig. 6), which is an almost exact match in size (for band and medallions) to those in Ann Arbor, has basically the same figure style (cf. figs. 3c and 6i), and includes a Psalm 90 medallion, Evil Eyes, and the same sort of solder join. Although heavily corroded, the armband in Paris (item 20), reputedly from Syria, is clearly a member of this Syrian/Palestinian subgroup as well; this is indicated by its design and construction, with narrow band and solder-join medallion, by what can be made out of its reduced figure style, and by its inclusion of a Psalm 90 medallion.

A second tight subgroup from Syria/Palestine is that formed by the five armbands showing a single medallion with the Holy Rider (items 6, 12, 17, 19 and 21; figs. 1 and 2), which are interrelated as well through their inscriptions (notably *Heis Theos*), and through such distinctive complementary motifs as the apotropaic running lion. Four of the five (items 6, 12, 19, and 21) are known to have come from Syria/Palestine (three specifically from Palestine), and the fifth (item 17) should be assigned there as well.[36] Moreover, a near relative to these three is the armband from Cyprus with the first six verses of Psalm 90 spread over four medallions, and a fifth medallion with the Holy Rider. Stylistically, that medallion is a close match for the five Holy Riders just noted, which are in turn basically of a kind in terms of style with the extended series of Syrian/Palestinian armbands already discussed (cf. figs. 2 and 5c).

There is one tight, distinctive subgroup of three silver armbands said by Maspero to have been found together near Saqqara (items 7, 8, and 11; figs. 9 and 10). Two (items 7 and 8) are virtually identical, and the third differs only insofar as a pair of magical motifs which are united on it (fig. 10d: Trinity[?] and Chnoubis) are each given their own medallion on the others (fig. 9b), effectively forcing the last *locus sanctus* image, the Ascension, out of the cycle. Uniting these three armbands are not only medium, provenance, and iconography, but also their distinctive wide-band design, the liberal use of decorative punchwork and engraving, and an elegant, linear figure style (contrast figs. 5c and 9a). The silver armband in Berlin (item 5), which also came from Egypt, is a close cousin to this subgroup of three, for although its hoop design is of the wide-narrow-wide sort and it lacks Psalm 90, it does show much of the same decorative punchwork, and basically the same elegant, linear style (cf. 8c, 9a). Also related is a silver armband catalogued in Cairo by Strzygowski (item 9), whose band profile matches that of the Berlin armband, and like that one shows pairs of elegant birds on its inter-medallion diamonds, as well as the abundant punchwork characteristic of all of the silver armbands from Egypt.[37]

In all, this makes for, on the one hand, a closely interrelated series of fifteen armbands localizable to Syria/Palestine and Cyprus, with eleven having a more or less securely known provenance and four attributed, and, on the other hand, seven armbands known to have come from Egypt, with five showing a unified style quite distinct from that of any of the armbands in the Syrian/Palestinian series. In light of this is it appropriate to speak of the genre as being constituted of a Syrian/Palestinian subgroup and an Egyptian subgroup?[38] Or should one instead imagine that all arm-

bands originated from a single center—which presumably would have been the Holy Land, by virtue of the *locus sanctus* iconography?[39]

Speaking in favor of the latter possibility are the many general similarities uniting all the armbands—the various close links in specific details of design, such as that uniting the ABCBA-type bands of item 18 (Syria) and item 5 (Egypt) (figs. 7 and 8) and the stylistic and iconographic links between the Walters (Syria) and Benaki (Egypt) armbands—and the fact that such comparable pilgrimage-related artifacts as the Monza/Bobbio ampullae are by findspot mostly Italian and Egyptian, but by origin universally recognized to be Palestinian.[40] The armbands are, after all, portable, and even if they did not have the sanctified oil of the ampullae to tie them specifically to Jerusalem, it is reasonable to suppose, by virtue of their iconography, that they held special appeal for pilgrims returning from the Holy Land. Furthermore, there are strong iconographic and stylistic bonds connecting the non-pilgrimage imagery on many of these armbands with other sorts of artifacts known to be Syrian/Palestinian, including, most notably, the ubiquitous Holy Rider pendant amulets that Bonner long ago realized were distinctive to that region, and the relatively unusual *aphlaston* tokens said to be from the area of Antioch (fig. 13).[41]

But as appealing as the one-source scenario might be, it cannot be sustained. First, while there is much to link these armbands generally to Syria/Palestine, there is little to tie them specifically to Jerusalem or the Holy Land, or even to the pilgrimage trade. Indeed, by virtue of its presumed amuletic power, *locus sanctus* iconography quickly acquired a life of its own, far removed from the holy site at which it originated and independent of the blessed oil, earth, water *et cetera* to which it was originally bound and for which it was originally invented.[42] The most revealing witnesses to this phenomenon are the four octagonal gold rings (fig. 19) that bear on the facets of their hoops basically the same cycle of Christological *locus sanctus* scenes as that shared by the ampullae and armbands (cf. figs. 10 and 18).[43] By design and technique, and through the marriage iconography on the bezels of three of the four, these rings may be linked to an extensive series of deluxe marriage rings which are certainly, as a type, of Constantinopolitan origin, and which are otherwise without any pilgrimage connection. The Christological scenes on their hoops were taken over and exploited far from the Holy Land, and at one remove, for the amuletic power they were thought to convey.

It might rather be argued that the iconographic connection with the Qal'at Sim'ān clay tokens (fig. 13), the inscriptional link (Psalm 90) with Syrian house lintels, and the numerous provenances "from Syria" more strongly suggest that region, and not Palestine, as the place of origin. But Syria, or even Syria/Palestine, as the sole source for the group may be too confining, since despite its general similarities with the others, the Egyptian subgroup of five is so thoroughly distinctive in style and internally so homogeneous as to suggest if not require a distinction in place of manufacture. Furthermore, it is noteworthy that only these armbands show the Chnoubis and the *zeta*-like ring signs, which are otherwise familiar primarily from Greco-Egyptian gem amulets, and that one armband among this Egyptian subgroup (item 9) bears a representation of St. Menas, renowned for his healing shrine southwest of Alexandria.[44] Finally, one must ask if there is any reason not to suppose multiple locations of manufacture for these armbands, across Syria/Palestine and in Egypt, in light of the internal variations that are apparent even in the Syrian/Palestinian series (cf. figs. 2, 5, and 7), and with the knowledge that, unlike the ampullae, this genre of object need not derive from a single sacred source. As for the question of where this object type was invented, Syria/Palestine would be the obvious answer, by virtue of the armbands' more or less localizable connection there to the ampullae's *locus sanctus* cycle, the Holy Rider, and Psalm 90. Moreover, it is in Syria/Palestine that the earliest members of the series, those with a single Holy Rider medallion, may be localized (see below).

The issue of dating is less problematic than that of localization, even though direct archaeological evidence is confined to the armband now in the Royal Ontario Museum, Toronto (item 22; fig. 5). According to the New York antiquities dealer who first offered the piece for sale, it was part of a small silver hoard from eastern Anatolia, comprising about two dozen objects of everyday life, including belt fittings, a key, rings, a spoon, phylactery cases, and several coins from the reign of Justinian (A.D. 527–565).[45] This dating can be further refined by the presence in the hoard of a ring and a spoon bearing cross monograms, which indicate a *terminus post quem* of about mid century.[46] Further, there is an apparent derivative relationship between (at least) the *locus sanctus* armbands and the Palestinian ampullae, which for a variety of reasons are universally recognized to belong somewhere between the mid-sixth and the early seventh century, and a parallel relationship between

those armbands and the octagonal *locus sanctus* rings, whose temporal center of gravity, on the basis of findspot information and the internal development of the genre, may well fall closer to the mid-seventh century.[47] Additionally, it should be noted that this mid-sixth- to mid-seventh-century time frame is consistent with the traditional dating of another of the armbands' close *comparanda*, the clay pilgrim tokens.[48] But there is good reason to believe that the series of twenty-two armbands herein catalogued has its roots significantly earlier than the mid-sixth century. Specifically, our subgroup of five bronze examples from Syria/Palestine showing just a single medallion with the Holy Rider and *Heis Theos* (items 6, 12, 17, 19, and 21; figs. 1 and 2) is, but for the band, of a kind with Bonner's Holy Rider pendant amulets.[49] And, significantly, a few of these sorts of amulets have been discovered in datable tombs of the fourth century.[50] There is therefore no reason to doubt that this subgroup of five armbands could date as early—which suggests that it may represent the genre's *Ur*-type, the substantially non-Christian early form from which the demonstrably later *locus sanctus* variant developed.[51]

When it comes to the question of use, the issue is not whether these armbands functioned as amulets, for obviously they did; Maspero knew that eighty years ago. Rather, the twofold issue is this: for whom and toward what end did they function? Because their average diameter is slightly in excess of 7.5 cm, it may be assumed that they were worn on the arm, at some point above the wrist (fig. 20).[52] Presumably this mode of self-adornment was not uncommon at the time, nor was the use of armbands as amulets; Severus of Antioch urged Christians to avoid those who proposed "the suspension and attachment to necks or arms . . . [of] *phylakteria*, or protective amulets. . .".[53] It might even be supposed that these armbands, like others, were made in pairs, one for each arm, since among the nineteen more or less complete examples in the group, there are two sets of twins (items 1/2; 7/8).[54] Moreover, the likely possibility that they were made specifically for women is strengthened by the example with a personalized invocation naming a certain "Anna" (fig. 5d), and that invoking protection for a certain "Severinam" (item 21).

A female clientele would be consistent as well with what may be surmised about the specific magical potency of a least some of these armbands. Certainly most of their iconography and inscriptions—the Holy Rider, Psalm 90, the lion and snake, the Evil Eye, ring signs, "Health," *et cetera*—were believed generically efficacious, with multivalent power against any variety of demons and illnesses.[55] But a few images were probably more specific: the *aphlaston*, under the umbrella of the name "Solomon," offered protection for the seafarer, and the Chnoubis, as I have argued elsewhere, was probably added to afford protection against afflictions of the abdomen.[56] But precisely because these Chnoubis armbands were likely women's amulets, I went on to argue that the Chnoubis would here probably be understood to function more specifically in its well-established role as the "Master of the Womb," to control, presumably, conception, menorrhagia, and/or parturition.[57] Among many late Roman Chnoubis gem amulets, the uterus, as a bell-shaped organ, appears on the reverse, with a skeleton key "locking" and thereby controlling its lower orifice. I argued further that corroboration for the possible association of the Chnoubis armbands with the magical manipulation of the womb comes in the form of the objects' very medium, silver, since while silver at this period is relatively rare for jewelry, it is conspicuous among these armbands and among a series of iconographically related Chnoubis rings and pendants, which by their identifying inscriptions and by the magical charms that some of them bear are revealed to be uterine amulets.[58]

It would be a mistake to view these armbands in isolation, either in terms of their manufacture or in terms of their use. Certainly the craftsmen who made them made amuletic pendants as well (fig. 15), and rings with the Holy Rider (fig. 21), with Psalm 90, and with various *locus sanctus* scenes (fig. 22); iconography, inscriptions, technique, medium, and even dimensions were all more or less interchangeable among these three object types.[59] So were, from the client's point of view, their various amuletic functions, for what counted when it came to these sorts of artifacts was much less self adornment than self protection, and how, or in how many seemingly redundant ways, that was accomplished, was likely of little concern, provided that the desired effect was achieved.[60] This is the message of late antique amulets generally, and this, specifically, is the message of these armbands.

Notes

N.B.: All figures are reproduced at or close to 1:1.

1. See footnote 11, item 4

2. Remnants of solder provide a clear match between the back of the first medallion and the front of the last.

3. Generally, the armbands in this group should be read beginning with the 90th Psalm *incipit*, which nearly all of them show. The structure of this armband, with Psalm 90 on the first, overlapping soldered medallion, indicates that order, which is explicit as well on the armbands with the fullest cycles (figs. 7, 9, 10), where the first few letters of Psalm 90 appear just to the left of the Annunciation medallion.

4. Figure 11 = destroyed during World War II (*olim* Berlin, Königliche Museen). See O. Wulff, *Altchristliche Bildwerke*, Königliche Museen zu Berlin, Beschreibung der Bildwerke der christlichen Epochen, 2/1 (Berlin, 1909), no. 825, pl. XL. For the Triumphal Entry/Holy Rider, see G. Vikan, "Art, Medicine and Magic in Early Byzantium," *Dumbarton Oaks Papers*, 38 (1984), 75, note 57; and footnote 20, below.

5. Figure 12 = The Hague, Kon. Penningkabinet (Mark Antony: 32–31 B.C.). See L. Casson, *Ships and Seamanship in the Ancient World* (Princeton, 1971), fig. 121, and, for the *aphlaston* generally, 86 etc., and figs. 114, 116, 119, 120, 129 etc. This symbol and its multiple appearances on late antique amulets are considered in more detail in my article "'Guided by Land and Sea': Pilgrim Art and Pilgrim Travel in Early Byzantium," *TESSERAE: Festschrift für Josef Engemann*, *Jahrbuch für Antike und Christentum*, Ergänzungsband 19 (1991), 90 f.

6. Figure 13 = Paris, Robert-Henri Bautier Collection. See Vikan, "Art, Medicine and Magic," 82, fig. 24; and *idem*, "'Guided'," 87–91, pl. 11c.

7. Figure 14 = location unknown (*olim* Brummer). See C. Bonner, *Studies in Magical Amulets, Chiefly Graeco-Egyptian* (Ann Arbor/London/Oxford, 1950), no. 281, illus., and also nos. 291, 292. See also H.D. Betz, *The Greek Magical Papyri in Translation* (Chicago/London, 1986), 319; and R. Kotansky, "Magic in the Court of the Governor of Arabia," *Zeitschrift für Papyrologie und Epigraphik*, 88 (1991), 42–45.

8. Figure 15 = location unknown. See *Objects with Semitic Inscriptions, 1100 B.C.–A.D. 700, Jewish, Early Christian and Byzantine Antiquities*, Zurich, Frank Sternberg, Auction XXIII, November 20, 1989 (Zurich, 1989), no. 190, illus. (auction catalogue). See, more generally, Bonner, *Amulets*, 214, nos. 298–326.

9. Figure 16 = New York, American Numismatic Society, Newell no. 45. See Bonner, *Amulets*, 218 f., no. 319, illus.

10. See footnote 11, item 3.

11. In 1908 Maspero (see item 7, below) knew of eight armbands. Piccirillo's survey of the genre seventy years later (see item 12, below) included just two more examples, to which Feissel (see item 17, below) added two in 1984. The group, listed alphabetically by location, now numbers twenty-two, two of which (items 4 and 13) have come to light since late 1989, and two others (items 15 and 16) were long ago catalogued as fragments of finger rings. I have recently received word from Lieselotte Kötzsche of two additional(?) iconographic armbands of this type in the possession of a Hamburg antiquities dealer, S. Simonian. Items 6 and 21 were kindly brought to my attention by Elisabeth Jastrzebowska.

 1. [FRAGMENTS] Ann Arbor, Kelsey Museum of Archaeology, University of Michigan, no. 26131/26160 (*olim*, Aleppo, Ayvas Collection). Bronze: three of originally four(?) medallions, plus one for a solder connec-

tion. From Syria (Aleppo). See Bonner, *Amulets*, no. 322, illus. Band inscription: none (Evil Eyes). Medallions: Holy Rider; Adoration of the Magi; ?; Psalm 90.

 2. Ann Arbor, Kelsey Museum of Archaeology, University of Michigan, no. 26198 (= our fig. 3). Bronze: four medallions, plus one for a solder connection (D = 7.5 cm). From Syria. See Bonner, *Amulets*, no. 321, illus. Band inscription: none (Evil Eyes). Medallions: Adoration of the Magi; Women at the Tomb; Holy Rider; Psalm 90.

 3. Athens, Benaki Museum, no. 11472 (= our fig. 4). Silver: four medallions (D = 6.4 cm). From Egypt. Unpublished. Band inscription: none (crosses). Medallions: Raising of Lazarus; *aphlaston*; Holy Rider; Women at the Tomb.

 4. Baltimore, the Walters Art Gallery, no. 54.2657A–C (*olim* Lebanon, private collection) (= our fig. 6). Bronze: eight medallions, plus one for a solder connection (D = ca. 8.3 cm). From Syria/Palestine. See *Antike Münzen . . . Geschnittene Steine und Schmuck der Antike . . . Schweizer Gold- und Silbermünzen*, Zurich, Frank Sternberg AG, Auction XXIV, November 19–20, 1990 (Zurich, 1990), no. 475, illus. (auction catalogue). Band inscription: none (Evil Eyes). Medallions: Psalm 90; Annunciation; Entry into Jerusalem; cross; *aphlaston* (with *Solomonos*); magical *character*; lion and snake; Women at the Tomb.

 5. Berlin, Staatliche Museen Preussischer Kulturbesitz, Frühchristlich-Byzantinische Sammlung, no. 4927 (= our fig. 8). Silver: four(?) medallions (D = 7.3 cm). From Egypt. See Wulff, *Bildwerke*, no. 1109, pl. LV. Band inscription: Trisagion (plus birds with branches in their beaks). Medallions: Adoration of the Magi; John the Baptist(?) or Zacharias(?) and aedicula; unclear; Holy Rider. (For the John the Baptist identification, compare figure 8b with the early panel of this saint in Kiev. See K. Weitzmann, *The Monastery of Saint Catherine at Mount Sinai: The Icons. Volume One: From the Sixth to the Tenth Century* [Princeton, 1976], no. B11. For the Zacharias identification, compare Bobbio ampulla 20. See A. Grabar, *Ampoules de Terre Sainte [Monza-Bobbio]* [Paris, 1958], pl. LII.)

 6. [FRAGMENT] Binyaminah, Israel, Mrs. E. Vilensky Collection. Bronze: one medallion. From Palestine (Caesarea). See A. Hamburger, "A Greco-Samaritan Amulet from Caesarea," *Israel Exploration Journal*, 9 (1959), 43–45, pl. 4a, b. Band inscription: Psalm 90 (plus lion). Medallion: Holy Rider (with *Heis Theos*; and on the reverse, a later[?] Samaritan inscription: "There is none like God, O Jeshurun [Deuteronomy 33:26]).

 7. Cairo, Egyptian Museum. Silver: eight medallions. From Egypt (near Saqqara). See J. Maspero, "Bracelets-amulettes d'époque byzantine," *Annales du service des antiquités de l'Égypte*, 9 (1908), 250–252. Band inscription: Psalm 90. Medallions: Annunciation; Nativity; Trinity(?) plus ring signs; Baptism; Chnoubis and pentalphas; Adoration of the Cross/Crucifixion; Women at the Tomb; Holy Rider.

 8. Cairo, Egyptian Museum (= our fig. 9). Silver: eight medallions. From Egypt (near Saqqara). See Maspero, "Bracelets-amulettes," 250–252, figs. 2–5 and pls. at end of volume. Band inscription: Psalm 90. Medallions: Annunciation; Nativity; Trinity(?) plus ring signs; Baptism; Chnoubis and pentalphas; Adoration of the Cross/Crucifixion; Women at the Tomb; Holy Rider.

9. Cairo, Egyptian Museum, no. 7022. Silver: four medallions (D = 7.5 cm). From Egypt. See J. Strzygowski, *Koptische Kunst* (Vienna, 1904), Catalogue général des antiquités égyptiennes du Musée du Caire, no. 7022, fig. 400. Band inscription: none (birds). Medallions: four orant saints, one of whom is Menas.

10. Cairo, Egyptian Museum, no. 7025. Iron: four medallions (D = 7.1 cm). From Egypt. See Strzygowski, *Koptische Kunst*, no. 7025, fig. 403. Band inscription: Psalm 90. Medallions: Women at the Tomb(?); unclear; Raising of Lazarus(?); Holy Rider.

11. Columbia, Museum of Art and Archaeology, University of Missouri–Columbia, no. 77.246 (*olim* Cairo, Fouquet Collection) (= our fig. 10). Silver: eight medallions (D = 7.7–7.9 cm). From Egypt (near Saqqara). See Maspero, "Bracelets-amulettes," 246–250, fig. 1 (line drawing). Band inscription: Psalm 90. Medallions: Annunciation; Nativity; Trinity(?) plus Chnoubis, ring signs, and pentalpha (with *Heis Theos*); Baptism; Adoration of the Cross/Crucifixion; Women at the Tomb; Holy Rider plus pentalpha; Ascension.

12. Jerusalem, private collection (*olim* Jerusalem, P. Godfrey Kloetzli Collection) (= our fig. 1). Bronze: one medallion (D = 7.5 cm). From Palestine (Bethlehem). See M. Piccirillo, "Un braccialetto cristiano della regione di Betlem," *Liber Annuus*, 29 (1979), 245–252, figs. pp. 25, 27. Band inscription: Psalm 90 (plus lion and inscribed cross [*IC/XC A/W*]). Medallion: Holy Rider (with *Heis Theos*).

13. [FRAGMENT] Jerusalem, private collection (*olim* Jerusalem, L. Alexander Wolfe Collection). Bronze: one medallion. Provenance unknown. See *Objects with Semitic Inscriptions*, no. 345, illus. Band inscription: ?. Medallion: Psalm 90.

14. London(?), Private collection (as of 1924). Silver: five medallions (D = 7.5 cm). From Cyprus. See O.M. Dalton, "A Gold Pectoral Cross and an Amuletic Bracelet of the Sixth Century," *Mélanges offerts à M. Gustave Schlumberger* (Paris, 1924), II, 386–390, pl. XVII/3. Band inscription: Psalm 90 and, inside, "Lord, help your servant and Sissinios." Medallions: Holy Rider and, on four medallions, portions of Psalm 90.

15. [FRAGMENTS] London, British Museum, no. AF 289. Bronze: two medallions. Provenance unknown. See O.M. Dalton, *Catalogue of Early Christian Antiquities and Objects from the Christian East in the . . . British Museum* (London, 1901), nos. 157, 191. Band inscription: none (Evil Eyes). Medallions: Psalm 90; Annunciation.

16. [FRAGMENT] London, British Museum, no. AF 256. Bronze: one medallion. Provenance unknown. See Dalton, *Catalogue*, no. 158. Band inscription: none. Medallion: Psalm 90.

17. Paris, Cabinet des Médailles, no. 756 (Froehner Collection, no. IX.284). Bronze: one medallion. Provenance unknown. See D. Feissel, "Notes d'épigraphie chrétienne (VII)," *Bulletin de correspondance hellénique*, 108 (1984), 575–579, fig. 3. Band inscription: Psalm 90. Medallion: Holy Rider (with *Heis Theos*).

18. Location unknown (*olim* Paris, Comtesse R. de Béarn Collection [as of 1921; see below]) (= our fig. 7). Silver: eight medallions (D = 7.7 cm). From Syria. See W. Froehner, "Deux bracelets de Syrie," *Collection de la Comtesse R. de Béarn* (Paris, 1905), 9–12, line drawing p. 10. Band inscription: Psalm 90. Medallions: Annun-

ciation (with Luke 1:28); Nativity (with Luke 2:14); Entry into Jerusalem; Baptism (with Matthew 3:17); Adoration of the Cross/Crucifixion; Women at the Tomb (with Luke 24:5–6/Matthew 28:6); Holy Rider; Ascension (with John 14:27).

The collection of the Comtesse R. de Béarn (Martine de Béhague [1870–1939]), after having been passed on to her nephew, the Marquis de Ganay, was dispersed in three auctions (1921, 1987, 1989). The fate of items 18 and 19 is unknown to me.

19. Location unknown (*olim* Paris, Comtesse R. de Béarn Collection [as of 1921; see above]) (= our fig. 2). Bronze: one medallion (D = 7.5–7.8 cm). From Syria. See Froehner, "Deux bracelets," 7–9, line drawing on p. 7. Band inscription: Psalm 90 (plus orant saint, and lion and snake). Medallion: Holy Rider (with *Heis Theos*).

20. Paris, Musée du Louvre, no. BR4329. Bronze: four medallions, plus one for a solder connection. From Syria. See Maspero, "Bracelets-amulettes," 252 f.; and E. Peterson, *HEIS THEOS: Epigraphische, formsgeschichtliche und religionsgeschichtliche Untersuchungen*, Forschungen zur Religion und Literatur der Alten und Neuen Testaments, New Series, 24 (Göttingen, 1926), 94. Band inscription: none. Medallions: Women at the Tomb(?); Holy Rider; military saint and snake; Psalm 90.

21. Philadelphia, Maxwell Sommerville Collection (as of 1926 [Peterson]). Bronze: one medallion. From Palestine (near Jerusalem). See Peterson, *HEIS THEOS*, 95 f. Band inscription: "One God (who) preserves, guard (your) servant Severinam" (plus lion and snake). Medallion: Holy Rider (with *Heis Theos*).

22. Toronto, Royal Ontario Museum, no. 986.181.93 (*olim* New York, Jeffrey Spier Collection) (= our fig. 5). Silver: four medallions (D = 7.7 cm). From eastern Anatolia (Syria?). See Vikan, "Art, Medicine and Magic," 75, fig. 10. Band inscription: Psalm 90. Medallions: Women at the Tomb; Trisagion; Entry into Jerusalem (with *Hygia*); Virgin and Child Enthroned (with *Theotoke*, help Anna; Grace). (A forged copy of this armband in gold was being offered for sale in New York and Switzerland during the mid-1980s.)

In the mid-nineteenth century E. Renan (*Mission de Phénicie* [1864], 432) made note of a "bracelet de cuivre à quatre médallions" with, inscribed on the "fermoir," the first six words of Psalm 90 (see Feissel, "Notes," 576). Whether this is one and the same with an armband in the list above (e.g., item 2), is uncertain. In addition, Strzygowski catalogued two silver armbands (*Koptische Kunst*, nos. 7023 and 7024) with four large and four small medallions each, organized in an ABCBA pattern; neither, however, shows decoration beyond simple crosses. Wulff catalogued a bronze armband from Egypt (*Bildwerke*, no. 850) with eight medallions, but only crosses for decoration.

12. The closest thing to a post-Maspero analysis of the genre is Michele Piccirillo's brief survey of ten examples in *Liber Annuus*, 1979 (cited under item 12, above). The Fouquet armband, which is now in Columbia, Missouri (item 11), is reproduced through the Maspero line drawing in, among others, P. Testini, "Alle origini dell'iconographia di Giuseppe di Nazareth," *Rivista di archeologia cristiana*, 48 (1972), 320 f., fig. 30; J. Engemann, "Palästinensische Pilgerampullen in F. J. Dölger Institut in Bonn," *Jahrbuch für Antike und Christentum*, 16 (1973), 18, fig. 3; E. Kitzinger, "Christian Imagery: Growth and Impact," *Age of Spirituality: A Symposium*, K. Weitzmann, ed. (New York, 1980), 151 f., fig. 14b; and G. Vikan, *Byzantine Pilgrimage Art*, Dumbarton Oaks Byzantine Collection Publications, 5 (Washington, D.C., 1982), 42, fig. 33.

13. See, most recently, E. Kitzinger, "Reflections on the Feast Cycle in Byzantine Art," *Cahiers archéologiques*, 36 (1988), 60 f., and note 64.

14. Figure 1 = item 12
 Figure 2 = item 19
 Figure 3 = item 2
 Figure 4 = item 3
 Figure 5 = item 22
 Figure 6 = item 4
 Figure 7 = item 18
 Figure 8 = item 5
 Figure 9 = item 8
 Figure 10 = item 11

Of nineteen more or less complete armbands (discounting solder medallions): five have eight medallions, one has five medallions, eight have four medallions, and five have one medallion.

15. For a comparison of the Psalm 90 inscriptions on ten of the armbands, with observations on letter forms and spelling (generally indicating "l'origine popolare"), see Piccirillo, "Un braccialetto," 245–248.

16. Feissel, "Notes," 575–579.

17. For *Heis Theos*, see Peterson, *HEIS THEOS*, esp. 91–96. For the Trisagion, *Hygieia*, and King Solomon, see Vikan, "Art, Medicine and Magic," 69, 75–80; *Testament of Solomon*, D.C. Duling, trans. and intro., in *The Old Testament Pseudepigrapha, I: Apocalyptic Literature and Testaments*, J.H. Charlesworth, ed. (Garden City, New York, 1983), 948–991; and, more recently, C. Walter, "The Intaglio of Solomon in the Benaki Museum and the Origins of the Iconography of Warrior Saints," *Deltion des Christianikes Archaiologikes Hetaireias*, 4/15 (1989–1990), 35 f.

18. Piccirillo, "Un braccialetto," 247 f., with references to the use of such invocations in amuletic papyri.

19. According to Wulff's description (*Bildwerke*, no. 825), the back side of this now-destroyed amulet bore a serpent-like form, the name Solomon, and an unidentified figure.

20. Vikan, "Art, Medicine and Magic," 75, 79–81; E. Dauterman Maguire, H.P. Maguire, and M.J. Duncan-Flowers, *Art and Holy Powers in the Early Christian House*, Illinois Byzantine Studies II, Urbana, Illinois, Krannert Art Museum, 1989 (Urbana/Chicago, 1989), 25–28 (exhibition catalogue); and Walter, "Intaglio of Solomon," 33–42.
 The demon-impaling Holy Rider, as distinct from the Entry into Jerusalem Holy Rider, appears on the armbands in two distinct iconographic variants: one wherein the demon is a long-haired female, nude above and mummy-wrapped below, lying on her back (figs. 1, 2, 3d, and 7); and one wherein the demon is a running lioness with a human head (figs. 9a and 10h). For the distinction, see Bonner, *Amulets*, nos. 324 and 325.

21. Figure 17 = Paris, Cabinet des Médailles, no. 2189. See A. Delatte and P. Derchain, *Les intailles magiques gréco-égyptiennes* (Paris, 1964), no. 80; and Vikan, "Art, Medicine and Magic," 75 f.
 The Chnoubis appears on three of the armbands, in two variant forms: one wherein the lion head, curling snake tail, halo, and solar rays are each clearly identifiable (fig. 10d); and one wherein the head and halo have coalesced into a misshapen bean-like form and the tail has become desiccated (fig. 9b). For the pentalpha, and various forms of the Chnoubis, see Vikan, "Art, Medicine and Magic," 69 f., 75–78; for ring signs (i.e., *characteres*), see R. Kotansky, "A Silver Phylactery for Pain," *The J. Paul Getty Museum Journal*, 11 (1983), 172 f.; and for the lion and snake, and the Evil Eye, see Bonner, *Amulets*, nos. 319, 324 etc. In this category, too, belongs the so-called Trinity above the Chnoubis in our figure 10d, though its precise meaning has yet to be determined.

22. Recall that the back of the amulet in figure 16 bears the opening letters of Psalm 90. For the group, see Bonner, *Amulets*, 208–228, nos. 298–319.

23. Kitzinger, "Reflections," 60 f. Iconographically, the cycle's individual scenes may be characterized as follows:

Annunciation: The Virgin stands at the left weaving the veil of the Temple; Gabriel approaches from the right with a hand raised in speech (figs. 6c, 7, 9a, and 10b).

Nativity: The Virgin lies half upright on a mattress at the right; Joseph sits at the left (fig. 10c) with a hand raised in speech; the Christ Child lies at the center on a block-like manger ornamented with a grille pattern, bearing a niche at its lower center; a star (the moon, a lamp?) appears above, with the ox and ass to the left and right (figs. 7 and 10c).

Adoration of the Magi: The Virgin and Child sit in profile at the left; a single Magus approaches from the right (figs. 3b and 8a).

Baptism: John the Baptist stands in profile at the left; one (or two; fig. 10e) angel(s) stand(s) in profile at the right, with towel(s); a child-like Christ stands against a curtain of water at the center turning slightly (fig. 7) toward John; the Dove of the Holy Spirit descends over Christ's head (figs. 7, 9b, and 10e).

Raising of Lazarus: Christ stands at the left; a mummy-wrapped Lazarus appears at the right, standing within a round-topped aedicula (fig. 4a).

Adoration of the Cross/Crucifixion: The Bust of Christ (flanked by the Sun and Moon; fig. 7) appears above the cross at the center; the crucified thieves flank him, with arms bound behind them(?) (figs. 7 and 10f) or extended at elbow level (fig. 9b); two small figures (suppliants) kneel before the cross at the bottom center (fig. 7).

Women at the Tomb: One (figs. 3c, 4d, 5a, and 6i) or two (figs. 7, 9a, and 10g) Marys approach/stand/recline(?) at the left; the angel (or no angel; fig. 4d) stands/sits at the right; a gabled aedicula is at the center, with a pagoda-like (fig. 9a) or dome-like top (fig. 10g), flanking columns (figs. 9a and 10g), a hanging lamp (fig. 4d and 7), a central opening (figs. 7, 9a, and 10g), and a finial cross (fig. 7).

Ascension: Christ sits within a mandorla, carried heavenward by two angels (fig. 10i) or flanked by the four beasts of the Apocalypse (fig. 7); a frontal orant Virgin stands below him at the center, flanked by the Apostles, in two rows.

24. Vikan, "Art, Medicine and Magic," 81; and Kitzinger, "Reflections," 60 f.

25. See A.S. Hunt, *The Oxyrhynchus Papyri*, VIII (London, 1911), 251–253; and H. Maguire: "Garments Pleasing to God: The Significance of Domestic Textile Designs in the Early Byzantine Period," *Dumbarton Oaks Papers*, 44 (1990), 221. For another such papyrus, see K. Preisendanz, *Papyri graecae magicae: Die griechischen Zauberpapyri*, 2nd ed., II (Stuttgart, 1974), 227 (P18).

26. See D.E. Aune, "Magic in Early Christianity," *Aufstieg und Niedergang der Römischen Welt*, 23/2: Principat (Berlin/New York, 1980), 1546.

27. *Ibid.*, 1547.

28. *Origène, Contre Celse*, M. Bourret, ed., I (Paris, 1967), 1.6.

29. Vikan, *Pilgrimage Art*, 19–23.

30. For the Holy Sepulchre's appearance, see J. Wilkinson, "The Tomb of Christ: An Outline of its Structural History," *Levant*, 4 (1972), 83–97; and for the ampullae, see Grabar, *Ampoules*; and Engemann, "Pilgerampullen."

31. Figure 18 = Monza, Treasury of the Cathedral of St. John the Baptist. See Grabar, *Ampoules*, Monza ampulla 2, pl. V. Much like Monza ampulla 2, though better preserved in some areas, is Bobbio ampulla 18 (Grabar, *Ampoules*, pl. XLVI).

The armbands' cycle compares iconographically with that of the ampullae as follows:

Annunciation: This scene on Monza ampulla 2 is composed left to right, and includes a large chair behind the Virgin; Bobbio ampulla 18 offers a closer match for the armbands in showing the action moving from right to left.

Visitation: This scene on the ampullae has no counterpart among the armbands.

Nativity: The armbands (especially item 11; fig. 10c), are generally close to Monza ampulla 2, although unlike that ampulla they give no hint of the cave, and instead of showing an aedicula-manger closed by a grille, both items 18 and 11 (figs. 7 and 10c) show a block-shaped manger with a grille-like texture, and a niche at its bottom center. On the origin of this *locus sanctus* iconography for the manger, see Engemann, "Pilgerampullen," 17 f.; and K. Weitzmann, "*Loca Sancta* and the Representational Arts of Palestine," *Dumbarton Oaks Papers*, 28 (1974), 36–39.

Adoration of the Magi: This scene does not appear on Monza ampulla 2 or Bobbio ampulla 18, and where it does appear among the ampullae (Monza ampullae 1 and 3), the Virgin is enthroned frontally and the Magi come from one side and the shepherds from the other. Just the winged angel preceding the Magi appears before the Virgin and Child on three rock crystal intaglios of the period, presumably because of the restricted size of the object and the relatively coarse technique. See J. Spier, "Early Byzantine Rock Crystal Intaglios," *Byzantine Jewelry*, D. Content, ed. (forthcoming), nos. 3–5 (with discussion).

Baptism: The armbands (especially item 18; fig. 7) closely match Monza ampulla 2.

Adoration of the Cross/Crucifixion: The armbands (especially item 18; fig. 7) closely match the ampullae, especially Bobbio 18. On the distinction between the Adoration of the Cross (as here in fig. 7, with Christ *en buste* and two suppliants) and the Crucifixion (as on some of the Monza/Bobbio ampullae), see Weitzmann, "*Loca Sancta*," 40; and Vikan, *Pilgrimage Art*, 22–24.

Women at the Tomb: The armbands (especially item 18; fig. 7) closely match Monza ampulla 2. Counterparts for those armbands with fewer figures (figs. 3c, 4d, 5a, and 6i) appear among the clay tokens from Qal'at Sim'ān (the angel, but no Marys; see Vikan, "Art, Medicine and Magic," fig. 24), again, presumably because of lack of space and the coarse technique, and not because of any direct iconographic link. The dome-like top to the Sepulchre aedicula in figure 10g, and the columns in figures 9a and 10g, are both paralleled among the rock crystals (Spier, "Intaglios," nos. 9 and 10), which in one case (no. 10) shows the aedicula, the angel, but no Marys. For the Holy Sepulchre aedicula, see Wilkinson, "Tomb of Christ," 83–97.

Ascension: The armbands (especially item 18; fig. 7) closely match Monza ampulla 2, though on the ampullae generally, the Apostles are aligned in one row. For the Apocalyptic beasts around the mandorla (fig. 7), see Bonner, *Amulets*, no. 324; and for the Ascension in *locus sanctus* art, see Weitzmann, "*Loca Sancta*," 43 f.

32. Grabar, *Ampoules*, 59; Engemann, "Pilgerampullen," 10, 12 f.; and Vikan, "'Guided'."

33. *Idem*, "Sacred Image, Sacred Power," *Icon* (Washington, D.C., 1988), 15–18.

34. *Idem*, "Early Byzantine Pilgrimage *Devotionalia* as Evidence of the Appearance of Pilgrimage Shrines," forthcoming in the Acts of the *12. Internationaler Kongress für Christliche Archäologie*.

35. Bonner, *Amulets*, 306.

36. This was first suggested by Feissel ("Notes," 576).

37. The Benaki armband, although known to have come from Egypt, shares its figure style with the Syrian/Palestinian armbands (cf. figs. 3c and 4d), and finds parallels for its *aphlaston* there as well (cf. figs. 4d, 6f; and 13). The ABCBA rhythm of its design, however, most closely matches that of the Egyptian armband in Berlin (fig. 8).

38. Some of the following observations on specifically Egyptian iconographic traits, and on the Syria-Egypt distinction in origin, were originally made by Maspero ("Bracelets-amulettes," 256–258).

39. This is Kitzinger's view ("Reflections," 61).

40. Engemann, "Pilgerampullen," 6, note 11; 13, note 65; 25 f.

41. Bonner, *Amulets*, 208–228; and for the provenance of the Qal'at Sim'ān tokens, see Vikan, "'Guided'," 76.

42. Weitzmann, "*Loca Sancta*," 39; Vikan, *Pilgrimage Art*, 39–43; and *idem*, "Sacred Image," 15–18.

43. Figure 19 = Baltimore, the Walters Art Gallery, no. 45.15. See P. Verdier, "An Early Christian Ring with a Cycle of the Life of Christ," *The Bulletin of the Walters Art Gallery*, 11/3 (1958); and G. Vikan, "Art and Marriage in Early Byzantium," *Dumbarton Oaks Papers*, 44 (1990), 57–61.

Some of the most noteworthy iconographic deviations of the cycle shared by the rings from that of the armbands include: the kneeling Virgin in the Annunciation; the inclusion of the Visitation scene; the inclusion of all the Magi and the accompanying angel in the Adoration of the Magi; the inclusion of Longinus and Stephaton in the Crucifixion.

44. It is noteworthy as well that Egyptian armbands (specifically, items 7, 8, and 11) show distinctive iconographic approaches to the Holy Rider (lioness), the Women at the Tomb (columns, pagoda or dome top), and the Ascension (angels). Moreover, in the latter two instances, the contrasting version of the scene attested on the fullest of the Syrian armbands, item 18 (fig. 7), is iconographically closer to the Palestinian ampullae.

45. I saw the hoard in New York in March 1983; it has since gone with the armband to the Royal Ontario Museum. Three pieces from the hoard were included in the *Art and Holy Powers* exhibition at the Krannert Art Museum in 1989 (catalogue nos. 63, 87, and 97).

46. For the spoon, see *Art and Holy Powers*, no. 63. On the dating of the Byzantine cross monogram, see E. Weigand, "Zur Monogramschrift der Theotokos (Koimesis) Kirche von Nicaea," *Byzantion*, 6 (1931), 412 f. Corroborating a mid-sixth century *terminus* is the fact that the letters forming the small medallion inscriptions on the Berlin armband (fig. 8) are similarly arranged in the shape of a cross.

47. Vikan, "Art and Marriage," 158.

48. *Idem*, "Two Pilgrim Tokens in the Benaki Museum and the

Group to Which They Belong," forthcoming in the Laskarina Bouras memorial volume.

49. Bonner, *Amulets*, 208–228, nos. 298–319; and *Objects with Semitic Inscriptions*, nos. 176–193.

50. Bonner, *Amulets*, no. 303; N. Makhouly, "Rock-cut Tombs at El Jish," *Quarterly of the Department of Antiquities in Palestine*, 8 (1930), 45–47; B. Bagatti, *The Church from the Circumcision*, reprint (Jerusalem, 1984), 223, 261 f., fig. 108 (first from right); Walter, "Intaglio of Solomon," 36; and H. Gitler, "Four Magical and Christian Amulets," *Liber Annuus*, 40 (1990), 371.

51. Among the five, explicitly Christian elements are confined to item 12 (fig. 1), which shows an inscribed cross and the "blood of Christ" addition to the Psalm 90 inscription, and item 19 (fig. 2), which shows an orant saint. The latter would suggest for that armband specifically a *terminus post* in at least the fifth century, if not the sixth.

52. Figure 20 = Vatican Library, cod. lat. 3867, fol. 106r: Aeneas and Dido in a Cave. See E. Rosenthal, *The Illuminations of the Vergilius Romanus* (Zurich, 1972). Measurements in the 6.0 to 6.5 cm range suggest that wear was restricted to the wrist. See *Age of Spirituality: Late Antique and Early Christian Art, Third to Seventh Century*, K. Weitzmann, ed., New York, Metropolitan Museum of Art, 1977–1978 (New York, 1979), nos. 282, 292, 297, and 299 (exhibition catalogue). On the distinction between a wrist band and a band worn up on the arm (*perikarpia* and *peribrachiona*), see F. Cabrol and H. Leclercq, *Dictionnaire d'archéologie chrétienne et de liturgie*, II/2 (Paris, 1925), 1118.

53. *Patrologia orientalis*, 29/1 (Paris, 1960), 583 f.

54. For pairs of bracelets and armbands, see *Age of Spirituality*, nos. 292, 297–300.

55. Bonner, *Amulets*, 208–228; and Vikan, "Art, Medicine and Magic," 74, note 52.

56. *Idem*, "'Guided'," 87–91; and *idem*, "Art, Medicine and Magic," 75–78.

57. On the Chnoubis and the womb, see Delatte and Derchain, *Les intailles*, 244–256; Vikan, "Art, Medicine and Magic," 77; and, most recently and comprehensively, J.-J. Aubert, "Threatened Wombs: Aspects of Ancient Uterine Magic," *Greek, Roman, and Byzantine Studies*, 30/3 (1989), 421–449.

58. Vikan, "Art, Medicine and Magic," 77 f. I took up the gender-specific question as it relates to these armbands and to silver in an unpublished paper entitled "The Magic of Silver in Early Byzantium," presented as part of the 1986 NEH sponsored symposium, *Ecclesiastical Silver Plate in Sixth-Century Byzantium*, jointly hosted by the Walters Art Gallery and Dumbarton Oaks. A measure of silver's rarity in early Byzantine jewelry is provided by its very minor role among marriage rings, which survive in bronze and gold in relative abundance. See Vikan, "Art and Marriage," notes 22, 45, and 97.

The connection between women, silver, and Selene, between silver's tendency to tarnish, the menstrual cycle, and the notion of "unclean" is an age-old one. (On the link between the uterus and the moon, see, most recently, Aubert, "Threatened Wombs," 441–448.) The silver chalice and paten set in the *vita* of St. Theodore of Sykeon is "unclean" and turns black because it had been refashioned from the chamber pot of a prostitute. (See *Three Byzantine Saints*, E. Dawes and N.H. Baynes, trans. [Oxford, 1948],

117 f.) The myrrh-collecting silver basin of the bishop of Herakleia was defiled because it had formerly been used by a sorcerer to collect blood from human sacrifice. (See *Theophylact Simocattes, Historiae*, Carl de Boor, ed. [Leipzig, 1887], I,11,59–62.)

Pliny has much to say about the (mostly bad) magical properties of "the monthly flux of women," including its power to tarnish and rust various metals, and dull mirrors (*Natural History*, XXVIII.23):

> First of all, they say that hailstorms and whirlwinds are driven away if menstrual fluid is exposed to the very flashes of lightening; that stormy weather too is thus kept away, and that at sea exposure, even without menstruation, prevents storms. Wild indeed are the stories told of the mysterious and awful power of the menstruous discharge itself, and the manifold magic which I have spoken of in the proper place.

See Pliny, *Natural History*, W.H.S. Jones, trans. (Cambridge, Massachusetts/London, 1975), 55.

59. Figure 21 = Toronto, Royal Ontario Museum, no. 986.181.125. See *Art and Holy Powers*, no. 84. Figure 22 = Toronto, Royal Ontario Museum, no. 986.181.26. See *Art and Holy Powers*, no. 89. For a ring from the period and region with Psalm 90, see G. Vikan, *Byzantine Objects of Daily Life in the Menil Collection*, I (forthcoming), no. R23. Matches on the bezels of rings, many known to have come from Syria/Palestine, may be cited for virtually all of the Christological scenes on the armbands. See, most recently, for the Raising of Lazarus and the Adoration of the Cross, L.Y. Rahmani, "On Some Byzantine Brass Rings in the State Collections," *'Atiqot*, English Series, 17 (1985), nos. 10, 11.

There are as well occasional pendants bearing *locus sanctus* scenes matching those of the ampullae. Although iconographically related at some remove to the armbands, and functionally like them insofar as they are clearly amulets, these pendants differ basically in style and, for the most part, in medium. The most familiar example, in copper, was published nearly a century ago by Gustave Schlumberger ("Quelques monuments byzantins inédits," *Byzantinische Zeitschrift*, 2 [1893], no. 1, illus.); it shows the Adoration of the Cross/Crucifixion over the Women at the Tomb, much as they appear on some of the ampullae, and it bears the inscription: "Cross, help Aba Moun." For a (now destroyed) cast lead pendant with the Women at the Tomb on one side and the Ascension on the other, see W.F. Volbach, *Mittelalterliche Bildwerke aus Italien und Byzanz*, 2 ed. (Berlin/Leipzig, 1930), no. 6726, pl. 5. And for a casting mold of the sort used to make such a pendant, showing the Adoration of the Cross and an equal-armed cross, see *Beyond the Pharaohs: Egypt and the Copts in the 2nd to 7th Centuries* A.D., F.D. Freidman, ed., Providence, Rhode Island, Museum of Art, Rhode Island School of Design, 1989 (Providence, Rhode Island, 1989), no. 106 (exhibition catalogue). For a pewter pendant with, recto and verso, the Adoration of the Cross/Crucifixion and the Women at the Tomb, both very closely matching the ampullae, see L. Kötzsche-Breitenbruch, "Pilgerandenken aus dem Heiligen Land," *VIVARIUM: Festschrift Theodor Klauser zum 90. Geburtstag, Jahrbuch für Antike und Christentum*, Ergänzungsband 11 (1984), 241–244, pl. 27 (with a discussion of the genre as well). Interestingly, all of these pendants plus the casting mold may be associated with Egypt.

60. Some of these same images might appear as well on the individual's clothing. See *Art and Holy Powers*, 28, no. 68.

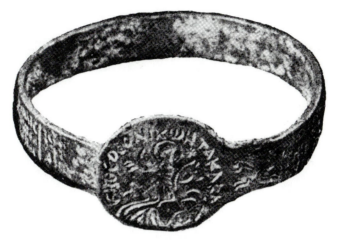

Fig. 1. Armband, *Holy Rider*, bronze, Jerusalem, Private Collection (*olim* Jerusalem, P. Godfrey Kloetzli Collection).

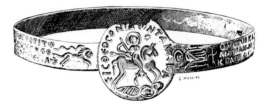

Fig. 2. Armband, *Holy Rider*, bronze, location unknown (*olim* Paris, Comtesse R. de Béarn Collection).

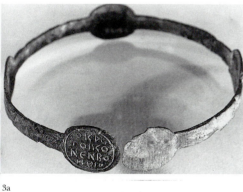

3a

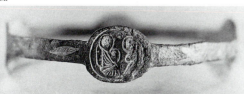

3b

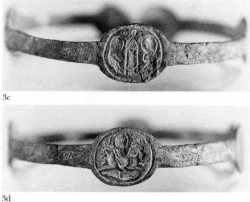

3c

3d

Fig. 3. Armband, *Annunciation et cetera*, bronze, Ann Arbor, Kelsey Museum of Archaeology, University of Michigan, no. 26198.

Fig. 4. Armband, *Raising of Lazarus et cetera*, silver, Athens, Benaki Museum, no. 11472.

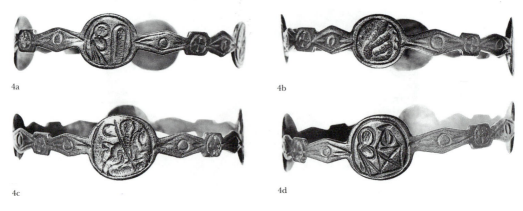

4a

4b

4c

4d

Fig. 5. Armband, *Women at the Tomb et cetera*, silver, Toronto, Royal Ontario Museum, no. 986.181.93.

5a

5b

5c

5d

Fig. 6. Armband, *Annunciation et cetera*, bronze, Baltimore, the Walters Art Gallery, no. 54.2657A–C.

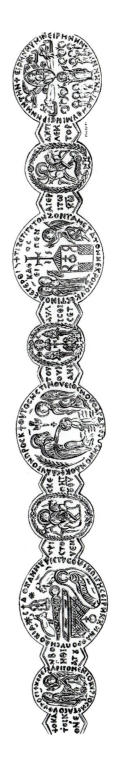

6a

6b 6c 6d

6e

6f 6g 6h

6i 6j

Fig. 7. Armband, *Annunciation et cetera*, silver, location unknown (*olim* Paris, Comtesse R. de Béarn Collection).

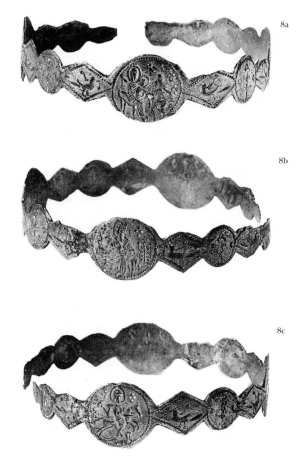

8a

8b

8c

Fig. 8 (above). Armband, *Annunciation et cetera*, silver, Berlin,
Staatliche Museen, Preussischer Kulturbesitz, Frühchristlich-
Byzantinische Sammlung, no. 4927.

Fig. 9 (right). Armband, *Annunciation et cetera*, silver, Cairo,
Egyptian Museum.

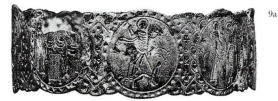

9a

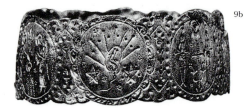

9b

Fig. 10. Armband, *Annunciation et cetera*, silver, Columbia, Museum of Art and Archaeology, University of Missouri–Columbia, no. 77.246.

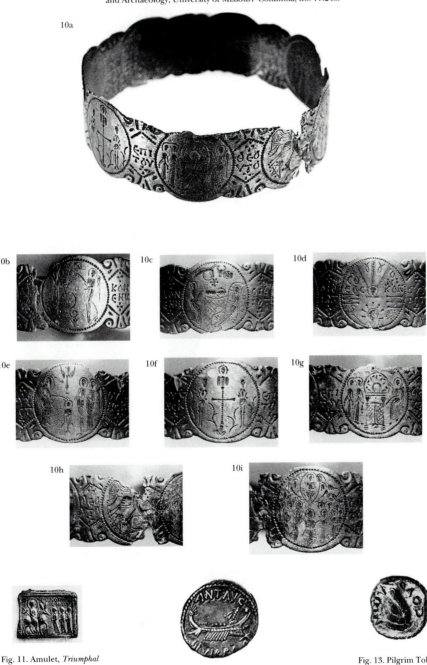

10a

10b

10c

10d

10e

10f

10g

10h

10i

Fig. 11. Amulet, *Triumphal Entry*, copper, destroyed during World War II (*olim* Berlin, Königliche Museen).

Fig. 12. Coin (Mark Antony: 32–31 B.C.), ship with *aphlaston*, copper, The Hague, Kon. Penningkabinet.

Fig. 13. Pilgrim Token, *Aphlaston*, clay, Paris, Robert-Henri Bautier Collection.

Fig. 14. Amulet, *Characteres*,
stone, location unknown
(*olim* Brummer).

17a 17b

Fig. 17. Amulet, *Chnoubis*, stone, Paris,
Cabinet des Médailles, no. 2189.

Fig. 15. Pendant, *Holy Rider et cetera*,
bronze, location unknown.

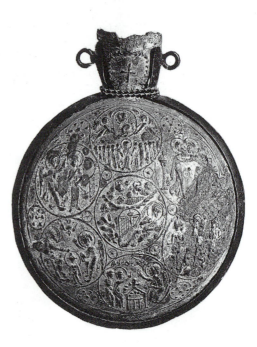

Fig. 16. Pendant, *Holy
Rider*, bronze, New York,
American Numismatic
Society, Newell no. 45.

Fig. 18. Pilgrim Flask, *Annunciation et cetera*, pewter, Monza,
Treasury of the Cathedral of St. John the Baptist (ampulla 2).

19a

19b

19c

Fig. 19. Ring, *Annunciation
et cetera*, gold, Baltimore,
the Walters Art Gallery, no.
45.15.

19d

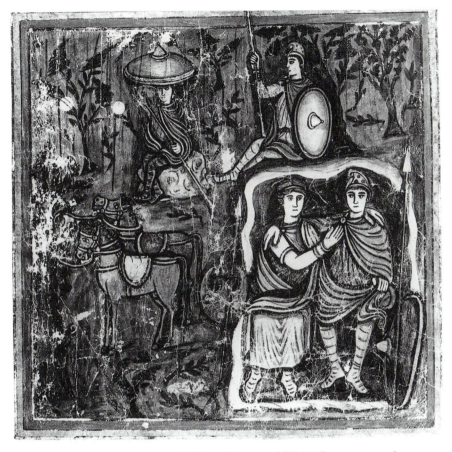

Fig. 20. Manuscript Miniature (*Vergilius Romanus*), Aeneas and Dido in a Cave, tempera on vellum, Vatican Library, cod. lat. 3867, fol. 106r.

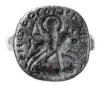

Fig. 21. Ring, *Holy Rider*, bronze, Toronto, Royal Ontario Museum, no. 986.181.125.

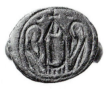

Fig. 22. Ring, *Women at the Tomb*, Toronto, Royal Ontario Museum, no. 986.181.26.

Two Unpublished Pilgrim Tokens in the Benaki Museum and the Group to Which they Belong

The enthusiasm that Laskarina Bouras brought to the study of Byzantium's material culture was matched only by the insight she achieved in its analysis. Above all, she had an unusual talent for inter-weaving everything that a Byzantine work of art had to offer — its material, design, style, iconography, and inscription — into a vivid tapestry revealing at once of the *realia* of everyday Byzantine life, and of the most complex rituals and the most subtle beliefs of its citizens. Moreover, Laskarina had a gift for finding that unusual, puzzling museum piece that somehow no one else had noticed, and then matching it with just the person who would find it most in-teresting and challenging. Every letter I received from her included, as if by afterthought, a photograph or two that she knew I, especially, would find of interest. With one of her letters, several years ago, arrived the prints here reproduced as plates 197₁ and 197₂: two clay pilgrim tokens[1]. Although only poorly preserv-ed, they are of such unusual iconographic interest as to merit their own publication; moreover, they of-fer the occasion to assemble and analyze the group of like objects to which they belong. My hope in this brief article is to impart to these simple objects the level of ennobling scholarship that Laskarina would have.

The token illustrated in plate 197₁ shows, at the left, a nimbed rider with cross-staff, and opposite him, three, perhaps four standing figures; just above the animal's head, facing toward the rider, is a bird. This is the Triumphal Entry into Jerusalem, and when juxtaposed with its counterpart in the Rossano Gospels, the amorphous shapes rising above the heads of the standing figures may be recognized as palm branches and the club-shaped object hanging from the hand of the foremost figure may be recognized as the cloak which he thrusts beneath the donkey's hooves. Discounting the cross-staff, whose seeming-ly proleptic appearance here will soon be seen to be an iconographic commonplace for this scene among objects of this sort, the only iconographically in-congruous element is the bird.

The composition filling the second token (pl. 197₂) is more immediately recognizable. The crucified Christ, wearing an ankle-length garment, dominates the center, the two thieves, with arms outstretched, appear to left and right, and just beside Christ are a pair of kneeling figures, their hands raised as if to touch his cloak. Although out of place in the Good Friday story, these two kneeling figures will soon be recognized, like the cross-staff in the Triumphal En-try, to be a common addition among Crucifixion scenes on objects of this sort.

These two objects are part of a large, loosely-interrelated group of about 220 early Byzantine pil-grim tokens identifiable by their size (.5 to 5 cm in diameter), medium (fired clay, clay and wax, plaster), technique of manufacture (intaglio stamp), place of origin (the east Mediterranean basin), and iconogra-phy (Simeon Stylites the Elder and Younger, *locus sanctus* scenes, amuletic motifs, iconic images)[2].

1. Plates 197₁, 197₂ = Athens, Benaki Museum, nos 13542 (4.6 cm; gift of Phokion Tanos, 1948), 13553 (4.5 cm; early museum purchase). Unpublished. Provenance unknown.

2. Not included in this total, which through chance finds continues to grow from month to month, is the "hoard" of several hundred (?) small tokens (c. 1.5 cm) bearing either a Latin cross flanked by a pair of frontal bust portraits or a Greek cross flanked by letters, that has recently appeared on the international antiquities market. For that hoard, which is of the region and period of the tokens here under examination, but stands apart iconographically, see G. Vikan, Art and Marriage in Early Byzantium, *DOP* 44 (1990), 156 f., fig. 20.
Also left out of the present analysis are the half dozen or so very large pilgrim tokens, like that of St Phokas in the Hermitage Museum (10.5 cm), and their related stamps, like that of the Virgin and Child discovered in the Gaza region (10 cm), for they form a group of their own, whose primary medium may not have been earth, but rather bread or, perhaps, the gypsum of amphora stoppers. For the Phokas token, see G. Vikan, *Byzantine*

There are three basic subgroups among them. The first is comprised of nearly sixty tokens measuring between 2 and 3.8 cm in diameter, and bearing a bust-length image of Simeon Stylites the Elder (d. 459) or Younger (d. 592) atop his column, crowned by flying angels, often venerated by suppliants with censers, and sometimes accompanied by tiny, abbreviated scenes of the Baptism and the Adoration of the Magi[3]. The second subgroup consists of a single, homogenous hoard of ninety-three very small tokens, none more than 1.5 cm in diameter, showing, for the most part, various abbreviated Christological scenes evocative of Holy Land pilgrimage shrines (e.g., the Nativity, the Women at the Tomb), several amuletic images (e.g., the Triumphal Entry/Holy Rider), and an iconic bust portrait of Christ[4]. The final, most heterogeneous subgroup includes a varied series of nearly sixty generally larger tokens, measuring up to 4.5 cm in diameter, bearing many of the same Holy Land Christological scenes that are found among the smaller tokens in the second subgroup, plus a few additions (e.g., the apocryphal Annunciation at the Well), as well as iconic images of the Virgin and Child enthroned, and of various unidentified saints[5].

As a group, all of these tokens belong to a still larger category of early Byzantine pilgrimage artifact known as the *eulogia* or "blessing"[6]. The Old Testament concept of blessing evoked by the word *eulogia* was thoroughly abstract; among the early Christians, however, the term gradually came to be applied to various blessed substances, such as *eulogia* bread, and eventually even to unblessed objects exchanged as gifts among the Faithful. But for the pilgrim, specifically, *eulogia* designated the blessing which could be received through contact with a relic, a holy man or a *locus sanctus*. It could be gained either immaterially, as by kissing the Wood of the True Cross, or it could

Pilgrimage Art, Dumbarton Oaks Byzantine Collection Publications, 5 (Washington, DC 1982), 14, fig. 13; and for the Gaza stamp, see L. Y. Rahmani, An *Eulogia* Stamp from the Gaza Region, *IEJ* 20 (1970), 105-108, pl. 28. For a discussion of these larger tokens and stamps, which range between 6 and 12 cm in diameter, see G. Vikan, *Byzantine Objects of Everyday Life in the Menil Collection,* vol. I, ch. 5 (forthcoming).

For surviving stamps appropriate by iconography and by size to the tokens in the present group, see Vikan, *Pilgrimage Art,* 15, fig. 8 (bronze: St Isidore [6.4 cm]); idem, Art, Medicine and Magic in Early Byzantium, *DOP* 38 (1984), 70, fig. 5 (stone, two-sided: Simeon Stylites and the Virgin and Child [c. 4.5 cm]), and an unpublished bronze St Menas stamp in the Cabinet des Médailles (Schlumberger 65 [c. 3 cm]).

3. A significant proportion of these "Simeon tokens" may be found catalogued in the following three publications: C. Celi,

Cimeli Bobbiesi, *La civiltà cattolica,* 74/3 (1923), 429-433; J. Lassus, Images de Stylites, *BEODam* 1 (1931), 71-75; J. Lafontaine-Dosogne, *Itinéraires archéologiques dans la région d'Antioche,* Bibliothèque de *Byzantion,* 4 (1967), 148-159, 170 f.; J.-P. Sodini, Remarques sur l'iconographie de Syméon l'Alépin, le premier stylite, *MonPiot* 70 (1989), 29-53. See also the discussion in Vikan, Art, Medicine and Magic (as in n. 2), 67-74.

This subgroup may in turn be divided into two series: (A) six compositionally distinctive, relatively large specimens, representing just two (?) mold types (see Celi and Vikan, above), bearing the "in the Miraculous Mountain" epithet of St Simeon the Younger, whose shrine is sixteen kilometers southwest of Antioch; and (B), about sixty generally smaller, more varied tokens which, because about half-a-dozen were found at the shrine of Simeon the Elder at Qal'at Sim'an, sixty kilometers northeast of Antioch, and because several others bear the inscription *Mar Shem'on* ("St Simeon") in Syriac, should be attributed to that stylite, whose shrine was by the early sixth century in the hands of Syrian Monophysites. (Special thanks are due to Susan A. Harvey, for reading the Syriac inscription and for making the important observation that while a clear Syriac/Greek language split between the two shrines was not in effect in the sixth century – as other, Greek-inscribed tokens in the second series themselves bear out – Syriac would not likely appear on tokens from the shrine of Simeon the Younger). For the localized tokens see Sodini, Syméon l'Alépin, 38-40; and for a token with the Syriac inscription see E. Dauterman Maguire - H. P. Maguire, M. J. Duncan-Flowers, *Art and Holy Powers in the Early Christian House,* Urbana, Illinois, Krannert Art Museum, 1989, exhibition catalogue (Urbana/Chicago, 1989), no. 127. On the theological conflict between the neighboring Simeon shrines see *La vie ancienne de S. Syméon Stylite le Jeune (521-592),* ed. and trans. P. van den Ven, SubsHag 32 (Brussels, 1962 [I], 1970 [II]), 168*-170*, n. 6.

4. See R. Camber, A Hoard of Terracotta Amulets from the Holy Land, *Actes du XVe congrès international d'études byzantines* (Athens 1981), 99-106; Vikan, Art, Medicine and Magic (as in n. 2), 81 f., n. 109; and idem, "Guided by Land and Sea": Pilgrim Art and Pilgrim Travel in Early Byzantium, *Tesserae: Festschrift für Josef Engemann, JAC,* Ergänzungsband 19 (1991), 76 f.

5. About 60% of the tokens in this subgroup may de found documented in the following publications: O. M. Dalton, *Catalogue of Early Christian Antiquities and Objects from the Christian East in the British Museum* (London 1901), nos 966-969; Celi, Cimeli Bobbiesi (as in n. 3), 426-429; G. Tchalenko, *Villages antiques de la Syrtie du Nord,* III (Paris 1958), 42-44; Lafontaine-Dosogne, *Itinéraires,* 159-162; L.Y. Rahmani, The Adoration of the Magi on Two Sixth-Century C.E. Eulogia Tokens, *IEJ* 29 (1979), 34-36; idem, A Representation of the Baptism on an *Eulogia* Token, '*Atigot,* English Series, 14 (1980), 109 f.; and Dauterman Maguire - Maguire - Duncan-Flowers, *Art and Holy Powers,* nos 128, 129. Several unpublished tokens belonging to this subgroup are in the Jeffrey Spier Collection, London.

6. For the term, see A. Stuiber, "Eulogia", *RAC* VI (Stuttgart 1966), 900-928; for its meaning among pilgrims, see B. Kötting, *Peregrinatio religiosa: Wallfahrten in der Antike und des Pilgerwesen in der alten Kirche* (Regensberg/Münster 1950), 403-413; and P. Maraval, *Lieux saints et pèlerinages d'orient* (Paris 1985), 237-241; and for its manifestation in pilgrimage art, see Vikan, *Pilgrimage Art,* 10-39.

be taken away materially, in the form of a relic frag-
ment or, more typically, by way of some everyday
substance of neutral origin, such as oil, wax, water
or earth, that had been blessed by direct contact with
a relic, a holy man or a *locus sanctus* ⁷. Among the
latter are the hundreds of extant early Byzantine
pilgrimage *devotionalia,* like these tokens, which by
virtue of their special origin were believed to be
"receptacles of the divine energy"⁸. Valued above all
for their presumed amuletic powers, they were used
mainly to preserve the pilgrim on his journey
homeward, and to heal him once he arrived there ⁹.
The quintessential "pilgrim souvenirs" of the first
generations of pious travelers, these *eulogiai* are iden-
tifiable from our vantage point solely by virtue of
their impressed imagery or words (into earth or wax),
or by their miniature canteen-like receptacles (for oil,
water or "manna dust"), many of which also bear
decoration evocative of the "blessing's" sacred origin,
of its ritualistic use, or of its amuletic power¹⁰.

Beyond the earthen tokens herein discussed, the
three other main categories of early Byzantine pilgri-
mage *eulogia* are all small flasks, either in pewter,
from Jerusalem, or in terracotta, from the shrine of
St Menas in Egypt or from that of St John the Evan-
gelist in Ephesos¹¹. By contrast with these, the to-
kens are not all localizable to a single *locus sanctus;*
indeed, it is clear that centers as far apart as Cherson
on the Black Sea and Abu Mena in Egypt were is-
suing their own blessed-earth tokens with their own
appropriate imagery¹². However, Syria, and more
specifically, the region of Antioch, seems to have been
the major point of token distribution, for not only
are the two series of Simon earthen *eulogiai* localiza-
ble to the two stylites' shrines proximate to Antioch,
the hoard comprising the entire second subgroup is
said to have come from near (or from?) the shrine
of Simon the Elder at Qal'at Sim'an, and a signifi-
cant proportion of the third subgroup (more than
one-third) is either now in the Antioch Museum, or
was discovered in or near Antioch or at Qal'at
Sim'an¹³. Indeed, there are among the three sub-
groups perhaps as many as 150 tokens, or roughly
70% of the total, that might reasonably be attributed
specifically to the area of Qal'at Sim'an¹⁴.

As for dating, the *vitae* of Simeon Stylites the Elder
(d. 459), which refer to the distribution at Qal'at

more generally, Maraval, *Lieux saints,* 222-224). For the pilgrim
Egeria, around 380, the typical *eulogia* was the occasional piece
of fruit offered by the monks at some holy site, as a gesture
of hospitality; by contrast, for the Piacenza Pilgrim, around 570,
the "pilgrim blessing" was a pervasive and specific aspect of his
daily activities, with a dual immaterial/material context of transfer
and a heavy reliance on such sanctified intermediaries as oil,
water, and earth (Stuiber, "Eulogia", 926). It seems that these
inexhaustible "secondary relics" flourished as a genre in response
to the burgeoning of pilgrimage traffic from the fourth century to the
sixth century; indeed, by then the production of *eulogia* water
flasks at the shrine of St Menas had become a minor industry
in itself (see n.11, below [Metzger]).

A similar, telling transformation in meaning takes place roughly
at the same time in the use of the word *proskynesis* ("adoration";
see Maraval, *op. cit.,* 145-147). Originally, following biblical
usage, *proskynesis* was reserved solely for the deity, but by the
fourth century it was being extended to include relics and holy
sites, and later it was applied to icons as well. Indeed, this
ever-expanding notion of localized, incarnate sanctity — the relic,
the *eulogia,* the icon — and what one does in relationship to
it (i.e., *proskynesis*) is traceable as well for the city of Jerusalem
and the region of Palestine, which between the time of Eusebius
of Caesarea (c. 260-339) and Cyril of Jerusalem (c. 320?-386)
undergo a sea change in the nature of their perceived identity,
from being merely documents of the historicity of Christ to being
bearers and sources of his sanctity (literally, *loca sancta*). See
P.W.L. Walker, *Holy City, Holy Places?* (Oxford 1990).

8. John of Damascus (*Contra imaginum calumniatores orat.,*
III. 34), referring to *loca sancta* and relics of all sorts. See Maraval,
Lieux saints, 146 f.

9. For the former, see Vikan, "Guided..." (as in n. 4) and
for the latter, idem, *Art, Medicine and Magic* (as in n. 2).

10. For a survey of such categories of *eulogia* decoration, see
Vikan, *Pilgrimage Art* (as in n. 2), 14-31. Naturally, those
substantive *eulogiai* lacking impressed identification or a
decorated container remain effectively unidentifiable.

11. See, respectively, A. Grabar, *Les ampoules de Terre Sainte*
(Paris 1958); C. Metzger, *Les ampoules à eulogie du musée du
Louvre* (Paris 1981), 9-16; and (for the Ephesos flasks) *ibid.,*
17-23.

12. See, respectively, Vikan, *op. cit.,* fig. 6; and *The Malcove
Collection,* ed. S. D. Campbell (Toronto/Buffalo/London 1985),
no. 104. It is, of course, also true that occasional pilgrim flasks
in both glass and terracotta were produced at other locations
for other saints (including Simeon Stylites). See, for example,
Lafontaine-Dosogne, *Itinéraires* (as in n. 3), fig. 115.

13. For the provenance of the second subgroup, see Vikan,
"Guided..." (as in n. 4), 76; and for some localizable members
of the third subgroup, see Lafontaine-Dosogne, *op. cit.,* nos
20-31; and Tchalenko, *Villages antiques* (as in n. 5), 42-44.

14. That the majority of these tokens do not bear images of
Simeon argues against the traditional notion (of Smirnov, Ainalov
et al.) that presupposed a direct linkage between *eulogia*
iconography and place of manufacture (see Vikan, *Art, Medicine
and Magic,* 113). Also arguing against that belief are the many
Simeon tokens bearing the Adoration of the Magi and the
Baptism, both of which evoke Palestinian *loca sancta,* and the
stamp cited in n. 2, above, which shows Simeon on one side
and the Virgin and Child enthroned on the other.

7. According to Cyril of Jerusalem, by the mid-fourth century
splinters of the True Cross had been carried to "the ends of the
earth" (*Catechetical Lectures,* 10.19, 13.39); soon, however, access
to that precious relic was curtailed (Egeria, *Travels,* 37.1; and,

Sim'an of blessed earth and to the amuletic use of the saint's image (though not in the same context), provides a *terminus post quem* of around 450 for the genre[15]. But the iconographic bond that exists between many of these tokens and the Jerusalem pewter flasks suggests that the former, as an emerging *eulogia* genre, should be dated where the latter have been securely dated; namely to the period between the mid-sixth century and early seventh[16]. And indeed, it is in the *vita* of Simeon the Younger, from around 600, that explicit reference is made to a stamped earthen token (*sphragis*) bearing an image (*typos*)[17]. As for the status of Qal'at Sim'an after 459, when Simeon died and his body was translated to Antioch, archaeological evidence indicates that it was only in the 470s that his huge cruciform shrine was begun, and that building activity continued on his sacred hill, and in the pilgrimage boom town of Deir Sim'an down below, well into the sixth century[18].

Iconographically, the two specimens in the Benaki Museum could belong to either the second or the third subgroup of tokens; by size, however, they clearly must be categorized with the third, for at about 4.5 cm, they are among the largest tokens of their type. Moreover, each is iconographically distinctive.

While the Triumphal Entry into Jerusalem is known on more than half-a-dozen other tokens, it most often appears in a yet more abbreviated form, with just Christ on the donkey (with cross staff) and an escort, which in one instance is winged (pl. 1973)[19]. Closer to the Benaki token is one in the British Museum that includes figures with palm branches and, above, a star (pl. 1974)[20]. I have argued elsewhere that Triumphal Entry iconography exists among pilgrimage *eulogiai* not because of any specific *locus sanctus*

the *vita* of Simeon the Younger reinforces the notion that such iconic pilgrimage artifacts were characteristic of the sixth to seventh centuries, and not the fifth. (For specific references see Vikan, *op. cit.*, n. 45; and for the distinction between these *eulogia* "icons" and the amuletic "icons" of Simeon the Elder evoked a century and a half earlier by Theodoret [*H.R.*, XXVI.11], see idem, Icons and Icon Piety in Early Byzantium in *Byzantine East, Latin West. Art Historical Studies in Honor of Kurt Weitzmann*, ed. D. Mouriki [forthcoming]). Additionally, these texts add greater plausibility to the idea that image-bearing *eulogiai* were then being distributed at Qal'at Sim'an as well. The dramatic emergence of images in the pilgrim experience during the sixth century is most clearly documented in the diary of the Piacenza Pilgrim, c. 570. See J. Wilkinson, *Jerusalem Pilgrims Before the Crusades* (Warminster 1977), 79-89; and, for the emergence of icons more generally in the sixth to seventh centuries, see E. Kitzinger, The Cult of Images in the Age Before Iconoclasm, *DOP* 8 (1954), 83-150.

At least three tokens are known which, although like these in medium, size, mode of manufacture, and provenance, differ basically insofar as each bears a block monogram (one includes as well an angel holding a long cross). They are not iconic, nor were they likely amuletic;moreover, by virtue or their monogram design they should be assigned to the early sixth century (see E. Weigand, Zur Monogramschrift der Theotokos [Koimesis] Kirche von Nicaea, *Byzantion* 6 [1931], 412 f.). These monogram sealings may represent the bureaucratic/commercial antecedent to the pilgrim token — that already familiar category of secular *sphragis* that the monastic communities managing the *loca sancta* could readily transform into an *eulogia*. One of the three is in the Jeffrey Spier Collection, London, and the other two were discovered at Sardis and will soon be published by Marcus Rautman. I owe these observations in part to John Nesbitt.

Further corroborating a sixth-century dating for the initiation of our iconic genre of earthen token is the iconographic bond that exists between the distinctive tokens from the second subgroup bearing the full-face image of Christ and later sixth-century lead sealings (see G. Zacos - A. Veglery, *Byzantine Lead Seals* [Basel 1972], nos 1100, 1101 [both "550-600"]). I owe these observations in part to John Cotsonis, whose dissertation, "The Religious Iconography of Byzantine Lead Seals...", includes an iconographic database drawing on nearly 6,000 published lead sealings.

More problematic than the issue of *terminus post* is the question of *terminus ante*. The Arab Conquest would have put to an end the sort of international pilgrimage that this genre of token might presuppose, and Iconoclasm would presumably have ensured that whatever trade in *eulogiai* that survived would be aniconic. The stratigraphic evidence of the Qal'at Sim'an finds should be carefully analyzed for what it might suggest about specific dating. The Walters Art Gallery, in collaboration with Dumbarton Oaks, will soon conduct thermoluminescence tests on several specimens to determine the period of firing.

15. *The Lives of Simeon Stylites*, trans. R. Doran, Cistercian Studies 112 (Kalamazoo, Mich. 1992), nos 33-39 etc., pp. 120-124 etc. (Syriac Life), 26.II, p. 75 (Theodoret, *H.R.*).

16. On the relationship, see Grabar, *Les ampoules*, 65 f.; Vikan, *Pilgrimage Art*, 28; and idem, Art, Medicine and Magic, 81-83. For the dating of the Jerusalem flasks, see J. Engemann, Palästinensische Pilgerampullen im F. J. Dölger-Institut in Bonn *JbAChr* 16 (1973), 25 f. For the iconographic and functional bond between these tokens and a series of early Byzantine amuletic armbands, which are likewise datable to the period between the mid-sixth and the mid-seventh century, see G. Vikan, Two Unpublished Byzantine Amuletic Armbands and the Group to Which They Belong, forthcoming in *J Walt* 49/50 (1991-92), 38 f.

17. *La vie ancienne* (as in n. 3), ch. 231; and Vikan, Art, Medicine and Magic, 72 f. Miracle 16 of St Artemios, miracles 54 and 55 of St Martha, and miracle 13 of Sts Cosmas and Damian also make reference to image-bearing *eulogiai* in wax or earth; moreover, their dating contemporary with or slightly later than

18. G. Tchalenko, *Villages antiques de la Syrie du Nord,* I (Paris 1953), 205-234.

19. Plate 1973 = Toronto, Royal Ontario Museum, no. 986.181.80. See Dauterman Maguire - Maguire - Duncan-Flowers, *Art and Holy Powers* (as in n. 3), no. 129; and Vikan, "Guided..." (as in n. 4), 84-86, pl. 10e. For the simpler version, with unwinged escort, see Camber, A Hoard of Amulets (as in n. 4), fig. 9.

20. Plate 1974 = London, British Museum. See Dalton, *Catalogue* (as in n. 5), no. 966.

association that it might carry, but rather because this is Christianity's ultimate reinterpretation of one of late antiquity's most powerful and pervasive amuletic images: the Holy Rider[21]. Not only is Christ here a "holy rider", he appears in a context of triumph; thus, the similarities with imperial *adventus* iconography, and thus, the proleptic cross cradled in Christ's arm — the Cross of Victory. Here, an amuletic image complements the amuletic material that bears it. And, in fact, the closest iconographic match for the Benaki Triumphal Entry is not to be found on another pilgrim token, but rather on a tin (?) capsule amulet formerly in Berlin (pl. 1985), whose accompanying inscription — *Eulogemenos* ("Blessed One") — leaves no doubt that it was intended to convey amuletic protection to the bearer[22]. As for that puzzling bird, which seems to have a counterpart along the upper left edge of the Triumphal Entry token illustrated in our plate 1973; this, like Christ's cross-staff, may be yet another ingredient in the amuletic *mélange* that is the composition's *raison d'être*. Perhaps it carries something in its beak; this is not clear, though the bird in plate 1973 appears to. In any case, a similar "misplaced" bird occasionally appears on Byzantine ring bezels of the fifth (pl. 1986) and sixth centuries, where, as a trenchant iconographic quotation from a familiar Old Testament story, it invokes God's salvation by evoking the climax of Noah's adventure on the Ark, when the bird returns with an olive branch in its beak, verifying that the Great Flood had begun to ebb[23]. As an ideogram for divine grace and protection the bird would fulfill essentially the same role on this token as does the "Blessed One" inscription on the Berlin amulet.

The Crucifixion does not, to my knowledge, otherwise appear among early Byzantine pilgrim tokens. What does appear, on five tokens in the second subgroup, are two variant mold types for the Adoration of the Cross: one whereon a pair of angels, in leaping pose, flank a simple cross with truncated cross-arms, large label plaque, and a substantial base (pl. 1987); and one whereon a pair of angels stands in profile, swinging censers (?) beside a cross whose form remains unarticulated yet clearly implied by the bust of Christ above, flanked by the sun and moon, and by the traditional multi-lobed hill of Golgotha below (pl. 1988)[24]. Further, there is a single clay token from Tyre published by George Tchalenko (pl. 1989), whereon a triumphant Christ with cross-staff has been assimilated to the cross; he is flanked on one side by an *omega* and on the other by a kneeling figure with an *alpha*[25].

Much closer comparisons for the Benaki token may be cited among three of the Jerusalem pewter flasks (pl. 19810), all made from a single mold which is iconographically unusual for that object type in showing Christ on the cross instead of the bust of Christ above the cross[26]. There, too, are the kneeling figures, which André Grabar rightly interpreted as venerating suppliants[27]. The only significant iconographic differences between token and flask exist in the elbow-bend of Christ's arms on the flask and, more generally, in the two thieves, who on the token have extended legs and arms whereas on the flask

21. I argued further that this could specifically have functioned as an amulet for travelers (see Vikan, *op. cit.*, 84-86). I use the term "Holy Rider" here in a generic sense, to encompass the amuletic conquering rider in its pagan manifestations (e.g., Heron, Horus) as well as in its various Christian versions (e.g., Solomon, St Sissinios). See Dauterman Maguire - Maguire - Duncan-Flowers, *op. cit.*, 25-28.

22. Plate 1985 = Destroyed during World War II. See O. Wulff, *Altchristliche Bildwerke,* Königliche Museen zu Berlin, Beschreibung der Bildwerke der christlichen Epochen, 2/1 (Berlin 1909), no. 825. The back side, inscribed "Solomon", is thoroughly amuletic in its iconography. For another such Triumphal Entry/Holy Rider metal amulet of the period, see *Beyond the Pharaohs: Egypt and the Copts in the 2nd to 7th Centuries A.D.,* ed. F.D. Friedman, Providence, Rhode Island, Museum of Art, Rhode Island School of Design, 1989, exhibition catalogue (Providence 1989), no. 105.

23. Plate 1986 = Baltimore, The Walters Art Gallery, no. TL 10.1985.051 (on loan from the Zucker Family Collection). See G. Vikan, Early Christian and Byzantine Rings in the Zucker Family Collection, *JWalt* 45 (1987), 33; and for a sixth-century marriage ring with this bird, Vikan, Art and Marriage (as in n. 2), 153 f., fig. 17. A similarly misplaced bird (or two) occasionally appears on Simeon tokens (Vikan, *Pilgrimage Art* [as in n. 2], fig. 25), but clearly with no branch in its beak.

24. Plates 1987, 1988 = Paris, Robert-Henri Bautier Collection. Unpublished. For twin tokens, see Camber, A Hoard of Amulets, figs 12,11. For similar compositions from the period, see M.C. Ross, *Catalogue of the Byzantine and Early Medieval Antiquities in the Dumbarton Oaks Collection,* Volume I: *Metalwork, Ceramics, Glass, Glyptics, Painting* (Washington, DC 1962), no. 119; and *Age of Spirituality:* nos 482, 525, 555. Compare also Grabar, *Les ampoules* (as in n. 11), Bobbio ampullae 1, 2.

25. Plate 1989 = Location unknown (after Tchalenko). See Tchalenko, *Villages antiques* (as in n. 5), 18, fig. 11.

26. Plate 19810 = Monza, Treasury of the Cathedral of St John the Baptist, ampulla 13. See Grabar, *op. cit.*, 28 f., 36, 55-58 (Monza ampullae 12, 13; Bobbio ampulla 7).

27. Grabar, *op. cit.*, 65 f.; and G. Vikan, Pilgrims in Magi's Clothing: The Impact of Mimesis on Early Byzantine Pilgrimage Art, *The Blessings of Pilgrimage,* Illinnois Byzantine Studies, I, ed. R. Ousterhout (Urbana/Chicago 1990), 103.

they have flexed legs, and arms bound behind their backs[28]. Yet parallels for these aspects of the token, too, may be found among the Jerusalem flasks, in a recently published specimen in the Württembergisches Landesmuseum, Stuttgart, whereon Christ's arms are fully extended and the thieves' legs and arms are likewise extended, though in the latter case with a bend at the elbow[29].

Such close iconographic bonds with *eulogia* flasks localizable to Jerusalem by their inscriptions — "Oil of the Wood of Life of the Holy Places of Christ" — suggests that this *eulogia* token, too, may have been produced there, a possibility strengthened by its iconographic distinction vis-a-vis its Qal'at Sim'an subgroup counterparts (pl. 1987,8). Furthermore, there are two suggestive Jerusalem-related textual passages from the later sixth century with which this token may be linked; one, from c. 570, appears in the diary of the Piacenza Pilgrim, just before his description of the ritual whereby little flasks of oil are blessed through contact with the True Cross, and the other, from 590, is found in Gregory of Tours' *Glory of the Martyrs,* among his descriptions of the relics of Christ[30]:

> [Piacenza Pilgrim] In the place where the Lord's body was laid, at the head, has been placed a bronze lamp. It burns there day and night, and we took a blessing from it, and then put it back. Earth is brought to the Tomb and put inside, and those who go in take some as a blessing.

> [Gregory of Tours] Marvelous power appears from the tomb where the Lord's body lay. Often the ground is covered with a natural radiant brightness; then it is sprinkled with water and dug up, and from it tiny [clay] tokens are shaped and sent to different parts of the world. Often ill people acquire cures by means of these tokens.

In the absence of inscriptions or hard archaeological evidence one cannot be certain; nevertheless, this Crucifixion token, perhaps more than any other among the hundreds of like objects that survive, has some legitimate claim to having originated at the very heart of early Byzantine pilgrimage, in Jerusalem[31]. For that reason it ought to assume a position of greater prominence among the material remains of early Byzantine pilgrimage, as should the other Benaki *eulogia* token, by virtue of its rich and unusual iconography.

28. For this Crucifixion typology, see K. Weitzmann, *Loca Sancta* and the Representational Arts of Palestine, *DOP* 28 (1974), 40 f.

29. See L. Kötzsche-Breitenbruch, Pilgerandenken aus dem Heiligen Land, *Vivarium: Festschrift Theodor Klauser zum 90. Geburtstag, JbAChr,* Ergänzungsband 11 (1984), 236 f., pl. 26a.

For amuletic tokens in copper and pewter, and a related casting mold, all of which are iconographically closely dependent on the Jerusalem ampullae, and thus close in appearance and function to the Benaki Crucifixion token, see Vikan, *Pilgrimage Art,* fig. 31; Kötzsche-Breitenbruch, *op. cit.,* pl. 27a; and *Beyond the Pharaohs* (as in n. 22), no. 106.

30. See Wilkinson, *Jerusalem Pilgrims* (as in n. 17), 83 (*Travels,* 18); and *Gregory of Tours, Glory of the Martyrs,* Translated Texts for Historians, Latin Series III, trans. and intr., R. Van Dam (Liverpool 1988), 27 (*GM,* 4).

31. For other (mostly later) textual references to various *eulogiai* from the Anastasis complex in Jerusalem, including blessed earth, see B. Begatti, Eulogia Palestinesi, *OCP* 15/1-2 (1949), 128-134.

Plate 197

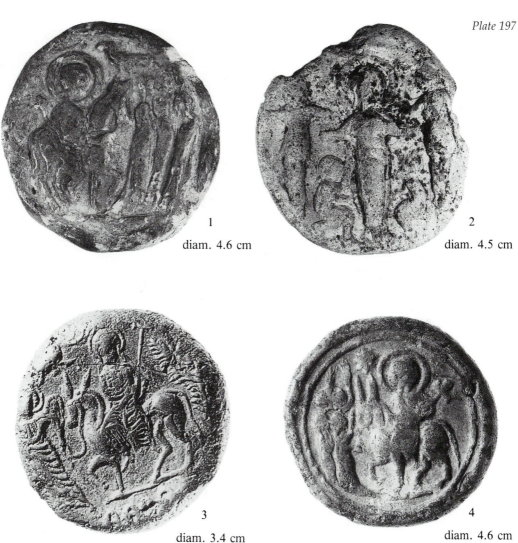

1
diam. 4.6 cm

2
diam. 4.5 cm

3
diam. 3.4 cm

4
diam. 4.6 cm

1. *Pilgrim token, Entry into Jerusalem, clay, d. 4.6 cm. Athens, Benaki Museum, no. 13542 (photo Courtesy of the Benaki Museum).*
2. *Pilgrim token, Adoration of the Cross/Crucifixion, clay, d. 4.5 cm. Athens, Benaki Museum, no. 13553 (photo Courtesy of the Benaki Museum).*
3. *Pilgrim token, Entry into Jerusalem, clay, d. 3.44 cm. Toronto, Royal Ontario Museum, no. 986.181.80 (photo Courtesy of the Royal Ontario Museum).*
4. *Pilgrim token, Entry into Jerusalem, clay, d. 4.6 cm. London, British Museum (photo Courtesy of the Trustees of the British Museum).*

Plate 198

5

2.5 × 3.2 cm

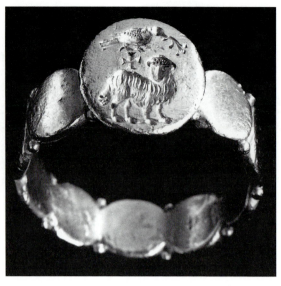

6

Diam. 1.2 cm

7

H. 1.0 cm

8

Diam. 1.5 cm

5. *Amulet, Entry into Jerusalem, tin (?), 2.5 × 3.2 cm. Destroyed during World War II (Wulff, 1909).*

6. *Ring, Lamb of God and the Dove of Noah, gold, d. (of bezel as shown) 1.2 cm. Baltimore, The Walters Art Gallery, no. TL 10.1985.051 (on loan from the Zucker Family Collection) (photo Courtesy of the Walters Art Gallery).*

7. *Pilgrim token, Adoration of the Cross, clay, d. 1.0 cm. Paris, Robert-Henri Bautier Collection (photo Courtesy of Robert-Henri Bautier).*

8. *Pilgrim token, Adoration of the Cross, clay, d. 1.5 cm. Paris, Robert-Henri Bautier Collection (photo Courtesy of Robert-Henri Bautier).*

Plate 198 (contd)

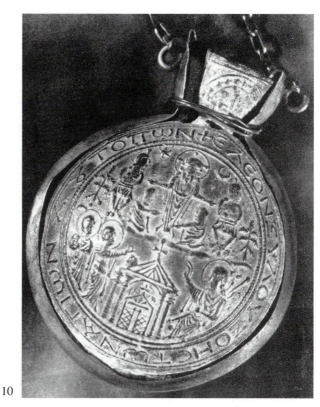

9

Diam. 4.7 cm

10

Diam. 7.5 cm

9. *Pilgrim token, Christ/Cross, clay, d. 4.7 cm. Location unknown (Tchalenko, 1958).*
10. *Pilgrim flask, Adoration of the Cross/Crucifixion and the Women at the Tomb, pewter, d. 7.5 cm. Monza, Treasury of the Cathedral of St John the Baptist, ampulla 13 (Grabar, 1958).*

XIII

Early Christian and Byzantine Rings in the Zucker Family Collection

In June 1985 The Walters Art Gallery was fortunate to receive on extended loan 143 rings and pendants from the Zucker Family Collection, New York. Of unusually high aesthetic and historic interest, these objects range in date from dynastic Egypt to the twentieth century. Among them are fifteen Early Christian and Byzantine rings which are distinguished at once by their fine quality and by the fact that they provide a substantially complete overview of major ring types in use in Eastern Christianity from the third to the fifteenth century. In a sense, they constitute a significant collection in their own right, and for that reason are here published together, for the first time.

No article of personal adornment was more prevalent in Byzantine society nor more important to the conduct of an individual's private and public business than was a signet ring.[1] The emperor wore an official ring as a symbol of power and as an implement for the authentication of certain communications and documents, and the same was true for a wide range of civil and ecclesiastical officials. As for the average citizen, signets in their locking capacity were essential for the maintenance of personal security, whereas signets in their authenticating capacity were required by law for the validation of wills and testaments.[2] Beyond this, rings functioned in a purely social context as jewelry—as a natural and traditional mode of self-adornment.

Neutral Bezel Devices

From the early years of the third century, if not

before, Christians of the eastern Mediterranean had begun to adopt neutral, pagan signet motifs for their own symbolic purposes.[3] Clement of Alexandria, probably writing at Caesarea in Cappadocia, has this advice for pious Christians:

> Let our seals be either a dove, or a fish, or a ship scudding before the wind, or a musical lyre, which Polycrates used, or a ship's anchor, which Seleucus got engraved as a device; and if there be one fishing, he will remember the apostle, and the children drawn out of the water. For we are not to delineate the faces of idols, we who are prohibited to cleave to them; nor a sword, nor a bow, following as we do, peace; nor drinking cups, being temperate.[4]

The two earliest rings in the Zucker series (figs. 1, 2)[5] probably date from the era of Clement, in that both continue traditional Roman hoop and bezel designs,[6] and both show appropriate neutral subjects. The fish on one (fig. 1) evokes the *ICHTHYS* acrostic for Christ, and the anchor on the other (fig. 2) calls to mind the cross, and the hope of the faithful (Heb., 6.18–19):

> ... we may have the strongest comfort, who have fled for refuge to hold fast the hope set before us: Which we have as an anchor of the soul, sure and firm. ...

Both motifs commonly appear on ring bezels of the Early Christian period.[7]

Like all but one ring in the Zucker series, these two are gold, and they are distinguished from most of the others by their small hoop size. In theory, this need not signify that they were worn by women or children, since in Roman times it was common for men and women alike to wear rings on all joints of the hand.

Two admonitions in the same Clement of Alexandria passage, however, suggest that rings this small would have been inappropriate for a Christian male of his era. Like many in the early church, Clement was opposed in principle to Christians wearing precious metal jewelry, but he acknowledged the practical necessity that women wear gold rings in their capacity as housekeepers " . . . for sealing [i.e., locking] things which are worth keeping safe in the house." Yet at the same time he implicitly denied very small rings in any metal to men:

> But men are not to wear the ring on the joint; for this is feminine; but to place it on the little finger at its root . . . and [thus] the signet will not very easily fall off, being guarded by the large knot of the joint.[8]

Salvation Bezel Devices

During the fourth century—and principally in the Latin West—Christians developed a more overtly religious repertoire of scenes, motifs, and inscriptions for their rings in response to the legitimation and growing dominance of their faith. As though created to document this phenomenon, one large, simply designed man's ring in the Zucker series (fig. 3)[9] bears on its bezel the word *FIDEM* and on its hoop the name *CONSTANTINO*, the sense of which may be "(May I pledge my) faith to (Emperor) Constantine," which suggests that it may have been a government official's ring.[10] Similarly responsive to Constantine and the recent triumph of the new religion are the many surviving rings like that in Figure 4[11] which bear one or another variant of the Chrismon. Here the famous Christian standard supposedly first adopted by Constantine at the Battle of the Milvian Bridge takes on a design remarkably close to the Golgotha Cross; it and its simple bezel thus stand in marked contrast to the relatively complex hoop with its rows of soldered pellets.

Explicitly Christian themes of salvation gradually replaced Clement's neutral subjects on rings with figures or scenes on their bezels. Like the images customarily found in Christian catacombs, most of these ring devices relate Old or New Testament stories symbolic of Christian deliverance, such as Jonah and the whale, and Daniel in the lion's den.[12] Indeed, protection and deliverance are the themes of the finest of the Zucker Early Christian rings (fig. 5),[13] which combines on its thick bezel superb intaglio quotations from two popular salvation compositions of the period: above is a bird with an olive branch in its beak, and below is a lamb. The latter evokes the Agnus Dei and the Good Shepherd—the Lord and his protection—and the former recalls the bird that returned to the Ark with the olive branch confirming that Noah and his family would be delivered from the flood (Gen. 8.10–11).[14] The addition of this otherwise inconspicuous piece of vegetation has thus transformed Clement's multivalent bird into an explicitly biblical, ultimately narrative iconographic element with very specific religious meaning for the ring's wearer.

Most Early Christian and Byzantine rings were seal rings, a function usually betrayed by retrograde inscriptions and/or deeply carved devices.[15] The two animals on this bezel are distinguished at once by the depth of the intaglio, and by the skill with which they were executed. Their high technical quality is paralleled by the sophisticated design of the hoop—with its nine discs and twenty soldered pellets—and by the ring's very weight (16.52 gr), which is roughly equal to that of three and one-half gold *solidi*. Certainly this was a ring of distinction in its own time, and it ranks today as one of the finest specimens of its type to have survived from the Early Christian period.

Closely related in design and quality, if not in specific iconography, are two gold rings in the British Museum (figs. 6, 7).[16] As with the Zucker ring, the hoop of each is formed of discs set off by pellets, but with these, the discs number seven and they bear their own intaglio compositions. One ring (fig. 6) shows Christ enthroned on its bezel and standing Apostles on its hoop, and the other (fig. 7) bears juxtaposed profile portraits on its bezel and frontal portraits on its hoop. The former was said to have been acquired in Smyrna, and since it shows Christ raising his left hand in blessing, it was clearly designed to function in reverse as a signet. The latter, on the other hand, belongs to a well-known category of Early Christian marriage ring, with facing portraits of husband and wife, which is firmly dateable from the later fourth to early fifth century.[17] Again, because the wife is misplaced in the position of honor at the left, this ring, too, must have been made specifically for sealing. That it and the two other rings should be assigned to the Eastern Empire is all but confirmed by a closely related marriage ring in the Dumbarton Oaks collection (fig. 8), that shows portraits virtually identical to those of the British Museum ring accompanied by a retrograde Greek inscription.[18] As a group, these four rings bear witness to the highest levels of craftsmanship and luxury then available among Christian signet rings.

Marriage Rings

To judge from the scores of surviving examples,

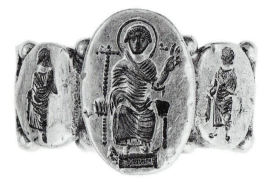

Figure 6. *Ring, Christ and the Apostles,* gold, London, British Museum, no. AF 288.

Figure 7. *Ring, Wedding Couple,* gold, London, British Museum, no. AF 304.

Figure 8. *Ring, Wedding Couple,* gold, Washington, D.C., Dumbarton Oaks Collection, no. 58.37.

marriage rings were both popular and lavish in early Byzantium; indeed, many fine gold specimens of fourth- to seventh-century date are preserved in such major collections as Dumbarton Oaks and the British Museum.[19] Iconographically, their bezel devices generally take one of four basic forms, three of which are represented by excellent examples in the Zucker Collection (figs. 9–11), and the fourth is attested by the related British Museum and Dumbarton Oaks rings just discussed (figs. 7, 8).

The earliest and simplest Christian marriage rings, dating from the fourth and fifth centuries, follow the religiously neutral Roman scheme by showing, as Figures 7 and 8, husband and wife facing one another, *en buste.* (On some examples, a small cross appears above and between the portraits.) Later, from the sixth to seventh century, a Christianized variant of this type appears wherein the profiles are replaced by frontal bust portraits with a large cross prominently displayed between them.[20] The Zucker ring illustrated in Figure 9 represents a simple version of this.[21] Others typically bear good wishes for the bride and groom such as "Harmony," "Grace of God," and "Health."

Quite distinct from the first two compositional formulae, though apparently contemporary with the later type, are two iconographic schemes that show actual events from the marriage ceremony, though in a Christianized and symbolic fashion, in that the rite is performed by Christ. In one case, the couple is brought together for the *dextrarum iunctio,* with Christ acting as symbolic *pronumba,*[22] and in the other, Christ (or Christ with the Virgin) takes the role of the priest and places wedding crowns on their heads.[23] The former iconography is represented by the Zucker ring illustrated in Figure 10,[24] whose bezel shows Christ standing at the center with the groom approaching from the left and the bride from the right; in the exergue below is the word *EVXI* (vow).[25] On the other hand, the latter, crowning formula is represented by the highly schematic scene on the bezel of the Zucker ring illustrated in Figure 11.[26] Here again Christ stands frontally at the center flanked by bride and groom, but instead of drawing the couple forward to join right hands, his hands are raised over their heads as if to crown them. Flanking Christ, in vertical columns, is the word *OMONVA* (Harmony), and around the octagonal hoop is an invocation on behalf of the couple: "*Theotoke,* help George and Plakela."[27]

Invocations beginning "*Theotoke,* help . . ." or "Lord, help . . ." are common on objects of the minor arts (and lead sealings) throughout the Byzantine period, and for the most part evoke only a fairly banal level of everyday piety. Yet here, and on marriage rings

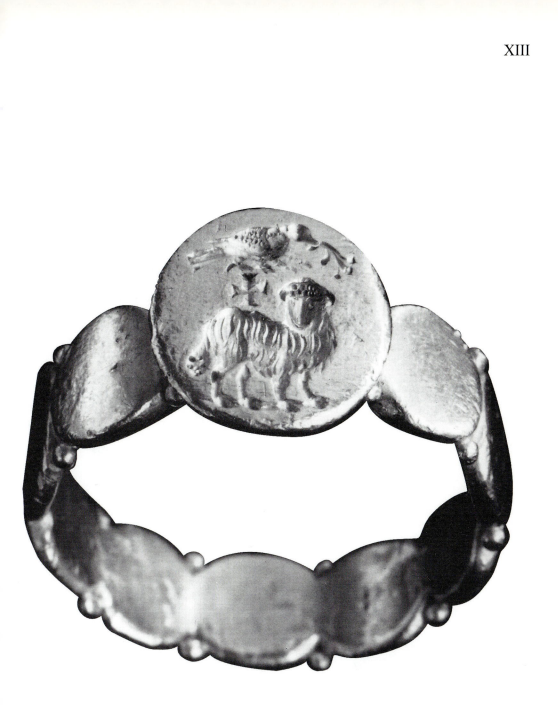

Figure 5. *Ring, Lamb and Dove*, gold, Baltimore, The Walters Art Gallery, Zucker Family Collection, no. TL 10.1985.051.

XIII

Figure 1. *Ring, Fish,* gold, Baltimore, The Walters Art Gallery, Zucker Family Collection, no. TL 10.1985.062.

Figure 4. *Ring, Chrismon,* gold, Baltimore, The Walters Art Gallery, Zucker Family Collection, no. TL 10.1985.049.

Figure 2. *Ring, Anchor,* gold, Baltimore, The Walters Art Gallery, Zucker Family Collection, no. TL 10.1985.052.

Figure 9. *Ring, Wedding Couple,* gold, Baltimore, The Walters Art Gallery, Zucker Family Collection, no. TL 10.1985.06.

Figure 3. *Ring, Acclamation,* gold, Baltimore, The Walters Art Gallery, Zucker Family Collection, no. TL 10.1985.050.

Figure 10. *Ring, Wedding Couple,* gold, Baltimore, The Walters Art Gallery, Zucker Family Collection, no. TL 1985.048.

Figure 11. *Ring, Wedding Couple,* gold, Baltimore, The Walters Art Gallery, Zucker Family Collection, no. TL 10.1985.053.

Figure 16. *Ring,* gold, Baltimore, The Walters Art Gallery, Zucker Family Collection, no. TL 10.1985.057.

Figure 12. *Ring, Monogram,* gold, Baltimore, The Walters Art Gallery, Zucker Family Collection, no. TL 10.1985.060.

Figure 13. *Ring, Monogram,* gold, Baltimore, The Walters Art Gallery, Zucker Family Collection, no. TL 10.1985.059.

Figure 17. *Ring, Invocation,* gold, Baltimore, The Walters Art Gallery, Zucker Family Collection, no. TL 10.1985.054.

Figure 15. *Ring,* gold, Baltimore, The Walters Art Gallery, Zucker Family Collection, no. TL 10.1985.058.

Figure 19. *Ring, Virgin* Hodegetria, bronze, Baltimore, The Walters Art Gallery, Zucker Family Collection, no. TL 10.1985.056.

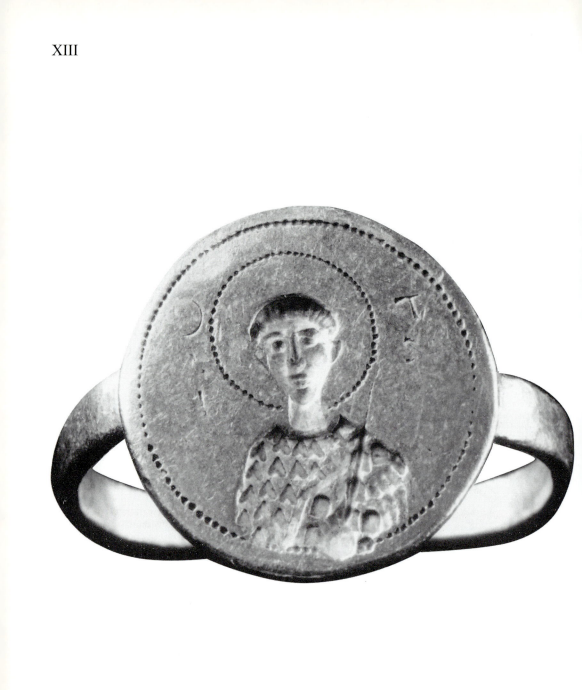

Figure 21. *Ring, St. Demetrios,* gold, Baltimore, The Walters Art Gallery, Zucker Family Collection, no. TL 10.1985.055.

generally, there is good reason to believe the formula was intended to be more specific. Consider, first, the very shape of the hoop: an octagon. Among surviving Early Byzantine rings, eight-sided hoops are consistently associated with apotropaic bezel devices;[28] and indeed, they were specifically prescribed by Alexander of Tralles for the treatment of colic:

> Take an iron ring and make its hoop eight-sided, and write thus on the octagon: "Flee, flee, O bile, the lark is pursuing you."[29]

Second, there is the fact that octagonal marriage rings very much like this one, with crowning iconography on the bezel, bear a thematically related, clearly apotropaic excerpt from Psalm 5.12 on their hoops: "Thou hast crowned us with a shield of favor."[30] And third, there are the words, already noted, which are shared by so many Early Byzantine marriage rings: "Harmony," "Grace of God," "Health." In a sense, these constitute the "shield of favor" invoked by God through the crowning. And obviously, "Harmony" would be a benefit applicable to husband and wife specifically as a couple.[31] But so also might be "Health," insofar as marital health, in a sense both literal and metaphoric, would be essential to the ultimate goal of Christian marriage—namely, successful childbearing.[32] Indeed, in the text of the Byzantine marriage ceremony there are, in addition to many invocations of "Harmony" and "Grace," numerous prayers directed toward childbearing, such as "Bless us, O Lord our God, as You blessed Zacharias and Elisabeth."[33]

The eight-sided hoop, the passage from Psalm 5, and words like "Harmony" and "Health" together reflect a level of intentionality for Early Byzantine marriage rings which was significantly above that of mere banal piety or simple ceremony. And this in turn suggests that when George and Plakela invoked the help of the *Theotokos* for themselves (and their marriage), they did so with a specific marital goal, most likely that of successful childbirth.

Monogram Rings

With the growth of the Byzantine capital, both the neutral and the salvation repertoires of signet themes gradually began to disappear, for the most part replaced by a new, distinctively post-classical sealing device: the personal monogram (figs. 12: "Theodore"; 13: "John").[34] Often the letters of the owner's name are incised backwards, and are either arranged around a large central letter, such as a *mu*, to form a block, or else are arranged on the arms of a cross (as in figs. 12, 13). As with the majority of other Byzantine

Figure 14. *Seal, Virgin* Hodegetria, *and Monogram,* lead, Washington, D.C., Dumbarton Oaks Collection, no. 55.1.253.

sealing devices, the genitive case ending is usually employed.[35] Many, like the two Zucker examples, are incised into a simple disc soldered to a wire hoop. Their seal impression would therefore be quite close in appearance to the monogram lead sealings (fig. 14)[36] which were then becoming extremely popular in Byzantium. The inscriptional sense of each was the same: "[Seal] of Theodore."

In Byzantium, the sixth century marked a basic shift from monograms constructed around a block letter (block monograms) to those formed around a cross (cross monograms); the latter are first dateable in Justinianic column capitals of the 530s.[37] This adds special significance to the fact that the majority of block-monogram ring seals are gemstone intaglios, whereas the majority of cross-monogram ring seals are, like the present examples, metal intaglios.[38] Indeed, this seems to mark the culmination of a trend begun centuries earlier. In Book 33 of his *Natural History,* Pliny the Elder notes the growing but still novel practice among Romans of sealing not with incised gems but with the metal of the ring itself:

> . . . many people do not allow any gems in a signet-ring, and seal with the gold itself; this was a fashion invented when Claudius Caesar was Emperor.[39]

To judge from surviving monogram rings, the shift in medium seems to have been all but fully accomplished by the end of the sixth century.[40] By then, the incised metal signet ring had become as common among and distinctive to the Byzantines as had gem signets formerly been to the Romans. Yet, its ancestry is unmistakable, especially in rings like that in our Figure 10, where a metal bezel has been set as if it were a stone.

Because Early Byzantine monogram signet rings were both popular and simple, it might be supposed that they were more or less mass produced. And indeed, the Zucker Collection includes important new evidence to corroborate this assumption. First, the back of the bezel of the ring illustrated in our Figure 13 shows two expertly incised Greek letters, a *pi* and an *epsilon,* which together would likely have formed the horizontal arms of a cross monogram. *PETROU* ("of Peter") would be a probable choice, but the absence of any trace of the last four letters suggests

that this intaglio was abandoned and the bezel simply flipped over and "John" incised instead. Second, there are two superb, uninscribed gold rings in the Zucker series (figs. 15, 16)[41] which by their design clearly belong with the monogram signet group exemplified by Figures 12 and 13. But because their bezels make no sense without sealing devices, one must assume that these were pre-fabricated rings awaiting their final personalization. An as yet unpublished private silver hoard of sixth-century date includes among its two dozen or so rings, coins, belt fittings, *et cetera*, both unattached blank ring bezels, and seemingly complete rings whose bezels bear no device.[42]

Invocational Rings

The final shift from incised stone to incised metal was but one of several areas wherein Byzantine rings were, as a group, fundamentally different from those worn by the Romans. Another lies in the fact that Byzantine bezel devices are heavily weighted toward inscriptions, in contrast to Rome's marked preference for figurative devices.[43] These usually take either one of two forms: monograms, which have already been discussed, or invocations (fig. 17).[44]

A Byzantine invocational signet ring usually bears on its bezel a short prayer calling upon the help of the deity (or a saint) for a specific individual: for example, "Lord, help John." Occasionally, however, as with the Zucker ring in Figure 17 ("Christ, help the wearer"),[45] a prayer is offered for a generic owner, which further corroborates the view that Byzantine rings were mass produced.[46] Invocational rings for the most part date to the Middle and Late Byzantine periods—in contrast to monogram rings, which are usually Early Byzantine in date—and most show relatively large bezel surfaces to accommodate the much greater number of letters (fig. 18).[47] The Zucker invocational ring, with its raised hexagonal sealing surface supported by tiny hands, its incised trefoils, and its heavily corrupted Greek, is one of relatively few known specimens that attest to the last phases of Byzantine ring production, when traditional designs and formulae were being thoroughly transformed under the impact of Western practice.[48] As a group, they bear witness to the accelerating erosion of traditional Byzantine forms on the level of everyday material culture.

Iconic Rings

Byzantium's third major contribution to the development of the finger ring was at once more sub-

Figure 18. *Ring, Invocation*, gold, Baltimore, The Walters Art Gallery, no. 57.1053.

tle and yet perhaps more significant than the shift from stone to metal and from figures to words. For the Romans, ring signets functioned primarily as tools for making seals and as objects of aesthetic enjoyment; indeed, gem carvers were highly esteemed and well paid, and there was a fashion for gem collecting.[49] For the Byzantines, of course, the sealing function of signet rings necessarily continued, but the aesthetic and antiquarian interests of the implement seem to have receded markedly. What developed in their place was an unprecedented concern for the spiritual (and/or magical) power of rings, for their ability to invoke supernatural help or to ward off evil. Again, Pliny the Elder anticipates the transformation when he observes that: "Now, indeed, men also are beginning to wear on their fingers Harpocrates and figures of Egyptian deities."[50]

The desire to invoke supernatural power is evident in Byzantine rings of all periods and designs. At one extreme are examples that portray Greco-Egyptian medico-magical creatures, like the Chnoubis, or the Judeo-Christian master of magic and power, King Soloman,[51] and at the other are simple invocational rings like that in Figure 18. Somewhere in between fall octagonal marriage rings, like that in Figure 11, as well as an entire category of Byzantine sealing implements for which there was no Roman antecedent, either for their decoration or for their function: the iconic ring.[52]

In essence, Byzantine craftsmen simply transferred to ring bezels icon types that had been developed and popularized in other media. The Virgin and Child was an especially popular subject throughout the Byzantine period, and was one of the first iconic images to commonly appear on ring bezels, from as

Figure 20. *Ring, Virgin* Hodegetria, gold, Washington, D.C., Dumbarton Oaks Collection, no. 58.37.

Figure 22. *Pendant Reliquary, St. Demetrios*, gold and enamel, Washington, D.C., Dumbarton Oaks Collection, no. 53.20.

early as the sixth to seventh century. A bronze ring of approximately that date in the Zucker Family Collection (fig. 19)[53] shows the familiar *Hodegetria* type, where the Christ Child is presented on the Virgin's left arm. It is remarkably similar to a contemporary gold ring in the Dumbarton Oaks collection (fig. 20),[54] and both, in turn, are closely paralleled among lead sealings of the period (fig. 14),[55] which are also their closest functional relatives.

Also very popular throughout the history of the Empire were rings with incised icons of famous military saints, and among the finest specimens to survive is one in the Zucker series with a frontal bust portrait of a beardless military saint with lance and sword (fig. 21).[56] Although the shallow inscription is substantially worn away, the figure corresponds so closely to that on the famous St. Demetrios pendant reliquary at Dumbarton Oaks (fig. 22)[57] as to leave no doubt as to his identity. Both certainly derive from an iconic type developed and popularized in more formidable media, especially panel painting.

That Byzantine icons should be as popular in the form of incised ring bezels as in the form of painted panels is fully consistent with what the Byzantine mind conceived the icon to be, namely, something without substance for which such criteria as size, technical quality, or even iconic verisimilitude carried little or no meaning.[58] Indeed, Theodore the Studite used the metaphor of a signet ring to help explain the

essential insubstantiality of icons:

> Or take the example of a signet ring engraved with the imperial image, and let it be impressed upon wax, pitch and clay. The impression is one and the same in the several materials which, however, are different with respect to each other; yet it would not have remained identical unless it were entirely unconnected with the materials.... The same applies to the likeness of Christ, irrespective of the material upon which it is represented....[59]

Thus by this definition, a wax sealing made with the Zucker ring in Figure 19 was no less a *Hodegetria* icon than was the original, preserved in the Hodegon Monastery, and all three, painted panel, seal ring, and seal impression, partook in a shared sacred power for which the Romans had no antecedent.[60] And it was this sacred power, whether conveyed through images or words (or even the ring's octagonal shape) that more than anything else gave Byzantine rings their distinctive character.

NOTES

1. A comprehensive, fully documented survey of Byzantine finger rings will appear as chapter two of my forthcoming catalogue of more than seven hundred Byzantine objects of the minor arts in the Menil Collection, Houston (hereafter, Vikan, *Menil*). For the half dozen Early Christian and Byzantine rings in The Walters' permanent collection, see *Jewelry, Ancient to Modern* (New York, 1979), nos. 425–430; and M. Ross, "Two Byzantine Nielloed Rings," *Studies in Art and Literature for Belle da Costa Greene* (Princeton, 1954), 169–71 (hereafter, Ross, "Rings").

2. On the distinction, see G. Vikan and J. Nesbitt, *Security in Byzantium: Locking, Sealing, Weighing*, Dumbarton Oaks Byzantine Collection Publications, 2 (Washington, D.C., 1980), 10–11 (hereafter, Vikan and Nesbitt, *Security*). In its locking capacity, a signet functioned as a complement to a key, as one might place a wax or clay sealing on the hasp of a jewelry box. In its authenticating capacity, a signet functioned as a complement to a signature.

3. See T. Klauser, "Studien zur Entstehungsgeschichte der christliche Kunst, I," *Jahrbuch für Antike und Christentum*, 1 (1958), 21–23.

4. *The Ante-Nicene Fathers*, II (reprint: Grand Rapids, Mich., 1971), 285 (*Paed.*, 3.11).

5. Figure 1 (3rd c): TL 10.1985.062 (gold; excellent condition). The polygonal hoop is flat in section with a 1.6–1.8 cm diameter; the attached bezel measures .5 x .6 cm. Figure 2 (3rd c): TL 10.1985.052 (gold; excellent condition). The circular hoop is round in section with a 1.5–1.6 cm diameter; the bezel measures 1.0 x .6 cm. Color photography of Figures 1–3, 5, 9, 11–13, 16, 17, 19, 21 by Peter Schaaf; Figures 4, 10, 15 by Susan Tobin.

6. See F. H. Marshall, *Catalogue of the Finger Rings, Greek, Etruscan, and Roman in the Departments of Antiquities, British Museum* (London, 1907), xliii, xlv (hereafter, Marshall, *Catalogue*).

7. See, for example, R. Garrucci, *Storia della arte cristiana* (Prato, 1880), VI, pl. 477 (hereafter, Garrucci, *Storia);* O. M. Dalton, *Catalogue of Early Christian Antiquities and Objects from the Christian East in the Department of British and Medieval Antiquities and Ethnography of the British Museum* (London, 1901), pl. II (hereafter, Dalton, *Catalogue);*

and F. J. Dölger, *ICHTHYS, V: Die Fisch-Denkmäler in der frühchristlichen Plastik, Malerei, und Kleinkunst* (Münster, 1932–39), 237, 246, 250–252, 293–298. The two motifs (fish and anchor) are often combined.

8. See note 4, above.

9. Figure 3 (4th c): TL 10.1985.050 (gold; excellent condition). Formerly in the Guilhou Collection. The circular hoop is flat in section with a 2.0–2.2 cm diameter; the bezel measures 1.0 x 1.4 cm. Like the rings in Figures 1 and 2, this one perpetuates a Roman design. See Marshall, *Catalogue,* x1vii.

10. I owe this reading to John Nesbitt and John Callahan. A number of such rings survive; see, for example, Marshall, *Catalogue,* no. 649.

11. Figure 4 (4th–5th c): TL 10.1985.049 (gold; hoop broken at back [one of 18 pellets lost]). The circular hoop, which is flat in section, is composed of eight rectangular sections set off by pairs of pellets. The broken and compressed hoop is 1.5–1.7 cm in diameter; the bezel measures 1.0 x .7 cm. For Chrismon rings (some combined with anchors and/or fish) see, for example, H. Leclercq, "Anneaux," *Dictionnaire d'archéologie chrétienne et de liturgie,* I, pt. 2 (Paris, 1907), figs. 687–689, 695–699, 712, 716, 727, 750 (hereafter, Leclercq, "Anneaux").

12. See T. Klauser, "Studien zur Entstehungsgeschichte der christlichen Kunst, IV," *Jahrbuch für Antike und Christentum,* 4 (1961), 128–145 (hereafter, Klauser, "Studien, IV").

13. Figure 5 (4th–5th c): TL 10.1985.051 (gold; excellent condition [one of 20 pellets lost]). The circular hoop, which is flat in section, is composed of nine discs set off by pairs of pellets. The hoop is 1.9–2.1 cm in diameter; the bezel, which takes the form of a truncated cone (.4 cm thick), is 1.2 cm in diameter.

14. See Garrucci, *Storia,* pl. 478, no. 10. For other parallels, see his pls. 477, 478; Dalton *Catalogue,* pls. I, II; and Klauser, "Studien, IV," 141, 142. Most often the bird appears without the Ark, in combination with another motif or symbol (e.g., a fish).

15. Vikan and Nesbitt, *Security,* 17.

16. Dalton, *Catalogue,* nos. 190, 207. See also *Spätantike und frühes Christentum,* Liebieghaus Museum alter Plastik, Frankfurt am Main, 1983–84 (Frankfurt am Main, 1983), no. 257 (exhibition catalogue). Figures 6 and 7 are reproduced by courtesy of the Trustees of the British Museum.

17. See M. C. Ross, *Catalogue of the Byzantine and Early Mediaeval Antiquities in the Dumbarton Oaks Collection, Volume II: Jewelry, Enamels and Art of the Migration Period* (Washington, D.C., 1965), no. 50 (hereafter, Ross, *Catalogue).*

18. Ross, *Catalogue,* no. 50. Figure 8 is reproduced courtesy of the Byzantine Collection, neg. 47.241.24A, (c) 1967 Dumbarton Oaks, Trustees of Harvard University, Washington, D.C. 20007.

19. See Ross, *Catalogue, passim;* and Dalton *Catalogue, passim.* According to the text of the Byzantine marriage ceremony (as attested in manuscripts from the mid- to the post-Byzantine period), the bride received a silver ring and the groom a gold ring. See P. N. Trempelas, "He akolouthia ton mnestron kai tou gamou," *Theologia,* 18 (1940) (hereafter, Trempelas, "Akolouthia").

20. For some examples, see Dalton, *Catalogue,* no. 133; Ross, *Catalogue,* nos. 4, 67, 68; A. Banck, *Byzantine Art in Collections of the USSR* (Leningrad/Moscow, [1966]), no. 102 (as links in a necklace) (hereafter, Banck, *USSR);* and J.-M. Spieser, "Collection Paul Canellopoulos (II)," *Bulletin de correspondance hellénique,* 96 (1972), no. 11 (hereafter, Spieser, "Canellopoulos").

21. Figure 9 (6th–7th c): TL 10.1985.061 (gold; excellent condition). The polygonal hoop is semicircular in section with a 1.6–1.8

cm diameter; the attached round bezel (with raised device) is .9 cm in diameter.

22. See, for example, Ross, *Catalogue,* nos. 64–66; and E. H. Kantorowicz, "On the Golden Marriage Belt and the Marriage Rings of the Dumbarton Oaks Collection," *Dumbarton Oaks Papers,* 14 (1960), 3–42.

23. See, for example, Ross, *Catalogue,* no. 69; and P. A. Drossoyianni, "A Pair of Byzantine Crowns," *XVI. Internationaler Byzantinistenkongress, Akten II/3, Jahrbuch der österreichischen byzantinischen Gesellschaft,* 32/3 (1982), 531, 532.

24. Figure 10 (6th–7th c): TL 10.1985.048 (gold; excellent condition [hoop slightly deformed]). The circular hoop, which is semicircular in section, terminates in a pair of fishlike heads between which is set a small disc. From this disc rise six curving, talonlike wires with terminating pellets which enclose and support the oval bezel. The hoop is 1.9–2.0 cm in diameter; the bezel measures 1.4 x 1.2 cm.

25. Although appropriate to a wedding ring, and common on inscribed Byzantine metalwork of the period, "vow" is, to my knowledge, otherwise unattested on contemporary rings.

26. Figure 11 (6th–7th c.): TL 10.1985.053 (gold; excellent condition). The octagonal hoop is rectangular in section with a 1.7–1.9 cm diameter; the attached round bezel is 1.2 cm in diameter. The unusual, "sketchy" technique of this intaglio is most clearly revealed in the head of Christ, which is formed of a large halo with a superimposed cross flanked by eye dots.

27. *Theotoke Boethe Georgi(ou) (kai) Plakelas.*

28. See G. Vikan, "Art, Medicine, and Magic in Early Byzantium," *Dumbarton Oaks Papers,* 38 (1984), 76–86 (hereafter, Vikan, "Magic").

29. *Alexander von Tralles,* T. Puschmann, ed. and trans., 2 vols. (Vienna, 1878–79), II, 377 (VIII, 2, *On Colic).*

30. For example, Banck, *USSR,* no. 106c. See also Vikan, "Magic," 83.

31. Thus, this word appears almost exclusively on objects related to marriage.

32. For an elaboration of this thesis, see Vikan, "Magic," 83.

33. See Trempelas, "Akolouthia," 149.

34. Figure 12 (6th–7th c): TL 10.1985.060 (gold; excellent condition). The circular hoop is round in section, with a 2.0 cm diameter; the bezel is 1.3 cm in diameter. Figure 13 (6th–7th c): TL 10.1985.59 (gold; excellent condition). The circular hoop is round in section, with a 1.8–2.0 cm diameter; the bezel is 1.0 cm in diameter (and unusually thick, at .3 cm).

35. See N. Oikonomidès, *Byzantine Lead Seals,* Dumbarton Oaks Byzantine Collection Publications, 7 (Washington, D.C., 1985), 20.

36. G. Zacos and A. Veglery, *Byzantine Lead Seals* (Basel, 1972), no. 1228 (7th c). Figure 14 is reproduced courtesy of the Byzantine Collection, acc. no. 55.1.253, (c) 1967 Dumbarton Oaks, Trustees of Harvard University, Washington, D.C. 20007.

37. E. Weigand, "Zur Monogramschrift der Theotokos (Koimesis) Kirche von Nicaea," *Byzantion,* 6 (1931), 412 f.

38. See Vikan, *Menil,* nos. RS1–RS9; R1–R8.

39. *Pliny, Natural History,* H. Rackham, trans., The Loeb Classical Library (Cambridge, Mass./London, 1952), IX; 21 *(N.H. 33.23)* (hereafter, *Pliny,* 1952).

40. For a pair of cross-monogram gold signet rings dateable on archaeological grounds to the first half of the seventh century, see J. Werner, *Der Grabfund von Malaja Pereščepina und Kuvrat, Kagan der Bulgaria,* Bayerische Akademie der Wissenschaften, philosophisch-

historische Klasse, Abhandlungen, neue Folge, Heft 91 (Munich, 1984), pl. 32.

41. Figure 15 (6th–7th c): TL 10.1985.058 (gold; excellent condition). The circular hoop is round in section with a 1.8–2.0 cm diameter; the attached bezel is 1.2 cm in diameter. Figure 16 (6th–7th c): TL 10.1985.57 (gold; excellent condition). The circular hoop is round in section with a 1.6–1.7 cm diameter; the attached bezel measures 1.6 x 1.7 cm.

42. Also included is an incised quatrefoil ring very much like the Zucker ring illustrated in Figure 16. The Zucker ring, by its small size, was likely made for a woman, and the hoard's silver ring bears a woman's name. This hoard, which was recently acquired by the Royal Ontario Museum, Toronto, will be published by Paul Denis.

43. See G. M. A. Richter, *Catalogue of Engraved Gems, Greek, Etruscan and Roman* (Rome, 1956) (hereafter, Richter, *Catalogue*).

44. Figure 17 (13th–15th c): TL 10.1985.054 (gold; excellent condition). The circular hoop is flat in section with a 1.8 cm diameter; the hollow, hexagonal bezel measures 1.3 x 1.5 cm.

45. *Ch(rist)e Boethe ton phobontrito*(?). The heavily corrupted inscription reads in a continuous loop.

46. As is well documented by the Menil Collection, such anonymous invocations appear frequently on rings, pectoral crosses, belt fittings, and fibulae—especially those in bronze.

47. Walters Art Gallery, no. 57.1053 (9th–10th c). The bezel is inscribed: "Lord, help Thy servant Michael, imperial *mandator* (messenger)." See Ross, "Rings," 170.

48. Others include: *Collection B. Khanenko: antiquités de la région du Dniepre et des côtes de la Mer Noire* (Kiev, 1907), V, pl. 23; Dalton, *Catalogue*, no. 171; Ross, *Catalogue*, nos. 105,131; Spieser, "Canellopoulos," nos. 21–23; and *Collection Hélène Stathatos, 2: les objets byzantins et post-byzantin* (n.l., n.d.), pl. IV (esp. nos. 29, 30).

49. See, for example, Richter, *Catalogue*, xxix-xxxi.

50. *Pliny*, 1952, 33 (*N.H.*, 33.41).

51. See Vikan, "Magic," 77–80.

52. The distinction here is between images of deities who could convey magic (e.g., Harpocrates), and those who were subject to iconic veneration (e.g., the Virgin *Hodegetria*). See M. Henig, *A Corpus of Roman Engraved Gemstones from British Sites, Part i: Discussion*, British Archaeological Reports 8(i) (Oxford, 1974), 27, 28.

53. Figure 19 (6th–7th c): TL 10.1985.056 (bronze; somewhat worn). The deformed circular hoop is slightly oval in section, with a 1.9–2.1 cm diameter; the raised, cone-shaped bezel is 1.4 cm in diameter.

54. Ross, *Catalogue*, no. 179,0. Figure 20 is reproduced courtesy of the Byzantine Collection, neg. no. 64.25.35A, (c) 1967 Dumbarton Oaks, Trustees of Harvard University, Washington, D.C. 20007. A closely related bronze ring inscribed "Holy Mary," excavated at Beisan, is preserved in the University of Pennsylvania Art Museum (no. 31.50.251).

55. See note 36, above.

56. Figure 21 (11th–12th c): TL 10.1985.055 (gold; slightly worn). The circular hoop is flat in section with a 2.0–2.4 cm diameter; the very thin bezel is 1.8 cm in diameter.

57. Ross, *Catalogue*, no. 160. Figure 22 is reproduced courtesy of the Byzantine Collection, acc. no. 53.20, (c) 1967 Dumbarton Oaks, Trustees of Harvard University, Washington, D.C. 20007. Traces of an *omicron* (upper left) and *tau* (upper right) on the Zucker ring bezel match corresponding letters on the pendant.

58. See C. Mango, *The Art of the Byzantine Empire: 312–1453*, Sources and Documents in the History of Art Series (Englewood Cliffs, N.J., 1972), 149.

59. *Ibid.*, 174 (*Epist. ad Platonem*).

60. For a further discussion of this question, see G. Vikan, "Ruminations on Edible Icons: Originals and Copies in the Art of Byzantium," *Studies in the History of Art* (forthcoming).

XIV

THE TRIER IVORY,
ADVENTUS CEREMONIAL,
AND THE RELICS OF ST. STEPHEN

KENNETH G. HOLUM and GARY VIKAN

NE of the most enigmatic monuments to have survived from the Early
Byzantine period is the so-called translation of the relics ivory now in
the Trier Domschatz (fig. 1).[1] The stylistic and iconographic interpre-
tation of this arresting piece has for decades excited enthusiastic but incon-
clusive debate. A consensus now seems to agree on an origin in an eastern Med-
iterranean, preiconoclastic workshop, with a majority of scholars apparently
favoring sixth-century Constantinople.[2] No semblance of consensus, however,
has formed around any of the current historical interpretations of the piece.[3]

The paucity of comparable monuments extant from the Early Byzantine
period will likely forever preclude the establishment of a secure provenance or
stylistic dating for the Trier ivory.[4] In the realm of iconography, however, the
outlook is not so bleak. For although the plaque is an artistic *unicum*, the event
it portrays is of a common type which is well known from a variety of literary
and visual sources—the *adventus* ceremony developed in classical antiquity and
employed in later periods to celebrate the triumphal arrival of rulers and their
portraits, of bishops and other holy men, and of the relics of saints.[5] Although
perceptive scholars have remarked upon the *adventus* character of the Trier
ivory,[6] surprisingly little has been made of this most striking aspect of the piece.
Thus, we propose to reinterpret the plaque in light of relic *adventus* typology,
with the two-fold aim of explaining more fully the elements of its visual narra-
tive and of identifying the specific *adventus* it was designed to celebrate.

[1] W. F. Volbach, *Elfenbeinarbeiten der Spätantike und des frühen Mittelalters*, Römisch-germanisches
Zentralmuseum zu Mainz, Katalog VII, 3rd ed. (Mainz, 1976) (hereafter Volbach, *Elfenbeinarbeiten*),
no. 143. For a detailed description, see R. Delbrueck, *Die Consulardiptychen und verwandte Denkmäler*
(Berlin-Leipzig, 1929) (hereafter Delbrueck, *Die Consulardiptychen*), no. 67; for excellent reproductions,
see H. Schnitzler, *Rheinische Schatzkammer. Tafelband* (Düsseldorf, 1957), pls. 1–5; and for its modern
provenance, see B. Fischer, "Die Elfenbeintafel des Trierer Domschatzes: zu ihrer jüngsten Deutung
durch Stylianos Pelekanidis 1952," *Kurtrierisches Jahrbuch*, 9 (1969), 5 ff.

[2] For a review of scholarship, see Volbach, *Elfenbeinarbeiten*, 95 f.; N. Irsch, *Der Dom zu Trier* (Düs-
seldorf, 1931), 319 ff.; and Fischer, *op. cit.*, 5. The most recent and exhaustive treatment of the piece
is S. Spain, "The Translation of Relics Ivory, Trier," *DOP*, 31 (1978), 279–304 (hereafter Spain, "Trans-
lation Ivory)." We would like to thank Ms. Spain for generously allowing us to read her manuscript in
advance of publication.

[3] These include the hypothesis of S. Pelekanidis ("Date et interprétation de la plaque en ivoire de
Trèves," *Mélanges Henri Grégoire* = *AIPHOS*, 12 [1952], 361–71), that it represents the translation of
the relics of SS. Joseph and Zacharias to Hagia Sophia in 415; the opinion originating with J. Strzy-
gowski (*Orient oder Rom, Beiträge zur Geschichte der spätantiken und frühchristlichen Kunst* [Leipzig,
1901], 85 ff.), that it is the translation of the Forty Martyrs of Sebaste to the church of St. Irene in Sycae
in 552; and the recent theory of S. Spain ("Translation Ivory"), that it is the return of the True Cross
to the Golgotha shrine in 630.

[4] Witness the recent exhaustive stylistic analysis by Spain.

[5] E. Peterson, "Die Einholung des Kyrios," *Zeitschrift für systematische Theologie*, 7 (1930), 682–702;
E. Kantorowicz, "The 'King's Advent' and the Enigmatic Panels in the Doors of Santa Sabina," *ArtB*,
26 (1944), 207–31 (repr. *idem, Selected Studies* [Locust Valley, N.Y., 1965], 37 ff.), S. MacCormack,
"Change and Continuity in Late Antiquity: The Ceremony of *Adventus*," *Historia*, 21 (1972), 721–52,
O. Nussbaum, "Geleit," *RAC*, fascs. 70–71 (1975), cols. 908–1049, esp. 1024 ff.

[6] A. Grabar, *Martyrium: Recherche sur le culte de reliques et l'art chrétien antique*, II (Paris, 1946),
352; N. Gussone, "Adventus-Zeremoniell und Translation von Reliquien: Victricius von Rouen, De
laude sanctorum," *FrMSt*, 10 (1976), 130.

I.

The migration of holy bodies and bones into the metropolitan centers of the Christian Roman Empire began in the fourth century and continued at a steady pace through the fifth and sixth centuries.[7] From the numerous accounts of translations which survive in chronicles, ecclesiastical histories, saints' lives, and panegyrics, we have assembled a mosaic image of the ceremonial around which the *adventus* of relics was customarily organized. In assembling this composite image we have occasionally drawn on descriptions of imperial and ecclesiastical *adventus* ceremonies, since both follow a pattern similar to that of relics.[8] We have also found it illuminating to adduce examples of sculpture and medieval miniature painting which suggest how various aspects of *adventus* ceremonial might be visualized.

The arrival of relics constituted a major community event which required the mobilization and participation of the populace.[9] According to Sozomen, the procession accompanying the coffin of St. Babylas into Antioch in 362 included all of the city's Christians, both men and women, the young and old, virgins and children.[10] Similarly, Victricius of Rouen describes how the arrival of relics in his city in 396 called forth citizens of all ages and classes, including priests, deacons, children, monks, virgins, and widows.[11] Such mobilizations responded to the hope that the arriving relics would benefit and protect the entire *polis*,[12] a theory which also accounts for the inclusion of relic arrivals in the consular chronicles of Constantinople along with other events which affected the entire community, like earthquakes, dedications of churches and cisterns, and imperial arrivals and anniversary celebrations.[13]

The first and most prominent phase of the ceremonial was the *synantesis* (also *hypantesis* or *apantesis*),[14] the joyous and tumultuous meeting of arriving relics (or emperor, imperial portrait, or bishop) and receiving populace. The

[7] H. Delehaye, *Les origines du culte des martyrs*, SubsHag, 20 (Brussels, 1933), 50 ff.

[8] Peterson, *op. cit.*, 693; Kantorowicz, *op. cit.*, 212 note 28; MacCormack, *op. cit.*, 746 ff.

[9] In the words of Delehaye (*op. cit.*, 55): "On déployait, pour les recevoir, une pompe vraiment royale, et la ville entière se mettait en mouvement."

[10] *Ecclesiastical History*, V.19, ed. J. Bidez and G. C. Hansen, GCS, 50 (Berlin, 1960), 226.

[11] *De laude sanctorum*, 2–3 and *passim*, ed. R. Herval, *Origines chrétiennes de la IIᵉ Lyonnaise gallo-romaine à la Normandie ducale (IVᵉ–XIᵉ siècles)* (Rouen-Paris, 1966), 112 ff. For another especially colorful example, see John Chrysostom, *De S. hieromartyre Phoca*, 1, PG, 50, cols. 699–700.

[12] E.g., John Chrysostom, *Laudatio martyrum Aegyptiorum*, 1, PG, 50, col. 694 f., claims that the relics of martyrs protect a city much more effectively than "walls, trenches, weapons, and hosts of soldiers" not only against human enemies but against unseen demons, the devil, and the Lord Himself, for "when He rages on account of our sin, these bodies may be set forth to shield us and will quickly make Him merciful toward the city." See also the Syriac *vita* of St. Symeon Stylites quoted *infra*, note 91.

[13] See the *Consularia constantinopolitana*, 356, 357, and *passim*, printed with parallels from the *Chronicon paschale*, in MGH, *AA*, IX (Berlin, 1892), 238–45. On the so-called *Konsultafelannalen* of Constantinople, cf. A. Freund, *Beiträge zur antiochenischen und zur konstantinopolitanischen Stadt-chronik* (Jena, 1882), 34 ff.; and esp. O. Holder-Egger, "Die Chronik des Marcellinus Comes und die oströmische Fasten," *NA*, 2 (1877), 82 ff., who observes that they included relic translations as "lokal städtische Ereignisse."

[14] Cf. Peterson, *op. cit.*, 693, on variant technical terms.

doors of the city would open, the citizens would emerge, and with various gestures and symbols of honor and victory they would greet the arrival.[15] Prominent among their symbolic props would be censers, lamps or candles, and palm branches or crosses, and their gestures of honor and greeting would customarily include psalms, hymns, and acclamations.[16] The *Vita* of Symeon Stylites the Elder provides an especially vivid example. When his body arrived in Antioch in 459,

> ... the entire city went out to greet (εἰς συνάντησιν) the incredible sight, everyone clad in white, with candles, lamps, and hymns, all shouting and saying: Our shepherd has come bringing to us a heavenly treasure which is beyond price. Make open the gates of the city, while men rejoice and the earth is made glad, and as we who are sinners give glory to God, saying: "Holy, Holy, Holy art Thou, O Lord."[17]

To our knowledge, no images survive from the preiconoclastic period which compare precisely with such textual accounts. Forty years ago Hans Lietzmann published a single papyrus leaf from a lost world chronicle of the fourth or fifth century (fig. 2).[18] On it is described and illustrated the translation of relics of SS. Andrew and Luke to Constantinople in 336. It is, however, a text-column illustration of the simplest variety,[19] which shows only a schematic *adventus*. Two men with relics in their hands approach the city walls and gate of Constantinople which, due to artistic economy, must suffice to evoke the receiving *polis*.[20]

A closer visual approximation of the *synantesis* phase of a relic *adventus* may be gained from iconographically related monuments. The arch of Galerius in Salonica, for example, offers an unusually detailed representation of the *synantesis* phase of an imperial *adventus* (fig. 3).[21] Seated in the imperial wagon, Ga-

[15] Proclus of Constantinople suggests a lively scenario for an imperial *synantesis* in a sermon: *In ramos palmarum*, PG, 65, cols. 772ff. Cf. also Peterson, *op. cit.*, 693; and MacCormack, *op. cit.*, 723, 748.

[16] See Victricius, *De laude sanctorum*, 3, ed. Herval, 114; Antonius, *Vita Simeonis*, 31–32, ed. H. Lietzmann, *TU*, 32,4 (1908), 72–76; *History of the Patriarchs of the Coptic Church of Alexandria*, I.14, ed. B. Evetts, PO, 1 (Paris, 1907), 506; Theophanes, *Chronographia*, A.M. 6119, ed. C. de Boor, I (Leipzig, 1883), 328 lines 2–6; and the Menologium of Basil, II.142, PG, 117, col. 284, for representative examples.

[17] Antonius, *Vita Simeonis*, 32, ed. Lietzmann, 76.

[18] "Ein Blatt aus einer antiken Weltchronik," *Quantulacumque: Studies Presented to Kirsopp Lake by Pupils, Colleagues and Friends* (London, 1937), 339ff. (with illustration).

[19] K. Weitzmann, *Illustrations in Roll and Codex: A Study of the Origin and Method of Text Illustration*, Studies in Manuscript Illumination, II, 2nd ed. (Princeton, 1970), 75.

[20] A similar economic mode of presentation characterizes the imperial *adventus* in numismatic art, e.g., in the Arras medallion of Constantius I and the nine-solidus piece of Constantine I in Paris; cf. J. M. C. Toynbee, *Roman Medallions*, American Numismatic Society: Numismatic Studies, V (New York, 1944), pls. 8.4, 17.11, p. 106ff.

We omit from this discussion an enigmatic late antique bas relief in the Musée des Antiquités Nationales de Saint-Germain-en-Laye (no. 79971), linked by R. Lantier to the Trier ivory; for a summary of Lantier's discussion, see, most recently, A. Pelletier, *Vienne gallo-romaine au bas-empire: 275–468 après J.-C.* (Lyons, 1974), 153f., fig. 29.

[21] H. P. Laubscher, *Der Reliefschmuck der Galeriusbogens in Thessaloniki*, Archäologische Forschungen, I (Berlin, 1975), 61ff., pls. 45–50.

lerius approaches with his cavalcade from the left. At the right are the walls of a city, out of which pour first the citizens with torches and flowers, then the soldiers with their standards. A more familiar *adventus* is that of Christ into Jerusalem on Palm Sunday.[22] The version of the sixth-century Rossano Gospels (fig. 4),[23] for example, shows Christ atop a donkey approaching from the left. At the far right are the city walls and open gate of Jerusalem, out of which has come the local citizenry—most holding palm branches, although a few are bowing to drape their garments before the path of Christ. Especially evocative of the spirit and makeup of the crowd is the small group of children in short tunics; some have just emerged from the city and appear to be fighting over a palm branch, while others are leaning out open windows above the gate, acknowledging Christ's triumphant arrival by thrusting forward small palm fronds. One can easily imagine their acclamation (John 12:13): "Hosanna: Blessed is the King of Israel that cometh in the name of the Lord."

Relic *adventus* descriptions are much less explicit and detailed in treating subsequent phases of the arrival ceremonial; the Symeon *Vita*, for example, notes only that "they carried him into the church, that named for Casianos."[24] Nevertheless, at least two distinct phases may be identified after the *synantesis*. The first is the procession or *propompe* which, perhaps through a combination of spontaneity and design, formed around the relics and accompanied them into the city. Scattered throughout the textual accounts are numerous references to such processions and to honorary escorts or *propempontes*. The Empress Eudoxia, for example, escorted (προέπεμψε) relics through Constantinople and its suburbs during the middle of the night;[25] the remains of John Chrysostom were accompanied by the Patriarch Proclus to the church of the Holy Apostles;[26] Ursus, the prefect of Constantinople, acted as escort (Οὔρσου προπέμποντος) for the bones of Joseph and Zacharias, and with him walked the entire senate;[27] while in the case of Ignatius, patriarch of Antioch, it is noted only that his remains were "conveyed...through the city, attended by a solemn procession."[28] Like the *synantesis*, this phase would be marked by acclamations, psalms, lights, and censers, although the tone of the translation would seem to be more solemn, organized, and exclusive. A few high-ranking figures step forward to act as escorts, while the relics themselves are likely given a position of greater prominence and honor. The remains of Ignatius, John the Baptist, Joseph and Zacharias, Symeon the Stylite, and the Forty

[22] E. Dinkler, *Der Einzug in Jerusalem: Ikonographische Untersuchungen in Anschluss an ein bisher unbekanntes Sarkophagfragment*, Arbeitsgemeinschaft für Forschung des Landes Nordrhein-Westfalen: Geisteswissenschaften, 167 (Opladen, 1970), esp. 42ff.

[23] A. Muñoz, *Il codice purpureo di Rossano e il frammento sinopense* (Rome, 1907), pl. II.

[24] Antonius, *Vita Simeonis, loc. cit.*

[25] John Chrysostom, *Homilia dicta postquam reliquiae martyrum, etc.*, PG, 63, cols. 467–72.

[26] Socrates, *Ecclesiastical History*, VII.45,3, ed. R. Hussey (Oxford, 1853), II, 834.

[27] *Chronicon paschale, a.* 415, Bonn ed. (1832), 572 f.; cf. MacCormack, *op. cit.*, 737 note 96, for senators of Rome escorting the chariot of an arriving emperor.

[28] Evagrius, *Ecclesiastical History*, I.16, ed. J. Bidez and L. Parmentier (London, 1898), 26.

Martyrs are described as being placed atop wagons, either civil or imperial,[29] and in at least two cases the reliquaries are under the personal protection of a pair of high ecclesiastics.[30]

No visual evocation of a relic *propompe* with which to compare the Trier ivory seems to have survived from the preiconoclastic period. Such scenes do, however, appear fairly frequently in Middle Byzantine manuscript illumination. For example, the fourth miniature marking January 22 in the famous Menologium of Basil II shows the procession of the remains of Anastasius of Persia to a church in the city of Caesarea (fig. 5).[31] The sarcophagus of the dead martyr is carried forward on the shoulders of two anonymous ecclesiastics, while leading the way as *propempontes* are four additional figures, two with candles and one with a censer. In the background are the encircling walls of Caesarea, while just before the advancing procession is the basilical church in which the body of Anastasius will soon be deposited. A composition basically similar to this one appears on folio 106v of the illustrated chronicle of John Scylitzes in Madrid, thought to date around the mid-twelfth century (fig. 6).[32] It represents the return to Constantinople of the remains of Emperor Michael III.[33] His bones are brought forward from the right in a gabled box supported by a plank resting on the shoulders of two young men. Acting as escorts are, from right to left, Patriarch Stephen I, Alexander, brother of Leo VI, and a tightly knit group of court singers. Their ultimate destination, at the far left of the miniature, is the church of the Holy Apostles.

The third and final phase of the relic *adventus* ceremonial, as it may be reconstructed from surviving textual accounts, is the *apothesis* (or *katathesis*), the "deposition" of the relics in a church. The first two recorded translations to Constantinople, that of Timothy in 356 and that of Andrew and Luke in 357, both end with the phrase: "... and [the relics] were deposited [ἀπετέθη] in the [church of the] Holy Apostles."[34] Victricius of Rouen notes that it is the *ecclesia civitatis* which welcomes the arriving relics; similarly, Samuel's remains were "deposited" in 406, those of Joseph and Zacharias in 415, those of Stephen in 421, those of Chrysostom in 438, and so on.[35] In each case the point of destina-

[29] *Ibid.*; Sozomen, *Ecclesiastical History*, VII.12,2, ed. Bidez and Hansen, 333; *Chronicon paschale*, *loc. cit.*; Antonius, *Vita Simeonis*, 31, ed. Lietzmann, 72; Theophanes, *Chronographia*, A.M. 6044, ed. de Boor, 228 lines 6–11.

[30] *Chronicon paschale*, *loc. cit.*; Theophanes, *loc. cit.*

[31] *Il Menologio di Basilio II*, Codices e vaticanis selecti, VIII (Turin, 1907), II, 344. On the date of this manuscript, see S. Der Nersessian, "Remarks on the Date of the Menologium and the Psalter Written for Basil II," *Byzantion*, 15 (1940–41), 104–25; and I. Ševčenko, "On Pantoleon the Painter," *JÖBG*, 21 (1972), 249.

[32] S. Cirac Estopañan, *Skyllitzes Matritensis*, I. *Reproducciones y Miniaturas* (Barcelona-Madrid, 1965), no. 250; for the date, see N. G. Wilson, "The Madrid Scylitzes," *Scrittura e civiltà*, 2 (1978), 209–19.

[33] For the text, see John Scylitzes, *Synopsis historiarum*, ed. J. Thurn, CFHB, V (1973), 172 lines 80–88.

[34] *Chronicon paschale*, aa. 356, 357, Bonn ed., 542. The earlier translation of Andrew and Luke (*supra*, p. 117 and note 18) had involved not the bodies of the saints but only their clothing.

[35] Victricius of Rouen, *De laude sanctorum*, 2, ed. Herval, 113; *Chronicon paschale*, aa. 406, 415, Bonn ed., 569, 573; Theophanes, *Chronographia*, A.M. 5920, ed. de Boor, 87 line 5 (using κατέθετο); Socrates, *Ecclesiastical History*, VII.45,3. ed. Hussey, II, 834.

tion is a church, and the common Greek term for deposition is *apothesis*. It has been suggested that this act was the single most universal and characteristic feature of the dedication of a church or altar in the East during the first centuries after the triumph of Christianity.[36]

Again, no representation of precisely this event survives in preiconoclastic art, nor, for that matter, in the art of the Middle or Late Byzantine periods. In the Menologium of Basil II texts describing the *apothesis* of relics are usually illustrated with the well-known *topos* of a dying martyr being buried by his faithful followers. For example, the miniature coupled with the text for October 18 commemorates the deposition of the relics of St. Luke in the nave of the Holy Apostles Church in 357 (fig. 7).[37] The *locus* is evoked by the enclosing city walls and by a five-domed church. Instead of showing the deposition of a reliquary below an altar, however, the illuminator has reverted to a well-known iconographic formula and has, quite inappropriately, shown the burial of the saint in a sarcophagus. Perhaps a more accurate image of the *apothesis* phase of a relic *adventus* is provided by a miniature found in a tenth-century manuscript on Mt. Athos (Vatopedi cod. 456, fol. 253ʳ), where it was apparently intended to illustrate a homily on the translation of the head of St. Abibos (fig. 8).[38] Here we see a procession made up of three clerics, one with censer and pyxis, and a civil official dressed in a chlamys. In the right background is a small basilical church. Apparently the group has reached its destination, since, with the exception of the figure at the far right, all of its members have stopped. That figure, however, advances briskly, thrusting forward a small reliquary box in his outstretched hands. The church, presumably that of the Abibos monastery, has been positioned so as to "receive" the offered shrine—conceptually if not physically.

This is the relic *adventus* ceremonial insofar as we have been able to reconstruct it from texts and to evoke it visually through sculpture and medieval miniature painting. With this evidence in mind, we can now turn our attention to the ivory plaque in the Trier Cathedral treasury.

II.

It should be obvious at once that the moment portrayed on the ivory is not the *synantesis*, the joyous public meeting outside the city gate. This is clear not only from the mise-en-scène, which shows neither city walls nor open city

[36] D. Stiefenhofer, *Die Geschichte der Kirchenweihe vom 1.–7. Jahrhundert* (Munich, 1909), 94. Theodore Balsamon, *Responsa ad interrogationes Marci*, 38, PG, 138, col. 989, gives *apothesis* of relics as the last step in the liturgy for dedicating a church, after the ἀνοίξια, the ἐνθρονισμός, and the χρίσμα ἁγίου μύρου. See also H. Emonds, "Enkainia," in *Gesammelte Arbeiten zum 800 jährigen Weihegedächtnis der Abteikirche Maria Laach am 24. August 1956*, ed. H. Emonds (Düsseldorf, 1956), 40f.

[37] *Il Menologio*, II, 121.

[38] K. Weitzmann, *Die byzantinische Buchmalerei des 9. und 10. Jahrhunderts* (Berlin, 1935), 20f., pl. xxv, no. 140. For the identification of the iconography, see *idem*, "The Mandylion and Constantine Porphyrogennetos," *CahArch*, 11 (1960), 139f. (repr. *idem*, *Studies in Classical and Byzantine Manuscript Illumination*, ed. H. Kessler [Chicago-London, 1971], 240f.).

gate, but also from the makeup and demeanor of the crowd, which shows neither the variety nor the spontaneity characteristic of textual accounts or visual representations of *synantesis*. Rather, the phase of the *adventus* ceremonial evoked by the Trier ivory is the *propompe*, the ritualized escorting of the holy treasure into and through the city after its public, extramural epiphany. Concealed in a small, gabled box, the relics have been placed atop an imposing, decorated wagon, perhaps an imperial wagon, drawn by a pair of stocky mules (fig. 1).[39] They have been assigned to the personal care of two bishops wearing dalmatic and *omophorion*, and are being escorted toward the church of the *apothesis* by four *chlamydati*, each carrying a candle. The first of these, and leader of the entire cortège, is an emperor.[40]

The elements of the ivory thus far described are fully consistent with the *adventus* typology constructed earlier from textual and visual sources. This iconographic "core" essentially matches that of the translation of Anastasius of Persia in the Menologium of Basil II (fig. 5), with the important distinction that on the Trier ivory the translation is conducted with the participation of the emperor and two important church figures. In this respect, the Trier *adventus* corresponds more closely to that of the bones of Michael III in the Scylitzes Chronicle (fig. 6). Conducted under imperial and patriarchal patronage, the latter includes among the *propempontes* both the Emperor Alexander and the Patriarch Stephen.

To this core of canonical *adventus* typology the Trier ivory carver, or the creator of his model, has added a number of elements which reveal the unusual character of this specific *adventus*. One of these elements is the structure toward

[39] The textual accounts cited *supra*, note 29, suggest that relics were customarily placed atop civil or imperial wagons drawn by mules. Several scholars (e.g., Delbrueck, *Die Consulardiptychen*, 266) have offered Christian interpretations for the three togate figures decorating the side of the Trier wagon or have attempted to link them symbolically with the saint being translated. It seems to us more probable that they were added in order to evoke the idea of imperial *Prachtwagen*. Folio 172[v] of the illustrated Scylitzes chronicle (cf. Cirac Estopañan, *op. cit.*, no. 450) shows the *adventus* of a revered icon on an imperial wagon decked in purple cloth. Proclus, *In ramos palmarum*, 1, PG, 65, col. 773, evokes an imperial *adventus* featuring ἅρματα χρυσοκόλλητα pulled by mules.

[40] This figure wears the normal "service costume" of Early Byzantine emperors, with, as its principle insignia, the diadem and chlamys, the full-length cloak secured on the right shoulder with an elaborate jeweled fibula; see Delbrueck, *Die Consulardiptychen*, 36 ff.; P. Grierson, *Catalogue of the Byzantine Coins in the Dumbarton Oaks Collection and in the Whittemore Collection*, II,1 (Washington, D.C., 1966), 76 ff., 80 ff., citing more recent literature; and P. Váczy, "Helm und Diadem (Numismatische Beiträge zur Entstehung der byzantinischen Kaiserkrone)," *ActaAntHung*, 20 (1972), 169-208. In our view insignia provide no evidence for precise dating of the piece; contrast, however, Delbrueck, *op. cit.*, 268 f., and Spain, "Translation Ivory," 283 ff. The diadem is of a unique type, consisting of a plain band with a series of half-circles projecting below it and crude "pendilia" suspended from it above the ears. Spain (p. 283) discerns "five short, scallop-like projections" above the band, but we see only locks of hair (fig. 1; cf. Delbrueck's description, p. 266). We would be most comfortable with a date for the diadem between the early fifth and late sixth centuries. Pendilia first appear in a dated monument on the Probus diptych of 406 (Volbach, *Elfenbeinarbeiten*, no. 1, pl. 1). On the other hand, the diadem of the Trier ivory emperor lacks not only the normal front jewel but also the striking cruciform ornament which rises from it regularly on examples from coin portraits beginning 578. Spain (pp. 284 f.), following N. M. Běljaev, "Očerki po vizantijskoj arheologii, I. Fibula v' Vizantii," *SemKond*, 3 (1929), 96, 114 (German summary), finds parallels for the emperor's fibula on coins of the seventh century, but the fibulae of the Trier ivory (including those of the other figures) are too crudely made to permit any conclusions. In addition, Spain's examples of seventh-century "two pendant fibulae" (which she attempts to compare with the emperor's fibula on the Trier ivory) would all show three pendants if one were not concealed behind a beard or a neighboring figure.

which the relics are being conveyed, a small basilical church with projecting apse (fig. 1). The four workmen clambering about on its roof[41] leave little doubt that this structure is just now being completed, specifically to enshrine the arriving treasure.[42]

Just before the open west door of the church is a woman who, to judge from her costume, must be an empress.[43] Though the mules still draw the wagon vigorously to the right toward this person, the head of the procession has already reached its destination. The emperor and other *propempontes* direct posture and gaze at the empress, who stands slightly in the foreground, her right hand extended to receive the relics. By virtue of both her gesture and her position before the church, and because (despite her relatively small size[44]) she alone is the focus of movement and attention, we believe that she must be recognized as the prime instigator or patron of this relic translation, and, by extension, as the founder (*ktistes*) of the church.[45]

The Menologium of Basil II again provides an instructive visual and thematic parallel, this time in the miniature marking January 27 and the return to Constantinople in 438 of the remains of John Chrysostom (fig. 9).[46] The core elements are much like those of the Anastasius translation: the sarcophagus is carried in from the left, preceded by a group of ecclesiastical *propempontes* with candles; in the background is the five-domed church of the Holy Apostles in which the *apothesis* soon will take place. This time, however, the relics are first to be received by the two instigators of the translation: the Patriarch Proclus, with *omophorion*, book, and censer, and the Emperor Theodosius II. According to Socrates, Proclus persuaded Theodosius to repatriate the bones of Chrysostom thirty-five years after his exile, and personally acted as escort during the procession to the church of the Holy Apostles.[47] Theodoret notes that Theodosius brought the treasure into the city; "laying his eyes and forehead upon the coffin, he uttered supplications for his parents, pleading that

[41] A fifth workman peers out of the open west portal of the church, while several additional heads are suggested in its hollowed interior.

[42] Both the large west portal and a small door in the center of the south side-aisle are conspicuously open. One is reminded of the text of Theodore Balsamon (note 36 *supra*) and of the ἀνοίξια which preceded the *apothesis* in the liturgy of church dedication.

[43] This figure wears the normal "service costume" of Early Byzantine empresses, including the same principle insignia (diadem, chlamys with jeweled fibula) as its masculine counterpart (note 40 *supra*). The marriage solidus of Valentinian III and Licinia Eudoxia, struck in 437 in Constantinople (see E. Kantorowicz, "On the Golden Marriage Belt and the Marriage Rings of the Dumbarton Oaks Collection, *DOP*, 14 [1960], 7, figs. 21, 22), provides a *terminus a quo* of sorts, because the costume of the Trier ivory empress shows the same enrichment of the female chlamys with a pearl border and a similar elaborate headdress with long pendilia. Even closer parallels for her costume and insignia exist in a number of ivories and full plastic empress heads most often dated *ca.* 470–550; cf. Volbach, *Elfenbeinarbeiten*, nos. 51–52, p. 27 (the "Ariadne" ivories in Florence and Vienna); and (most recently) S. Sande, "Zur Porträtplastik des sechsten nachchristlichen Jahrhunderts," *ActaIRNorv*, 6 (1975), 67 ff., pls. 9–14 (empress heads in the Lateran and Palazzo dei Conservatori, Rome, and in the Louvre), 93 ff., pls. 46–48 (the "Theodora" head in Milan).

[44] Determined, at least in part, by the miniature scale of the church to which she is linked both compositionally and iconographically. Were she any taller she would block the open west portal, an element integral to the ceremonial of translation and deposition.

[45] This reading of the piece was anticipated by E. Dyggve, *History of Salonitan Christianity* (Oslo, 1951), 60 f. [46] *Il Menologio*, II, 353.

[47] *Ecclesiastical History*, VII.45, ed. Hussey, II, 833 f.

they be forgiven for the wrongs they had committed out of ignorance."[48] The similarity between the iconography of this miniature and that of the Trier ivory is obvious. In the ivory, however, the empress acts alone as the receiving party, and her gesture is not one of supplication or humility, but rather of open hospitality, as if she were about to meet a friend at the threshold of her dwelling and welcome him in.[49]

In her left arm the empress cradles a large, simply-fashioned cross, consisting of a long vertical member and a short crosspiece, both squared. Within the framework of *adventus* typology this object should be recognized not as an attribute of rank or sainthood,[50] but as an attribute of the meeting itself. It is the Christianized descendant, both morphologically and symbolically, of the *vexilla* offered by the receiving soldiers on the arch of Galerius (fig. 3), of the ubiquitous palm fronds offered to Christ at the gates of Jerusalem (fig. 4), and, to adduce an example from further afield, of the *vexilla* carried by the personified *natio* or province which receives the emperor on *adventus* coins of Hadrian.[51] According to Victricius of Rouen, the arrival of relics in his city in 396 was greeted by a choir of pious virgins, each bearing the sign of the cross.[52] Similarly, when Bishop Porphyry returned to Gaza in 402, the Christians of the city came forth to meet him and his party (ὑπήντησαν) "carrying the sign of the precious cross...and singing hymns."[53] The cross cradled in the left arm of the Trier empress, like the gesture of her right hand, at once identifies her as the receiving party and characterizes the *adventus* as a triumphant event, partaking in the ultimate victory of Christ on Golgotha.[54]

[48] *Ecclesiastical History*, V.36,2, ed. L. Parmentier, rev. ed. F. Scheidweiler (Berlin, 1954), 338. In contrast with the apposite miniature, the text of the Menologium (II.140, PG, 117, col. 284) reports only that "the revered relics arrived and were placed with honor in the Church of the Holy Apostles."

[49] Contrast also the Empress Eudoxia, who escorted relics of unknown martyrs *ca.* 400 (p. 118 *supra*), attending the saints "like a handmaiden" (θεραπαινίς), admirable in "the contrition of her spirit and her humility": John Chrysostom, *Homilia dicta postquam reliquiae martyrum, etc.*, 1–2, PG, 63, col. 469f. G. Dagron, *Naissance d'une capitale* (Paris, 1974), 102, identifies the "caractère plus ou moins penitentiel" of such events.

[50] E. Schäfer, "Die Heiligen mit dem Kreuz in der altchristlichen Kunst," *RQ*, 44 (1936), 73 note 39; and Spain, "Translation Ivory," 285, assume that it is an attribute of rank, although Schäfer admits disquiet: "...obwohl es in seiner Form von dem üblichen Kreuzszepter abweicht und die Gestalt des Triumfkreuzes aufweist" (cf. note 54 *infra*). Strzygowwski, *op. cit.* (note 3 *supra*), 87f., identifies the female figure as the martyr St. Irene, presumably implying that the cross is an attribute of sanctity.

[51] H. Mattingly and E. A. Sydenham, *The Roman Imperial Coinage*, II, *Vespasian to Hadrian* (London, 1926), 451 no. 875, 453 no. 883, 455–56 nos. 897–900, 904; Kantorowicz, "The 'King's Advent'" (note 5 *supra*), 213. Contrast J. M. C. Toynbee, *The Hadrianic School* (Cambridge, 1934), 34, 69, 124ff., who interprets the *vexillum* on these coins as an attribute not of the *adventus* but of the personified province.

[52] *De laude sanctorum*, 3, ed. Herval, 114f.

[53] Mark the Deacon, *Vita Porphyrii*, 58, ed. H. Grégoire and M.-A. Kugener (Paris, 1930), 47. Cf. *Liber pontificalis*, CIV. 9–10, ed. L. Duchesne (Paris, 1886–1957), II, 88, for crosses honoring the advent of a secular ruler, *id est signa, sicut mos est imperatorem aut regem suscipere.*

[54] See Schäfer, *op. cit.*, 101. In size, shape, and the manner in which it is held, the Trier ivory cross is closest to that carried by St. Peter in a fifth-century marble fragment now in East Berlin (no. 3234); cf. K. Wessel, "Ein kleinasiatisches Fragment einer Brüstungsplatte," *Staatliche Museen zu Berlin: Forschungen und Berichte*, 1 (1957), 77–81. There it serves not as an attribute of St. Peter and his martyrdom, but rather as a symbol of the victory of Christ on Golgotha, manifest in the miracle scene to which Peter serves as witness (see Schäfer, *op. cit.*, 81; and E. Kitzinger, "A Marble Relief of the Theodosian Period," *DOP*, 14 [1960], 40f., cf. p. 37, where Kitzinger interprets the cross held by St. Paul in a closely related relief at Dumbarton Oaks).

124

Of equal importance with church and empress for determining the specific historical context of this relic procession is the dense curtain of figures and architectural motifs lining its route. Clearly, this is not a random cityscape, nor is it a heterogeneous group of citizens, each spontaneously expressing his greeting for the arriving cortège. Rather, it is a single piece of impressive architecture—a three-story arcade—inhabited by an orderly, disciplined group of men.[55] In marked contrast to the normal typology of relic *adventus* there are here neither women, children, nor old people; there is variety neither in rank nor in behavior. The nine men lining the second story seem to have been charged with the sole responsibility of censing the procession, and, to judge from their peculiar gestures, of singing its acclamations.[56] The nine respond as one, as if well rehearsed or guided by some unseen director. Above and below them are more than two dozen nearly identical male busts. Strangely, these figures look neither toward the relics nor toward the church. Rather, like rows of wooden duckpins, they stare rigidly and mutely ahead.

The discipline and order of this group and its setting could hardly stand in greater contrast to the confused spontaneity evoked by an *adventus* miniature from the famous Ashburnham Pentateuch (fig. 10),[57] which portrays Joseph's triumphant procession through the streets of Egypt after his promotion by Pharaoh to viceroy. He advances from the left in a large wagon preceded by two heralds. At the right is a jumble of roofs and windows in which appears a variety of Egyptians, some looking on passively and others falling to their knees to honor the arriving viceroy. That the artist responsible for the Trier ivory was capable of such liveliness is clear from his treatment of the workmen on the roof of the church. That he chose to avoid it in the background of the piece suggests that the staging of this particular translation was special, both in terms of location and in terms of the choice and behavior of its participants.

Indeed, the compositional relationship of the procession to its background suggests that the advancing wagon has just passed through a gate into a special precinct. An instructive comparison, both visually and thematically, is provided by a fragmented sarcophagus lid in Stockholm which was produced in Rome toward the end of the third century (fig. 11).[58] It shows the triumphal procession of a deceased magistrate with an unidentified companian. Although most investigators have interpreted this procession as a symbolic "last ride" into the hereafter, Winfried Weber has recently suggested that the Stockholm piece and the more than two dozen contemporary sarcophagus lids and *loculus* plaques related to it present an allegory of the deceased's lifespan, his *cursus*

[55] It consists of an arcade resting on piers which is surmounted by a colonnaded window level, and above that a terrace roof backed by a shallow arcade.

[56] A. Hermann, "Mit der Hand singen: Ein Beitrag zur Erklärung der trierer Elfenbeintafel," *JbAChr*, 1 (1958), 105–8.

[57] O. von Gebhardt, *The Miniatures of the Ashburnham Pentateuch* (London, 1883), fol. 40ʳ.

[58] J. Wilpert, *I sarcofagi cristiani antichi*, I (Rome, 1929), pl. 24.1. For its dating and pagan interpretation, see N. Himmelmann, *Typologische Untersuchungen an römischen Sarkophagreliefs des 3. und 4. Jahrhunderts n. Chr.* (Mainz, 1973), 31 ff., pl. 50.

vitae.[59] The wagon with its contingent of escorts has just passed through a triumphal arch marked with trophies and a heroic rider and is being welcomed—either into the realm of the hereafter or onto "life's way"—by an old woman waving a garment out of her window. The wagon's ultimate destination, as may be deduced from the related reliefs, is the deceased's mausoleum—an obvious counterpart to the church on the Trier ivory. The compositional and iconographic similarities between the Trier and Stockholm processions suggest that the two-story *tetrapylon* structure at the far left of the Trier relief is also a gate,[60] and that the relics have just passed through it into a significant area. This impression is fully consistent with the three-dimensional effect of the piece itself,[61] which creates a strong sense of movement from left to right, as though the wagon were sweeping through the gate, along the arcade, and toward the empress and the church.

It is now worth recalling that over the years many scholars[62] have recognized in the Trier *tetrapylon* the famous Chalke gate, the main entrance to the imperial palace in Constantinople over whose great bronze portals was set, at least as early as the seventh century, a revered icon of Christ.[63] Such an interpretation harmonizes perfectly with the compositional dynamics of the piece, and with its pervasively imperial, courtly iconography. Indeed, it would be hard to believe that this imposing portal with its prominent bust portrait of Christ and its proximity to emperor and empress was not intended to evoke the famous Chalke, and that it did not have that meaning for an Early Byzantine viewer.

If the relics are passing through the Chalke gate, then the significant area must be either within or outside the palace complex. A number of scholars have recognized the three-story arcade on the relief as generally representative of palace architecture,[64] as a palace façade or as the arcade surrounding an interior court ("salone ipetrale"); others might prefer a structure on the *mese*,[65] the main thoroughfare of Constantinople which was flanked by two-story porticoes and which abutted on the Chalke.[66]

[59] W. Weber, *Die Darstellungen einer Wagenfahrt auf römischen Sarkophagdekeln und Loculusplatten des 3. und 4. Jahrhunderts n. Chr.*, Archaeologica, 5 (Rome, 1978), no. 16 and *passim*. The striking relationship between the Trier and Stockholm reliefs is noted in a review of Ms. Weber's book by J. Carder, forthcoming in *Archaeological News*.

[60] The Trier structure recedes diagonally toward the left. It consists of four columns resting on a high plinth, above which is set a narrow, four-column attic topped by a very low gabled roof.

[61] This effect is especially clear in a diagonal photograph published by Delbrueck, *Die Consulardiptychen*, 263, fig. 3.

[62] E.g., O. Wulff, *Die altchristliche Kunst*, I (Berlin-Neubabelsberg, 1913), 195; E. Dyggve, *Ravennatum palatium sacrum*, Det Kgl. Danske Videnskabernes Selskab. Archaeologisk-kunsthistoriske Meddelelser, III,2 (Copenhagen, 1941), 13; Pelekanidis, *op. cit.* (note 3 *supra*), 371; V. Grumel, "A propos de la plaque d'ivoire du trésor de Trèves," *REB*, 12 (1954), 189; Fischer, *op. cit.* (note 1 *supra*), 11f.; Volbach, *Elfenbeinarbeiten*, 96. Cf. most recently P. Speck, *Kaiser Konstantin VI. Die Legitimation einer fremden und der Versuch einer eigenen Herrschaft* (Munich, 1978), I, 606ff. note 90.

[63] C. Mango, *The Brazen House*, Det Kgl. Danske Videnskabernes Selskab. Arkaeologisk-kunsthistoriske Meddelelser, IV,4 (Copenhagen, 1959), esp. 108ff. Mango (p. 104) refrains from using the Trier ivory as evidence for the Chalke because of controversy over its "origin, date and subject-matter."

[64] E.g., Strzygowski, *op. cit.* (note 3 *supra*), 86; Dyggve, *Ravennatum palatium sacrum*, 13f.; Pelekanidis, *op. cit.*, 371; Grumel, *op. cit.*, 189; Fischer, *op. cit.*, 11.

[65] Delbrueck reacts against this opinion: *Die Consulardiptychen*, 267.

[66] R. Guilland, *Etudes de topographie de Constantinople byzantine* (Berlin-Amsterdam, 1969), II, 69ff.

Although we know of no description of a relic procession through this gate, Corippus does provide an account of Justinian's funeral cortège which passed through the Chalke, along the *mese*, and toward the church of the Holy Apostles:[67]

> Without further delay he [Justin] ordered the bier to be lifted with his imperial nod, and the people left the whole palace, and the sad procession lit the funeral candles. Every sex and age met for the exsequies. Who can enumerate the wonders of so great a procession? On one side a venerable line of singing deacons, on the other a choir of virgins sang: their voices reached the sky. Tears flowed like snow: the clothes of everyone were wet with the rain, and their streaming eyes swam in their own moisture and watered their faces and breasts. Mothers walked with their hair loosened in grief; some were in front of the doors, others in the higher parts of the building filling the tall windows with their crowded numbers: like the gathering of birds massed together on the banks of the Hyperborean Hister, forced by the harshness of winter to leave the icy lands. . . . many burned pious incense for his passing. From all sides the sad people came running in their anxiety to look.

Especially striking in this account is the "venerable line of singing deacons" and the image of spectators filling doorways and windows. It would be a mistake, however, to conclude from such parallels between ivory and text that the Trier *propompe* must be leaving the palace. The "singing deacons" or their equivalent were part of court ceremonial and would be as appropriate inside as outside the palace.[68] Similarly, the idea of crowded doors and windows is a *topos* applicable to any procession. On the other hand, the selectivity and discipline evident in the background of the Trier ivory stand in marked contrast to the confused, popular demonstration evoked by the Corippus description, and accordingly speak for a location inside the palace for both procession and church.

III.

Isolation of iconographical elements which do not reflect the general typology of the late antique relic *adventus* is the key to the interpretation of our ivory. These elements make it clear that despite the commonplaces (*propompe* with imperial participation, wagon with two bishops, use of incense, lights, and song, dedication of a church) the event portrayed is not ideal but historical.

[67] *In laudem Iustini*, III.36–56, ed. and trans. Averil Cameron (London, 1976), 61 f., 103.

[68] In his sermon *In ramos palmarum*, 1, PG, 65, col. 773, Proclus imagines an imperial *adventus* scenario in which "they organize choruses in various places to chant praises" (χορούς ἐγκωμίων κατὰ τόπους συνυφαίνουσιν). Pacatus, *Panegyricus Theodosio Augusto dictus*, 37.3, ed. E. Galletier, III (Paris, 1955) 103f., describes similar "choruses" which greeted Theodosius in Emona in 388 with antiphonal songs on the triumph of Theodosius and the defeat of the usurper Maximus. Alan Cameron, *Circus Factions* (Oxford, 1976), 246, suggests that these were "choirs of professional singers."

Moreover, the atypical elements (entry into a significant area, court atmosphere, especial emphasis on an empress as recipient and *ktistes*) are unusual and specific enough to indicate that there can have been few events which might invite our attention as possibilities. Happily, one relic *adventus* is known from literary sources which corresponds so closely with the iconography of the Trier ivory that it has a strong claim to be the event portrayed.

The main text is a passage of Theophanes Confessor (ninth century) which records a sequence of events in the reign of Theodosius II (d. 450) and of his sister Pulcheria Augusta:

> Under the influence of the blessed Pulcheria, the pious Theodosius sent a rich donation to the archbishop of Jerusalem for distribution to the needy, and also a golden cross studded with precious stones to be erected on Golgotha. In exchange for these gifts, the archbishop dispatched relics of the right arm of Stephen Protomartyr, in the care of St. Passarion. When this man had reached Chalcedon, in that very night the blessed Pulcheria saw St. Stephen in a vision saying to her: "Behold, your prayer has been heard and your desire has come to pass, for I have arrived in Chalcedon." And she arose taking her brother with her and went to greet the holy relics. Receiving them into the palace, she founded a splendid chapel for the holy Protomartyr, and in it she deposited the holy relics.[69]

George Cedrenus (eleventh century)[70] and Nicephorus Callistus (fourteenth century)[71] relate the same sequence of events, the former copying Theophanes and the latter drawing upon the same chronicle tradition, but conflating it ineptly with legendary accounts of another translation of Stephen's remains to Constantinople,[72] and adding also nonsensical speculation on Pulcheria's motives in the transaction.[73]

[69] Theophanes, *Chronographia*, A.M. 5920, ed. de Boor, I, 86 line 26–87 line 5: Θεοδόσιος ὁ εὐσεβὴς κατὰ μίμησιν τῆς μακαρίας Πουλχερίας πολλὰ χρήματα τῷ ἀρχιεπισκόπῳ Ἱεροσολύμων ἀπέστειλεν εἰς διάδοσιν τῶν χρείαν ἐχόντων, καὶ σταυρὸν χρυσοῦν πρὸς τὸ παγῆναι ἐν τῷ ἁγίῳ κρανίῳ. ὁ δὲ ἀρχιεπίσκοπος ἀντίδωρον ἀποστέλλει λείψανα τῆς δεξιᾶς χειρὸς τοῦ πρωτομάρτυρος Στεφάνου διὰ τοῦ ἐν ἁγίοις Πασσαρίωνος. τούτου δὲ εἰς Χαλκηδόνα φθάσαντος, θεωρεῖ ἡ μακαρία Πουλχερία αὐτῇ τῇ νυκτὶ ἐν ὁράματι τὸν ἅγιον Στέφανον λέγοντα αὐτῇ· ἰδού, ἡ προσευχή σου εἰσηκούσθη, καὶ ἡ αἴτησίς σου γέγονεν, καὶ ἦλθον εἰς Χαλκηδόνα. ἡ δὲ ἀναστᾶσα καὶ τὸν ἀδελφὸν αὐτῆς λαβοῦσα ἐξῆλθεν εἰς συνάντησιν τῶν ἁγίων λειψάνων, καὶ ταῦτα εἰς τὸ παλάτιον λαβοῦσα κτίζει οἶκον ἔνδοξον τῷ ἁγίῳ πρωτομάρτυρι κἀκεῖ τὰ ἅγια κατέθετο λείψανα.

[70] *Historiarum compendium*, 337d–338a, Bonn ed. (1838), 592.

[71] *Ecclesiastical History*, XIV.9, PG, 146, col. 1084f.

[72] For the other translation, see MSS and editions cited in *BHG³*, nos. 1650–51; and cf. F. Winkelmann, *Die Kirchengeschichte des Nicephorus Callistus Xanthopulus und ihre Quellen*, TU, 98 (Berlin, 1966), 126. Legend dated it to the time of Constantine, a century before Stephen's relics first appeared (see note 73 *infra*), but its real perpetrator seems to have been Anicia Juliana, the distinguished great-granddaughter of Theodosius II (d. *ca.* 530); see C. Capizzi, "L'attività edilizia di Anicia Giuliana," *Collectanea byzantina* (=OCA, 204) (Rome, 1977), 134f.; following R. Janin, *La géographie ecclésiastique de l'Empire byzantin*, III,1, *Les églises et les monastères* (Paris, 1953), 490f.

[73] Pulcheria nourished an "unspeakable yearning" for Stephen because more relics reappeared "from where I know not" in Palestine in the year of her birth (399). For the actual date of the invention (415), see the nearly contemporary *inventio* narrative of Lucianus: S. Vanderlinden, "*Revelatio Sancti Stephani* (BHL 7850–6)," *REB*, 4 (1946), 178–217. We conclude that Nicephorus is without in-

Pulcheria's real motives are easy enough to disengage, once the translation and *adventus* of the Stephen relics are placed in the correct historical and ideological context. First, the *adventus* must be dated to the correct year, not 427 as in Theophanes and modern scholars following him, but almost certainly 421.[74]

In that year the court of Pulcheria and Theodosius II ordered an attack on Sassanian Persia, Rome's powerful antagonist to the east. The ostensible casus belli was persecution of Christians in the Persian Empire which had broken out in the previous year, but the more profound cause, as has recently been suggested,[75] lay in the inner logic of Roman absolutism. The Roman emperor, above all a "master of victory,"[76] had to win battles to secure his power, while military inertia or defeat threatened the independence of the ruler and even his personal safety. With an imperial woman the problem was compounded. Like other *augustae*, Pulcheria possessed no power of military command, and thus could not use it to establish her claims to independent authority.[77]

Since the death of Theodosius I in 395 the eastern branch of his house had experienced weakness. Ambitious politicians had overshadowed both his son Arcadius and his grandson Theodosius II, who was only seven when Arcadius died in 408. Neither son nor grandson had ever led troops into battle or shared the life of the camp, and thus neither could claim to be "master of victory" in the traditional sense. Although in the early years of Theodosius II there may have been at least one attempt to assassinate him,[78] for ambitious politicians violence was not the most comfortable route to a share in the imperial power. Three daughters of Arcadius also lived in the imperial palace: Arcadia (b. 400), Marina (b. 403), and his senior child Pulcheria (b. 399). As the daughters reached puberty men of imperial ambitions hoped for a most profitable marriage connection, one which would inevitably limit the independence of the Theodosian house.[79]

Thus, in 412 or early 413, just as she reached the age of marriage, Pulcheria dedicated herself to virginity and persuaded her sisters to do likewise. To ensure that no amount of coercion could reverse this decision, she called to witness "her brother's subjects, the priests of Constantinople, and God himself" as she dedicated an altar "for her own virginity and her brother's rule" in the Great Church of Constantinople.[80]

dependent value and that Theophanes is the only usable source (except for an important allusion in Proclus of Constantinople, quoted *infra*, pp. 131–32).

[74] K. Holum, "Pulcheria's Crusade A.D. 421–22 and the Ideology of Imperial Victory," *GRBS*, 18 (1977), 163 note 46.

[75] *Ibid.*, 153–72. Some conclusions of Holum's study will be adopted here to provide a historical and ideological context for the *adventus* of St. Stephen.

[76] J. Gagé, "Σταυρὸς νικοποιός: La victoire impérial dans l'empire chrétien," *Revue d'histoire et de philosophie religieuses*, 13 (1933), 370–400, esp. 372; O. Treitinger, *Die oströmische Kaiser- und Reichsidee* (Jena, 1938), 168ff.; A. Grabar, *L'empereur dans l'art byzantin* (Paris, 1936), 31ff.

[77] Cf. S. Maslev, "Die staatsrechtliche Stellung der byzantinischen Kaiserinnen," *Byzantinoslavica*, 27 (1966), 308–43.

[78] The attack of Lucius, known from Damascius, *Vita Isidori*, frag. 303, ed. C. Zintzen (Hildesheim, 1967), 241; cf. A. Demandt, "Magister Militum," *RE*, suppl. 12 (1970), col. 747.

[79] Sozomen, *Ecclesiastical History*, IX.1,3, ed. Hansen, 390; and Holum, *op. cit.*, 158ff.

[80] Sozomen, *Ecclesiastical History*, IX.1,4, ed. Hansen, 390.

It might be argued that this event as much as any other accounts for Pul-
cheria's own power and for the long and prosperous reign of Theodosius II. It
ruined the hopes of the politicians, of course, but it was also an imperial act of
first magnitude which moved the entire edifice of the Roman *basileia* decisively
in new directions. The imperial palace, we are told, took on the atmosphere of
a cloister. The imperial family fasted, learned and recited Scripture, and gather-
ed to sing antiphons at canonical hours. Pulcheria and her sisters gave up the
female vanities of cosmetics, fine clothing, and luxurious idleness to spend
their time at the loom, in household pursuits worthy of "admirable" women,
and especially on works of charity—founding oratories, homes for the poor
and vagabond, and monasteries, and supporting the inmates generously from
their personal incomes.[81] Bishop Atticus of Constantinople responded to this
asceticism with a treatise addressed to the imperial sisters, "On Faith and
Virginity," in which he apparently recommended Mary as a model for their
virgin life.[82]

Undoubtedly, the vows of Pulcheria and her sisters and their consequent
lifestyle renewed the prestige of the dynasty among the increasingly Chris-
tianized aristocracy of Constantinople, but in the view of contemporaries they
also served a more potent function—conciliation of the emperor's divine pro-
tector. According to Sozomen, whose *Ecclesiastical History* provides much of
our image of life in the Theodosian court, it was the vow of Pulcheria and her
pious life which secured God's favor for Theodosius, through which in turn
"every conspiracy and war raised against him dispersed spontaneously
(αὐτομάτως)."[83] Emperors (and empresses) had been pious before, but in this
reign even the usually conservative visual media of official propaganda took
up the theme. On a monolithic granite column at the Hebdomon stood an
equestrian statue of Theodosius II "exalting in victory"; the statue's base
bore an inscription, which still survives, attributing the emperor's success to
"the vows of his sisters (*pro] votis sororum*)."[84] In this reign victory depended
less on the emperor's warlike qualities than on conciliation of the divine pro-
tector. The coinage attests the same victory ideology. Between 420 and early
422 the mint of Constantinople initiated a new victory type, the much-dis-
cussed Long-Cross Solidi. With obverses of Theodosius II, of his Western
colleague Honorius, and of Pulcheria and other empresses, these solidi present
on their reverses, held by the goddess Victory, a long jeweled cross studded with
precious stones. To contemporaries, who understood the meaning of the cross,

[81] Socrates, *Ecclesiastical History*, VII.22,4–6, ed. Hussey, II, 779; Sozomen, *Ecclesiastical History*,
IX.3,2, ed. Hansen, 395; Theodoret, *Ecclesiastical History*, V.36,4, ed. Parmentier and Scheidweiler,
339; Proclus of Constantinople, note 103 *infra*.
[82] This much may be extracted from a brief notice of Gennadius, *De viris illustribus*, 53, published
with Jerome, *De viris illustribus*, ed. G. Herding (Leipzig, 1924), 93=Marcellinus comes, *Chronicon, a.*
416.2, MGH, *AA*, XI (Berlin, 1874), 73: *scripsit ad reginas... "de fide et virginitate" librum valde
egregium, in quo praeveniens Nestorianum dogma impugnat.* K. Holum explores the imperial cult of
Mary in a forthcoming monograph on Pulcheria and other empresses of the Theodosian house.
[83] Sozomen, *Ecclesiastical History*, IX.3,3, ed. Hansen, 395.
[84] R. Demangel, *Contribution à la topographie de l'Hebdomon*, Recherches françaises en Turquie,
III (Paris, 1945), 33 ff.; cf. B. Croke, "Evidence for the Hun Invasion of Thrace in A.D. 422," *GRBS*,
18 (1977), 365 f., supporting 422 as the date of the monument.

their message was clear. Using the most potent victory symbol known in the vocabulary of Christian art, they declared that the victory of the emperor and Christ's victory on Golgotha were identical.[85]

Mention of these Long-Cross Solidi, first issued *ca.* 420–22, draws us inexorably into the orbit of the Persian war of 421 and the text of Theophanes quoted earlier. "Under the influence of the blessed Pulcheria," Theophanes relates, "the pious Theodosius sent...a golden cross studded with precious stones to be erected on Golgotha." It appears likely that this cross and the long jeweled cross of the solidi shared not only a common victory symbolism, conceived on the occasion of the Persian war, but also a common pattern, the much-revered processional "cross of Constantine."[86] This pattern cross existed in Constantinople by late in the fourth century, when it was kept at the Helenianae palace outside the Constantinian walls for use in coronation ceremonial.[87] In the early sixth century, however, Theodore Anagnostes located the same processional cross, now said to contain a fragment of the True Cross, in the imperial palace, from which it was carried forth "for the festal processions of emperors."[88] It also appears likely (and textual evidence exists to support the hypothesis)[89] that Pulcheria and Theodosius II introduced this cross into the palace to serve as a palladium of victory, a physical guarantee that Christ's victory on Golgotha would be repeated in the warlike undertakings of Theodosius and his sister.[90]

Theophanes continues: "In exchange for these gifts, the archbishop dispatched relics of the right arm of Stephen Protomartyr, in the care of St. Passarion." Treatment of Theodosian victory ideology has now clarified Pulcheria's motives in the transaction. Like the "cross of Constantine," the relics of St. Stephen would also function as a palladium of victory. Like the ascetic successes of Pulcheria and her sisters, the intercessions of the Saint would conciliate the divine protector.[91] Again, victory over Persia would repeat Christ's victory on Golgotha, and the *basileia* of Theodosius and Pulcheria would be secure.

[85] Holum, *op. cit.*, 153 ff., 164 ff., 172.

[86] *Ibid.*, 166 f.

[87] Constantine Porphyrogenitus, *De ceremoniis aulae Byzantinae*, I.91, Bonn ed. (1929), 414; cf. V. Tiftixoglu, "Die Hellenianai nebst einigen anderen Besitzungen im Vorfeld des frühen Konstantinopel," *Studien zur Frühgeschichte Konstantinopels*, ed. H.-G. Beck, Miscellanea byzantina monacensia, XIV (Munich, 1973), 79 ff., who dates the protocol of which this passage is a part to 393.

[88] Theodoros Anagnostes, *Kirchengeschichte*, ed. G. C. Hansen, GCS, 54 (Berlin, 1971), 13 lines 5–8, a previously unpublished comment in his *Historia tripartita* on Constantine's use of a fragment of the True Cross.

[89] Pseudo-Chrysostom, in PG, 50, col. 715; cf. F. Leroy, *L'homilétique de Proclus de Constantinople*, ST, 247 (Vatican City, 1967), 158, 216 f., identifying Proclus as the author.

[90] Holum, *op. cit.*, 166 f.

[91] Cf. the *Vita Symeonis syriaca*, 136, trans. H. Hilgenfeld, *TU*, 32,4 (1908), 179: "Auch der siegreiche und christliche Kaiser Leo...schickte Briefe und Gesandte mit grossem Eifer und schrieb an die Heerführer und Bischöfe, sie sollten ihm den Körper des heiligen Herrn Simeon schicken, um ihn bei sich zu ehren entsprechend den in ihm enthaltenen Schätzen, und um ihr Kaisertum durch seine Gebete zu behüten." Pulcheria's motives and her request to the archbishop Praÿllius paralleled exactly those of Leo, but unlike the archbishop of Jerusalem the people of Antioch refused to part with their treasure: "Da erhob sich ganz Antiochia samt allen Einwohnern, und mit Tränen und Seufzern schrieben sie und baten ihn: 'Weil unsere Stadt keine Mauer hat,...haben wir ihn geholt, damit er unsere Mauer ist und wir durch seine Gebete geschützt werden.' Kaum liess er sich dadurch bewegen, ihn bei ihnen zu lassen" (*ibid.*).

St. Stephen arrived with Passarion in Chalcedon, announced himself to Pulcheria in a vision, "and she arose taking her brother with her and went to greet the holy relics (εἰς συνάντησιν)." Appropriately, Theophanes mentions no joyous thronging of citizens, mighty and humble, young and old, male and female, because this *adventus* would benefit not the *polis* but the *basileia*. "Receiving them into the palace, she founded (κτίζει) a splendid chapel for the holy Protomartyr, and in it she placed the holy relics (κατέθετο)." In the final act of the sequence the focus is clearly on Pulcheria, who is identified as the *ktistes* and as the authority responsible for the *apothesis*.

For this last act of the sequence no more precise visualization could be contrived than that of the Trier Ivory. The two bishops who bear the relics may be Atticus of Constantinople and St. Passarion himself, a famous ascetic of Palestine also attested as *chorepiskopos*.[92] The imperial wagon on which they ride has just emerged from the tetrapylon into a special precinct which invites identification with the imperial palace. Like the words of the text, the design of the Trier ivory focuses attention on Pulcheria, who stands as *ktistes* before the splendid chapel with an open door which awaits the *apothesis*. Workmen clamber about on the superstructure, indicating that she founded the chapel[93] for these relics, as in the text of Theophanes. Pulcheria extends her right arm to receive St. Stephen, for the moment is at hand when the saint whose very name evoked the crown of victory[94] will be joined with the empress in a dynamic union.

Another text, this one nearly contemporary with the events of 421, clarifies with convincing precision the force of this gesture, and indeed the entire dynamic of the Trier ivory:

ἐν βασιλείοις στέφανος· ἐθαλάμευσε γὰρ αὐτὸν ἡ βασιλὶς καὶ Παρθένος.

The crown/St. Stephen is in the palace, for the virgin empress has brought him into her bridechamber.

This passage is from an encomium of St. Stephen, published among the *spuria* of St. John Chrysostom[95] but delivered most likely by Proclus, his sixth successor as bishop of Constantinople (d. 447).[96] In other sermons Proclus employed the verb θαλαμεύειν for Mary's reception of the Logos into her womb[97] and

[92] Cyril of Scythopolis, *Vita Euthymii*, 16, ed. E. Schwartz, *TU*, 49,2 (1939), 26; cf. F. Delmas, "Saint Passarion," *EO*, 3 (1900), 162–63.

[93] On the chapel of St. Stephen in Daphne, cf. Janin, *op. cit.* (note 72 *supra*), 489f.; and esp. T. F. Mathews, "Architecture et liturgie dans les premières églises palatiales de Constantinople," *Revue de l'Art*, 24 (1974), 22ff., who observes that it was "en aucun sens une église paroissiale ordinaire" but rather "une église palatiale conçue pour s'accorder avec le palais du point de vue architectural et pour répondre aux besoins liturgiques de la cour impériale." In its small scale the Trier ivory basilica corresponds well with this description, but it does not support Mathews' additional hypothesis that St. Stephen's in Daphne was octagonal or central in plan. To project a structure joined compactly with others in the palace complex, the artist would have to distort somewhat and draw on a general pictorial vocabulary, but as with the Chalke (*supra*, pp. 125–26) one would except some verisimilitude.

[94] Gagé, *op.cit.* (note 76 *supra*), 381.

[95] PG, 63, col. 933.

[96] Leroy, *op. cit.*, 158.

[97] *Oratio* V.2–3, PG, 65, col. 720: ὃν πᾶσα ἡ κτίσις φόβῳ καὶ τρόμῳ ὕμνησεν, αὐτὴ μόνη ἀνερμηνεύτως ἐθαλάμευσε...θάλαμος, ὡς ἐν νυμφῶνι γὰρ ὁ Θεὸς Λόγος ἐν αὐτῇ κατεσκήνωσε.

for the mystical union of Pulcheria herself with the crucified Christ,[98] and identified the symbolic "bridechamber" in question with virginity,[99] which Pulcheria, of course, shared with Mary. In the present text he uses the same symbolic language with dynastic and imperial overtones, for he declares that the mystical union of virgin empress and Stephen the victory crown took place within the palace.

As we observed above, the long cross which Pulcheria cradles on her left arm makes perfect sense as an attribute of *adventus* ceremonial. But if our historical interpretation of the Trier ivory is accepted we may also exploit the hypothesis expressed earlier, that when Pulcheria introduced St. Stephen's relics into the palace she placed the revered "cross of Constantine" there as well. In the sixth century Theodore Anagnostes merely attests the presence of this cross "in the palace," but in the tenth century the *De ceremoniis* does specify the church of St. Stephen.[100] It seems likely that Pulcheria founded St. Stephen's not only to receive the relics of the Protomartyr but also to serve as a palace repository for other objects which might reinforce the Theodosian notion of *basileia*[101]—in particular for the "cross of Constantine" which, as the pattern for Pulcheria's Golgotha cross and the cross of the long-cross solidi, formed part of the same ideological program. If this is so, then those who created the iconography of the Trier ivory would have placed a cross on Pulcheria's arm not only as an attribute of *adventus* ceremonial, but also to evoke the "cross of Constantine" as well, as a potent instrument to draw together the various manifestations of Christ's victory in the events of 421. For those sensitive to its meaning, the cross of the ivory symbolized both Christ's victory on Golgotha and the repetition of this victory in the martyrdom of St. Stephen,[102] in the ascetic achievement of Pulcheria,[103] and in the promise of success in the Persian war.

We wish to point out in conclusion that our study is based on the premise that an iconographic interpretation of the Trier ivory could not proceed from its stylistic dating even if such a dating were possible. By its very nature a relic translation was both a historical and a ceremonial-liturgical event, one which

[98] *Oratio* XII.1, *ibid.*, col. 788, quoted *infra*, note 103.

[99] *Oratio* XXVI.31, ed. Leroy, 187: παρθενεία, τῆς ἡμετέρας σωτηρίας ὁ θάλαμος.

[100] *De ceremoniis*, I.1,44, ed. A. Vogt, I (1935), 6; II (1939), 33; also II.8,10, 40, Bonn ed., 539, 549 f., 640.

[101] This function is confirmed as early as the reign of Zeno (474–91), who deposited in St. Stephen's a Gospel of Matthew copied by St. Barnabas and found on Cyprus with the relics of Barnabas himself; Theodore Anagnostes, *Epitome*, 436, ed. Hansen, 121.

[102] Cf. Basil of Seleucia, *Oratio* XLI, PG, 85, col. 472: καλῶς κατεκόσμησέν σε [i.e., St. Stephen] ὁ σταυρὸς τοῦ ὑπὲρ ἡμῶν παθόντος, νευρώσας τῆς σῆς προθυμίας τὰ αἰσθητήρια συνηρίθμησεν τοῖς ἀγγέλοις, κατηρίθμησεν ταῖς ἀσωμάτοις δυνάμεσιν, i.e., the cross adorns St. Stephen because the instrument of Christ's passion "firmed him up" for his own martyrdom. Cf. note 54 *supra*.

[103] Cf. Proclus, *Oratio* XI.1, PG, 65, col. 788, paralleling the ascetic achievement of Pulcheria with the martyrdom of St. Stephen: πάλαι μὲν γὰρ οἱ Ἰουδαῖοι λίθοις κατὰ Στεφάνου ἠκόντιζον, καταχῶσαι βουλόμενοι τὸν τοῦ σταυρωθέντος πρώταρχον ἀθλητὴν καὶ ἄμαχον ῥήτορα· ἡ δὲ ἑαυτὴν τῷ Χριστῷ ἀναθεῖσα παρθένος, πλοῦτον δι᾽ εὐλάβειαν ἐκένωσέ τε καὶ ἀνάλωσεν. τὴν οἰκείαν σάρκα τοῖς πάθεσιν ἐνέκρωσε· τὸν σταυρωθέντα ἐν ψυχῇ ἐθαλάμευσεν· τὸν ἐπίγειον οὐρανὸν τὸν ὁρώμενον ἐκαλλώπισεν κτλ. Leroy, *op. cit.*, 158, who believes that this sermon was delivered in St. Stephen's in Daphne, proposes that the final words quoted here refer to its mosaic decorations.

entered the church calendar for celebration on a yearly basis and which had, therefore, a continuing present reality and a continuing reason to be illustrated.[104] No scholar would confuse the date of the Menologium of Basil II, for example, with the dates of the translations depicted in its miniatures, or would interpret these miniatures, if their subjects were unknown, from stylistic affinities or from datable hairstyles, fibula forms, architectural motifs, and the like. Within any visual tradition reillustration naturally meant the reinterpretation of such details according to contemporary fashion.[105]

It has long been assumed—correctly, we believe—that the Trier plaque once decorated the side of a reliquary box in which were kept the remains, or part of the remains, which are translated in the relief.[106] This hypothesis provides a complementary rationale for separating the date of the carving from the date of the procession. For it was characteristic of the early Church to respond to a growing martyr cult by subdividing and redistributing the saints' relics.[107] One can easily imagine the box employed for the redistribution of St. Stephen's remains being decorated with reliefs of his martyrdom and burial, of the invention of his relics, and of the circumstances of their original translation in 421.[108]

The Trier ivory could, of course, represent an event unknown from the literary sources, but this does not appear likely. There can have been relatively few occasions in the Early Byzantine period when an empress translated relics to support her own *basileia*,[109] and fewer still when *apothesis* occurred in a newly constructed church within the palace complex. Thus *nihil obstante* we believe that we have identified an important visual document which clarifies the dynamics of relic *adventus* and the characteristic victory ideology of the Theodosian house.

[104] Evagrius, *Ecclesiastical History*, I.16, ed. Parmentier, 26, after describing the translation of the bones of Ignatius of Antioch in 371, adds: "From this a public feast is celebrated down to our own time with rejoicing of the whole people." We cannot offer direct evidence for celebration of the Stephen *adventus* immediately after 421. Proclus of Constantinople delivered an *encomium* of St. Stephen, *Oratio* XII, PG, 65, col. 809 ff., on his feast day, December 26, with no mention of the *adventus*. Proclus did allude to it in another encomium quoted *supra*, p. 131, but with no hint of the date or circumstances of delivery. Of course, celebration of this *adventus* may have been limited to the liturgical cycle of the court.

[105] Weitzmann, *Illustrations* (note 19 *supra*), 157 ff. Thus, the Trier ivory might show updating in imperial costume (notes 40, 43 *supra*) and in the decoration of the Chalke gate (p. 13 *supra*).

[106] E.g., Delbrueck, *Die Consulardiptychen*, 262; Volbach, *op. cit.*, 95; Fischer, *op. cit.*, 7f.

[107] Delehaye, *op. cit.* (note 7 *supra*), 60 ff. and *passim*.

[108] The first illustration of the translation of 421, if it was not the Trier ivory itself, may have been an illustrated chronicle (K. Weitzmann, "Illustration for the Chronicles of Sozomenos, Theodoret and Malalas," *Byzantion*, 16 [1942–43], 87–134) or an illustrated saint's life (*idem*, "The Selection of Texts for Cyclic Illustration in Byzantine Manuscripts," in *Byzantine Books and Bookmen* [Washington, D.C., 1975], 84 ff.). The ivory might well be a deluxe, expanded redaction based on something as simple as the Berlin chronicle fragment (fig. 2). Another likely source is the mural decoration of St. Stephen's in Daphne. Gregory of Nyssa, *De S. Theodoro Martyre*, PG, 46, col. 737, describes a *martyrium* of St. Theodore at Euchaita with painted images of the Saint's life and martyrdom. Similar decorations in Pulcheria's palatine chapel (note 103 *supra*) could not have lacked illustration of the *adventus* of 421 and would have interpreted the event in the same manner as the Trier ivory.

[109] A possible example: Marcellinus comes, *Chronicon*, a. 439.2, MGH, *AA*, XI, 80, reports that when Pulcheria's sister-in-law Eudocia returned from the Holy Land, she brought more relics of St. Stephen with her which were deposited (later?) in the basilica of St. Lawrence.

1. Trier, Domschatz, Translation of the Relics Ivory (*ca.* 1:1)

2. Berlin, Staatliche Museen, Papyrus 13296,
Adventus of the Relics of SS. Luke and Andrew

3. Salonika, Arch of Galerius, *Adventus* of Galerius

4. Rossano, Cathedral Treasury, Gospels (p. 2), Entry of Christ into Jerusalem

5. Vatican Library, cod. 1613 (p. 344), Procession of the Relics of Anastasius of Persia

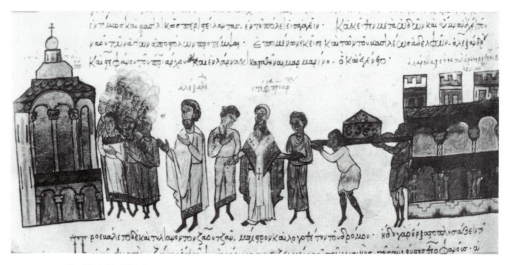

6. Madrid, Bibl. Nac., cod. 5-3, n. 2 (fol. 106ᵛ), Procession of the Relics of Michael III

7. Vatican Library, cod. 1613 (p. 121), Deposition of the Relics of St. Luke

8. Mount Athos, Vatopedi, cod. 456 (fol. 253ʳ),
Deposition of the Relics of St. Abibos

9. Vatican Library, cod. 1613 (p. 353), Procession of the Relics of John Chrysostom

10. Paris, Bibl. Nat., cod. nouv. acq. lat. 2334 (fol. 40ʳ), *Adventus* of the Patriarch Joseph

11. Stockholm, Nationalmuseum, Sarcophagus Lid Fragment, Triumphal Procession of the Deceased

XV

Meaning in Coptic Funerary Sculpture
(with plates 4-13)

Both our concept of what Coptic art is and the substance of most books bearing
that title have, to a surprising degree, taken their form from the analysis of
Coptic sculpture[1]. For decades art historians have been attracted by Coptic
stone carving; they have been fascinated by its strangely modern, expressive
style and intrigued by the puzzle of its dating, localization, and of its very
meaning. That this puzzle exists owes much to the haphazard nature of Egyptian
archaeology and to the demands of the international art market, for unlike the
sites and monuments associated with the pharaohs, those linked with the Roman
and Byzantine periods of Egyptian culture have not had the benefit of syste-
matic excavation. As archaeologists searched for papyri, stone carvings were
often consigned, by default, to the *sebakhin* - and these peasants, in turn, fed
the art trade[2]. The unhappy result was two-fold: a disturbing number of fakes
and recut pieces (a problem exacerbated by the highly friable limestone charac-
teristic of Coptic sculpture)[3], and an inordinately high ratio of architectural
reliefs, such as niche heads, capitals, keystones, and friezes, whose original
architectural context is unknown. Moreover, because most Coptic reliefs which
are not purely decorative are explicitly pagan, and because a few early
archaeologists (notably, Edouard Naville in the 1890's)[4] were willing to
speculate that such pieces had come from Christian churches, the art historian
found himself confronted with the dilemma of how to reconcile the licentiousness
of Coptic stone carving with the piety of Coptic Christianity. Charles Rufus
Morey's solution was as feeble as it was canonical:[5]

> Coptic art is the most primitive phase of the early Christian; its inspiration,
> when one can penetrate its content, is more superstition than faith. The obsession
> with sex which transpires from the detailed account of temptation in the lives of
> Egyptian monastic saints is apparently present also in the treatment of the mytholo-

1 Cf. Klaus Wessel's Koptische Kunst (Recklinghausen, 1963), where 80 of 133 figures
 are of stone sculpture; in Arne Effenberger's book of the same title, published
 twelve years later (Leipzig, 1975),76 of the 126 figures are devoted to sculpture.
2 F. Petrie, Tombs of the Courtiers and Oxyrhynkhos (London, 1925), 12f.
3 See G. Vikan, "The So-Called 'Sheidkh Ibada Group' of Early Coptic Sculpture",
 Third Annual Byzantine Studies Conference: Abstracts of Papers (New York, 1977),
 15f.; and S. Boyd and G. Vikan, Questions of Authenticity Among the Arts of
 Byzantium, Dumbarton Oaks Byzantine Collection Publications, 3 (Washington, D.C.,
 1981), 8f.
4 E. Naville and T. Hayter Lewis, Ahnas el Medineh (Heracleopolis Magna), Eleventh
 Memoir of the Egypt Exploration Fund (London, 1894), 32.
5 Medieval Art (New York, 1942), 59.

gical motifs which are much used in Coptic stone carving; a favorite theme is Leda and the swan, rendered with a sensual fatness in the nudes and an obvious interest in the implications of the story. ...

For decades correct iconographic interpretation of Coptic sculpture was stymied by ignorance of (or misinformation on) its true context of origin. It was only in 1969 that Hjalmar Torp, in a short article, proved that the dilemma did not in fact exist[6]. He went back to the original archaeological reports of Naville and Breccia and concluded that their pagan reliefs - respectively from Ahnas and Oxyrhynchus - came not from Christian churches but from pagan tombs. The key had been found and the *comparanda* were now legion, for Torp at last recognized that Coptic sculpture was predominantly sepulchral, and that it was a regional, stylistically distinctive offshoot of earlier Roman sepulchral art. The morphological threads connecting the marble urns and sarcophagi of Imperial Rome, via Roman Alexandria, to the tomb chamber reliefs of Ahnas and Oxyrhynchus were shown to be many and strong. But what was less clear for Torp was the question of contentual genealogy. True, the appropriate actors were there - Leda, Herakles, Dionysus, victories, meanads, and satyrs - but were they players in a Roman or in an Egyptian eschatological drama? Or had they, in transit, degenerated to meaningless props? Torp, in closing his article, suggested a solution somewhere between the first and third possibilities[7]:

It (Coptic mythological sculpture) evokes association felt somehow to be foreign to the (pagan) religious world of Upper Egypt. Perhaps it is this feeling of curious "displacement" that for so long has rendered it difficult to determine the true nature of this sector of Coptic art.

Hjalmar Torp provided the first essential key to solving the puzzle of Coptic sculpture; by identifying its context he was able to trace its morphological antecedents. This in turn (through the juxtaposition of ancestor and progeny) has helped to clarify our image of what makes Coptic figure style so distinc-tive. But all of this seemed, through Torp, to come only at the expense of Coptic iconography, which was left looking derivative and naive. Thus in a sense, Torp's key was his reader's challange - a challenge to find in Coptic mythological sculpture a distinctive Egyptian *meaning* comparable to its distinctive Egyptian *style*. To this end I here offer a brief reexamination of a well-known Coptic niche head in the Dumbarton Oaks Collection *(plates 4-5)*[8].

6 H. Torp, "Leda christiana: The Problem of the Interpretation of Coptic Sculpture with Mythological Motifs", ActaIRNorv, 4 (1969), 104ff. See also H.-G. Severin, "Gli scavi eseguiti ad Ahnas, Bahnasa, Bawit et Saqqara: Storia delle inter-pretazioni e nuovi risultati", XXVIII corso di cultura sull'arte ravennate e bizantina, Ravenna, April 26 - May 8, 1981 (Ravenna, 1981), 299ff.
7 Torp, 1969, 112.
8 Acc. no. 43.6 (45 x 117.5 x 34.5 cm). The present article is adapted from the entry on this piece in my forthcoming Catalogue of the Byzantine and Early Mediaeval Antiquities in the Dumbarton Oaks Collection, Volume 5: The Sculpture (no. 9, with full description and bibliography). See also the perceptive article by T. Whittemore, "An epiphaneia of Dionysos on a Coptic Carved Stone", Coptic Studies in Honor of Walter Ewing Crum, bulletin of the Byzantine Institute 2 (1950), 541ff.

This heavily recut and restored limestone relief is formed of a steeply rising broken pediment whose central span is bridged by a thick arch. The structural clarity of both gable and arch is obscured by a deeply carved vegetal scroll consisting of an undulating tendril encircling a spiky leaf form of five or six curling points. Sprouting at regular intervals in the spaces between these motifs are hemispherical lotus pods (each with three buds), while running beneath the scroll is a large bead and reel molding. In the spandrels are a fragmented pair of floral wreaths, each trailing a thick ribbon and enclosing a heavily-draped female bust; unfortunately, both figures have been severely reworked.

Squeezed into the low, vaulted tympanum is a representation of Dionysus driving a wagon. He is portrayed as the youthful, androgenous wine god evoked by Nonnus (Dionysiaca, 16.172), "soft-haired ... shaped like a woman"[9]. His hair is arranged in carefully order vertical curls and he wears, instead of the more customary loose mantle, a long-sleeved feminine robe which reaches to his ankles. This is the "woman's dress of purple" or *peplos* described by Nonnus and Macrobius (Saturnalia, I.18, 22); it appears frequently in North African mosaic pavements and occasionally in Egypto-Roman sculpture[10]. Dionysus is seated in a simple, large-wheeled *biga* to which is attached, with a heavy wooden yoke, a pair of steers, each with an ornamental disk between its horns. More typically the wagon of Dionysus is drawn by centaurs, panthers, or elephants. However, the wine god had long been associated with the bull[11]; Nonnus, for example, speaks of the "bull-shaped Dionysus" (Dionysiaca 6.205), an image precisely paralleled by an Egypto-Roman terracotta medallion showing the Dionysus-Bull surrounded by bunches of grapes *(plate 6,1)*[12]. Occasionally, as in the frescoes of the Casa di Marco Lucrezio and the Casa di Frontone at Pompeii, the wagon of Dionysus is drawn by bulls[13]. With his left hand Dionysus holds the thick reins of the bulls, while in his right hand he raises an unusually long whip to spur them on. Growing out of the gable behind the wagon is a vine tendril sprouting disporportionately large bunches of grapes, and spiky leaves. The entire image evokes yet another passage in the Dionysiaca (17.19ff.), whose author, Nonnus of Panopolis, was a countryman (and a near-contemporary) of the carver of the niche:

9 Loeb, II (Cambridge, Mass./London, 1940), for this and subsequent quotations from the Dionysiaca.
10 Cf. K. Dunbabin, "The Triumph of Dionysus on Mosaics in North Africa", BSR 39 (1971), 53, pls. XII-XVII; and G. Duthuit, La sculpture copte (Paris, 1931), pl. XVIII.
11 A.W. Curtius, Der Stier des Dionysos (Jena, 1882), 4ff.
12 P. Perdrizet, Les terres cuites gresques d'Egypte de la Collection Fouquet (Nancy/Paris/Strasbourg, 1921), no. 197 (with discussion).
13 P. Herrmann, Denkmäler der Malerei des Altertums: Series I (Munich, 1904-1931), pls. 61, 158.

...This (ivy) he planted in the soil of Asia, as he drove the savage car of divine Cybele, with a broad rein of grapevine, under the shadow of ivy, the vine's fellow, touching up his travelling team with a blossoming whip. ...

Partially concealed at the lower left corner of the tympanum is a small circular structure with a heavy domed roof; just five of its supporting columns are visible. It is strikingly similar to a miniature *tholos* placed atop the cornucopia of Isis on one of the panels of the famous ivory ambo in Aachen, a monument traditionally assigned to Egypt and to the sixth century *(plate 6,2)*[14]. Such a building, apparently dating to the Antonine period, has been excavated in the Athenian Agora *(plate 7,1)*[15]. It has been suggested that the Athenian structure served to enshrine a cult statue of a divinity or a hero – perhaps Aphrodite, Herakles or Dionysus[16]: similarly, the tiny temple on the ivory is usually taken to be the sanctuary of Horus, whose cult statue is prominently displayed inside. By analogy, the *tholos* in the Dumbarton Oaks niche head should probably also be recognized as a sanctuary – and specifically, that of Dionysus. Dionysus is occasionally represented inside a small sanctuary[17], which in some cases, as on a bronze medaillion of Antoninus Pius *(plate 7,2)*, is specifically circular and domed[18]. The cult of Dionysus had long been associated with circular sanctuaries, some of which have survived[19]; Macrobius (Saturnalia, 1.18, 11), for example, described such a structure in Thrace, dedicated to Dionysus-Helios. Moreover, during the great Dionysiac procession instituted at Alexandria by Ptolemy Philadelphos (Callixenus of Rhodes, Athenaeus, 5.198c), a giant cult statue was paraded inside a *skias*, a canopy of ivy and vines which was, in effect, a vegetal *tholos*.

The form of this niche head and the details of its ornament leave little doubt that it came from Oxyrhynchus (modern Behnesa) in Middle Egypt. It is closely matched in both design and ornamentation by a set of four niche heads excavated at that site by Evaristo Breccia *(e.g. plate 8)*[20]. Each consists of a steeply-rising broken pediment whose central span is bridged by a thick arch. At least two are flanked by wreaths with ribbons, one includes an over-sized

14 W.F. Volbach, Elfenbeinarbeiten der Spätantike und des frühen Mittelalters, Römisch-Germanisches Zentralmuseum zu Mainz: Katalog VII, 3rd ed. (Mainz, 1976), no. 72.

15 W.B. Dinsmoor, Jr., "The Monopteros in the Athenian Agora", Hesperia 43 (1974), fig. 11.

16 Ibid., 426.

17 Cf. F. Matz, Die dionysischen Sarkophage, Die antiken Sarkophagreliefs (Berlin, 1968), I, pl. 41; M. Bernhart, "Dionysos und seine Familie auf griechischen Münzen", JNG I (1949), 28, 94ff., pl. II, 22, 24-26; and P. du Bourguet, Musée National du Louvre, catalogue des étoffes coptes: I (Paris, 1964), D88.

18 F. Knecchi, I medaglioni romani: II, Bronzo (Milan, 1912), 22f., pl. 55,9.

19 F. Robert, Thymélè (Paris, 1939), 424f., and 377ff., 383ff., 398.

20 E. Breccia, Le Musée Gréco-Romain: 1925-1931 (Bergamo, 1932), fig. 155. See also figs. 153, 154; and idem, Le Musée Gréco-Romain: 1931-1932 (Bergamo, 1933), fig. 116.

bead and reel molding, one a Dionysus scene in its tympanum, and in all four
the structural elements are covered by a deeply-cut leafy scroll whose in-
dividual motifs are drawn from the same repertoire as those of the Dumbarton
Oaks niche. Moreover, these same motifs, including the pod with buds, the
dehydrated nine-pointed vine leaf, and the curling five-pointed leaf whose final
point is drawn around to the stem to form a circle, all appear frequently, in
varying forms, among the wealth of carved architectural fragments found at
Oxyrhynchus *(plate 9,1.2)* [21].

According to the widely-accepted chronology of Egypto-Roman and Coptic
sculpture proposed by Ernst Kitzinger more than four decades ago, most of the
Oxyrhynchus material should be assigned to the fourth century, although Anna
Gonosova's recent analysis of a pair of monogram capitals in the Fogg Art
Museum leaves no doubt that its activity extended at least to the late sixth
century[22]. Within the Oxyrhynchus series, the Dumbarton Oaks niche probably
occupies a relatively late position. This is suggested both by the highly-
stylized, desiccated treatment of its leaf forms, and by the thoroughly
unclassical organization of its pediment, for among the dozen broken-outline
niche heads published by Breccia, the Dumbarton Oaks type is clearly furthest
removed from the Late Antique version exemplified at Baalbeck. Several of the
floral motifs shared by the Dumbarton Oaks niche and the four niches most
closely related to it appear also in a Christian funeral chapel at Oxyrhynchus,
excavated by Petrie[23]. While Petrie's suggested sixth-century dating may be too
late, the stylization and structural degeneration of the acanthus capitals found
in the tomb as well as the large wreath-enclosed cross on one capital *(plate
10,1)* would be hard to imagine before the mid-fifth century. Hans-Georg
Severin's recent dating of some of these pieces to the second half of the fifth
century is probably close to the mark for the Dumbarton Oaks niche nead as
well[24].

Torp demonstrated that most Oxyrhynchus sculpture probably did not come from
"churces and oratories" as Breccia had thought, but rather from a vast necro-
polis outside the Roman walls of the city[25]. To judge from its size and shape,
the Dumbarton Oaks relief was probably used to decorate the top of a shallow
wall niche of the sort which customarily lined Late Antique tomb chambers

21 Idem, 1932, figs. 152, 176. See also idem, 1933, 105.
22 E. Kitzinger, "Notes on Early Coptic Sculpture", Archaeologica 87 (1938), 200; and
 A. Gonosova, "A Note on Coptic Sculpture", in press.
23 Petrie, 1925, pl. XLV,1, 7 (tomb 42).
24 On Oxyrhynchus tomb 42, see Severin, 1981, 303ff.
25 Breccia, 1933, 44; Torp, 1969, 105f.

throughout Egypt, including those at Oxyrhynchus *(plate 11)* [26] ; originally it would have been painted and perhaps stuccoed as well.

From the early Hellenistic period the cult of Dionysus enjoyed extraordinary popularity in Egypt. Ptolemy Philadelphos instituted a major Dionysiac procession in Alexandria, while Ptolemy Philopator, the self-styled "New Dionysus", conducted a campaign to identify and enroll all initiates, a fact suggestive of the breadth and depth of its penetration[27]. Papyri from Oxyrhynchus attest to the existence there of a temple of Dionysus through the late Roman period[28]. And certainly, Dionysus would have been an appropriate fixture in a late Roman tomb chamber (there or anywhere), since he had long been associated with death and the Underworld[29], and in Egypt had been specifically identified, according to Herodotus (2.144), Plutarch (De Iside, 35.364) and numerous local inscriptions, with Osiris, the ancient god of the dead[30]. Indeed Egypt, like Italy, had a rich tradition of Dionysiac sepulchral art; his symbols and members of his *thiasos* figure prominently on Egypto-Roman garland sarcophagi, in sculpted and frescoed tomb decoration, and in niche heads from Ahnas which, like those of Oxyrhynchus, likely came from tomb chambers[31]. An especially explicit Alexandrian grave stela of the second or third century shows the deceased, a three-year-old boy, portrayed with the attributes of Dionysus *(plate 12)* [32].

Images of Dionysus and, more precisely, of Dionysiac processions were among the favord sepulchral themes of Imperial roman stone carvers[33] - a fact which at once reenforces Torp's basic contention and invites the testing, through specific comparisons, of its implications. No monument speaks more eloquently for the tradition of Rome than does the famous marble sarcophagus of the Procession

26 Petrie, 1925, tomb 48 (page 17, pls. XLII, XLVI, 6). Illustrated is the underground tomb chamber proper; the bench at the right probably covers the actual grave, while at the left is a small, blind niche topped by a limestone pediment. See also Torp, 1969, 107, pls. IIa, IXc.
27 M.P. Nilsson, The Dionysiac Mysteries of the Hellenistic and Roman Age, Skrifter utgivna av Svenska Institute i Athen, 8°, V (Lund, 1957), 11f.
28 E.G. Turner, "Roman Oxyrhynchus", JEA 38 (1952), 82.
29 Nilsson, 1957, 118ff.
30 Perdrizet, 1921, 81f.; and A. Bruhl, Liber pater: Origine et expansion du culte dionysiaque à Rome et dans le monde romain, BEFAR 175 (Paris, 1953), 250ff.
31 See A. Adriani, Repertorio d'arte dell'Egitto greco-romano: Series A, volume I (Palermo, 1961), nos. 11, 19, 20, 24; idem, Repertorio ..., Series C, volume I-II (Palermo, 1963), no. 122; S. Gabra and É. Drioton, Peintures à fresques et scènes peintes à Hermoupolis-Ouest (Tourna el-Gebel) (Cairo, 1954), 9, pls. 2, 3. 6. 11, 12. 18. For Ahnas, see Torp, 1969, 101ff., 109, and U.M. de Villard, La scultura ad Ahnâs (Milan, 1923), figs. 29, 32, 47.
32 K. Schauenburg, "Pluton und Dionysos", JdI 68 (1953), 72, fig. 24.
33 Matz, 1968, II, 188ff., nos. 78ff.

of Dionysus in the Walters Art Gallery, Baltimore *(plate 13)* [34]. Our concern here is not with obvious and profound differences in style (second-century Roman vs. fifth-century Coptic), changes in medium (from marble to limestone), or alterations in context (from sarcophagus to niche head); these are all qualities Torp himself recognized and helped to isolate a characteristically Egyptian. Rather, our concern is with iconography and, specifically, with whether the Dumbarton Oaks relief is somehow distinctively Egyptian in this quality as well.

The Walters sarcophagus typifies the Roman approach to the procession of Dionysus by showing the wine god in the company of his festive *thiasos*, and by including a profuse display of spoils from his Indian campaign. The idealized bacchic revelry of the group is usually taken as a general allusion to the sort of afterlife to be expected by the *mystae*, while the reference to the Indian campaign is understood as an evocation of the fact that Dionysus, a mortal, earned apotheosis for having distinguished himself on earth through a series of extraordinary deeds – a reward that an initiate into his cult would likewise anticipate as *quid pro quo* for his earthly *virtus* [35]. In the words of Prudentius (Symm., 1.122) [36]:

A young man of Thebes (i.e. Dionysus) becomes a god because he has conquered India and comes wantoning in triumph for his victory, bringing home the gold of the vanquished nation. ...

Obviously the Dumbarton Oaks niche head descends from this Roman tradition neither in its morphology nor in its eschatology; there is no tipsy *thiasos* nor are there any allusions to the Indian campaign. Rather, a solitary and sober Dionysus is purposefully driving toward – in fact, *returning to* – his own shrine. This disjuncture seems all the more surprising since Nonnus takes care to perpetuate the traditional Roman view (Dionysiaca, 13.19):

O mighty Dionysos! Your father bids you destroy the race of Indians, untaught of piety. Come, lift the thyrsus of battle in your hands, and earn heaven by your deeds.

What sense then, if any, is to be made of the Dumbarton Oaks relief?

The idea of the return of Dionysus was always basic to his cult. Most of the Orphic hymns devoted to the wine god end with an invocation for his return among the initiates, numerous epigraphic sources refer to feasts celebrated at fixed intervals in honor of the returning Dionysus, and at Delphi the *Thyiads* went out in alternate Novembers to find and awaken the infant Dionysus and to

34 Ibid., no. 95.
35 Nilsson, 1957, 131; Bruhl, 1953, 311; and R. Turcan, Les sarcophages romains à représentations dionysiaques, BEFAR, 210 (Paris, 1966), 468ff.
36 Loeb, I (Cambridge, Mass./London, 1949), 359.

return him to his tomb in the temple of Apollo[37]. Since Dionysus was, almost from his origins, a god of vegetation and a god of the Underworld[38], it is hardly surprising that his return was associated with regeneration and resurrection. Witness the many springtime festivals associated with his awakening or return[39], a number of which included a *pompa* wherein a cult statue would be paraded into the city or from one sanctuary to another[40]. During the famous *Anthesteria*, for example, a statue of Dionysus was brought up out of the sea on a car-boat and was escorted to a sanctuary in the *Limnaion*[41]. The fifty-third Orphic hymn more specifically evokes resurrection (and not simple vegetal regeneration) since it speaks of the return of the *chthonian* Dionysus who, in biennial cycles, lies asleep in the realm of the dead[42]:

> I call upon Bacchos, appearing every second year, the chthonian Dionysos, aroused together with fair-haired nymphs, who, reposing in the holy house of Persephone, sleeps a holy Bacchic time of two years, but when he again arouses the trieteric revel he turns to a hymn with his fair-girdled nurses, now lulling to sleep, now arousing the times as the seasons wheel by.

This escatology is fully consistent with myths of various origins – but all of thoroughly *Egyptian* flavor – which make of Dionysus a god who was murdered and brought back to life. Nonnus (Dionysiaca, 6.169ff.), for example, describes the dismemberment of Dionysus-Zagreus at the hands of the Titans and his rebirth as Dionysus. Both Plutarch (De Iside, 35.364) and Servius (In Georg., 1.166) expressly parallel this legend with the dismemberment of Osiris and his subsequent resurrection, and the former links it specifically with the Delphic rite of the periodic return of Dionysus to the temple of Apollo. By the Late Antique period, and specifically in Egypt, the identification of Dionysus with Helios Apollo was firmly established, both in literature and art[43]. The return of Dionysus to his own temple, therefore, is probably to be understood in the same sense as the return of Apoll to his. Claudian, an Egyptian and near-contemporary of the carver of the Dumbarton Oaks niche, describes the return of Apollo to his (and Dionysus') temple at Delphi as a time when "... the woods, the caven regain their voice, and the streams their life ..."[44]. Indeed, the prominent substitution of bulls, the primordial image of Dionysiac fecundity, with

37 Nilsson, 1957, 38, n. 2; A.J. Festugière, "Les mystères de Dionysos", RBibl 44 (1935), 210; and O. Kern, "Dionysos", RE 5, cols. 1018f.
38 Bruhl, 1953, 310.
39 Nilsson, 1957, 39.
40 F. Bömer, "Pompa", RE 21², cols. 1936ff.
41 L. Deubner, Attische Feste (Berlin, 1956), 93ff., fig. 1.
42 Nilsson, 1957, 40.
43 See, for example, Macrobius, Saturnalia, 1.18, 22; and Nonnus, Dionysiaca, 17.19, 21, and 38.80ff. for the identification of Dionysus and Helios in literature, and in Egyptian art, the Dionysus-Helios and Selene diptych in Sens (Volbach, 1976, no. 61).
44 Claudian, 2.28, 25ff. Claudian is here drawing a parallel between the adventus of Apollo and the ceremonial arrival of Honorius into Rome, in 404.

the sun-like disk between their horns (an allusion to the Apis Bull and Osiris), may well have been calculated to reenforce that point[45].

But what of the two heavily-reworked spandrel busts? Garlands enclosing figures or symbols were a common ingredient of Late Antique sepulchral art, including that at Oxyrhynchus where the most frequent central motif is a cross or Christogram[46]. Despite their deteriorated state, both of the Dumbarton Oaks *imagines clipeatae* appear to be female and to be raising their hands. Moreover, the figure in the right spandrel is clearly holding a long thin object in her left hand, whose lower extension overlaps the wreath. This suggests that both are Victories holding a crown in the right hand and a palm branch in the left. Such Victories appear often on Aldexandrian garland sarcophagi and occasionally in Coptic funerary niche heads *(plate 10,2)*[47]. In general, they evoke the victory of the initiate over death, either through earthly *virtus*[48] or, as here, through participation in the resurrection of Dionysus.

Returning now to the challenge implicit in Torp's article, I think that three interrelated conclusions are justified: first, that the Dumbarton Oaks niche head does indeed make good sense within its sepulchral context; second, that this eschatological sense, that of resurrection as opposed to apotheosis through *virtus*, is destinct from the traditional Dionysiac eschatology of Imperial Rome; and, third, that this distinctiveness reflects a characteristically *Egyptian* (Osirian) point of view. Thus, despite the general affinity that this piece shows with the Greco-Roman tradition of decorating the buildings and furniture of the dead with images of Dionysus, it specifically distinguishes itself from the immediate tradition of Imperial Rome not only through its style, medium, and setting, but also through its iconography. Of course, this is not to say that all Coptic mythological sculpture shares this level of meaning (for much of it is clearly naive and banal)[49] or that all of it with meaning diverges so clearly from traditional Roman practice (for indeed, as Torp has shown, a number of pieces are quite precisely dependent on Roman antecedents)[50]. It does, however, make of this relief a key in its own right - a key to the door just beyond Torp's, which invites the student of Coptic sculpture, once having entered the realm of the dead, to enter a specifically Egyptian world of funereal symbolism.

45 Curtius, 1882, 30ff.; and Bruhl, 1953, 251.
46 See Breccia, 1932, pl. p. 102, figs. 154, 155, 166, 167; idem, 1933, figs. 100, 101, 107.
47 Wessel, 1963, fig. 47.
48 Cf. Cairo, Coptic Museum 7281, a section of a coptic frieze on which Herakles, with lion and club, is about to be crowned by a Victory holding a palm frond (Wessel, 1963, fig. 9).
49 Cf. Torp, 1969, pl. IVc, a niche head showing a satyr in pursuit of a maenad.
50 Cf. Torp, 1969, pl. IIIa, c; VIIa-d.

Plate 4

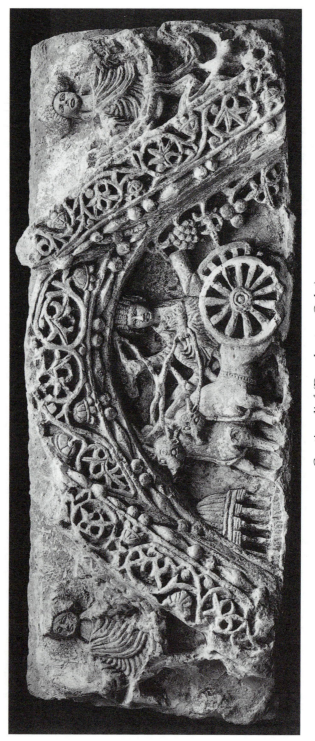

Coptic relief (Dumbarton Oaks)
Dionysus driving a wagon

Plate 5

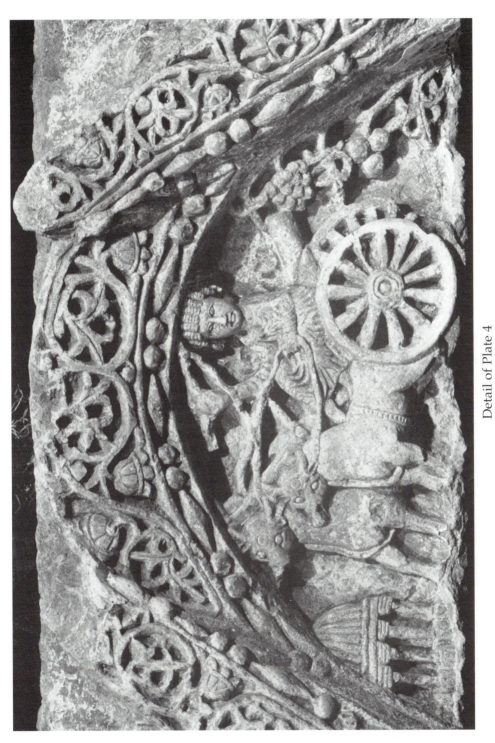

Detail of Plate 4

Plate 6

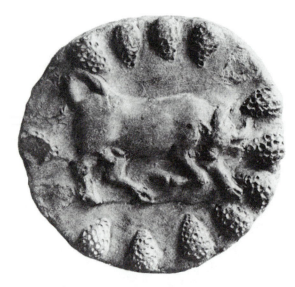

1. Terracotta medallion from Egypt

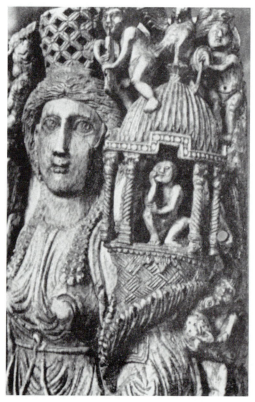

2. Ivory (Aachen)

1. Bronze medallion of Antoninus Pius

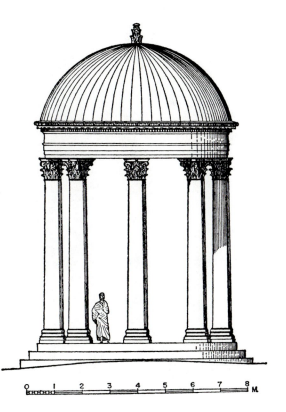

2. Monopteros
(Athens)

Plate 8

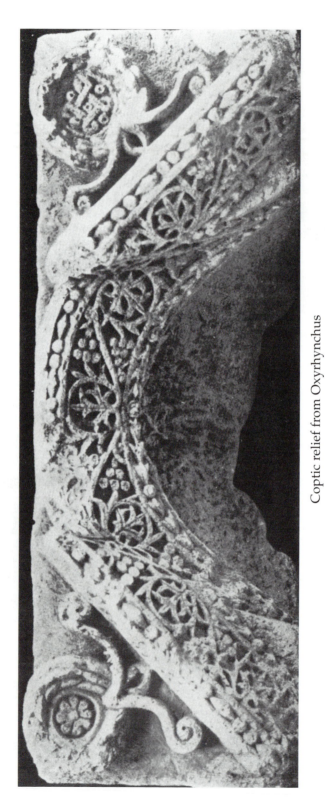

Coptic relief from Oxyrhynchus

Plate 9

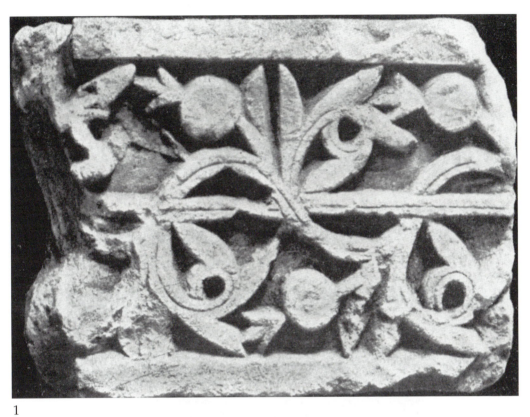

1

(1 & 2) Fragments from Oxyrhynchus

2

Plate 10

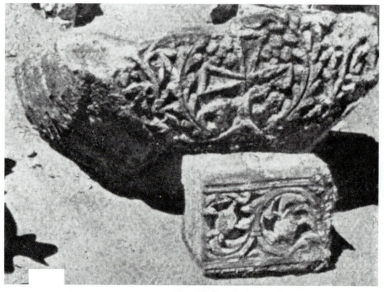

1. From a funerary chapel at Oxyrhynchus

2. Victory (at head of a funerary niche)

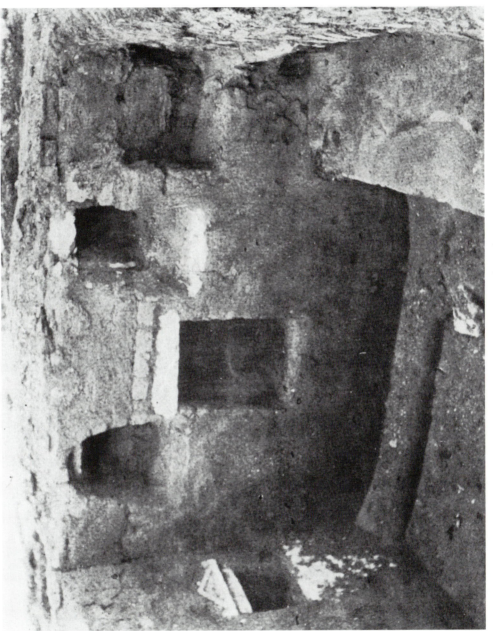

Tomb chamber at Oxyrhynchus

Plate 12

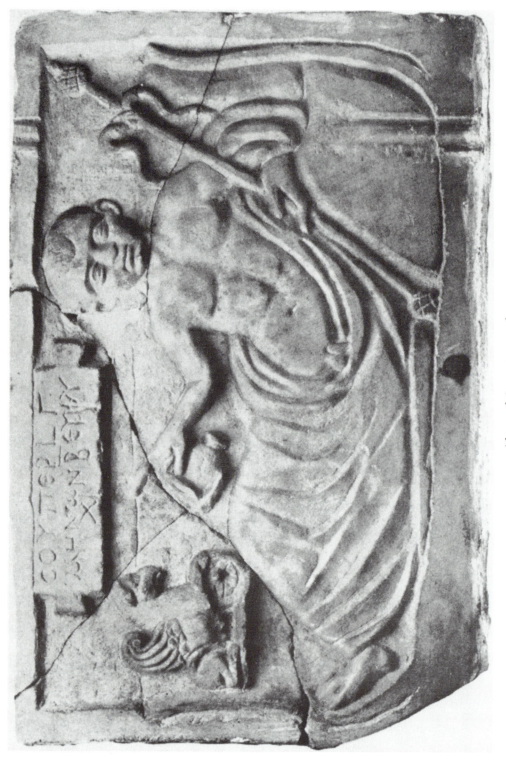

Alexandrian grave stele

Sarcophagus with Procession of Dionysus (Baltimore)

INDEX